DAVID BUSCH'S NIKON® Z6

GUIDE TO DIGITAL PHOTOGRAPHY

David D. Busch

rockynook

David Busch's Nikon* Z6 Guide to Digital Photography David D. Busch

Project Manager: Jenny Davidson

Series Technical Editor: Michael D. Sullivan

Layout: Bill Hartman

Cover Design: Mike Tanamachi Indexer: Valerie Haynes Perry Proofreader: Mike Beady

ISBN: 978-1-68198-468-1

1st Edition (1st printing, May 2019)

© 2019 David D. Busch

All images @ David D. Busch unless otherwise noted

Rocky Nook, Inc. 1010 B Street, Suite 350 San Rafael, CA 94901 USA www.rockynook.com

Distributed in the UK and Europe by Publishers Group UK
Distributed in the U.S. and all other territories by Ingram Publisher Services

Library of Congress Control Number: 2018956099

All rights reserved. No part of the material protected by this copyright notice may be reproduced or utilized in any form, electronic or mechanical, including photocopying, recording, or by any information storage and retrieval system, without written permission of the publisher.

Many of the designations in this book used by manufacturers and sellers to distinguish their products are claimed as trademarks of their respective companies. Where those designations appear in this book, and Rocky Nook was aware of a trademark claim, the designations have been printed in caps or initial caps. All product names and services identified throughout this book are used in editorial fashion only and for the benefit of such companies with no intention of infringement of the trademark. They are not intended to convey endorsement or other affiliation with this book.

While reasonable care has been exercised in the preparation of this book, the publisher and author assume no responsibility for errors or omissions, or for damages resulting from the use of the information contained herein or from the use of the discs or programs that may accompany it.

This book is printed on acid-free paper.

Printed in Korea

For Cathy

Acknowledgments

Thanks to everyone at Rocky Nook, including Scott Cowlin, managing director and publisher, for the freedom to let me explore the amazing capabilities of the Nikon Z6 in depth. I couldn't do it without my veteran production team, including project manager, Jenny Davidson and series technical editor, Mike Sullivan. Also thanks to Bill Hartman, layout; Valerie Haynes Perry, indexing; Mike Beady, proofreading; Mike Tanamachi, cover design; and my agent, Carole Jelen, who has the amazing ability to keep both publishers and authors happy.

About the Author

With more than 2.5 million books in print, **David D. Busch** is the world's #1 selling digital camera guide author, and the originator of popular digital photography series like *David Busch's Pro Secrets* and *David Busch's Quick Snap Guides*. He has written more than four dozen hugely successful guidebooks and compact guides for Nikon digital cameras, several dozen additional user guides for other camera models, as well as many popular books devoted to dSLRs, including *Mastering Digital SLR Photography, Fourth Edition* and *Digital SLR Pro Secrets*. As a roving photojournalist for more than 20 years, he illustrated his books, magazine articles, and newspaper reports with award-winning images. He's operated his own commercial studio, suffocated in formal dress while shooting weddings, and shot sports for a daily newspaper and an upstate New York college. His photos and articles have been published in magazines as diverse as *Popular Photography, Rangefinder, Professional Photographer*, and hundreds of other publications. He's also reviewed dozens of digital cameras for CNet Networks and other CBS publications. His advice has been featured on National Public Radio's *All Tech Considered*.

When About.com named its top five books on Beginning Digital Photography, debuting at the #1 and #2 slots were Busch's *Digital Photography All-In-One Desk Reference for Dummies* and *Mastering Digital Photography*. He's had as many as five of his books listed in the Top 20 of Amazon.com's Digital Photography Bestseller list—simultaneously! Busch's 250-plus other books published since 1983 include bestsellers like *Digital SLR Cameras and Photography for Dummies*.

Busch is a member of the Cleveland Photographic Society (www.clevelandphoto.org), which has operated continuously since 1887. Visit his website at http://www.nikonguides.com or his Facebook group *David D. Busch Photography Guides*.

Contents

Preface	xvii
Introduction	xix
Chapter 1	
Thinking Outside the Box	1
First Things First	2
In the Box	3
Optional and Non-Optional Add-Ons	5
Initial Setup	11
Mastering the Multi Selector and Command Dials	11
Setting the Clock	15
Battery Included	15
1 mai oceps	1/
Chapter 2	
Nikon Z6 Quick Start	21
Selecting a Release Mode	21
Selecting an Exposure Mode	24
Choosing a Metering Mode	2.5
Choosing a Focus Mode	27
Choosing the Focus Area Mode	28
Adjusting White Balance and ISO	28
Reviewing the Images You've Taken	29
Transferring Photos to Your Computer	30
Changing Default Settings	31
Recommended Default Changes	31

Shooting Tips	34
Photo Shooting Menu Recommendations	34
Custom Setting Menu Recommendations	37
Chapter 3	
Nikon Z6 Roadmap	49
Nikon Z6: Up Front	
The Nikon Z6's Business End	54
Playing Back Images	59
Zooming the Nikon Z6 Playback Display	60
Viewing Thumbnails	61
Using the Photo Data Displays	63
Going Topside	65
Lens Components	67
Underneath Your Nikon Z6	68
The Viewfinder/Monitor Displays	69
What's the Fuss about BSI?	71
Chapter 4	
Chapter 4	
NI 11 - the Dielet Errogoums	73
Nailing the Right Exposure	73
Nailing the Right Exposure Getting a Handle on Exposure	74
Nailing the Right Exposure Getting a Handle on Exposure Equivalent Exposure	74 77
Nailing the Right Exposure Getting a Handle on Exposure	
Nailing the Right Exposure Getting a Handle on Exposure Equivalent Exposure How the Z6 Calculates Exposure Correctly Exposed	
Nailing the Right Exposure Getting a Handle on Exposure Equivalent Exposure How the Z6 Calculates Exposure Correctly Exposed Overexposed	
Nailing the Right Exposure Getting a Handle on Exposure Equivalent Exposure How the Z6 Calculates Exposure Correctly Exposed Overexposed Underexposed	
Nailing the Right Exposure Getting a Handle on Exposure Equivalent Exposure How the Z6 Calculates Exposure. Correctly Exposed Overexposed Underexposed Metering Mid-Tones.	
Nailing the Right Exposure Getting a Handle on Exposure Equivalent Exposure How the Z6 Calculates Exposure Correctly Exposed Overexposed Underexposed Metering Mid-Tones. Choosing a Metering Method	
Nailing the Right Exposure Getting a Handle on Exposure Equivalent Exposure How the Z6 Calculates Exposure. Correctly Exposed Overexposed Underexposed Metering Mid-Tones. Choosing a Metering Method Matrix Metering	
Nailing the Right Exposure Getting a Handle on Exposure Equivalent Exposure How the Z6 Calculates Exposure. Correctly Exposed Overexposed Underexposed Metering Mid-Tones. Choosing a Metering Method Matrix Metering Center-weighted Metering	
Nailing the Right Exposure Getting a Handle on Exposure Equivalent Exposure How the Z6 Calculates Exposure Correctly Exposed Overexposed Underexposed Metering Mid-Tones. Choosing a Metering Method Matrix Metering Center-weighted Metering Spot Metering	
Nailing the Right Exposure Getting a Handle on Exposure Equivalent Exposure How the Z6 Calculates Exposure Correctly Exposed Overexposed Underexposed Metering Mid-Tones. Choosing a Metering Method Matrix Metering Center-weighted Metering Spot Metering Highlight-weighted Metering	
Nailing the Right Exposure Getting a Handle on Exposure Equivalent Exposure How the Z6 Calculates Exposure. Correctly Exposed Overexposed Underexposed Metering Mid-Tones. Choosing a Metering Method Matrix Metering Center-weighted Metering Spot Metering Highlight-weighted Metering Choosing an Exposure Method	
Nailing the Right Exposure Getting a Handle on Exposure Equivalent Exposure How the Z6 Calculates Exposure Correctly Exposed Overexposed Underexposed Metering Mid-Tones. Choosing a Metering Method Matrix Metering Center-weighted Metering Spot Metering Highlight-weighted Metering Choosing an Exposure Method Aperture-Priority	
Nailing the Right Exposure Getting a Handle on Exposure Equivalent Exposure How the Z6 Calculates Exposure Correctly Exposed Overexposed Underexposed Metering Mid-Tones. Choosing a Metering Method Matrix Metering Center-weighted Metering Spot Metering Highlight-weighted Metering Choosing an Exposure Method Aperture-Priority Shutter-Priority.	
Nailing the Right Exposure Getting a Handle on Exposure Equivalent Exposure How the Z6 Calculates Exposure Correctly Exposed Overexposed Underexposed Metering Mid-Tones. Choosing a Metering Method Matrix Metering Center-weighted Metering Spot Metering Highlight-weighted Metering Choosing an Exposure Method Aperture-Priority	

Adjusting Exposure with ISO Settings	
Dealing with Noise	
Bracketing	
White Balance Bracketing	
ADL Bracketing	104
Working with HDR	104
Auto HDR	105
Bracketing and Merge to HDR	107
Fixing Exposures with Histograms	110
Tonal Range	111
Histogram Basics	113
Understanding Histograms Fine-Tuning Exposure	114
Tine-Tuning Exposure	118
Chapter 5	
Marie 1 Marie 1 D	
Mastering the Mysteries of Focus	121
Auto or Manual Focus?	121
How Focus Works	
Contrast Detection	
Phase Detection	
Adding Circles of Confusion	
Using Autofocus with the Nikon Z6	129
Autofocus vs. Manual Focus Revisited	129
Bringing the Z6's AF System into Focus	130
Focus Mode and Priority	131
Autofocus Mode	
Choosing an Autofocus Area Mode	
Face Detection and Subject Tracking	138
Face-Priority AF	138
Subject Tracking	
Store by Orientation	140
Autofocus Activation and More	1.12
Manual Focus	
	142
Split-Screen Display Zoom	142
Split-Screen Display ZoomBack Button Focus	142 144 146
Split-Screen Display Zoom	142 144 146

Lens Tune-up Options	151
Evaluating Current Focus	152
Changing the Fine-Tuning Setting	
Setting the Default Value	156
Chapter 6	
Advanced Techniques	157
Continuous Shooting	
A Tiny Slice of Time	
Working with Short Exposures	163
Long Exposures	166
Three Ways to Take Long Exposures	166
Working with Long Exposures	167
Delayed Exposures	170
Self-Timer	
Interval/Time-Lapse Photography	171
Using Interval Photography	
Time-Lapse Movies	176
Multiple Exposures	177
Geotagging with the Nikon GP-1a	
Focus Shift Shooting	
Trap (Auto) Focus	
Using SnapBridge	189
Using the SnapBridge App	
Camera Page	
Smart Device	
Cloud	196
Chapter 7	
Focus on Lenses	197
Sensor Sensibilities	
Choosing Native Z-mount Lenses	203
Nikkor Z 35mm f/1.8 S	
Nikkor Z 50mm f/1.8 S	
Nikkor Z 24-70mm f/4 S	
Nikkor Z 58mm f/0.95 S Noct	
Nikkor Z 14-30mm f/4 S	209

Universal VR	
How It Works	
Using the FTZ Adapter	212
Ingredients of Nikon's Alphanumeric Soup	214
Zoom or Prime?	216
Categories of Lenses	217
Using Wide-Angle and Wide-Zoom Lenses	218
Avoiding Potential Wide-Angle Problems	
Using Telephoto and Tele-Zoom Lenses	222
Avoiding Telephoto Lens Problems	223
Telephotos and Bokeh	225
Nikon's Lens Roundup	226
The Magic Three	
Wide Angles	
Wide to Medium/Long Zooms	230
Telephoto and Normal Lenses	
Macro Lenses	237
Chapter 8	
	220
Mastering Light	239
Mastering Light Light That's Available	239
Continuous Lighting Basics	239
Continuous Lighting Basics	239
Continuous Lighting Basics	239 244 245 247
Continuous Lighting Basics	239 244 245 247 248
Continuous Lighting Basics Living with Color Temperature Daylight Incandescent/Tungsten/Halogen Light Fluorescent Light/LEDs	239 244 245 247 248
Continuous Lighting Basics	239 244 245 247 248
Continuous Lighting Basics Living with Color Temperature Daylight Incandescent/Tungsten/Halogen Light Fluorescent Light/LEDs Other Lighting Accessories	239 244 245 247 248
Continuous Lighting Basics Living with Color Temperature Daylight Incandescent/Tungsten/Halogen Light Fluorescent Light/LEDs	239 244 245 247 248
Continuous Lighting Basics Living with Color Temperature Daylight Incandescent/Tungsten/Halogen Light Fluorescent Light/LEDs Other Lighting Accessories	239 244 245 247 248 249 251
Continuous Lighting Basics Living with Color Temperature Daylight Incandescent/Tungsten/Halogen Light Fluorescent Light/LEDs Other Lighting Accessories. Chapter 9 Electronic Flash with the Nikon Z6	239 244 245 247 248 249 251
Continuous Lighting Basics Living with Color Temperature Daylight Incandescent/Tungsten/Halogen Light Fluorescent Light/LEDs Other Lighting Accessories Chapter 9 Electronic Flash with the Nikon Z6 Electronic Flash Basics	239 244 245 247 248 251
Continuous Lighting Basics Living with Color Temperature Daylight Incandescent/Tungsten/Halogen Light Fluorescent Light/LEDs Other Lighting Accessories. Chapter 9 Electronic Flash with the Nikon Z6 Electronic Flash Basics The Moment of Exposure	239 244 245 247 248 251 251
Continuous Lighting Basics Living with Color Temperature Daylight Incandescent/Tungsten/Halogen Light Fluorescent Light/LEDs Other Lighting Accessories Chapter 9 Electronic Flash with the Nikon Z6 Electronic Flash Basics The Moment of Exposure A Tale of Two Exposures	239 244 245 247 249 251 256 256 257
Continuous Lighting Basics Living with Color Temperature Daylight Incandescent/Tungsten/Halogen Light Fluorescent Light/LEDs Other Lighting Accessories Chapter 9 Electronic Flash with the Nikon Z6 Electronic Flash Basics The Moment of Exposure A Tale of Two Exposures Measuring Exposure	239 244 245 247 249 251 251 256 256 256 260
Continuous Lighting Basics Living with Color Temperature Daylight Incandescent/Tungsten/Halogen Light Fluorescent Light/LEDs Other Lighting Accessories Chapter 9 Electronic Flash with the Nikon Z6 Electronic Flash Basics The Moment of Exposure A Tale of Two Exposures	239 244 245 247 248 251 251 256 256 260 262

David Busch's Nikon Z6 Guide to Digital Photography

X

High-Speed Sync	
Using External Flash	
Using Flash Exposure Compensation	
Specifying Flash Shutter Speed	
Previewing Your Flash Effect	
Flash Control	
Working with Nikon Flash External Units	275
Nikon SB-300	275
Nikon SB-400	275
Nikon SB-500	276
Nikon SB-700	277
Nikon SB-R200	277
Nikon SB-910	278
SB-5000	279
Light Modifiers	279
Using Zoom Heads	281
Flash Modes	
	202
Repeating Flash	283
Repeating Flash	283
	283
Chapter 10 Wireless and Multiple Flash	285
Chapter 10	285
Chapter 10 Wireless and Multiple Flash	285 286
Chapter 10 Wireless and Multiple Flash Elements of Wireless Flash	285 286287
Chapter 10 Wireless and Multiple Flash Elements of Wireless Flash Master Flash	285 286 287 290
Chapter 10 Wireless and Multiple Flash Elements of Wireless Flash Master Flash Remote Flashes Channels	285 286 290 290
Chapter 10 Wireless and Multiple Flash Elements of Wireless Flash Master Flash Remote Flashes Channels Groups	285 286 290 290 290
Chapter 10 Wireless and Multiple Flash Elements of Wireless Flash Master Flash Remote Flashes Channels Groups Lighting Ratios.	285286287290290290291
Chapter 10 Wireless and Multiple Flash Elements of Wireless Flash Master Flash Remote Flashes Channels Groups Lighting Ratios. Setting Your Master Flash	285286290290291293
Chapter 10 Wireless and Multiple Flash Elements of Wireless Flash Master Flash Remote Flashes Channels Groups Lighting Ratios. Setting Your Master Flash Setting Commander Mode for the SB-5000	285
Chapter 10 Wireless and Multiple Flash Elements of Wireless Flash Master Flash Remote Flashes Channels Groups Lighting Ratios. Setting Your Master Flash Setting Commander Mode for the SB-5000 Setting Commander Modes for the SB-910 or SB-900	285286290290291293294297
Chapter 10 Wireless and Multiple Flash Elements of Wireless Flash Master Flash Remote Flashes Channels Groups Lighting Ratios. Setting Your Master Flash Setting Commander Mode for the SB-5000 Setting Commander Modes for the SB-910 or SB-900 Setting Commander Modes for the SB-700	285
Chapter 10 Wireless and Multiple Flash Elements of Wireless Flash Master Flash Remote Flashes Channels Groups Lighting Ratios. Setting Your Master Flash Setting Commander Mode for the SB-5000 Setting Commander Modes for the SB-910 or SB-900 Setting Commander Modes for the SB-700 Setting Commander Modes for the SB-700 Setting Commander Modes for the SB-700	285
Chapter 10 Wireless and Multiple Flash Elements of Wireless Flash Master Flash Remote Flashes Channels Groups Lighting Ratios. Setting Your Master Flash Setting Commander Mode for the SB-5000 Setting Commander Modes for the SB-910 or SB-900 Setting Commander Modes for the SB-700	285

Chapter 11 Playback, Photo Shooting, and Movie Shooting Menus	303
Anatomy of the Nikon Z6's Menus	
Playback Menu Options	
Delete	
Playback Folder	
Playback Display Options	
Image Review	
After Delete	
After Burst, Show.	
Rotate Tall	
Slide Show	
Rating	
Photo Shooting Menu Options	
Reset Photo Shooting Menu	
Storage Folder	
File Naming	
Choose Image Area	
Image Quality	
Image Size	
NEF (RAW) Recording.	
ISO Sensitivity Settings.	
White Balance	
Set Picture Control	
Manage Picture Control.	
Color Space	
Active D-Lighting.	
Long Exposure NR	
High ISO NR	
Vignette Control.	
Diffraction Compensation	
Auto Distortion Control.	
Flicker Reduction Shooting	
Metering	
Flash Control	
Flash Mode	
Flash Compensation	
Focus Mode	
1 Ocus Mout	301

	AF-Area Mode	361
	Vibration Reduction	362
	Auto Bracketing	362
	Multiple Exposure	363
	HDR (High Dynamic Range)	364
	Interval Timer Shooting	
	Time-Lapse Movie	366
	Focus Shift Shooting	367
	Silent Photography	367
Mo	ovie Shooting Menu	368
	Reset Movie Shooting Menu	368
	File Naming	
	Choose Image Area	
	Frame Size/Frame Rate	371
	Movie Quality	371
	Movie File Type	
	ISO Sensitivity Settings	
	White Balance	
	Set Picture Control	372
	Manage Picture Control	372
	Active D-Lighting	
	High ISO NR	
	Vignette Control	373
	Diffraction Compensation	
	Auto Distortion Control.	
	Flicker Reduction	
	Metering	
	Focus Mode	
	AF-Area Mode	
	Vibration Reduction	
	Electronic VR	
	Microphone Sensitivity	
	Attenuator	
	Frequency Response	
	Wind Noise Reduction	
	Headphone Volume	
	Timecode	

	Contents XII
Chapter 12	
The Custom Settings Menu	379
Custom Settings Menu Layout	
Reset Custom Settings	
a. Autofocus	
a1 AF-C Priority Selection	
a2 AF-S Priority Selection	
a3 Focus Tracking with Lock-on	
a4 Auto-Area AF Face-Detection	
a5 Focus Points Used	
a6 Store Points by Orientation	
a7 AF Activation	
a8 Limit AF-Area Mode Selection	
a9 Focus Point Wrap-Around	
a10 Focus Point Options	
a11 Low-Light AF	
a12 Built-in AF-Assist Illuminator	
a13 Manual Focus Ring in AF Mode	
o. Metering/Exposure	
b1 EV Steps for Exposure Cntrl	
b2 Easy Exposure Compensation	
b3 Center-Weighted Area	
b4 Fine-Tune Optimal Exposure	
c. Timers/AE Lock	
c1 Shutter-Release Button AE-L	
c2 Self-Timer	
c3 Power Off Delay	
d. Shooting/Display	
d1 CL Mode Shooting Speed	
d2 Max. Continuous Release	
d3 Sync. Release Mode Options	
d4 Exposure Delay Mode	
d5 Electronic Front-Curtain Shutter	
d6 Limit Selectable Image Area	
d7 File Number Sequence	
d8 Apply Settings to Live View	404

d9 Framing Grid Display405d10 Peaking Highlights406d11 View All in Continuous Mode406

e. Bracketing/Flash	
e1 Flash Sync Speed	
e2 Flash Shutter Speed	408
e3 Exposure Compensation for Flash	
e4 Auto Flash ISO Sensitivity Control	409
e5 Modeling Flash	410
e6 Auto Bracketing (Mode M)	410
e7 Bracketing Order	411
f. Controls	411
f1 Customize <i>i</i> Menu	
f2 Custom Control Assignment	414
f3 OK Button	
f4 Shutter Spd & Aperture Lock	
f5 Customize Command Dials	
f6 Release Button to Use Dial	
f7 Reverse Indicators	
g. Movie	
g1 Customize <i>i</i> Menu	
g2 Custom Control Assignment	
g3 OK Button	
g4 AF Speed	
g5 AF Tracking Sensitivity	
g6 Highlight Display	427
Chapter 13	
The Setup Menu, Retouch Menu, and My Menu	429
Setup Menu Options	
Format Memory Card	
Save User Settings	
Reset User Settings	
Language	
Time Zone and Date	
Monitor Brightness	
Monitor Color Balance	
Viewfinder Brightness	
Viewfinder Color Balance	
Control Panel Brightness	
Limit Monitor Mode Selection	435

Information Display	36
AF Fine-Tune	
Non-CPU Lens Data43	
Clean Image Sensor	
Image Dust Off Ref Photo	
Image Comment44	
Copyright Information	
Beep Options	
Touch Controls	
HDMI	
Location Data	
Wireless Remote (WR) Options	
Assign Remote (WR) Fn Button	
Airplane Mode44	
Connect to Smart Device	16
Connect to PC	
Wireless Transmitter (WT-7)44	
Conformity Marking44	
Battery Info	
Slot Empty Release Lock	18
Save/Load Settings	18
Reset All Settings	
Firmware Version44	19
Retouch Menu	
NEF (RAW) Processing	
Trim45	
Resize	
D-Lighting	
Red-Eye Correction	
Straighten45	
Distortion Control	
Perspective Control	
Image Overlay	
Trim Movie	
Side-by-Side Comparison	
Using My Menu	

Chapter 14	
Capturing Video with the Z6	463
Quick Start Checklist	463
Lean, Mean, Movie Machine	
Capturing Video	466
Slow-Motion Movies	472
Shooting Your Movie	473
Using the <i>i</i> Button	474
Stop That!	475
Viewing Your Movies	477
Trimming Your Movies	478
Saving a Frame	480
Chapter 15	
Tips for Shooting Better Video	481
Using an External Recorder	482
Refocusing on Focus	486
Lens Craft	487
Depth-of-Field and Video	487
Zooming and Video	489
Keep Things Stable and on the Level	490
Shooting Script	491
Storyboards	492
Storytelling in Video	493
Composition	493
Lighting for Video	496
Illumination	497
Creative Lighting	497
Lighting Styles	498
Audio	499
Tips for Better Audio	499
External Microphones	501
Special Features	502
Index	503

Preface

The new Nikon Z6 is proof that a mirrorless full-frame camera can be highly affordable, too. This 24-megapixel camera packs a surprising number of high-end features into a compact body priced at less than \$2,000. Although it's all-new from sensor to lens mount, the Z6 looks and handles like a Nikon, with controls and menus that veteran Nikon owners will find comfortably familiar as they explore its exciting enhancements. Newcomers to the world of Nikon or the realm of mirrorless digital photography will easily master the Z6's capabilities, even though the sheer number of features and options can be daunting. The only thing standing between you and pixel proficiency is the fat, but confusing book included in the box as a manual.

Everything you need to know is in there, somewhere, but you don't know where to start, nor how to find the information you really need to master your camera. In addition, the Z6 camera manual doesn't offer much guidance on the principles that will help you master digital photography. Nor does it really tell you much about how mirrorless shooting might differ from the kinds of digital photography you may already be used to. If you're like most enthusiasts, you're probably not interested in spending hours or days studying a comprehensive book on digital photography that doesn't necessarily apply directly to the enhanced features of your Z6.

What you really need is a guide that explains the purpose and function of the Z6's basic controls, available lens options, and most essential accessories from the perspective of mirrorless cameras. It should tell you how you should use them, and *why*. Ideally, there should be information about the exciting features at your disposal, how to optimize image quality, when to use exposure modes like aperture- or shutter-priority, and the use of special autofocus modes. In many cases, you'd prefer to read about those topics only after you've had the chance to go out and take a few hundred great pictures with your new camera. Why isn't there a book that summarizes the most important information in its first two or three chapters, with lots of illustrations showing what your results will look like when you use this setting or that? This is that book.

If you can't decide on what basic settings to use with your camera because you can't figure out how changing ISO or white balance or focus defaults will affect your pictures, you need this guide. I won't talk down to you, either; this book isn't padded with dozens of pages of checklists telling you how to take a travel picture, a sports photo, or how to take a snapshot of your kids in overly simplistic terms. There are no special sections devoted to "real-world" recipes here. All of us do 100 percent of our shooting in the real world! So, I give you all the information you need to cook up great photos on your own!

Introduction

Your new Nikon Z6 has to be one of the top photographic bargains on the market today. Although priced at an affordable \$2,000 for the body alone, the Z6 has all the killer features found in its upscale mirrorless sibling, the Z7, at less than 60 percent of its price. And the trade-offs go both ways: while the Z6's 24 megapixels don't match the 46 megapixel resolution of the mirrorless flagship Z7, your camera can capture sports and action sequences at 12 frames per second, rather than the 9 fps available with its high-end counterpart. If you've been delaying your jump to the mirrorless world waiting for Nikon to introduce a worthy offering, your wait is over. For most of us on a budget, the Z6 is the dream mirrorless camera we've been hoping for.

Despite what you might read elsewhere, the Nikon Z-series cameras are not the first mirrorless interchangeable-lens cameras Nikon has offered. That distinction belongs to the company's Nikon 1 product line, a series of consumer-oriented cameras that were truly small in size, and which used small 1-inch sensors. Those cameras, targeted at amateur snapshooters, allowed Nikon to develop considerable expertise in mirrorless technology. Your Z6 builds on what the company learned in carefully designing a new platform that fully meets the needs of a much different group: dedicated photo enthusiasts, semi-professionals, and professional photographers.

With the Z6, you're not giving up much, other than a mirror and a pentaprism/pentamirror optical viewfinder, and the extra weight and bulk found in traditional dSLRs. Indeed, the Z6 is Nikon's affordable mirrorless "do-everything" camera. It has enough resolution—at 24 MP—guaranteed to satisfy the needs of landscape and fine-art photographers. It can capture action at up to 12 frames per second and has a 1.5X "crop" mode that make it an excellent machine for sports photographers. Its built-in intervalometer effortlessly captures the beauty of an unfolding blossom, and can shoot time-lapse movies with up to 4K resolution in the camera (or faux 8K video using a video editor) to track the progress of a construction project. The new N-log gamma option will make this camera prized by those assembling and editing serious video productions.

You may be asking yourself—how do I use this thing? Nikon's manual is mind-numbingly dense, and online YouTube tutorials can't cover all these features in depth. Who wants to learn how to use a camera by sitting in front of a television or computer screen? Do you want to watch a movie or click on HTML links, or do you want to go out and take photos with your camera?

The included manual is thick and filled with information, but there's really very little about why you should use particular settings or features. Its organization makes it difficult to find what you need. Multiple cross-references send you searching back and forth between two or three sections of the book to find what you want to know. The basic manual is also hobbled by black-and-white line drawings and tiny monochrome pictures that aren't very good examples of what you can do.

I've tried to make *David Busch's Nikon Z6 Guide to Digital Photography* different from your other Z6 learn-up options. The roadmap sections use larger, color pictures to show you where all the buttons and dials are, and the explanations of what they do are longer and more comprehensive. I've tried to avoid overly general advice, including the two-page checklists on how to take a "sports picture" or a "portrait picture" or a "travel picture." You won't find half the content of this book taken up by generic chapters that tell you how to shoot landscapes, portraits, or product photographs. Instead, you'll find tips and techniques for using all the features of your Nikon Z6 to take any kind of picture you want. If you want to know where you should stand to take a picture of a quarterback dropping back to unleash a pass, there are plenty of books that will tell you that. This one concentrates on teaching you how to select the best autofocus mode, shutter speed, f/stop, or flash capability to take, say, a great sports picture under any conditions.

This book is not a lame rewriting of the manual that came with the camera. Some folks spend five minutes with a book like this one, spot some information that also appears in the original manual, and decide "Rehash!" without really understanding the differences. Yes, you'll find information here that is also in the owner's manual, such as the parameters you can enter when changing your Z6's operation in the various menus. Basic descriptions—before I dig in and start providing in-depth tips and information—may also be vaguely similar. There are only so many ways you can say, for example, "Hold the shutter release down halfway to lock in exposure." But not *everything* in the manual is included in this book. If you need advice on when and how to use the most important functions, you'll find the information here.

David Busch's Nikon Z6 Guide to Digital Photography is aimed at both Nikon and dSLR veterans as well those who have used other mirrorless cameras and those who are total newcomers to digital or mirrorless photography. Both groups can be overwhelmed by the options the Z6 offers, while underwhelmed by the explanations they receive in their user's manual. The manuals are great if you already know what you don't know, and you can find an answer somewhere in a booklet arranged by menu listings and written by a camera vendor employee who last threw together instructions on how to operate a camcorder.

Family Resemblance

If you've owned previous models in the Nikon digital camera line, and copies of my books for those cameras, you're bound to notice a certain family resemblance. Nikon has been very crafty in introducing upgraded cameras that share the best features of the models they replace, while adding new capabilities and options. You benefit in two ways. If you used a previous Nikon camera prior to switching to this latest Z6 model, you'll find that the parts that haven't changed have a certain familiarity for you, making it easy to make the transition to the newest model. There are lots of features and menu choices of the Z6 that are exactly the same as those in the most recent models. This family resemblance will help level the learning curve for you.

Similarly, when writing books for each new model, I try to retain the easy-to-understand explanations that worked for previous books dedicated to earlier camera models, and concentrate on expanded descriptions of things readers have told me they want to know more about, a solid helping of fresh sample photos, and lots of details about the latest and greatest new features. Rest assured, this book was written expressly for you, and tailored especially for the Z6.

Who Am I?

After spending many years as the world's most successful unknown author, I've become slightly less obscure in the past few years, thanks to a horde of camera guidebooks and other photographically oriented tomes. You may have seen my photography articles in the late, lamented *Popular Photography* magazine. I've also written about 2,000 articles for magazines like *Rangefinder*, *Professional Photographer*, and dozens of other photographic publications. But, first, and foremost, I'm a photojournalist who made my living in the field until I began devoting most of my time to writing books. Although I love writing, I'm happiest when I'm out taking pictures, which is why I spend four to six weeks in Florida each winter as a base of operations for photographing the wildlife, wild natural settings, and wild people in the Sunshine State. In recent years, I've spent a lot of time overseas, too, photographing people and monuments. You'll find photos of some of these visual treasures within the pages of this book.

Like all my digital photography books, this one was written by a Nikon devotee with an incurable photography bug who has used Nikon cameras professionally for longer than I care to admit. Over the years, I've worked as a sports photographer for an Ohio newspaper and for an upstate New York college. I've operated my own commercial studio and photo lab, cranking out product shots on demand and then printing a few hundred glossy $8 \times 10 \mathrm{s}$ on a tight deadline for a press kit. I've served as a photo-posing instructor for a modeling agency. People have actually paid me to shoot their weddings and immortalize them with portraits. I even prepared press kits and articles on photography as a PR consultant for a large Rochester, NY company, which older readers may recall as an industry giant. My trials and travails with imaging and computer technology have made their way into print in book form an alarming number of times, including a few dozen on scanners and photography.

Like you, I love photography for its own merits, and I view technology as just another tool to help me get the images I see in my mind's eye. But, also like you, I had to master this technology before I could apply it to my work. This book is the result of what I've learned, and I hope it will help you master your Nikon Z6, too.

Some readers who visit my blog have told me that the Nikon Z6 is such an advanced camera that few people really need the kind of basics that so many camera guides concentrate on. "Leave out all the basic photography information!" On the other hand, I've had many pleas from those who are trying to master digital photography as they learn to use their Z6, and they've asked me to help them climb the steep learning curve.

Rather than write a book for just one of those two audiences, I've tried to meet the needs of both. You veterans will find plenty of information on getting the most from the Z6's features, and may even learn something from an old hand's photo secrets. I'll bet there was a time when you needed a helping hand with some confusing photographic topic.

In closing, I'd like to ask a special favor: let me know what you think of this book. If you have any recommendations about how I can make it better, visit my website at www.nikonguides.com, click on the E-Mail Me tab, and send your comments, suggestions on topics that should be explained in more detail, or, especially, any typos. (The latter will be compiled on the Errata page you'll also find on my website.) I really value your ideas, and appreciate it when you take the time to tell me what you think! Most of the organization and some of the content of the book you hold in your hands came from suggestions I received from readers like yourself. If you found this book especially useful, tell others about it. Visit http://www.amazon.com/dp/1681984687 and leave a positive review. Your feedback is what spurs me to make each one of these books better than the last. Thanks!

Thinking Outside the Box

For a photo enthusiast, nothing is quite as exciting as unboxing a new camera—particularly one as innovative as your new Nikon Z6. That's why YouTube and Nikon-oriented forums are inundated with "unboxing" videos as soon as a highly anticipated camera starts shipping. After waiting a very long time for Nikon's answer to the booming trend toward compact, fully featured mirrorless cameras, many of us have been eager to see what's in the box, what kind of accessories we have to enhance our shooting, and—finally—what kinds of pictures we can take.

If you're like me, the first thing you probably did when you first extracted your Z6 from the box, was attach one of the available lenses, power the beast up, and begin taking photos through a tentative trial-and-error process. Who has time to even scan a manual when you're holding some of the most exciting technology Nikon has ever offered in your hands? If you're a veteran Nikon shooter, you probably found many of the controls and menus very similar to what you're used to, even though the camera itself is much more compact and lighter in weight than your previous Nikon.

But now that you've taken a few hundred (or thousand) photos with your new Nikon Z6, you're ready to learn more. You've noted some intriguing features and adjustments that you need to master. Some aren't available at all on other Nikon models, or are new features, such as focus-shift shooting found in the Z6 and the Z6's 46-megapixel sibling the Z7, or their dSLR counterpart, the Nikon D850. Goodies packed inside your Z6 include diffraction correction, in-body five-axis vibration reduction, totally silent shooting, a high-resolution *electronic* viewfinder, and other enhanced capabilities.

Of course, on the other hand, you may be *new* to the Nikon world, or the Z6 may be your first advanced digital camera, and you need some guidance in learning to use all the creative options this camera has to offer. In either case, despite your surging creative juices, I recommend a more considered approach to learning how to operate the Nikon Z6. This chapter and the next are

designed to get your camera fired up and ready for shooting as quickly as possible. And while it boasts both Auto and sophisticated Programmed Auto modes, the Z6 is not a point-and-shoot model; to get the most out of your camera, you'll want to explore its capabilities fully.

So, to help you begin shooting as quickly as possible, I'm going to first provide a basic pre-flight checklist that you need to complete before you really spread your wings and take off. You won't find a lot of detail in these initial two chapters. Indeed, I'm going to tell you just what you absolutely *must* understand, accompanied by some interesting tidbits that will help you become acclimated to your Z6. I'll go into more depth and even repeat a little of what I explain here in the chapters that follow, so you don't have to memorize everything you see. Just relax, follow a few easy steps, and then go out and begin taking your best shots—ever.

I hope that even long-time Nikon owners won't be tempted to skip this chapter or the next one. No matter how extensive your experience level is with dSLRs, your new mirrorless camera has a lot of differences from what you may be used to. Yet, I realize you don't want to wade through a manual to find out what you must know to take those first few tentative snaps. I'm going to help you hit the ground running with this chapter, which will help you set up your camera and begin shooting in minutes. Because some of you may already have experience with previous Nikon cameras, each of the major sections in this chapter will begin with a brief description of what is covered in that section, so you can easily jump ahead to the next if you are in a hurry to get started.

Note

In this book you'll find short tips labeled My recommendation or My preference, each intended to help you sort through the available options for a feature, control, or menu entry. I'll provide my preference, suitable for most people in most situations. I don't provide these recommendations for every single feature, and you should consider your own needs before adopting any of them.

First Things First

This section helps get you oriented with all the things that come in the box with your Nikon Z6, including what they do. I'll also describe some optional equipment you might want to have. If you want to get started immediately, skim through this section and jump ahead to "Initial Setup" later in the chapter.

The Nikon Z6 comes in an impressive black and Nikon-yellow box (and two more boxes inside if you purchased the body/24-70mm kit) filled with stuff, including a connecting cord, and lots of paperwork. The most important components are the camera and lens (if you purchased your Z6 with a lens), battery, battery charger, and, if you're the nervous type, the neck strap. You'll also need an XQD memory card, plus a spare, as they are not included.

The first thing to do is carefully unpack the camera and double-check the contents. While this level of setup detail may seem as superfluous as the instructions on a bottle of shampoo, checking the contents *first* is always a good idea. No matter who sells a camera, it's common to open boxes, use a particular camera for a demonstration, and then repack the box without replacing all the pieces and parts afterward. Someone might have helpfully checked out your camera on your behalf—and then mispacked the box. It's better to know *now* that something is missing so you can seek redress immediately, rather than discover two months from now that the HDMI/USB cable clip you thought you'd never use (but now *must* have for an important video project) was never in the box.

In the Box

At a minimum, the box should contain the following components:

- Nikon Z6 digital camera. It almost goes without saying that you should check out the camera immediately, making sure the back-panel LCD monitor and top-panel LCD control panel aren't scratched or cracked, the memory and battery doors open properly, and, when a charged battery is inserted and lens mounted, the camera powers up and reports for duty. Out-of-the-box defects like these are very rare, but they can happen. It's more common that your dealer played with the camera or, perhaps, it was a customer return. That's why it's best to buy your Z6 from a retailer you trust to supply a factory-fresh camera.
- Lens (optional). At its introduction the Z6 was available *only* as an unadorned body or in a kit with the Nikkor 24-70mm/f4 S-series lens. Nikon may offer *other* lenses as part of a kit in the future, even though only the kit lens and Nikkor 35mm f/1.8 S-series lens were available initially (with the Nikkor 50mm f/1.8 and 14-30mm f/4 following a few months later). As new lenses are introduced, most retailers will readily package this camera with the lens of your choice, often at a savings over buying them individually. The Nikon S-series "roadmap" listed some intriguing optics that were expected around the time this book is published—or shortly thereafter—including a fast 24-70mm f/2.8 lens and 70-200mm f/2.8 zoom.
- USB cable UC-E24. This is a Type-C cable (the easy-insert kind that doesn't require a specific orientation). You can use this cable to transfer photos from the camera to your computer (I don't recommend that because direct transfer uses a lot of battery power), to upload and download settings between the camera and your computer (highly recommended), and to operate your camera remotely using Nikon Camera Control Pro software (optional, and not included in the box).

My recommendation: This cable is a standard USB Type-C cord that works with a few other digital cameras that have adopted the USB Type-C interface. If you already own such a cable, you can use it as a spare. The UC-E24 cable is designed to work with the USB cable clip (described next). If you need a cable that's longer than this two-foot connector, you can find them for much lower than this unit's \$34.95 list price online. I've tried several third-party cables and they work fine.

- **USB and HDMI cable clip.** This snaps onto fittings beneath the USB and HDMI port covers and holds the USB and optional HDMI cables snugly in place.
 - My recommendation: For occasional use of either cable, say, to transfer files from the camera to your computer over USB, or to temporarily route the Z6's output to a TV/monitor, using the HDMI interface, you will not need these clips. The unadorned cables fit quite snugly. However, you'll find the clips invaluable in other applications. For example, if you want to shoot tethered over USB while connected to a laptop running Camera Control Pro, Lightroom, or Capture One, or plan to direct HDMI output to a video recorder, high-definition monitor, or other device, you'll want to use the clips to make sure your Z6 remains connected.
- Rechargeable Li-ion battery EN-EL15b. You'll need to charge this 7.0V, 1900mAh (milliampere hour) battery before use, and then navigate immediately to the Setup menu's Battery Info entry to make sure the battery accepted the juice and is showing a 100 percent charge. (You'll find more on accessing this menu item in Chapter 13.) You'll want a second EN-EL15b battery (about \$60) as a spare (trust me), so buy one as soon as possible.
- Quick charger MH-25a. This charger comes with both a power cable and a power adapter that can be used instead of the cable to plug the charger directly into a wall outlet.
- AN-DC19 neck strap. Nikon provides you with a neck strap emblazoned with the Nikon Z logo. It's not very adjustable, and, while useful for showing off to your friends exactly which nifty new camera you bought, the Nikon strap also can serve to alert observant unsavory types that you're sporting a higher-end model that's worthy of their attention.
 - My recommendation: I never attach the Nikon strap to my cameras, and instead opt for a more serviceable strap like the one shown in Figure 1.1. I strongly prefer this type over holsters, slings, chest straps, or any support that dangles my camera upside down from the tripod socket and allows it to swing around too freely when I'm on the run. Give me a strap I can hang over either shoulder, or sling around my neck, and I am happy.

I use the UPstrap shown in the figure, with a patented non-slip pad that keeps your Z6 on your shoulder, and not crashing to the ground. Inventor-photographer Al Stegmeyer (www.upstrap-pro.com) can help you choose the right strap for you.

- BF-N1 body cap. The body cap keeps dust from infiltrating your camera when a lens is not mounted. Always carry a body cap (and rear lens cap) in your camera bag for those times when you need to have the camera bare of optics for more than a minute or two. (That usually happens when repacking a bag efficiently for transport, or when you are carrying an extra body or two for backup.) The body cap/lens cap nest together for compact storage.
- **DK-29 eyepiece.** This is the round rubber eyepiece that comes installed on the viewfinder of the Z6. It slides on and off the viewfinder. If you prefer, you can augment it or replace it with several accessories discussed in the next section.
- User's manuals. Even if you have this book, you'll probably want to check the user's guide that Nikon provides, if only to check the actual nomenclature for some obscure accessory, or to double-check an error code. You'll find both a printed User's Manual and a SnapBridge Connection Guide leaflet in the package.
 - My recommendation: If you lose your printed books, just Google "Nikon Z6 manual PDF" to find a downloadable version that you can store on your laptop, on a USB stick, or other media in case you want to access this reference when the paper version isn't handy. You'll then be able to access the reference anywhere you are, because you can always find someone with a computer that has a USB port and Adobe Acrobat Reader available. Nikon also offers a "manual reader" app for Android and iOS smart devices you can use to read the factory manual. The Nikon app includes links to let you download manuals directly from their website, without needing to Google them.
- Warranty and registration card. Don't lose these! You can register your Nikon Z6 by mail or online (in the USA, the URL is www.nikonusa.com/register), and you may need the information in this paperwork (plus the purchase receipt/invoice from your retailer) should you require Nikon service support.

Optional and Non-Optional Add-Ons

Don't bother rooting around in the box for anything beyond what I've listed. There are a few things Nikon classifies as optional accessories, even though you (and I) might consider some of them essential. Here's a list of what you *don't* get in the box, but might want to think about as an impending purchase. I'll list them roughly in the order of importance:

■ **Memory card.** As I mentioned, the Z6 does *not* come with a memory card. That's because Nikon doesn't have the slightest idea of what capacity or speed card you prefer, so why charge you for one? The Nikon Z6 is likely to be purchased by photographers who have quite definite ideas about their ideal card. Perhaps you're a wedding photographer who prefers to use 32GB cards (generally the smallest available in the XQD form factor) as a safety measure when

capturing a nuptial event. Other photographers, especially sports shooters, instead prefer larger cards to minimize swapping during non-stop action. If you are shooting at high frame rates, or transfer lots of photos to your computer with a speedy card reader, you might opt for the speediest possible memory card.

My recommendation: The Z6's 24-megapixel image files each amount to roughly 9.4 MB for JPEG Fine to 44.1 MB for uncompressed 14-bit NEF (RAW) files. I recommend Sony 64GB G-series cards as the best price/capacity compromise, although I also own Sony 128GB media. It's better to have two 64GB cards available (one for overflow or backup) than depend on a single 128GB XQD card.

■ Extra EN-EL15b battery. As a mirrorless model, the Z6's sensor and electronic viewfinder and/or LCD monitor are energized anytime you are using the camera, so you may note that you are getting fewer shots per charge than you may be used to. Nikon says that if you shoot with the viewfinder only, you can expect to get 330 images before you'll need to swap batteries; if using the less energy-hungry LCD monitor, around 400 shots should be possible. You should be able to capture 85 minutes worth of video with either display.

As a result, at least one extra battery is virtually mandatory. Fortunately, you can use the previous model EN-EL15 and EN-EL15 batteries originally introduced with the Nikon D7000 in 2011 and used in many subsequent models, with one caveat. The older versions of the EN-EL15 battery, marked with a *Li-ion 01* designation to the left of the hologram on the cell's bottom, are not fully compatible with the Z6, and will, in fact, show less capacity than they really contain when used. The newer EN-EL15 version (marked *Li-ion 20*) and latest EN-EL15a batteries do not have this problem. In addition, I have not found *any* third-party EN-EL15/EN-EL15a batteries that will work in the Z6 at all. (The camera reports a "dead" battery even if it's fully charged.)

My recommendation: Buy an extra EN-EL15b or two. They have slightly higher capacity than the older versions, and are the only batteries that can be charged while in the camera using a USB-C cable connected to a power supply. Keep all your batteries charged, and free your mind from worry. Even though you might get 380 or more shots from a single battery, it's easy to exceed that figure in a few hours of shooting sports at 12 fps. Batteries can unexpectedly fail, too, or simply lose their charge from sitting around unused for a week or two. Although third-party vendors may eventually reverse engineer the encoding required to allow their batteries to function in the Z6, I don't recommend using them simply to save \$60 or so with a camera that costs around \$2,000.

■ EH-7P charging AC adapter. Plug this small, square "wall wart" into an AC outlet and connect its non-removable Type-C USB connector cable to the USB port of the Z6 and you can recharge the battery of the camera internally while the camera is turned off. It cannot be used to supply power to the camera for taking pictures, however. It is an optional accessory priced at about \$50.

My recommendation: You can pick up one of these if you feel the need, but you can do the same thing with any Type-C USB cable and an external USB power source that supplies 5V/3A juice.

- Nikon Capture NX-D or Nikon ViewNX-i software. You can download a free copy of these software utilities from Nikon's website. Nikon no longer packs a CD-ROM with its cameras.
- Camera Control Pro 2 software. This is the utility you'll use to operate your camera remotely from your computer. Nikon charges extra for this software, but you'll find it invaluable if you're hiding near a tethered, tripod-mounted camera while shooting, say, close-ups of humming-birds. There are lots of applications for remote shooting, and you'll need Camera Control Pro to operate your camera.
 - My recommendation: You may already own Adobe Lightroom, which does an excellent job for tethered shooting, or DxO Labs' Capture One. Buy a suitably longer USB-C cable, too.
- Add-on Speedlight. Like all Nikon's flagship full-frame cameras, the Z6 does not have a built-in electronic flash. If you do much flash photography at all, consider an add-on Speedlight as an important accessory.
 - My recommendation: An add-on flash can serve as the main illumination for your picture, diffused or bounced and used as a fill light, or, if you own several Speedlights, serve as a remote trigger for an off-camera unit. At around \$220, the Nikon SB-500 has the most affordable combination of reasonable power, compact size, and features, including a built-in LED video light. If you need more power, the Speedlight SB-700, SB-910, or SB-5000 also offer more flexibility. For example, the SB-5000 can be triggered by radio control using another radio-compatible flash, or the WR-R10 transmitter. I'll provide more information on electronic flash in Chapters 9 and 10.
- Remote control cable MC-DC2. You can plug this one-meter-long electronic release cable accessory into the accessory port on the side of the Z6, and then fire off the camera without the need to touch the camera itself. In a pinch, you can use the Z6's self-timer to minimize vibration when triggering the camera. But when you want to take a photo at the exact moment you desire (and not when the self-timer happens to trip), or need to eliminate all possibility of human-induced camera shake, you need this release cord.
 - My recommendation: These sometimes get lost in a camera bag or are accidentally removed. I bought an extra MC-DC2 cable and keep it in a small box in the trunk of my car, along with an extra memory card. There are many third-party equivalent cables, but the Nikon-brand release costs only about \$30 and sometimes it's wise not to pinch pennies.
- BS-1 accessory shoe cover. This little piece of optional plastic protects the electrical contacts of the "hot" shoe on top of the Z6. You can remove it when mounting an electronic flash, Nikon GP-1/1a GPS device, or other accessory, and then safely leave it off for the rest of your life. I've never had an accessory shoe receive damage in normal use, even when not protected. The paranoid among you who use accessories frequently can keep removing/mounting the shoe cover as required. Note that Nikon also offers a BS-3 shoe cover (\$10) with better weather sealing to protect the hot shoe if you're working in damp environments.

My recommendation: Find a safe place to keep it between uses, or purchase replacements for this easily mislaid item. The previous low-cost source for these covers has gone out of business, so I've imported a stock of them, in both standard and bubble-level versions, which I'll send you for a few bucks. (Visit www.laserfairepress.com for more details.)

- HDMI audio/video cable. The Z6 can be connected to a high-definition television, and can export its video output to an external recorder. You'll need to buy a mini-HDMI C (high-definition multimedia interface) cable to do that. No HDMI cable is included with the camera.
- Nikon GP-1a global positioning system (GPS) device. This accessory attaches to the accessory shoe on top of the Nikon Z6 and captures latitude, longitude, and altitude information, which is embedded in a special data area of your image files. The "geotagging" data can be plotted on a map in Nikon ViewNX-i or other software programs.
- AC adapter EH-5b/EH-5c, EP-5b adapters. There are several typical situations where this AC adapter set for your Z6 can come in handy, such as when in the studio shooting product photos, portraits, class pictures, and so forth for hours on end; when using your Z6 for remote shooting as well as time-lapse photography; for extensive review of images on your standard-definition or high-definition television; or for file transfer to your computer. These all use significant amounts of power. The EH-5c and EH-5b power supplies each require the EP-5B adapter to connect to the camera.

My recommendation: Unless you regularly do time-lapse or interval photography for long periods of time, you can probably skip these expensive accessories. The included EH-7P adapter cannot be used as a substitute, however. It won't power the Z6 when the camera is on, and only charges the battery while the camera is off.

■ Multi-power battery pack MB-N10. This battery/grip was announced but still in development when the Z6 was introduced. Lots of photographers consider a battery pack/vertical grip to be an essential item. Nikon says the pack will hold two EN-EL15b batteries and increase the number of shots and video recording time by approximately 1.8X. It will provide the same level of environmental sealing as the Z6, and its internal batteries can be recharged using an external adapter. Your camera already has a removable battery door and two mounting holes on the bottom to accept it. You can bet that third-party suppliers are busy designing compatible grips, too.

My recommendation: Hold out for the MB-N10. Many people love third-party grips from Meike, Neewer, Vivitar, and others, at a cost of less than \$70. I purchased a Meike grip for my D850 to test it out, and found it acceptable for occasional use. I expect a similar unit will be available for the Z6 by the time this book is published. However, most people like to clamp their add-on grips onto the camera and remove them only rarely. If you intend to make a battery grip part of your permanent setup, the Nikon model will be better made, more rugged, and guaranteed to work seamlessly with your camera.

- SC-28 TTL flash cord. Allows using Nikon Speedlights off-camera, while retaining all the automated features.
- SC-29 TTL flash cord. Similar to the SC-28, this unit has its own AF-assist lamp, which can provide extra illumination for the Z6's autofocus system in dim light (which, not coincidentally, is when you'll probably be using an electronic flash).

My recommendation: If you intend to work with an external flash extensively, you'll definitely want to use it off camera. Either of these cables will give you that flexibility. Wireless flash operation (described in Chapter 10) is more versatile, but requires more setup and has a steeper learning curve. With a flash cord, you just connect the cable to your camera and flash and fire away.

Your XQD Cards

One of the early "controversies" (if you can call it that) about the Z6 is that it has a single card slot. Apparently, all professional or semi-professional cameras (often automatically applied to any model, such as the Z6, with an MSRP of \$2,000 or more) must have the ability to use two card slots, for overflow or backup purposes. Those of us who made our living for a few decades using cameras that held just a single roll of film (which required after-the-fact processing to confirm that you got anything at all) are less upset. Of course, in those days it was common to wield two or more cameras per shoot, which provided for overflow (back when we depended on 36-exposure rolls of film) and a rudimentary form of interleaved backup.

After more than a decade of daily use of cameras with dual card slots, dating back to my Nikon D3, my take is that a second card slot is useful, but not really used that much for most shooting. I tend not to save to both cards simultaneously, as that can slow down continuous shooting, but I do spend some evenings copying my day's shots to a second card for backup. If I still did weddings or daily newspaper photography, I'd probably be more inclined to need backup mode.

Dual memory cards in overflow mode come in especially handy for spot news and sports, as a photojournalist will frequent swap out a card that's 80 percent (or slightly more) full for a fresh one to avoid missing something important during an inopportune trade. But most of the time I simply store my images on my fastest or largest memory card and treat the second slot as convenient insurance.

I am quite glad, however, that in choosing to provide only one card slot Nikon elected to go with the XQD form factor. Compact Flash media are on the way out. Secure Digital cards have a lower top-speed ceiling than XQD cards and typically don't have the ruggedness and comforting larger size afforded by XQD that many advanced enthusiasts and professionals prefer. XQD and its up-and-coming sibling media *CFexpress* are the most robust and fastest storage options available for digital photography. In early January, 2019, Nikon announced that you will be able to use faster CFexpress cards in the future—which use the same form factor—with a firmware upgrade to your Z6.

XQD cards are available in speeds up to 440Mbs transfer rates with UHS-II-compliant cameras like the Z6. Keep in mind that different vendors (such as Lexar, which may re-enter the XQD market in the near future) use different specifications for speed (both "X" factors and megabytes per second), and that *write* speed means how fast the device can transfer an image file to storage, while *read* speed (which may be emphasized because it is faster) represents how quickly the image can be transferred to your computer though a sufficiently fast connection (such as a USB 3.1 link).

For that reason, I have standardized on Sony XQD G-series media for my Z6. They're rated at 440Mbs/read and 400Mbs/write, fast enough to suck up images as quickly as the Z6's (relatively small) buffer is able to deliver them. In read mode, the cards can feed images to my computer as fast as my Windows or Mac machines can receive them. (I use Sony USB 3.1 card readers to transfer images.)

My recommendation: I suggest sticking with Sony's G-series memory cards, rather than their slower M series, because the Z6 can benefit from fast transfer. Sony has also introduced a more expensive "tough" version that resists bending, x-rays, magnetic fields, and other hazards in 120GB and 240GB capacities. While Lexar previously offered speedy memory cards, parent company Micron shut down Lexar in June 2017. The Lexar branding and trademark were acquired by Longsys, a Chinese flash memory company, in August 2017, and the "new" Lexar has not, at this writing, resumed manufacturing XQD media and the speed and quality of any new products they will offer is unknown as I write this. SanDisk, owned by Western Digital, also makes popular memory cards, but their popularity has led to widespread counterfeiting, with the fakes even slipping into the distribution channels of some major retailers. SanDisk does not support XQD cards in any event. Delkin offers some excellent "rugged" XQD cards in 64GB, 120GB, and 240GB capacities, and promises very fast replacement of cards that fail.

USB 3 FLUX

The conglomerate of corporations in charge of promoting the current USB specification (Hewlett-Packard, Intel, Microsoft, and NEC, among others, and cleverly named the USB 3.0 Promoter Group) keep meddling with the nomenclature, first merging the original USB 3.0 moniker with its successor the USB 3.1 (as USB 3.1 Gen 1 and USB Gen 2). There is now a USB 3.2 spec to accommodate the USB Type-C connector found on the Z6. Don't panic; devices labeled with these variations are all compatible, differing only by top theoretical transfer speed and type of connector at the end that plugs into your device. If you see a card reader or other add-on labeled USB 3.0, it will work fine in any USB slot, even though, officially, USB 3.0 (as a name) no longer exists.

Initial Setup

This section familiarizes you with the three important controls most used to make adjustments: the multi selector and the main and sub-command dials. You'll also find information on setting the clock, charging the battery, mounting a lens, and making diopter vision adjustments.

Once you've unpacked and inspected your camera, the initial setup of your Nikon Z6 is fast and easy. Basically, you just need to set the clock, charge the battery, attach a lens, and insert a memory card. If you already are confident you can manage these setup tasks without further instructions, feel free to skip this section entirely. While most buyers of a Z6 tend to be experienced photographers, I realize that some readers are ambitious, if inexperienced, and should, at a minimum, skim the contents of the next section, because I'm going to list a few options that you might not be aware of.

Mastering the Multi Selector and Command Dials

I'll be saving descriptions of most of the other controls used with the Nikon Z6 until Chapter 3, which provides a complete "roadmap" of the camera's buttons and dials and switches. However, you may need to perform a few tasks during this initial setup process, and most of them will require the MENU button and the multi/sub-selector buttons and pad. (See Figure 1.2.)

- **MENU button.** It requires almost no explanation; when you want to access a menu, press it. To exit most menus or to confirm and exit in some cases, press it again.
- Multi selector pad. This pad may remind you of the similar control found on many point-and-shoot cameras, and other digital cameras. It consists of a thumbpad-sized button with notches at the up, down, left, right, and diagonal positions.

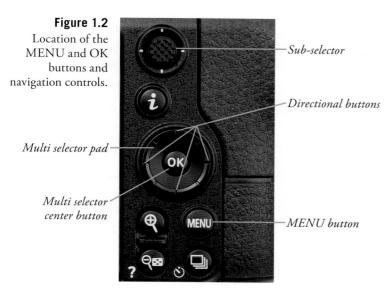

The multi selector is used extensively for navigation, for example, to navigate among menus; to advance or reverse display of a series of images during picture review; or to change the kind of photo information displayed on the screen. It can also be used interchangeably with the subselector "joystick" (described later) to choose one of the user-selectable focus areas on the view-finder and LCD monitor displays.

- Multi selector center (OK) button. The center button (as well as the right directional button) can be used to select a highlighted item from a menu. (I find pressing the right button faster and easier.) The center button also can function as an OK/Enter key.
- Sub-selector button. The sub-selector can be moved like a joystick, or pressed as if it were a button. As a navigational control, the sub-selector joystick's default function is as a convenient control for selecting the focus point *only*, as I'll explain in Chapters 3 and 5. If you also want to use the joystick for menu navigation scrolling or playback functions, you can add those behaviors using Custom Setting f2: Custom Control Assignment, as described in Chapter 12. The sub-selector center button, by default, can be pressed to lock focus or exposure (as an AE/AF lock button), but it can also be redefined to other behaviors with Custom Setting f2.

The main command dial and sub-command dial are located on the rear and front of the Z6, respectively. The main command dial is used to change settings such as shutter speed, while the sub-command dial adjusts an alternate or secondary setting. For example, in Manual exposure mode, you'd use the sub-command dial to change the aperture, while the main command dial is used to change the shutter speed. (In both cases, the dial is "active" for these adjustments only when the Z6's exposure meter is on.) The meter will automatically go to sleep after an interval (you'll learn how to specify the length of time in Chapter 12), and you must wake the camera (just tap the shutter release button) to switch the meter back on and activate the main and sub-command dials.

Touch Screen

The tilting LCD monitor supports a number of touch operations. For example, you can use it to navigate menus or make many settings. However, the touch screen can be especially useful during image playback and when shooting in live view. Here's a list of things you can do:

■ In Playback mode:

- Navigate among images. You can flick the screen to advance to other images during playback. (I'll explain all the touch screen gestures shortly.)
- Zoom in or out. Double-tap on the touch screen to zoom in or out of an image under review.
- **Relocate zoomed area.** You can slide a finger around the monitor to reposition the zoomed area.
- View thumbnails and movies. You can navigate among index thumbnails and movies.

■ In Photo shooting mode (when using the LCD monitor):

- **Take pictures.** In photo mode, when the monitor is active you can tap the touch screen to take a picture without pressing the shutter release. (However, you can't begin video capture with a tap.)
- **Select a focus point.** In both Photo and Movie modes, you can tap a location on the touch screen to specify a focus point.
- Navigate menus. Personally, I find the touch screen clumsy for navigating menus. The menu bars and icons are a bit too small on the 3.2-inch screen to be tapped with precision. You still must press the MENU button to produce the menus, tap the main menu tab at the left of the screen, then tap the specific item, and then choose among its options. Most of the time the multi selector directional buttons are a lot faster.
- Enter text. When working with a text entry screen (for example, to enter copyright information in the Setup menu), you can tap the on-screen keyboard to enter your text. That's *much* faster than the alternative—using the directional buttons to tediously move the highlighting from one character to another.

You can disable touch functions entirely or enable them for Playback functions only (and thus disabling touch menu navigation) in the Setup menu, as described in Chapter 13. You can also specify direction for full-frame playback "flicks" (left/right or right/left) using the Touch Controls entry. In addition, you can turn the Touch Shutter/AF feature off by tapping an icon that appears at the left side of the screen during live view and movie shooting.

When adjustments are available, a white rectangle is drawn around the indicator that can be accessed by touch. You will see up/down and left/right triangles used to adjust increments, or other icons for various functions. Available gestures include:

- Flick. Move a single finger a short distance from side to side across the monitor. Note that if a second finger or other object is also touching the monitor, it may not respond. During playback, a flick to right or left advances to the next or previous image.
- **Slide.** Move a single finger across the screen in left, right, up, or down directions. You can use this gesture during playback to rapidly move among subsequent or previous images in full-frame view, or to scroll around within a zoomed image. (See Figure 1.3, top left.)
- **Stretch/pinch.** Spread apart two fingers to zoom into an image during playback, or pinch them together to zoom out. (See Figure 1.3, bottom left.)
- **Tap.** Touch the screen with a single finger to make a menu adjustment. (See Figure 1.3, right.) For example, you can tap an up/down or left/right triangle to increment or decrement a setting, such as monitor brightness. When Touch Shutter is activated, tapping the screen locates the focus point at the tapped location and takes a picture when you remove your finger from the screen. When Touch Shutter is deactivated, tapping the screen simply relocates the focus point. (You'll find a Touch Shutter on/off icon at the left side of the LCD monitor screen, as explained in Chapter 14.)

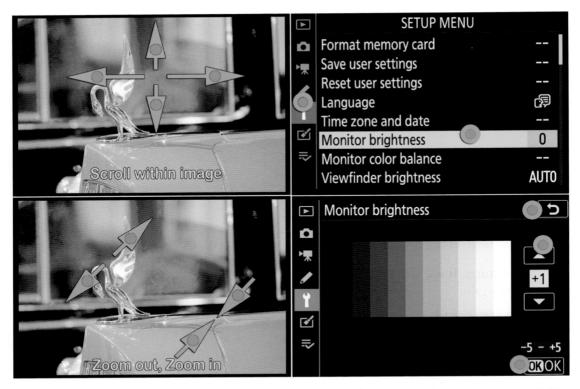

Figure 1.3 Flick or slide your finger across the touch screen to scroll from side to side or up or down (top left), pinch or spread two fingers to zoom in and out (bottom left). Tap menu tabs, entries, and settings to make adjustments (right).

A TOUCH OF SCREEN

Throughout this book, when telling you how to use a touch-compatible feature, I'm going to stick to referring to the physical buttons and dials, for the benefit of those who prefer to use the traditional controls. From time to time I'll remind you that a particular function can also be accessed using the touch screen.

Nikon really needs to redesign the camera interface to take full advantage of the touch-screen capabilities. Cameras from other vendors, for example, use more slider controls instead of left/right touch arrows to make many adjustments. While some may find Nikon's implementation helpful, it's best when used with the Touch Shutter/AF feature, zooming in/out of a playback image, or, especially, when "typing" text rather than scrolling around with the directional buttons. Those functions are perfect for touch control.

Because the screen uses static electricity, it may not respond when touched with gloved hands, fingernails, or when covered with a protective film. I have a GGS glass screen over my Z6's monitor and it works just fine; your experience may vary, depending on the covering you use. Don't use a stylus, pen, or sharp object instead of a finger; if your fingers are too large, stick to the physical controls such as the buttons or dials. As you'll learn in Chapter 13, you can enable or disable the touch controls or enable them only during playback, using an option in the Setup menu.

Setting the Clock

The Z6's clock settings are stored in internal memory powered by a rechargeable battery that's not accessible to the user. It is recharged whenever a removable battery is installed in the battery compartment, and two days of normal use will recharge the internal battery enough to power the clock for about a month. The Z6 is normally sold without its main battery installed, so you'll probably see a Clock Not Set icon the first time you power it up. In addition, if you store your Z6 for a long period without a charged main battery, the "clock" battery may go dead and "forget" your time/date/zone settings. It will recharge when a fresh EN-EL15b battery is inserted, and you'll need to set the clock again.

So, when you receive your camera, it's likely that its internal clock hasn't been set to your local time, so you may need to do that first. You'll find complete instructions for setting the four options for the date/time (time zone, actual date and time, the date format, and whether you want the Z6 to conform to Daylight Savings Time) in Chapter 13. However, if you think you can handle this step without instruction, press the MENU button, use the multi selector (that thumb-friendly button I just described, located to the immediate right of the back-panel LCD monitor) to scroll down to the Setup menu, press the multi selector button to the right, and scroll down to Time Zone and Date choice, and press right again. The options will appear on the screen that appears next. Keep in mind that you'll need to reset your camera's internal clock from time to time, as it is not 100 percent accurate.

Battery Included

Your Nikon Z6 is a sophisticated hunk of machinery and electronics, but it needs a charged battery to function, so rejuvenating the EN-EL15b lithium-ion battery pack furnished with the camera, an EN-EL15a pack, or EN-EL15 battery (Li-ion 20 version, if you're using an older EN-EL15 battery, please!) should be your first step. A fully charged power source should be good for approximately 380 shots, based on standard tests defined by the Camera & Imaging Products Association (CIPA) document DC-002. In the real world, of course, the life of the battery will depend on how much image review you do, and many other factors. You'll want to keep track of how many pictures *you* are able to take in your own typical circumstances, and use that figure as a guideline, instead.

All rechargeable batteries undergo some degree of self-discharge just sitting idle in the camera or in the original packaging. Lithium-ion power packs of this type typically lose a few percent of their charge every few days, even when the camera isn't turned on. Li-ion cells lose their power through a chemical reaction that continues when the camera is switched off. So, it's very likely that the battery purchased with your camera is at least partially pooped out, so you'll want to revive it before going out for some serious shooting.

Charging the Battery

When the battery is inserted into the MH-25a charger properly (it's impossible to insert it incorrectly), a Charge light begins flashing, and remains flashing until the status lamp glows steadily indicating that charging is finished, in about 2.5 hours. You can use the supplied connector cable or attach a handy included plug adapter that allows connecting the charger directly to a wall outlet (both shown at top left in Figure 1.4). When the battery is charged, flip the lever on the bottom of the camera and slide the battery in, as shown at top right in Figure 1.4. As noted earlier, when the camera is powered down, you can also charge the battery in the camera using the EH-7P AC adapter (Figure 1.4, bottom). Check the Setup menu's Battery Info entry as I recommended earlier

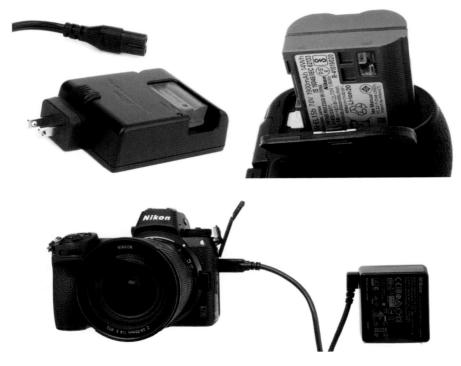

Figure 1.4
Charge the battery before use, and then insert the battery in the camera; it only fits one way.

to make sure the battery is fully charged. If not, try putting it in the charger again. One of three things may be the culprit: a.) the actual charging cycle sometimes takes longer than you (or the charger) expected; b.) the battery is new and needs to be "seasoned" for a few charging cycles, after which it will accept a full charge and deliver more shots; c.) you've got a defective battery. The last is fairly rare, but before you start counting on getting a particular number of exposures from a battery, it's best to make sure it's fully charged, seasoned, and ready to deliver.

My recommendation: Because Li-ion batteries don't have a memory, you can top them up at any time. However, their capacity when fully charged will eventually change over time. Once in a while, it's a good idea to use a battery until it is fully discharged, and then recharge it beyond the normal charging time. (Don't remove the battery from the charger until the light has gone out *and* the battery has fully cooled down.) It's also best to not store a battery for long periods either fully discharged or completely charged in order to maintain its longevity. If you own several (as you should), you'll probably want to rotate them to even the electronic wear and tear. I'll show you how to monitor battery use in Chapter 13.

Final Steps

Your Nikon Z6 is almost ready to fire up and shoot. You'll need to select and mount a lens, adjust the viewfinder for your vision, and insert a memory card. Each of these steps is easy, and if you've used any Nikon before, you already know exactly what to do. I'm going to provide a little extra detail for those of you who are new to the Nikon or digital camera worlds.

Mounting the Lens

As you'll see, my recommended lens mounting procedure emphasizes protecting your equipment from accidental damage and minimizing the intrusion of dust. If your Z6 has no lens attached, select the lens you want to use and loosen (but do not remove) the rear lens cap. I generally place the lens I am planning to mount vertically in a slot in my camera bag, where it's protected from mishaps, but ready to pick up quickly. By loosening the rear lens cap, you'll be able to lift it off the back of the lens at the last instant, so the rear element of the lens is covered until then.

After that, remove the body cap by rotating the cap away from the release button. You should always mount the body cap when there is no lens on the camera, because it helps keep dust out of the interior of the camera. (Although the Z6's sensor cleaning mechanism works fine, the less dust it has to contend with, the better.) The body cap also protects the sensor from damage caused by intruding objects (including your fingers, if you're not cautious).

Once the body cap has been removed, remove the rear lens cap from the lens, set it aside, and then mount the lens on the camera by matching the alignment indicator on the lens barrel with the raised white bump on the camera's lens mount. Rotate the lens toward the shutter release until it seats securely.

DEALING WITH ERRORS

After you've mounted your lens properly (or *think* you have), you might find various error codes appearing on the control panel, viewfinder, and back-panel color LCD monitor. Here are the most common error codes, and what you should do next:

F --. Lens not mounted. Make sure the lens is securely seated.

[-E-]. No memory card inserted.

*Card Err (flashing). Some error has taken place with your memory card.

Err. A camera malfunction. Release the shutter, turn off the camera, remove the lens, and remount it. Try another lens. If the message persists, then there is a problem unrelated to your lens, and your Z6 may need service.

* For (flashing). Card has not been formatted.

Set the focus mode switch on the lens to A (autofocus). If the lens hood is bayoneted on the lens in the reversed position (which makes the lens/hood combination more compact for transport), twist it off and remount with the "petals" (found on virtually all lens hoods for newer Nikon optics) facing outward. (See Figure 1.5.) A lens hood protects the front of the lens from accidental bumps, and reduces flare caused by extraneous light arriving at the front element of the lens from outside the picture area.

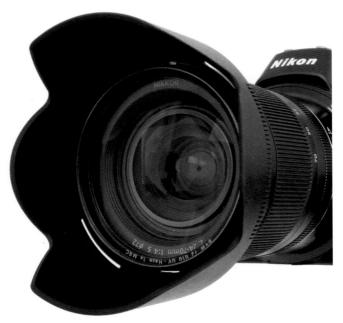

Figure 1.5
A lens hood protects the lens from extraneous light and accidental bumps.

Adjusting Diopter Correction

Those of us with less than perfect eyesight can often benefit from a little optical correction in the viewfinder. Your contact lenses or glasses may provide all the correction you need, but if you are a glasses wearer and want to use the Z6 without your glasses, you can take advantage of the camera's built-in diopter adjustment, which can be varied from -4 to +2 correction. Pull out, then rotate the diopter adjustment control next to the viewfinder (see Figure 1.6) while looking through the viewfinder until the image of your subject is sharp. (The focus screen where your subject appears, and the indicators outside the image area are at slightly different "distances" optically, so you should use an actual image rather than the status indicators if you want to be able to evaluate focus through the viewfinder accurately.)

If more than one person uses your Z6, and each requires a different diopter setting on the camera itself, you can save a little time by noting the number of clicks and direction (clockwise to increase the diopter power; counterclockwise to decrease the diopter value) required to change from one user to the other.

Inserting a Memory Card

You've probably set up your Z6 so you can't take photos without a memory card inserted. (There is a Slot Empty Release Lock entry in the Setup menu that enables/disables shutter release functions when a memory card is absent—learn about that in Chapter 13.) So, your final step will be to insert a memory card. Slide the door on the back-right edge of the body toward the back of the camera to release the cover, and then open it. (You should only remove a memory card when the camera is switched off, or, at the very least, the yellow-green memory access light that indicates the camera is writing to the card is not illuminated.)

Insert the XQD card with the label facing the back of the camera, oriented so the edge with the contacts goes into the slot first. (See Figure 1.7.) Close the door, and, if necessary, format the card. The card can be removed just by pressing it inward; it will pop out far enough that you can extract it.

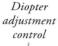

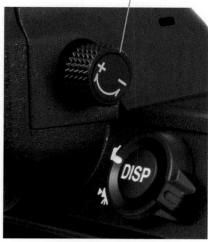

Figure 1.6 Viewfinder diopter correction from –4 to +2 can be dialed in.

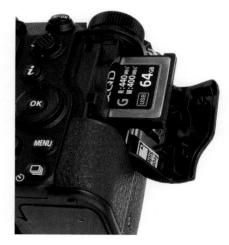

Figure 1.7 The memory card is always inserted with the label facing the back of the camera.

Formatting a Memory Card

There are three ways to create a blank memory card for your Z6, and two of them are wrong. Here are your options, both correct and incorrect:

- Transfer (move) files to your computer. When you transfer (rather than copy) all the image files to your computer from the memory card (either using a direct cable transfer or with a card reader), the old image files are erased from the card, leaving the card blank. Theoretically. Unfortunately, this method does *not* remove files that you've labeled as Protected (by pressing the *i* button during Playback and selecting Protect from the screen that pops up), nor does it identify and lock out parts of your memory card that have become corrupted or unusable since the last time you formatted the card. Therefore, I recommend always formatting the card, rather than simply moving the image files, each time you want to make a blank card. The only exception is when you *want* to leave the protected/unerased images on the card for a while longer, say, to share with friends, family, and colleagues.
- (Don't) Format in your computer. With the memory card inserted in a card reader or card slot in your computer, you *can* use Windows or Mac OS to reformat the memory card. Don't! The operating system won't necessarily install the correct file system. The only way to ensure that the card has been properly formatted for your camera is to perform the format in the camera itself. The only exception to this rule is when you have a seriously munged memory card that your camera refuses to format. Sometimes it is possible to revive such a corrupted card by allowing the operating system to reformat it first, then trying again in the camera.
- Setup menu format. To use the recommended method to format a memory card, press the MENU button, use the up/down buttons of the multi selector to choose the Setup menu (which is represented by a wrench icon), navigate to the Format Memory Card entry with the right button of the multi selector, and select Yes from the screen that appears. Press OK to begin the format process.

My recommendation: I always use the Setup menu format before each shoot, as long as the images thereon have already been transferred to my computer. Nothing is worse than beginning a session and discovering that your memory card is almost full and contains images you don't want to delete to make room for new shots. If you neglected to bring along an extra memory card, you may have some difficult decisions to make.

Nikon Z6 Quick Start

You'll find that it takes only a few minutes to learn the basics of operating your new Nikon Z6, and I'll give you everything you need to begin taking great pictures in this chapter. If you've mounted a lens and inserted a fresh, fully charged battery as I explained in the last chapter, you're ready to begin. Power your camera up—the On/Off switch is on the right side, concentric with the shutter release button. All you need to do next is select a release mode, exposure mode, metering mode, and focus mode.

SWITCHING FROM VIEWFINDER TO MONITOR

The Z6 has a sensor located just above the viewfinder window. When it detects you've brought the camera up to your eye, the Z6 switches its display from the LCD monitor to the viewfinder, and then back again when you remove the camera from your eye. You can change this default behavior, as I'll explain in Chapter 3, or manually switch between them using the Monitor Mode button located on the left side of the viewfinder "pentaprism" hump.

Selecting a Release Mode

This section shows you how to choose from Single frame, Continuous (low speed, high speed, or high speed [extended]), and Self-timer. Unless you have need of burst shooting or the self-timer, you can set your camera to Single frame mode and skip ahead to "Selecting an Exposure Mode" (next). Just press the release mode button at the lower-right corner of the back of the camera and when the selection screen pops up, rotate the command dial to the first, or S position, if it's been changed to something else. (See Figure 2.1.)

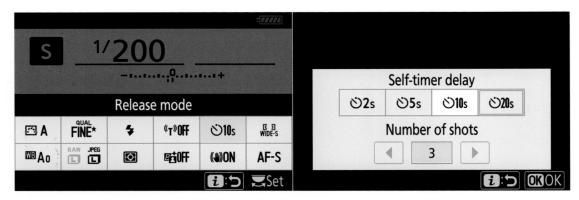

Figure 2.1 Choose a release mode from the *i* menu.

The shooting mode determines when (and how often) the Z6 makes an exposure. If you're a late-comer moving to the interchangeable-lens camera world from a point-and-shoot camera, you might have used a model that labels these options as *drive modes*, a term that dates back to the film era when cameras could be set for single shot or "motor drive" (continuous) shooting modes. Your Z6 has five release (shooting) modes, described below. I'll explain all these modes in more detail and provide tips for using them in particular situations in Chapter 4. The shooting modes are as follows:

- **Single frame.** In single-frame mode, the Z6 takes one picture each time you press the shutter release button down all the way. If you press the shutter and nothing happens (which is very frustrating!), you may be using a focus mode that requires sharp focus to be achieved before a picture can be taken. This is called *focus-priority*, and is discussed in more detail under "Choosing a Focus Mode," later in this chapter.
- Continuous L. This "low-speed" shooting mode can be set to produce bursts from 1 to 5 frames per second, at your option. When Continuous L is highlighted, rotate the *sub-command dial* on the front of the camera to select your frame rate. You can also set a *default* frame rate for Continuous L in Custom Setting d1.

I use this setting when slicing a scene into tiny fragments of time isn't necessary or desirable (say, I'm bracketing in multi-shot bursts, or don't want a zillion versions of a scene that really isn't changing that fast). Custom settings are explained in more detail in Chapter 12. In continuous low-speed and high-speed mode (described below), the viewfinder and LCD monitor update in real time while shooting is underway, so you are always looking at the actual image you are capturing.

My recommendation: I find continuous low speed, set to 2 fps, to be particularly useful for street photography and photojournalism applications. Because the speed is so slow, you can use it like single frame most of the time and capture a single image by pressing the shutter release

once and then lifting your finger. But if you find a subject that merits a more rapid-fire approach, you can keep the shutter release pressed down, and fire off several shots sequentially. That's faster than switching from single to continuous mode, and you can avoid the intrusive, distracting "machine gun" approach.

- Continuous H. This mode fires off shots at *up to 5.5* fps, and you can't change this frame rate to some other value, as you can with the continuous low-speed setting. However, the frame rate can slow down as your Z6's memory buffer fills, which forces the camera to wait until some of the pictures you have already taken are written to the memory card, freeing up more space in the buffer. The frame rate may also decrease when you're using the Z6's electronic shutter, or mechanical shutter speeds slower than 1/250th second, when using high ISO or Auto sensitivity settings or small apertures, when vibration reduction is active, or when some other operations force the Z6 to work at a slightly slower interval.
- Continuous H (Extended). This setting has a fixed setting of roughly 12 fps when shooting in JPEG or 12-bit NEF (RAW) modes, and 9 fps when capturing 14-bit NEF (RAW) files. (The frame advance rate can slow down given the constraints listed above.) At the speedy top rate, the Z6 does not update exposure between frames: it's locked at the exposure setting for the first frame of a sequence. You may notice some lag in the viewfinder/monitor displays, which may not show the exact current image being captured. Flicker reduction is ignored, and you can't use flash in this release mode. (Your flash could not recycle fast enough to keep pace!)
- Self-timer. If you want to set a short delay before your picture is taken, you can use the self-timer. When self-timer is highlighted, you can press the down directional button and choose delays of 2s, 5s, 10s, or 20s, as well as the number of shots taken after the delay. You can also choose these parameters in the Self-timer entry of the Photo Shooting menu (as described in Chapter 11).

Once the self-timer has been selected as the release mode, press the shutter release to lock focus and start the timer. The self-timer lamp on the front of the camera will blink and the beeper will sound (unless you've silenced it in the menus) until the final two seconds, when the lamp remains on and the beeper beeps more rapidly.

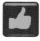

TIP

If you plan to dash in front of the camera to join the scene when working with the self-timer, consider using manual focus so the Z6 won't refocus on your fleeing form and produce unintended results. (Nikon really needs to offer an option to autofocus at the *end* of the self-timer cycle.) An alternative is to use one of the optional wireless remotes, including the WR-R10/WR-T10, WR-A10, or WR-1, because the camera focuses when you press the button (after you've ensconced yourself safely in the frame). The SnapBridge feature of the Z6 also allows you to control your camera remotely from a smart device app running on your iOS or Android phone. I have a special section on using SnapBridge in Chapter 6.

SHOOTING MOVIES

You'll learn more about shooting HDTV movie clips with your Z6 later in Chapter 15. But if you want to get started right away, it's easy. Just rotate the Photo/Movie selector switch (located on the back of the camera to the immediate right of the viewfinder window) to the Movie position and press the button with the red dot on the top-right panel, southwest of the shutter release button. Press the button again to stop shooting. That's it!

Selecting an Exposure Mode

This section shows you how to choose an exposure mode, by pressing the mode dial release button on the top-left shoulder of the camera and rotating the mode dial. If you already understand exposure modes, jump to the next section on choosing a metering mode.

The Nikon Z6 has one full Auto mode (marked with a green camera icon on the mode dial located on the left shoulder of the camera). It's more likely you'll be working with the four manual and semi-automatic modes including Programmed auto (or Program mode), Shutter-priority auto, Aperture-priority auto, and Manual exposure mode. These modes allow you to specify how the camera chooses its settings when making an exposure, for greater creative control. (The other three positions on the mode dial, marked U1, U2, and U3 are not exposure modes, either, but, rather User Setting memory registers to store preferred settings for quick recall.)

If you're very new to digital photography, you might want to set the camera to P (Program mode) and start snapping away. That mode will make all the appropriate settings for you for many shooting situations. If you have more photographic experience, you might want to opt for one of the semi-automatic modes. These, too, are described in more detail in Chapter 4. These modes all let you apply a little more creativity to your camera's settings. To set the exposure mode, hold down the mode dial lock release button, and rotate the mode dial. (See Figure 2.2.)

- P (Program). This mode allows the Z6 to select the basic exposure settings, but you can still override the camera's choices to fine-tune your image, while maintaining metered exposure, as I'll explain in Chapter 4.
- S (Shutter-priority). This mode is useful when you want to use a particular shutter speed to stop action or produce creative blur effects. Choose your preferred shutter speed by rotating the main command dial when the meter is active, and the Z6 will select the appropriate f/stop for you.

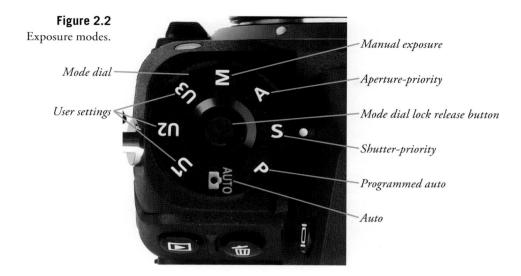

- A (Aperture-priority). Choose when you want to use a particular lens opening, especially to control sharpness or how much of your image is in focus. Specify the f/stop you want using the sub-command dial when the meter is "awake" (tap the shutter release to activate the meter, if necessary), and the Z6 will select the appropriate shutter speed for you.
- M (Manual). Select when you want full control over the shutter speed and lens opening, either for creative effects or because you are using a studio flash or other flash unit not compatible with the Z6's automatic metering when using an attached electronic flash. Use the main command dial and sub-command dial when the exposure meter is active to specify the shutter speed and f/stop (respectively).

Choosing a Metering Mode

This section shows you how to choose the area the Z6 will use to measure exposure, giving emphasis to the center of the frame or to highlight areas; evaluating many different areas of the frame; or measuring light from a small spot in the center of the frame.

The metering mode you select determines how the Z6 calculates exposure. You might want to select a particular metering mode for your first shots, although the default Matrix metering is probably the best choice as you get to know your camera. I'll explain when and how to use each of the four metering modes later. To change metering modes, press the *i* button (located to the right of the LCD monitor) and use the multi selector directional buttons to navigate to the Metering icon, third from the left in the bottom row. When it's highlighted, you can rotate either command dial to select one of the choices listed below. I'll discuss selection of all types of metering in Chapter 4 (see Figure 2.3):

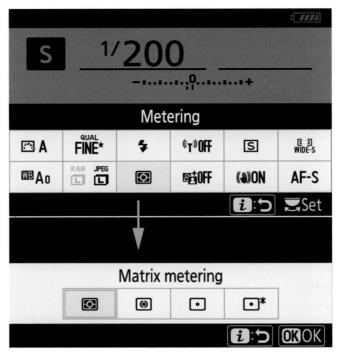

Figure 2.3
Choose a metering mode from the *i* menu. Bottom, left to right: Matrix, Center-weighted, Spot, and Highlight-weighted metering.

- Matrix metering. The standard metering mode; the Z6 attempts to intelligently classify your image and choose the best exposure based on readings from the sensor.
- Center-weighted metering. The Z6 meters the entire scene, but gives the most emphasis to the central area of the frame, measuring about 12mm (by default; you can choose full-frame averaging instead, Custom Setting b3, as I'll describe in Chapter 12).
- **Spot metering.** Exposure is calculated from a smaller 4mm central spot, about 1.5 percent of the image area, centered on the current focus point.
- **Highlight-weighted metering.** Despite its icon (a "spot" accompanied by an asterisk), this is not a spot metering variation. Highlight-weighted metering uses a matrix measuring system to emphasize the highlights of an image, retaining detail in the brightest areas.

You'll find a detailed description of each of these modes in Chapter 4.

Choosing a Focus Mode

This section shows how to select *when* the Z6 calculates focus: all the time (continuously), only once when you press a control like the shutter release button (single autofocus), or manually when you rotate a focus ring on the lens.

You can easily switch between automatic and manual focus by moving the AF/MF or M-AF/MF switch on the lens mounted on your camera. You can select the autofocus mode (*when* the Z6 measures and locks in focus) and autofocus pattern (*which* of the available autofocus points are used to interpret correct focus). To specify when the Z6 locks in focus, follow these steps:

- 1. **Activate autofocus.** Make sure the camera is set for autofocus mode by sliding any A/M switch on the lens to the A position.
- 2. **Enter setting mode.** Access the *i* menu. Press the *i* button and navigate to the Focus Mode label, located at far right in the bottom row.
- 3. **Choose AF mode.** Rotate either command dial until AF-S or AF-C (or M if you want Manual focus) is shown on the top-side monochrome control panel, or in the viewfinder or back-panel color LCD monitor when the information display screen is visible. (Press the button labeled DISP, located to the right of the LCD monitor, to produce it.) If you haven't activated autofocus mode, as described in Step 1, you can select AF-S or AF-C, but the focus mode will not change until you set the switch on the lens to A. The focus modes are described in more detail next.

The two autofocus modes available in still shooting mode are as follows:

- (AF-C) Continuous-servo autofocus. This mode, sometimes called *continuous autofocus*, sets focus when you partially depress the shutter button (or other autofocus activation button), but continues to monitor the frame and refocuses if the camera or subject is moved. This is a useful mode for photographing sports and moving subjects. Focus- or release-priority can be specified for AF-C mode using Custom Setting a1.
- (AF-S) Single-servo autofocus. This mode, sometimes called *single autofocus*, locks in a focus point when the shutter button is pressed down halfway (there are other autofocus activation button options, described in Chapter 13), and the focus confirmation light glows at bottom left in the viewfinder. The focus will remain locked until you release the button or take the picture. This mode is best when your subject is relatively motionless. As you'll learn in Chapter 13, you can set your Nikon Z6 using Custom Setting a2 so that the camera will not take a photo unless sharp focus is achieved (*focus-priority*), or so that it will go ahead and snap a photo while still adjusting focus (*release-priority*).

Choosing the Focus Area Mode

The Nikon Z6 uses up to 273 different focus points to calculate correct focus, using one or more points selected automatically by the camera, or chosen by you. I'll show you exactly where these focus areas are located in Chapter 5. To choose a focus area mode, follow these steps:

- 1. **Enter setting mode.** Access the *i* menu and navigate to the AF-area label, located at the far right of the top row.
- 2. **Rotate either command dial.** Rotate either command dial to highlight Pinpoint-AF (available in AF-S focus mode only), Single-point AF, Dynamic-area AF (available in AF-C focus mode only), Wide-area AF (Small), Wide-area AF (Large), or Auto-area AF.
- 3. **Choose AF-area mode.** For now, you should set to Auto-area AF (Auto) and allow the Z6 to choose the focus zone for you. Press OK to confirm and exit.

The AF-area modes are as follows. You'll find more information in Chapter 5.

- Pinpoint-AF (AF-S only). The camera uses a small point to calculate focus. Use this for precise focus on a specific area.
- Single-point (AF-S or AF-C). The camera focuses on a point you select, using the multi selector directional buttons or sub-selector joystick. This mode is good for non-moving subjects.
- Dynamic-area (AF-C only). You select the focus point, but if the subject moves from the selected area, it will use information from the surrounding points. It's often the best AF-area mode for moving subjects.
- Wide-area AF (Small). Calculates focus from a larger area than Single-point AF, and is best for stationary subjects that occupy more space in the frame.
- Wide-area AF (Large). Calculates focus from an even larger zone, and can achieve accurate focus on subjects that may be located in a wider area of the frame.
- Auto-area AF (AF-S or AF-C). The Z6 chooses a focus point without input from you, rapidly detecting likely subject matter, especially humans. If a portrait subject is detected, faces will be indicated by a yellow border. You can automatically track them by pressing the OK button.

Adjusting White Balance and ISO

If you like, you can custom-tailor your white balance (color balance) and ISO sensitivity settings. To start out, it's best to set white balance (WB) to $Auto_0$, and ISO to ISO 200 for daylight photos, and to ISO 400 for pictures in dimmer light. (Don't be afraid of ISO 1600 or even higher, however; the Z6 does a *much* better job of producing low-noise photos at higher ISOs than earlier generations.) You can adjust white balance now by pressing and holding down Fn1, the default White Balance button on the front of the camera to the right of the lens, and rotating the main command dial until A_0 , A_1 , or A_2 appear. Then, with the button still held down, rotate the sub-command dial,

if necessary, to select A_0 (Keep White/Reduce Warm Colors), which is the default auto white balance setting. (The other two partially or fully preserve the warm color cast produced by incandescent lighting, as I'll explain in Chapter 12.)

To set ISO, press the ISO button on the top-right shoulder just aft of the On/Off switch, and rotate the main command dial until the setting you want is displayed in the viewfinder or monitor.

Reviewing the Images You've Taken

Read this section when you're ready to take a closer look at the images you've taken, and you want to know how to review pictures and zoom in.

The Nikon Z6 has a broad range of playback and image review options, and I'll cover them in more detail in Chapter 11. For now, you'll want to learn just the basics. Here is all you really need to know at this time, as seen in Figure 2.4:

- View image. Press the Playback button (marked with a white right-pointing triangle) at the extreme left corner of the back of the camera to display the most recent image on the LCD monitor.
- View additional images. Press the multi selector left or right to review additional images. Press right to advance to the next image, or left to go back to a previous image.

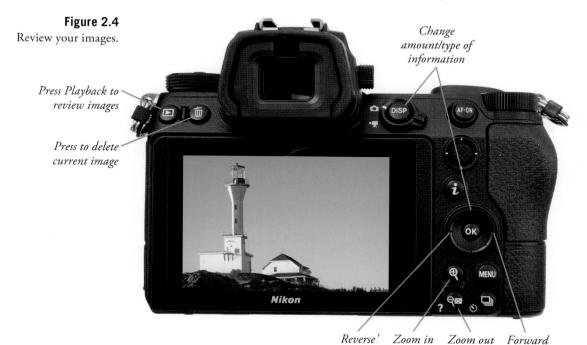

- Change information display. Press the multi selector button up or down or the DISP button to change among overlays of basic image information or detailed shooting information.
- Change magnification. Press the Zoom In button repeatedly to zoom in on the image displayed; the Zoom Out button reduces the image. (Both buttons are located to the right of the color LCD monitor.) A thumbnail representation of the whole image appears in the lower-right corner with a yellow rectangle showing the relative level of zoom. At intermediate zoom positions, the yellow rectangle can be moved around within the frame using the multi selector.
- Exit image review. Press the Playback button again, or just tap the shutter release button to exit playback view.

Transferring Photos to Your Computer

The final step in your picture-taking session will be to transfer the photos you've taken to your computer for printing, further review, or image editing. Your Z6 allows you to print directly to PictBridge-compatible printers and to create print orders right in the camera, plus you can select which images to transfer to your computer. I'll outline those options in Chapter 11.

I always recommend using a card reader attached to your computer to transfer files, because that process is generally a lot faster and doesn't drain the Z6's battery. However, you can also use a cable for direct transfer, which may be your only option when you have the cable and a computer, but no card reader (perhaps you're using the computer of a friend or colleague, or at an Internet café).

To transfer images from the camera to a Mac or PC computer using the USB cable:

- 1. Turn off the camera.
- 2. Pry back the rubber cover that protects the Z6's USB port on the left side of the camera, and plug the USB cable furnished with the camera into the USB port. (See Figure 2.5.)
- 3. Connect the other end of the USB cable to a USB port on your computer.
- 4. Turn on the camera. The operating system itself, or installed software such as Nikon Transfer or Adobe Photoshop Elements Transfer, usually detects the camera and offers to copy or move the pictures. Or, the camera appears on your desktop as a mass storage device, enabling you to drag and drop the files to your computer.

Figure 2.5 Images can be transferred to your computer using a USB cable connected to this port.

To transfer images from a memory card to the computer using a card reader, as shown in Figure 2.6:

- 1. Turn off the camera.
- 2. Open the memory card door and extract the XQD card containing your photos.
- 3. Insert the memory card into your memory card reader. Your installed software detects the files on the card and offers to transfer them. The card can also appear as a mass storage device on your desktop, which you can open and then drag and drop the files to your computer.

Figure 2.6 A card reader is the fastest way to transfer photos.

Changing Default Settings

This section is purely optional, especially for true beginners, who should skip it entirely for now, and return when they've gained some experience with this full-featured camera. This section is for the benefit of those who want to know *now* some of the most common changes I recommend to the default settings of your Z6. Nikon has excellent reasons for using these settings as a default, covered earlier in the chapter in the "Selecting a Release Mode" section; I have better reasons for changing them.

Even if this is your first experience with a Nikon interchangeable-lens digital camera, you can easily make a few changes to the default settings that I'm going to recommend, and then take your time learning *why* I suggest these changes when they're explained in the more detailed chapters of this book. I'm not going to provide step-by-step instructions for changing settings here; I'll give you an overview of how to make any setting adjustment, and leave you to navigate through the fairly intuitive Z6 menu system to make the changes yourself.

Resetting the Nikon Z6

If you want to change from the factory default values, you might think that it would be a good idea to make sure that the Nikon Z6 is set to the factory defaults in the first place. After all, even a brand-new camera might have had its settings changed at the retailer, or during a demo. Unfortunately, Nikon doesn't make it easy to reset *all* settings in the camera to their factory defaults. In fact, there are no fewer than *four* different menu resetting options, each of which does slightly different things.

Those ways include:

- Photo Shooting/Movie Shooting menu reset. The Photo Shooting and Movie Shooting menus each have a reset entry as their first listing. You'll zero out the changes you've made to the default options. You can view the settings and their defaults in Chapter 11.
- Custom Settings menu reset. The Custom Settings menu also has a separate Reset Custom Settings option that zeroes out most of the changes you've made to the default options to Custom Settings menu entries. The default values are listed in Chapter 12.
- Setup menu reset. The Reset All Settings entry in the Setup menu (described in Chapter 13), will restore almost all the camera's settings to their factory defaults, including Copyright information and IPTC presets, but *not* Language or Time Zone/Date information. Before doing this type of reset, it's a good idea to save your settings to a memory card using the Save/Load Settings entry in the Setup menu. As most Setup menu entries are camera configuration items rather than operational options, I won't be recommending preference changes for them in this chapter. The default Setup menu settings can be found in Chapter 13.

Photo Shooting Menu/Movie Shooting Menu/Custom Settings Menu Reset

If you'd like to reset all the options in the Photo Shooting, Movie Shooting, or Custom Settings menus, follow these steps:

- 1. Access menus. Press the MENU button located on the right back panel of the Z6.
- 2. Choose Photo Shooting, Movie Shooting, or Custom Settings menus. Press the multi selector down button to scroll down to the Photo Shooting menu (represented by a still camera), the Movie Shooting menu (represented by a movie camera icon), or the Custom Settings menu (represented by a pencil icon). Press the right multi selector button to reveal the Photo Shooting, Movie Shooting, or Custom Settings menus.
- 3. Access Reset. Use the down button to scroll to the entries labeled Reset Photo Shooting Menu, Reset Movie Shooting Menu, or Reset Custom Settings, then press the right button.
- 4. **Reset.** You'll be presented immediately with the option of choosing Yes or No to reset the respective menu. Highlight Yes and press OK.
- 5. Repeat. If you want to reset other menus, repeat steps 3 and 4.
- 6. Exit. When finished, press MENU or tap the shutter release to exit.

Recommended Default Changes

Although I won't be explaining how to use the Nikon Z6's menu system in detail until Chapter 11, you can make some simple changes now. These general instructions will serve you to make any of the default setting changes I recommend next. To change any menu setting, follow these steps:

1. **Access menus.** Press the MENU button located below the multi selector on the back-panel LCD monitor.

- 2. Choose the main menu you need to access. Press the multi selector down button to scroll down to the menu containing the entry you want to change. The available menus include (from top to bottom in the left column of the menu screen): Playback menu (right-pointing triangle icon); Photo Shooting menu (still camera icon); Movie Shooting menu (movie camera icon); Custom Settings menu (pencil icon); Setup menu (wrench icon); Retouch menu (paintbrush icon); My Menu (text page/text page with checkmark icon).
- 3. **Select main menu.** Press the right multi selector button to choose the menu heading containing the submenu entry you want to change.
- 4. **Choose menu entry.** Press the down multi selector button to move within the main menu to the entry you want to change. A scroll bar at the right side shows your progress through the menu, as all the main menus except for the Custom Settings menu and My Menu (if it contains fewer than five custom entries) have more items than can fit on a single screen.
- 5. **Choose options.** Press the right multi selector button to choose the highlighted menu entry, and view a screen with options. Select the options you want, and press OK to confirm. Some menus allow you to confirm by pressing the right button again, or require you to select and confirm Done before exiting.
- 6. **Exit menus.** Usually you can exit the menu system by pressing the MENU button. If an option has variations, I'll explain them when I discuss each of the menu choices in Chapters 11, 12, and 13.

Nikon does an excellent job with specifying default values, but here are some of the changes I recommend you make to the defaults that Nikon sets up for you. There are only a few, and I have no changes to recommend for the Playback, Setup, and My Menu settings, which are fine the way they are for most people, nor for the Retouch menu (which doesn't have parameters that can be stored).

Here are my suggestions for the Photo Shooting menu entries listed:

- Image Quality. Change from JPEG Normal to JPEG Fine *, to produce better image quality. (The star indicates least compression, and best quality.)
- **High ISO NR.** Nikon recently changed the default value from Normal to Off for its high-end cameras, and, even if you want the minimum amount of grainy visual noise in your images, resist the temptation to change it. Wait until you've had a chance to evaluate whether the Z6 performs to your liking at high sensitivity settings. Off produces the least amount of noise reduction, but also doesn't degrade the amount of detail as much as any of the On settings.
- Auto ISO sensitivity control: Maximum sensitivity. The default value for the Z6 is a lofty 51200. You should lower it to ISO 6400 or below. New users of this camera shouldn't want to allow the camera to select a higher value until they've had a chance to decide if images at settings higher than ISO 6400 are acceptable to them. It's better to be unable to take pictures at all in very dim light than to end up with excessively grainy images when the Z6 chooses an ISO setting automatically that isn't acceptable.

Recommendations for the Movie Shooting menu:

- Auto ISO sensitivity control: Maximum sensitivity. The default value for movie shooting is also 51200. You should lower it to ISO 6400 or below, for the reasons described above.
- **High ISO NR.** The default value for movie shooting is Normal (not Off, as for still shooting). Nikon reasons that noise reduction, with an accompanying loss of detail, is more acceptable with video because each frame is viewed for only a fraction of a second. While that is true, I do recommend you turn it off, at least temporarily, and shoot some test video and then compare to video with noise reduction set to Normal to see which best suits your needs.

Make these changes to the Custom Settings and Setup menu entries listed:

- Custom Setting c3: Standby timer. If you shoot sports or other events where you don't want the camera going to sleep and delaying your ability to snap off a shot *now*, change from the default 30 seconds to 5 minutes or 10 minutes. You'll use more power, but won't lose a shot from a split-second delay while the camera wakes up.
- Setup menu: Slot empty release lock. This controls what happens when you press the shutter release while no memory card is loaded in the camera. Change from the default OK: Enable Release to LOCK: Release Locked. Why would you want to be able to take pictures with no memory card in the camera, other than to demonstrate the camera or a few other reasons? Even though a DEMO label appears on the LCD monitor when you "take" pictures with no memory card inserted, it's easy to overlook. Turn this capability to LOCK.

Shooting Tips

I'm ending this chapter with some tips on settings to use for different kinds of shooting, including recommended settings for some Photo Shooting and Custom Setting menu options. You can set up your camera to shoot the main type of scenes you work with, then use the tables that follow to make changes for other kinds of images. Most will set up their Z6 for my basic settings, and adjust from there. I'm not going to provide recommendations for *every* menu setting, as many are simply personal preferences that don't apply to everyone. If you see a listing missing, it's because the setting should be made to your preference. Chapters 11, 12, and 13 provide more detailed recommendations.

Photo Shooting Menu Recommendations

I'll list my Photo Shooting menu suggestions first, in Tables 2.1 and 2.2. The Custom Setting menu recommendations are divided into the exact same categories but, of course, deal with different options. In Table 2.1, the second column shows the default settings, as the Z6 comes from the factory. (I have no specific recommendations for the Movie Shooting or Setup menus.)

Table 2.1 Phot	o Shooting Menu	Recommendati	ons #1	
Option	Camera Default	Basic Setting	Studio Flash	Portrait
File Naming	DSC/_DSC	NZ6/_NZ6 or your choice	NZ6/_NZ6 or your choice	NZ6/_NZ6 or your choice
Image Quality	JPEG Normal	JPEG Fine*	NEF	NEF+JPEG Fine*
Image Size: >JPEG/TIFF >NEF (RAW)	Large RAW Large	Large RAW Large	Large RAW Large	Large RAW Large
NEF (RAW) Recording: >Type	Lossless	Lossless	Lossless	Lossless
>NEF(RAW) bit depth	compressed 14 bit	compressed 14 bit	compressed 14 bit	compressed 14 bit
ISO Sensitivity Settings:				
>ISO sensitivity	100	100	100	100
>ISO sensitivity auto control:	Off	On	Off	Off
Maximum sensitivity	51200	6200	1600	1600
Maximum sensitivity/flash	51200	1600	800	800
Minimum shutter speed	Auto	1/60 sec.	1/60 sec.	1/60 sec.
White Balance	Auto 0	Auto 0	Preset Manual	Preset Manual
Set Picture Control	Standard	Save as C-1 (Standard + Sharp 7)	Standard	Save as C-3 (Neutral + Sharp –2)
Color Space	sRGB	Adobe RGB	Adobe RGB	Adobe RGB
Active D-Lighting	Off	Off	Off	Off
Long Exp. NR	Off	Off	Off	Off
High ISO NR	Normal	Low	Low	Low
Auto Distortion Control	Off	Off	Off	Off

Table 2.2 Photo	Shooting Menu	ı Recommendatio	ns #2	
Option	Long Exposure	Sports Outdoors	Sports Indoors	Landscape
File Naming	NZ6/_NZ6 or your choice	NZ6/_NZ6 or your choice	NZ6/_NZ6 or your choice	NZ6/_NZ6 or your choice
Image Format/ Quality	NEF	JPEG Fine	JPEG Fine	NEF+JPEG Fine*
Image Size:				
>JPEG/TIFF	Large	Large	Large	Large
>NEF (RAW)	RAW Large	RAW Large	RAW Large	RAW Large
NEF (RAW) Recording:				
>Type	Lossless compressed	Lossless compressed	Lossless compressed	Lossless compressed
>NEF (RAW) bit depth	14 bit	14 bit	14 bit	14 bit
ISO Sensitivity				
Settings:				
>ISO sensitivity	100	400	1600	100
>ISO sensitivity auto control:	Off	On	Off	Off
Maximum sensitivity	51200	3200	1600	1600
Maximum sensitivity/flash	51200	1600	800	800
Minimum shutter speed	Auto	1/60 sec.	1/60 sec.	1/60 sec.
White Balance	Auto 0	Auto 0	Auto 0	Auto 0
Set Picture Control	Standard	Standard	Standard	Landscape
Color Space	sRGB	Adobe RGB	Adobe RGB	Adobe RGB
Active D-Lighting	Off	Off	Off	Auto
Long Exp. NR	Off	Off	Off	Off
High ISO NR	Normal	Low	Low	Low
Auto Distortion Control	Off	Off	Off	Off

Custom Setting Menu Recommendations

Next come the Custom Setting menu recommendations—Tables 2.3 and 2.4. They are divided into categories. And, of course, they all deal with different options. I don't have any recommendations for CSM g Movie Settings, which assigns functions for movie shooting only; your preferences will depend entirely on what kind of video you capture.

Item	Option	Camera Default	Basic Setting	Studio Flash	Portrait	Long Exposure
Auto	focus					
al	AF-C priority selection	Release	Release	Release	Release	Release
a2	AF-S priority selection	Focus	Focus	Focus	Focus	Focus
a3	Focus tracking with lock-on	3	3	3	3	3
a4	Auto-area face detection	On	On	On	On	Off
a5	Focus points used	All points				
a6	Store points by orientation	No	No	Yes	Yes	No
a7	AF activation	Shutter/ AF-ON	Shutter/ AF-ON	Shutter/ AF-ON	Shutter/ AF-ON	Shutter/ AF-ON
a8	Limit AF-area mode selection	All Available				
a9	Focus point wrap-around	No wrap (OFF)				
a10	Focus point options:					
	>Manual focus mode	On	On	On	On	On
	>Dynamic- area AF assist	On	On	On	On	On

Item	Option	Camera Default	Basic Setting	Studio Flash	Portrait	Long Exposure
Auto	focus (continued	1)				
a11	Low-light AF	Off	Off	Off	Off	On
a12	Built-in AF assist	On	On	Off	Off	Off
a13	Manual focus ring in AF mode (with supported lenses only)	Enable	Enable	Enable	Enable	Enable
Mete	ring/Exposure					
b1	EV steps for exposure control	1/3 step	1/3 step	1/3 step	1/3 step	1/3 step
b2	Easy exposure compensation	Off	Off	Off	Off	Off
b3	Center- weighted area	12mm	12mm	12mm	12mm	12mm
b4	Fine-tune opti- mal exposure:					
	>Matrix metering	0	0	0	0	0
	>Center- weighted metering	0	0	0	0	0
	>Spot metering	0	0	0	0	0
	>Highlight- weighted metering	0	0	0	0	0

Item	Option	Camera Default	Basic Setting	Studio Flash	Portrait	Long Exposure
Time	ers/AE Lock					
c1	Shutter-release button AE-L	Off	Off	Off	On (Half-press)	Off
c2	Self-timer >Self-timer delay	10 sec. 10 sec.	20 sec. 10 sec.	10 sec. 10 sec.	10 sec. 20 sec.	2 sec. 10 sec.
	>Number of shots	1	1	1	3	1
	>Interval between shots	0.5 sec.	0.5 sec.	3 sec.	0.5 sec.	0.5 sec.
c3	Power off delay:					
	>Playback	10 sec.	10 sec.	10 sec.	10 sec.	20 sec.
	>Menus	1 min.	20 sec.	20 sec.	20 sec.	20 sec.
	>Image review	4 sec.	10 sec.	4 sec.	4 sec.	4 sec.
	>Standby timer	10 sec.	10 sec.	20 sec.	20 sec.	20 sec.
Shoo	ting/Display					
d1	CL mode shooting speed	5 fps				
d2	Max. continu- ous release	200	200	200	200	200
d3	Sync. release mode options	Sync	Sync	Sync	Sync	Sync
d4	Exposure delay mode	Off	Off	Off	Off	3 sec.
d5	Electronic front-curtain shutter	Off	Off	Off	Off	Off
d6	Limit selectable image area	All selected	Your preference	Your preference	Your preference	Your preference

Item	Option	Camera Default	Basic Setting	Studio Flash	Portrait	Long Exposure
Shoo	ting/Display (co	ntinued)				
d7	File No. sequence	On	On	On	On	On
d8	Apply settings to live view	On	On	On	On	Off
d9	Framing grid display	Off	Off	Off	Off	On
d10	Peaking highlights	Off/Red	3/Yellow	3/Color contrasting with subject	3/Color contrasting with subject	3/Color contrasting with subject
d11	View all in continuous mode	On	On	On	On	Off
Brac	keting/Flash					
e1	Flash sync speed	1/200	1/250	1/250	1/250	1/250
e2	Flash shutter speed	1/60	1/60	1/60	1/60	1/60
e3	Exposure comp. for flash	Entire Frame	Entire Frame	Entire Frame	Background Only	Entire Frame
e4	Auto flash ISO sensitivity control	Subject and background	Subject and background	Subject and background	Subject only	Subject only
e5	Modeling flash	ON	ON	OFF	ON	ON
e6	Auto bracket- ing (Mode M)	Flash/speed	Flash/speed	Flash/ aperture	Flash/ aperture	Flash only
e7	Bracketing order	Normal: Meter> Under> Over	Normal: Meter> Under> Over	Under> Meter> Over	Under> Meter> Over	Under> Meter> Over

Item	Option	Camera Default	Basic Setting	Studio Flash	Portrait	Long Exposure
Cont	rols					
f1	Customize i menu	Set Picture Control; White balance; Image quality; Image Size; Flash Mode; Metering; Wi-Fi connection; Active D-Lighting; Release mode; Vibration Reduction; AF-area mode; Focus Mode	Replace Wi-Fi and Vibration Reduction with your preference	Replace Wi-Fi and Vibration Reduction with your preference	Replace Wi-Fi and Vibration Reduction with your preference	Replace Wi-Fi and Vibration Reduction with your preference
f2	Custom control assignment	Multiple defaults	Multiple defaults	See Chapter 12	See Chapter 12	See Chapter 12
f3	OK: >Shooting mode >Playback mode >Live view	Reset to center focus point Zoom on/ off Reset to center focus point	Reset to center focus point Zoom on/ off Reset to center focus point	Reset to center focus point Zoom on/ off Reset to center focus point	Reset to center focus point View histograms Zoom on/ off	Reset to center focus point View histograms Zoom on/ off

Tab	le 2.3 Custom	Setting Men	u Recommen	dations #1 (c	ontinued)	
Item	Option	Camera Default	Basic Setting	Studio Flash	Portrait	Long Exposure
Cont	rols (continued)		161			
f4	Shutter speed and aperture lock (S, A, and M modes only)	Shutter/ Aperture both off	Shutter/ Aperture both off	Shutter/ Aperture both on	Shutter/ Aperture both on	Shutter/ Aperture both on
f5	Customize command dials:					
	>Reverse rotation	Exposure compensa- tion and Shutter speed/ Aperture both off				
	>Change main/sub	Exposure/ Autofocus setting both off				
	>Menus and playback	Off	Off	Off	Off	Off
	>Sub-dial frame advance	10 frames				
f6	Release button to use dial	No (OFF)				
f7	Reverse indicators	-0+	-0+	-0+	-0+	-0+

Item	Option	Sports Indoors	Sports Outdoors	Landscape	Bracketing
Auto	focus			-	
al	AF-C priority selection	Release	Release	Focus	Focus
a2	AF-S priority selection	Release	Release	Focus	Focus
a3	Focus tracking with lock-on	+4	+4	3	3
a4	Auto-area face detection	On	On	Off	Off
a5	Focus Points used	Every other point	Every other point	All points	All points
a6	Store points by orientation	Yes	Yes	No	No
a7	AF activation	AF ON only	AF ON only	Shutter/ AF-ON	Shutter/ AF-ON
a8	Limit AF-area mode selection	Unmark Pinpoint-area and Wide-area Large	Unmark Pinpoint-area and Wide-area Large	Unmark Pinpoint-area and Wide-area Large	All Available
a9	Focus point wrap-around	No wrap (OFF)	No wrap (OFF)	No wrap (OFF)	No wrap (OFF)
a10	Focus point options >Manual focus mode	s: On	On	On	On
	>Dynamic-area AF assist	On	On	On	On
a11	Low-light AF	Off	Off	Off	Off
a12	Built-in AF illuminator	Off	Off	Off	Off
a13	Manual focus ring in AF mode (With supported lenses only)	Enable	Enable	Enable	Enable

Item	Option	Sports Indoors	Sports Outdoors	Landscape	Bracketing
Mete	ring/Exposure				
b1	EV steps for expo- sure control	1/3 step	1/3 step	1/3 step	1/3 step
b2	Easy exposure compensation	Off	Off	Off	Off
b3	Center-weighted area	12mm	12mm	12mm	12mm
b4	Fine-tune optimal exposure:				
	>Matrix metering	0	0	0	0
	>Center- weighted metering	0	0	0	0
	>Spot metering	0	0	0	0
	>Highlight- weighted metering	0	0	0	0
Time	rs/AE Lock				
c1	Shutter-release button AE-L	On (Half-press)	On (Half-press)	Off	On (Half-press)
c2	Self-timer >Self-timer delay >Number of shots >Interval between shots	10 sec. 10 sec. 1 0.5 sec.	20 sec. 10 sec. 1 0.5 sec.	10 sec. 10 sec. 1 3 sec.	10 sec. 20 sec. 3 0.5 sec.
c3	Power off delay:				
	>Playback	10 sec.	10 sec.	10 sec.	10 sec.
	>Menus	1 min.	20 sec.	20 sec.	20 sec.
	>Image review	2 sec.	2 sec.	4 sec.	4 sec.

Item	Option	Sports Indoors	Sports Outdoors	Landscape	Bracketing
Shoo	oting/Display				
d1	CL mode shoot- ing speed	5 fps	5 fps	3 fps	3 fps
d2	Max. continuous release	75	75	200	200
d3	Sync. release mode options	Sync	Sync	Sync	Sync
d4	Exposure delay mode	Off	Off	Off	Off
d5	Electronic front- curtain shutter	Off	Off	Off	Off
d6	Limit Selectable image area	Check only FX and DX	Check only FX and DX	All available	All available
d7	File No. Sequence	On	On	On	On
d8	Apply settings to live view	On	On	On	On
d9	Framing grid display	Off	Off	On	Off
d10	Peaking highlight color	Off/Red	Off/Red	Off/Red	Off/Red
d11	View all in continuous mode	Off	Off	On	On
Brack	ceting/Flash				
e1	Flash sync speed	1/250	1/250	1/250	1/250
e2	Flash shutter speed	1/60	1/60	1/60	1/60
e3	Exposure comp. for flash	Entire Frame	Entire Frame	Entire Frame	Background Only
e4	Auto flash ISO sensitivity control	Subject and background	Subject and background	Subject and background	Subject only

Item	Option	Sports Indoors	Sports Outdoors	Landscape	Bracketing
Brac	keting/Flash (conti	nued)			
e5	Modeling flash	ON	ON	OFF	ON
e6	Auto bracketing (Mode M)	Flash/speed	Flash/speed	Flash/aperture	Flash/aperture
e7	Bracketing order	Normal: Meter>Under> Over	Normal: Meter>Under> Over	Under>Meter> Over	Under>Meter> Over
Cont	rols				
f1	Customize i menu	Set Picture Control; White balance; Image quality; Image Size; Flash Mode; Metering; Wi-Fi connection; Active D-Lighting; Release mode; Vibration Reduction; AF-area mode; Focus Mode	Replace Wi-Fi and Vibration Reduction with your preference	Replace Wi-Fi and Vibration Reduction with your preference	Replace Wi-Fi and Vibration Reduction with your preference
f2	Custom control assignment	Multiple defaults	Multiple defaults	See Chapter 12	See Chapter 12
f3	Multi selector center button: >Shooting mode >Playback mode	Reset to center focus point Zoom on/off	Reset to center focus point Zoom on/off	Reset to center focus point Zoom on/off	Reset to center focus point View histograms
	>Live view	Reset to center focus point	Reset to center focus point	Reset to center focus point	Zoom on/off

Table 2.4 Custom Setting Menu Recommendations #2 (continued) Sports Sports					
Item	Option	Indoors	Sports Outdoors	Landscape	Bracketing
Cont	trols (continued)				
f4	Shutter speed and aperture lock (S, A, and M modes only)	Shutter/ Aperture both off	Shutter/ Aperture both off	Shutter/ Aperture both on	Shutter/ Aperture both on
f5	Customize command dials:				
	>Reverse rotation	Exposure compensation and Shutter speed/Aperture both off			
	>Change main/ sub	Exposure/ Autofocus set- ting both off			
	>Menus and playback	Off	Off	Off	Off
	>Sub-dial frame advance	10 frames	10 frames	10 frames	10 frames
f6	Release button to use dial	No (OFF)	No (OFF)	No (OFF)	No (OFF)
f7	Reverse indicators	-0+	-0+	-0+	-0+

Nikon Z6 Roadmap

For some of us, shooting with the Z6 mirrorless camera is like working with an old friend. Someone who has used virtually any previous Nikon dSLR will find the Z6 mirrorless camera comfortably familiar in shape and placement of the controls. The only things missing are the mirror and quite a bit of weight and bulk. The Z6 has been right-sized to fit in your hand, with all the buttons, dials, and knobs needed for the most frequently adjusted functions arranged for easy access. Another 12 settings can be adjusted from the i menu, and you can substitute other options for any of the dozen default i menu settings to suit your own working habits. (I'll show you how to personalize the i menu in Chapter 12.) With so many control choices available, you'll find that the bulk of your shooting won't be slowed down by a visit to the vast thicket of text options called Menu-land.

As a bonus, if you're a photographer who likes (or needs) to work with multiple bodies, the Z6 and its upscale sibling the Z7 make perfect companions, as the bodies are identical. So, if you need a camera with speedy 12 fps continuous shooting, say, for sports photography, and a higher resolution model for landscapes or for capturing portraits suitable for printing in large sizes, the Z6/Z7 are an excellent tandem. Pro photographers may rely on two (or more bodies) for backup purposes, and it's a definite plus if both cameras have exactly the same controls and virtually identical menus.

Of course, if you want to operate your Z6 efficiently, you'll need to learn the location, function, and application of all these controls. What you really need is a street-level roadmap that shows where everything is, and how it's used. But what Nikon gives you in the user's manual is akin to a world globe with an overall view and many cross-references to the pages that will tell you what you really need to know. Check out the "Getting to Know the Camera" section, primarily pages 1 through 5, in Nikon's manual, which offers four tiny black-and-white line drawings of the camera body that show front, back, two sides, and the top and bottom of the Z6. There are about six dozen

callouts pointing to various buttons and dials. If you can find the control you want in this cramped layout, you'll still need to flip back and forth among multiple pages (individual buttons can have several different cross-references!) to locate the information.

Most other third-party books follow this format, featuring black-and-white photos or line drawings of front, back, and top views, and many labels. I originated the up-close-and-personal, full-color, street-level roadmap (rather than a satellite view) that I use in this book and my previous camera guidebooks. I provide you with many different views and lots of explanation accompanying each zone of the camera, so that by the time you finish this chapter, you'll have a basic understanding of every control and what it does. I'm not going to delve into menu functions here—you'll find a discussion of your Playback, Photo Shooting, Movie Shooting, Custom Settings, and Setup options in Chapters 11, 12, and 13. Everything here is devoted to the button pusher and dial twirler in you.

You'll also find this "roadmap" chapter a good guide to the rest of the book, as well. I'll try to provide as much detail here about the use of the main controls as I can, but some topics (such as autofocus and exposure) are too complex to address in depth right away. So, I'll point you to the relevant chapters that discuss things like setup options, exposure, use of electronic flash, and working with lenses with the occasional cross-reference.

Nikon Z6: Up Front

This is the side seen by your subjects as you snap away. For the photographer, though, the front is the surface your fingers curl around as you hold the camera, and there are really only a few buttons to press, all within easy reach of the fingers of your left and right hands. There are additional controls on the lens itself. You'll need to look at several different views to see everything. Figure 3.1 shows the front of the camera with the lens removed.

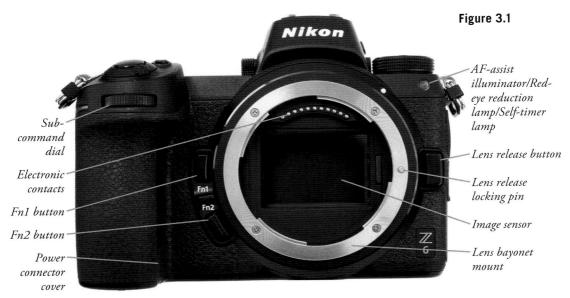

The components are as follows:

- Sub-command dial. This dial is used to change shooting settings. When settings are available in pairs (such as shutter speed/aperture), this dial will be used to make one type of setting, such as aperture, while the main command dial (on the back of the camera) will be used to make the other, such as shutter speed. Using the Custom Setting f5 menu adjustments, you can reverse the default rotational direction, swap the functions of the sub-command and main command dials, control how the sub-command dial is used to set aperture, and tell the Z6 that you want to use the main command dial to scroll through menus and images. All these options are discussed in more detail in Chapter 12.
- **Electronic contacts.** These 11 contact points mate with matching points on the bayonet mount of the lens itself, and allow two-way communication between the camera and lens for functions like aperture size and autofocus information.
- Image sensor. The Z6's 24 MP sensor is fully exposed when the lens is removed. You should be careful and never touch or press against it, to avoid damaging the in-body image stabilization system or the protective surface of the sensor itself.
- Function 1 (Fn1) button. This conveniently located button has the White Balance function assigned by default. (Just hold down the button and rotate either command dial.) However, using Custom Setting f1, it can be programmed to perform any one of 38 different actions, ranging from metering modes (Matrix, Center-weighted, Highlight-weighted, or Spot) to flash off or bracketing bursts. I'll explain how to define a function in Chapter 12.
- Function 2 (Fn2) button. By default, this button adjusts Focus-area mode when you hold it and rotate the sub-command dial, and Focus mode when held while you spin the main command dial. This button can be redefined using the same functions offered for the Fn1 button, as discussed in Chapter 12.
- Lens bayonet mount. This precision bayonet mount mates with the matching mount on the back of each compatible lens. The all-new Z-mount is held on the camera using four screws that provide a secure attachment to the body, but not *too* secure. Their mounting holes are shallow enough to allow the bayonet mount to pop off if you drop the camera on the lens (which avoids even worse damage to the camera body itself). But don't worry, the mount is more than secure enough for everyday use, even with the heaviest lenses.
- Lens release button. Press this button to retract the locking pin on the lens mount so a lens can be rotated to remove it from the camera.
- Lens release locking pin. This pin slides inside a matching hole in the lens to keep it from rotating until the lens release button is pressed.
- AF-assist illuminator/Red-eye reduction lamp/Self-timer lamp. When using the self-timer, this lamp flashes to mark the countdown until the photo is taken.
- **Power connector cover.** This little door flips open to allow plugging a cable from the AC/DC adapter into the battery compartment in the hand grip.

Figure 3.2 shows a view of the left side Nikon Z6, as seen from the front. The main components you need to know about are as follows:

- **Memory card door.** Your memory card can be inserted here when you slide the door toward the rear of the camera to open it.
- Shutter release button. Angled on top of the hand grip is the shutter release button, which has multiple functions. Press this button down halfway to lock exposure and focus. Press it down all the way to actually take a photo or sequence of photos if you've set the release mode to any of the continuous shooting modes, or if you've defined the behavior of the self-timer to take 1 to 9 exposures when its delay has expired. (I'll show you how to take multiple shots with the self-timer in Chapter 11.) Tapping the shutter button when the Z6's exposure meters have turned themselves off reactivates them, and a tap can be used to remove the display of a menu or image from the rear color LCD monitor.
- On/Off switch. Rotating this switch to the detent turns the camera on.
- Hand grip. This provides a comfortable handhold, and also contains the Z6's battery.

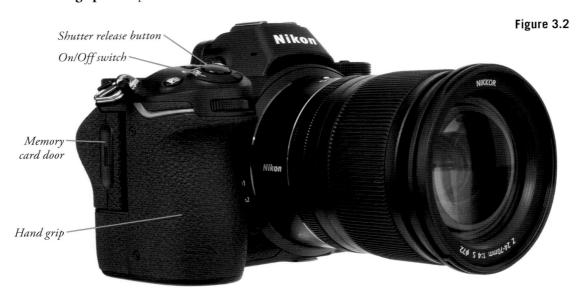

You'll find more controls on the other side of the Z6, shown in Figure 3.3. In the illustration, you can see the rubber covers on the side that protect the camera's USB, HDMI, headphone, and microphone ports, and accessory terminal. The main points of interest shown include:

- Lens mounting index. Match the dot on the lens with this indicator when mounting your lens.
- **Port covers.** These two rubber covers protect the USB, HDMI, microphone, and headphone ports, and accessory terminal when not in use.
- **Headphone connector.** Plug in your headphones or other audio device here using a stereo miniplug to monitor your sound as you record, or to listen to the audio when playing back a video clip.
- Microphone connector. Although the Z6 has built-in microphones on top, if you want better quality (and want to shield your video clip soundtracks from noises emanating from the camera and/or your handling of it), you can plug in an accessory mic, such as the Nikon ME-1, here.
- **USB connector.** Plug in the USB cable furnished with your Nikon Z6 and connect the other end to a USB port in your computer to transfer photos, to upload Picture Control settings, or to upload/download other settings between your camera and computer. This USB 3 Type-C connector is also used for charging the battery.
- **HDMI connector.** You need to buy an accessory HDMI mini-C cable to connect your Z6 to an HDTV, as one to fit this port is not provided with the camera. If you have a high-resolution television, it's worth the expenditure to be able to view your camera's output in all its glory.

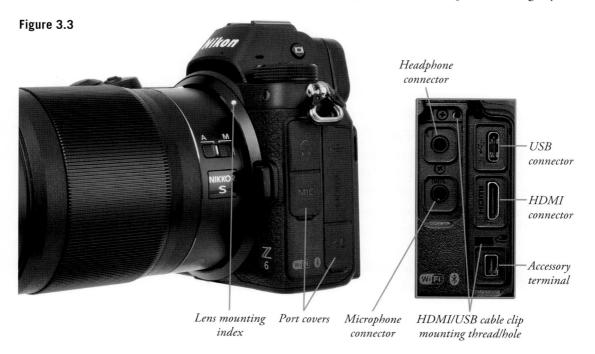

■ HDMI/USB cable clip mounting thread/hole. Attach the supplied cable clip (shown in Figure 3.4) using the upper threaded socket and lower positioning hole. An HDMI or a USB cable (or both) can be inserted in the clip, which prevents them from accidental detachment from the camera. You'll find the cable clip especially useful when shooting video with an external HDMI monitor or recorder, or working tethered through a USB connection.

Figure 3.4 HDMI/USB cable clip.

The Nikon Z6's Business End

The back panel of the Nikon Z6 bristles with more than a dozen different controls, buttons, and knobs. That might seem like a lot of controls to learn, but you'll find, as I noted earlier, that it's a lot easier to press a dedicated button and spin a dial than to jump to a menu every time you want to change a setting. You can see the controls clustered along the top edge of the back panel in Figure 3.5. The key buttons and components and their functions are as follows:

- Playback button. Press this button to review images you've taken, using the controls and options I'll explain in the next section. To remove the image display, press the Playback button again, or simply tap the shutter release button.
- Trash button. Press to erase the image shown on the LCD monitor. A display will pop up on the LCD monitor asking you to press the Trash button once more to delete the photo, or press the Playback button to cancel.
- Viewfinder eyepiece/Viewfinder window. You can frame your composition by peering into the 3,690,000-pixel (Quad-VGA) OLED electronic viewfinder, which shows 100 percent of your image frame at a generous 0.8 percent magnification. It's surrounded by a soft rubber frame that seals out extraneous light when pressing your eye tightly up to the viewfinder, and it also protects your eyeglass lenses (if worn) from scratching. Your eye can be up to 21mm away from the viewfinder window (the "eyepoint") and still view the entire focus screen area.

- Eye sensor. Detects when your eye (or anything else) approaches the viewfinder window (anything closer than about three inches in my tests). Unfortunately, it is *not* disabled when the LCD is tilted.
- **Diopter adjustment control.** Pull this knob out, and then rotate it to adjust the diopter correction for your eyesight from −4 to +2; then push it in to lock the setting.
- **DISP button.** Shows or hides informational displays in the LCD monitor or viewfinder. Press to cycle among the available displays in photo, movie, and playback modes.
- Photo/movie selector. Switches the camera from still photo shooting mode to movie mode.

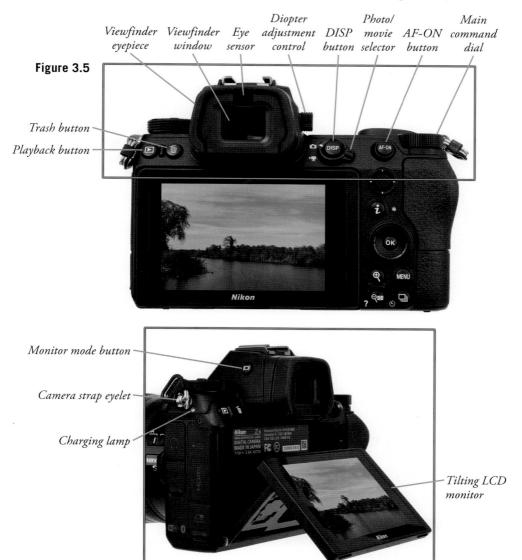

- **AF-ON button.** Press this button to activate the autofocus system without needing to partially depress the shutter release. This control, used with other buttons, allows you to lock exposure and focus separately: Lock exposure by pressing the shutter release halfway; autofocus by pressing the shutter release halfway, or by pressing the AF-ON button. There are lots of cool ways you can use the AF-ON button, and I'll explain them in detail in Chapter 12.
- Main command dial. This is the main control dial of the Z6, used to set or adjust most functions, such as shutter speed, bracketing sequence, white balance, ISO, and so forth, either alone or when another button is depressed simultaneously. It is often used in conjunction with the sub-command dial on the front of the camera when pairs of settings can be made, such as image formats (main command dial: image format; sub-command dial: resolution); exposure (main: shutter speed; sub: aperture); flash (main: flash mode; sub: flash compensation); or white balance (main: WB preset; sub: fine-tune WB). You can swap functions of the main and sub-command dials, reverse the rotation direction, choose whether the aperture ring on the lens or the sub-command dial will be used to set the f/stop, and activate the main command dials to navigate menus and images. You'll learn about these Custom Settings menu options (Custom Setting f5) in Chapter 12.
- Tilting LCD monitor. The 3.2-inch LCD monitor has a 2,100,000-dot XGA TFT touch-sensitive screen with a 170-degree viewing angle that allows you to see the screen clearly even from the side or slightly above. It provides a 100 percent view of what the sensor sees. It swivels up 90 degrees and down 45 degrees so you can position the camera down low (say, for macro shots of flowers) or up high for a periscope view.
- Charging lamp. This LED glows amber while charging the camera's EN-EL15b battery when an external USB power adapter (not supplied with the Z6) and Type-C cable is plugged into the USB port. The lamp turns off when charging is complete. The charging adapter is disabled if the camera is turned on. You can continue to use the camera when the charging adapter is plugged in; *however*, the battery will not charge and the camera will not be powered by the adapter. If you want to operate the Z6 on AC power, you must use the AC adapter EH-5b/EH-5c or EP-5b. Remember that EN-EL and EN-Ela batteries cannot be charged.
- Camera strap eyelet. It comes with a split-ring attached that can be used to fasten a neck strap to the Z6.
- Monitor mode button. Press this button to cycle among the four LCD monitor modes. You can disable unwanted modes in the Setup menu's Limit Monitor Mode Selection entry.
 - Automatic display switch. Alternates between viewfinder and monitor as your eye approaches the eye sensor or is moved away.
 - Viewfinder only. Displays in the viewfinder only.
 - Monitor only. Displays on the monitor only.
 - **Prioritize viewfinder.** The viewfinder is turned on and off by the eye sensor, but the monitor does not illuminate in photo mode. In movie mode, playback, or menu modes, the monitor does turn on when you remove your eye from the viewfinder.

On the lower right of the back panel of the Z6 you'll find a cluster of essential controls (see Figure 3.6):

- Sub-selector. In shooting mode, this joystick-like control can be pressed sideways instead of the multi selector (described soon) to select a focus point (autofocus is covered in Chapter 5), whereas pressing the sub-selector down (as if it were a button) locks focus and exposure while it's held down. In playback mode, it behaves the same as the multi selector to scroll around within a zoomed image. Or, you can reprogram it to display the next or previous image instead, using Custom Setting f2, as I'll explain in Chapter 12.
- *i* button. Pressing this button in photo or movie shooting modes summons the *i* menu, which I first showed you in Figure 2.1 in the previous chapter. A total of 12 adjustments can be accessed from the *i* menu, but you can replace any entry you don't use much with another function of your choice, using Custom Setting f1: Customize *i* Menu, as described in Chapter 12. In Playback mode, the *i* button has a different function. When reviewing a still image, press the *i* button and choose Rating, Select to Send/Deselect (Smart Device), Retouch, Choose Folder, Protect, or Unprotect All. When a movie clip is displayed during Playback mode, your choices are Rating, Volume Control, Trim Movie, Choose Folder, Protect, and Unprotect All. (See Figure 3.7.)

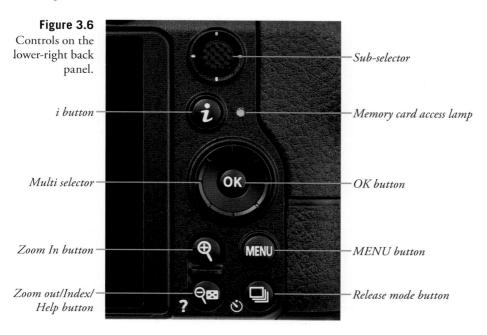

Figure 3.7 In Playback mode (left), the *i* button allows you to select a rating, send an image to a smart device, retouch a still image, choose a folder, protect an image from erasure, or unprotect all. An additional option, Quick Crop, appears when the image is magnified. For video clips (right), your choices are Rating, Volume Control, Trim Movie, Choose Folder, Protect, and Unprotect All.

- Memory card access lamp. When lit or blinking, this lamp indicates that a memory card is being accessed.
- Multi selector. This joypad-like disk can be shifted up, down, side to side, and diagonally for a total of eight directions. It can be used for several functions, including AF point selection, scrolling around a magnified image, trimming a photo, or setting white balance bias along the green/magenta and blue/yellow axes. Within menus, pressing the up/down arrows moves the on-screen cursor up or down; pressing toward the right selects the highlighted item and displays its options; pressing left cancels and returns to the previous menu.
- **OK button.** The OK button in the center of the multi selector can be pressed to activate several different default functions, depending on your current mode. Like many other controls, it can be redefined; in this case use Custom Setting f2. I'll explain those options in Chapter 12.
 - Shooting mode. Resets focus point to the center of the frame.
 - Playback mode. Turns zoom on/off.
 - Menu mode. Selects highlighted menu option (same as right arrow button).
- **MENU button.** Summons/exits the menu display. When you're working with submenus, this button also serves to exit a submenu and return to the main menu.
- Zoom In button. Used exclusively in Playback mode. Press to zoom in on an image when in full-screen view, or to decrease the number of thumbnails when in index view (described next). Note: you can also zoom in and out in playback mode using "squeeze" and "stretch" gestures on the touch screen, similarly to the techniques used with smartphones. I'll explain zooming and other playback options in the next section.

- Zoom Out/Index/Help button. This button has separate Playback and Shooting mode functions:
 - Playback mode. Use this button to change from full-screen view to four, nine, or 72 thumbnails. Press the Zoom In button to go the other way back to full screen and magnified views.
 - **Shooting mode.** When viewing most menu items on the monitor, if a ? icon appears in the bottom-left corner of the screen, pressing this button produces a concise Help screen with tips on how to make the relevant setting. You can scroll through the screen using the up/down buttons or press this button again to return to the menus.
- Release mode button. Allows choosing the Z6's release modes: Single Frame, Continuous L, Continuous H, Continuous H (Extended), and Self-timer, using the command dials as described in Chapter 2.

Playing Back Images

Reviewing images is a joy, whether you use the big 3.2-inch color LCD monitor or the viewfinder (which is especially handy for viewing images in bright light under which the monitor may tend to wash out).

Here are the basics involved in reviewing images on the Z6's displays (or on a television/HDTV screen you have connected with a cable). You'll find more details about some of these functions later in this chapter, or, for more complex capabilities, in the chapters that I point you to. This section just lists the must-know information.

- **Start review.** To begin review, press the Playback button at the upper-left corner of the back of the Z6. The most recently viewed image will appear on the display.
- Playback folder. If you have more than one folder on your XQD card, you can change which folder is used for playback by starting playback with the Playback button, and then pressing the *i* button and selecting Choose Folder. Press the right directional button and choose from a list of available folders. Press the right button again to activate that slot/folder.
 - You can also select the active folder using the Playback Folder option (choose NZ6 folders, All, or Current Folder) in the Playback menu. You can create and activate a *new* folder using the Storage Folder entry in the Photo Shooting menu. See Chapter 11 for more information on both options.
- **View thumbnail images.** To change the view from a single image to four, nine, or 72 thumbnails, follow the instructions in the "Viewing Thumbnails" section that follows.
- Zoom in and out. To zoom in or out, press the Zoom In or Zoom Out buttons, following the instructions in the next section. (It also shows you how to move the zoomed area around using the multi selector keypad.)

- Move back and forth. To advance to the next image, press the right edge of the multi selector pad; to go back to a previous shot, press the left edge. When you reach the beginning/end of the photos in your folder, the display "wraps around" to the end/beginning of the available shots. Note: You can assign a special behavior to the sub-command dial such that rotating it skips ahead either 10 or 50 images, or advance by other parameters, such as rating. See the discussion of Custom Setting f5 (Customize Command Dials > Sub-dial Frame Advance) in Chapter 12 for more information.
- See different types of data. To change the type of information about the displayed image that is shown, press the up and down portions of the multi selector pad. You must first select which combination of seven informational screens appear, using the Playback Options entry in the Playback menu (described in Chapter 11).
- Remove images. To delete an image that's currently on display, press the Trash button once, then press it again to confirm the deletion. To select and delete a group of images, use the Delete option in the Playback menu to specify particular photos to remove, as described in more detail in Chapter 11.
- Cancel playback. To cancel image review, press the Playback button again, or simply tap the shutter release button.

Zooming the Nikon Z6 Playback Display

The Nikon Z6 zooms in and out of preview images using the procedure that follows:

- 1. **Zoom in.** When an image is displayed (use the Playback button to start), press the Zoom In button to fill the screen with a slightly magnified version of the image. When viewing on the monitor, you can also press the multi selector center button, tap the touch screen twice, or touch two fingers to the LCD monitor and spread them apart to enlarge the image.
- 2. **Continue zooming.** A navigation window appears in the lower-right corner of the LCD monitor showing the entire image. Keep pressing to continue zooming in to the maximum of 24X enlargement (with a full resolution large image in FX format). (Medium and Small images can be enlarged up to 18X and 12X, respectively.)
- 3. **Zoomed area indicated.** A yellow box in the navigation window shows the zoomed area within the full image. (See Figure 3.8.) The entire navigation window vanishes from the screen after a few seconds, leaving you with a full-screen view of the zoomed portion of the image.
- 4. **Move zoomed area around.** Use the multi selector buttons to move the zoomed area around within the image. The navigation window will reappear for reference when zooming or scrolling around within the display. You can also slide one finger around the touch screen to move the zoomed area.
- 5. **Find faces.** To detect faces, rotate the sub-command dial while an image is zoomed. Up to 35 faces will be detected by the Z6, indicated by white borders in the navigation window. Rotate the sub-command dial or tap the on-screen guide (seen at the lower-right bottom edge in the figure) to move highlighting to the individual faces.

Figure 3.8
The Nikon Z6
incorporates a small
thumbnail image
with a yellow box
showing the current
zoom area.

- 6. **Quick Crop (optional).** While the image is magnified during Playback, you can press the *i* button and choose Quick Crop. The Z6 will save a new file cropped to that image size. Your original image is untouched.
- 7. **Review same area on another image.** Use the main command dial or tap the left/right triangles at the bottom of the touch screen to move to the same zoomed area of the next/previous image. This allows you to compare a detail in a series of similar shots. I often use the capability to see if a spot in an image is a dust spot (it shows up in the same place in other images), or just an artifact found in a single image.
- 8. Zoom out. Use the Zoom Out button to zoom back out of the image.
- 9. **Exit.** To exit zoom in/zoom out display, keep pressing the Zoom Out button until the full screen/full image/information display appears again. Or, just tap the shutter release halfway or press the Playback button to exit playback entirely.

Viewing Thumbnails

The Nikon Z6 provides other options for reviewing images in addition to zooming in and out. You can switch between single-image view and 4, 9, or 72 reduced-size thumbnail images on a single LCD monitor screen.

Pages of thumbnail images offer a quick way to scroll through a large number of pictures quickly to find the one you want to examine in more detail. The Z6 lets you switch quickly with a scroll bar displayed at the right side of the screen to show you the relative position of the displayed thumbnails within the full collection of images in the active folder on your memory card. Figure 3.9 offers a comparison between the three levels of thumbnail views. The Zoom In and Zoom Out/Thumbnail buttons are used, or you can use the pinch and spread gestures with two fingers on the touch screen to increase or decrease the number of thumbnail indexes shown.

Figure 3.9 Switch between four thumbnails (left), nine thumbnails (center), or 72 thumbnails (right), by pressing the Zoom Out and Zoom In buttons or using pinch and spread gestures on the touch screen.

- Add thumbnails. To increase the number of thumbnails on the screen, press the Zoom Out button or pinch the touch screen. The Z6 will switch from single image to 4 thumbnails to 9 thumbnails to 72 thumbnails. (The display doesn't cycle back to single image again.)
- **Reduce number of thumbnails.** To decrease the number of thumbnails on the screen, press the Zoom In button or use the spread gesture on the touch screen to change from 72 to 9 to 4 thumbnails, or from 4 thumbnails to single-image display. Continuing once you've returned to single-image display starts the zoom process described in the previous section.
- **Change folder.** When viewing images, press the *i* button to produce the dialog box (shown earlier in Figure 3.7) that includes an option to choose the folder of the memory card that contains the images you want to view. When 72 thumbnails are displayed, you can also press the Zoom Out button to summon the folder selection screen.
- Switch between thumbnails and full image. When viewing thumbnails, you can quickly switch between thumbnail view and full-image display by pressing the OK button in the center of the multi selector, or by tapping the thumbnail image on the touch screen.
- **Retouch an image/thumbnail.** When an image or thumbnail is viewed, press the *i* button to access the options screen that includes a Retouch option for that image (described in Chapter 13).
- Change highlighted thumbnail area. Use the multi selector to move the yellow highlight box around among the thumbnails, or, preferably, use the monitor and a single finger on the touch screen to scroll back and forth or to select a particular thumbnail. Note that *touching* a thumbnail moves the highlighting to that thumbnail, while *tapping* the thumbnail produces a full-screen view of the image.
- **Protect and delete images.** When viewing thumbnails or a single-page image, press the *i* button and choose Protect to preserve the highlighted image against accidental deletion (a key icon is overlaid over the thumbnail image; return to the *i* menu to remove protection).
- Exit image review. Tap the shutter release button or press the Playback button to exit image review. You don't have to worry about missing a shot because you were reviewing images; a half-press of the shutter release automatically brings back the Z6's exposure meters, the autofocus system, and, unless you've redefined your controls or are using manual focus, cancels image review.

Using the Photo Data Displays

When reviewing an image on the viewfinder or monitor displays, your Z6 can supplement the image itself with a variety of shooting data, ranging from basic information presented at the bottom of the display, to a series of text overlays that detail virtually every shooting option you've selected. There is also a display for GPS data if you're using a GPS device, and two views of histograms. I'll explain how to work with histograms in the discussion on achieving optimum exposure in Chapter 4. However, this is a good place to provide an overview of the kind of information you can view when playing back your photos.

You can change the *types* of information displayed using the Playback Display Options entry in the Playback menu. There you will find checkboxes you can mark for both basic photo information (overexposed highlights and the focus point used when the image was captured) and detailed photo information (which includes an RGB histogram and various data screens). You must mark any unchecked box to enable that type of information display. I'll show you how to activate these info options in Chapter 11, and provide more detailed reasons why you might want to see each type of data when you review your pictures. This section will simply show you the type of information available. Most of the data is self-explanatory, so the labels in the accompanying figures should tell you most of what you need to know. To change to any of these views while an image is on the screen in Playback mode, press the DISP button or up/down buttons.

- File information screen. The basic full-image review display is officially called the file information screen, and looks like Figure 3.10. Press the multi selector down button to advance to the next information screen (or the up button to cycle in the other direction).
- **Highlights.** When highlights display is active (after being chosen in the Display Mode entry of the Playback menu, as described in Chapter 11), any overexposed areas will be indicated by a flashing black border. As I am unable to make the printed page flash, you'll have to check out this effect for yourself. You can visualize what these "blinkies" look like in Figure 3.11, as they are most easily discerned as the black splotches in the sky.

Figure 3.10 File information screen.

Figure 3.11 Highlights screen.

- RGB histogram. Another optional screen is the RGB histogram, which you can see in Figure 3.12. I'm going to leave the discussion of histograms for Chapter 4.
- Shooting data 1–6. These are a series of screens that collectively provide everything else you might want to know about a picture you've taken. Note that each screen may not show all the information that can be displayed on that screen, and that all the screens may not appear. Only the data and screens that apply to your image will be shown. For example, the GPS screen appears only if a picture has GPS information embedded in it; the Artist/Copyright screen is shown only if you have chosen to embed that information in your image file. (I'll show you how to do that in Chapter 13.) The six screens are shown in Figures 3.13 to 3.18.
- Overview data. This screen, shown in Figure 3.19, provides a smaller image of your photo, but more information, including a luminance (brightness) histogram, metering mode used, lens focal length, exposure compensation, flash compensation, and lots of other data that's self-explanatory.

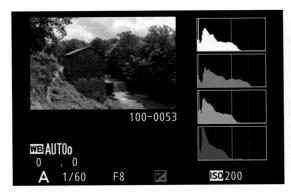

Figure 3.12 RGB histogram screen.

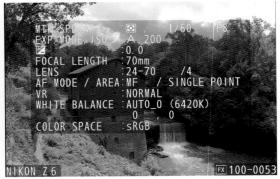

Figure 3.13 Exposure, lens, and autofocus/VR information appears here.

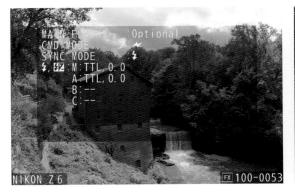

Figure 3.14 Information about flash exposures are shown on this screen.

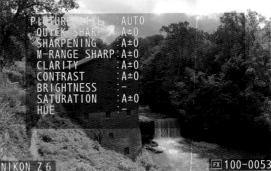

Figure 3.15 Picture Control adjustments appear here.

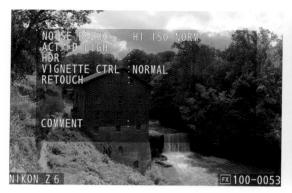

Figure 3.16 Noise reduction, Active D-Lighting, Retouching, Comments, and other information are shown here.

Figure 3.17 GPS data is displayed if the image was taken using a GPS device.

Figure 3.18 Artist information and copyright notices, if enabled, are shown.

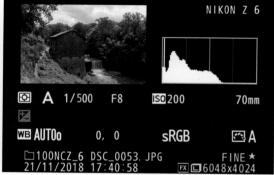

Figure 3.19 This overview screen includes a brightness histogram and basic information about the image.

Going Topside

The top surface of the Nikon Z6 has its own set of frequently accessed controls. (See Figure 3.20.)

- Mode dial lock release. Before you can choose any of the mode dial's settings, you must hold down this button to free the dial so it can rotate.
- Accessory shoe. Slide an electronic flash into this mount when you need a more powerful Speedlight. A dedicated flash unit, like the Nikon SB-5000, can use the multiple contact points shown to communicate exposure, zoom setting, white balance information, and other data between the flash and the camera. There's more on using electronic flash in Chapters 9 and 10. You can also mount other accessories on this shoe, such as the Nikon GP-1a GPS adapter or Nikon ME-1 microphone.

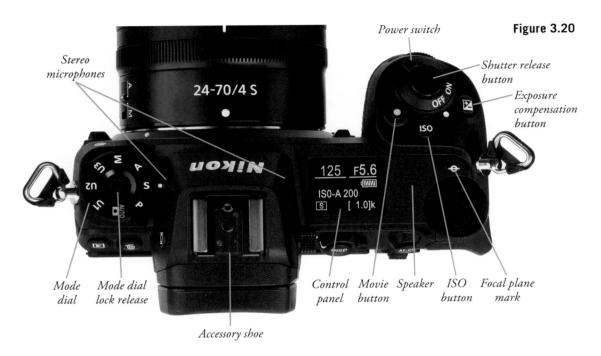

- **Stereo microphones.** This pair captures sounds when shooting video.
- Power switch. Rotate this switch clockwise to turn on the Nikon Z6 (and virtually all other Nikon interchangeable-lens digital cameras).
- Shutter release button. Partially depress this button to activate the exposure meter (and the main and sub-command dials that adjust metering settings), lock in exposure, and focus (unless you've redefined the focus activation button, as outlined in Chapter 12). Press all the way to take the picture. Tapping the shutter release when the camera has turned off the autoexposure and autofocus mechanisms reactivates both. When a review image is displayed on the backpanel color monitor, tapping this button removes the image from the display and reactivates the autoexposure and autofocus mechanisms. You can also tap the button to exit image review and menus, readying the camera to take a picture.
- Exposure compensation button. Hold down this button and spin the main command dial to add or subtract exposure when using Program, Aperture-priority, or Shutter-priority modes. (In Manual mode, the exposure remains the same, but the "ideal" exposure shown in the electronic analog display [more on that in the next section] is modified to reflect the extra/reduced exposure you're calling for.) The exposure compensation amount is shown on the monochrome status panel as plus or minus values.

- **Focal plane mark.** This indicator shows the *plane* of the sensor, for use in applications where exact measurement of the distance from the focal plane to the subject is necessary. (These are mostly scientific/close-up applications.)
- Movie button. Press to begin video capture; press a second time to stop.
- Control panel. This useful indicator shows the status of many settings.
- **ISO button.** Hold this button and rotate the main command dial until the ISO value you want is shown on the top control panel, in the viewfinder, and on the monitor.

Lens Components

Not all Nikon lenses include all of the features shown in Figure 3.21. For example, G-series lenses (learn about different lens types in Chapter 7) do not have an aperture ring. Components shown in the figure include:

- Filter thread. Most lenses have a thread on the front for attaching filters and other add-ons. Some, generally older F-mount lenses, also use this thread for attaching a lens hood (you screw on the filter first, and then attach the hood to the screw thread on the front of the filter). Some F-mount lenses, such as the AF-S Nikkor 14-24mm f/2.8G ED lens, have no front filter thread, either because their front elements are too curved to allow mounting a filter and/or because the front element is so large that huge filters would be prohibitively expensive. Some of these front-filter-hostile lenses allow using smaller filters that drop into a slot at the back of the lens.
- Lens hood bayonet. Lenses use this bayonet to mount the lens hood. Such lenses generally will have a *lens hood alignment indicator*, a dot on the edge showing how to align the lens hood with the bayonet mount.

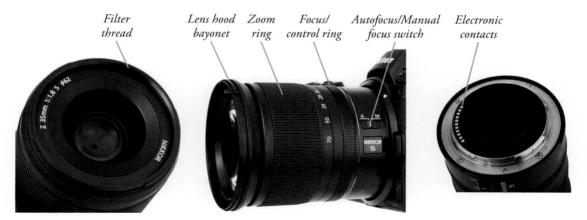

Figure 3.21

- Focus/control ring. This is the ring you turn when you manually focus the lens, or fine-tune autofocus adjustment. It's a narrow ring at the very front of the lens on some lenses, or a wider ring located somewhere else. The function of the focus/control ring (on Z-mount lenses only) can be redefined, as I'll explain in Chapter 12.
- **Zoom ring.** Turn this ring to change the zoom setting.
- Autofocus/Manual focus switch. Allows you to change from automatic focus to manual focus.
- Electronic contacts. These metal contacts pass information to matching contacts located in the camera body, allowing a firm electrical connection so that exposure, distance, and other information can be exchanged between the camera and lens.

Underneath Your Nikon Z6

There's not a lot going on with the bottom panel of your Nikon Z6. You'll find the battery compartment access door and a tripod socket, which secures the camera to a tripod. The socket accepts other accessories, such as quick-release plates that allow rapid attaching and detaching the Z6 from a matching platform affixed to your tripod. The socket is also used to secure the optional MB-N10 battery grip, which provides more juice to run your camera to take more exposures with a single charge. Figure 3.22 shows the underside view of the camera.

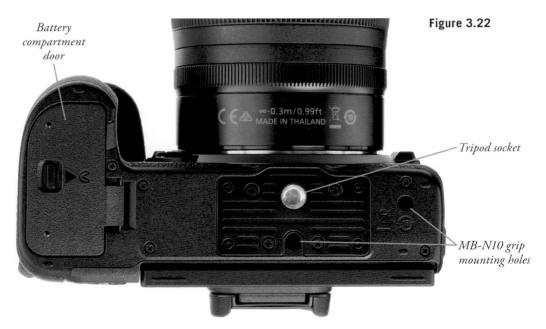

The Viewfinder/Monitor Displays

Much of the important shooting status information is shown inside the electronic viewfinder and LCD monitor of the Nikon Z6. In shooting mode, you can press the DISP button to cycle through the available views. The shooting information display appears only on the monitor (in still photo mode), and can be shown in dark-on-light or light-on-dark color schemes. (See Figure 3.23.) Choose your scheme using the Information Display entry in the Setup menu, as explained in Chapter 13. One additional Information Display is available when an SB-300, SB-400, SB-500, or SB-5000 flash unit is attached and powered up, or a WR-R10 wireless remote controller is commanding a flash using radio control. (See Figure 3.24.)

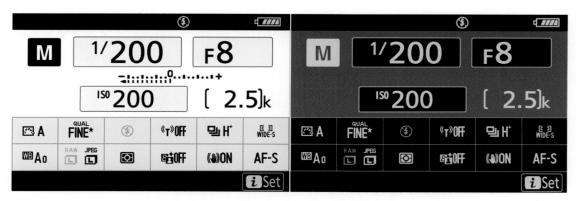

Figure 3.23 Photo information displays can be shown in light and dark color schemes.

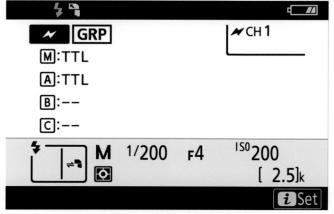

The other displays show information overlaid on the frame. As with the status control panel up on top, not all of this information will be shown at any one time. Figure 3.25 shows what you can expect to see on the LCD monitor. The viewfinder display is similar, but the icons are arrayed along the top and bottom instead of overlaid along the sides of the frame. The histogram is not displayed when Overlay Shooting is used in multiple exposure mode (see Chapter 11) or Custom Setting d8: Apply Settings to Live View is set to Off (see Chapter 12).

In addition to the features shown, a framing grid can be applied. This optional grid (it can be turned on and off in Custom Setting d9) can be useful when aligning horizontal or vertical shapes as you compose your image. The virtual horizon, shown in Figure 3.26, shows rotational and front/back tilt.

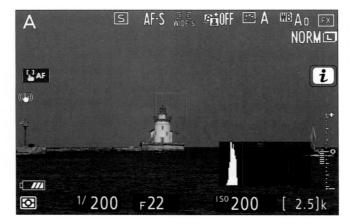

Figure 3.25 Overlaid information on the monitor screen.

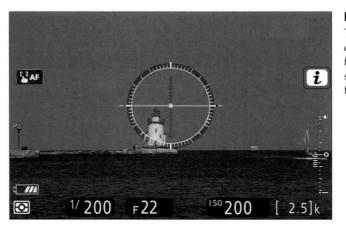

Figure 3.26
The virtual horizon display is useful for correcting side to side and front/back tilt.

What's the Fuss about BSI?

Traditionally, packing more pixels into a given sensor size yields higher resolution, but results in smaller pixels with less surface area to gather light. So, the Z6's 24 MP sensor surely must have required squeezing even tinier photosites into your camera's $35.9 \text{mm} \times 23.9 \text{mm}$ (roughly $36 \text{mm} \times 24 \text{mm}$) sensor, right?

Fortunately for us, not so! Like its sibling, the Z7, and dSLR counterpart, the D850, the Nikon Z6 has an innovative back-side illuminated (BSI) sensor. (Some call this sensor configuration back-illuminated, but the term back-side illuminated is the more common industry term.) Nikon hasn't revealed a lot of information, but the Z6's sensor was designed entirely by Nikon in-house. The 24.5-megapixel full-frame sensor's technology, supported by Nikon's EXPEED 6 multi-processor chip, gives the Z6 excellent low-light performance—tempered by some banding that is the result of the embedded phase-detect autofocus (PDAF) pixels. However, it does boast reduced noise, compared to other high-resolution sensors. The secret to all this good stuff is flipping the electronics around so the light-sensitive photosites are larger and closer to the incoming photons, thanks to the BSI configuration.

As I mentioned earlier, packing more light-gathering "pixels" (photodiodes) onto a sensor to produce high resolution requires using the tiniest "pixels" possible. Smaller pixels are less efficient at collecting light (photons), and processing the captured image to increase sensitivity results in more random artifacts. We call that "high ISO" noise. (A second type of visual noise is produced from long exposures.)

The Z6 reduces high ISO noise by *increasing* the relative size of the photosites. That's possible because with a traditional front-illuminated sensor (shown at left in Figure 3.27), the chip's image-processing circuitry occupies much of the surface, leaving only a small photosensitive area at the bottom of a deep "well." Nikon's BSI sensor reverses the position of the circuitry and photodiode

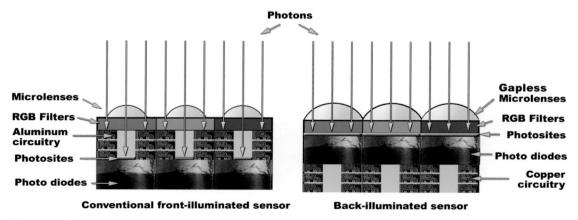

Figure 3.27 A conventional front-illuminated sensor (left), and a back-illuminated sensor (right).

components, so that a larger area can be occupied by the photosites, with the electronics positioned *underneath*, closer to the back of the camera, rather than closer to the rear of the lens.

The figure shows a super-simplified rendition of what happens. (Actual sensors look nothing like this; the diagram includes only one set of three red, green, and blue photosites, is not to scale, and I show only three "beams" of light arriving at the sensor, when photons actually come from multiple directions.) With the conventional front-illuminated sensor at left, incoming light passes through microlenses that focus it on the photosites, which are located at the bottom of a well that resides between the on-chip aluminum circuitry. Even accounting for the microlens's focusing properties, the relative angles that result in light falling on the photosensitive area collected from the edges of the incoming image can be rather steep. Other photons (not shown) strike the sides of the wells or the area of the chip occupied by electronic circuitry, and bounce back or around.

This limitation on the angle of incidence accounts for why vendors have been forced to develop "digital" lenses, which, unlike lenses designed for film cameras, focus light on the sensor from less steep angles. That explains, in general, why the Z6 functions better in this regard than most other digital cameras when using older "non-digital" lenses. Because a BSI sensor lacks those deep wells, your Z6 is less sensitive to more acute angles of incidence than most digital cameras.

At right in the figure is a representation of a back-illuminated sensor. Like the conventional sensor, it includes microlenses that focus the illumination before it passes through a red, green, or blue filter to the photosite. But because those photosites are larger, the minuscule focusing optics are larger, too, providing *gapless microlenses* that gather virtually all the illumination falling on the sensor. And, unlike the front-illuminated sensor, there is no deep well, and, without the need for intervening circuitry, the photosensitive area (shown in magenta for both types of sensors) is much larger. The electronics—faster copper (not aluminum) circuitry with lower resistance—have been moved to the back side of the sensor.

A typical conventional full-frame sensor captures only 30 to 80 percent of the light striking it, whereas a BSI sensor can grab nearly 100 percent of the photons. The angle of incidence is not nearly as crucial, making BSI sensors more similar in that respect to old-time film grain technology. The combination of larger photosensitive surface area and improved acceptable angles for incoming photons are the main factors in the Nikon Z6's superior low-light performance. The speedy copper wiring and enhanced processing algorithms in the EXPEED 6's digital image processor chip also help.

I don't normally venture so deeply into techie territory in my camera guides, but BSI sensors (which previously have been used in other devices with especially tiny sensors, such as cell phone cameras) will henceforth play a major part in enthusiast photography technology.

Nailing the Right Exposure

If you consider the qualities that constitute the most important tools for creating an outstanding image, an appropriate exposure is easily in the top three, along with picture sharpness/focus, and framing/composition. Within this triumvirate, exposure potentially involves the largest number of variables and can improve (or hinder) the impact of your image in a variety of ways. That's particularly true because *how* you achieve a particular exposure setting can have as much impact as *what* settings you select.

Think about it. Incorrect exposure can affect the tonal values in your image in a detrimental way, obscuring detail in shadows or washing out the highlights. But even exposure that's *theoretically* satisfactory can still produce an image that is objectionably blurry because the shutter speed is too slow; or objectionably grainy looking because the ISO sensitivity has been set too high or lacks sufficient detail in some areas because depth-of-field is lacking. Nailing the right exposure involves more than just appropriate settings. You also need to understand how the elements of exposure affect your final photograph.

Your Z6 has an exceptional amount of intelligence when it comes to calculating a proper exposure for a wide variety of scenes. Even so, you are smarter—and have creative vision the camera lacks. The more you shoot, the more ways you'll discover how to improve on your camera's picture-taking decisions and, even when to *ignore* them when you want to create a particular look or effect. For example, when you shoot with the main light source behind the subject, you end up with *backlighting*, which can result in an overexposed background and/or an underexposed subject. The Nikon Z6 recognizes backlit situations nicely, and, in most cases, can properly base exposure on the main subject using the default Matrix metering mode, producing a decent photo.

But, as an inventive photographer, there will be many instances where you would rather *not* have automatic correction for backlighting. What if you *want* to underexpose the subject, to produce a silhouette effect? The Z6 does a poor job of exposing intentional silhouettes, and will end up

producing unwanted detail in what should have been inky black areas of your image. Fortunately, the camera has metering modes and other exposure options that allow you to produce the image you are looking for. If you're looking for an extensive exposure range, features like the Z6's built-in HDR and Active D-Lighting can fine-tune your exposure as you take photos, preserving detail in the highlights and shadows as required. Your Nikon Z6 also has the capability of *fine-tuning* exposure separately for each of the metering modes, so you can consistently add or subtract a little exposure to suit your creative tastes.

In the next few pages, I'm going to give you a grounding in exposure concepts, either as an introduction or as a refresher course, depending on your current level of expertise. When you finish this chapter, you'll understand most of what you need to know to take well-exposed photographs creatively in a broad range of situations.

Getting a Handle on Exposure

This section explains the fundamental concepts that go into creating an exposure. If you already know about the role of f/stops, shutter speeds, and sensor sensitivity in determining an exposure, you might want to skip to the next section, which explains how the Z6 calculates exposure.

In the most basic sense, exposure is all about light. Correct exposure brings out the detail in the areas you want to picture, providing the range of tones and colors you need to create the desired image. Poor exposure can cloak important details in shadow, or wash them out in glare-filled featureless expanses of white. However, getting the perfect exposure requires some intelligence—either that built into the camera or the smarts in your head—because digital sensors can't capture all the tones we are able to see. If the range of tones in an image is extensive, embracing both inky black shadows and bright highlights, we often must settle for an exposure that renders most of those tones—but not all—in a way that best suits the photo we want to produce.

As the owner of a Nikon Z6, you're probably well aware of the traditional "exposure triangle" of aperture (quantity of light, light passed by the lens), shutter speed (the amount of time the shutter is open), and the ISO sensitivity of the sensor—all working proportionately and reciprocally to produce an exposure. The trio is itself affected by the amount of illumination that is available to work with. So, if you double the amount of light, increase the aperture by one stop, make the shutter speed twice as long, or boost the ISO setting 2X, you'll get twice as much exposure. Similarly, you can increase any of these factors while decreasing one of the others by a similar amount to keep the same exposure.

Working with any of the three controls always involves trade-offs. Larger f/stops provide less depth-of-field, while smaller f/stops increase depth-of-field and decrease sharpness through a phenomenon called diffraction. Shorter shutter speeds do a better job of reducing the effects of camera/subject motion, while longer shutter speeds make that motion blur more likely. Higher ISO settings increase the amount of visual noise and artifacts in your image, while lower ISO settings reduce the effects of noise. (See Figure 4.1.)

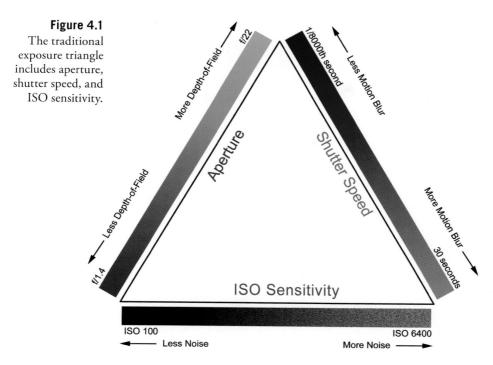

To further understand exposure, you need to understand the six aspects of light that combine to produce an image. Start with a light source—the sun, an interior lamp, electronic flash, or the glow from a campfire—and trace its path to your camera, through the lens, and finally to the sensor that captures the illumination. Here's a brief review of the things within our control that affect exposure, listed in "chronological" order (that is, as the light moves from the subject to the sensor):

- Light at its source. Our eyes and our cameras—film or digital—are most sensitive to that portion of the electromagnetic spectrum we call *visible light*. That light has several important aspects that are relevant to photography, such as color and harshness (which is determined primarily by the apparent size of the light source as it illuminates a subject). But, in terms of exposure, the important attribute of a light source is its *intensity*. We may have direct control over intensity, which might be the case with an interior light that can be brightened or dimmed, or electronic flash output that can be increased or decreased manually or automatically. In other cases, we might have only indirect control over intensity, as with sunlight, which can be made to appear dimmer by introducing translucent light-absorbing or reflective materials in its path.
- **Light's duration.** We tend to think of most light sources as continuous. But, as you'll learn in Chapter 8, the duration of light can change quickly enough to modify the exposure, as when the main illumination in a photograph comes from an intermittent source, such as an electronic flash.

- Light reflected, transmitted, or emitted. Once light is produced by its source, either continuously or in a brief burst, we are able to see and photograph objects by the light that is reflected from our subjects toward the camera lens; transmitted (say, from translucent objects that are lit from behind); or emitted (by a candle or television screen). When more or less light reaches the lens from the subject, we need to adjust the exposure. This part of the equation is under our control to the extent we can increase the amount of light falling on or passing through the subject (by adding extra light sources or using reflectors), or by pumping up the light that's emitted (by increasing the brightness of the glowing object).
- **Light passed by the lens.** Not all the illumination that reaches the front of the lens makes it all the way through. Filters can remove some of the light before it enters the lens. Inside the lens barrel is a variable-sized diaphragm that produces an opening called an *aperture* that dilates and contracts to control the amount of light that enters the lens. You, or the Z6's autoexposure system, can control exposure by varying the size of the aperture. The relative size of the aperture is called the *flstop*. (See Figure 4.2.)
- Light passing through the shutter. Once light passes through the lens, the amount of time the sensor receives it is determined by the Z6's shutter, which can remain open for as briefly as 1/8,000th of a second, or, for as long as 30 seconds—or even longer if you use the Bulb or Time settings (located past the 30-second speed as you rotate the command dial, and available only in Manual exposure mode).
- Light captured by the sensor. Not all the light falling onto the sensor is captured. If the number of photons reaching a particular photosite doesn't pass a set threshold, no information is recorded. Similarly, if too much light illuminates a pixel in the sensor, then the excess isn't recorded or, worse, spills over to contaminate adjacent pixels. We can modify the minimum and maximum number of pixels that contribute to image detail by adjusting the ISO setting. At higher ISOs, the incoming light is amplified to boost the effective sensitivity of the sensor.

Figure 4.2
Top row (left to right): f/4, f/5.6, f/8; bottom row: f/11, f/16.

F/STOPS AND SHUTTER SPEEDS

If you're *really* new to more advanced cameras (and I realize that a few ambitious amateurs do purchase the Z6 as their first serious camera), you might need to know that the lens aperture, or f/stop, is a ratio, much like a fraction, which is why f/2 is larger than f/4, just as 1/2 is larger than 1/4. However, f/2 is actually *four times* as large as f/4. (If you remember your high school geometry, you'll know that to double the area of a circle, you multiply its diameter by the square root of two: 1.4.)

Lenses are usually marked with intermediate forces that appears the consequence of the co

Lenses are usually marked with intermediate f/stops that represent a size that's twice as much/half as much as the previous aperture. So, a lens might be marked: f/4, f/5.6, f/8, f/11, f/16, with each larger number representing an aperture that admits half as much light as the one before, as shown in Figure 4.2. Of course, you can also set *intermediate* apertures with the Nikon Z6, such as f/6.3 and f/7.1, which fall between f/5.6 and f/8.

Shutter speeds are actual fractions (of a second), but the numerator is omitted, so that 60, 125, 250, 500, 1,000, and so forth represent 1/60th, 1/125th, 1/250th, 1/500th, and 1/1,000th second. To avoid confusion, Nikon uses quotation marks to signify longer exposures: 2", 2"5, 4", and so forth representing 2.0-, 2.5-, and 4.0-second exposures, respectively.

Four of these factors—quantity of light, light passed by the lens, the amount of time the shutter is open, and the sensitivity of the sensor—all work proportionately and reciprocally to produce an exposure. That is, as I mentioned, if you double the amount of light, increase the aperture size by one stop, make the shutter speed twice as long, or double the ISO sensitivity, you'll get twice as much exposure. Similarly, you can reduce any of these and reduce the exposure when that is preferable.

As we'll see however, changing any of those aspects in P, A, or S mode does not change the exposure; that's because the camera also makes adjustments when you do so, in order to maintain the same exposure. That's why Nikon provides other methods for modifying the exposure in those modes.

Equivalent Exposure

Most commonly, exposure settings are made using the aperture and shutter speed, followed by adjusting the ISO sensitivity, if it's not possible to get the preferred exposure (that is, the one that uses the "best" f/stop or shutter speed for the depth-of-field or action stopping we want).

One of the most important aspects in this discussion is the concept of "equivalent exposure." This term means that exactly the same amount of light will reach the sensor at various combinations of aperture and shutter speed. Whether we use a small aperture (large f/number) with a long shutter speed or a wide aperture (small f/number) with a fast shutter speed, the amount of light reaching the sensor can be exactly the same. Table 4.1 shows equivalent exposure settings using various shutter speeds and f/stops; in other words, any of the combination of settings listed will produce exactly the same exposure.

Table 4.1 Equivalent Exposures			
Shutter speed	f/stop	Shutter speed	f/stop
1/30th second	f/22	1/1,000th second	f/4
1/60th second	f/16	1/2,000th second	f/2.8
1/125th second	f/11	1/4,000th second	f/2
1/250th second	f/8	1/8,000th second	f/1.4
1/500th second	f/5.6		

When the Z6 is set for P mode, the metering system selects the correct exposure for you automatically, but you can change quickly to an equivalent exposure by spinning the main command dial until the desired equivalent exposure combination is displayed, with an asterisk appearing next to the P when you're using this "Flexible Program" feature. You can make Flexible Program adjustments more easily if you remember that you need to rotate the command dial toward the left when you want to increase the amount of depth-of-field or use a slower shutter speed; rotate to the right when you want to reduce the depth-of-field or use a faster shutter speed. The need for more/less DOF and slower/faster shutter speed are the primary reasons you'd want to use Flexible Program. This program shift mode does not work when you're using flash.

In Aperture-priority (A) and Shutter-priority (S) modes, you can change to an equivalent exposure, but only by either adjusting the aperture with the sub-command dial in A mode (the camera chooses the shutter speed) or shutter speed with the main command dial in S mode (the camera selects the aperture). I'll cover all these exposure modes later in the chapter.

F/STOPS VERSUS STOPS

In photography parlance, *f/stop* always means the aperture or lens opening. However, for lack of a current commonly used word for one exposure increment, the term *stop* is often used. In the past, EV (Exposure Value) served this purpose, and was used as a measure of the total sensitivity range of a device such as a light meter, but exposure value and its abbreviation have since been inextricably intertwined with its use in describing exposure compensation. In this book, when I say "stop" by itself (no *f/*), I mean one whole unit of exposure, and am not necessarily referring to an actual *f/s*top or lens aperture. So, adjusting the exposure by "one stop" can mean changing to the next shutter speed increment (say, from 1/125th second to 1/200th second) or the next aperture (such as *f/*4 to *f/*5.6). Similarly, 1/3-stop or 1/2-stop increments can mean either shutter speed or aperture changes, depending on the context. Be forewarned.

How the Z6 Calculates Exposure

Although it can make some good guesses based on how the brightness levels vary within a scene, your Z6 has no way of knowing for sure what it's pointed at. So, it must make some assumptions and calculate the correct exposure based on its internal rules. One parameter is that the brightness of all—or part—of a scene will average down to a so-called middle gray tone. The conventional wisdom is that this tone is roughly 18 percent gray. Unfortunately, while the traditional 18 percent value is a middle gray in terms of what the eye sees, the Z6 is actually calibrated for a slightly darker tone. This section explains how your Z6 decides on an exposure in one of its semi-automatic (non-manual) modes.

The exposure is measured using a specific pattern of exposure measuring areas that you can select (more on that later). Exposure is calculated based on the assumption that each area being measured reflects about the same amount of light as a neutral gray card that reflects a "middle" gray of about 12 to 18 percent reflectance. (The photographic "gray cards" you buy at a camera store have an 18 percent gray tone. Your camera is calibrated to interpret a somewhat darker 12 percent gray; I'll explain more about this later, too.) That "average" 12 to 18 percent gray assumption is necessary, because different subjects reflect different amounts of light. In a photo containing, say, a white cat and a dark gray cat, the white cat might reflect five times as much light as the gray cat. An exposure based on the white cat will cause the gray cat to appear to be black, while an exposure based only on the gray cat will make the white cat appear to be washed out.

This is more easily understood if you look at some photos of subjects that are dark (they reflect little light), those that have predominantly middle tones, and subjects that are highly reflective. The next few figures show a simplified scale with a middle gray 18 percent tone, plus black and white patches, along with a human figure (not a cat) to illustrate how different exposure measurements actually do affect an exposure.

Correctly Exposed

The image shown in Figure 4.3, left, represents how a photograph might appear if you inserted the patches shown at the bottom, and then calculated exposure by measuring the light reflecting from the middle gray patch, which, for the sake of illustration, we'll assume reflects approximately 12 to 18 percent of the light that strikes it. The exposure meter in the Z6 sees an object that it thinks is a middle gray, calculates an exposure based on that, and the patch in the center of the strip is rendered at its proper tonal value. Best of all, because the resulting exposure is correct, the black patch at left and white patch at right are rendered properly as well.

When you're shooting pictures with your Z6, and the meter happens to base its exposure on a subject that averages that "ideal" middle gray, then you'll end up with similar (accurate) results. The camera's exposure algorithms are concocted to ensure this kind of result as often as possible, barring any unusual subjects (that is, those that are backlit, or have uneven illumination). The Z6 has three metering modes (described shortly), each of which is equipped to handle certain types of unusual subjects, as I'll outline.

Overexposed

At center in Figure 4.3 you can see would happen if the exposure were calculated based on metering the leftmost, black patch. The light meter sees less light reflecting from the black square than it would see from a gray middle-tone subject, and so figures, "Aha! I need to add exposure to brighten this subject up to a middle gray!" That lightens the "black" patch, so it now appears to be gray.

But now the patch in the middle that was *originally* middle gray is overexposed and becomes light gray. And the white square at right is now seriously overexposed and loses detail in the highlights, which have become a featureless white. Our human subject is similarly overexposed.

Underexposed

The third possibility in this simplified scenario is that the light meter might measure the illumination bouncing off the white patch, and try to render *that* tone as a middle gray. A lot of light is reflected by the white square, so the exposure is *reduced*, bringing that patch closer to a middle gray tone. The patches that were originally gray and black are now rendered too dark, as you can see at right in Figure 4.3. Clearly, measuring the gray card—or a substitute that reflects about the same amount of light—is the only way to ensure that the exposure is precisely correct.

Metering Mid-Tones

As you can see, the ideal way to measure exposure is to meter from a subject that reflects 12 to 18 percent of the light that reaches it. If you want the most precise exposure calculations, the solution is to use a stand-in. Any mid-tone subject—including green grass or a rich, medium-blue sky—also reflects about 12 to 18 percent of the light. Metering such an area should ensure that the exposure for the entire scene will be correct or close to correct for average subjects.

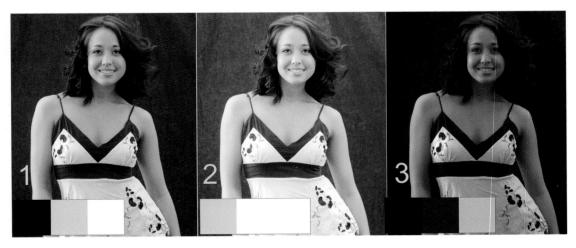

Figure 4.3 1.) Exposure calculated from the middle gray patch produces a correct exposure for all three patches and the subject. 2.) Exposure measured from the black patch yields an overexposed image. 3.) Exposure calculated from the white patch produces underexposure.

In some very bright scenes (like a snowy landscape or a lava field), you won't have a mid-tone to meter. Another substitute for a gray card is the palm of a human hand (the backside of the hand is too variable). But a human palm, regardless of ethnic group, is even brighter than a standard gray card, so instead of one-half stop more exposure, you need to add one additional stop. That is, if your meter reading is 1/500th of a second at f/11, use 1/500th second at f/8 or 1/200th second at f/11 instead. (Both exposures are equivalent.)

Or, you might want to resort to using an evenly illuminated gray card mentioned earlier. Small versions are available that can be tucked in a camera bag. Place it in your frame near your main subject, facing the camera, and with the exact same even illumination falling on it that is falling on your subject. Then, use the Spot metering function (described in the next section) to calculate exposure.

But the standard Kodak gray card reflects 18 percent of the light while, as I noted, your camera is calibrated for a somewhat darker 12 percent tone. If you insisted on getting a perfect exposure, you would need to add about one-half stop more exposure than the value provided by taking the light meter reading from the card. Of course, in most situations, it's not necessary to do this. Your camera's light meter will do a good job of calculating the right exposure, especially if you use the exposure tips in the next section. But I felt that explaining exactly what is going on during exposure calculation would help you understand how your Z6's metering system works.

ORIGIN OF THE 18 PERCENT 'MYTH'

Why are so many photographers under the impression that camera light meters are calibrated to the 18 percent "standard," rather than the true value, which may be 12 to 14 percent, depending on the vendor? You'll find this misinformation in an alarming number of places. I've seen the 18 percent "myth" taught in camera classes; I've found it in books, and even been given this wrong information from the technical staff of camera vendors. (They should know better—the same vendors' engineers who design and calibrate the cameras have the right figure.)

The most common explanation is that during a revision of Kodak's instructions for its gray cards in 1977, the advice to open up an extra half stop was omitted, and a whole generation of shooters grew up thinking that a measurement off a gray card could be used as is. Kodak restored the proviso in 1997, it's said, but by then it was too late.

EXTERNAL METERS CAN BE CALIBRATED

The light meters built into your Z6 are calibrated at the factory and can only be changed using the Fine Tune Optimal Exposure option (Custom Setting b4). But if you use a hand-held incident or reflective light meter, you *can* calibrate it, using the instructions supplied with your meter. Because a hand-held meter *can* be calibrated to the 18 percent gray standard (or any other value you choose), my rant about the myth of the 18 percent gray card doesn't apply.

MODES, MODES, AND MORE MODES

Call them modes or methods, the Nikon Z6 seems to have a lot of different sets of options that are described using similar terms. Here's how to sort them out:

- Metering method. These modes determine the *parts of the image* within the sensor that are examined in order to calculate exposure. The Z6 may look at many different points within the image, segregating them by zone (Matrix metering); examining the same number of points, but giving greater weight to those located in the middle of the frame (Center-weighted metering); evaluating only a limited number of points in a limited area (Spot metering); or adjusting exposure to preserve detail in highlights (Highlight-weighted metering).
- Exposure method. These modes (Program, Aperture-priority, Shutter-priority, or Manual) determine *which* settings are used to expose the image. The Z6 may adjust the shutter speed, the aperture, or both, or even ISO setting (if Auto ISO is active), depending on the method you choose.

To meter properly you'll want to choose both the *metering method* (how light is evaluated) and *exposure method* (how the appropriate shutter speeds and apertures are chosen). I'll describe both in the following sections.

Choosing a Metering Method

The Z6 has four different schemes for evaluating the light received by its exposure sensors: Matrix, Center-weighted, Spot, and Highlight-weighted. Select the mode you want from the *i* menu (or you can assign the metering adjustment function to a custom control using Custom Setting f2, as noted in the sidebar below).

Your Z6 calculates exposure by measuring the light that passes through the lens and strikes the sensor. These pixels are said to be able to detect light over a range of -4 to +17 EV at ISO 100. That translates into exposures from sixteen minutes at f/16 to 1/2,000th second at f/16.

In everyday terms, 0 EV represents the illumination you might see outdoors at night under a full moon, while the brightest daytime scene you're likely to encounter (a snow scene in full daylight) would be 16 EV. Your Z6 is able to *detect* photons under an extremely broad EV span—two stops dimmer than full moonlight, and one stop brighter than a daylight snow scene. However, your camera's ability to *capture* images is limited to a much smaller range. Note that the sensor's dynamic range (the tones it can preserve in your final image) is less than the full range of tones it can *detect*. It's easy to get these two separate aspects confused.

INSTANT SWITCHING

If you frequently use one metering method, but occasionally like to switch to another method on the fly, you can redefine the Z6's Fn1 or Fn2 buttons to shift to your alternate mode instantly. The buttons can be programmed to provide Matrix metering, Center-weighted metering, Spot metering, or Highlight-weighted metering (as well as other functions discussed in Chapter 12), using Custom Setting f2.

The really cool thing is that you can define one button for, say, Center-weighted metering, another one for Spot metering, and then set the main metering mode switch to Matrix, and thus be able to switch among those three on a whim. I've done this as a way to compare the exposure settings of the three metering methods while composing a single image in the viewfinder. I've also found the capability useful when I'm, say, working with Matrix metering and want to zero in on a particular area of the frame temporarily using Spot metering. The indicators in the viewfinder will help you remember what metering mode you've switched to. (See Figure 4.4.)

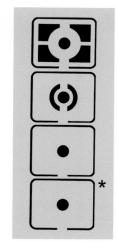

Figure 4.4 Top to bottom: Matrix, Center-weighted, Spot, and Highlight-weighted metering icons.

Matrix Metering

For Matrix metering mode, the Z6 reads the light falling on the sensor and compares the brightness of many areas using a matrix array. When Matrix metering is active, an icon indicator appears in the photo information screen, which you can summon by pressing the DISP button until it's shown. Then, the Z6 evaluates the differences between the many zones, and compares them with a built-in database of 30,000 actual images to make an educated guess about what kind of picture you're taking. For example, if the top sections of a picture are much lighter than the bottom portions, the algorithm can assume that the scene is a landscape photo with lots of sky. However, if there is a lighter area in the center of the frame, and the camera detects skin tones, the Z6 will assume that you're shooting a portrait and not a landscape photo, and expose for the human subject. A typical image suitable for Matrix metering is shown in Figure 4.5. (The Matrix Metering icon is shown at upper left for reference; it does not appear overlaid on your image or in the viewfinder/monitor display!)

A Matrix metering mode can often recognize many types of bright scenes and automatically increase the exposure to reduce the risk of a dark photo. This will be useful when your subject is a snow-covered landscape or a close-up of a bride in white. Granted, you may occasionally need to use a bit of exposure compensation, but often, the exposure will be close to accurate even without it. In my experience, Matrix metering is most successful with light-toned scenes on bright days, and is especially good when humans are in the frame. When shooting in dark, overcast conditions, it's more likely to underexpose a scene of that type.

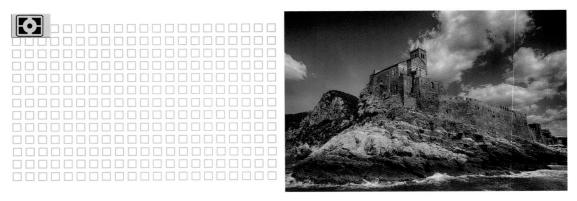

Figure 4.5 Complex scenes lend themselves to the exposure interpretation provided by Matrix metering.

Exposure meters have long used brightness to calculate correct exposure. The Nikon Z6's advanced technology uses other information to make more intelligent settings. These factors include:

- Patterns. As mentioned earlier, the camera compares exposure across the entire sensor with a database of tens of thousands of picture types, looking for differences among pixels, and similarities to images in the database. When it finds a match, it uses that information as a basis for its recommended exposure. If the contrast in a scene is high enough that the sensor probably won't be able to preserve detail in both highlights and shadows, in most cases, the Z6 will favor the highlights. As you'll learn later in this chapter, once highlights are lost, they are gone for ever, but it is sometimes possible to retrieve data in shadow areas. If you are shooting RAW, the exposure setting and other adjustments can often boost information in darker areas.
- Colors. The camera can enhance its readings based on the colors detected in the frame. Large areas of blue in the upper part of the image can be deemed to be sky, greens, foliage, and skin tones indicating human beings.
- Autofocus area. Whether you or the camera selects which autofocus zone is used, the exposure system assumes, logically, that the part of the image that is in focus contains your subject matter.
- **Distance and focal length.** The Z6 is able to use the distance and focal length supplied by your Z-mount lenses to better calculate what kind of scene you have framed. For example, if you're shooting a portrait with a longer focal-length lens focused to about 5 to 12 feet from the camera, and the upper half of the scene is very bright, the camera assumes you would prefer to meter for the rest of the image, and will discount the bright area. However, if the camera has a wide-angle lens attached and is focused at infinity, the Z6 can assume you're taking a landscape photo and take the bright upper area into account to produce better looking sky and clouds.

Matrix metering is best for most general subjects, because it is able to intelligently analyze a scene and make an excellent guess of what kind of subject you're shooting a great deal of the time. The camera can tell the difference between low-contrast and high-contrast subjects by looking at the

range of differences in brightness across the scene. Because the Z6 has a fairly good idea about what kind of subject matter you are shooting, it can underexpose slightly when appropriate to preserve highlight detail when image contrast is high. (It's often possible to pull detail out of shadows that are too dark using an image editor, but once highlights are converted to white pixels, they are gone forever.)

CAUTION

If you're using a strong filter, including a polarizing filter, split-color filter, or neutral-density filter (particularly a graduated neutral-density filter), you should switch from Matrix metering to Centerweighted, because the filter can affect the relationships between the different areas of the frame used to calculate a Matrix exposure. For example, a polarizing filter produces a sky that is darker than usual, hindering the Matrix algorithm's recognition of a landscape photo. Extra-dark or colored filters disturb the color relationships used for color Matrix metering, too.

Center-weighted Metering

In this mode, the exposure meter emphasizes a zone measuring 12mm in the center of the frame to calculate exposure. This type of metering was the only available option with cameras some decades ago, and was considered an upgrade from averaging, which simply based exposure on an average of the illumination of the entire frame.

With Center-weighted metering, you end up with conventional metering without any "intelligent" scene evaluation. The light meter considers brightness in the entire frame but places the greatest emphasis on a large area in the center of the frame (shown in blue in Figure 4.6, left), on the theory that, for most pictures, the main subject will not be located far off-center.

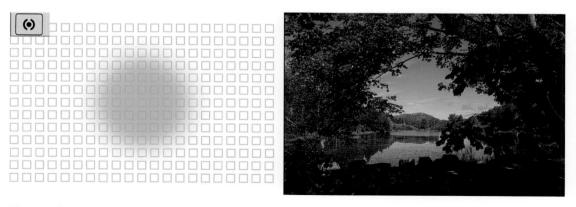

Figure 4.6 Scenes with the main subject in the center, surrounded by areas that are significantly darker or lighter, are perfect for Center-weighted metering.

About 75 percent of the exposure is based on the selected 12mm central area, and the remaining 25 percent of the exposure is based on the rest of the frame. So, if the Z6 reads the center portion and determines that the exposure for that region should be f/4 at 1/250th second, while the outer area, which is a bit darker, calls for f/16 at 1/250th second, the camera will give the center portion the most weight and arrive at a final exposure on the order of f/5.6 at 1/250th second.

Of course, Center-weighted metering is most effective when the subject in the central area is a midtone. Even then, if your main subject is surrounded by large, extremely bright or very dark areas, the exposure might not be exactly right. (You might need to use exposure compensation, a feature discussed shortly.) However, this scheme works well in many situations if you don't want to use one of the other modes, for scenes like the one shown in Figure 4.6. This mode can be useful for close-ups of subjects like flowers, or for portraits. You can adjust the size of the area assigned the greatest weight using Custom Setting b3, as described in Chapter 12. You can select the default 12mm circle, or choose "Average" (which in effect, covers the entire screen to produce what is called Average metering). Since Center-weighted metering is "fuzzy" anyway, I find the default 12mm to be the best compromise.

Spot Metering

Spot metering is favored by those of us who have used a hand-held light meter to measure exposure at various points (such as metering highlights and shadows separately). However, you can use Spot metering in any situation where you want to individually measure the light reflecting from light, midtone, or dark areas of your subject—or any combination of areas.

This mode confines the reading to a limited 4mm area in the viewfinder, making up only 1.5 percent of the image, as shown by the blue circle in Figure 4.7, left. The circle is centered on the *current focus point* (which can be *any* of the available focus points, *not* just the center one shown in the

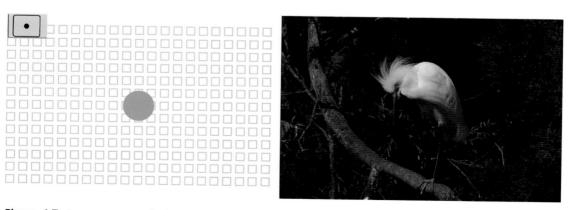

Figure 4.7 Spot metering calculates exposure based on a center spot that's only 1.5 percent of the image area, centered around the current focus point.

figure), but is larger than the focus point, so don't fall into the trap of believing that exposure is being measured only within the viewfinder indicators that represent the active focus point. This is the only metering method you can use to tell the Z6 exactly where to measure exposure. However, if you have selected Auto-area AF, only the center focus point is used to spot meter.

You'll find Spot metering useful when you want to base exposure on a small area in the frame. If that area is in the center of the frame, so much the better. If not, you'll have to make your meter reading for an off-center subject using an appropriate focus point, and then lock exposure by pressing the shutter release halfway, or by pressing an AE-L/AF-L button you may have defined using Custom Setting f2. This mode is best for subjects where the background is significantly brighter or darker.

If you Spot meter a very light-toned area or a dark-toned area, you will get underexposure or over-exposure, respectively; you would need to use an override for more accurate results. On the other hand, you can Spot meter a small mid-tone subject surrounded by a sky with big white clouds or by an indigo blue wall and get a good exposure. (The light meter ignores the subject's surroundings so they do not affect the exposure setting.) That would not be possible with Center-weighted metering, which considers brightness in a much larger area.

Using Spot Metering

Matrix and Center-weighted metering basically have few options to worry about. They are both affected by exposure compensation changes and Custom Setting b4: Fine-Tune Optimal Exposure adjustments. Spot metering, on the other hand, can benefit from your input in selecting the spot used. Here are some considerations to keep in mind:

- Moving the spot. Remember that you don't move the metering spot itself; the Z6 uses the current *focus* spot. So, you must be using an AF-area mode that allows changing the AF spot, which happens to be any of the AF-area modes *except* Auto-area AF. In that mode the center focus point is *always* used as the metering spot, and you cannot change it.
- Choosing a compatible AF-area mode. Use the *i* menu to cycle among the available AF areas, which differ depending on the focus mode you've chosen. All these AF-area modes will allow you to switch the AF point to any of the available focus areas in the display:
 - **AF-S focus mode:** Pinpoint AF, Single-point-AF, Wide-area AF (Small), or Wide-area AF (Large). (**Note:** Dynamic-area AF is not available.)
 - **AF-C focus mode:** Single-point-AF, Dynamic-area AF, Wide-area AF (Small), or Wide-area AF (Large). (**Note:** Pinpoint-AF is not available.)
 - Manual focus mode: Only Single-point selection is available. Note: With Manual focus, the Z6 does not autofocus, of course; the position of the focus point is used only for the electronic rangefinder and Spot metering functions. You can find information on all the focus and AF-area modes in Chapter 5.

- Wrap around. You'll use the sub-selector joystick or the multi selector's directional buttons to move the AF point around within the display—and the metering spot with it. The focus point's movement will stop at the left/right/top/bottom edges *unless* you've turned on focus point wraparound in Custom Setting a9.
- When using Auto-area AF. If you've selected Auto-area AF, the center focus point will always be used—even if the camera selects a different point for the autofocus function. That's actually a positive: since in Auto-area AF mode you don't know what the focus spot will be until you press the shutter release halfway, it's good to know that the Z6 will be using the center spot. While Spot metering is most useful when not using Auto-area AF, it still functions, albeit in a less flexible way.
- Reminder: when the focus point moves, the spot metering point moves, too. If you're using Dynamic-area AF and continuous autofocus (AF-C, described in Chapter 5), the Z6 may move the focus point you originally selected and base focus on the surrounding focus points. *The metering area will tag along.*

A good example of a scene where you might want to use Spot metering is shown in Figure 4.7, which shows an egret surrounded by very dark foliage. The illumination might have fooled both Matrix and Center-weighted metering (although Center-weighted might have come close), but Spot metering allowed taking a reading directly from the bird's plumage. While I preferred Spot metering in this case, another option might have been Highlight-weighted metering, described next.

Highlight-weighted Metering

In this metering mode, the Z6 examines your entire scene, just as it does using Matrix metering. It is *not* a spot metering mode, despite its icon, which is the same as the Spot icon, with an asterisk added. With this mode, the camera's Expeed 6 processor seeks out highlight areas of your image and bases exposure on a setting that will keep those highlights from being overexposed. Less emphasis ("weight") is given to non-highlight areas. That's why Highlight-weighted *might* have worked for the egret image above, but it's actually better suited for images in which the highlights are spread over a larger area of the frame.

So, if you're shooting spotlit performers on-stage at a concert or play, the Z6 is able to calculate the correct exposure using the performers, and ignoring, for the most part, the dark surroundings. You'd have your choice of measuring exposure in Spot mode, as described in the previous section, placing the metering spot on the dancer's face or shirt, or, you could select Highlight-weighted metering and allow the camera to identify the performer when figuring exposure. Your results might be similar with either, depending on how well you "placed" the Spot area and how cleverly the Z6 sorts out your subject from the background. I tend to use Spot mode when the area I want to meter is clearly defined, and Highlight-weighted when there is a range of highlights that I'd like to preserve, as in the photo of Billy Zoom, from the LA punk band X, shown in Figure 4.8.

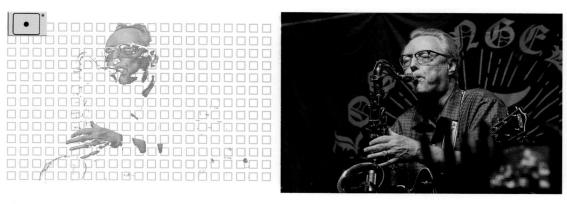

Figure 4.8 Highlight-weighted metering is especially useful for stage performances.

LOCKING EXPOSURE

An important tool when using any metering method is the ability to *lock* exposure once you've set shutter speed, aperture, and ISO to your satisfaction, allowing you to reframe your image before taking a picture. The default behavior of the sub-selector center button is AE-L/AF-L, which locks both exposure and autofocus. However, you can define another control for that function using Custom Setting f2: Custom Control Assignment, described in Chapter 12.

Your defined control can be set to function as an AE/AF lock, or AE Lock Only (which is useful if you're using back button focus, described in the next chapter). The same custom setting can also be used to define a Shutter Speed and Aperture Lock button, which effectively locks exposure by freezing the shutter speed in Aperture-priority mode and aperture in Shutter-priority mode.

Choosing an Exposure Method

You'll find four methods for choosing the appropriate shutter speed and aperture when using the semi-automatic/manual modes. You can choose among Aperture-priority, Shutter-priority, Program, or Manual options by pressing the mode dial release button on the top-left shoulder of the Z6 and rotating the mode dial. Your decision on which is best for a given shooting situation will depend on things like your need for lots of (or less) depth-of-field, a desire to freeze action or allow motion blur, or how much noise you find acceptable in an image. Each of the Z6's exposure methods emphasizes one aspect of image capture or another. This section introduces you to all four.

Aperture-Priority

In Aperture-priority (A) mode, you specify the lens opening used, and the Z6 will set a suitable shutter speed appropriate for the aperture and the ISO sensitivity in use. If you change the aperture, from f/5.6 to f/11, for example, the camera will automatically set a longer shutter speed to maintain the same exposure, using guidance from the built-in light meter. (I discussed the concept of equivalent exposure earlier in this chapter and provided the equivalent exposure table.)

Aperture-priority is especially good when you want to use a particular lens opening to achieve a desired effect. Perhaps you'd like to use the smallest f/stop possible (such as f/22) to maximize depth-of-field (DOF) in a close-up picture. Or, you might want to work with a large f/stop to throw everything except your main subject out of focus, as in Figure 4.9. Maybe you'd just like to "lock in" a particular f/stop because it's the sharpest available aperture with that lens. Or, you might prefer to use, say, f/2.8 on a lens with a maximum aperture of f/1.4, because you want the best compromise between shutter speed and sharpness.

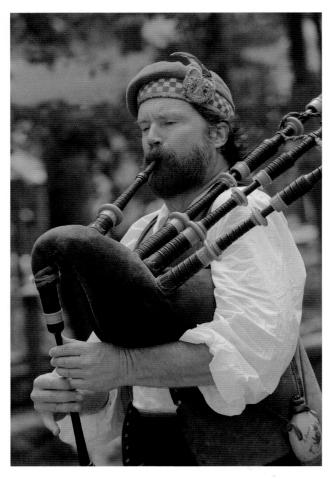

Figure 4.9
Use Aperture-priority to "lock in" a large f/stop when you want to blur distracting elements, or emphasize the main subject in the photo, in this case a Scottish bagpiper.

Aperture-priority can even be used to specify a *range* of shutter speeds you want to use under varying lighting conditions, which seems almost contradictory. But think about it. You're shooting a soccer game outdoors with a telephoto lens and want a relatively high shutter speed, but you don't care if the speed changes a little should the sun duck behind a cloud. Set your Z6 to A, and adjust the aperture until a shutter speed of, say, 1/1,000th second is selected at your current ISO setting. (In bright sunlight at ISO 400, that aperture is likely to be around f/11.) Then, go ahead and shoot, knowing that your Z6 will maintain that f/11 aperture (for sufficient depth-of-field as the soccer players move about the field), but will drop down to 1/640th or 1/500th second if necessary should the lighting change a little.

When the shutter speed indicator in the viewfinder and the top-panel monochrome LCD blink, that indicates that the Z6 is unable to select an appropriate shutter speed at the selected aperture and that over- or underexposure will occur at the current ISO setting. That's the major pitfall of using A: you might select an f/stop that is too small or too large to allow an optimal exposure with the available shutter speeds. For example, if you choose f/2.8 as your aperture and the illumination is quite bright (say, at the beach or in snow), even your camera's fastest shutter speed might not be able to cut down the amount of light reaching the sensor to provide the right exposure. Or, if you select f/8 in a dimly lit room, you might find yourself shooting with a very slow shutter speed that can cause blurring from subject movement or camera shake. Aperture-priority is best used by those with a bit of experience in choosing settings. Many seasoned photographers leave their Z6 set on A all the time. The exposure indicator scale in the control panel and viewfinder indicate the amount of under- or overexposure.

When to use Aperture-priority:

- General landscape photography. The Z6 is a great camera for landscape photography, of course, because its high resolution allows making huge, gorgeous prints, as well as smaller prints that are filled with eye-popping detail. Aperture-priority is a good tool for ensuring that your landscape is sharp from foreground to infinity, if you select an f/stop that provides maximum depth-of-field, as shown in Figure 4.10.
 - If you use A mode and select an aperture like f/11 or f/16, it's your responsibility to make sure the shutter speed selected is fast enough to avoid losing detail to camera shake, or that the Z6 is mounted on a tripod. One thing that new landscape photographers fail to account for is the movement of distant leaves and tree branches. When seeking the ultimate in sharpness, go ahead and use Aperture-priority, but boost ISO sensitivity a bit, if necessary, to provide a sufficiently fast shutter speed, whether shooting hand-held or with a tripod.
- Specific landscape situations. Aperture-priority is also useful when you have no objection to using a long shutter speed, or, particularly, want the Z6 to select one. Waterfalls are a perfect example. You can use A mode, set your camera to ISO 100, use a small f/stop, and let the camera select a longer shutter speed that will allow the water to blur as it flows. Indeed, you might need to use a neutral-density filter to get a sufficiently long shutter speed. But Aperture-priority mode is a good start.

Figure 4.10 Extra depth-of-field came in handy when shooting this covered bridge.

- Portrait photography. Portraits are the most common applications of selective focus. A medium-large aperture (say, f/5.6 or f/8) with a longer lens/zoom setting (in the 85mm-135mm range) will allow the background behind your portrait subject to blur. A *very* large aperture (I frequently shoot wide open with my 85mm f/1.4G Nikkor) lets you apply selective focus to your subject's *face*. With a three-quarters view of your subject, as long as his or her eyes are sharp, it's okay if the far ear or her hair is out of focus.
- When you want to ensure optimal sharpness. All lenses have an aperture or two at which they perform best, providing the level of sharpness you expect from a camera with the resolution of the Z6. That's usually about two stops down from wide open, and thus will vary depending on the maximum aperture of the lens.
- Close-up/Macro photography. Depth-of-field is typically very shallow when shooting macro photos, and you'll want to choose your f/stop carefully. Perhaps you might want to use a wider stop to emphasize your subject. Or, you might need the smallest aperture you can get away with to maximize depth-of-field. Aperture-priority mode comes in very useful when shooting close-up pictures, too. Because macro work is frequently done with the Z6 mounted on a tripod, and your close-up subjects, if not living creatures, may not be moving much, a longer shutter speed isn't a problem. Aperture-priority can be your preferred choice.

Shutter-Priority

Shutter-priority (S) is the inverse of Aperture-priority: you choose the shutter speed you'd like to use, and the camera's metering system selects the appropriate f/stop. Perhaps you're shooting action photos and you want to use the absolute fastest shutter speed available with your camera; in other cases, you might want to use a slow shutter speed to add some blur to an action photo that would be mundane if the action were completely frozen. Shutter-priority mode gives you some control over how much action-freezing capability your digital camera brings to bear in a particular situation.

Take care when using a slow shutter speed such as 1/8th second or slower, because you'll get blurring from camera shake unless you're using a lens with vibration reduction (described in Chapter 7), or have mounted the Z6 on a tripod or other firm support.

You'll also encounter the same problem as with Aperture-priority when you select a shutter speed that's too long or too short for correct exposure under some conditions. As in A mode, it's possible to choose an inappropriate shutter speed. If that's the case, the shutter speed indicator in the view-finder and control panel LCD will blink.

When to use Shutter-priority:

- To reduce blur from subject motion. Set the shutter speed of the Z6 to a higher value to reduce the amount of blur from subjects that are moving. The exact speed will vary depending on how fast your subject is moving and how much blur is acceptable. You might want to freeze a basketball player in mid-dunk with a 1/1,000th second shutter speed, or use 1/200th second to allow the spinning wheels of a motocross racer to blur a tiny bit to add the feeling of motion.
- To add blur from subject motion. There are times when you want a subject to blur, say, when shooting waterfalls with the camera set for a one- or two-second exposure in Shutter-priority mode.
- To add blur from camera motion when *you* are moving. Say you're panning to follow a pair of relay runners. You might want to use Shutter-priority mode and set the Z6 for 1/60th second, so that the background will blur as you pan with the runners. The shutter speed will be fast enough to provide a sharp image of the athletes, while reducing their distracting background to a blur. For Figure 4.11, I was panning to follow the great blue heron taking flight, and shot at 1/30th second to allow the waterfall in the background to blur.
- To reduce blur from camera motion when *you* are moving. In other situations, the camera may be in motion, say, because you're shooting from a moving train or auto, and you want to minimize the amount of blur caused by the motion of the camera. Shutter-priority is a good choice here, too.
- Landscape photography hand-held. If you can't use a tripod for your landscape shots, you'll still probably want the sharpest image possible. Shutter-priority can allow you to specify a shutter speed that's fast enough to reduce or eliminate the effects of camera shake. Just make sure that your ISO setting is high enough that the Z6 will select an aperture with sufficient depth-of-field, too.

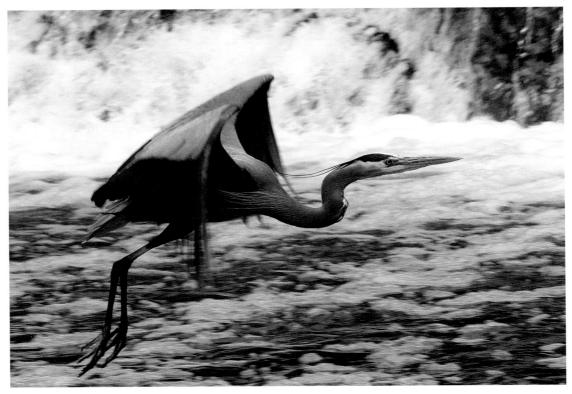

Figure 4.11 Shutter-priority allows you to specify a speed that will render a moving subject like this heron reasonably sharp as you pan.

■ Concerts and stage performances. I shoot a lot of concerts with my 70-200mm f/2.8 VR Nikkor lens, using the FTZ adapter if I elect to work with my Z6, and have discovered that, when vibration reduction is taken into account, a shutter speed of 1/160th second is fast enough—along with vibration reduction—to eliminate camera shake that can result from hand-holding the Z6 with this lens, and also to avoid blur from the movement of all but the most energetic performers. I use Shutter-priority and set the ISO so the camera will select an aperture in the f/4-5.6 range.

Program Mode

Program mode (P) uses the Z6's built-in smarts to select the correct f/stop and shutter speed using a database of picture information that tells it which combination of shutter speed and aperture will work best for a particular photo. If the correct exposure cannot be achieved at the current ISO setting, the shutter speed and aperture will blink in the viewfinder and control panel. You can then boost or reduce the ISO to increase or decrease sensitivity.

The Z6's recommended exposure can be overridden if you want. Use the EV (exposure value) setting feature (described later, because it also applies to S and A modes) to add or subtract exposure from the metered value. And, as I mentioned earlier in this chapter, in Program mode you can rotate the main command dial to change from the recommended setting to an equivalent setting (as shown previously in Table 4.1) that produces the same exposure, but using a different combination of f/stop and shutter speed.

This is called "Flexible Program" by Nikon. Rotate the main command dial left to reduce the size of the aperture (going from, say, f/4 to f/5.6), so that the Z6 will automatically use a slower shutter speed (going from, say, 1/200th second to 1/125th second). Rotate the main command dial right to use a larger f/stop, while automatically producing a shorter shutter speed that provides the same equivalent exposure as metered in P mode. An asterisk appears next to the P in the viewfinder/monitor display so you'll know you've overridden the Z6's default program setting. Your adjustment remains in force until you rotate the main command dial until the asterisk disappears, or you switch to a different exposure mode, or turn the Z6 off.

MAKING EV CHANGES

Sometimes you'll want more or less exposure than indicated by the Z6's metering system. Perhaps you want to underexpose to create a silhouette effect, or overexpose to produce a high-key look. It's easy to use the Z6's exposure compensation system to override the exposure recommendations. Press the exposure compensation (EV) button on the top of the camera (just southeast of the shutter release). Then rotate the main command dial left to add exposure, and right to subtract exposure. The EV change you've made remains for the exposures that follow, until you manually zero out the EV setting. The EV plus/minus icon appears in the viewfinder and control panel to warn you that an exposure compensation change has been entered. You can increase or decrease exposure over a range of plus or minus five stops. (If you've activated Easy Exposure Compensation using Custom Setting b2, as described in Chapter 12, you don't have to hold down the EV button; rotating the main or sub-command dials alone changes the EV value when using Program, Aperture-priority, Shutter-priority, or Manual exposure modes.)

When to use Program mode:

- When you're in a hurry to get a grab shot. The Z6 will do a pretty good job of calculating an appropriate exposure for you, without any input from you.
- When you hand your camera to a novice. Set the Z6 to P, hand the camera to your friend, relative, or *trustworthy* stranger you meet in front of the Eiffel Tower, point to the shutter release button and viewfinder, and say, "Look through here, and press this button." I like this option more than using Auto mode, because I can make slight adjustments to suit before handing over my camera.

■ When no special shutter speed or aperture settings are needed. If your subject doesn't require special anti- or pro-blur techniques, and depth-of-field or selective focus aren't important, use P as a general-purpose setting. You can still make adjustments to increase/decrease depth-of-field or add/reduce motion blur with a minimum of fuss.

Manual Exposure

Part of being an experienced photographer comes from knowing when to rely on your Z6's automation (with P mode), when to go semi-automatic (with S or A), and when to set exposure manually (using M). Some photographers actually prefer to set their exposure manually, as the Z6 will be happy to provide an indication of when its metering system judges your manual settings provide the proper exposure, using the analog exposure scale at the bottom of the viewfinder.

Manual exposure can come in handy in some situations. You might be taking a silhouette photo and find that none of the exposure modes or EV correction features give you exactly the effect you want. Set the exposure manually to use the exact shutter speed and f/stop you need. Or, you might be working in a studio environment using multiple flash units. The additional flash are triggered by slave devices (gadgets that set off the flash when they sense the light from another flash unit, or, perhaps from a radio or infrared remote control). Your camera's exposure meter doesn't compensate for the extra illumination, so you need to set the aperture manually.

Because, depending on your proclivities, you might not need to set exposure manually very often, you should still make sure you understand how it works. Fortunately, the Z6 makes setting exposure manually very easy. Just press the mode dial lock release and rotate the mode dial to M to change to Manual mode, and then turn the main command dial to set the shutter speed, and the sub-command dial to adjust the aperture. Press the shutter release halfway or press your defined AE lock button, and the exposure scale in the viewfinder shows you how far your chosen setting diverges from the metered exposure.

METERING WITH OLDER LENSES

Older lenses that lack the CPU chip that tells the Nikon Z6 what kind of lens is mounted can be used with Aperture-priority and Manual exposure modes only, assuming you've entered the Non-CPU Lens information in the Setup menu, as described in Chapter 7. If the Z6 knows the maximum aperture of the lens, you can set the aperture using the lens's aperture ring, and, in A mode, the camera will automatically select an appropriate shutter speed. In Manual mode, you can set the aperture, and the analog exposure scale in the viewfinder will indicate when you've set the correct shutter speed manually.

When to use Manual exposure:

- When working in the studio. If you're working in a studio environment, you generally have total control over the lighting and can set exposure exactly as you want. The last thing you need is for the Z6 to interpret the scene and make adjustments of its own. Use M, and shutter speed, aperture, and (as long as you don't use ISO-Auto) the ISO setting are totally up to you.
- When using non-dedicated flash. The Nikon Creative Lighting System (CLS) and the new Advanced Lighting System (ALS, introduced with the SB-5000) are cool, and can even be used to coordinate use of your Z6 with external compatible dedicated flash units, like the SB-5000 or SB-910. But if you're working with non-CLS flash units, particularly studio flash plugged into the Z6's PC/X connector, the camera has no clue about the intensity of the flash, so you'll have to dial in the appropriate aperture manually.
- If you're using a hand-held light meter. The appropriate aperture, both for flash exposures and shots taken under continuous lighting, can be determined by a hand-held light meter, flash meter, or combo meter that measures both kinds of illumination. With an external meter, you can measure highlights, shadows, backgrounds, or additional subjects separately, and use Manual exposure to make your settings.
- When you want to outsmart the metering system. Your Z6's metering system is "trained" to react to unusual lighting situations, such as backlighting, extra-bright illumination, or low-key images with murky shadows. In many cases, it can counter these "problems" and produce a well-exposed image. But what if you don't want a well-exposed image? Manual exposure allows you to produce silhouettes in backlit situations, wash out all the middle tones to produce a luminous look, or underexpose to create a moody or ominous dark-toned photograph.
- When you want to select shutter speed and aperture. Aperture- and Shutter-priority give you autoexposure while allowing you to lock in a preferred shutter speed or aperture—but not both at the same time. Manual exposure makes it possible to specify both and *retain* autoexposure capabilities. All you have to do is activate ISO Auto. The Z6 will keep the shutter speed and aperture you want, but raise or lower the sensitivity setting to provide an appropriate exposure.
- When you want extra-long exposures. None of the semi-automatic modes will give you an exposure longer than 30 seconds. In Manual mode, however, you can spin the command dial past 30 seconds to Time or Bulb and achieve exposures as long as you want. For example, I used a three-minute exposure (and an Aurora Aperture PowerND 16-stop neutral-density filter) to capture the scene shown in Figure 4.12. I'll give you some more uses for time and bulb exposures in Chapter 6.

Figure 4.12 A three-minute exposure (using a neutral-density filter) yielded this unusual shot.

Adjusting Exposure with ISO Settings

As I mentioned above, another way of adjusting exposures is by changing the ISO sensitivity setting. Sometimes photographers forget about this option, because the common practice is to set the ISO once for a particular shooting session (say, at ISO 200 for bright sunlight outdoors, or ISO 800 when shooting indoors) and then forget about ISO. ISOs higher than ISO 200 or 400 are seen as "bad" or "necessary evils." However, changing the ISO is a valid way of adjusting exposure settings, particularly with the Nikon Z6, which produces good results at ISO settings that create grainy, unusable pictures with some other camera models.

Indeed, I find myself using ISO adjustment as a convenient alternate way of adding or subtracting EV when shooting in Manual mode, and as a quick way of choosing equivalent exposures when in Program or Shutter-priority or Aperture-priority modes. For example, I've selected a Manual exposure with both f/stop and shutter speed suitable for my image using, say, ISO 200. I can change the exposure in 1/3-stop increments by holding down the ISO button located on the top-right shoulder of the camera, and spinning the main command dial one click at a time. The difference in image quality/noise at ISO 200 is negligible if I dial in ISO 160 or ISO 125 to reduce exposure a little, or change to ISO 250 or 320 to increase exposure. I keep my preferred f/stop and shutter speed, but still adjust the exposure. (And, as I noted earlier, if ISO Auto is active, I can even allow the Z6 to set the exposure automatically using the f/stop and shutter speed I want.)

Or, perhaps, I am using S mode and the metered exposure at ISO 200 is 1/500th second at f/11. If I decide on the spur of the moment I'd rather use 1/500th second at f/8, I can press the ISO button and spin the main command dial to switch to ISO 100. Of course, it's a good idea to monitor your ISO changes, so you don't end up at ISO 6400 accidentally. An ISO indicator appears in the control panel and in the viewfinder to remind you what sensitivity setting has been dialed in.

ISO settings can, of course, also be used to boost or reduce sensitivity in particular shooting situations. The Z6 can use ISO settings from Lo 1 (ISO 50 equivalent) and thence to ISO 100 up to ISO 51200, plus Hi 1 to Hi 2 (equivalent to ISO 102,400 and 204,800). The camera can also adjust the ISO automatically as appropriate for various lighting conditions. When you choose the Auto ISO setting in the Photo Shooting menu, as described in Chapter 11, the Z6 adjusts the sensitivity dynamically to suit the subject matter, based on minimum shutter speed and ISO limits you have prescribed. As I note in Chapter 13, you should use Auto ISO cautiously if you don't want the Z6 to use an ISO higher than you might otherwise have selected.

Fortunately, the Z6 includes several useful wrinkles in its Auto ISO arsenal. You can set limits, specifying both a *maximum sensitivity* (for both ambient exposures and flash) and a *minimum* shutter speed. If Auto ISO is active (it will be indicated in the viewfinder, control panel, and photo information display on the monitor), the camera will never select an ISO you deem to be too high. Moreover, if your exposure will result in a speed slower than the minimum you set (thereby risking blur from subject motion and/or camera movement), the Z6 will switch to a higher ISO setting to allow using the minimum shutter speed or faster.

However, as I'll explain in Chapter 13, buried in the Photo Shooting menu within the Minimum Shutter Speed option in the Auto ISO settings is an additional Auto setting that allows you to specify how quickly the camera reacts to counter that longer shutter speed. Select Slower, and the Z6 will delay raising the ISO (useful if you want to keep a constant shutter speed, even if slow, to maintain a consistent "look" in a series of photos). Choose Faster, and the camera responds more quickly to reduce the possibility of image blur. Nikon has given the enthusiast photographers a useful tool that allows you to fine-tune your Z6's behavior so it works the way you want it to in a wider variety of circumstances.

Dealing with Noise

Visual image noise is that random grainy effect that some like to use as a special effect, but which, most of the time, is objectionable because it robs your image of detail even as it adds that "interesting" texture. Noise is caused by two different phenomena: high ISO settings and long exposures.

High ISO noise commonly appears as you increase your camera's ISO setting, which causes the Z6 to amplify the base signal (captured at ISO 100). In the other direction, you can easily capture relatively low-noise images at ISO 800 and above. However, some noise may become visible at ISO

1600, and is often fairly noticeable at ISO 6400. At ISO 25600 and above, noise is often quite bothersome, although I have used ISO 25600 when photographing subjects that are fairly low in contrast. Nikon tips you off that settings higher than ISO 51200 may be tools used in special circumstances only by labeling them Hi 0.3 through Hi 2. You can expect noise and increase in contrast in any pictures taken at these lofty ratings.

High ISO noise appears as a result of the amplification needed to increase the sensitivity of the sensor. While higher ISOs do pull details out of dark areas, they also amplify non-signal information randomly, creating noise. You'll find a High ISO NR choice in the Photo Shooting menu, where you can specify High, Normal, or Low noise reduction, or turn the feature off entirely. Because noise reduction tends to soften the grainy look while robbing an image of detail, you may want to disable the feature if you're willing to accept a little noise in exchange for more details.

A similar noisy phenomenon occurs during long time exposures, which allow more photons to reach the sensor, increasing your ability to capture a picture under low-light conditions. However, the longer exposures also increase the likelihood that some pixels will register random phantom photons, often because the longer an imager is "hot," the warmer it gets, and that heat can be mistaken for photons. There's also a special kind of noise that CMOS sensors like the one used in the Z6 are potentially susceptible to. CMOS imagers contain millions of individual amplifiers and A/D converters, all working in unison. Because these circuits don't necessarily all process in precisely the same way all the time, they can introduce something called fixed-pattern noise into the image data.

Fortunately, Nikon's electronics geniuses have done an exceptional job minimizing noise from all causes in the Z6. Even so, you might still want to apply the optional long exposure noise reduction that can be activated using Long Exp. NR in the Photo Shooting menu, where the feature can be turned On or Off. This type of noise reduction involves the Z6 taking a second, blank exposure, and comparing the random pixels in that image with the photograph you just took. Pixels that coincide in the two represent noise and can safely be suppressed. This noise reduction system, called dark-frame subtraction, effectively doubles the amount of time required to take a picture, and is used only for exposures longer than one second. Noise reduction can reduce the amount of detail in your picture, as some image information may be removed along with the noise. So, you might want to use this feature with moderation.

You can also apply noise reduction to a lesser extent using Photoshop, and when converting RAW files to some other format, using your favorite RAW converter, or an industrial-strength product like Noise Ninja (www.picturecode.com) to wipe out noise after you've already taken the picture.

Bracketing

Bracketing is a method for shooting several consecutive exposures using different settings, as a way of improving the odds that one will be exactly right. Alternatively, bracketing can be used to create a series of photos with slightly different exposures (or white balances) in anticipation that one of the exposures will be "better" from a creative standpoint. For example, bracketing can supply you with a normal exposure of a backlit subject, one that's "underexposed," producing a silhouette effect, and a third that's "overexposed" to create still another look.

Before digital cameras took over the universe, it was common to bracket exposures, shooting, say, a series of three photos at 1/125th second, but varying the f/stop from f/8 to f/11 to f/16. In practice, smaller than whole-stop increments were used for greater precision, and lenses with apertures that were set manually commonly had half-stop detents on their aperture rings, or could easily be set to a mid-way position between whole f/stops. It was just as common to keep the same aperture and vary the shutter speed, although in the days before electronic shutters, film cameras often had only whole increment shutter speeds available.

Today, cameras like the Z6 can bracket exposures much more precisely, and bracket white balance and Active D-Lighting (described later in this chapter) as well. While WB bracketing is sometimes used when getting color absolutely correct in the camera is important, autoexposure bracketing is used much more often. When this feature is activated, the Z6 takes a series of consecutive photos: starting with the metered "correct" exposure, then progressing to shots with less exposure, and additional shots with more exposure, using an increment of your choice up to +3/–3 stops. In A mode, the shutter speed will change, while in S mode, the aperture will change as the bracketed exposures are made.

Setting up autoexposure bracketing parameters is trickier than it needs to be, but you can follow these steps:

- 1. **Choose type of bracketing.** First, select the type of bracketing you want to do, using Auto Bracketing Set within the Auto Bracketing entry in the Photo Shooting menu, as explained in Chapter 11. You can select autoexposure and flash, autoexposure only, flash only, white balance only, and ADL bracketing.
 - If you plan on shooting in Manual exposure mode, you can specify how bracketing is performed using Custom Setting e6. Your choices there are flash+shutter speed, flash+shutter speed+aperture, flash+aperture, or flash only. White balance and ADL bracketing are not available in Manual exposure mode.
- 2. Choose bracketing order. With Custom Setting e7 you can select MTR > Under > Over or Under > MTR > Over bracket orders. I prefer the latter order, as it makes it easier to have the frames of certain types of manual HDR exposures in order of increasing exposure.

- 3. **Select number of bracketed exposures.** In the Auto Bracketing entry of the Photo Shooting menu, select Number of Shots and use the multi selector left/right buttons or touch screen, pressing left to choose the number of shots in the sequence, 0 (which turns bracketing off), -2, +2, -3, or +3. Press the right button to specify 3-, 5-, 7-, or 9-shot bracket sets centered around the metered exposure.
- 4. **Choose bracket increment.** Next, select Increment, and use the left/right buttons or touch screen to choose the exposure increment: 1/3, 2/3, 1, 2, or 3 EV. **Note:** If you select an increment of 2 EV or 3 EV, then the number of shots in the bracketed set that you specified in Step 4 is limited to 5. If you had chosen 7 or 9 shots in Step 4, the Z6 will automatically change the setting to 5 shots.
- 5. **Frame and shoot.** As you take your photos, the camera will vary exposure, flash level, or white balance for each image, based on the bracketing "program" you selected, and in the order you specified in Custom Setting e7. In Single-frame mode, you'll need to press the shutter release button the number of times you specified for the exposures in your bracketed burst. I've found it easy to forget that I am shooting bracketed pictures, stop taking my sequence, and then wonder why the remaining pictures in my defined burst are "incorrectly" exposed. To avoid that, I often set the Z6 to one of the two continuous shooting modes, so that all my bracketed pictures are taken at once.
- 6. **Turn bracketing off.** When you're finished bracketing shots, remember to return to the Auto Bracketing entry and change Number of Shots to 0, and the BKT indicator is no longer displayed, as the setting remains in effect when you power down the camera and subsequently turn it on again.

ACTIVATING BRACKETING

Once you've set up the type of bracketing you want to use, as described next, taking a bracketed set of exposures is easy. When bracketing is active, to initiate exposing a set, just press the Bracketing Burst button. (Use Custom Setting f2 as described in Chapter 12 to assign the Bracketing Burst behavior to a button.) Once the button is pressed, all shots in the set will be taken each time you press the shutter release button once.

White Balance Bracketing

When you choose white balance bracketing, the Z6 does not take three different exposures (even if you've defined a Bracketing Burst button, only one shot will be taken). There's no need, if you think about it. The camera always takes a RAW exposure first, no matter whether the camera is set to JPEG, RAW, or RAW+JPEG. If you've selected JPEG-only mode, the camera converts the initial RAW exposure to JPEG format using the settings you've opted for in the camera, and then discards the RAW data. In RAW mode, the camera stores the RAW data as a NEF file, and also creates a

Basic JPEG version of the image that is embedded in the RAW file as a thumbnail. That thumbnail is what you're actually looking at on the back-panel LCD monitor when you review your pictures; you never actually see the RAW file itself until you import it into your image editor. Your computer may also use the embedded JPEG file when it displays a RAW image. Finally, if you save in RAW+JPEG, you end up with two files: the NEF RAW file (with its embedded JPEG image) and a separate JPEG file at the quality level you specify (Fine, Normal, or Basic).

Since the RAW file that the camera initially captures contains all the digital information captured during exposure, when you specify white balance bracketing, the Z6 needs to take only one picture—and then save a JPEG file at each of the required white balance settings. One snap, and you get either two or three JPEG files at the quality level you specified, bracketed as you directed. Very slick. As you might guess, WB bracketing is applied only to JPEG files; you can't specify WB bracketing if you've chosen RAW or RAW+JPEG. RAW files created are always unmodified, and will be converted according to the white balance settings you opted for in the camera when the photo is imported into your image editor (if you make no white balance changes during importation).

White balance bracketing produces JPEG files that vary, not by f/stops (which is the case with exposure bracketing), but by units called *mireds* (micro reciprocal degrees) that are used to specify color temperature. You don't really need to understand mireds at all, other than to know that WB bracketing varies the color temperature of your images by 5 mireds for each shot taken in the bracket set. Changes are made only in the amber-blue range; bracketing isn't applied to the green-magenta color bias.

To activate White Balance bracketing, just follow these steps:

- JPEG only. Make sure you've selected a JPEG-only setting in the Image Quality entry of the Photo Shooting menu.
- 2. **Specify WB Bracketing.** In the Auto Bracketing entry of the Photo Shooting menu, choose WB Bracketing as your bracketing set.
- 3. **Choose number of shots.** In the Auto Bracketing screen, after you've chosen WB Bracketing, scroll down to Number of Shots and select how many bracketed exposures you want. You can choose two different ways:
 - Select 0, 3, 5, 7, or 9 (use the right directional button) and the Z6 will take the specified number of shots, in the amber and blue directions, equally spread on either side of the zero point of the amber-blue scale. For example, if you choose 5 as your number of shots, the sequence will include one neutral shot, plus two biased by 5 and 10 mireds in both amber and blue directions. With 0 as your number of shots, bracketing is disabled, just as it is with exposure bracketing.
 - Select B2, A2, B3, A3 bias (using the left directional button) and the Z6 will take either two or three shots biased in the blue or amber directions. For example, B3 would include shots biased 5, 10, and 15 mireds *only* in the blue direction.

ADL Bracketing

To initiate Active D-Lighting bracketing, select it from the Photo Shooting menu's Auto Bracketing Set menu entry and select number of shots and amount, as described next. As with exposure bracketing, you can trigger a burst with one press of the shutter release if you've defined a Bracketing Burst button.

- 0 (Number of shots). Active D-Lighting bracketing is disabled. Only *bracketing* is turned off. If you've turned basic Active D-Lighting on in the Shooting menu, then each shot you take will have the amount of ADL applied that you specified (Auto, Extra High, High, Normal, or Low).
- 2 (Number of shots). Only two shots will be taken, one Off (ADL turned Off, your control, so to speak) and one at the setting you specify. Scroll down to the Amount box. You can select OFF/Auto (No ADL, plus Auto ADL), Off/Extra High, Off/High, Off/Normal, or Off/Low.
- 3–5 (Number of shots). You can choose 3, 4, or 5 shots. One will be Off (ADL disabled) and the others will be taken at the settings indicated in the Amount box. (You cannot choose the ADL settings in the Amount box when 3, 4, or 5 shots are taken.)
 - 3 shots: Off, plus Low and Normal.
 - 4 shots: Off, plus Low, Normal, and High.
 - 5 shots: Off, plus Low, Normal, High, and Extra-High.

As with exposure, flash, and WB bracketing, remember to turn off ADL bracketing when you no longer want to use it. Once set, it is automatically invoked each time you take a picture until disabled.

Working with HDR

High Dynamic Range (HDR) photography is quite the rage these days, and entire books have been written on the subject. It's not really a new technique—film photographers have been combining multiple exposures for ages to produce a single image of, say, an interior room while maintaining detail in the scene visible through the windows.

It's the same deal in the digital age. Suppose you wanted to photograph a dimly lit room that had a bright window showing an outdoors scene. Proper exposure for the room might be on the order of 1/60th second at f/2.8 at ISO 200, while the outdoors scene probably would require f/11 at 1/400th second. That's almost a 7 EV step difference (approximately 7 f/stops) and well beyond the dynamic range of any digital camera, including the Nikon Z6.

Until camera sensors gain much higher dynamic ranges (which may not be as far into the distant future as we think), special tricks like Active D-Lighting and HDR photography will remain basic tools. With the Nikon Z6, you can create in-camera HDR exposures, or shoot HDR the old-fashioned way—with separate bracketed exposures that are later combined in a tool like Photomatix or Adobe's Merge to HDR image-editing feature. I'm going to show you how to use both.

Auto HDR

The Z6's in-camera HDR feature is simple, not particularly flexible, but still surprisingly effective in creating high dynamic range images. It's also remarkably easy to use. Although it combines only two images to create a single HDR photograph, in some ways it's as good as the manual HDR method I'll describe in the section after this one. For example, it allows you to specify an exposure differential of three stops/EV between the two shots, the same as when shooting bracketed exposures.

As I noted, with digital camera sensors, it's often tricky to capture detail in both highlights and shadows in a single image, because the number of tones, the *dynamic range* of the sensor, is limited. The solution, in this particular case, was to resort to the Z6's Auto HDR feature, in which the two exposures were combined in the camera to produce a final image.

Figure 4.13 illustrates how the two shots that the Z6's HDR feature merges might look. There is a three-stop differential between the underexposed image at left, and the overexposed image at center.

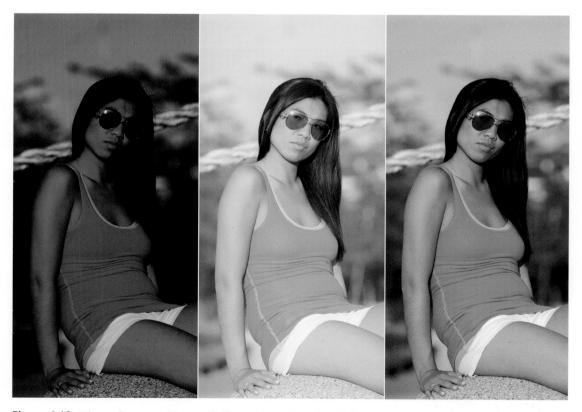

Figure 4.13 The underexposed image (left) can be combined with the overexposed image (center) to produce the merged HDR image (right).

The in-camera HDR processing is able to combine the two to derive an image similar to the one shown in Figure 4.13, right, which has a much fuller range of tones.

To use the Z6's HDR feature, just follow these steps. The feature does not work if you have selected RAW or RAW+JPEG formats, and cannot be used simultaneously with bracketing features, multiple exposure, or time-lapse photography.

- 1. **Activate the menu.** Press the MENU button and navigate to the Photo Shooting menu, represented by a camera icon. (If you need more help using the Z6's menu system, you'll find an introduction at the beginning of Chapter 11.)
- 2. **Scroll down to HDR.** Press the right multi selector button. A screen appears with four choices: HDR Mode, Exposure Differential, Smoothing, and Save Individual Images (NEF). (See Figure 4.14, upper left.)
- 3. **Turn on HDR.** Choose HDR Mode, press right, and select either On (series) if you want to shoot multiple HDR photos consecutively or On (single photo) to take a single HDR image and then shut the feature off. Choose OFF to disable the feature. Press OK to confirm. (See Figure 4.14, upper right.)

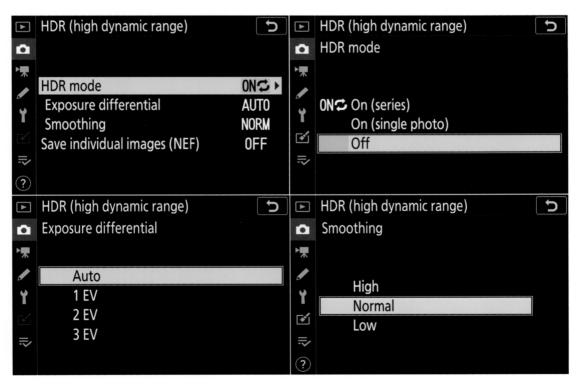

Figure 4.14 Choose HDR parameters.

- 4. **Set amount.** Choose Exposure Differential, press the right button, and select Auto (the Z6 chooses the differential based on how contrasty it deems your scene to be), 1 EV, 2 EV, or 3 EV. Auto is a good choice for your initial experiments. Or, select a higher EV strength for higher-contrast subjects, and a lower value for lower-contrast subjects. Press OK to confirm. (See Figure 4.14, lower left.)
- 5. **Choose smoothing.** HDR can cause haloing around the boundaries of areas within an image. You can control the effect by choosing a Smoothing value of High, Normal, or Low. (See Figure 4.14, lower right.)
- 6. **Save Individual Images (optional).** Ordinarily, the Z6 captures two images, combines them to produce an HDR shot, and then deletes the individual images. Turn Save Individual Images (NEF) on, and the camera will store a Large RAW version of each shot (even if you have not selected RAW or Large image quality/size). You'll have the intermediate images available for editing/tweaking on your computer.
- 7. **Set Aperture-priority mode.** You want the camera to adjust the exposure by changing the f/stop, rather than using a different aperture, in order to keep your depth-of-field the same for each shot.
- 8. **Take your shot.** Set your camera to Aperture-priority mode. Although you can shoot HDR hand-held, you'll get the best results with the Z6 mounted on a tripod, and with subjects that don't display a lot of motion. Waterfalls are a poor choice. While the Z6 is combining your two shots, the message "Job" and HDR will flash in the monochrome status control panel. Note that because the camera tries to align shots, even if there is slight camera movement, some portion of the images at the edges will be cropped out. You're better off using a tripod for Auto HDR, even though it does a decent job handheld.

Bracketing and Merge to HDR

If your credo is "If you want something done right, do it yourself," you can also shoot HDR manually, without resorting to the Z6's HDR mode. Instead, you can shoot individual images either by manually bracketing or using the Z6's auto bracketing modes, described earlier in this chapter.

While my goal in this book is to show you how to take great photos *in the camera* rather than how to fix your errors in Photoshop, the Merge to HDR Pro feature in Adobe's flagship image editor is too cool to ignore. The ability to have a bracketed set of exposures that are identical except for exposure is key to getting good results with this Photoshop feature, which allows you to produce images with a full, rich dynamic range that includes a level of detail in the highlights and shadows that is almost impossible to achieve with digital cameras.

When you're using Merge to HDR Pro, you take several pictures, some exposed for the shadows, some for the middle tones, and some for the highlights. The exact number of images to combine is up to you. Four to seven is a good number. Then, use the Merge to HDR Pro command to combine all of the images into one HDR image that integrates the well-exposed sections of each version. Here's how.

The images should be as identical as possible, except for exposure. So, it's a good idea to mount the Z6 on a tripod, use a remote release like the MC-DC2, and take all the exposures in one burst. Just follow these steps:

- 1. Set up the camera. Mount the Z6 on a tripod.
- 2. Set the camera to shoot a bracketed burst with an increment of 2 EV or 3 EV. This was described earlier in this chapter.
- 3. **Choose an f/stop.** Set the camera for Aperture-priority and select an aperture that will provide a correct exposure at your initial settings for the series of manually bracketed shots. *And then leave this adjustment alone!* As I noted earlier, you don't want the aperture to change for your series, as that would change the depth-of-field. You want the Z6 to adjust exposure *only* using the shutter speed.
- 4. **Choose manual focus.** You don't want the focus to change between shots, so set the Z6 to manual focus, and carefully focus your shot.
- 5. **Choose RAW exposures.** Set the camera to take RAW files, which will give you the widest range of tones in your images.
- 6. **Take your bracketed set.** Press the button on the remote (or carefully press the shutter release or use the self-timer) and take the set of bracketed exposures.
- 7. **Continue with the Merge to HDR Pro steps listed next.** You can also use a different program, such as Photomatix, if you know how to use it.

DETERMINING THE BEST EXPOSURE DIFFERENTIAL

How do you choose the number of EV/stops to separate your exposures? You can use histograms, described at the end of this chapter, to determine the correct bracketing range. Take a test shot and examine the histogram. Reduce the exposure until dark tones are clipped off at the left of the resulting histogram. Then, increase the exposure until the lighter tones are clipped off at the right of the histogram. The number of stops between the two is the range that should be covered using your bracketed exposures. You can learn more about histograms in the section following this one.

The next steps show you how to combine the separate exposures into one merged HDR image. The sample images in Figure 4.15 (left) show the results you can get from a three-shot bracketed sequence.

- 1. **Copy your images to your computer.** If you use an application to transfer the files to your computer, make sure it does not make any adjustments to brightness, contrast, or exposure. You want the real raw information for Merge to HDR Pro to work with.
- 2. Activate Merge to HDR Pro. Choose File > Automate > Merge to HDR Pro.
- 3. **Select the photos to be merged.** Use the Browse feature to locate and select your photos to be merged. You'll note a check box that can be used to automatically align the images if they were not taken with the camera mounted on a rock-steady support. This will adjust for any slight movement of the camera that might have occurred when you changed exposure settings.
- 4. **Choose parameters (optional).** The first time you use Merge to HDR Pro, you can let the program work with its default parameters. Once you've played with the feature a few times, you can read the Adobe help files and learn more about the options than I can present in this non-software-oriented camera guide.
- 5. Click OK. The merger begins.
- 6. Save. Once HDR merge has done its thing, save the file to your computer.

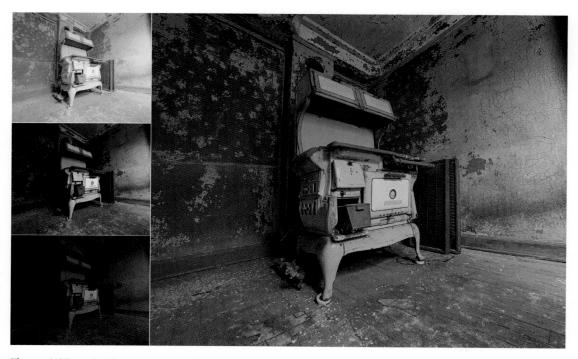

Figure 4.15 Left: Three bracketed photos should look like this. Right: You'll end up with an extended dynamic range photo like this one.

If you do everything correctly, you'll end up with a photo like the one shown in Figure 4.15 (right).

What if you don't have the opportunity, inclination, or skills to create several images at different exposures, as described? If you shoot in RAW format, you can still use Merge to HDR, working with a *single* original image file. What you do is import the image into Photoshop several times, using Adobe Camera Raw to create multiple copies of the file at different exposure levels.

For example, you'd create one copy that's too dark, so the shadows lose detail, but the highlights are preserved. Create another copy with the shadows intact and allow the highlights to wash out. Then, you can use Merge to HDR to combine the two and end up with a finished image that has the extended dynamic range you're looking for. (This concludes the image-editing portion of the chapter. We now return you to our alternate sponsor: photography.)

Fixing Exposures with Histograms

While you can often recover poorly exposed photos in your image editor, your best bet is to arrive at the correct exposure in the camera, minimizing the tweaks that you have to make in post-processing. However, you can't always judge exposure just by simply looking at the preview image on your Z6's display before the shot is made, nor the review image in Playback. Ambient light may make the monitor difficult to see, and the brightness level you've set for the monitor and viewfinder in the Setup menu can affect the appearance of the image.

Instead, you can use a histogram, which is a chart shown on the Z6's display that shows the number of tones that have been captured at each brightness level. Histograms are available in real time on your display as you shoot and in the review image during playback, but they are available only when enabled. To view histograms in live view or playback mode, press the DISP button until a screen with the histogram appears.

- Photo and Movie modes. For still and movie shooting, the histogram can be activated by choosing On for Custom Setting d8: Apply Settings to Live View (see Chapter 12). In addition, if you're capturing multiple exposures, you must choose On for Overlay Shooting in the Multiple Exposure entry in the Photo Shooting menu (as discussed in Chapter 11). The histogram appears at lower right, as seen in Figure 4.16.
- Playback. To see histograms during image review, check the Histogram box in the Playback Display Options entry of the Playback menu (discussed in Chapter 11). The Z6 offers four histogram variations in two screens: one histogram that shows overall brightness levels for an image (see Figure 4.17, left) and an alternate version that also shows brightness (also called *luminance*), but offers additional histograms that separate the red, green, and blue channels of your image into separate graphs (see Figure 4.17, right).

Figure 4.16
In Photo and Movie shooting modes the histogram appears in your live view image when enabled.

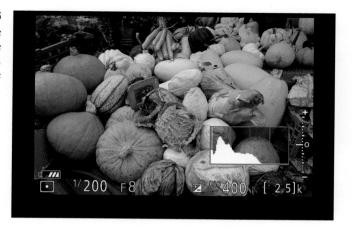

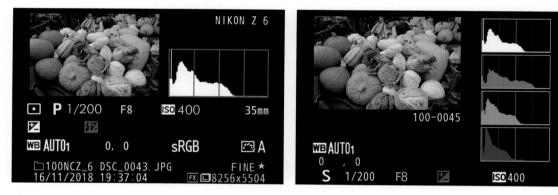

Figure 4.17 Histograms are available on two different screens during playback.

Tonal Range

Histograms help you adjust the tonal range of an image, the span of dark to light tones, from a complete absence of brightness (black) to the brightest possible tone (white), and all the middle tones in between. Because all values for tones fall into a continuous spectrum between black and white, it's easiest to think of a photo's tonality in terms of a black-and-white or grayscale image, even though you're capturing those tones in three separate color layers of red, green, and blue.

Because your images are digital, the tonal "spectrum" isn't really continuous: it's divided into discrete steps that represent the different tones that can be captured. Figure 4.18 may help you understand this concept. The gray steps shown range from 100 percent gray (black) at the left, to 0 percent gray (white) at the right, with 20 gray steps in all (plus white).

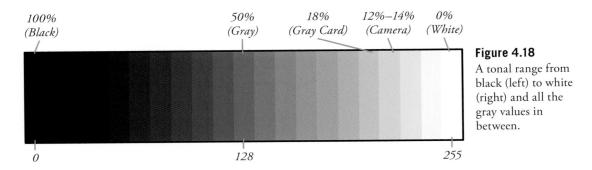

Along the bottom of the chart are the digital values from 0 to 255 recorded by your sensor for an image with 8 bits per channel. (8 bits of red, 8 bits of green, and 8 bits of blue equal a 24-bit, full-color image.) Any black captured would be represented by a value of 0, the brightest white by 255, and the midtones would be clustered around the 128 marker. The actual information captured may be "finer" and record say, 0 to 4,094 for an image captured when the Z6 is set to 14 bits per channel in the NEF (RAW) Recording Bit Depth setting of the Photo Shooting menu (see Chapter 11 for more detail on that option).

Grayscale images (which we call black-and-white photos) are easy to understand. Or, at least, that's what we think. When we look at a black-and-white image, we think we're seeing a continuous range of tones from black to white, and all the grays in between. But, that's not exactly true. The blackest black in any photo isn't a true black, because *some* light is always reflected from the surface of the print, and if viewed on a screen, the deepest black is only as dark as the least-reflective area a computer monitor can produce. The whitest white isn't a true white, either, because even the lightest areas of a print absorb some light (only a mirror reflects close to all the light that strikes it), and, when viewing on a computer monitor, the whites are limited by the brightness of the display's LCD or LED picture elements. Lacking darker blacks and brighter, whiter whites, that continuous set of tones doesn't cover the full grayscale tonal range.

The full scale of tones becomes useful when you have an image that has large expanses of shades that change gradually from one level to the next, such as areas of sky, water, or walls. Think of a picture taken of a group of campers around a campfire. Since the light from the fire is striking them directly in the face, there aren't many shadows on the campers' faces. All the tones that make up the *features* of the people around the fire are compressed into one end of the brightness spectrum—the lighter end.

Yet, there's more to this scene than faces. Behind the campers are trees, rocks, and perhaps a few animals that have emerged from the shadows to see what is going on. These are illuminated by the softer light that bounces off the surrounding surfaces. If your eyes become accustomed to the reduced illumination, you'll find that there is a wealth of detail in these shadow images.

This campfire scene would be a nightmare to reproduce faithfully under any circumstances. If you are an experienced photographer, you are probably already wincing at what is called a *high-contrast* lighting situation. Some photos may be high in contrast when there are fewer tones and they are all bunched up at limited points in the scale. In a low-contrast image, there are more tones, but they are spread out so widely that the image looks flat. Your digital camera can show you the relationship between these tones using a *histogram*.

Histogram Basics

Your Z6's histograms are a simplified display of the numbers of pixels at each of 256 brightness levels, producing an interesting "mountain range" shape in the graph. Although separate charts may be provided for brightness and the red, green, and blue channels, when you first start using histograms, you'll want to concentrate on the brightness histogram.

Each vertical line in the graph represents the number of pixels in the image for each brightness value, from 0 (black) on the left to 255 (white) on the right. The vertical axis measures that number of pixels at each level.

Although histograms are most often used to fine-tune exposure, you can glean other information from them, such as the relative contrast of the image. Figure 4.19, top, is a simplified rendition of the upper half of the Overview screen, with an image having normal contrast. In such an image, most of the pixels are spread across the image, with a healthy distribution of tones throughout the midtone section of the graph. That large peak at the right side of the graph represents all those light

Figure 4.19 Top: This image has fairly normal contrast, even though there is a peak of light tones at the right side representing the sky. Center: This low-contrast image has all the tones squished into one section of the grayscale. Bottom: A high-contrast image produces a histogram in which the tones are spread out.

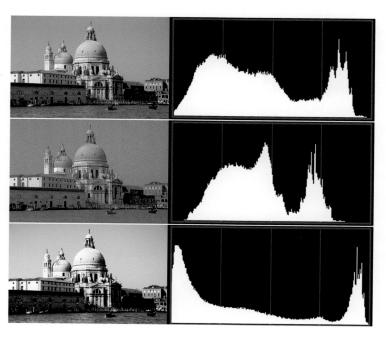

tones in the sky. A normal-contrast image you shoot may have less sky area, and less of a peak at the right side, but notice that very few pixels hug the right edge of the histogram, indicating that the lightest tones are not being clipped because they are off the chart.

With a lower-contrast image, like the one shown in Figure 4.19, center, the basic shape of the previous histogram will remain recognizable, but gradually will be compressed together to cover a smaller area of the gray spectrum. The squished shape of the histogram is caused by all the grays in the original image being represented by a limited number of gray tones in a smaller range of the scale.

Instead of the darkest tones of the image reaching into the black end of the spectrum and the whitest tones extending to the lightest end, the blackest areas of the scene are now represented by a light gray, and the whites by a somewhat lighter gray. The overall contrast of the image is reduced. Because all the darker tones are actually a middle gray or lighter, the scene in this version of the photo appears lighter as well.

Going in the other direction, increasing the contrast of an image produces a histogram like the one shown in Figure 4.19, bottom. In this case, the tonal range is now spread over the entire width of the chart, but, except for the bright sky, there is not much variation in the middle tones; the mountain "peaks" are not very high. When you stretch the grayscale in both directions like this, the darkest tones become darker (that may not be possible) and the lightest tones become lighter (ditto). In fact, shades that might have been gray before can change to black or white as they are moved toward either end of the scale.

The effect of increasing contrast may be to move some tones off either end of the scale altogether, while spreading the remaining grays over a smaller number of locations on the spectrum. That's exactly the case in the example shown. The number of possible tones is smaller and the image appears harsher.

Understanding Histograms

The important thing to remember when working with the histogram display in your Z6 is that changing the exposure does *not* change the contrast of an image. The curves illustrated in the previous three examples remain exactly the same shape when you increase or decrease exposure. I repeat: The proportional distribution of grays shown in the histogram doesn't change when exposure changes; it is neither stretched nor compressed. However, the tones as a whole are moved toward one end of the scale or the other, depending on whether you're increasing or decreasing exposure. You'll be able to see that in some illustrations that follow.

So, as you reduce exposure, tones gradually move to the black end (and off the scale), while the reverse is true when you increase exposure. The contrast within the image is changed only to the extent that some of the tones can no longer be represented when they are moved off the scale.

To change the contrast of an image, you must do one of four things:

- Change the Z6's contrast setting using the menu system. You'll find these adjustments in your camera's Picture Controls menus, as explained in Chapter 11.
- Use your camera's shadow-tone "booster." As previously discussed, Active D-Lighting (or plain old D-Lighting applied after the fact from the Retouch menu) can also adjust contrast.
- Alter the contrast of the scene itself, for example, by using a fill light or reflectors to add illumination to shadows that are too dark.
- Attempt to adjust contrast in post-processing using your image editor or RAW file converter. You may use features such as Levels or Curves (in Photoshop, Photoshop Elements, and many other image editors), or work with HDR software to cherry-pick the best values in shadows and highlights from multiple images.

Of the four of these, the third—changing the contrast of the scene—is the most desirable, because attempting to fix contrast by fiddling with the tonal values is unlikely to be a perfect remedy. However, adding a little contrast can be successful because you can discard some tones to make the image more contrasty. However, the opposite is much more difficult. An overly contrasty image rarely can be fixed, because you can't add information that isn't there in the first place.

What you can do is adjust the exposure so that the tones that are already present in the scene are captured correctly. Figure 4.20, top, shows the histogram for an image that is badly underexposed. You can guess from the shape of the histogram that many of the dark tones to the left of the graph have been clipped off. There's plenty of room on the right side for additional pixels to reside without

Figure 4.20
Top: A histogram of an underexposed image may look like this. Center: Adding exposure will produce a histogram like this one.

Bottom: A histogram of an overexposed image will show clipping at the right side.

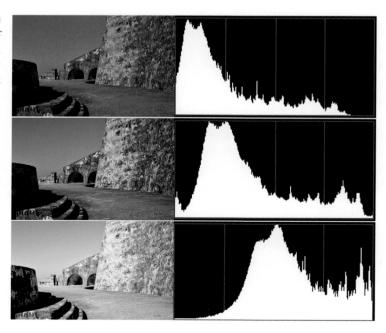

having them become overexposed. So, you can increase the exposure (either by changing the f/stop or shutter speed, or by adding an EV value) to produce the corrected histogram shown in Figure 4.20, center.

Conversely, if your histogram looks like the one shown in Figure 4.20, bottom, with bright tones pushed off the right edge of the chart, you have an overexposed image, and you can correct it by reducing exposure. In addition to the histogram, the Z6 has its Highlights option, which, when activated, shows areas that are overexposed with flashing tones (often called "blinkies") in the review screen. Depending on the importance of this "clipped" detail, you can adjust exposure or leave it alone. For example, if all the dark-coded areas in the review are in a background that you care little about, you can forget about them and not change the exposure, but if such areas appear in facial details of your subject, you may want to make some adjustments.

In working with histograms, your goal should be to have all the tones in an image spread out between the edges, with none clipped off at the left and right sides. Underexposing (to preserve highlights) should be done only as a last resort, because retrieving the underexposed shadows in your image editor will frequently increase the noise, even if you're working with RAW files. A better course of action is to expose for the highlights, but, when the subject matter makes it practical, fill in the shadows with additional light, using reflectors, fill flash, or other techniques rather than allowing them to be seriously underexposed.

A traditional technique for optimizing exposure is called "expose to the right" (ETTR), which involves adding exposure to push the histogram's curve toward the right side *but not far enough to clip off highlights*. The rationale for this method is that extra shadow detail will be produced with a minimum increase in noise, especially in the shadow areas. It's said that half of a digital sensor's response lies in the brightest areas of an image, and so require the least amount of amplification (which is one way to increase digital noise). ETTR can work, as long as you're able to capture a satisfactory amount of information in the shadows.

Exposing to the Right

It's easier to understand exposing to the right if you mentally divide the histogram into fifths (unfortunately, the Z6's histogram uses quarters instead). And, for the sake of simplicity and smaller numbers, assume you're shooting in 14-bit RAW. Any 14-bit image can record a maximum of 16,383 different tones per channel. However, each fifth of the histogram does *not* encompass 3,277 tones (one-fifth of 16,383).

Instead, the right-most fifth, the highlights, shown in Figure 4.21, accounts for 8,192 different captured tones. Moving toward the left, the next fifth represents 4,096 levels, followed by 2,048 levels, 1,024 levels, and, in the left-most section where the deepest shadows reside, only 512 different tones are captured. When processing your RAW file, there are only 512 tones to recover in the shadows, which is why boosting/amplifying them increases noise. (The effect is most noticeable in the red and blue channels; your sensor's Bayer array has twice as many green-sensitive pixels as red or blue.)

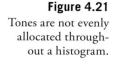

Black

256 Shades of Gray (JPEG) 16383 Shades of Gray (14-bit RAW)

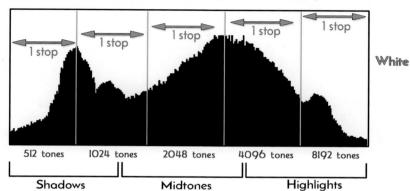

Instead, you want to add exposure—as long as you don't push highlights off the right edge of the histogram—to brighten the shadows. Because there are 8,192 tones available in the highlights, even if the RAW image *looks* overexposed, it's possible to use your RAW converter's Exposure slider (such as the one found in Adobe Camera Raw) to bring back detail captured in that surplus of tones in the highlights. This procedure is the exact opposite of what was recommended for film of the transparency variety—it was fairly easy to retrieve detail from shadows by pumping more light through them when processing the image, while even small amounts of extra exposure blew out highlights. You'll often find that the range of tones in your image is so great that there is no way to keep your histogram from spilling over into the left and right edges, costing you both highlight and shadow detail. Exposing to the right may not work in such situations. A second school of thought recommends *reducing* exposure to bring back the highlights, or "exposing to the left." You would then attempt to recover shadow detail in an image editor, using tools like Adobe Camera Raw's Exposure slider. But remember, above all, that this procedure will also boost noise in the shadows, and so the technique should be used with caution. In most cases, exposing to the right is your best bet.

Dealing with Channels

The more you work with histograms, the more useful they become. One of the first things that histogram veterans notice is that it's possible to overexpose one channel even if the overall exposure appears to be correct. For example, flower photographers soon discover that it's really, really difficult to get a good picture of a red rose, like the one shown at left in Figure 4.22. The exposure looks okay—but there's no detail in the rose's petals. Looking at the histogram (see Figure 4.22, right) shows why: the red channel is blown out. If you look at the red histogram, there's a peak at the right edge that indicates that highlight information has been lost. In fact, the green channel has been blown, too, and so the green parts of the flower also lack detail. Only the blue channel's histogram is entirely contained within the boundaries of the chart, and, on first glance, the white luminance histogram at top of the column of graphs seems fairly normal.

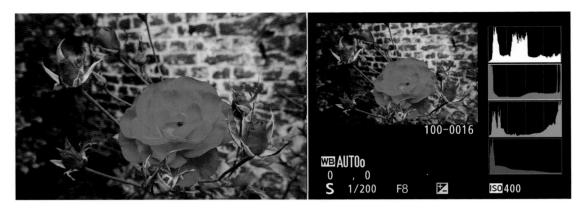

Figure 4.22 It's common to lose detail in bright red flowers because the red channel becomes overexposed even when the other channels are properly exposed (left). The RGB histograms show that both the red and green channels are overexposed, with tones extending past the right edge of the chart (right).

Any of the primary channels—red, green, or blue—can blow out all by themselves, although bright reds seem to be the most common problem area. More difficult to diagnose are overexposed tones in one of the "in-between" hues on the color wheel. Overexposed yellows (which are very common) will be shown by blowouts in *both* the red and green channels. Too-bright cyans will manifest as excessive blue and green highlights, while overexposure in the red and blue channels reduces detail in magenta colors. As you gain experience, you'll be able to see exactly how anomalies in the RGB channels translate into poor highlights and murky shadows.

The only way to correct for color channel blowouts is to reduce exposure. As I mentioned earlier, you might want to consider filling in the shadows with additional light to keep them from becoming too dark when you decrease exposure. In practice, you'll want to monitor the red channel most closely, followed by the blue channel, and slightly decrease exposure to see if that helps. Because of the way our eyes perceive color, we are more sensitive to variations in green, so green channel blowouts are less of a problem, unless your main subject is heavily colored in that hue. If you plan on photographing a frog hopping around on your front lawn, you'll want to be extra careful to preserve detail in the green channel, using bracketing or other exposure techniques outlined in this chapter.

Fine-Tuning Exposure

When all else fails—that is, when you find your camera *consistently* over- or underexposes when using a particular exposure mode—you can recalibrate the Z6 to produce images more to your liking. This setting is a powerful adjustment that allows you to dial in a specific amount of exposure adjustment that will be applied, invisibly, to every photo you take using each of the three metering modes. No more can you complain, "My Z6 always underexposes by 1/3 stop!" If that is actually

the case, and the phenomenon is consistent, you can use this custom menu adjustment to compensate.

Exposure compensation is usually a better idea (does your camera *really* underexpose that consistently?), but this setting does allow you to adjust your Z6's behavior yourself. Your dialed-in modifications will survive a two-button reset. However, you have no indication that fine-tuning has been made, so you'll need to remember what you've done. After all, you someday might discover that your camera is consistently *over*exposing images by 1/3 stop, not remembering that you've made the adjustment.

In practice, it's rare that the Nikon Z6 will *consistently* provide the wrong exposure in any of the three metering modes, especially Matrix metering, which can alter exposure dramatically based on the Z6's internal database of typical scenes. This feature may be most useful for Spot metering, if you always take a reading off the same type of subject, such as a human face or gray card. Should you find that the gray card readings, for example, always differ from what you would prefer, go ahead and fine-tune optimal exposure for Spot metering, and use that to read your gray cards.

I explain how to use the Z6's menus at the beginning of Chapter 11, and won't repeat those instructions here. You can jump ahead to that explanation, or, if you're comfortable working with the camera's menu system, you can fine-tune your exposure now:

- Select fine-tuning. Choose Custom Setting b4: Fine-Tune Optimal Exposure from the Custom Settings menu.
- 2. **Consider yourself warned.** In the screen that appears, choose Yes after carefully reading the warning that Nikon insists on showing you each and every time this option is activated. The screen shown in Figure 4.23, left, appears.
- 3. **Select metering mode to correct.** Choose Matrix metering, Center-weighted metering, Spot metering, or Highlight-weighted metering by highlighting your choice and pressing the multi selector right button.

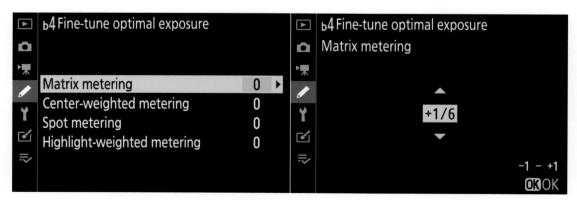

Figure 4.23 Fine-tune optimal exposure.

- 4. **Specify amount of correction.** Press the up/down buttons to dial in the exposure compensation you want to apply. (See Figure 4.23, right.) You can specify compensation in increments of 1/6 stop, half as large a change as conventional exposure compensation. This is truly *fine-tuning*.
- 5. **Confirm your change.** Press OK when finished. You can repeat the action to fine-tune the other two exposure modes if you wish. To return your settings to your defaults, simply repeat the process and dial in 0 correction for the desired mode.

Mastering the Mysteries of Focus

How far we've come! My first professional job was as a reporter/sportswriter/photographer for a daily newspaper (back when a backslash really *meant* something), and focusing to achieve a sharp image was a manual process accomplished by turning a ring or knob on the camera or lens until, in one's highly trained professional judgment, the image was satisfactorily in focus. Manual focus was particularly challenging when shooting sports.

Today, modern digital cameras like the Z6 can identify potential subject matter, lock in on human faces, if present, and automatically focus faster than the blink of an eye. Usually. Of course, sometimes a camera's AF will zero in on the *wrong* subject, become confused by background pattern, or be totally unable to follow a fast-moving target like a bird in flight. While autofocus *has* come a long way in the last 30-plus years, it's still a work-in-progress that relies heavily on input from the photographer. Your Nikon Z6 can calculate and set focus for you quickly and with a high degree of accuracy, but you still need to make a few settings that provide guidance on three W's of autofocus: *what*, *where*, *and when*. Your decisions in how you apply those choices supplies the fourth W: *why*. This chapter will provide you with everything you need to put all four to work.

Auto or Manual Focus?

Advances in autofocus technology have given photographers the confidence to rely on AF most of the time. For the average subject, a camera like the Z6 will do an excellent job of evaluating your scene and quickly focusing on an appropriate subject. Interestingly enough, however, the switch to mirrorless technology has actually revived interest in old-school manual focus.

There are five reasons why manual focus is being used more by creative photographers.

- WYSIWYG. What you see (in the viewfinder or LCD monitor) is what you get, in terms of sharp focus. When focusing manually with the Z6, you're evaluating the exact same sensor image that will be captured when you press the shutter release. Traditional single-lens reflex (SLR) cameras use a mirror to direct the image to a separate focusing screen (when not in live view mode), which can be coarser, not as bright, and possibly out of alignment.
- WYSIWYW. Focusing manually can mean that what you see is what you want, that is, you can select the precise plane of focus you desire for, say, a macro photo or portrait, rather than settle for what the camera thinks you want. Your camera doesn't have any way of determining, for certain, what subject you want to be in sharp focus. It can't read your mind (at least, not yet). Left to its own devices, the Z6 may select a likely object—often the one nearest the camera—and lock in focus with lightning speed, even though the subject is not the one that's the center of interest of your photograph.
- Less confusion. Nikon has given us faster and more precise autofocus systems, with many more options, and it's common for the sheer number of these choices to confuse even the most advanced photographers. If you'd rather not wade through the AF alternatives for a given shot, switch to manual focus and shoot. You won't have to worry about whether the camera locks focus too soon, or too late.
- Focus aids. You can zoom in on the sensor image as you focus manually, use split-image comparison of two parts of the image simultaneously, and a feature called *focus peaking* to accentuate in-focus areas with distinct colored outlines. I'll explain all these options later.
- More lenses. All mirrorless cameras—and not just the Nikon Z-series—have had a limited number of lenses available when they were introduced. But fortunately, the reduced flange-to-sensor distance (which I'll explain in more detail in Chapter 7) offers plenty of room to insert an adapter that allows mounting an extensive number of existing lenses, including those from manufacturers other than Nikon. Many of those third-party optics are inexpensive manual focus lenses, or lenses intended for other camera platforms which function only in manual focus on the Z-series models. A whole generation of photographers who grew up using nothing but autofocus have discovered that focusing manually is a reasonable tradeoff for access to this wide range of optics.

How Focus Works

Simply put, focus is the process of adjusting the camera so that parts of our subject that we want to be sharp and clear are, in fact, sharp and clear. We allow the camera to focus for us, automatically, or we can rotate the lens's focus ring manually to achieve the desired focus. Manual focusing is especially problematic because our eyes and brains have poor memory for correct focus. That's why your eye doctor conducting a refraction test must shift back and forth between pairs of lenses and ask, "Does that look sharper—or was it sharper before?" in determining your correct prescription. Too often, the slight differences are such that the lens pairs must be swapped multiple times.

Similarly, manual focusing involves jogging the focus ring back and forth as you go from almost in focus, to sharp focus, to almost focused again. The little clockwise and counterclockwise arcs decrease in size until you've zeroed in on the point of correct focus. What you're looking for is the image with the most contrast between the edges of elements in the image.

The Nikon Z6's autofocus mechanism, like all such systems found in modern cameras, also evaluates these increases and decreases in sharpness, but it is able to remember the progression perfectly, so that autofocus can lock in much more quickly and, with an image that has sufficient contrast, more precisely. Unfortunately, while the camera's focus system finds it easy to measure degrees of apparent focus at each of the focus points in the viewfinder, it doesn't really know with any certainty which object should be in sharpest focus. Is it the closest object? The subject in the center? Something lurking behind the closest subject? A person standing over at the side of the picture? Using autofocus effectively involves telling the Z6 exactly what it should be focusing on.

Learning to use the Z6's modern autofocus system is easy, but you do need to fully understand how the system works to get the most benefit from it. Once you're comfortable with autofocus, you'll know when it's appropriate to use the manual focus option, too.

As the camera collects focus information from the sensors, it then evaluates it to determine whether the desired sharp focus has been achieved. The calculations may include whether the subject is moving, and whether the camera needs to "predict" where the subject will be when the shutter release button is fully depressed and the picture is taken. The speed with which the camera is able to evaluate focus and then move the lens elements into the proper position to achieve the sharpest focus determines how fast the autofocus mechanism is. Although your Z6 will almost always focus more quickly than a human eye, there are types of shooting situations where that's not fast enough. For example, if you're having problems shooting a sport with many fast-moving players because the Z6's autofocus system manically follows each moving subject, a better choice might be to switch Autofocus modes, or shift into Manual and prefocus on a spot where you anticipate the action will be, such as a goal line or soccer net.

The Z6 has a hybrid autofocus system, using two technologies called contrast detection autofocus (CDAF) and phase detection autofocus (PDAF). I'm going to provide a quick overview of contrast detection first, and then devote much of the rest of this chapter to the complexities of phase detection.

Contrast Detection

This is a slower, but potentially more accurate mode, best suited for static subjects, and was originally the only kind of autofocus available for mirrorless cameras and for dSLRs when shooting in their live view and movie modes. The recent innovation of adding phase detection abilities to the sensor itself (as I'll describe shortly) made contrast detection a fine-tuning option for hybrid autofocus systems that combined CDAF and PDAF.

Contrast detection is very easy to understand, and is illustrated by Figure 5.1, a close-up of some weathered wood. At top in the figure, the transitions between the edges found in the image are soft and blurred because of the low contrast between them. Whether the edges are horizontal, vertical, or diagonal doesn't matter in the least; the focus system looks only for contrast between edges, and those edges can run in any direction at all.

At the bottom of Figure 5.1, the image has been brought into sharp focus, and the edges have much more contrast; the transitions are sharp and clear. Although this example is a bit exaggerated so you can see the results on the printed page, it's easy to under-

Figure 5.1 Focus in contrast detection mode evaluates the increase in contrast in the edges of subjects, starting with a blurry image (top) and producing a sharp, contrasty image (bottom).

stand that when maximum contrast in a subject is achieved, it can be deemed to be in sharp focus. Although achieving focus with contrast detection is generally quite a bit slower, there are several advantages—and disadvantages—to this method:

- Works with more image types. Any subject that has edges will work with CDAF.
- Focus on any point. With contrast detection, any portion of the image can be used to focus: you don't need dedicated AF sensors. Focus is achieved with the actual sensor image, so focus point selection is simply a matter of choosing which part of the sensor image to use. It's easy to move the focus frame around to virtually any location.
- Potentially more accurate. Contrast detection is clear-cut. The camera can clearly see when the highest contrast has been achieved, as long as there is sufficient light to allow the camera to examine the image produced by the sensor. However, some "hunting" may be necessary. As the camera seeks the ideal plane of focus, it may overshoot and have to back up a little, then re-correct if the new focus plane is not optimal. However, once CDAF settles on the ideal focus plane, the results are generally very accurate. Contrast detection is an excellent way of fine-tuning focus that has been achieved through PDAF.

Phase Detection

Phase detection is easily much more rapid than contrast detection. The challenge is to make its operation as accurate as possible. Digital SLRs, like the Nikon D850, have always used PDAF. Such dSLR systems include an array of tiny autofocus sensors, located in the "floor" of the mirror box, with a small portion of the illumination directed downward to the autofocus sensor array.

In the Z6, that separate AF sensor is replaced by 273 phase detect autofocus points embedded in the camera's imaging sensor. These points are located in the center of the boxes shown in Figure 5.2. The boxes represent the positions you can individually select as your AF area in Single-point AF area mode—not the size of the PDAF pixels themselves, which are much smaller.

Figure 5.2
The boxes represent the 273 selectable AF areas when using Single-point autofocus.

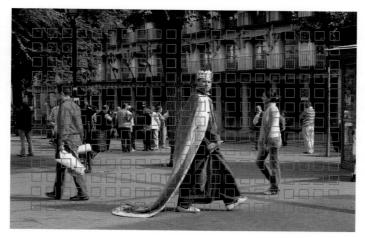

The phase detection pixels in the Z6's sensor split incoming photons arriving from opposite sides of the lens into two parts, forming a pair of images, exactly like the rangefinders used for surveying and in rangefinder-focusing cameras like the venerable Leica M series. The dual images are separated when out of focus, and then gradually brought together to achieve sharp focus, as shown from top to bottom in Figure 5.3.

This process tells the camera when the image pair are "in phase" and aligned. The rangefinder approach of phase detection tells the Z6 exactly how out of focus the image is, and in which direction (focus is too near, or too far) thanks to the amount and direction of the displacement of the split image. The camera can quickly and precisely snap the image into sharp focus and match the lines.

Figure 5.3
In phase detection, parts of an image are split in two and compared (top).
When the image is in focus, the two halves of the image align, as with a rangefinder (bottom).

The PDAF sensors in the Z6 are all *line sensors*, which means they work best with features that transect the sensor either perpendicularly or at an angle, as visualized in Figure 5.4, top. It's easy to detect when the two halves of the vertical lines of the weathered wood—actually a 19th century outhouse—are aligned. However, when the same sensor is asked to measure focus for, say, horizontal lines that don't split up quite so conveniently, or, in the worst case, subjects such as the sky (which may have neither vertical nor horizontal lines), focus can slow down drastically, or even become impossible. One such scenario is pictured in Figure 5.4, bottom left. A possible solution is to incorporate vertically oriented AF sensors, which can easily focus horizontal subject matter (Figure 5.4, bottom right). The line sensors arranged perpendicularly to each other are called "crosstype" sensors.

However, the Z6 has no cross sensors, as such PDAF pixels are difficult to embed in today's image sensors. Nikon uses a different approach. Once the focus plane has been achieved using the line sensors of the phase detect system, the Z6 is able to use contrast detection to fine-tune focus, if necessary. The combination provides the speed of PDAF with the accuracy of CDAF.

As with any rangefinder-like function, phase detection accuracy is better when the "base length" between the two images is larger. (Think back to your high school trigonometry; you could calculate a distance more accurately when the separation between the two points where the angles were

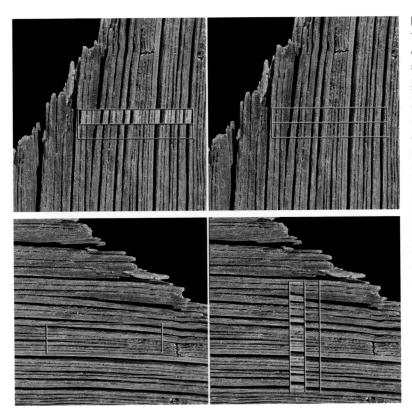

Figure 5.4 When an image is out of focus, the split lines don't align precisely (top left). Using phase detection, the Z6 is able to align the features of the image and achieve sharp focus quickly (top right). Horizontal lines aren't ideal for horizontally oriented sensors (bottom left) and require vertically oriented AF sensors (bottom right).

measured was greater.) For that reason, phase detection autofocus is more accurate with larger (wider) lens openings—especially those with maximum f/stops of f/2.8 or better—than with smaller lens openings, and may not work at all when the f/stop is smaller than f/8. As I noted, the Z6 is able to perform these comparisons very quickly.

Adding Circles of Confusion

But there are other factors in play, as well. You know that increased depth-of-field brings more of your subject into focus. But more depth-of-field also makes autofocusing (or manual focusing) more difficult because the contrast is lower between objects at different distances. So, autofocus with a 200mm lens (or zoom setting) may be easier than at a 28mm focal length (or zoom setting) because the longer lens has less apparent depth-of-field. By the same token, a lens with a maximum aperture of f/1.8, such as the Z-mount 50mm f/1.8 and 35mm f/1.8 optics, will be easier to autofocus (or manually focus) than one of the same focal length with an f/4 maximum aperture, such as the 24–70mm kit zoom, because the f/4 lens has more depth-of-field *and* a dimmer view at a particular focal length.

To make things even more complicated, many subjects aren't polite enough to remain still. They move around in the frame, so that even if the Z6 is sharply focused on your main subject, it may change position and require refocusing. An intervening subject may pop into the frame and pass between you and the subject you meant to photograph. You (or the Z6) have to decide whether to lock focus on this new subject, or remain focused on the original subject. Finally, there are some kinds of subjects that are difficult to bring into sharp focus because they lack enough contrast to allow the Z6's AF system (or our eyes) to lock in. Blank walls, a clear blue sky, birds-in-flight, or other subject matter may make focusing difficult.

If you find all these focus factors confusing, you're on the right track. Focus is, in fact, measured using something called a *circle of confusion*. An ideal image consists of zillions of tiny little points, which, like all points, theoretically have no height or width. There is perfect contrast between the point and its surroundings. You can think of each point as a pinpoint of light in a darkened room. When a given point is out of focus, its edges decrease in contrast and it changes from a perfect point to a tiny disc with blurry edges (remember, blur is the lack of contrast between boundaries in an image). (See Figure 5.5.)

Figure 5.5
When a pinpoint of light (left) goes out of focus, its blurry edges form a circle of confusion (center and right).

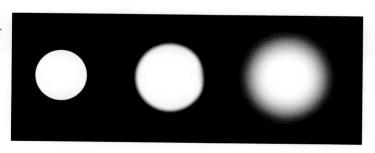

If this blurry disc—the circle of confusion—is small enough, our eye still perceives it as a point. It's only when the disc grows large enough that we can see it as a blur rather than a sharp point that a given point is viewed as out of focus. You can see, then, that enlarging an image, either by displaying it larger on your computer monitor or by making a large print, also enlarges the size of each circle of confusion. Moving closer to the image does the same thing. So, parts of an image that may look perfectly sharp in a 5 x 7—inch print viewed at arm's length, might appear blurry when blown up to 11 x 14 and examined at the same distance. Take a few steps back, however, and it may look sharp again.

To a lesser extent, the viewer also affects the apparent size of these circles of confusion. Some people see details better at a given distance and may perceive smaller circles of confusion than someone standing next to them. For the most part, however, such differences are small. Truly blurry images will look blurry to just about everyone under the same conditions.

Technically, there is just one plane within your picture area, parallel to the back of the camera (or sensor, in the case of a digital camera), that is in sharp focus. That's the plane in which the points of the image are rendered as precise points. At every other plane in front of or behind the focus plane, the points show up as discs that range from slightly blurry to extremely blurry. In practice, the discs in many of these planes will still be so small that we see them as points, and that's where we get depth-of-field. Depth-of-field is just the range of planes that include discs that we perceive as points rather than blurred splotches. The size of this range increases as the aperture is reduced in size and is allocated roughly one-third in front of the plane of sharpest focus, and two-thirds behind it. The range of sharp focus is always greater behind your subject than in front of it. (See Figure 5.6.)

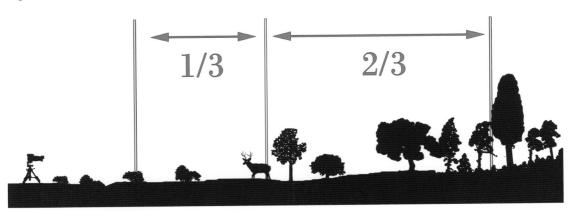

Figure 5.6 The range of sharp focus is greater behind your subject than in front of it.

Using Autofocus with the Nikon Z6

Autofocus can sometimes be frustrating for the new digital photographer, especially those coming from the point-and-shoot world. That's because correct focus plays a greater role among your creative options with a digital camera, even when photographing the same subjects. Most point-and-shoot digital cameras and smartphones have sensors that are much tinier than the sensor in the Z6. Those smaller sensors require shorter focal length lenses and zoom settings, which have, effectively, more depth-of-field.

The bottom line is that with the average point-and-shoot camera or smartphone, *everything* is in focus from about one foot to infinity and at virtually every f/stop. Unless you're shooting close-up photos a few inches from the camera, the depth-of-field is prodigious, and autofocus is almost a non-factor. The Z6, on the other hand, is a full-frame camera that uses longer focal length lenses to achieve the same field of view with its larger sensor, so there is less depth-of-field. That's a *good* thing, creatively, because you have the choice to use selective focus to isolate subjects. But it does make the correct use of autofocus more critical. To maintain the most creative control, you have to choose three attributes:

- How much is in focus. Generally, by choosing the f/stop used, you'll determine the *range* of sharpness/amount of depth-of-field. The more extensive the DOF, the "easier" it is for the autofocus system's locked-in focus point to be appropriate (even though, strictly speaking, there is only one actual plane of sharp focus). With less depth-of-field, the accuracy of the focus point becomes more critical, because even a small error will result in an out-of-focus shot.
- What subject is in focus. The portion of your subject that is zeroed in for autofocus is determined by the autofocus zone that is active, and which is chosen either by you or by the Nikon Z6 (as described next). For example, when shooting portraits, it's actually okay for part of the subject—or even part of the subject's face—to be slightly out of focus as long as the eyes (or even just the *nearest* eye) appear sharp.
- When focus is applied. For static shots of objects that aren't moving, when focus is applied doesn't matter much. But when you're shooting sports, or birds in flight, or children, the subject may move within the viewfinder as you're framing the image. Whether that movement is across the frame or headed right toward you, timing the instant when autofocus is applied can be important.

Autofocus vs. Manual Focus Revisited

I described the surprising revival of interest in manual focus at the beginning of this chapter. However, manual focus does require judgment and fast reflexes (if your subject is moving). On the one hand, autofocus does save time and allows us to capture subjects (particularly fast-moving sports) that are difficult to image sharply using manual focusing (unless you have training and know certain techniques). On the other hand, learning to apply the Nikon Z6's autofocus system most effectively also requires a bit of study and some practice. Then, once you're comfortable with

autofocus, you'll know when it's appropriate to use the manual focus option, too. Your Z6 includes some useful features that help you focus manually—including magnification and *focus peaking*, a way of highlighting out-of-focus areas that may need correction just as "blinkies" show you what parts of the image are overexposed. I'll show you how to use these manual focus aids later in this chapter.

The important thing to remember is that focus isn't absolute. For example, some things that look in sharp focus at a given viewing size and distance might not be in focus at a larger size and/or closer distance. In addition, the goal of optimum focus isn't always to make things look sharp. Not all of an image will be or should be sharp. Controlling exactly what is sharp and what is not is part of your creative palette. Use of depth-of-field characteristics to throw part of an image out of focus while other parts are sharply focused is one of the most valuable tools available to a photographer. But selective focus works only when the desired areas of an image are in focus properly. For the digital photographer, correct focus can be one of the trickiest parts of the technical and creative process.

Bringing the Z6's AF System into Focus

I've explained individual bits and pieces of the Nikon Z6's autofocus system earlier in this book, particularly in the "roadmap" sections that showed you where all the controls were located, and the "setup" chapters that explained the key autofocus options. Now it's time to round out the coverage as we tie everything together. There are three aspects of autofocus that you need to understand to use this essential feature productively. They apply—in slightly different ways—to both autofocus when using the optical viewfinder, and in Photo/Movie shooting modes. For now, we're going to concentrate on the system's most important features:

- Autofocus mode and priority. This governs when during the framing and shooting process autofocus is achieved. Should the camera focus once when activated, or continue to monitor your subject and refocus should the subject move? Is it okay to take a picture even if sharp focus isn't yet achieved, or should the camera lock out the shutter release until the image is sharp?
- Autofocus point selection. This aspect controls how the Z6 selects which areas of the frame are used to evaluate focus. Point selection allows the camera (or you) to specify a subject and lock focus in on that subject.
- **Autofocus activation.** When should the autofocus process *begin*, and when should it be locked? This aspect is related to the autofocus mode, but uses controls that you can specify to activate and/or lock the autofocus process.

As the camera collects information from the sensors, it then evaluates the data to determine whether the desired sharp focus has been achieved. The calculations may include whether the subject is moving, and whether the camera needs to "predict" where the subject will be when the shutter release button is fully depressed and the picture is taken.

The speed with which the camera is able to evaluate focus and then move the lens elements into the proper position to achieve the sharpest focus determines how fast the autofocus mechanism is. Although your Z6 will almost always focus more quickly than a human, there are types of shooting situations where that's not fast enough. At night football games, for example, when I am shooting with a telephoto lens almost wide open, I often focus manually on one of the referees who happens to be standing where I expect the action to be taking place (say, a halfback run or a pass reception).

Focus Mode and Priority

Choosing the right focus mode (AF-S, AF-C, or Manual) is another key to focusing success. (Your Z6 also has an additional focus mode, AF-F—full-time autofocus in Movie mode, as explained in Chapter 14.) To save battery power, when shooting stills, your Z6 doesn't start to focus the lens until you partially depress the shutter release or press the AF-ON button on the back of the camera (unless you've reprogrammed the button for some other function or have specified another control to activate autofocus, as described in Chapter 12). But, autofocus isn't some mindless beast out there snapping your pictures in and out of focus with no feedback from you after you press that button. There are several settings you can modify that return at least a modicum of control to you. Your first decision should be whether you set the Z6 to AF-S, AF-C, or manual focus.

You can easily specify either of the two automatic modes: just press Fn2 and rotate the main command dial (unless you've redefined the button for some other behavior). Or press the i button and access Focus Mode, located by default at the far right in the bottom row of the i menu. If you have a lot of time on your hands, use the Focus Mode entry in the Photo or Movie Shooting menus. The AF mode appears at the top of the viewfinder or on the monitor screen as you make the adjustments.

Autofocus Mode

This choice determines when your Z6 starts to autofocus, and what it does when focus is achieved. In still photo mode, automatic focus is not something that happens all the time when your camera is turned on. As I mentioned, to save battery power, your Z6 generally doesn't start to focus the lens until you partially depress the shutter release. (You can also use the sub-selector center button or a defined AE/AL Lock button to start autofocus, as described under Custom Setting f2 in Chapter 12.)

Single-Servo Autofocus (AF-S)

In this mode, also called *Single Autofocus* or *AF-S*, focus is set once and remains at that setting until the button is fully depressed, taking the picture, or until you release the shutter button without taking a shot. For non-action photography, this setting is usually your best choice, as it minimizes out-of-focus pictures (at the expense of spontaneity). The drawback here is that you might not be able to take a picture at all while the camera is seeking focus; you're locked out until the autofocus mechanism is happy with the current setting. As described in Chapter 12, you can set AF-S mode to use either focus-priority (the default) or release-priority using Custom Setting a2.

When sharp focus is achieved, the selected focus point will turn green. By keeping the shutter button depressed halfway, you'll find you can reframe the image while retaining the focus (and exposure) that's been set. You can also use your AE-L/AF-L button (such as the sub-selector button). If the camera is unable to focus, the focus point will flash red. Because of the small delay while the camera zeroes in on correct focus, you might experience slightly more shutter lag. This mode uses less battery power.

You can select any of the 273 focus areas in this AF mode when your Autofocus Area setting (described shortly) is set to Single-point AF. AF-S is the mode to use if you want to place the focus point within your frame with even more accuracy. And, AF-S is the autofocus mode in which you can specify Pinpoint-area AF as your focus area, and place a tiny focus point virtually anywhere in the frame encompassed by the boxes in Figure 5.2.

LOW-LIGHT AF

All digital cameras find autofocusing in low-light environments a challenge. The Z6's abundant PDAF pixels slightly reduce the area of the sensor available to capture photons, and some report the bands or stripes that can appear in darker areas of an image. You may be able to improve autofocus performance for subjects that are within the range of about three feet to nearly 10 feet (1 to 3 meters) with the built-in AF-assist illuminator lamp on the front of the camera, which is activated by default but may be disabled using Custom Setting a12. You can also activate Custom Setting a11: Low-Light AF, which works in any still photo shooting mode other than Auto. Autofocus may take longer in Low-Light mode, so a warning appears on the display. Both settings operate only when using the AF-S focus mode.

Continuous-Servo Autofocus (AF-C)

This mode, also known as *AF-C*, is the mode to use for sports and other types of photography with fast-moving subjects. In this mode, once the shutter release is partially depressed, the camera sets the focus but continues to monitor the subject, so that if it moves or you move, the lens will be refocused to suit. Focus and exposure aren't really locked until you press the shutter release down all the way to take the picture. You'll find that AF-C produces the least amount of shutter lag of any autofocus mode when set to release-priority: press the button and the camera fires, even if sharp focus has not quite been achieved. It also uses the most battery power, because the autofocus system operates as long as the shutter release button is partially depressed.

Continuous-servo autofocus uses a technology called *predictive tracking AF*, which allows the Z6 to calculate the correct focus if the subject is moving toward or away from the camera at a constant rate. It uses either the automatically selected AF point (in Auto-area AF mode) or the point you select manually to set focus. As described in Chapter 12, you can set AF-C mode to use release-priority (the default), or focus-priority using Custom Setting a1. You can temporarily lock the focus point by partially depressing the shutter release, or pressing the defined AE-L/AF-L button.

Full-time Autofocus (AF-F) (Movie Mode Only)

This mode, also known as AF-F, is available only in Movie mode. You don't need to activate focus with a button: the camera adjusts focus continually as your subject moves. Focus locks only when the shutter release is pressed halfway. Obviously, this mode uses the most juice.

Manual Focus

Set manual focus by sliding the switch on the lens to the M position, or by using the Fn2 button, *i* menu, or Photo/Movie Shooting menu options. There are some advantages and disadvantages to this approach. While your batteries will last longer in manual focus mode, it will take you longer to focus the camera for each photo, a process that can be difficult. Modern digital cameras depend so much on autofocus that the viewfinders are no longer designed for optimum manual focus. Pick up any film camera and you'll see a bigger, brighter viewfinder with a focusing screen that's a joy to focus on manually. I'll tell you more about manual focus later in this chapter.

Choosing an Autofocus Area Mode

If your Z6 isn't focusing on the correct subject, autofocus speed and activation are pretty much wasted effort. As you've learned, the Z6 has up to 273 different points on the screen that can be individually selected to determine the active focus zone. You can choose which of those points is used by selecting an AF-area mode. As with AF mode, you can select the AF-area mode from the *i* menu, Photo/Movie Shooting menus, or by holding down the Fn2 button and rotating the subcommand dial. The Z6 has six different focus point selection modes. I'm going to describe each of the modes, and explain how to use them.

Pinpoint AF

This mode is available only in Single AF (AF-S) focus mode. In this mode, you always select the focus point manually, using the sub-selector joystick *or* the multi selector (which, helpfully, will respond to your thumb presses not only in the left/right and up/down directions, but diagonally, as well). Return the focus point to the center at any time by pressing the OK button.

The focus point is represented by the tiny box shown in Figure 5.7. You have an extraordinary amount of freedom in placing the focus area, which is half the size of that used for Single-Point AF (described next). Pinpoint AF uses contrast detection within the selected area; it's not limited by the position of the fixed PDAF pixels represented by the larger boxes.

Figure 5.7 The Pinpoint AF selection box can be moved in tiny increments virtually anywhere within the area represented by the 273 AF point boxes.

Figure 5.8 By default, Single-Point AF allows you to choose from all 273 focus zones.

Obviously, selecting an AF point so precisely can be time-consuming, so Pinpoint AF is best suited for subjects that don't move. It's especially good for macro work and any photography undertaken with the camera mounted on a tripod.

Single-Point AF

As with the other user-selectable area modes, you can select the focus point manually, using the sub-selector joystick *or* the multi selector. The Z6 evaluates focus based solely on the point you select, making this another good choice for subjects that don't move much. You can choose Custom Setting a5: Focus Points Used, to select whether the focus point resides within the 273-area array by choosing ALL (see Figure 5.8) or a more widely spaced distribution (Every Other Point) which activates only one-quarter of the focus areas (see Figure 5.9). The alternate point mode allows much faster positioning of your focus zone. I use Every Other Point a lot for sports, because I plan on filling as much of the frame as possible with players, and can usually estimate where they will appear in the frame. (That's usually off center, closer to the edge where I expect them to enter the frame.) Single-Point AF is excellent for achieving focus on a subject that might otherwise blend in with its background.

TIP

The Every Other Point setting does not affect the number of focus points used with Wide Area AF (Small or Large), which I'll describe shortly.

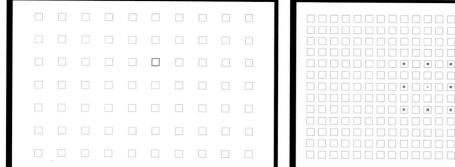

Figure 5.9 The number of focus points is reduced by three-quarters when you specify Every Other Point with Custom Setting a5.

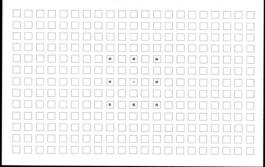

Figure 5.10 You can select a primary focus point with Dynamic-area AF, but adjacent points will also be used if your subject moves outside the primary area.

Dynamic-Area AF

In this mode, available only when AF-C is active, you still select the primary focus point yourself from among the 273 available using the multi selector or sub-selector controls. The camera will focus on that point, but if the subject departs from the selected area, the Z6 uses information from the surrounding areas. The red-highlighted points in the middle of Figure 5.10 show the active focus points when the dynamic area is centered in the frame. You can move the grouping to any of the other points, but when the grouping reaches the top border or corners (as shown in the corners of the figure), some of the potential points are outside the array.

Dynamic-area AF is a more sophisticated version of Single-Point AF. You can select the initial focus point, and then trust the Z6's smarts to continue focusing on a moving subject. That frees you to concentrate on framing your composition rather than worrying about whether your subject remains in focus.

This setting is excellent for slow-moving subjects, as seen in Figure 5.11, left, but flexible enough to follow subjects that move erratically from side to side (say, a child at play or a basketball player moving around the court on defense), because the camera can use the distance information to differentiate the original subject from objects that are closer or farther away, especially human subjects (see Figure 5.11, right). However, many photographers also use this setting for birds in flight. Very rapid motion may call for the Z6's tracking feature, described shortly.

TIP

In Pinpoint AF, Single-point AF, or Dynamic-area AF, if you want to lock the focus point you've selected for a series of shots, you can temporarily lock the focus point by partially depressing and holding the shutter release, or pressing and holding the AE-L/AF-L button (by default the sub-selector button). Press the multi selector center button to move the single focus point back to the center of the frame quickly.

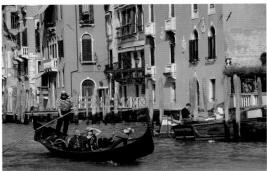

Figure 5.11 Focus on slow-moving subjects with Dynamic-area AF (left). More erratic subjects (right) can work, too, but may require using the Z6's tracking feature.

Wide-Area AF (Small and Large)

Uses the focus points within zones you can move around the display. You can choose the smaller of the wide-area zones (shown in the corner positions in Figure 5.12, or even larger zones, seen in the corners of Figure 5.13). I don't use these much, especially Wide-area (L), because they each encompass so much of the frame that they're best suited for large subjects that will reside in a predictable area, and those are often handled quite efficiently with Single-point AF.

Figure 5.12 Wide-area AF zones can be moved around the frame. Examples shown are the Small area version.

Figure 5.13 The Wide-area AF Large zones occupy a larger area of the frame, and cannot be located as close to the edges as their Small counterparts.

Automatic-Area AF

In this mode, autofocus point selection is out of your hands; the Z6 performs the task for you using its own intelligence. Red brackets will be displayed to show the area the camera will use to establish focus (see Figure 5.14). The camera can even work with the distance information supplied by the lens and its face detection technology to distinguish humans from their background, so a person standing at the side of the frame will be detected and used to evaluate focus, while the camera ignores the background area in the frame.

Figure 5.14
The red brackets show the area covered in Automaticarea AF.

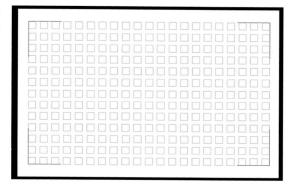

In AF-S mode, the active focus points are highlighted with an array of green boxes that illuminate as you hold the shutter release down halfway. In AF-C mode, a dancing array of red boxes appears around the focused area, highlighted in that color to indicate that the current focus point is only tentative and won't be locked in until you press the shutter release down all the way. Birds in flight—one of the most difficult of all autofocus targets—can often be grabbed using Automaticarea AF.

This mode's face-detection and tracking features merit a more detailed discussion of their own, which I'll provide in the next section.

REDUCING YOUR OPTIONS

If you find yourself using only certain AF-area modes, you can tell the Z6 to "hide" the modes you do not work with. Custom Setting a8: Limit AF-Area Mode Selection allows you to enable or disable any of the AF-area modes (except Single-Point AF, which is mandatory). If you need more help activating this option, I'll explain it for you in Chapter 12.

Face Detection and Subject Tracking

The Auto-area AF feature has two great features that allow you to identify human targets and track any kind of moving subjects (birds-in-flight, people-in-flight, and others). *Face detection* allows the camera to locate potential portrait subjects when the visage of a human being appears in the frame. *Focus tracking with lock-on* directs the Z6 to follow the movement of a subject you specify and continue to focus on it as it roams around the frame.

Face-Priority AF

Use this mode for portraits and people pictures. The camera automatically detects faces, and focuses on subjects facing the camera, as when you're shooting a portrait. With live view's Face-priority AF, the Z6 really does assign finding faces and autofocusing on them its number-one priority.

To use this feature, you must first enable Custom Setting a4: Auto-Area AF Face Detection. Once enabled, you can't directly select the focus zone yourself. Instead, a yellow border will be displayed on the LCD when the camera detects a face. You don't need to press the shutter release to activate this behavior—in this mode, the camera starts looking for faces immediately. Up to five faces may be detected, with the yellow border aligned with the selected face (usually, the face that is closest to the camera).

If more than one face is found, a triangle will appear at the side of the yellow box (see Figure 5.15). Use the sub-selector joystick or the multi selector buttons to switch to a different face. If touch operation is enabled, you can touch a face with your finger and the Z6 will focus on that face and take a picture immediately.

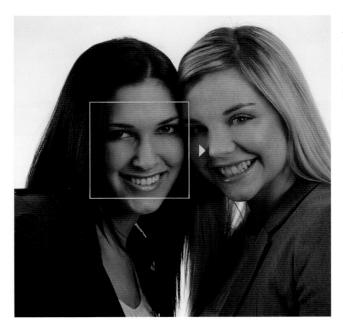

Figure 5.15
You can move the focus point from the selected face to another one in the frame.

Otherwise, when you press down the shutter release halfway, the box around the selected face turns red, but the triangle allowing you to change faces remains. If the camera is unable to focus, the triangle disappears, but the red border remains. Focus may also be lost if the subject turns away from the camera and is no longer detectable by Face-priority.

Subject Tracking

The useful Subject-tracking autofocus feature of Auto-area AF is one of those capabilities that can be confusing at first, but once you get the hang of it, it's remarkably easy to use. In fact, it's always available any time you're using Auto-area AF. Here's the quick introduction you need to Subject Tracking.

- Choose refocus delay. Navigate to Custom Setting a3: Focus Tracking with Lock-on. Choose the Blocked Shot AF Response value from 1 (Quick) to 5 (Delayed). This determines how quickly the camera refocuses when an intervening object passes in front of the subject you have chosen to track. With Quick, the Z6 will wait only a short moment, then refocus on the new object. With the maximum Delay setting, the interrupting subject matter will be ignored for a period of time. You'll want to use a delay setting when shooting sports in which players or officials are likely to pass in front of the camera unexpectedly. A Quick setting will work well when shooting continuously, allowing the camera to refocus rapidly.
- Ready, aim... To select a subject for tracking, press the OK button at any time. A white border with directional arrows at its edges appears in the center of the frame. You can move the border around with the multi selector or sub-selector. Use that border to "aim" the camera until the subject you want to focus on and track is located within the border. (See Figure 5.16.) Because you can select at any time, if, say, you're shooting sports, you can wait until just before some action is going to begin, and then choose your subject.
- **Select your subject.** When you're ready, press the OK button (but *not* the sub-selector button) to activate tracking. The box will change from white to yellow. Press the center button again to de-select and re-select a different subject.

Figure 5.16
Press OK to produce
a frame you can use
to select an object
to track.

- **Touch options.** Note that if the touch screen is active, you have several options. Once you've enabled Touch Controls in the Setup menu, you can cycle among Touch AF (Off), Touch AF, and Touch Shutter/AF by tapping the touch icon at the left side of the monitor.
 - Touch AF (only) is on. You don't need to press the OK button. *Start* tracking by tapping your subject on the monitor. You'll bypass the white box completely. The yellow box will appear at the place you tap. If you've *already activated* tracking (with the touch screen or OK button), touching the monitor will move the yellow tracking box to the new subject.
 - Touch shutter/AF is on. Tap the screen, and the Z6 will *immediately* focus on that point and take a picture, but will continue tracking at that point. This is a great feature. For example, if you unexpectedly see some action taking place, tap the touch screen to take a photo right away, and then continue to shoot (if you like) with the camera tracking the subject you just shot.
- Reframe as desired. Once the focus frame has turned yellow, it seemingly takes on a life of its own, and will "follow" your subject around on the LCD as you reframe your image. (In other words, the subject being tracked doesn't have to be in the center of the frame for the actual photo.) Best of all, if your subject moves, the Z6 will follow it as required.
- Tracking continues. The only glitches that may pop up might occur if your subject is small and difficult to track, or is too close in tonal value to its background, or if the subject approaches the camera or recedes sufficiently to change its relative size on the LCD significantly. The Z6 may also be unable to track subjects that leave the frame, are moving too fast, are too large/small, or too bright/dark.
- ...Focus. If you're not using the touch options, when you've activated tracking on your subject, press the shutter button halfway to activate the Z6's autofocus feature. The focus frame will turn red and the camera will emit a beep (unless you've disabled the beep within the Setup menu) when locked in.
- Or exit. To cancel focus tracking, press the Zoom Out/Index button.
- Take your picture. Press the shutter release down all the way.

Store by Orientation

Some types of shooting call for different ways of choosing a focus point's orientation. For example, say you're shooting a sport like basketball that lends itself to both horizontal and vertical framing. You may rotate your camera constantly as the action unfolds but want the focus point to remain in the upper portion of your horizontal or vertical frame. That won't happen if you are shooting with a Z6 in its default mode. Your chosen focus point will stay fixed relative to the other points and "rotate" along with the camera, as shown at top in Figure 5.17.

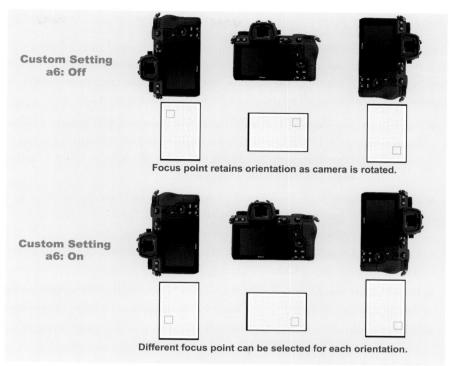

The same focus point in the camera's array is used regardless of the Z6's orientation. If you've set your focus point for the basket or net when the camera is rotated in one direction vertically (that is, the top of the vertical frame), the focus point will encompass the right side of the frame when the camera is in the horizontal position, and evaluate the floor if you happen to rotate it vertically in the other direction.

With the Z6, however, you have another option, tucked away in Custom Setting a6: Store Points by Orientation. When enabled, the focus point does not shift as the camera is rotated, as shown in the upper half of Figure 5.17. This feature allows *different* focus points to be selected for each of the three likely camera orientations (ignoring the possible, but less likely, upside-down horizontal position).

When Store Points by Orientation is activated, simply rotate the camera to any of the three configurations, and select the focus point you want. Repeat, if you like, for the other two. (It's best to do this during a lull in the action, although you can re-select points on the fly if you like.) Then, as you shoot you'll notice the focus point shifting in the viewfinder as you rotate the camera. You don't need to keep the point in the same relative position in the frame (as I just described). You can select any focus point for any of the three orientations if, for example, you're shooting architecture and want to focus on a different position in the frame as you vary camera orientation.

Autofocus Activation... and More

The final considerations in using autofocus are the control or controls used to activate and lock autofocus, plus a few odds and ends. I'll cover them in ample detail in Chapter 12 under Custom Settings, which explains all the options, but here are some cross references if you feel you need some review. Descriptions of all of these can be found in Chapter 12.

- Autofocus override. After the Z6 has focused automatically, you can fine-tune focus using the focus ring on the lens while the shutter release is pressed halfway if you've set Custom Setting a13: Manual Focus Ring in AF Mode to Enable. To refocus using AF, lift your finger and press the shutter release down halfway once more.
- Focus tracking with lock on. As I mentioned, intervening subjects passing in front of your main area of interest can interfere with autofocus. Set a delay time before the camera refocuses using Custom Setting a3: Focus Tracking with Lock-On.
- Limit AF-Area Mode Selection. As I mentioned earlier, you can limit the availability of AF-area modes using Custom Setting a8.
- Focus point wraparound. Do you want the focus point to wrap around to the opposite side during manual selection? Use Custom Setting a9: Focus Point Wrap-Around.
- Which controls activate/lock autofocus. You can use a half-press of the shutter release or a press of the AF-ON button (or both), or another button. See the instructions for Custom Setting a7: AF Activation in Chapter 12 for your options.
- Center/show focus point. You can program the OK (multi selector center) button to either jump the active focus point to the center or to turn zoom on or off, using Custom Setting f3, as described in Chapter 12.

Manual Focus

As I've noted several times, some subjects lend themselves to manual focus, especially close-up or *macro* photography, in which AF can be a creative hindrance. If you're photographing a flower, why let the camera decide which leaf or petal should be sharpest—particularly if you are using a relatively large aperture and selective focus as an effect? A mirrorless camera's live view is especially useful when focusing manually, because you have extra tools at your disposal to focus precisely and quickly. Here are the basic steps for quick and convenient setting of focus manually with the Z6:

- Activate manual focus. Switch to manual focus by sliding the switch on the lens to the M position, or by selecting Manual focus using the *i* menu, or by holding the Fn2 button and rotating the main command dial.
- Aim at your subject and turn the control/focusing ring on the lens. Turn the focusing ring until that appears to be in the sharpest possible focus. Note that while you can redefine the focus/control ring's function (as described in Chapter 12), in Manual focus mode it can *only* be used to adjust focus.

- If you have difficulty focusing. If you are unable to focus precisely, you have three options: zooming, magnification, and focus peaking. The first two give you a larger image to focus, but have their own advantages and disadvantages. The third is a new feature in the Nikon dSLR product line.
 - Zooming in optically. If you are using a zoom lens (rather than a fixed focal length *prime* lens), you can zoom in on your subject using the longest available focal setting. Even if you plan to take a wide-angle photo, the reduced depth-of-field at a telephoto setting can make it easier to see the exact effect of slight changes in focus while zoomed in. With most lenses, when you zoom back out to take the picture, the center of interest will still be in sharp focus. However, some lenses (generally less expensive optics) can change focus as they zoom. The most blatant of these are called *varifocal* lenses. Sticklers refer to lenses that *don't* change focus as they zoom as "true" zoom or *parfocal* lenses. However, even a true zoom can change focus slightly when zooming.
 - Magnification. To magnify a portion of the image and enhance your ability to focus, press the Zoom In button located to the left of the LCD monitor. As you press the button repeatedly, to enlarge the view to three different levels of magnification, a navigation window, seen at lower right in Figure 5.18, displays a yellow box at the approximate location within the overall frame of the magnified view. You can relocate the zoomed area using the multi selector or sub-selector joystick. Press the center button at any time to restore the zoom window to the center of the frame.
 - Focus Peaking. Activate focus peaking using the instructions for Custom Setting d10: Peaking Highlights in Chapter 12. Focus peaking provides a colored overlay around edges within your image that are sharply focused. As the color fades or becomes stronger, it is easier to determine when your subject is precisely focused. Choose Peak 1 (low sensitivity), Peak 2 (standard sensitivity), or Peak 3 (high sensitivity), depending on the contrast of your subject, as seen in Figure 5.19. The flowers shown tended to blend in with the foliage in the

Figure 5.18 You can magnify the image to make manual focusing easier.

Figure 5.19 With Peaking Highlights activated, in-focus areas are highlighted in color.

background, so I selected high sensitivity. The default peaking highlight color of red was fine in this case, but you can use Custom Setting d10 to change it to yellow, blue, or white. The alternate hue may be needed to provide a strong contrast between the peaking highlights and the color of your subject. Yellow might be the best choice to focus on, say, a red rose. Access the Peaking Color item of the Setup menu to adjust the color. To make the overlay even more visible, select High in the Peaking Level item; you can also turn peaking Off with this item, if desired.

• Use the electronic rangefinder. Position the focus point over the subject and rotate the focus ring until sharp focus is achieved using the electronic rangefinder feature. The focus point will change to green and the in-focus indicator at lower left in the display will change according to the symbols shown in Figure 5.20.

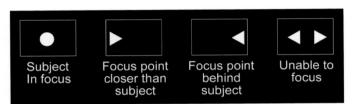

Figure 5.20
The electronic rangefinder in the lower-left corner of the display shows manual focus status.

■ Preview depth-of-field. Focusing is always done with the lens set to its largest f/stop (except in Manual exposure mode when Enable (the default) is specified for Custom Setting d8: Apply Settings to Live View). The maximum aperture provides the least depth-of-field, so focus snaps in and out more precisely. When the picture is captured, the Z6 closes down the iris to the "taking aperture," which is old-school terminology for the aperture used to take the picture (natch). If that f/stop is smaller than the maximum aperture, the depth-of-field in your finished image will be larger—but unknown to you without a preview. For critical applications, especially when you're using selective focus, you'll want to see the actual DOF on the live view screen.

The Z6 doesn't have a Pv (Preview) button by default, but you can define one for, say, Fn1 or Fn2 in Custom Setting f2: Custom Control Assignment. Then, when you press the defined Pv button, the lens will stop down to the aperture selected by you (in Manual mode) or by the camera (in Aperture Priority mode). (This doesn't work in Program or Shutter-priority mode, because the aperture isn't determined in either mode until you lock exposure or take a photo.) To open the aperture to maximum again, release the button.

Split-Screen Display Zoom

To use this feature, you must assign the Split-screen Display Zoom behavior to the *i* menu, using Custom Setting f1: Customize *i* Menu, as described in Chapter 12. When you activate this feature, the Z6 divides the live view LCD display into two boxes, each showing a separate area of the frame side-by-side.

To use this capability, just follow these steps.

- 1. **Split the screen.** Press the *i* button and scroll down to the icon representing the Split-screen Display Zoom function. Press OK to activate.
- 2. **Areas are indicated by a navigation window.** The screen will split into two areas, shown next to each other. The relative positions of the two areas are shown in a magnification window, seen at lower right in Figure 5.21.

Figure 5.21 Split-screen display in live view.

- 3. **Zoom in or out of the split display.** Use the Zoom In and Zoom Out buttons to magnify or reduce magnification of both portions of the image.
- 4. **Choose one of the two sides of the frame.** Press the OK button to select one of the two sides of the frame.
- 5. **Move selected area horizontally.** You can use the left/right buttons to scroll that box's selected area from side to side.
- 6. **Move both areas vertically.** Press the up or down buttons to scroll *both* areas up or down simultaneously. In other words, the split-screen images will always match horizontally, but you can adjust either of their positions left or right. Landscape photographers have already noted that they'd like the ability to change the locations in both horizontal and vertical directions.
- 7. **Focus on selected area.** When either box is selected, you can focus the image on *that* area by pressing the shutter release button halfway.
- 8. Exit. Press the *i* button again to exit the split-screen display.

You're probably wondering what this feature is useful for—unless you're way ahead of me. Here are some typical applications. These are all fairly technical in nature, and likely to be needed only for specialized types of photography, particularly in the architectural and landscape fields. But if you do need the split-screen feature, you'll really need it.

- Check horizontal alignment. Some subjects lend themselves to symmetrical compositions (or, demand such treatment, in the case of buildings or other bi-laterally symmetrical scenes that look weird if the camera has been placed slightly to one side or the other). Use the split screen to view comparable parts of the same image simultaneously to see if the camera is aligned appropriately.
- Check front/back tilt. Sometimes you unintentionally lean the camera forward or back slightly, which can produce fall-back or fall-forward effects when shooting very tall or very deep subjects (pitch), or rotate the camera around its base (imagine a line running vertically through, say, the tripod socket; that's yaw). You might also roll the camera by rotating it along the axis that runs through the center of the lens.
 - When these rotations are severe, you'll probably notice it visually; lean way back to take in the top of a building, and you'll see the effect on the screen. However, less drastic tilting may escape your attention. You can use the split-screen feature in conjunction with the live view virtual horizon (discussed earlier in this chapter) to ensure the camera is completely level. The virtual horizon's indicators will show you when the camera is rotated around the axis running through the center of the front element of the lens, or pitched forward or back. The split-screen capability can help you counter yaw by comparing the two magnified sides of the image.
- Control perspective and focus. The split screen allows you to check the focus of different parts of a scene, which landscape photographers will like. Those using shift-tilt lenses will like the feature even more. These specialized lenses can be tilted without changing the position of the camera, providing control over which part of subjects photographed at an angle are in focus. The split screen can be used to select either side of the image, and focus on the side that you want to be rendered most sharply. These lenses can also be shifted side to side, say to allow photographing the top of a building while keeping the focal plane of the camera parallel to the structure. In such cases, you can use the Z6 in portrait orientation (in which case the screen will be split top and bottom, rather than side to side), and then view both parts of the image before making additional shift adjustments for the best perspective control.

Back Button Focus

Once you've been using your camera for awhile, you'll invariably encounter the terms *back focus* and *back button focus*, and wonder if they are good things or bad things. Actually, they are *two different things*, and are often confused with each other. *Back focus* is a bad thing, and occurs when a particular lens consistently autofocuses on a plane that's *behind* your desired subject. This malady may be found in some of your lenses, or all your optics may be free of the defect. The good news is that if the problem lies in a particular lens (rather than a camera misadjustment that applies to *all* your lenses), it can be fixed. I'll show you how to do that at the end of this chapter.

Back button focus, on the other hand, is a tool you can use to separate two functions that are commonly locked together—exposure and autofocus—so that you can lock in exposure while allowing focus to be attained at a later point, or vice versa. It's a *good* thing, although using back button focus effectively may require you to unlearn some habits and acquire new ways of coordinating the action of your fingers.

As you have learned, the default behavior of your Nikon Z6 is to set both exposure and focus (when AF is active) when you press the shutter release down halfway. When using AF-S mode, that's that: both exposure and focus are locked and will not change until you release the shutter button, or press it all the way down to take a picture and then release it for the next shot. In AF-C mode, exposure is locked and focus set when you press the shutter release halfway, but the Z6 will *continue to refocus* if your subject moves for as long as you hold down the shutter button halfway. Focus isn't locked until you press the button down all the way to take the picture.

What back button focus does is *decouple* or separate the two actions. You can retain the exposure lock feature when the shutter is pressed halfway, but assign autofocus *start* and/or autofocus *lock* to a different button. So, in practice, you can press the shutter button halfway, locking exposure, and reframe the image if you like (perhaps you're photographing a backlit subject and want to lock in exposure on the foreground, and then reframe to include a very bright background as well).

But, in this same scenario, you *don't* want autofocus locked at the same time. Indeed, you may not want to start AF until you're good and ready, say, at a sports venue as you wait for a ballplayer to streak into view in your viewfinder, or when you're photographing a garden and expect a butterfly to alight somewhere nearby. With back button focus, you can lock exposure on the spot where you expect the athlete or insect to be, and activate AF at the moment your subject appears. The Z6 gives you a great deal of flexibility, both in the choice of which button to use for AF, and the behavior of that button. That's where the learning of new habits and mind-finger coordination comes in. You need to learn which back button focus techniques work for you, and when to use them.

Back button focus lets you avoid the need to switch from AF-S to AF-C when your subject begins moving unexpectedly. You retain complete control. It's great for sports photography when you want to activate autofocus precisely based on the action in front of you. It also works for static shots. You can press and release your designated focus button, and then take a series of shots using the same focus point. Focus will not change until you once again press your defined back button. (See Figure 5.22.)

Want to focus on a spot without moving the focus point within your frame? Use back button focus to zero in focus with the current focus area—no need to move it—then reframe. Focus will not change. Don't want to miss an important shot at a wedding on a photojournalism assignment? If you're set to *focus-priority* your camera may delay taking a picture until the focus is optimum; in *release-priority* there may still be a slight delay. With back button focus you can focus first, and wait until the decisive moment to press the shutter release and take your picture. The Z6 will respond immediately and not bother with focusing at all. Back button focus can also save battery power. Constantly refocusing in AF-C mode can consume a lot of power.

Figure 5.22
Lock your exposure for the garden by pressing the shutter release halfway; then activate autofocus when the butterfly decides where to land.

Activating Back Button Focus

Here's how to set up back button focus on your Z6. Just follow these steps:

- Assign exposure lock to the shutter button. That's the default behavior, so you should not need to make a change. However, double-check Custom Setting c1: Shutter-Release Button AE-L to make sure that On (Half-Press) is enabled. In that mode, depressing the shutter button halfway always locks the exposure at the setting the camera has selected. (In Manual exposure mode, of course, exposure does not change until you adjust it yourself.)
- Assign AF activation to AF-ON function only. You'll find the key control for enabling back button focus in Custom Setting a7: AF Activation. There, the options are Shutter/AF-ON or AF-ON only. With the former option, pressing the shutter release halfway *or* the AF-ON

control will enable *both* autoexposure and autofocus. Select AF-ON only to decouple the two functions, so that AF activation starts *only* when you press your designated AF-ON button.

Note that choosing AF-ON Only does not mean you must press the physical AF-ON button to activate autofocus. *Any* button that you assign the AF-ON behavior to will initiate autofocus. That button can be the actual AF-ON button, or another button, such as Fn1. In practice, you could assign AF-ON to the Fn1 button and a completely different function to the physical AF-ON button. Just remember which function belongs to which button.

■ Assign AF-ON function. Use Custom Setting f2: Custom Control Assignment (described in more detail in Chapter 12) and assign the AF-ON button to the control of your choice. As I've noted, most prefer to use the physical AF-ON button, and since that is its default function, you may need to make no change at all. But you can assign AF-ON to a different button if you like. In all cases, if you've followed these steps, the defined button is used to *initiate* autofocus. The shutter release button cannot be used to initiate autofocus.

Fine-Tuning the Focus of Your Lenses

Theoretically, at least, there should be no need at all to fine-tune the focus of native Z-mount lenses. With a traditional dSLR, the autofocus mechanism is a separate component located in the floor of the mirror box. That module can be slightly misaligned in relationship to the lens and the dSLR's optical manual focusing screen. AF fine-tune can correct for that error. The Z6, in contrast, calculates autofocus using the actual sensor image, and so should "see" any misalignment and correct for it automatically. In practice, though, the Z6's PDAF system may benefit from fine-tuning.

So, Nikon, in its wisdom, has included an AF fine-tune feature in the Z6. You can use it with both native Z-mount lenses as well as F-mount lenses attached using the FTZ adapter. In this section, I'll show you how to calibrate your lenses using the Z6's AF Fine-tune feature. The high resolution of the Z6 tends to make even slight focus errors visible, so AF Fine Tuning may be more useful than with cameras with fewer pixels, even given the camera's on-sensor PDAF pixels.

Why is the focus "off" for some lenses in the first place? There are lots of factors, including the age of the lens (an older lens may focus slightly differently), temperature effects on certain types of glass, humidity, and tolerances built into a lens's design that all add up to a slight misadjustment, even though the components themselves are, strictly speaking, within specs. A very slight variation in your lens's mount can cause focus to vary slightly. With any luck (if you can call it that) a lens that doesn't focus exactly right will at least be consistent. If a lens always focuses a bit behind the subject, the symptom is *back focus*. If it focuses in front of the subject, it's called *front focus*.

If it's the lens that's at fault, or if your camera consistently mis-focuses, you're almost always better off sending your lens or Z6 to Nikon to have them make it right. But that's not always possible or advised. Perhaps you need your lens recalibrated right now, or you purchased a gray market lens that Nikon isn't willing to fix. You may have a problem only with one or two lenses, while the rest focus with more accuracy. If you want to do the fine-tuning yourself, the first thing to do is determine whether your lens has a back focus or front focus problem.

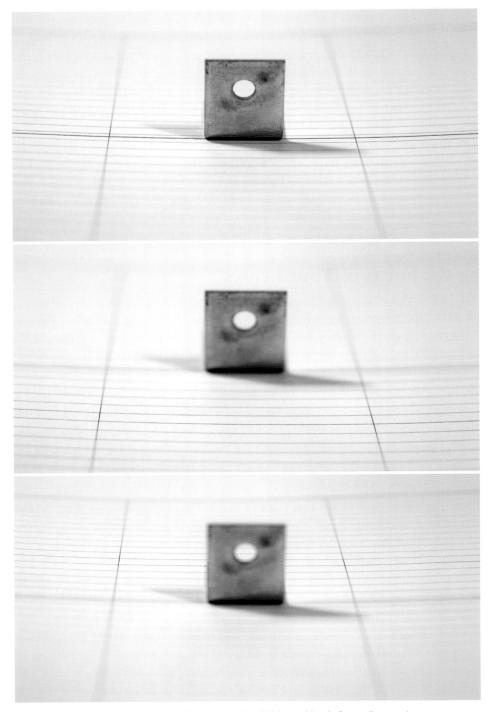

Figure 5.23 Correct focus (top), front focus (middle), and back focus (bottom).

For a quick-and-dirty diagnosis (*not* a calibration; you'll use a different target for that), lay down a piece of graph paper on a flat surface, and place an object on the line at the middle, which will represent the point of focus (we hope). Then, shoot the target at an angle using your lens's widest aperture and the autofocus mode you want to test. Mount the camera on a tripod so you can get accurate, repeatable results.

If your camera/lens combination doesn't suffer from front or back focus, the point of sharpest focus will be the center line of the chart, as you can see at top in Figure 5.23. If you do have a problem, one of the other lines will be sharply focused instead. Should you discover that your lens consistently front or back focuses, it needs to be recalibrated. Unfortunately, it's only possible to calibrate a lens for a single focusing distance. So, if you use a particular lens (such as a macro lens) for close focusing, calibrate for that. If you use a lens primarily for middle distances, calibrate for that. Close-to-middle distances are most likely to cause focus problems, anyway, because as you get closer to infinity, small changes in focus are less likely to have an effect.

Lens Tune-up Options

There are products available, such as Reikan FoCal (\$89) a tool for both PCs and Macs that comes with software and a focusing target. Also available is the LensAlign MkII Focus Calibration system (\$85). You can fine-tune your camera's focus manually using the instructions that follow.

To manually adjust your camera/lens AF setting, just follow these steps. The key tool you can use to fine-tune your lens is the AF Fine-Tune entry in the Setup menu, shown in Figure 5.24. You'll find the process easier to understand if you first run through this quick overview of the menu options:

■ AF fine-tune (On/Off). This option enables/disables autofocus fine-tuning for all the lenses you've defined using the menu entry. If you discover you don't care for the calibrations you make in certain situations (say, it works better for the lens you have mounted at middle distances, but is less successful at correcting close-up focus errors) you can deactivate the feature as you require. You should set this to On when you're doing the actual fine-tuning.

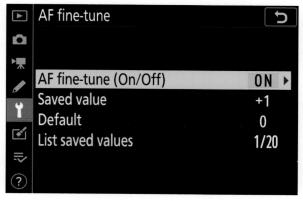

- Saved value. This setting lets you tune the autofocus calibration for the current Z-mount and CPU-chipped F-mount lenses (virtually all Nikon-brand autofocus lenses) mounted on the Z6. When you first fine-tune a lens, the saved value will be 0 (zero). You can press the multi selector up/down buttons to choose a value between +20 and −20. Positive numbers move the focal point farther from the camera, and would be used if your lens consistently suffers from front focus problems. Negative numbers move the focal point closer to the camera, and would be used if your lens is plagued with consistent back focus. The value is relative, and doesn't correlate to any particular distance or percentage.
- **Default.** This entry often confuses. It is a value that is applied to *every* lens mounted on the camera that doesn't already have a customized saved value associated with it. That is, if your Z6 has consistent front or back focus problems with *all* lenses, you can enter a value here, and the camera will apply the correction to each CPU lens you use. This default setting can be overridden by saved values you've stored for particular lenses. So, you can change the default focal plane for all lenses, and still further fine-tune specific lenses that need more autofocus correction. My recommendation is that if your camera and lenses are so out of whack that you need global correction and individual fine-tuning, you *really* ought to consider shipping the whole kit off to Nikon for proper calibration.
- List saved values. This screen shows you the saved fine-tuning values for all lenses. If the currently mounted lens has a stored value, it will be marked with a solid black box icon. You can delete lenses from this list by highlighting them and pressing the Trash button. You can also change the number (a two-digit number from 00 to 99) used to identify a particular lens.

Evaluating Current Focus

The first step is to capture a baseline image that represents how the lens you want to fine-tune autofocuses at a particular distance. You'll often see advice for photographing a test chart with millimeter markings from an angle, and the suggestion that you autofocus on a particular point on the chart. Supposedly, the markings that actually *are* in focus will help you recalibrate your lens. The problem with this approach is that the information you get from photographing a test chart at an angle doesn't actually tell you what to do to make a precise correction. So, your lens back focuses three millimeters behind the target area on the chart. So what? Does that mean you change the saved value by -3 clicks? Or -15 clicks? Angled targets are a "shortcut" that don't save you time.

Instead, you'll want to photograph a target that represents what you're actually trying to achieve: a plane of focus locked in by your lens that represents the actual plane of focus of your subject. For that, you'll need a flat target, mounted precisely perpendicular to the sensor plane of the camera. Then, you can take a photo, see if the plane of focus is correct, and if not, dial in a bit of fine-tuning in the AF Fine-Tuning menu, and shoot again. Lather, rinse, and repeat until the target is sharply focused.

You can use the focus target shown in Figure 5.25, or you can use a chart of your own, as long as it has contrasty areas that will be easily seen by the autofocus system, and without very

Figure 5.25 Use this focus test chart, or create one of your own.

small details that are likely to confuse the AF. Download your own copy of my chart from www.nikonguides.com/FocusChart.pdf (*the URL is case-sensitive*). Then print out a copy on the largest paper your printer can handle. (I don't recommend just displaying the file on your monitor and focusing on that; it's unlikely you'll have the monitor screen lined up perfectly perpendicular to the camera sensor.) Then, follow these steps:

- 1. **Position the camera.** Place your Nikon Z6 on a sturdy tripod with a remote release attached, positioned at roughly eye-level at a distance from a wall that represents the distance you want to test for. Keep in mind that autofocus problems can be different at varying distances and lens focal lengths, and that you can enter only *one* correction value for a particular lens. So, choose a distance (close-up or mid range) and zoom setting with your shooting habits in mind.
- 2. Set the autofocus mode. Choose the autofocus mode (AF-C or AF-S) you want to test.
- 3. Level the camera (in an ideal world). If the wall happens to be perfectly perpendicular, you can use a bubble level, plumb bob, or other device of your choice to ensure that the camera is level to match. Many tripods and tripod heads have bubble levels built in. Avoid using the center column, if you can. When the camera is properly oriented, lock the legs and tripod head tightly.
- 4. Level the camera (in the real world). If your wall is not perfectly perpendicular, use this old trick. Tape a mirror to the wall, and then adjust the camera on the tripod so that when you look through the viewfinder at the mirror, you see directly into the reflection of the lens. Then, lock the tripod and remove the mirror.
- 5. **Mount the test chart.** Tape the test chart on the wall so it is centered in your camera's view-finder. You should place the chart roughly 30X to 40X the focal length of the lens setting you'll be testing. For example, for a 100mm lens, place the chart 3,000mm from the camera (roughly 9.8 feet).
- 6. **Photograph the test chart using AF.** Allow the camera to autofocus, and take a test photo, using the remote release to avoid shaking or moving the camera.
- 7. **Make an adjustment and rephotograph.** Make a fine-tuning adjustment and photograph the target again. Follow the instructions in the next section. I've separated the fine-tuning adjustments from these steps because some people may want to just tweak the focus at a later time without going through all these evaluation steps. Follow steps 1 to 8 in the section that follows this one to make evaluation images at a range of corrections, say, –5 through +5.
- 8. **Evaluate the image.** If you have the camera connected to your computer with a USB cable and Camera Control Pro or other linkup software such as Nikon Transfer, or through a Wi-Fi connection, so much the better. You can view the image after it's transferred to your computer. Otherwise, *carefully* open the camera card door and slip the memory card out and copy the images to your computer.
- 9. **Evaluate focus.** Which image is sharpest? That's the setting you need to use for this lens. If your initial range doesn't provide the correction you need, repeat the steps between –20 and +20 until you find the best fine-tuning.

Changing the Fine-Tuning Setting

Adjust the fine-tuning for the lens you have mounted on the camera by following these steps:

- 1. **Mount lens.** If you haven't been running the test described previously, mount the Z-mount or F-mount CPU-equipped lens (with FTZ adapter) you want to fine-tune on the Nikon Z6. The camera will automatically recognize the lens you are using during the "calibration" process and display its name on the screen.
- 2. **Activate fine-tuning.** If you haven't already done so, choose AF Fine-Tune (On/Off) and turn it ON.
- 3. Select Saved Value. A screen similar to the one shown in Figure 5.26 will appear.
- 4. **Adjust focus.** Press the multi selector up/down buttons to tell the Z6 to adjust the autofocus from +20 (move the focal point away from the camera to fix front-focus problems) to –20 values (move the focal point toward the camera to fix back focus).
- 5. **Confirm adjustment.** Press OK when the value you want is entered. You may have to run the test described above several times and use some trial and error to determine the correct adjustment.
- 6. **View saved values.** Choose List Saved Values to see the names of the lenses you've fine tuned. (See Figure 5.27.) With the lens you want to assign a number to highlighted, press the right directional button to produce the screen shown in Figure 5.28.
- 7. **Assign a number.** Choose a lens identifier from 00 to 99 to the lens you've just calibrated. This identifier can be used to differentiate a particular lens from other lenses of the same type, if you own, say, some duplicate lenses. That's not as far-fetched as you might think. Some organizations, such as newspapers, allow their photographers to use favorite lenses exclusively, but may need to share other specialized optics among several photographers. If you don't know which of the pooled AF-S Nikkor 600mm f/4G ED VR lenses you'll be using on any particular day, you can calibrate your camera separately for each of them.
- 8. Exit. Press MENU to exit.

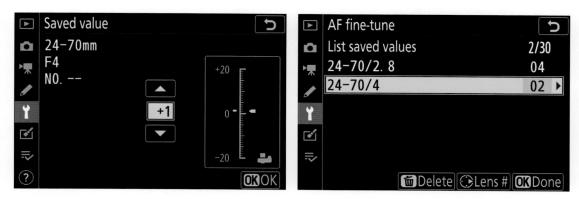

Figure 5.26 Change a saved value for a particular lens. **Figure 5.27** List the saved values you've stored.

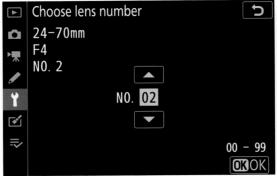

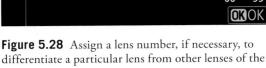

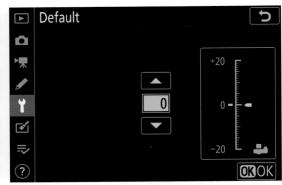

Figure 5.29 Choose a default value to be applied to all lenses not already fine-tuned.

Setting the Default Value

same type you may use.

If you want to set a default value for lenses that aren't in your Saved Values list (say, because your camera always back or front focuses slightly), choose the Default setting from the AF Fine-Tune menu, and adjust as shown in Figure 5.29.

Advanced Techniques

Your Z6 has more special features than a DVD box set. In designing its all-new Z-series camera platform, Nikon drew on its expertise in providing leading-edge capabilities in the digital single-lens reflex realm, and leveraged the advanced features possible with mirrorless technology. As a result, your Z6 has the kind of totally silent shooting that's not possible with conventional dSLRs and their clunky mechanical mirrors. You won't find in-body image stabilization in any Nikon dSLR, and cool features like focus-shift "stacking," and split-screen live view are currently available only in high-end models like the Nikon D850. Other capabilities built into your Z6 are more common, but have some special applications in a mirrorless model like the Z6. So, I've saved some of my favorite advanced techniques that the Z6 excels at for this chapter, which devotes a little extra space to some special features of the camera. This chapter covers GPS techniques and special exposure options, including time-lapse photography and very long and very short exposures. You'll even find an introduction to using SnapBridge and focus stacking.

Continuous Shooting

Even a seasoned action photographer can miss the decisive instant during a football play when a crucial block is made, or a baseball superstar's bat shatters and pieces of cork fly out. Continuous shooting simplifies taking a series of pictures, either to ensure that one has more or less the exact moment you want to capture or to capture a sequence that is interesting as a collection of successive images, as seen in Figure 6.1. Your Nikon Z6 can capture up to 12 fps using Continuous H (Extended) mode for JPEG or 12-bit NEF (RAW) images.

I use continuous shooting *a lot*—and not just for sports. The upside is that I may be able to capture an image or a sequence that I could never grab in single-shot mode. The downside is that I end up with many shots to wade through to find the "keepers." I know that sounds like I am using my

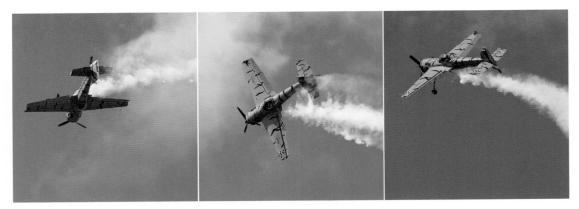

Figure 6.1 Continuous shooting allows you to capture an entire sequence of exciting moments as they unfold.

Nikon like a machine gun, and hoping that I capture a worthwhile moment through sheer luck, but that's not really the case. Here are some types of scenes where the rapid-fire capabilities of the Z6 pay big dividends.

- Action. Of course. If you're shooting a fast-moving sport, continuous shooting is your only option. But it's important to remember that lightning-quick bursts don't replace good timing. A 90 mph fastball moves about 11 feet between frames when you're shooting at the Z6's maximum frame rate of 12 fps. A ball making contact with a bat is *still* likely to escape capture. Continuous shooting may provide its best advantages in capturing sequences, so that each shot tells part of the story.
- Bracketing. I almost always set my camera to continuous shooting when bracketing. My goal is not to capture a bunch of different moments, each slightly different from the last, but, rather, to grab virtually the *same* moment, at different exposures (or, less frequently, with different white balance or Active D-Lighting settings). I can then choose which of the nearly identical shots has the exposure I prefer, or can assemble some of them into a high dynamic range. The high burst rate of the Z6 makes bracketing and hand-held HDR (high dynamic range) photography entirely practical. Software that combines such images does an excellent job of aligning images that are framed slightly differently when creating the final HDR version.
- Ersatz vibration reduction. I shoot three or four concerts a month, always hand-held, and always with VR turned on. I usually add a little simulated vibration reduction by shooting in continuous mode. While I have a fairly steady hand, I find that the *middle* exposures of a sequence are often noticeably sharper than those at the beginning, because my motions have "settled down" after initially depressing the shutter release button. My only caution for using this tool is to limit your shots during quiet passages, and avoid continuous shooting during acoustic concerts, if you are not using the electronic shutter. The rat-a-tat-tat of a Nikon Z6's mechanical shutter will earn you no friends. Activating the electronic shutter from the Photo Shooting menu is a better idea in such venues.

■ Variations on a theme. Some subjects benefit from sequences more than others, because some aspect changes between shots. Cavorting children, emoting concert performers (as described above), fashion models, or participants at weddings or other events all can look quite different within the span of a few seconds.

To use the Z6's continuous shooting modes use the *i* menu and navigate to Release Mode to select Continuous (L), Continuous (H), or Continuous (H) Extended. When you partially depress the shutter button, the viewfinder will display at the right side a number representing the maximum number of shots you can take at the current quality settings—the Shots Remaining indicator will show [r35] or some other value. That number will decrease as you take photos and they are stored in the Z6's buffer before being dumped onto the memory card. As the card catches up, the number will increase again. Nikon's estimates for the number of shots you can take consecutively with Image Area set to full-frame FX (2624) and the (currently) fastest-available Sony G-series XQD card are as shown in Table 6.1. Using Fine *, Normal *, or Basic * will reduce these numbers. In practice, if you shoot JPEGs using Continuous (H), the Z6 writes fast enough that the buffer is virtually "bottomless."

Table 6.1 Buffer Capacity		
Image Quality	Image Size	Buffer Capacity
NEF (RAW)		
12-bit Lossless Compressed	Large	35
	Medium	26
	Small	26
14-bit Lossless Compressed	Large	43
12-bit Compressed	Large	37
14-bit Compressed	Large	43
12-bit Uncompressed	Large	33
14-bit Uncompressed	Large	34
TIF (RGB)	Large	28
	Medium	31
	Small	35
JPEG Fine	Large	35
	Medium	44
	Small	50
JPEG Normal	Large	44
	Medium	50
	Small	51
JPEG Basic	Large	46
	Medium	50
	Small	50

Naturally, there are factors that can reduce both the number of continuous shots, as well as the frame rate. If you use slower XQD cards or shoot RAW + JPEG, expect some performance penalties. Slow shutter speeds obviously reduce frame rates; you can't fire off 5.5 frames per second with a 1/4-second shutter speed, for example.

The frame rate you select will depend on the kind of shooting you want to do. For example, when shooting multiple exposures, if you're carefully planning and composing each individual exposure, you might not want to shoot continuously at all. But if your subject is moving, your double exposure might be more effective if you select a frame rate that matches the speed of motion of your target. Here are some guidelines:

■ 9–12 fps. In High-Speed Continuous (Extended) you can capture JPEGs at up to 12 fps or 14-bit NEF (RAW) at 9 fps. Use these for sports and other subjects where you want to optimize your chances of capturing the decisive moment. Perhaps you're shooting some active kids and want to grab their most appealing expressions. This fast frame rate can improve the odds. However, there is no guarantee that even at 12 fps the crucial instant won't occur between frames. For example, when shooting major league baseball games, if I want to photograph a batter, I keep both eyes open, and keep one of them on the pitcher. Then, I start taking my sequence just as the pitcher releases the ball. My goal is to capture the batter making contact with the ball. But even at 12 fps, I find that a hitter connects between frames (remember that 90 mph fastball jumps 11 feet between shots). I usually must take pictures of a couple dozen at-bats to get a shot of bat and ball connecting, either for a base hit or a foul ball.

The very fastest continuous speeds come with some tradeoffs. The Z6 does not recalculate exposure between shots; it is fixed at the exposure calculated for the first image in the sequence. Flicker reduction is not used in this continuous mode, so the display is not updated in real time, and you may notice some lagging. You can set Custom Setting d11: View All in Continuous Mode to Off, and the display will blank during a sequence, giving you the fastest speed, but no feedback. I always leave d11 set to On.

- 4.0–5.5 fps. High-Speed Continuous has a top rate of 5.5 fps, but you can choose any setting between 1 and 5 fps for Low-Speed Continuous. A slightly slower rate can be useful for activities that aren't quite so fast moving. But, there's another benefit. If your frame rate is likely to be slowed by one of the factors I mentioned earlier, using a moderately slower frame rate can provide you with a constant shooting speed without the buffer filling.
- 1.0–3.0 fps. You can set Low-Speed Continuous to use a relatively pokey frame rate, too. Use these rates when you just want to be able to take pictures quickly and aren't interested in filling up your memory card with mostly duplicated images. At 1 fps you can hold down the shutter release and fire away, or ease up when you want to pause. At higher frame rates, by the time you've decided to stop shooting, you may have taken an extra three or four shots that you really don't want. Slow frame rates are good for bracketing, too. You'll find that slower frame rates also come in handy for subjects that are moving around in interesting ways (photographic models come to mind) but don't change their looks or poses quickly enough to merit a 7 fps burst.

- Movie stills. As I'll note in Chapter 14, you can take up to 50 single or continuous still photos in JPEG Fine * format using the dimensions of the movie frame (e.g., 1920 × 1080 pixels) while capturing video. Do that by enabling the shutter release button in Movie mode, if necessary, using Custom Setting f2: Custom Control Assignment > Shutter-release button. (The default setting is Take Photos.) When the Photo/Movie switch is set to the Movie position, pressing the Release Mode button produces only two choices: Single frame or Continuous.
 - **Single-frame release mode.** You can take pictures without interrupting movie shooting; only one photo is taken each time the shutter release is pressed.
 - Continuous mode. The Z6 will capture images continuously for a period of up to three seconds while the shutter button is held down. The frames-per-second rate will depend on the frame rate you've selected for movie shooting. However, continuous capture works *only* when you are in movie mode, but *not* actually capturing video. During video recording, only a single image will be captured even if the release mode is set to Continuous.

A Tiny Slice of Time

Exposures that seem impossibly brief can reveal a world we didn't know existed. Electronic flash freezes action by virtue of its extremely short duration—as brief as 1/50,000th second or less. The Z6's optional external electronic flash unit can give you these ultra-quick glimpses of moving subjects. You can read more about using electronic flash to stop action in Chapter 9.

Of course, the Z6 is fully capable of immobilizing all but the fastest movement using only its shutter speeds, which range all the way up to 1/8,000th second. Indeed, you'll rarely have need for such a brief shutter speed in ordinary shooting. (For the record, I don't believe I've *ever* used a shutter speed of 1/8,000th second, except when testing a camera's ISO 25800 or higher setting outdoors in broad daylight.) But at more reasonable sensitivity settings, say, to use an aperture of f/1.8 at ISO 200 outdoors in bright sunlight, a shutter speed of 1/8,000th second would more than do the job. You'd need a faster shutter speed only if you moved the ISO setting to a higher sensitivity (but why would you do that, outside of testing situations like mine?). Under less than full sunlight, even 1/4,000th second is more than fast enough for any conditions you're likely to encounter.

Indeed, most sports action can be frozen at 1/2,000th second or slower, as you can see in the image of the soccer player in Figure 6.2; I caught the two soccer players at the peak of the action, so 1/800th second was easily fast enough to freeze them in mid-stride. At ISO 100, I used f/5.6 on my 70-200mm f/2.8 lens to allow the distracting background to blur.

Of course, in many sports a slower shutter speed is actually preferable—for example, to allow the wheels of a racing automobile or motorcycle, or the rotors on a helicopter to blur realistically, as shown in Figure 6.3. At top, a 1/1,000th second shutter speed effectively stopped the rotors of the helicopter, making it look like a crash was impending. At bottom, I used a slower 1/200th second shutter speed to allow enough blur to make this a true action picture.

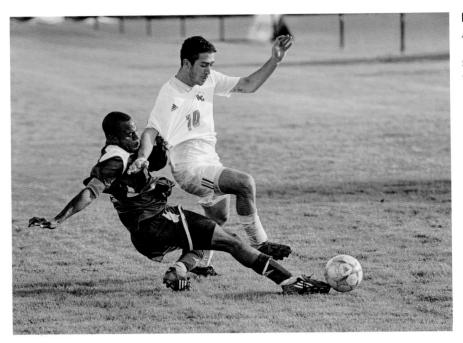

Figure 6.2 A shutter speed of 1/800th second was fast enough to stop this action.

Figure 6.3
A little blur can be a good thing, as these shots of a helicopter at 1/1,000th second (top) and 1/200th second (bottom)

show.

But if you want to do some exotic action-freezing photography without resorting to electronic flash, the Z6's top shutter speed is at your disposal. Here are two things to think about when exploring this type of high-speed photography:

- You'll need a lot of light. Very high shutter speeds cut extremely fine slices of time and sharply reduce the amount of illumination that reaches your sensor. To use 1/8,000th second at an aperture of f/6.3, you'd need an ISO setting of 1600—even in full daylight. To use an f/stop smaller than f/6.3 or an ISO setting lower than 1600, you'd need *more* light than full daylight provides. (That's why electronic flash units work so well for high-speed photography when used as the sole illumination; they provide both the effect of a brief shutter speed and the high levels of illumination needed.)
- High shutter speeds with electronic flash. You might be tempted to use an electronic flash with a high shutter speed. Perhaps you want to stop some action in daylight with a brief shutter speed and use electronic flash only as supplemental illumination to fill in the shadows. Unfortunately, under ordinary conditions you can't use flash in subdued illumination with your Z6 at any shutter speed faster than 1/200th second. That's the fastest speed at which the camera's focal plane shutter is fully open. Shorter shutter speeds are achieved by releasing the rear curtain before the front curtain has reached the end of the frame, so the sensor is exposed by a moving slit (described in more detail in Chapter 9). The flash will expose only the small portion of the sensor exposed by the slit throughout its duration. (Check out "High-Speed Sync" in Chapter 9 if you want to see how you can use shutter speeds shorter than 1/200th, albeit at much-reduced effective flash power levels.)

Working with Short Exposures

You can have a lot of fun exploring the kinds of pictures you can take using very brief exposure times, whether you decide to take advantage of the action-stopping capabilities of your built-in or external electronic flash or work with the Nikon Z6's faster shutter speeds. Here are a few ideas to get you started:

- Take revealing images. Fast shutter speeds can help you reveal the real subject behind the façade, by freezing constant motion to capture an enlightening moment in time. Legendary fashion/portrait photographer Philippe Halsman used leaping photos of famous people, such as the Duke and Duchess of Windsor, Richard Nixon, and Salvador Dali to illuminate their real selves. Halsman said, "When you ask a person to jump, his attention is mostly directed toward the act of jumping and the mask falls so that the real person appears." Try some high-speed portraits of people you know in motion to see how they appear when concentrating on something other than the portrait. Figure 6.4 provides an example.
- Create unreal images. High-speed photography can also produce photographs that show your subjects in ways that are quite unreal. A motocross cyclist leaping over a ramp, but with all motion stopped so that the rider and machine look as if they were frozen in mid-air, make for an unusual picture. When we're accustomed to seeing subjects in motion, seeing them stopped in time can verge on the surreal.

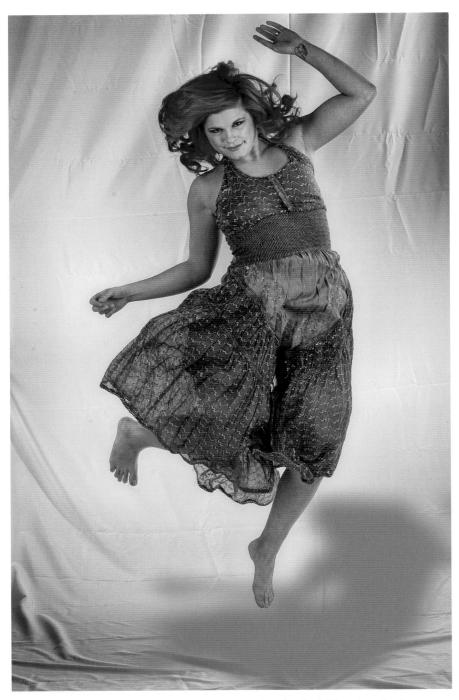

Figure 6.4 Shoot your subjects leaping and see what they look like when they're not preoccupied with posing.

- Capture unseen perspectives. Some things are *never* seen in real life, except when viewed in a stop-action photograph. MIT electronics professor Harold Edgerton's famous 1962 photo of a bullet passing through an apple was only a starting point. Freeze a hummingbird in flight for a view of wings that never seem to stop. Or, capture the splashes as liquid falls into a bowl, as shown in Figure 6.5. No electronic flash was required for this image. Instead, two high-intensity lamps with green gels at left and right and an ISO setting of 1600 allowed the camera to capture this image at 1/2,000th second.
- Vanquish camera shake and gain new angles. Here's an idea that's so obvious it isn't always explored to its fullest extent. A high enough shutter speed can free you from the tyranny of a tripod, and the somewhat limited anti-shake capabilities of image stabilization, making it easier to capture new angles, or to shoot quickly while moving around, especially with longer lenses. I tend to use a monopod or tripod frequently, and I end up missing some shots because of a reluctance to adjust my camera support to get a higher, lower, or different angle. If you have enough light and can use an f/stop wide enough to permit a high shutter speed, you'll find a new freedom to choose your shots. I have a favored Nikon AF-S 200-500mm f/5.6E ED VR lens that I use for sports and wildlife photography, almost invariably with a tripod, as I don't find the "reciprocal of the focal length" rule particularly helpful in most cases. I would not hand-hold this hefty lens at its 500mm setting with a 1/500th second shutter speed under most circumstances. However, at 1/2,000th second or faster, it's entirely possible for a steady hand to use this lens without a tripod or monopod's extra support, and I've found that my whole approach to shooting animals and other elusive subjects changes in high-speed mode. Selective focus allows dramatically isolating my prey wide open at f/5.6, too. Of course, at such a high shutter speed, you may need to boost your ISO setting—even when shooting outdoors.

Figure 6.5
A large amount of artificial illumination and an ISO 1600 sensitivity setting allowed capturing this shot at 1/2,000th second without use of an electronic flash.

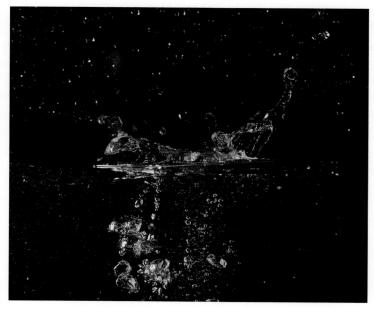

Long Exposures

Longer exposures are a doorway into another world, showing us how even familiar scenes can look much different when photographed over periods measured in seconds. At night, long exposures produce streaks of light from moving, illuminated subjects like automobiles or amusement park rides. Extra-long exposures of seemingly pitch-dark subjects can reveal interesting views using light levels barely bright enough to see by. At any time of day, including daytime (in which case you'll often need the help of neutral-density filters to make the long exposure practical), long exposures can cause moving objects to vanish entirely, because they don't remain stationary long enough to register in a photograph.

Three Ways to Take Long Exposures

There are actually three common types of lengthy exposures: *timed exposures*, *bulb exposures*, and *time exposures*. The Z6 offers all three. Because of the length of the exposure, all of the following techniques should be used with a tripod to hold the camera steady.

- Timed exposures. These are long exposures from 1 second to 30 seconds, measured by the camera itself. To take a picture in this range, simply use Manual or S modes and use the main command dial to set the shutter speed to the length of time you want, choosing from preset speeds of 1.0, 1.5, 2.0, 3.0, 4.0, 6.0, 8.0, 10.0, 15.0, 20.0, or 30.0 seconds (if you've specified 1/2-stop increments for exposure adjustments), or 1.0, 1.3, 1.6, 2.0, 2.5, 3.2, 4.0, 5.0, 6.0, 8.0, 10.0, 13.0, 15.0, 20.0, 25.0, and 30.0 seconds (if you're using 1/3-stop increments). The advantage of timed exposures is that the camera does all the calculating for you. There's no need for a stopwatch. If you review your image on the monitor and decide to try again with the exposure doubled or halved, you can dial in the correct exposure with precision. The disadvantage of timed exposures is that you can't take a photo for longer than 30 seconds.
- Bulb exposures. This type of exposure is so-called because in the olden days the photographer squeezed and held an air bulb attached to a tube that provided the force necessary to keep the shutter open. Traditionally, a bulb exposure is one that lasts as long as the shutter release button is pressed; when you release the button, the exposure ends. To make a bulb exposure with the Z6, set the camera on Manual mode and use the main command dial to select the first shutter speed immediately after 30 seconds—Bulb. Then, press the shutter or the button on a remote control (such as the MC-DC2) to start the exposure, hold it down, and then release it to close the shutter.

■ Time exposures. On the Z6, this type of exposure is similar to Bulb, except you don't have to hold the shutter release down. Simply press the shutter release or your remote button to start the exposure, and press a second time to stop the exposure. The setting is located just beyond Bulb when rotating the main command dial in Manual exposure mode, and is labeled Time or "--" on the LCD monitor and top control panel, respectively. I use this instead of Bulb most of the time, especially when using the MC-DC2 release cable or making long exposures (where it would be tedious to stand there pressing a button during a Bulb exposure). You can start the exposure, go off for a few minutes, and come back to close the shutter (assuming your camera is still there). If you are *not* using a cable release, the advantage of using Bulb is you don't have to touch the camera twice; just press the button and release it when finished. With shorter exposures it's possible for the vibration of manually opening and closing the shutter to register in the photo. For longer exposures, the period of vibration is relatively brief and not usually a problem. A typical time exposure I took of the Rock & Roll Hall of Fame in Cleveland, is shown in Figure 6.6, left.

Note: If you choose Bulb or Time in Manual mode and then switch to Shutter-priority mode, the Bulb or Time setting will "stick," but the Z6 will *not* take a picture in either mode. Instead, an indicator on the display and top control panel will flash, warning you to change to a usable setting. Nikon's reasoning is that you might not realize that Bulb or Time are no longer available, and wouldn't want the camera to choose some other setting on your behalf.

Working with Long Exposures

Because the Z6 produces such good images at longer exposures, and there are so many creative things you can do with long exposure techniques, you'll want to do some experimenting. Get yourself a tripod or another firm support and take some test shots with long exposure noise reduction both enabled and disabled (to see whether you prefer low noise or high detail) and get started. Here are some things to try:

Figure 6.6 The Z6's time exposure setting can give you long time exposures, such as this 60-second shot of the Rock & Roll Hall of Fame (left) or this cascade in the Youghiogheny River in Pennsylvania (right).

- Show total darkness in new ways. Even on the darkest, moonless nights, there is enough starlight or glow from distant illumination sources to see by, and, if you use a long exposure, there is enough light to take a picture.
- Blur waterfalls, etc. You'll find that waterfalls and other sources of moving liquid produce a special type of long-exposure blur, because the water merges into a fantasy-like veil that looks different at varying exposure times, and with different waterfalls. Cascades with turbulent flow produce a rougher look at a given longer exposure than falls that flow smoothly, as you can see in Figure 6.6, right. Although blurred waterfalls have become almost a cliché, there are still plenty of variations for a creative photographer to explore.
- Make people invisible. One very cool thing about long exposures is that objects that move rapidly enough won't register at all in a photograph, while the subjects that remain stationary are portrayed in the normal way. That makes it easy to produce people-free landscape photos and architectural photos at night or, even, in full daylight if you use a neutral-density filter (or two) (or three) to allow an exposure of at least a few seconds. At ISO 100, f/22, and a pair of 8X (three-stop) neutral-density filters, you can use exposures of nearly two seconds; overcast days and/or even more neutral-density filtration would work even better if daylight people-vanishing is your goal. They'll have to be walking *very* briskly and across the field of view (rather than directly toward the camera) for this to work. At night, it's much easier to achieve this effect with the 20- to 30-second exposures that are possible, as you can see in Figure 6.7. At left, with an exposure of several seconds, the crowded street in Segovia, Spain, is fully populated. At right, with a 20-second exposure, the folks moving slowly (at left) show up as blurs; those standing still (at right) are portrayed normally; and the fast-moving walkers in the foreground are barely perceptible blurs.

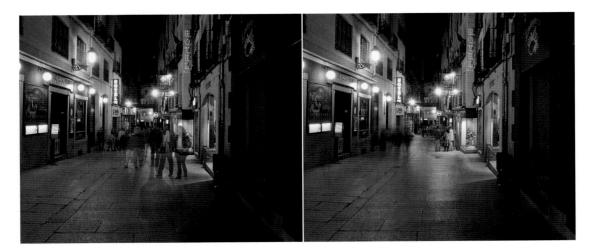

Figure 6.7 This European alleyway is thronged with people (left), but with the camera on a tripod, a 20-second exposure rendered most of the passersby almost invisible.

- Create streaks. If you aren't shooting for total invisibility, long exposures with the camera on a tripod can produce some interesting streaky effects. Even a single 8X ND filter will let you shoot at f/22 and 1/6th second in daylight. Indoors, you shouldn't have a problem using long shutter speeds to get shots like the one shown in Figure 6.8.
- **Produce light trails.** At night, car headlights and taillights and other moving sources of illumination can generate interesting light trails, as shown in the image of the carnival ride in Figure 6.9. Your camera doesn't even need to be mounted on a tripod; hand-holding the Z6 for longer exposures adds movement and patterns to your streaky trails. If you're shooting fireworks with a tripod, a longer exposure may allow you to combine several bursts into one picture.

Figure 6.8 Long exposures can turn dancers into a swirling image.

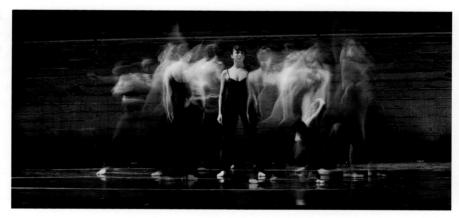

Figure 6.9
The carnival ride's motion produces interesting light trails.

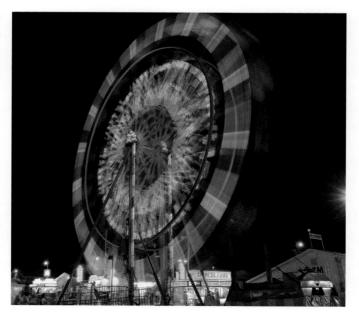

Delayed Exposures

Sometimes it's desirable to have a delay of some sort before a picture is actually taken. Perhaps you'd like to get in the picture yourself, and would appreciate it if the camera waited 10 seconds after you press the shutter release to actually take the picture. Maybe you want to give a tripod-mounted camera time to settle down and damp any residual vibration after the release is pressed to improve sharpness for an exposure with a relatively slow shutter speed. It's possible you want to explore the world of time-lapse photography. The next sections present your delayed exposure options.

Self-Timer

The Z6 has a built-in self-timer with a user-selectable delay. Activate the timer by pressing the Release Mode button and rotating the main command dial to the self-timer icon. Press the shutter release button halfway to lock in focus on your subjects (if you're taking a group shot of yourself and several others, focus on an object at a similar distance and use focus lock). When you're ready to take the photo, continue pressing the shutter release the rest of the way. The lamp on the front of the camera will blink slowly for eight seconds (when using the 10-second timer) and the beeper will chirp (if you haven't disabled it in the Custom Settings menu, as described in Chapter 12). During the final two seconds, the beeper sounds more rapidly and the lamp remains on until the picture is taken. It's a good idea to close the viewfinder eyepiece shutter if you're not using live view or shooting in Manual exposure mode, to prevent light from the viewing window getting inside the camera and affecting the automatic exposure.

You can customize the settings of the self-timer. Your adjustments are "sticky" and remain in effect until you change them. Your options include:

- Self-timer delay. Choose 2, 5, 10, or 20 seconds, using Custom Setting c2. If I have the camera mounted on a tripod or other support and am too lazy to dig around for my wired remote, I can set a two-second delay that is sufficient to let the camera stop vibrating after I've pressed the shutter release. A longer delay time of 20 seconds is useful if you want to get into the picture and are not sure you can make it in 10 seconds.
- Number of shots. After the timer finishes counting down, the Z6 can take from 1 to 9 different shots. This is a godsend when shooting photos of groups, especially if you want to appear in the photo itself. You'll always want to shoot several pictures to ensure that everyone's eyes are open and there are smiling expressions on each face. Instead of racing back and forth between the camera to trigger the self-timer multiple times, you can select the number of shots taken after a single countdown. For small groups, I always take at least as many shots as there are people in the group—plus one. That gives everybody a chance to close their eyes.
- Interval between shots. If you've selected 2 to 9 as your number of shots to be snapped off, you can use this option to space out the different exposures. Your choices are 0.5, 1, 2, or 3 seconds. Use a short interval when you want to capture everyone saying "Cheese!" The 3-second option is helpful if you're using an external flash, as 3 seconds is generally long enough to allow the flash to recycle and have enough juice for the next photo.

Interval/Time-Lapse Photography

The Z6 is capable of both interval photography (for still pictures) and time-lapse video, both available from the Photo Shooting menu. The commands for both are described in Chapter 11. Who hasn't marveled at a time-lapse photograph of a flower opening, a series of shots of the moon marching across the sky, or one of those extreme time-lapse picture sets showing something that takes a very, very long time, such as a building under construction.

You probably won't be shooting such construction shots, unless you have a spare Z6 you don't need for a few months (or are willing to go through the rigmarole of figuring out how to set up your camera in precisely the same position using the same lens settings to shoot a series of pictures at intervals). However, other kinds of interval and time-lapse photography are entirely within reach. If you're willing to tether the camera to a computer (a laptop will do) using the USB cable, you can take time-lapse photos using the optional extra-cost Nikon Camera Control Pro.

For Figure 6.10, I set up my camera on a tripod and pointed it at the North Star, hoping to use Interval Timing Shooting to capture some star trails. I left the camera running for a full hour, shooting a 30-second exposure every 32 seconds. I combined the resulting pictures in Photoshop

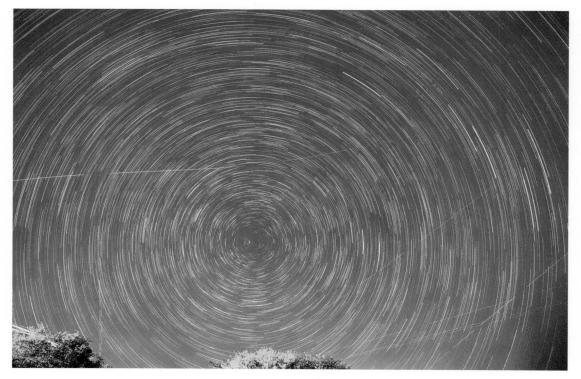

Figure 6.10 This time-lapse series captured the apparent motion of the stars as Earth rotated for a one-hour period.

to produce the photo of the stars—with the sky's canopy crossed by the lights from airplanes at intervals. I've also used interval shooting for images of sunsets. Typically, I aim the camera at the horizon and set it to shoot a three-shot bracket with a 3.0-stop increment. Then, I set the interval time to take a bracket burst every 10 seconds. Over a 10-minute span, I'll end up with 180 images I can assemble in a variety of ways to create an interesting HDR photograph. Here are the essential tips for effective time-lapse and interval photography:

- Use AC power. If you're shooting a long sequence of stills or a lengthy time-lapse movie, consider connecting your camera to an AC adapter, as leaving the Z6 on for long periods of time will rapidly deplete the battery. To minimize power drain, set Image Review to Off in the Playback menu, and enable Silent Photography in the Interval Timer Shooting entry.
- Make sure you have enough storage space. Unless your memory card has enough capacity to hold all the images you'll be taking, you might want to change to a higher compression rate or reduced resolution to maximize the image count.
- Make a movie. While stills shot at intervals are interesting, you can increase your fun factor by producing a time-lapse movie instead. You can also combine your interval shots into a motion picture using your favorite desktop movie-making software.
- Protect your camera. If your camera will be set up, make sure it's protected from weather, earthquakes, animals, young children, innocent bystanders, and theft.
- Vary intervals. Experiment with different time intervals. You don't want to take pictures too often or less often than necessary to capture the changes you hope to image.

Nikon Z6's built-in time-lapse photography feature allows you to take pictures for up to 999 intervals in bursts of as many as nine shots, with a delay of up to 23 hours and 59 minutes between shots/bursts, and an initial start-up time of as long as 23 hours and 59 minutes from the time you activate the feature. That means that if you want to photograph a rosebud opening and would like to photograph the flower once every two minutes over the next 16 hours, you can do that easily. If you like, you can delay the first photo taken by a couple hours so you don't have to stand there by the Z6 waiting for the right moment.

Or, you might want to photograph a particular scene every hour for 24 hours to capture, say, a landscape from sunrise to sunset to the following day's sunrise again. I will offer two practical tips right now, in case you want to run out and try interval timer shooting immediately: use a tripod, and for best results over longer time periods, plan on connecting your Z6 to an external power source!

Movies Two Ways

Your Z6 allows you to capture time-lapse movies, rather than just a series of still pictures, in two ways. One is highly automated, while the other requires a little work on your part. I'll explain the differences between the two, and then show you how to use either of them.

- Your camera does all the work. If you use the Z6's Time-Lapse Movie option, which I'll describe shortly, the camera will take all the pictures using the interval and other parameters that you specify, and then combine them to produce a movie. You can watch the video as-is, or use a video-editing program to combine it with other clips. The Time-Lapse movie entry is located in the Photo Shooting menu, and is grayed out if the photo/movie selector switch is not set to the Movie position. I describe its parameters in Chapter 11, but the process basically works much like Interval Photography, which I will detail in the following sections.
- **Do-it-yourself.** You gain more flexibility and some options if you capture the individual frames using the Z6's Interval Timer, and then combine them in a video editor to produce a video. That allows you to have individual frames as stills—and at a higher resolution, too (up to the full 24 megapixels the Z6 offers)—as well as video (which is described in Chapter 11).

In fact, you aren't limited to 1080p video, as you are when using the Time-Lapse Movie option. You can assemble the individual shots into a 4K movie, or even a faux 8K video (you'll need a high-end monitor to display any "8K" video you produce). Nikon calls the latter 8K Time-Lapse, which it is not, because the standard frame size for 8K video is 7680×4320 , and the Z6's full-resolution frames measure 6048×4024 pixels.

Using Interval Photography

This next section will tell you everything you need to know to capture images using the Z6's built-in intervalometer—whether you intend to use the resulting still photos as such, or plan to combine them into a home-brewed time-lapse movie. To set up interval timer shooting, just follow these steps.

Before you start:

- 1. **Check your time.** The Z6 uses its internal clock to activate, so make sure the time has been set accurately in the Setup menu before you begin.
- 2. **Ignore release mode.** You don't need to set the camera for continuous shooting. The Z6 will take the specified number of shots at each interval regardless of release mode setting.
- 3. **Set up optional bracketing.** However, if you'd like to bracket exposures during interval shooting, set up bracketing prior to beginning. (You learned how to bracket in Chapter 4.) The Z6 will expose the requested number of bracketed images regardless of the number of shots per interval requested. Exposure, flash, ADL, and white balance bracketing can all be used.
- 4. Position camera. Mount the camera on a tripod or other secure support.

- 5. **Fully charge the battery.** You might want to connect the Z6 to the Nikon AC adapter power connector if you plan to shoot long sequences. Although the camera more or less goes to sleep between intervals, some power is drawn, and long sequences with bursts of shots can drain power even when you're not using the interval timer feature.
- 6. Make sure the camera is protected from the elements, accidents, and theft.

When you're ready to go, set up the Z6 for interval shooting:

- 1. **Access feature.** Choose Interval Timer Shooting from the Photo Shooting menu. (See Figure 6.11, left.)
- 2. **Specify a starting time.** Highlight Choose Start Day/Time, and press the right directional button. A screen appears allowing you to choose either Now (to begin interval shooting immediately) or Choose Day/Time. To set a start time in the future, highlight Choose Day/Time, and press the right directional button. A screen appears that allows entering a Start Date, H (Hour), and M (Minute). You can set the current date, or up to seven days in the future. Hours are available in 24-hour format. Press OK when you've specified the start time. You'll be returned to the main screen shown in Figure 6.11, left.
- 3. **Set the interval between exposures.** Scroll down to the Interval entry and press the right directional button. In the screen that appears, you can use the left/right buttons to move among hours, minutes, and seconds, and use the up/down buttons to choose an interval from one second to 24 hours. Press the OK button when finished to move back to the main screen.
- 4. **Select the spacing and number of shots.** Highlight Intervals × Shots/Interval and press the right directional button. Use the left/right buttons to highlight the number of intervals (that is, how many times you want the camera activated) and the number of shots taken after each interval has elapsed (as many as nine images taken at each activation). The total number of shots to be exposed overall will be shown at far right once you've entered those two parameters. You can highlight each number column separately, so that to enter, say, 250 intervals, you can set the 100s, 10s, and 1s columns individually (rather than press the up button 250 times!). You can select up to 9,999 intervals, and 9 shots per interval for a maximum of 89,991 exposures with one interval shooting cycle. Press OK to return to the main screen. **Tip:** Your memory card won't hold 89,991 exposures at full resolution!

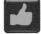

Tip

The interval cannot be shorter than the shutter speed; for example, you cannot set one second as the interval if the images will be taken at two seconds or longer.

5. **Specify Exposure Smoothing.** You can turn this feature on or off. When activated, the Z6 will adjust the exposure of each shot to match that of the previous shot in P, S, or A mode. So, if you want the shutter speed to remain the same for each image (and don't care if the aperture

is adjusted), use Shutter-priority mode. If you'd rather lock in your selected aperture (say, to keep the same depth-of-field), use Aperture-priority mode. Smoothing can also be used in Manual mode, but, of course, the Z6 won't vary either the shutter speed *or* aperture. You must have set ISO Sensitivity to Auto, to allow the camera to conform exposures by adjusting the ISO instead. Press OK to confirm.

- 6. Activate Silent Shooting (if desired). You can choose On or Off for this parameter. When Silent Shooting is activated, the shutter will be silenced. This option comes in handy when you don't want your interval photography to disturb those who might be present, or you don't want them to know that you're shooting entirely.
- 7. **Set Interval Priority.** Scroll down the screen to reveal additional choices shown in Figure 6.11, right. Interval Priority can be set to On or Off. This parameter handles situations in which the shutter speed automatically selected in Program or Aperture-priority ends up being longer than the interval between shots. Perhaps you're shooting outdoors and daylight has waned into night and a shutter speed of, say, 2 seconds is required even though your selected interval is one second.
 - Interval Priority On: The Z6 takes the picture at the specified interval anyway, even though the image may be taken at a shorter shutter speed and, therefore underexposed. You can avoid the underexposure by activating Auto ISO Sensitivity, and selecting a minimum shutter speed that is shorter than the interval time. In that case, the Z6 will increase the ISO setting (if necessary) to produce the correct exposure using the automatically selected shutter speed.
 - Interval Priority Off: The chosen interval is lengthened to allow a correct exposure.
- 8. **Starting Storage Folder.** Highlight New Folder and press the right button to tell the Z6 to create a new folder for each time-lapse sequence. This allows you to easily keep your sequences separate in their own folders. If you've chosen New Folder, you can also activate Reset File Numbering, which resets the numbering of each sequence to 0001 when a new folder is created. It's handy to have each sequence numbered separately.

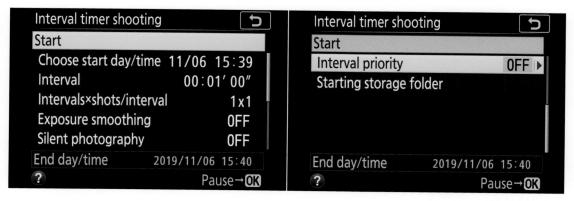

Figure 6.11 Interval timer shooting options.

9. Activate shooting. When all the parameters have been entered, scroll to the Start option at the top of the menu and press OK. If you've selected Now under Start Options, then interval shooting will begin immediately. If you chose a specific date/time instead, the appropriate delay will elapse before recording begins. Leave your camera turned on (and connected to an external power source if necessary). Once you activate interval shooting, immediately before the next shooting interval begins, the shutter speed display shows the number of intervals remaining and the aperture display shows the number of shots remaining in the current interval. Between intervals, you can view that information by pressing the shutter release button halfway; when you release the button, the data appears until the standby timer expires.

PAUSE OR CANCEL INTERVAL SHOOTING

While interval shooting is underway, you can review the images already taken using the Playback button. The monitor will clear automatically about four seconds before the next interval begins. Press the OK button between intervals (but not when images are still being recorded to the memory card) or choose the Interval Timer Shooting menu entry, and select Pause. Interval shooting can also be paused by turning the camera on or off. To resume the Interval Timer Shooting menu again, press the multi selector left button, and choose Restart. You may also select Off to stop the shooting entirely.

Time-Lapse Movies

If you've mastered Interval Photography, shooting Time-Lapse movies to allow the Z6 to capture the individual frames and assemble them into a movie for you is a snap! The settings screen is similar to the one for interval shooting, with some additional options. The key entries include:

- Start. Unlike the similar Interval Timer found in the Photo Shooting menu, Time-Lapse Photography has no Start Options. Make your other settings, select Start, and time-lapse photography will begin automatically about three seconds later. Be sure to double-check your settings before triggering the camera.
- Interval. Select an interval between frames; use a longer value for slow-moving action, such as a flower bud unfolding. You might want to experiment and choose a time between shots of one minute or longer. Some blooms mature faster than others. Use a shorter value for movies, say, depicting humans moving around at a comical pace for a Charlie Chaplin—like effect. This parameter can be set from one second to 10 minutes.
- **Shooting time.** You can specify time-lapse movie duration. The longest movie you can create is a total of 7 hours, 59 minutes. That should be plenty for most applications. Andy Warhol's 1963 flick *Sleep* was only 5 hours, 20 minutes long!
- Exposure smoothing. You can turn exposure smoothing on or off. When activated, the camera adjusts the exposure of each frame to match that of the previous frame in P, S, or A mode. That avoids sudden changes in exposure modes other than Manual exposure (which, of course,

will remain at your manual settings throughout). Smoothing can also be used in Manual mode, but, of course, the Z6 won't vary either the shutter speed *or* aperture. You must have set ISO Sensitivity to Auto to allow the Z6 to compensate appropriately for changes in brightness. Press OK to confirm.

- Silent photography. Silences the shutter sound for unobtrusive or stealth video capture.
- Image area. You must scroll down to view this option, and those that follow. You can select FX-based movie format or DX-based movie format, which I'll explain in detail in Chapter 15. You can also turn Auto DX crop on or off, so the Z6 will recognize DX lenses and crop appropriately.
- Frame size/frame rate. Here you can select the frame size and frames per second setting for your time-lapse movie. You can choose from 4K, 3840 × 2160 30/15/24p; full HD, 1920 × 1060 60/50/30p (in both High Quality and Normal modes, also explained in Chapter 15); and standard HD, 1280 × 720 60/50p formats.
- Interval priority. This setting is similar to its intervalometer counterpart, as explained previously. It takes care of situations in which the shutter speed automatically selected in Program or Aperture-priority ends up being longer than the interval between shots. When enabled, the Z6 captures the movie frame at the specified interval, even though the image may be taken at a shorter shutter speed and underexposed.

To compensate, activate Auto ISO Sensitivity, and select a minimum shutter speed that is shorter than the interval time. The Z6 will boost ISO to allow exposure at the correct interval. When disabled, the camera increases the interval you specified to allow correct exposure. However, with some subjects, the increased time may be visible in the finished movie as a jump or delay.

Multiple Exposures

Some of my very first images captured when I was a budding photographer at age 11 were double exposures. Some were unintentional, as my box camera, using 620-size film, could take several pictures on one frame if you forgot to wind it between shots. But my initial foray into special effects as a pre-teen were shots of my brother throwing a baseball to himself, serving as both pitcher and batter thanks to a multiple exposure.

The Z6's multiple exposure feature is remarkably flexible. It allows you to combine two to ten exposures into one image without the need for an image editor like Photoshop, and it can be an entertaining way to return to those thrilling days of yesteryear, when complex photos were created in the camera itself. In truth, prior to the digital age, multiple exposures were a cool, groovy, far-out, hep/hip, phat, sick, fabulous way of producing composite images. Today, it's more common to take the lazy way out, snap two or more pictures, and then assemble them in an image editor like Photoshop, or use the Z6's Image Overlay feature in the Retouch menu.

However, if you're willing to spend the time planning a multiple exposure (or are open to some happy accidents), there is a lot to recommend the multiple exposure capability that Nikon has

bestowed on the Z6. For one thing, the camera is able to combine two to ten images using the RAW data from the sensor, producing photos that are blended together more smoothly than is likely for anyone who's not a Photoshop guru. To take your own multiple exposures, just follow these steps (although it's probably a good idea to do a little planning and maybe even some sketching on paper first, if that's possible):

- 1. Activate the feature. Choose Multiple Exposure from the Photo Shooting menu.
- 2. **Choose Multiple Exposure mode.** Select Multiple Exposure mode. A submenu appears with three choices:
 - On (series). The Multiple Exposure feature remains active even after you've taken a complete set of exposures for the number of shots you specified. Use this if you want to shoot several multiple exposures in a row. Remember to turn it off when you're done.
 - On (single photo). Once you've taken a single set of multiple exposures, the feature turns itself off.
 - Off. Use this option to cancel multiple exposures.
- 3. **Choose exposures per frame.** Select Number of Shots, choose a value from 2 to 10 with the multi selector up/down buttons, and press OK.
- 4. **Specify ratio of exposure between frames.** Choose Overlay Mode and select Add, Average, Lighten, or Darken.
 - Add. Each new exposure is added to the previous shots, with each individual image fully exposed and overlaid on the others in the frame. Use when photographing a subject that is moving against a dark background, to track movement.
 - Average. The overall exposure is divided by the number of shots in the series, and each image is allocated that fraction of the overall exposure. Use this when shooting subjects with a great deal of overlap.
 - **Lighten.** The camera compares pixels in the same position in each exposure, and uses only the brightest. This effect is similar to the Lighten blending mode in Photoshop, Lightroom, and other image-editing software. Use this to allow the lightest tones of each shot in the series to show through, such as multiple bursts in a fireworks show. The sky will remain dark, but the pyrotechnics will be captured perfectly. You may have to experiment with this setting until you become familiar with what it does to your images.
 - Darken. Similar to the Lighten blending mode, only just the darkest pixel is saved. You'd use this in situations that are the opposite of those typical of the Add selection. That is, if the background is light, and a darker subject is moving across that background, Darken would provide separate images.
- 5. Confirm gain setting. Press OK to set the gain.
- 6. **Keep all exposures?** Ordinarily, the Z6 combines all the shots into a single exposure. However, you can ask the camera to save *all* the individual images in the series by choosing On in the Keep All Exposures entry.

7. **Shoot your multiple exposure set.** Take the photo by pressing the shutter release button multiple times until all the exposures in the series have been taken. (In continuous shooting mode, the entire series will be shot in a single burst.) The blinking multiple exposure icon vanishes when the series is finished. **Reminder:** you'll need to deactivate the Multiple Exposure feature once you've finished taking a set in On (series) mode, as the setting remains even after the camera has been powered off.

Keep in mind if you wait longer than 30 seconds between any two photos in the series, the sequence will terminate and combine the images taken so far. If you want a longer elapsed time between exposures, go to the Playback menu and make sure On has been specified for Image Review, and then extend the Standby Timer using Custom Setting c3: Power Off Delay to an appropriate maximum interval. The camera will grant you an additional 30 seconds beyond that. The Multiple Exposure feature will then use the monitor-off delay as its maximum interval between shots. To capture Ana Popović, the world's best Serbian blues guitarist, for Figure 6.12, I used a three-shot multiple exposure.

Figure 6.12
The Z6's Multiple
Exposure capability
allows combining
images without an
image editor.

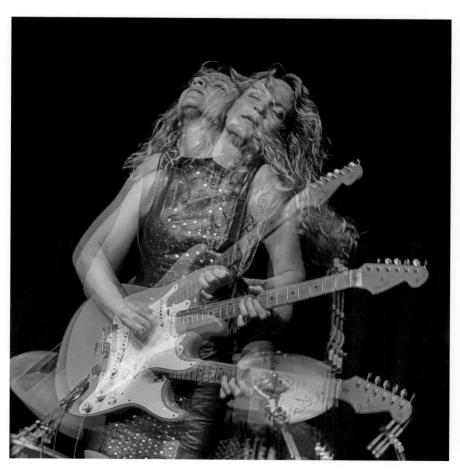

Geotagging with the Nikon GP-1a

A swarm of satellites in geosynchronous orbits above Earth became a big part of my life even before I purchased the Nikon Z6. I use the GPS features of my iPhone Xs Max and iPad Air and the GPS device in my car to track and plan my movements. When family members travel without me—most recently to Europe—I can use the Find my iPhone feature to see where they are roaming and vicariously accompany them with Google Maps' Street View features. And, since the introduction of the Nikon GP-1a accessory, GPS has become an integral part of my shooting regimen, too.

The GP-1a unit makes it easy to tag your images with the same kind of longitude, latitude, altitude, and time stamp information that is supplied by the GPS unit you use in your car. (Don't have a GPS? Photographers who get lost in the boonies as easily as I do *must* have one of these!) The geotagging information is stored in the metadata space within your image files, and can be accessed by Nikon NX-i, or by online photo services such as mypicturetown.com and Flickr.

Geotagging can also be done by attaching geographic information to the photo after it's already been taken. This is often done with online sharing services, such as Flickr, which allow you to associate your uploaded photographs with a map, city, street address, or postal code. When properly geotagged and uploaded to sites like Flickr, users can browse through your photos using a map, finding pictures you've taken in a given area, or even searching through photos taken at the same location by other users. Of course, in this day and age it's probably wise not to include GPS information in photos of your home, especially if your photos can be viewed by an unrestricted audience.

Having this information available makes it easier to track where your pictures are taken. That can be essential, as I learned from a trip out west, where I found the red rocks, canyons, and arroyos of Nevada, Utah, Arizona, and Colorado all pretty much look alike to my untrained eye. I find the capability especially useful when I want to return to a spot I've photographed in the past and am not sure how to get there. I can enter the coordinates shown into my hand-held or auto GPS (or an app in my iPad or iPhone) and receive instructions on how to get there. That's handy if you're returning to a spot later in the same day, or months later.

Like all GPS units, the Nikon GP-1a obtains its data by triangulating signals from satellites orbiting Earth. It works with the Nikon Z6, as well as many other Nikon cameras. At about \$312, it's not cheap, but those who need geotagging—especially for professional mapping or location applications—will find it to be a bargain.

The GP-1a (see Figure 6.13, left) slips onto the accessory shoe on top of the Nikon Z6. It connects to the remote/accessory port on the camera using the Nikon GP1-CA90 cable, which plugs into the connector marked CAMERA on the GP-1a.

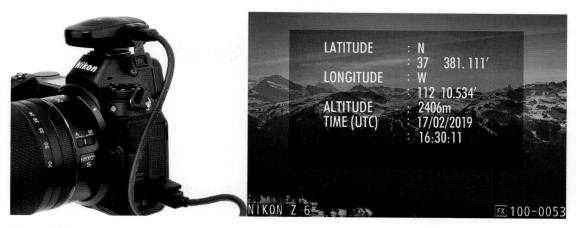

Figure 6.13 Nikon GP-1a geotagging unit (left). Captured GPS information can be displayed when you review the image (right).

EXTRA REMOTE

The GP-1a has a port labeled with a remote-control icon, so you can plug in the Nikon MC-DC2 remote release, and it will work just fine, even when the GPS accessory is attached.

A third connector connects the GP-1a to your computer using a USB cable. Nikon has released a utility for Windows and Mac operating systems that allows you to read GPS data from the GP-1a directly in your computer—no camera required. I tried the driver, and discovered that the GP-1a couldn't "see" any satellites from inside my office (big surprise). I plan on trying it with my netbook outdoors, in a car, or in some other more satellite-accessible location. Once attached, the device is very easy to use. You need to activate the Nikon Z6's GPS capabilities in the GPS choice within the Setup menu, as described in Chapter 13.

The first step is to allow the GP-1a to acquire signals from at least three satellites. If you've used a GPS in your car, you'll know that satellite acquisition works best outdoors under a clear sky and out of the "shadow" of tall buildings, and the Nikon unit is no exception. It takes about 40 to 60 seconds for the GP-1a to "connect." A red blinking LED means that GPS data is not being recorded; a green blinking LED signifies that the unit has acquired three satellites and is recording data. When the LED is solid green, the unit has connected to four or more satellites, and is recording data with optimum accuracy.

Next, set up the camera by selecting the GPS option found under Location Data in the Setup menu on the Nikon Z6. There are four choices:

- **Download From Smart Device.** This setting allows you to download GPS/location data collected by your smart device, and then embed that information in the EXIF metadata within the image file. Choose Yes, and the data will be included *when you are not using a GPS device* while the two are connected for a period of up to two hours while the camera is powered up and the standby timer has not expired. If the GPS unit is connected, its location data *will be used instead* when both the GPS and smart device are in play.
- Standby Timer. Setting to Enable reduces battery drain by enabling turning off exposure meters while using the GP-1/1a after the time specified for the Standby Timer in Custom Setting c3: Power Off Delay (discussed in Chapter 12) has elapsed. When the meters turn off, the GP-1/1a becomes inactive and must reacquire at least three satellite signals before it can begin recording GPS data once more. Setting to Disable causes exposure meters to remain on while using the GP-1/1a, so that GPS data can be recorded at any time, despite increased battery drain.
- **Position.** This is an information display, rather than a selectable option. It appears when the GP-1/1a is connected and receiving satellite positioning data. It shows the latitude, longitude, altitude, and Coordinated Universal Time (UTC) values.
- Set Clock From Satellite. Choose Yes to allow the camera to update its internal clock from information provided by the GPS device when attached. Choosing No disables this updating feature. You might want to avoid updating the clock if you're traveling and want all the basic date/time information embedded in your image files to reflect the settings back home, rather than the date and time where your pictures are taken. Note that if the GPS device is active when shooting, the local date and time will be embedded in the GPS portion of the EXIF data.

Once the unit is up and running, you can view GPS information using photo information screens available on the color monitor (and described in Chapter 2). The GPS screen, which appears only when a photo has been taken using the GPS unit, looks something like Figure 6.13, right.

Focus Shift Shooting

If you are doing macro (close-up) photography of flowers, or other small objects at short distances, the depth-of-field often will be extremely narrow. In some cases, it will be so narrow that it will be impossible to keep the entire subject in focus in one photograph. Although having part of the image out of focus can be a pleasing effect for a portrait of a person, it is likely to be a hindrance when you are trying to make an accurate photographic record of a flower, or small piece of precision equipment. One solution to this problem is focus stacking (which Nikon calls "Focus Shift Shooting"), a procedure that can be considered like HDR translated for the world of focus—taking multiple shots with different settings, and, using software as explained below, combining the best parts from

each image in order to make a whole that is better than the sum of the parts. Focus stacking requires a non-moving object, so some subjects, such as flowers, are best photographed in a breezeless environment, such as indoors.

With the Z6's Focus Shift Shooting feature, the camera takes a series of pictures, adjusting the focus slightly between each image, refocusing from closest to your subject to the farthest point that needs to appear sharp. You end up with a series of up to 300 different images that can be combined using two simple Photoshop commands, which I will describe shortly.

You can visualize how focus stacking works if you examine Figure 6.14, which is cropped versions of three actual frames from one of my own focus shift series. All three used an exposure of 1/30th

Figure 6.14
Closest focus (top),
farthest focus
(center), merged
image (bottom).

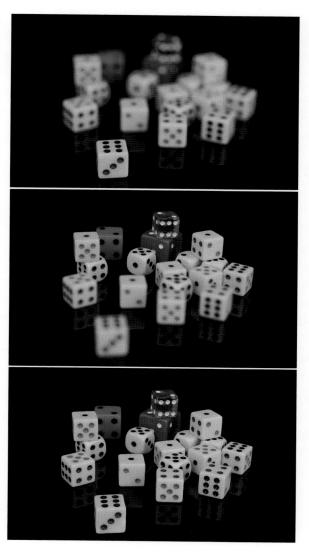

second at f/4 with my 50mm f/1.8 Nikkor-S. At top is the original exposure, with the lens focused on the closest die. The center image shows the 35th exposure in the series, in which the focus shift feature had adjusted focus on the red die in the back. In between were 33 intermediate-focus shots that I merged in Photoshop to produce the finished image at bottom. Here are the detailed steps you can take to use Focus Shift shooting for your own deep-focus images:

- 1. **Set the camera firmly on a solid tripod.** A tripod or other equally firm support is absolutely essential for this procedure. You don't want the camera (or the subject) to move at all during the exposures.
- 2. Attach a remote release, such as the MC-DC2. You want to be able to trigger the camera without moving it. However, the procedure does pause for a short period of time once you activate it, perhaps giving your tripod/camera time to settle down.
- 3. Attach a lens with an appropriate focus range. Focus Shift uses the lens's built-in autofocus motor, so you cannot use a manual focus lens or one that does not have an internal autofocus motor.
- 4. **Set the focus modes.** Activate AF-S (single focus) as your focus mode and Single-Point AF as your AF-area mode. The lens switch must be set to Autofocus.
- 5. **Set the quality of the images to JPEG FINE** *. Use the Photo Shooting menu to make this adjustment.
- 6. **Set the exposure, ISO, and white balance manually.** Use test shots if necessary to determine the best values. This step in the Photo Shooting menu will help prevent visible variations from arising among the multiple shots that you'll be taking. You don't want the camera to change the exposure, ISO setting, or white balance between shots.
 - **Note:** Even though you'll be effectively increasing depth-of-field through focus stacking, you should still avoid the widest apertures of your lens, as they are rarely the sharpest f/stops. I always stop down at least 1.5 f/stops—using f/4 in the example. Shutter speed is not as important, because the camera is on a tripod, but I tend to avoid very slow speeds anyway. You can manually set a slightly higher ISO sensitivity, if needed, to obtain the shutter speed/aperture combination you want to use.
- 7. **Turn off image stabilization.** Disable Vibration Reduction in the Photo Shooting menu. If your FTZ-adapted lens has VR, slide the VR switch to Off.
- 8. **Set focus point to nearest object.** Use the directional buttons to position the red focus box on the subject nearest the camera lens.
- 9. **Access the Focus Shift Shooting menu.** You'll find it near the end of the Photo Shooting menu, and shown at left in Figure 6.15.

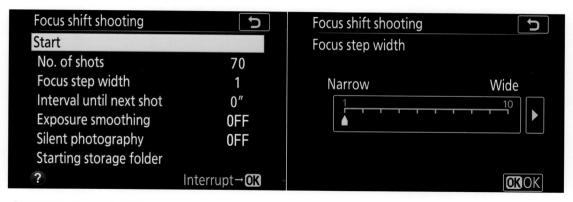

Figure 6.15 Focus Shift Shooting options.

Select an appropriate setting for each of the following six parameters, using my guidelines:

- No. of Shots. You can choose from 1 to 300 individually refocused shots. The number of images captured will depend on how finely you want to have the Z6 change focus between shots (and you'll combine this with the step width option described next). I rarely need more than 50 shots, and used only 35 for the example shown earlier in Figure 6.14.
- Focus Step Width. You can specify values from 1 (a narrow slice per adjustment) and 10 (a much wider focus change). Nikon does not specify how much each increment changes the focus, for a very good reason: it *can't*. Depending on the focal length of your lens and your f/stop, the effective plane of apparent focus may vary from narrow, to very narrow, to supernarrow in macro shooting environments. (If you're confused, see "Circles of Confusion" in Chapter 5.)

You may need some trial-and-error to choose the correct number of shots and focus step width. For example, with 50 shots and a wide focus step, the first 10 may encompass your entire subject and the last 40 may be wasted on completely out-of-focus images. It's often worthwhile to take a test shot, view a slide show of all your images, and decide whether to increase/decrease the number of shots and/or focus step width.

- Interval Until Next Shot. You can select 00 seconds to 30 seconds. At 00 seconds, the Z6 will take all the photos consecutively at a rate of 5 frames per second in Single Shot, or either Continuous mode. The 00-second setting works well when shooting by ambient light that doesn't change. However, you can use flash, too. Just specify an interval that is greater than the maximum recycle rate of your flash.
- Exposure Smoothing. I recommend shooting under a steady, constant source of illumination and using Manual exposure. However, if you're working outdoors that may not be possible. In that case, in semi-automatic modes turn Exposure Smoothing On and allow the Z6 to match exposure between frames. Exposure Smoothing works in Manual exposure mode, too, if you enable Auto ISO Sensitivity so the camera can change ISO sensitivity during your sequence if required.

- **Silent Photography.** You can capture your images silently using the electronic shutter if you activate this option. I prefer to hear the comforting click as my camera captures its sequence, but if you're in stealth or "do not disturb" modes, silent photography is available.
- Starting Storage Folder. Choose New Folder, and each time you shoot a sequence, the Z6 will create a fresh folder. I can't think of a reason you would not want to do that. Select Reset File Numbering, and the file numbering is reset each time a new folder is created, which makes it easier to differentiate between the first, last, and in-between images of your set.
- 10. **Capture images.** When all the parameters are locked in, highlight Start and press the OK button. The LCD monitor displays a "Preparing..." message and then commences the capture within a second or two. Note that Focus Shift is not "sticky." Once you've grabbed a sequence, the feature is turned off and you must Start again to repeat, or change parameters and Start anew.
- 11. Combine your images. I'll describe the steps for that next.

The next step is to process the images you've taken in Photoshop. Transfer the images to your computer, and then follow these steps:

- 1. In Photoshop, select File > Scripts > Load Files into Stack. In the dialog box that then appears, navigate on your computer to find the files for the photographs you have taken, and highlight them all.
- 2. At the bottom of the next dialog box that appears, check the box that says, "Attempt to Automatically Align Source Images," then click OK. The images will load; it may take several minutes for the program to load the images and attempt to arrange them into layers that are aligned based on their content.
- 3. Once the program has finished processing the images, go to the Layers panel and select all of the layers. You can do this by clicking on the top layer and then Shift-clicking on the bottom one.
- 4. While the layers are all selected, in Photoshop go to Edit > Auto-Blend Layers. In the dialog box that appears, select the two options, Stack Images and Seamless Tones and Colors, then click OK. The program will process the images, possibly for a considerable length of time.
- 5. If the procedure worked well, the result will be a single image made up of numerous layers that have been processed to produce a sharply focused rendering of your subject. If it did not work well, you may have to take additional images the next time, focusing very carefully on small slices of the subject as you move progressively farther away from the lens.
- 6. You'll want to flatten the final image before saving it. Given the 24 MP resolution of the Z6, the stack of individual shots will easily be more than 2GB, which exceeds the maximum file size of some storage media and/or OS file systems.

Although this procedure can work very well in Photoshop, you also may want to try it with programs that were developed more specifically for focus stacking and related procedures, such as Helicon Focus (www.heliconsoft.com), PhotoAcute (www.photoacute.com), or CombineZP (https://alan-hadley.software.informer.com/).

Trap (Auto) Focus

Trap focus comes in handy when you know where the action is going to take place (such as at the finish line of a horse race), but you don't know exactly *when*. The solution is to prefocus on the point where the action will occur, and then tell your camera not to actually take the photo until something moves into the prefocus spot (see Figure 6.16). It's a good technique for sports action when you know that, say, a runner is going to pass by a certain position. You can also use trap focus for hand-held macro shots—set focus for a particular distance and then move the camera toward your subject. The shutter will trip automatically when your subject comes into focus.

Figure 6.16

By prefocusing on the area between two hurdles, trap focus captured the center athlete the instant he moved into the point of focus.

Trap focus isn't as difficult as you might think. The key is to decouple the focusing operation from the shutter release function, just as you do with back button focus. Just follow these steps:

- 1. **Confirm AF-ON button.** First, access Custom Setting f2 and make sure the definition for the AF-ON button is set to its default value, AF-ON, and not some other behavior. You want the AF-ON button to activate autofocus.
- 2. **Disable Out-of-Focus Release.** Navigate to Custom Setting a7: AF Activation. Highlight AF-ON Only, press the right button, and set Out-of-Focus Release to Disable. Then, pressing the shutter release halfway down does *not* activate autofocus. That happens *only* when you press the AF-ON button.
- 3. **Set Custom Setting a2 to Focus Priority.** Because you've just disabled Out-of-Focus Release (above), henceforth the shutter will trip only when your subject is in focus.
- 4. **Set focus mode to AF-S.** Press the Fn2 button and rotate the main command dial to select Single Focus.
- 5. **Set your point selection mode to Single-point AF.** Press the Fn2 button and rotate the subcommand dial to select the Single-point AF-area mode.
- 6. Make sure your lens is set to autofocus (either A or M/A). Duh! And yet some people forget this step.
- 7. **Prefocus on the spot where the action will occur, or an equivalent distance.** I like to manually focus on that point to make sure it is the exact position I want to capture. For Figure 6.16, I focused on a plane between the third and fourth hurdles, which were located 30 feet apart (the standard for men's hurdle events). You can also press the AF-ON button to focus on that point, and then release the button. In either case, further AF activity will cease. The prefocused distance is the "trap" you've set for your pending subject.
- 8. Reframe your picture, if necessary, so that nothing is at the prefocused distance. (If an object occupies that spot, the camera will take the photo immediately when you press the shutter release.)
- 9. Press and hold down the shutter release all the way. The camera will not refocus, because you've disconnected the autofocus function from the shutter release. Nor will it take a picture, because Focus-priority has been set. You can now reframe your image to the point where the action will take place.
- 10. **Trap sprung!** The picture will be taken when a subject moves into the prefocused area. Note that trap focus may not work well with some subjects, particularly when using small f/stops. Increased depth-of-field may cause the Z6 to take the photo when your subject has barely entered the trap and not yet perfectly in the preselected focus plane. Even so, trap focus is a very useful technique.

DANGER, WILL ROBINSON!

If you don't use trap focus often, or don't work with the AF-ON button as your primary autofocus start control regularly, don't make the mistake I did. One time I forgot that I had followed the steps above, and used a different camera in the interim. The next time I picked up my Z6, it "refused" to autofocus—at least when I pressed the shutter release halfway. Much consternation followed until I remembered what I had done a few days earlier, pressed the AF-ON button, and found that the AF function was just fine. I had simply "turned off" the shutter release as an AF start control. While in olden times it was common to keep a settings log, the Z6 has a simpler way of heading off this problem. Just dedicate a User Setting to the parameters I describe above for trap focus. Then spin the mode dial to that position (U1, U2, or U3) when you want to use trap focus, and switch to a different position on the dial to return to your previous settings. I'll show you how to save User Settings in Chapter 13.

Using SnapBridge

Nikon has elected to blaze a trail of its own in implementing wireless connectivity on the Z6, using a new system it calls SnapBridge. It features both Bluetooth LE (Low Energy) and Wi-Fi connections. You can connect to your computer over Wi-Fi, or to your smart device running the SnapBridge app using *either* Wi-Fi or Bluetooth. Bluetooth can safely be left active at all times, because it provides little drain on the Z6's battery when not being actively used. That makes connecting camera and smart device much quicker. A Wi-Fi connection, using the Z6's built-in Wi-Fi access point, is the *required* choice for movies and a good idea for transferring large numbers of images in one session.

WI-FI COMPUTER CONNECTIONS

Unless you have LAN or IT experience, all the options available (and explained in Nikon's lengthy 60-page Network Guide) probably will have your eyes glazing over. Indeed, Page X of the guide says it "assumes basic knowledge of wireless LANs." *Wait, what?*

You can link the Z6 to your computer using the camera's built-in wireless local area network by access-point mode, by infrastructure mode using a wireless router, or using Nikon's optional, but very pricey (about \$750) WT-7a transmitter. The latter has both wireless and Ethernet connections and can upload photos and movies to a computer, your smart device, or FTP server, plus control the Z6 remotely using the optional Camera Control 2 software, or view/capture pictures (but *not* movies) wirelessly with a browser on your computer or smart device.

All this is beyond the scope of this book, even if there were room for a 60-page chapter that deals with computer technology rather than photography. Instead, I'm going to provide you with an introduction to SnapBridge that should get you up and running, and urge you to download the Network Guide PDF from your country's Nikon website, and use that if you need more help.

Here's some of what you can do with SnapBridge:

- **Auto uploads.** You can use SnapBridge to automatically upload JPEG images (but not RAW files) from your camera to your smart device.
- **Upload selected photos.** During image review (Playback mode), you can press the *i* button and choose Select to Send to Smart Device/Deselect to choose specific images to transfer to your smart device. You can also use the Select to Send to Smart Device entry in the Playback menu. Up to 1,000 photos can be marked for upload in one session.
- Resize images. Obviously uploading full-resolution images to your smart device would be slow and use a lot of storage space on your device. SnapBridge defaults to low-resolution 2-megapixel images (which should be fine for smart device display or sharing on social media), and the app lets you specify a different upload size.
- Add credits. The app also lets you choose to embed comments and copyright information entered in the Setup menu (as described in Chapter 13) or entered using the SnapBridge app itself.
- Multiple devices. If you own multiple phones and tablets, you can pair the camera with as many as five different devices. However, the Z6 can connect to only one at a time. You can manually switch between devices using the connection options described shortly.
- **Remote control.** You can trigger the shutter using your smart device (as long as the camera is on), giving you wireless remote control without the need of purchasing an accessory.
- Imprint photos. You can overlay comments or the time the photo was taken.

As I noted earlier, the Z6's SnapBridge app supports camera-to-smart-device communications. Your first step in using SnapBridge is to download and install the SnapBridge app onto your smart device from the Google Play store or the Apple iTunes store. There are several ways to connect your Z6 to your device, either using the Setup menu's Connect to Smart Device entry or by loading the SnapBridge app and using its Connect feature.

Make sure both Bluetooth is enabled on your smart device, and the Airplane mode in the Z6's Setup menu is set to Off. Then follow these steps to link your camera and device using the camera's Setup menu. Your screens may vary depending on whether you are using an Android or iOS device, and whether Nikon has issued one of its frequent updates to SnapBridge since this book went to press. Version 2.5.3 was current as I wrote this book. You may need to use your device's Settings menu to connect to the camera, which will appear as a connection option in the device's Bluetooth and Wi-Fi entries.

- 1. **Open the SnapBridge app.** Access the app on your device and tap the menu at upper right represented by three dots, and circled in green at left in Figure 6.17. Choose Add Camera from the screen that appears next. Select Mirrorless Camera in the next screen (Figure 6.17, center left), and then Pairing (Bluetooth) in the Connection Type screen seen center right in the figure.
- 2. **Read the instructions.** Help screens will appear telling you what to do next using the Z6's Connect to Smart Device menu entry. Follow the directions, and tap Understood when you've followed them. The app will search for available connections.

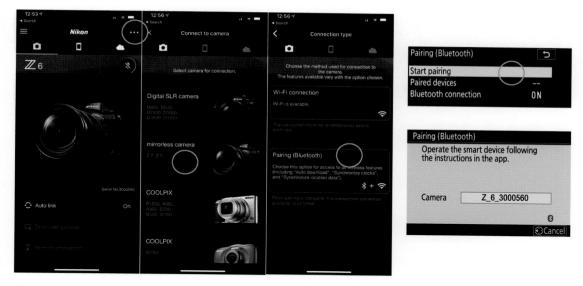

Figure 6.17 Connecting to a smart device with SnapBridge.

- 3. **Navigate to Connect to Smart Device in the Setup menu.** As with all menu entries, and those that follow in this list, proceed by pressing the right directional arrow or pressing OK. Choose Pairing (Bluetooth) and when the screen shown in Figure 6.17, upper right, appears, choose Start Pairing.
- 4. **Begin connection.** Return to the Connect to Smart Device screen on the Z6, choose Start, and press the right button. Initially, you should see a screen like the one at lower right in Figure 6.17. Follow the directions on the screens that appear, which will look something like those in Figure 6.18, left, depending on your smart device.
- 5. **Confirm connection.** The name of your camera on the smart device will be the same displayed on the Z6's display.
- 6. **Select an Accessory.** This screen (see Figure 6.18, center) appears next on your smart device. Tap your camera's name.
- 7. **Connect Bluetooth.** The Bluetooth Pairing Request message appears on the device (see Figure 6.18, lower right), along with an authorization code. The same code will appear on the Z6's LCD monitor. If they match, press/tap OK on the camera and tap Pair on the device screen.
- 8. **Pairing success**. When pairing is completed successfully, the screen shown at upper right in Figure 6.18 will appear on the Z6. Press OK, and, depending on your release of SnapBridge, two more screens may be shown asking for permission for the smart device to share location data with the camera and to synchronize the camera with the smart device's information. Select Yes and press the right directional button or the OK button to confirm each. A "Done" message appears and you'll return to the Setup menu.

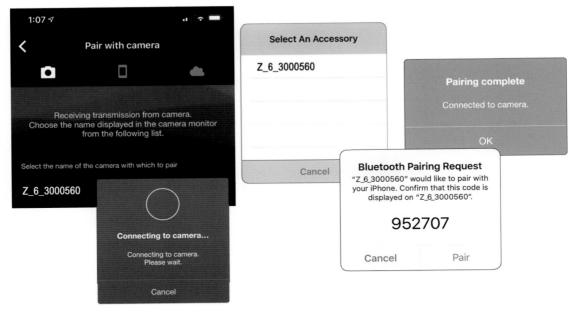

Figure 6.18 The Z6's connection screens lead you through linking your camera and smart device.

- 9. **Choose autosend (Optional).** If you want your images to be transferred automatically, choose Send to Smart Device (Auto), and in the screen that appears, select and confirm On.
- 10. **Activate Bluetooth.** Next, return to the Connect to Smart Device entry in the Setup menu of the Z6, and find the Send While Off entry. Enable it if you'd like to allow the camera to maintain a Bluetooth connection with your device and continue to upload images even when the Z6 is powered down. **Note:** This setting will consume even more power if you have many images to upload. Your images will be stored in the Snapshot Gallery in the app.
- 11. **Use both Wi-Fi and Bluetooth.** If you have an iOS device, you can connect using both Wi-Fi and Bluetooth. Pair your Z6 with the camera using the Settings menu of your smart device, but Wi-Fi is faster and used for transferring movies or large numbers of files. You can connect your smart device to the camera using Wi-Fi through your device's Settings menu, too. I'll explain the Wi-Fi option shortly.

Using the SnapBridge App

When you first access the SnapBridge app, you'll be invited to register for Nikon Image Space and receive a Nikon ID. Just follow the instructions presented on your smart device to create an account and register a password.

The SnapBridge app itself has a fairly simple interface. There are three icons at the top of the main screen, representing the Camera, Smart Device, and Cloud (see Figure 6.19, left). Tapping each icon takes you to a page of functions, which I'll describe separately.

Figure 6.19 Camera page (left); Auto link options (center); Download pictures (right).

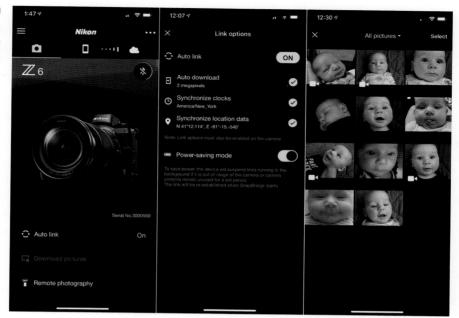

Camera Page

The page with the Camera icon has a menu at upper left and upper right, represented by three lines and three dots, respectively. The rest of the screen is occupied by an image of the camera, and three functions arrayed underneath.

Autolink

You can allow SnapBridge to automatically connect to your camera when the camera is powered up and you launch the SnapBridge app on your device. The screen that appears (see Figure 6.19, center) has four options:

- Auto download. You can enable automatic download of compact, 2 MP images or disable auto download from your camera to your device entirely. Note that if you prefer to manually download photos, as I'll describe shortly, you can also elect to transfer full resolution images.
- Synchronize clock. You can synchronize your camera's internal clock from the information supplied by your smart device (which generally will have access to GPS and precise time information). If you enable that behavior here, you must also have answered Yes to the Z6's setup prompt "Sync clock with smart device?" as described in Step 8 above.
- Synchronize location data. You can elect to include the location from which your uploads are made (using your device's GPS features), or disable sharing that information for privacy reasons. If you enable that behavior here, you must also have answered Yes to the Z6's prompt "Download location data from smart device?" as described in Step 8 above.

■ Power saving mode. When enabled, your smart device will suspend its link to the camera when the camera controls aren't being accessed or the camera is out of range. The device and camera will relink when the two are within range of each other and you are using SnapBridge.

Download Pictures

When you tap Download Pictures, a message appears reminding you that you must switch from a Bluetooth connection to your smart device to a connection using the Z6's built-in Wi-Fi Hot spot. Then follow these steps:

- 1. When the Enable Camera Wi-Fi screen appears, tap OK.
- 2. A message "SnapBridge Wants to Join Wi-Fi Network "Z_6_xxxxxxx_SnapBridge" appears. Tap Join. The first time you connect, you'll see screens similar to those in Figure 6.20. You may need to go to your device's Settings screen and manually connect to the camera's Wi-Fi hotspot, as shown in Figure 6.21; thereafter, the connection should be made automatically.
- 3. A screen showing available photos on your camera appears. (Seen earlier in Figure 6.19, right.) Tap Select and then tap the individual images you want to transfer.
- 4. When finished, tap Download to transfer from the camera to your smart device. You can select either 2 MP or Original Size images.
- 5. Start download.
- 6. **Note:** You can mark images using the Select to Send to Smart Device entry in the Playback 2 menu, as well, and then download them from there. You might want to do this whenever you've disabled automatic downloads and want to set up the transfer at the camera.

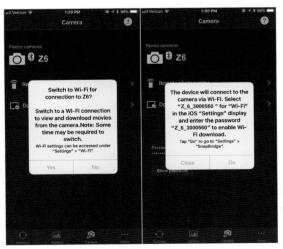

Figure 6.20 Follow the directions on the Wi-Fi connection screens.

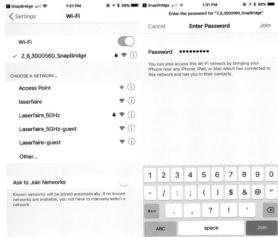

Figure 6.21 You may need to link to the camera's Wi-Fi hotspot in your device's Settings menu.

Remote Photography

Tap Remote Photography and the camera switches the Z6 into live view mode display on your smart device. You can see the camera image and then take photos using your phone or tablet. (See Figure 6.22, left.) You'll need to switch to a Wi-Fi connection to shoot remotely. Don't worry, the Z6 has its own built-in Wi-Fi access point. If you are using an iOS device, just follow the instructions in the section that follows this one; your Android device will lead you through the steps automatically.

Top Left Menu

The menu at top left of the screen represented by three lines has three choices: Notices (which presents news and reminders from Nikon, including firmware updates for your Z6), Help, and App Options. Your App Options are shown in Figure 6.22, right, and include:

- Location Data Accuracy. You can choose the level of detail for GPS information imported from your smart device.
- **Nickname.** Choose the name for your smart device.
- Show credits. You can enable adding credit information to each photo when it's downloaded.
- Add hashtag. Define a hashtag to be appended to your uploaded photos on social media.
- Nikon ID signup/edit profile. Use this to sign up for a free Nikon Image Space account, or to change your account settings.
- Terms of Use. Nikon's usage terms and restrictions are shown here.
- **Support.** Provides a five-screen tutorial that, in general, tells you things you already know if you've gotten this far.

Top Right Menu

This menu, not shown in a figure, has just four options:

- Add camera. Link to a new camera, or relink to one that no longer connects reliably.
- Switch cameras. If you own more than one SnapBridge-compatible camera, you can switch from your current camera to one or more additional cameras here.
- Forget camera. If I am having trouble connecting to a camera, I can tell SnapBridge to "forget" about that camera. It's a good idea to go to your smart device's Settings screen and remove that camera as a Wi-Fi hotspot as well. Then I can go through the Add Camera process to re-link. That fixes many potential problems, including glitches that pop up when you upgrade to a newer version of the SnapBridge app.
- Wi-Fi mode. Allows you to set up a Wi-Fi connection or to reconnect to a network that has been set up previously. Just follow the directions on the screen of your smart device.

Nikon

Nikon

Nikon

Nikon

Nikon Mage Space

Launch an app

Connect to camera and download images

The downloaded mages will be displayed.

Figure 6.22 Remote photography using your smart device (left); App options (right).

Figure 6.23 Screens for Smart Device (left) and Cloud (right) options.

Smart Device

Tapping the center "device" icon takes you to a screen like that shown in Figure 6.23, left. Tap the center of the screen to display the images that have already been downloaded to your smart device. They'll be shown on a screen similar to the one shown earlier at right in Figure 6.19. The upper left (three line) menu is the same as for the Camera screen. The upper right menu (three dots) has just one option: Select Photos, plus Cancel.

Once you select photos, you can tap the Trash icon to delete them or the Upload icon (at bottom left) to transmit them using options available for your smart device. For my iPhone, the choices include sending by SMS message, posting on Facebook, adding to Notes, sending by E-mail, Twitter, Instagram, plus a handful of other options, including printing.

Cloud

This screen, seen in Figure 6.23, right, allows you to log in or out of your Nikon Image Space Account, activate Auto upload to Image Space, and designate whether images should be uploaded only by Wi-Fi (rather than using your smart device's cellular data allowance. Tap the Image Space area in the center of the screen, and you can view the number of images you've uploaded to Image Space, as well as the number of images available locally. While, images can be auto uploaded from the device to Nikon Image Space so they will be immediately available over the Internet. I generally leave auto download turned off most of the time so I can select images for transfer at a later time, but activate it when I am shooting "tethered" and want to have, say, 2 MP images quickly transferred to the smart device for review.

Focus on Lenses

It's not an overstatement to say that Nikon has built its reputation on its expertise in lenses. Founded in 1917 as Nippon Kogaku, K.K. (Japan Optical Company), the company specialized in optics for many years before it began producing cameras. In fact, all Canon cameras through mid-1947 used Nikkor lenses!

Of course, in the ensuing years Nikon has developed advanced camera technology, too, combining its proficiency in both arenas to produce the Z-series mirrorless cameras and S-series lenses. Photographers who started out using Nikon camera bodies and optics have tended to hang onto their lenses for many years, even as they upgraded to newer camera bodies with more features. Indeed, many of us have stuck with the Nikon brand at least partially because we were able to use our existing kit of lenses with our latest and greatest camera. After all, an enthusiast's optics collection can easily have cost many times the price of the body itself.

Backward compatibility of lenses is a 60-year tradition for Nikon, which is what makes the Z6's all-new Z-mount so interesting and exciting. Nikon's SLR and dSLR product lines have always, with few exceptions, been able to work surprisingly well with virtually all Nikkor F-mount lenses dating back to the very first, introduced with the Nikon F itself in April 1959, and emblazoned *Nikkor-S Auto 1:2 f=5cm* (a 50mm f/2 lens). Since then, Nikon has sold more than 110 million F-mount lenses, and millions more are available from third parties like Tamron, Sigma, and Tokina. Nearly all are compatible with every Nikon single-lens reflex built since then, although those made before 1977 may need an inexpensive \$35 modification to be used safely on bodies that debuted after that.

So, introducing the brand-new Z-mount for Nikon's first full-frame mirrorless camera could have been a risky proposition, and perhaps not worth the possibility of current Nikon owners migrating to a different mirrorless platform, including current industry leader Sony and newcomer Canon. Fortunately, Nikon anticipated this possibility, and announced the Nikon Mount Adapter FTZ at

the same time as the Z6 and Z7 cameras. Hundreds of F-mount Nikon lens models are compatible, from the AF-S Fisheye Nikkor 8-15mm f/3.5-4.5E ED zoom to the AF-S Nikkor 800mm f/5.6E FL ED VR super-telephoto, plus four Nikon teleconverter add-ons.

The availability of the FTZ adapter was essential to the success of the Z-series cameras for these three reasons:

■ **Dearth of native lenses.** The adapter compensates for the tiny number of native Z-mount lenses available for the Z6 and Z7 at introduction. Only four lenses were announced along with the cameras: the Nikkor Z 24-70mm f/4 S, Nikkor Z 35mm f/1.8 S, Nikkor Z 50mm f/1.8 S, and Nikkor Z 58mm f/0.95 S Noct. The 24-70mm "kit" lens and 35mm f/1.8 shipped at the same time as the Z6, while the 50mm f/1.8 became available a few months later, followed by the introduction in early 2019 of a fifth lens, the 14-30mm f/4 zoom. The super-fast 58mm f/0.95 manual focus lens was promised for early 2019. The huge number of legacy F-mount lenses—which many early Z6 and Z7 owners will already own—allows Nikon to introduce additional Z-mount optics at a reasonable pace. Five more lenses are slated for unveiling in 2019, and at least three more scheduled for the following year.

Meanwhile, most of us are delighted we can use our favorite F-mount lenses on the Z6, or can purchase and use specialty lenses that may not be introduced in Z-mount for some time. My own 105mm f/1.4E ED lens (shown in Figure 7.1) is one of my favorite accessories for my Nikon mirrorless camera.

■ Current owner loyalty. Many current Nikon dSLR owners have been coveting the lighter weight, compact size, and other advantages of mirrorless cameras, and while there have been some defections, a large number of us have been waiting for an alternative from Nikon more suited to the enthusiast's needs than the ill-fated Nikon 1 line. Indeed, Nikon expects current Nikon dSLR fans to make up the bulk of purchases for the Z6 and Z7. The FTZ adapter makes the adoption of either new Z-mount camera much more seamless and less painful.

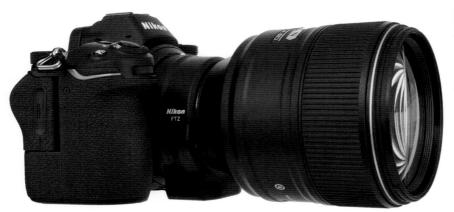

Figure 7.1 Nikon's excellent 105mm f/1.4 E ED F-mount lens is a perfect match for the Z6.

■ **Technical innovations.** Nikon could have, perhaps, provided the Z-series cameras with a lens mount that would accept F-mount lenses without an adapter. However, that would have meant larger lenses, and the submitting to the technical restrictions imposed by the venerable 60-year-old lens system. The F-mount, designed for film cameras, has a 44mm "throat" and a flange to focal plane (*registration*) distance of 46.5mm. These dimensions impose severe restrictions on lens design, including the maximum size of the largest aperture, and the angles at which photons can approach the sensor.

In contrast, the Z-mount's diameter is a generous 55mm, and the flange/registration distance a mere 16mm, the least of any competing camera from Nikon, Canon, Sony, Panasonic, Olympus, or Fujifilm. Nikon says it can use the mount's flexibility to design lenses that are both faster and optically superior. Indeed, the "S" moniker is said to *represent* Superior.

As a bonus, the reduced flange dimension means there is plenty of room between the sensor and the rear mount of many lenses designed for other camera platforms to be accommodated by additional adapters. Third-party manufacturers have already announced such add-ons to allow using certain Canon, Yashica/Contax, Leica, Minolta, Nikon, Pentax, and Olympus lenses in manual focus and exposure mode on the Z6 and Z7. Although Nikon would prefer you purchase Nikkor lenses, it knows that the ability to use other optics on their cameras—even in manual focus mode—can allay some of the reservations of those considering a switch.

The current hybrid situation, in which there are not many Z-mount lenses for the Z6—but plentiful compatible lenses in the existing F-mount lineup—means that this chapter will be a hybrid, as well. For this book, at least, I'm going to embrace both Z-mount and F-mount products, so that I can explain the real-world options—especially to those who may be new to the Nikon world. After all, even if you did not own any Nikon lenses when you purchased your Z6, you probably will consider both types as you expand your optical horizons, because Z-mount and F-mount lenses work seamlessly with your camera. A vast number of affordable pre-owned F-mount lenses are available from sources like www.keh.com.

Later in this chapter, I'll have more details on how adapted F-mount lenses work with the Z6 and FTZ adapter. There are some differences, especially with older lenses, and with F-mount lenses that have vibration reduction built in. It's true that there is a mind-bending assortment of high-quality lenses available to enhance the capabilities of your camera. These lenses can give you a wider view, bring distant subjects closer, let you focus closer, shoot under lower light conditions, or provide a more detailed, sharper image for critical work. Other than the sensor itself, the lens you choose for your Z6 is the most important component in determining image quality and perspective of your images.

This chapter explains how to select the best lenses for the kinds of photography you want to do.

Sensor Sensibilities

Ever since Nikon introduced its first digital camera with a full-frame sensor (the Nikon D3, in August 2007), the debate over full-frame versus cropped sensor DX cameras has been hot and heavy in the Nikon community. Full-frame cameras like the Z6 have a sensor that measures roughly 24×36 mm, while APS-C (DX) cameras have a sensor that measures about 24×16 mm. Each type of sensor has its own advantages. Full-frame sensors typically have larger pixels than their counterparts with equivalent resolution, and better low-light performance, while DX models offer extra telephoto "reach" thanks to their cropped sensors, which create an image from a smaller center portion of the image transmitted by the lens.

ARCHAIC NOMENCLATURE?

The common industry term for cameras with this smaller sensor is APS-C, which stands for Advanced Photo System—Classic. It refers to an ill-fated snapshot film format for cameras offered by Kodak and others from 1996 to about 2004. APS-C is one of many film-era terms that live on, including bulb exposure, rangefinder focus, and the designation "full frame" itself. You'll want to remember the APS-C designation when evaluating lenses from third-party vendors, as Nikon is the only company that uses the term "DX."

Because many enthusiasts have been confused by the full-frame/crop debate, it's useful to take a look at exactly what the "crop factor" means. In addition to the term *crop factor*, you've probably also heard the term *lens multiplier*. In truth, both are misleading and inaccurate terms used to describe the same phenomenon: the fact that cameras like Nikon's high-end DX model, the D500, provide a field of view that's smaller and narrower than that produced by so-called FX (full-frame) cameras like the Z6 when fitted with the same lens.

Figure 7.2 quite clearly shows the phenomenon at work. The outer rectangle, marked 1X, shows the field of view you might expect with a 35mm lens mounted on a Z6 or another one of Nikon's FX cameras. The area marked 1.5X shows the field of view you'd get with that 35mm lens installed on a DX model. It's easy to see from the illustration that the 1X rendition provides a wider, more expansive view, while the inner field of view is, in comparison, *cropped*.

The cropping effect is produced because the sensors of DX cameras, and the Nikon Z6 in its crop modes, take in a smaller amount of area than the full-frame sensors of the Z6, D5, and multiple earlier Nikon FX models. As I mentioned earlier, these "full-frame" cameras have a sensor that's approximately the size of the standard 35mm film frame, 24mm × 36mm. Any DX sensor or crop does *not* measure 24mm × 36mm; instead, it specs out at approximately 23.5mm × 15.7mm (in the case of the D500). You can calculate the relative field of view by multiplying the actual focal length by 1.5.

Figure 7.2
Nikon offers
digital SLRs with
full-frame (1X)
crops, as well as
DX (1.5X). The Z6
has other optional
formats, too.

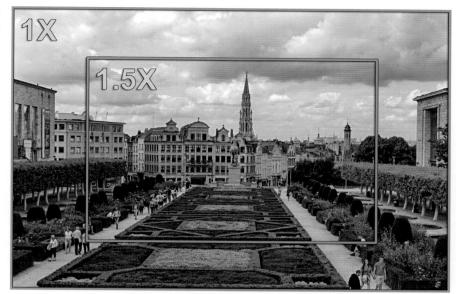

In the past, this translation was generally necessary only if you happened to use your full-frame camera accompanied by a DX model. It also comes in handy today if you are working with any lens using one of the Z6's crop modes, and want to know how a familiar lens will perform. I strongly prefer *crop factor* over *lens multiplier*, because nothing is being multiplied; a 100mm lens doesn't "become" a 150mm lens—the depth-of-field and lens aperture remain the same, despite what you may have read elsewhere. (I'll explain more about these later in this chapter.) Only the field of view is cropped. But *crop factor* isn't much better, as it implies that the 24mm × 36mm frame is "full" and anything else is "less." I get e-mails all the time from photographers who point out that they own full-frame cameras with 33mm × 44mm sensors (like the Hasselblad X1D medium-format digital). By their reckoning, the "half-size" sensors found in cameras like the Nikon Z6 are "cropped."

If you work with both FX and DX cameras, or you use DX lenses on your Z6 with the FTZ adapter, you might sometimes find it helpful to use the crop factor "multiplier" to translate a lens's real focal length into the full-frame equivalent, even though, as I said, nothing is being multiplied. Lenses designed for the DX format may or may not be usable for full-frame images on your Z6, so Nikon automatically switches to DX mode when it detects that a DX lens has been mounted using the FTZ adapter. If the camera is unable to discern that an APS-C lens has been mounted (although in my tests of a few Tamron and Sigma lenses it did a pretty good job), you can manually choose the DX crop in the Choose Image Area entry of the Photo Shooting menu.

That's because an APS-C lens used without crop mode on an FX camera usually exhibits severe darkening, or vignetting in the corners of the image, because its image circle is generally smaller

than the area of a full frame. Of course, the same lens at a longer focal length setting may produce an enlarged image coverage circle so that the lens is *almost* acceptable for full-frame use. Unfortunately, with the current firmware, the Z6 disables the Choose Image Size option when it thinks an APS-C/DX lens is mounted, so there is no way to experiment with any DX lenses you may already own.

OTHER CROPS

The Z6 has additional optional crops, including 1:1 (which keep the same vertical dimension, but snips off a some of the image at either side), and 16:9, which is the same width as the full frame, but crops pixels at the top and bottom to mimic high-definition video proportions. DX mode is the only crop that preserves the 3:2 aspect ratio of the full-frame image. (See Figure 7.3.)

One advantage the Z6 has over its dSLR siblings is that it is able to completely fill the viewfinder and monitor frame with the image in DX crop mode. Non-mirrorless Nikon models mask off the unused area, so you're effectively forced to compose and view with a smaller preview. (They *can* fill the frame in live view mode, which mimics the Z6's full-time live view.)

Figure 7.3 The Z6's full-frame field of view (top left); DX crop (top right); and 1:1 crop (bottom).

As I noted earlier, the good news for those who presently *do* own DX lenses is that the Z6's extremely high resolution means that you can use APS-C lenses in the Z6's DX mode—or one of its other crop modes—and still have acceptable resolution. That allows you to continue to use your legacy lenses, while gaining the extra telephoto "reach" a crop format offers. And, best of all, the crop factor works with *any* lens, not just DX optics.

You can give a telephoto boost to your FX lenses, too, if you don't mind losing some resolution. Flip to DX mode, and your 24-70mm f/4 kit lens has the same field of view as a 36-105mm f/4 zoom (but with only 10 megapixels of resolution), the 50mm f/1.8 is transformed into a 75mm f/1.8 portrait lens, and the Nikkor 105mm f/1.4 that I love using on my Z6 becomes a 157mm f/1.4 high-speed telephoto lens—with three-axis VR that the lens ordinarily lacks. (I'll explain how the Z6's in-body image stabilization fights camera shake later in this chapter.)

Some will tell you that with full-frame lenses, a crop mode doesn't do anything you can't do in an image editor. In one sense, that's true. You could always shoot in FX mode, and then trim to the DX format—or any other crop—in an image editor, with a bit more flexibility over what part of the frame is cropped. But consider the other side of the coin: if you're shooting a field sports event, such as football or soccer, and need the telephoto reach crop mode provides, would you prefer to manually crop each and every image you select, or would it be more efficient to let the camera crop the frame to match what you're seeing with the viewfinder or monitor?

Choosing Native Z-mount Lenses

If you're new to FX photography or to the Nikon system, you're probably wondering which lenses from the vast array of available optics can be added to your growing collection (trust me, it will grow). You need to know which lenses are suitable and, most importantly, which lenses are fully compatible with your Nikon Z6.

With the Z6, Nikon's current limited roster of S-line lenses is, of course, fully compatible. At the time Z6 and Z7 were announced, they consisted of precisely three lenses, with a fourth one formally announced, but not available. Here's what the initial S-line optics have in common:

■ Nikon Z-mount bayonet. Designed exclusively for attaching Z-series lenses to the Z6, Z7, and future models in the product line, the lens mount has 11 electrical *CPU contacts* that allow two-way communication with the camera. The data flow includes lens focal length, current and maximum f/stop, distance information supplied by the lens to the camera, autofocus functions, and aperture control.

Unlike Nikon F-mount lenses, the Nikon Z cameras do not have a physical aperture lever to change the f/stop from wide open (for viewing and focusing) to the aperture used to take the picture (in common photo parlance, the *taking aperture*). Your f/stop is set electronically by the camera based on its autoexposure calculation, or as specified by you (in A and M modes).

One byproduct of this system is that Z lenses will need to have electrically compatible extension tubes and similar accessories; lower-cost manual alternatives will have no way of physically setting the aperture.

■ **Programmable control ring.** Your lens' focus ring is not just for focusing anymore! For that reason, Nikon has renamed this rotating band the *control ring*. When you're using manual focus mode, the control/focusing ring has one mandatory function: focus. You can always count on the control ring providing focus adjustment when you select M using the A/M switch on the lens, the Focus Mode entry in the Photo Shooting menu, or from the *i* menu. (Note that the switch takes precedence, regardless of what you've selected in the menus.)

When either autofocus mode is active, the control ring can have one of four different behaviors, specified using Custom Setting f2: Custom Control Assignment:

- Focus (M/A). The control ring can be used to fine-tune focus after autofocus has been achieved.
- Aperture. You can use the control ring to set the aperture instead of one of the command dials.
- Exposure compensation. If you add/subtract exposure using exposure compensation a lot, you'll love the optional ability to do this by rotating the control ring, rather than holding down the Exposure Compensation button while spinning either command dial.
- None. The best use of this option is to prevent accidentally messing with the camera's autofocus setting. You won't be able to fine-tune focus, either on purpose or by mistake.
- Stepping motor technology. All the Z-series lenses with AF capabilities announced to date feature stepping motors for fast, quiet automatic focus. Fast is required for shooting sports and subjects that move unpredictably or rapidly, while quiet is desirable for both movie making (to avoid recording the sound of the AF motor in your video) and stealth shooting.
 - A stepper motor is a brushless DC motor that divides one rotation into equal steps, allowing the camera to move quickly to one of those fixed steps without the need for electronic feedback or a sensor to confirm the amount of rotation. Nikon has been using stepper motors in its AF-P lenses for its dSLRs for several years (the "P" stands for the electronic pulse used to drive the motor). The technology allows changing focus mode (AF-S, AF-C, or M) without the need to flip a physical switch on the lens or camera body; you can do it within a menu.
- Nano Crystal and Super Integrated Coatings. Light is your friend when you're creating an image—except when unwanted photons (say, from illumination coming from backlighting or entering the lens diagonally) cause flare, glare, ghost images, or reduced contrast. Vendors try to counter these effects by applying coatings to lenses, filters, and other optical devices. Often, multiple layers of anti-reflection coatings are needed to handle all the various wavelengths of light. Nikon's Nano Crystal Coat's nanometer-sized (one millionth of a meter) particles work with all wavelengths of light and allows more of the desirable photons to pass unheeded.

A complex lens with more than a dozen elements suffers only a 0.75 percent reduction in light, compared with a 15 percent loss with older coating technologies. These lenses also benefit from rugged fluorine coatings on the front element that repels dust, dirt, water, and even grease, making them easier to remove, and which have anti-reflective properties of their own.

■ Weather-sealed construction. Moisture is unavoidable, and Nikon expects the Z6 to be heartily accepted by pros who must capture images in inclement weather. The Z6 itself has remarkable weather sealing, and its lenses offer a significant amount of resistance to less-than-ideal shooting conditions (don't dunk your camera in water, however!).

Better Lenses with Z-mount?

There's been a great deal of discussion about the advantages of Nikon's new Z-mount lenses. Much of it seems to assume that the larger 55mm diameter (and 52mm throat size) will make it possible to design lenses with faster maximum apertures, such as the 58mm f/0.95 Nikkor Noct. However, it's *not* simply that the larger opening lets in more light and they can now magically make lenses with larger f/stops. If that were true, there wouldn't already be lenses faster than f/1.4 for cameras with smaller "throats." An f/0.95 lens is available in Leica's 40.5mm mount, for example.

What the wider opening actually does is give lens designers more freedom in creating optics that are sharper, faster, and with fewer aberrations. For example, typical wide-angle lenses for dSLRs use a retrofocus design to move the optical center of the lens so the rear element does not protrude into the mirror chamber. To do that, the rear element must be very large in order to avoid vignetting and other forms of distortion. The Z-mount's 16mm registration distance and wider throat makes it easier to optimize the convergent and divergent elements without worrying about long exit pupil distances between the rear element and sensor plane.

Digital sensors, compared to film, have their particular challenges for lens designers, including the need for a less steep angle of incidence emerging from the rear element, because of the need to send photons down those deep "wells" in non-BSI sensors. Microlenses were the primary solution, especially when so many lenses designed for film (which is more tolerant of the angles) were in use. BSI sensors have helped, as I noted in Chapter 3, and, along with the Z-mount's advantages, mean we can expect much better lenses for our new Z-series cameras.

Nikkor Z 35mm f/1.8 S

Priced at a tad under \$850, the Nikkor Z 35mm f/1.8 S lens is an exceptionally sharp basic wide-angle lens, suitable for landscapes, street photography, exterior architecture, and shooting interiors that aren't so cramped that they call for a wider lens. You can use it for photographing small groups, and it's especially valuable for available-light photography because of its fast f/1.8 maximum aperture.

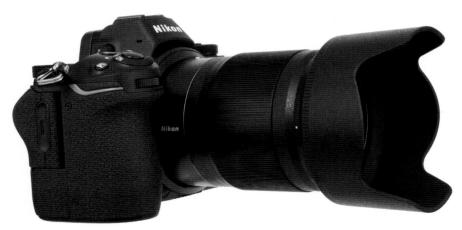

Figure 7.4 The Nikkor Z 35mm f/1.8 S is a fast wide-angle lens.

It focuses down to 9.84 inches, not particularly close enough for true macro work with its 1:5.25 reproduction ratio (true macro lenses have a 1:2 or 1:1 or better reproduction ratio). Its minimum aperture is just f/16 if you're looking for a lens with extra depth-of-field. But this lens's nine-bladed rounded diaphragm produces pleasing bokeh wide open. (I explain bokeh later in this chapter.)

Overall, this lens (shown in Figure 7.4 with its hood attached) is an excellent performer with two ED (extra-low-dispersion) and three aspherical elements with plenty of sharpness to match the Z6's resolution, so there's little need to consider an adapted F-mount 35mm lens, unless you already own one, or need the extra speed of Nikon's phenomenal 35mm f/1.4G optic, which costs almost exactly twice as much. (I'll explain the alphabet soup of Nikon lens nomenclature later in this chapter.)

Nikkor Z 50mm f/1.8 S

By and large, 50mm f/1.8 "normal" lenses tend to be inexpensive "starter" prime lenses for those who need a lens faster than the typical zoom, but who can't afford pricier 50mm f/1.4 alternatives. This particular lens is inexpensive only in comparison with the other S-Line lenses, at \$596, but for that price you get a super-sharp lens worthy of Nikon's "superior" classification.

Lenses of this focal length lend themselves to general photography, and, with the automatic extension tubes for the Z-series that should be available in the near future, for macro work with subjects at distances closer than the 15.7 inches this lens can focus at. Shift into DX crop mode, and you have a 75mm (equivalent) portrait lens with an f/1.8 maximum aperture that's excellent for selective focus head-and-shoulders portraits of individuals or twosomes. Its nine-blade aperture produces good bokeh. Even those new to photography will have heard the phrase "nifty

Figure 7.5 The Nikkor Z 50mm f/1.8 S is an exceptionally sharp "normal" lens.

50" that is often applied to lenses of this focal length. Lodged between the realms of wide-angle and short telephoto focal lengths, a fast and sharp 50mm lens is an important tool for those looking for versatility at a (relatively) affordable price.

Nikkor Z 24-70mm f/4 S

I was mildly surprised when Nikon unveiled this lens, with an f/4 maximum aperture, as its kit lens and sole zoom for the Z6 and Z7 cameras. One might expect a lens in the popular 24-105mm or 24-120mm focal lengths that some pros might prefer. However, Nikon had several challenging requirements to fulfill. In order to attract both existing Nikon dSLR owners and those currently using other platforms, the kit lens had to be sharp (sharper, at least, than its sturdy, but conventional F-mount 24-120mm f/4 zoom). The kit lens also needed to be versatile, compact, and, most of all, affordable. As the 24-70mm focal length is also quite popular and considered versatile enough to use for everything from landscapes to portraits (despite its limited zoom range), Nikon selected this lens as its initial Z-mount zoom.

Affordability was of utmost importance; if purchased in a bundle with the Z6, this lens adds only \$600 to the price tag. If you're going to charge almost \$2,000 for the body for a new camera platform, you can't win many fans by asking them to lay out an additional \$2,000 or so for their basic lens. That's the price range for Nikon's existing F-mount 24-70mm f/2.8 optics in versions with vibration reduction (\$2,396) and without (\$1,796).

Compactness was also paramount; mirrorless cameras like the Z6 are prized precisely because of their reduced size and weight. This lens weighs less than 18 ounces and measures about 3×3.5 inches when collapsed. (See Figure 7.6.) In a brilliant stroke, Nikon designed the lens so that you don't need to press a button to retract it into its most compact configuration; just rotate the zoom ring past its widest 24mm setting, and you feel a brief resistance before the ring continues rotating while the lens retracts fully.

Figure 7.6
Relatively inexpensive, the 24-70mm kit lens is an impressive performer.

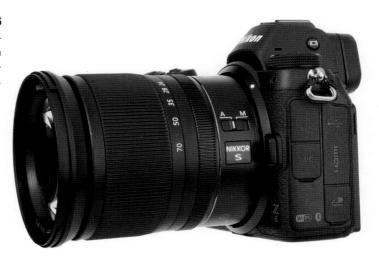

This zoom, like all the Z-mount optics, is sufficiently sharp even wide open, and gets even better as you stop down. It focuses down to about 12 inches (for a reproduction ratio of 1:33) and has a minimum aperture of f/22 for a bit of extra depth-of-field if you need it.

Should you want a faster lens in this focal length range, Nikon's "lens map" has a 24-70mm f/2.8 version slated for 2019. At this time, no 24-105mm or 24-120mm zoom has been promised; Nikon is concentrating on fast prime lenses (see the sidebar Things to Come), with only four zooms listed for the next year or two.

Nikkor Z 58mm f/0.95 S Noct

At the time I write this, Nikon's super-fast, super-sharp "normal" lens is more of a proof-of-concept than a legitimate practical option for most of us. In December 2018, Nikon indicated the lens would be released by late January 2019. However, Z-series owners have not been lining up to purchase this rather exotic optic.

Yes, it is almost two full f/stops faster than a 50mm f/1.8 lens, meaning, on your average city street at night at ISO 1600 you could shoot wide open at 1/125th second instead of 1/30th second. Or, in full daylight and ISO 64 you'd need a shutter speed of 1/8,000th second for your selective focus images at f/0.95. This lens is purported to be exceptionally sharp wide open, thanks to the Z-series cameras' wide "throat" that loosed many of the chains facing Nikon's lens designers.

Before you available-light photographers add this lens to your birthday "want" list, keep in mind that the cost of ownership is likely to remain lodged in the \$6,000 stratosphere. And it is a *manual focus* lens. Most folks buying a \$6,000 lens would expect autofocus, at least, if not the ability to slice Julienne fries and run a few Android apps as a bonus. But, alas, manual focus and a hefty price tag are the key specs for this 58mm lens, for which Nikon resurrected the venerable name originally applied to the legendary Noct-Nikkor 58mm f/1.2 optic introduced in 1977. The Noct (for Nocturne) was the sharpest f/1.2 lens ever made, so this new version has considerable shoes to fill.

Nikon claims exceptional performance, even wide open, using ultra-high refractive index aspherical (non-spherical) lens elements, and two (count 'em) different reflective coatings to combat glare: ARNEO (I'm still trying to find out what the acronym means) which reduces vertical incidental light and Nano Crystal coating to counter photons reaching the lens from a diagonal direction.

Its controls are as unconventional as its other design elements. In addition to the control ring found on other Z-mount lenses, it includes what Nikon calls a high-precision focus ring with "extreme accuracy and natural torque." On a manual focus lens with such a large maximum aperture and resulting shallow depth-of-field, you can bet that correct focus will be critical. It also includes a Lens Fn button, and a novel LCD display (and accompanying DISP button) that can provide information on aperture, focal length, and depth-of-field.

My guess is that few photographers will buy or need this lens (the original Noct sold only a few thousand copies), but Nikon wanted to show off the excellence possible in designing lenses for the new Z-mount, and this one is likely to become a legend in its own right.

THINGS TO COME

Nikon's three-year "lens map," outlining their plans for the near future, is ambitious, to say the least. The company says it will be concentrating on very sharp prime lenses (because ultra-sharp lenses are easier to design if you don't have to contend with the need to change focal lengths, too). In addition to the lenses listed above, Nikon has plans to produce a much-needed fast wide-angle 20mm f/1.8 lens, and a portraiture-worthy short telephoto 85mm f/1.8 next year. In 2020, we can look forward to a 50mm f/1.2 lens (which should have autofocus and be quite a bit more affordable than the Noct), and a 24mm f/1.8 lens.

Zoom lenses on the horizon in 2019 include a faster 24-70mm f/2.8 mid-range zoom and a 70-200mm f/2.8 zoom. Since Nikon's current 70-200mm f/2.8 lens for F-mount is among the sharpest and most popular lenses Nikon offers, a Z-mount version that is (dare we say it?) even sharper would be the dream of any sports photographer. The faster 14-24mm f/2.8 S-Line lens forecast for 2020 is likely to be more costly, but still offer excellent performance.

Nikkor Z 14-30mm f/4 S

Nikon introduced this exciting \$1,300 lens in January, 2019. The compact lens weighs just 17 ounces and—unusual for such a wide zoom—accepts screw-in 82mm filters. It has 14 elements, including four aspherical and four ED elements, and a quiet STM motor that's perfect for video capture. It has dust and moisture sealing, and the customizable control ring.

My copy has sharpness that is comparable to my F-mount 14-24mm f/2.8 Nikkor, in a much smaller package.

Universal VR

As a Z6 owner, at this point you won't need to pay extra for purchasing lenses with *vibration reduction* (VR) built in. Because the Z-series cameras include in-body image stabilization (IBIS), *every* lens you use—even adapted lenses and manual focus lenses—will have some form of VR available to counter camera movement as you shoot. After all, even the highest resolution lenses and sensors, like those found on the Z6, can do nothing to correct image sharpness lost due to movement. And while higher shutter speeds can eliminate most blur caused by *subject* movement, when it's the *camera* that's causing blur due to vibration, other approaches have to be taken. Your Z6 has improved technology that can help avoid blur caused by mechanical shutter movement and bounce, but when the entire camera and lens are vibrating, that's where *image stabilization* (IS) comes into play.

Image stabilization/vibration reduction can take many forms, and Nikon has expertise in all of them. Electronic IS is used in video cameras (and also available in the Z6 while shooting movies). It involves shifting pixels around from frame to frame so that pixels that are not moving remain in the same position, and portions of the image that *are* moving don't stray from their proper path. Optical image stabilization, which Nikon calls vibration reduction (VR), is built into many Nikon

F-mount lenses and involves lens elements that shift in response to camera movement, as detected by motion sensors included in the optics. In-body anti-shake technology included in the Z6 adjusts the position of the sensor carriage itself along five different axes to counteract movement.

The results can be spectacular, with up to a 5-stop improvement from in-body image stabilization technology. That is, a photograph taken at 1/30th second should have the same sharpness (at least in terms of resistance to camera shake) as one shot at 1/1,000th second. In practical terms, you probably won't experience such a dramatic gain, however.

Of course, no amount of vibration reduction can eliminate blur from moving subjects, but you should find yourself less tied to a tripod when using longer lenses, or when working with wide-angle lenses under dim lighting conditions than in the past. If you're taking photos in venues where flash or tripods are forbidden, you'll find the Z6's image stabilization invaluable.

How It Works

As I mentioned, stabilization uses gyroscope-like motion sensors to detect camera motion. When such motion is sensed, the carriage holding the sensor is shifted a precise amount in the opposite direction. Movement can occur along one of five different axes, as shown in Figure 7.7:

■ X and y axes. These movements occur when the camera shifts in the x and y directions; that is, the camera moves from side to side or up and down within the plane of the sensor. Shifts in the x and y directions (the camera moves from side to side or up and down along the plane of the sensor) are likely to occur when shooting macro images hand-held but can take place any time. This motion is very easy for the IBIS to detect.

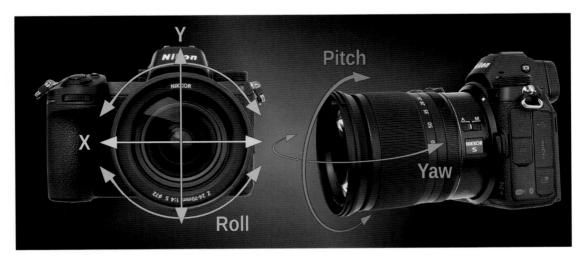

Figure 7.7 The five axes of in-body vibration reduction stabilization.

- Roll. This is the rotation of the camera along an axis passing through the center of the front of the lens, or an axis parallel to it. It's easiest to picture the rotational point as the center of the lens, but it may actually be located closer to your hand as you grip the camera body. Roll happens when you, say, align the horizon while shooting a landscape. There may be a tendency to continue to "correct" for the horizon as you shoot, producing vibration along the roll axis. Roll is especially noticeable in video clips, because it's easy to see straight lines changing their orientation during a shot. This type of motion can also be easily handled by IBIS.
- Pitch. This type of movement happens when the camera shake is such that the lens is tilted up or down, often because the lens itself is a front-heavy telephoto lens. The magnification of the tele only serves to exaggerate the changes in pitch. Pitch movement tends to be less critical with wide-angle lenses. The Z6's in-body image stabilization is less adept at countering this type of movement. It's one case in which vibration reduction built into the lens potentially provides superior correction. While none of the lenses introduced for the Z6 so far have their own optical image stabilization system, it's quite possible that future lenses, such as the planned 70-200mm f/4 S-line optic, will have it.
- Yaw. Telephotos are also a major contributor to *yaw* vibrations, in which the camera pivots slightly as if you were shooting a panorama—even when you're *not*. VR built into future Z-mount lenses could provide higher degrees of correction.

Here's a quick summary of some things you should keep in mind:

- **Tripod use.** For best results, turn off vibration reduction when the camera is mounted on a tripod.
- **Vibration reduction doesn't stop action.** Please don't forget this! No type of stabilization is a panacea to replace the action-stopping capabilities of a faster shutter speed. If you need to use 1/1,000th second to freeze a high jumper in mid-air, VR doesn't help you.
- Stabilization might slow you down. The process of adjusting the sensor to counter camera shake takes time, just as autofocus does, so you might find that VR adds to the lag between when you press the shutter and when the picture is actually taken. In a situation where you want to capture a fleeting instant that can happen suddenly, image stabilization might not be your best choice.
- Give vibration reduction a helping hand. When you simply do not want to carry a tripod all day and you'll be relying on the IBIS system, brace the camera or your elbows on something solid, like the roof of a car or a piece of furniture. Remember that an inexpensive monopod can be quite compact when not extended; many camera bags include straps that allow you to attach this accessory. Use a monopod for extra camera-shake compensation. Brace the accessory against a rock, a bridge abutment, or a fence and you might be able to get blur-free photos at surprisingly long shutter speeds. When you're heading out into the field to photograph wild animals or flowers and want to use longer exposures and think a tripod isn't practical, at least consider packing a monopod.

Using the FTZ Adapter

Nikon says that the FTZ adapter (see Figure 7.8) is compatible with roughly 360 F-mount lenses. This includes more than 90 lenses that have full autofocus and autoexposure compatibility when using FX or DX AF-S type G/D/E, AF-P type G/E, AF-I type D, and AF-S/AF-I Teleconverters. As for other lenses:

- AF, AF-D lenses. You must focus these optics manually, but with AF-D lenses the electronic rangefinder will assist in determining correct focus, and Peaking Highlights (described in Chapters 5 and 12) works with either type. You can adjust the aperture electronically and use Aperture-priority autoexposure.
- AI-P and all lenses with a CPU chip. You get manual focus only (with Peaking Highlights) and Aperture-priority exposure.

Figure 7.8 The FTZ adapter.

■ AI, AI-S, and Series E lenses. Manual focus and manual exposure only, but you can use the non-CPU Lens Data entry in the Setup menu to specify the maximum aperture and focal length of the lens, as described in Chapter 13. However, zoom focal length ranges are not supported. You may also be able to mount and use non-AI F-mount lenses (pre-1977), but may have mechanical interference problems.

As I noted earlier, DX lenses must be used in one of the Z6's crop modes if you want some assurance that the entire image area will be filled. Spotting DX lenses is easy: Nikon's versions all have the letters DX in their names.

The process is a bit more complicated when it comes to third-party manufacturers. Tamron uses the Di (Digitally integrated) designation for its lenses that are compatible with full-frame digital (and film) cameras, and applies the Di II label to lenses suitable only for cropped-sensor models. With Sigma lenses, DG is used for lenses suitable for both FX and DX cameras, and DC indicates a DX-only model. Tokina seems to use the D (for FX) and DX (for DX) nomenclature. All three vendors have been making lenses for (full-frame) film cameras for many years, well before the digital/DX factor became a factor, so when purchasing one of their lenses you may not see a special designation, but, if the lens was introduced prior to about 2004, it's almost certainly a full-frame model.

That's the case with Nikon's older lenses, too, such as the Nikon AI, AI-S, or AI-P lens, which are manual focus lenses produced starting in 1977 and effectively through the present day, because Nikon continues to offer a limited number of manual focus lenses for those who need them. All are full-frame models.

Nikon lenses produced prior to 1977 must have a minor conversion done to be used safely with most Nikon dSLRs and is recommended for Z6 owners as well, because of possible mechanical issues. John White at www.aiconversions.com will do the work for about \$35 to allow these older lenses to be safely used on any Nikon digital camera.

Adapted Lenses and VR

What happens to vibration reduction when you use an F-mount lens with the Z6 using the FTZ adapter? Lenses that *do not* have VR built-in gain 3-axis VR, with the camera body providing pitch, yaw, and roll correction. That's even true for older lenses that don't have a CPU chip. However, you must visit the Non-CPU Lens Data entry in the Setup menu and input the lens's focal length and maximum aperture, and then select that lens number when it is mounted on the Z6. You'll find more information on working with non-CPU lens data in Chapter 13. Compatible F-mount lenses that do have vibration reduction for pitch and yaw receive the addition of roll axis correction from the Z6's IBIS, giving them 3-axis VR as well.

Since optical image stabilization (OIS) built into lenses generally does a better job of detecting and correcting for pitch and yaw, why doesn't Nikon simply direct the Z6 to use the lens OIS for those two axes and correct for x, y, and roll using in-body image stabilization? Unfortunately, that's more complicated than you might think.

The two systems have to work together, so the IBIS would know what the lens VR had already done, how the image has been adjusted, in what directions, and by how much. Ideally, the system would have the adapted lens's VR correct for pitch and yaw (because optical image stabilization is better at that, particularly with telephoto lenses, because of the relatively large movements in those directions) and the in-body stabilization would oversee motion along the other three axes.

Although Nikon optical engineers have been somewhat vague with their answers, they seem to indicate that Nikon's VR lenses do communicate their activity to the body, so the in-camera stabilization system can accommodate the action of the lenses during the VR process.

Ingredients of Nikon's Alphanumeric Soup

I've been tossing around a lot of cryptic letters and descriptors that Nikon applies to the names of its lenses, both Z-mount and F-mount. I've collected here an alphabetical list of lens terms you're most likely to encounter, either as part of the lens name or in reference to the lens's capabilities. Not all of these are used as parts of a lens's name, but you may come across some of these terms in discussions of particular Nikon optics:

- AF, AF-D, AF-I, AF-P, AF-S. In all cases, AF stands for *autofocus* when appended to the name of a Nikon F-mount lens. An extra letter is added to provide additional information. A plain old AF lens is an autofocus lens that uses a slot-drive motor in the camera body to provide autofocus functions (and so cannot be used in AF mode on the Z6, which lacks that motor). The D means that it's a D-type lens (described later in this listing); the I indicates that focus is through a motor inside the lens; AF-P is used to designate lenses with that very quiet stepper motor that's especially useful for sound video applications. The most common Nikon focus designation for F-mount lenses is still AF-S, and the S means that a Silent Wave motor in the lens provides focusing. (Don't confuse a Nikon AF-S lens with the AF-S [Single-Servo Autofocus] mode.) Nikon has upgraded most of its older AF lenses in F-mount with AF-S (or AF-P) versions, but it's not safe to assume that *all* newer Nikkors are AF-S/AF-P, or even offer autofocus. For example, the PC-E Nikkor 24mm f/3.5D ED perspective control lens must be focused manually, and Nikon offers a surprising collection of other manual focus lenses to meet specialized needs.
- AI, AI-S. All Nikkor F-mount lenses produced after 1977 have either automatic aperture indexing (AI) or automatic indexing-shutter (AI-S) features that eliminate the previous requirement to manually align the aperture ring on the camera when mounting a lens. Within a few years, all Nikkors had this automatic aperture indexing feature (except for G-type lenses, which have no aperture ring at all), including Nikon's budget-priced Series E lenses, so the designation was dropped at the time the first autofocus (AF) lenses were introduced.
- **D.** Appended to the maximum f/stop of the lens (as in f/2.8D), a D-Series lens is able to send focus distance data to the camera, which uses the information for flash exposure calculation and metering.
- **DC.** The DC stands for defocus control, which allows managing the out-of-focus parts of an image to produce better-looking portraits and close-ups.
- DX. The DX lenses are designed for use with digital cameras using the APS-C-sized sensor having the 1.5X crop factor. The image circle they produce isn't large enough to fill up a full 35mm frame at all focal lengths, but they can be used on Nikon's full-frame dSLR models using the automatic/manual DX crop mode.
- E. The E designation was used for Nikon's budget-priced E-Series optics, five prime and three zoom manual focus lenses built using aluminum or plastic parts rather than the preferred brass parts of that era, so they were considered less rugged. All are effectively AI-S lenses. They do have good image quality, which makes them a bargain for those who treat their lenses gently

and don't need the latest autofocus features. They were available in 28mm f/2.8, 35mm f/2.5, 50mm f/1.8, 100mm f/2.8, and 135mm f/2.8 focal lengths, plus 36-72mm f/3.5, 75-150mm f/3.5, and 70-210mm f/4 zooms. (All these would be considered fairly "fast" today.)

However, today the E designation is applied to lenses to represent those that stop down the lens to the "taking" aperture electronically. (During framing, focusing, exposure metering, and other pre-photo steps, the lens always remains at its maximum aperture unless you stop it down using a Preview—depth-of-field preview—button.) Non-E lenses use a lever in the camera body that mates with a lever in the lens mount. Lenses with an E in their names, such as the 16-80mm f/2.8-4E ED VR optic, use an electronic mechanism instead.

- ED (or LD/UD). The ED (extra-low dispersion) designation indicates that some lens elements are made of a special hard and scratch-resistant glass that minimizes the divergence of the different colors of light as they pass through, thus reducing chromatic aberration (color "fringing") and other image defects. A gold band around the front of the lens indicates an optic with ED elements. You sometimes find LD (low dispersion) or UD (ultra-low dispersion) designations.
- FX. When Nikon introduced the Nikon D3 as its first full-frame camera, it coined the term "FX," representing the nominal 24mm × 36mm sensor format as a counterpart to "DX," which was used for its 16mm × 24mm APS-C-sized sensors. Although FX hasn't been officially applied to any Nikon lenses so far, expect to see the designation used more often to differentiate between lenses that are compatible with any Nikon digital SLR (FX) and those that operate only on DX-format cameras, or in DX mode when used on an FX camera like the Z6, Z7, D700, D600/D610, D800/D810, Z6, D3, D3s, D3x, D4/D4s, and D5.
- **G.** G-type lenses have no aperture ring, and you can use them at other than the maximum aperture only with electronic cameras like the Z6 that set the aperture automatically. Fortunately, this includes all Nikon digital dSLRs.
- IF. Nikon's *internal focusing* lenses change focus by shifting only small internal lens groups with no change required in the lens's physical length, unlike conventional double helicoid focusing systems that move all lens groups toward the front or rear during focusing. IF lenses are more compact and lighter in weight, provide better balance, focus more closely, and can be focused more quickly.
- IX. These lenses were produced for Nikon's long-discontinued Pronea 6i and S APS film cameras. While the Pronea could use many standard Nikon lenses, IX lenses cannot be mounted on any Nikon digital SLR.
- **Micro.** Nikon uses the term *micro* to designate its close-up lenses. Most other vendors use *macro* instead.
- N (Nano Crystal Coat). Nano Crystal lens coating virtually eliminates internal lens element reflections across a wide range of wavelengths, and is particularly effective in reducing ghost and flare peculiar to ultra-wide-angle lenses. Nano Crystal Coat employs multiple layers of Nikon's extra-low refractive index coating, which features ultra-fine crystallized particles of nano size (one nanometer equals one millionth of a meter).

- NAI. This is not an official Nikon term, but it is widely used to indicate that a manual focus lens is *Not-AI*, which means that it was manufactured before 1977, and therefore cannot be used safely on modern digital Nikon SLRs (other than the retro Df model) without modification.
- NOCT (Nocturne). Used originally to refer to the prized Nikkor AI-S Noct 58mm f/1.2, a "fast" (wide aperture) prime lens, with aspherical elements, capable of taking photographs in very low light. It's been revived to describe the 58mm f/0.95 Noct lens for Nikon's Z-series mirrorless cameras.
- PC (Perspective Control). A PC lens is capable of shifting the lens from side to side (and up/down) to provide a more realistic perspective when photographing architecture and other subjects that otherwise require tilting the camera so that the sensor plane is not parallel to the subject. Older Nikkor PC lenses offered shifting only, but more modern models, such as the PC-E Nikkor 24mm f/3.5D ED lens introduced early in 2008 allow both shifting and tilting.
- UV. This term is applied to special (and expensive) lenses designed to pass ultraviolet light.
- UW. Lenses with this designation are designed for underwater photography with Nikonos camera bodies, and cannot be used with Nikon digital SLRs.
- VR. Nikon has an expanding line of vibration reduction (VR) F-mount lenses, including several very affordable models, which shift lens elements internally to counteract camera shake. The VR feature allows using a shutter speed up to 4.5 stops slower than would be possible without vibration reduction, according to Nikon.

Zoom or Prime?

While the Z6 has only one zoom and 2.5 prime lenses available now, you're probably considering using, borrowing, or buying some F-mount optics to use with your camera, and among those lenses there are plenty of both zoom and prime lenses available. So, within this chapter's "hybrid" mode, I'm going to offer you some help to use when selecting between zoom and prime lenses. There are several considerations to ponder. Here's a checklist of the most important factors, in addition to image quality and maximum aperture earlier, but those aspects take on additional meaning when comparing zooms and primes.

■ Logistics. As prime lenses offer just a single focal length, you'll need more of them to encompass the full range offered by a single zoom. More lenses mean additional slots in your camera bag, and extra weight to carry. Just within Nikon's F-mount product line alone you can choose from a good selection of prime lenses in 28mm, 35mm, 50mm, 85mm, 105mm, 135mm, 200mm, and 300mm focal lengths, all of which are overlapped by a single zoom: the AF-S FX Nikkor 28-300mm f/3.5-5.6G ED VR lens. Even so, you might be willing to carry an extra prime lens or two in order to gain the speed or image quality that lens offers.

- Image quality. Prime lenses usually produce better image quality at their focal length than even the most sophisticated zoom lenses at the same magnification. Zoom lenses, with their shifting elements and f/stops that can vary from zoom position to zoom position, are, in general, more complex to design than fixed focal length lenses. That's not to say that the very best prime lenses can't be complicated as well. However, the exotic designs, aspheric elements, and low-dispersion glass can be applied to improving the quality of the lens, rather than wasting a lot of it on compensating for problems caused by the zoom process itself.
- Maximum aperture. Because of the same design constraints, zoom lenses usually have smaller maximum apertures than prime lenses, and the most affordable zooms have a lens opening that grows effectively smaller as you zoom in. The difference in lens speed verges on the ridiculous at some focal lengths. For example, the 18-55mm super-bargain kit lens Nikon offers for its entry-level digital SLRs gives you a 55mm f/5.6 lens when zoomed all the way out, while prime lenses in that focal length commonly have f/1.8 or faster maximum apertures. Indeed, the fastest f/2, f/1.8, and f/1.4 lenses are all primes, and if you require speed, a fixed focal length lens is what you should rely on.
- **Speed.** Using prime lenses takes time and slows you down. It takes a few seconds to remove your current lens and mount a new one, and the more often you need to do that, the more time is wasted. If you choose not to swap lenses, when using a fixed focal length lens, you'll still have to move closer or farther away from your subject to get the field of view you want. A zoom lens allows you to change magnifications and focal lengths with the twist of a ring and generally saves a great deal of time.

Categories of Lenses

Lenses can be categorized by their intended purpose—general photography, macro photography, and so forth—or by their focal length. The range of available focal lengths is usually divided into three main groups: wide angle, normal, and telephoto. Prime lenses fall neatly into one of these classifications. Zooms can overlap designations, with a significant number falling into the catch-all, wide-to-telephoto zoom range. This section provides more information about focal length ranges, and how they are used.

Any lens with a focal length of 12mm to 20mm is said to be an *ultra-wide-angle lens*; from about 20mm to 35mm is said to be a *wide-angle lens*. *Normal lenses* have a focal length roughly equivalent to the diagonal of the film or sensor, in millimeters, and so fall into the range of about 45mm to 60mm on a Z6. *Short telephoto lenses* start at about 70mm to 105mm, with anything from 135mm to 300mm qualifying as a conventional *telephoto*. For the Nikon Z6, anything from about 350mm to 400mm or longer can be considered a *super-telephoto*.

Using Wide-Angle and Wide-Zoom Lenses

To use wide-angle prime lenses and wide zooms, you need to understand how they affect your photography. Here's a quick summary of the things you need to know.

- More depth-of-field. Practically speaking, wide-angle lenses offer more depth-of-field at a particular subject distance and aperture. You'll find that helpful when you want to maximize sharpness of a large zone, but not very useful when you'd rather isolate your subject using selective focus (telephoto lenses are better for that).
- Stepping back. Wide-angle lenses have the effect of making it seem that you are standing farther from your subject than you really are. They're helpful when you don't want to back up, or can't because there are impediments in your way.
- Wider field of view. While making your subject seem farther away, as implied above, a wideangle lens also provides a larger field of view, including more of the subject in your photos.
- More foreground. As background objects retreat, more of the foreground is brought into view by a wide-angle lens. That gives you extra emphasis on the area that's closest to the camera. Photograph your home with a normal lens/normal zoom setting, and the front yard probably looks fairly conventional in your photo (that's why they're called "normal" lenses). Switch to a wider lens and you'll discover that your lawn now makes up much more of the photo. So, wide-angle lenses are great when you want to emphasize that lake in the foreground, but problematic when your intended subject is located farther in the distance.
- Super-sized subjects. The tendency of a wide-angle lens to emphasize objects in the fore-ground, while de-emphasizing objects in the background can lead to a kind of size distortion that may be more objectionable for some types of subjects than others. Shoot a bed of flowers up close with a wide angle, and you might like the distorted effect of the larger blossoms nearer the lens. Take a photo of a family member with the same lens from the same distance, and you're likely to get some complaints about that gigantic nose in the foreground.
- Perspective distortion. When you tilt the camera so the plane of the sensor is no longer perpendicular to the vertical plane of your subject, some parts of the subject are now closer to the sensor than they were before, while other parts are farther away. So, buildings, flagpoles, or NBA players appear to be falling backward. While this kind of apparent distortion (it's not caused by a defect in the lens) can happen with any lens, it's most apparent when a wide angle is used. The "falling back" look is particularly troublesome with subjects that actually do get narrower towards the top, such as pyramids and the worst-case scenario Nova Scotia lighthouse seen in Figure 7.9.

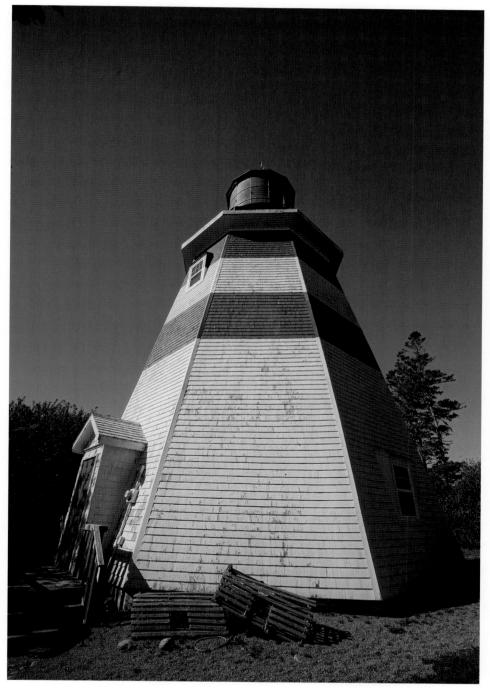

Figure 7.9 Tilting the camera back produces or accentuates this "falling back" look in architectural photos.

- Steady cam. Hand-holding a wide-angle lens at slower shutter speeds, without vibration reduction, produces steadier results than with a telephoto lens. The reduced magnification of the wide-lens or wide-zoom setting doesn't emphasize camera shake like a telephoto lens does.
- Interesting angles. Many of the factors already listed combine to produce more interesting angles when shooting with wide-angle lenses. Raising or lowering a telephoto lens a few feet probably will have little effect on the appearance of the distant subjects you're shooting. The same change in elevation can produce a dramatic effect for the much-closer subjects typically captured with a wide-angle lens or wide-zoom setting.

Avoiding Potential Wide-Angle Problems

Wide-angle lenses have a few quirks that you'll want to keep in mind when shooting so you can avoid falling into some common traps. Here's a checklist of tips for avoiding common problems:

- Symptom: converging lines. Unless you want to use wildly diverging lines as a creative effect, it's a good idea to keep horizontal and vertical lines in landscapes, architecture, and other subjects carefully aligned with the sides, top, and bottom of the frame. That will help you avoid undesired perspective distortion. Sometimes it helps to shoot from a slightly elevated position so you don't have to tilt the camera up or down.
- Symptom: excessive foreground. The tendency of very wide angle lenses to make foreground subjects appear large can be a problem with landscape and architectural photographs. Your landscape may have majestic mountains in the background, but most of your frame may be filled with the nearby terrain. Limited space forced me to use a wide-angle lens to capture Église Sainte-Marie in Nova Scotia, at 184 feet the tallest wooden building in North America. With my back at the edge of the roadway that passed in front of the structure, the edifice's parking lot occupied an excessive amount of space in my original uncropped shot (see Figure 7.10).
- Symptom: color fringes around objects. Lenses are often plagued with fringes of color around backlit objects, produced by *chromatic aberration*, which is produced when all the colors of light don't focus in the same plane or same lateral position (that is, the colors are offset to one side). This phenomenon is more common in wide-angle lenses and in photos of subjects with contrasty edges. Some kinds of chromatic aberration can be reduced by stopping down the lens, while all sorts can be reduced by using lenses with low diffraction index glass (or ED elements, in Nikon nomenclature) and by incorporating elements that cancel the chromatic aberration of other glass in the lens.

- Symptom: lines that bow outward. Some wide-angle lenses cause straight lines to bow outward, with the strongest effect at the edges. In fisheye (or *curvilinear*) lenses, this defect is a feature. When distortion is not desired, you'll need to use a lens that has corrected barrel distortion. Manufacturers like Nikon do their best to minimize or eliminate it (producing a *rectilinear* lens), often using *aspherical* lens elements (which are not cross-sections of a sphere). You can also minimize barrel distortion simply by framing your photo with some extra space all around, so the edges where the defect is most obvious can be cropped out of the picture. Some image editors, including Photoshop and Photoshop Elements and Nikon Capture NX-D, have a lens distortion correction feature.
- Symptom: dark corners and shadows in flash photos. The Nikon Z6's optional external electronic flash are generally designed to provide even coverage for lenses as wide as 17mm. If you use a wider lens, you can expect darkening, or *vignetting*, in the corners of the frame.

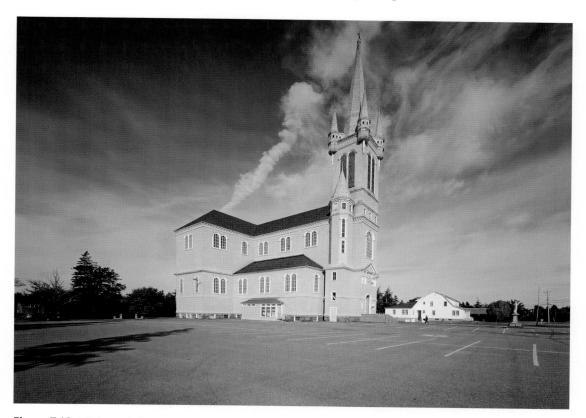

Figure 7.10 Wide-angle lenses can overemphasize the foreground in landscape and architectural shots.

Using Telephoto and Tele-Zoom Lenses

Telephoto lenses also can have a dramatic effect on your photography, and Nikon is especially strong in the long-lens arena, with lots of choices in many focal lengths and zoom ranges. You should be able to find an affordable telephoto or tele-zoom to enhance your photography in several different ways. Here are the most important things you need to know. In the next section, I'll concentrate on telephoto considerations that can be problematic—and how to avoid those problems.

- Selective focus. Long lenses have reduced depth-of-field within the frame, allowing you to use selective focus to isolate your subject. You can open the lens up wide to create shallow depth-of-field, or close it down a bit to allow more to be in focus. The flip side of the coin is that when you *want* to make a range of objects sharp, you'll need to use a smaller f/stop to get the depth-of-field you need. Like fire, the depth-of-field of a telephoto lens can be friend or foe. Figure 7.11 shows a photo of a bird shot at the 200mm focal length setting of my 70-200mm zoom, and a wide f/2.8 f/stop to de-emphasize the distracting background.
- **Getting closer.** Telephoto lenses bring you closer to wildlife, sports action, and candid subjects. No one wants to get a reputation as a surreptitious or "sneaky" photographer (except for paparazzi), but when applied to candids in an open and honest way, a long lens can help you capture memorable moments while retaining enough distance to stay out of the way of events as they transpire.

Figure 7.11
A wide f/stop helped isolate the bird against a distracting background.

- Reduced foreground/increased compression. Telephoto lenses have the opposite effect of wide angles: they reduce the importance of things in the foreground by squeezing everything together. This compression even makes distant objects appear to be closer to subjects in the foreground and middle ranges. You can use this effect as a creative tool to squeeze subjects together. You'll find the effect used all the time in TV shows, where the hero dashes toward the camera while racing between slow-moving automobiles, seemingly each just a foot or two apart.
- Accentuates camera shakiness. Telephoto focal lengths hit you with a double whammy in terms of camera/photographer shake. The lenses themselves are bulkier, more difficult to hold steady, and may even produce a barely perceptible see-saw rocking effect when you support them with one hand halfway down the lens barrel. Telephotos also magnify any camera shake. It's no wonder that vibration reduction is a popular feature when using longer focal lengths.
- Interesting angles require creativity. Telephoto lenses require more imagination in selecting interesting angles, because the "angle" you do get on your subjects is so narrow. Moving from side to side or a bit higher or lower can make a dramatic difference in a wide-angle shot, but raising or lowering a telephoto lens a few feet probably will have little effect on the appearance of the distant subjects you're shooting.

Avoiding Telephoto Lens Problems

Many of the "problems" that telephoto lenses pose are really just challenges and are not that difficult to overcome. Here is a list of the seven most common picture maladies and suggested solutions.

- Symptom: flat faces in portraits. Head-and-shoulders portraits of humans tend to be more flattering when a focal length of 85mm to 105mm is used. Longer focal lengths compress the distance between features like noses and ears, making the face look wider and flat. A wide angle might make noses look huge and ears tiny when you fill the frame with a face. So stick with 85mm to 105mm focal lengths, going longer only when you're forced to shoot from a greater distance, and wider only when shooting three-quarters/full-length portraits, or group shots.
- Symptom: blur due to camera shake. Use a higher shutter speed (boosting ISO if necessary), consider an image-stabilized lens, or mount your camera on a tripod, monopod, or brace it with some other support. Of those three solutions, only the first will reduce blur caused by *subject* motion; vibration reduction/image stabilization or tripod won't help you freeze a race car in mid-lap.
- Symptom: color fringes. Chromatic aberration is the most pernicious optical problem found in telephoto lenses. There are others, including spherical aberration, astigmatism, coma, curvature of field, and similarly scary-sounding phenomena. The best solution for any of these is to use a better lens that offers the proper degree of correction, or stop down the lens to minimize the problem. But that's not always possible. Your second-best choice may be to correct the fringing in your favorite RAW conversion tool or image editor. Photoshop's Lens Correction filter offers sliders that minimize both red/cyan and blue/yellow fringing.

- Symptom: lines that curve inward. Pincushion distortion is found in many telephoto lenses. You might find after a bit of testing that it is worse at certain focal lengths with your particular zoom lens. Like chromatic aberration, it can be partially corrected using tools like the correction tools built into Photoshop and Photoshop Elements, and the Distortion and Perspective tools in the Z6's Retouch menu (see Chapter 13). You can see an exaggerated example in Figure 7.12, especially at the edge; pincushion distortion isn't always this obvious.
- Symptom: low contrast from haze or fog. When you're photographing distant objects, a long lens shoots through a lot more atmosphere, which generally is muddied up with extra haze and fog. That dirt or moisture in the atmosphere can reduce contrast and mute colors. Some feel that a skylight or UV filter can help, but this practice is mostly a holdover from the film days. Digital sensors are not sensitive enough to UV light for a UV filter to have much effect. So, you should be prepared to boost contrast and color saturation in your Picture Controls menu or image editor if necessary.

Figure 7.12 Pincushion distortion in telephoto lenses causes lines to bow inward from the edges.

- Symptom: low contrast from flare. Lenses are furnished with lens hoods for a good reason: to reduce flare from bright light sources at the periphery of the picture area, or completely outside it. Because telephoto lenses often create images that are lower in contrast in the first place, you'll want to be especially careful to use a lens hood to prevent further effects on your image (or shade the front of the lens with your hand).
- Symptom: dark flash photos. Edge-to-edge flash coverage isn't a problem with telephoto lenses as it is with wide angles. The shooting distance is. A long lens might make a subject that's 50 feet away look as if it's right next to you, but your camera's flash isn't fooled. You'll need extra power for distant flash shots. The Nikon SB-5000 and SB-910 Speedlights, for example, can automatically zoom coverage to illuminate the area captured by a 200mm telephoto lens, with three light distribution patterns (Standard, Center-weighted, and Even).

Telephotos and Bokeh

Bokeh describes the aesthetic qualities of the out-of-focus parts of an image and whether out-of-focus points of light—circles of confusion—are rendered as distracting fuzzy discs or smoothly fade into the background. Boke is a Japanese word for "blur," and the h was added to keep English speakers from rendering it monosyllabically to rhyme with broke. Although bokeh is visible in blurry portions of any image, it's of particular concern with telephoto lenses, which, thanks to the magic of reduced depth-of-field, produce more obviously out-of-focus areas.

Bokeh can vary from lens to lens, or even within a given lens depending on the f/stop in use. Bokeh becomes objectionable when the circles of confusion are evenly illuminated, making them stand out as distinct discs, or, worse, when these circles are darker in the center, producing an ugly "doughnut" effect. A lens defect called spherical aberration may produce out-of-focus discs that are brighter on the edges and darker in the center, because the lens doesn't focus light passing through the edges of the lens exactly as it does light going through the center. (Mirror or *catadioptric* lenses also produce this effect.)

Other kinds of spherical aberration generate circles of confusion that are brightest in the center and fade out at the edges, producing a smooth blending effect, as you can see at bottom in Figure 7.13. Ironically, when no spherical aberration is present at all, the discs are a uniform shade, which, while better than the doughnut effect, is not as pleasing as the bright center/dark edge rendition. The shape of the disc also comes into play, with round smooth circles considered the best, and nonagonal or some other polygon (determined by the shape of the lens diaphragm) considered less desirable.

If you plan to use selective focus a lot, you should investigate the bokeh characteristics of a particular lens before you buy. Nikon user groups and forums will usually be full of comments and questions about bokeh, so the research is fairly easy.

BOKEH AND SPHERICAL ABBERATION

The characteristics of out-of-focus discs in your image are affected both by the number of blades in the aperture (rounder is better; sharp-sided polygons are worse), and the evenness of illumination of those discs. Highlights may be brighter on the edges and darker in the center, because the lens doesn't focus light passing through the edges of the lens exactly as it does light going through the center. That's bad.

Other kinds of spherical aberration generate circles of confusion that are brightest in the center and fade out at the edges, producing a smooth blending effect. Ironically, when no spherical aberration is present at all, the discs are a uniform shade, which, while better than the doughnut effect, is not as pleasing as the bright center/dark edge rendition. Defocus controls allow you to adjust the amount of spherical aberration to refine the bokeh produced by DC lenses.

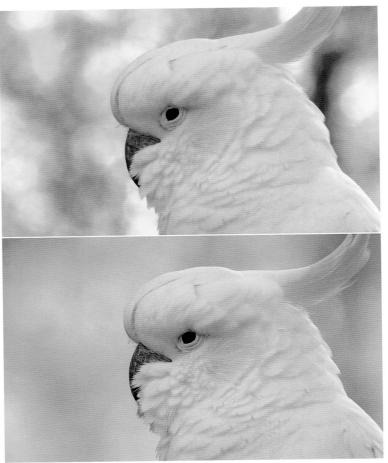

Figure 7.13
Bokeh is less pleasing when the discs are prominent (top), and less obtrusive when they blend into the background (bottom).

Nikon's Lens Roundup

The following section represents my personal recommendations on Nikon F-mount lenses, based on the more than four dozen lenses I owned in the past and the more than 30 lenses that remain in my collection today. What follows are just my opinions, and descriptions of what has worked for me. If you want lens testing and more detailed qualitative/quantitative data, you're better off visiting one of the websites devoted to providing up-to-date information of that type. I recommend Bjørn Rørslett's original Nature Photograph website (which no longer receives updates, but has a lot of information about older lenses) at www.naturfotograf.com, and the newer www.nikongear.com, as well as DPReview at www.dpreview.com.

Here, my goal is simply to let you know the broad range of F-mount optics available and help you narrow down your choices from the vast array of lenses offered. Not all of the lenses I mention will be currently available new from Nikon, but all can be readily found in mint used condition.

Generally, I'm not going to cover non-Nikon lenses. I expect it will be awhile before Tamron, Sigma, or Tokina begin to offer Z-mount lenses. As for adapted third-party F-mount lenses, your results may be hit-or-miss, as there were reports of incompatibilities among lenses that *should* have been usable on the Z6. In addition, I have always concentrated on Nikon optics in my books, primarily because I have stuck to Nikon products for most of my career. While Nikon lenses aren't always the best in their focal length/speed ranges, they are always near the top and have proved to be dependable and consistent. I'm not going to provide a lot of exact pricing information, as you can easily Google that, and prices have been trending upward for some time. One of my favorite lenses, which I purchased new for \$1,300 now lists at \$1,800!

The Magic Three

If you cruise the forums, you'll find the same three lenses mentioned over and over, often referred to as "The Trinity," "The Magic Three," or some other affectionate nickname. They are the three lenses you'll find in the kit of just about every serious Nikon photographer (including me). They're fast, expensive, heavier than you might expect, and provide such exquisite image quality that once you equip yourself with a member of the Trinity, you'll never be happy with anything else. One big advantage of these lenses is that they are all full-frame lenses, and so usable on both Nikon full-frame and DX cameras, and the hefty price you must pay for this collection won't be wasted.

Over the years, Nikon has gradually replaced the original members of the Magic Three with new lenses, and upgraded the middle lens—the 24-70mm f/2.8—to VR status. The 24-70mm Z-mount kit lens is both less expensive and arguably sharper than its counterpart F-mount lens, so you should stick to that one, unless you already have an F-mount 24-70mm lens in your collection. (See Figure 7.14.)

- AF-S Nikkor 14-24mm f/2.8G ED. I own this lens, use it on the Z6, and its image quality is incredible, with very low barrel distortion (outward bowing at the edges) and very little of the chromatic aberrations common to lenses this wide. Because it has full-frame coverage, it's immune to obsolescence. It focuses down to 10.8 inches, allowing for some interesting close-up/wide-angle effects. The downside? The outward-curving front element precludes the use of most filters, although I haven't tried this lens with add-on Cokin-style filter holders, including one very expensive (\$200) Lee Kit-SW150 Super Wide Filter Holder, which uses 150mm × 170mm and 150mm × 150mm filters. Usually, lack of filter compatibility isn't a fatal flaw for most users, as the use of polarizers, in particular, would be problematic at wider focal lengths. The polarizing effect would be highly variable because of this lens's extremely wide field of view.
- AF-S Nikkor 24-70mm f/2.8E ED VR. This lens seems to provide even better image quality than any of its predecessors, especially when used wide open or in flare-inducing environments. (You can credit the new internal Nano Crystal Coat treatment for that improvement.) I recommend the Z-mount 24-70mm f/4 optic (and the promised 24-70mm f/2.8 Z-mount version) over this one, but if you already own one, it can be used on your mirrorless Nikon.

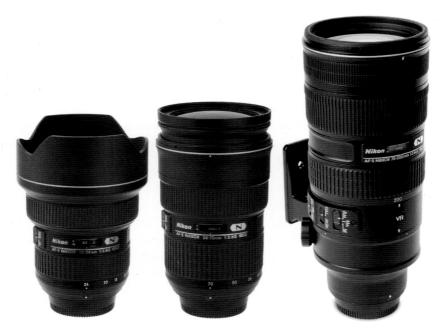

Figure 7.14The reigning Magic Three.

■ AF-S Nikkor 70-200mm f/2.8E FL ED VR. Not a lot to say about the latest version of this lens, introduced late in 2016 with a price tag of about \$2,800. It replaces the AF-S Nikkor 70-200mm f/2.8G ED VR II, introduced in 2009, and which is still available at reduced prices from some retailers. The latest edition adds fluorite lens elements and improved VR, and exhibits less focus breathing than its predecessor, which is a worthy representative of the telephoto zoom range in this "ideal" trio of lenses. It does have better performance in the corners on full-frame cameras, but most of its other attributes remain the same.

Nikon also offers an additional "affordable" replacement for its 70-200mm f/2.8 zoom. The Nikkor AF-S 70-200mm f/4G ED VR lens, priced at about \$1,400, is a slower, lower-cost zoom with the same zoom range. It does focus down to 3.3 feet, but, unlike virtually all of Nikon's "pro" lenses, takes 67mm filters instead of the standard 77mm diameter filters. Plan to buy yourself a 67mm-77mm step-up ring.

Wide Angles

Among its FX lenses, Nikon has an interesting collection of wide-angle prime lenses and zooms, both old and new, that range in price from a few hundred dollars to around \$2,000. Here's a list of some of the key lenses that are readily available. I'll describe the zooms and prime lenses separately.

■ 17-35mm f/2.8D IF-ED. This lens is still offered, and, unless you find a mint used copy, isn't even that affordable. It's an excellent lens, but the internal autofocus motor has been known to fail over time.

- 16-35mm f/4G ED VR AF-S. A tiny bit slower with a constant f/4 maximum aperture, this lens includes VR if you also use it for an F-mount Nikon, and the Z6 will automatically substitute its own IBIS. For hand-held shots, that means you won't miss f/2.8 at all. Instead of 1/60th second at f/2.8, you can shoot at 1/30th second at f/4 and expect the same sharpness.
- 18-35mm f/3.5-4.5G ED AF-S. This is a \$750 ultra-wide-angle zoom lens for those who don't want to spend the bucks for the 17-35mm and 16-35mm VR optics. It's small and light (at just under 14 ounces), and has three aspherical and two ED elements for great image quality.

Many photographers build a nice kit of lenses using only primes rather than zoom lenses. Most of these lenses are compact, light in weight, and fast, with an f/2.8 or better maximum aperture. A large number of us grew up using only prime lenses—we're the folks you might have seen a few decades ago with two and three cameras around our neck, each outfitted with a different prime lens. We learned quickly how to use "sneaker zoom" to move in closer or to back up to change our field of view without swapping optics. Not all of these lenses are ancient; Nikon has introduced an affordable 28mm f/1.8 lens, and two wide-angle f/1.4 lenses in 24mm and 35mm focal lengths are fairly recent additions.

- 20mm f/1.8G AF-S ED. This is an \$800 full-frame wide angle that works well on the Z6, giving you a large maximum aperture that provides a little more selective focus control despite the wide depth-of-field found in lenses of this focal length. In other words, you *can* throw your backgrounds and/or foregrounds out of focus if you shoot with this lens wide open.
- 24mm f/1.4G AF-S ED. Oh, the howls of anguish and outrage could be heard world-wide, especially among photojournalists, when the predecessor of this lens, a 28mm f/1.4D AF optic, was discontinued without a replacement some years back. The old lens had a list price of about \$2,000, and reportedly cost Nikon a lot more than that to make (which is why it was axed), and soon sold for up to \$4,000 on the used market. This new, sharp, fast lens is a worthy successor, and a must-have for architectural photographers, photojournalists, and street shooters. Its roughly \$2,000 price tag seems cheap compared to the prices commanded by the old 28mm f/1.4 lens.
- 24mm f/1.8G AF-S ED. Introduced in September 2015, this lens gives you a mild wide-angle view and fast f/1.8 maximum aperture for a mere \$750. It's a suitable substitute for the pricey f/1.4 version.
- 28mm f/1.8G AF-S. If a maximum aperture of f/1.8 is fast enough for you, at \$700, this lens is an amazing bargain at roughly one-third the price of its new 28mm f/1.4 cousin (described next) or the wider/faster 24mm f/1.4 optic listed above. It's got all the latest features, including the Nano Crystal lens coating found on most other recently introduced Nikkors for reduced flaring and ghost effects. Light in weight at 11 ounces, it focuses down to less than one foot. Unfortunately, unlike most of Nikon's "pro" lenses, it takes 67mm filters instead of 77mm filters. You may be able to find a very thin step-up ring that allows you to mount the larger filters without vignetting.

- 28mm f/1.4E AF-S ED. Apparently, Nikon feels you can never have enough f/1.4 lenses in your lineup. Introduced in 2017, this lens commands a premium \$2,000 price. It has nine diaphragm blades for smooth out-of-focus highlights (bokeh), and Nikon claims it has "stunning sharpness, edge-to-edge clarity and virtually no distortion or aberrations."
- 35mm f/1.4G AF-S. If you need a fast f/1.4 aperture and a slightly narrower field of view, this lens should fill the bill. It, too, takes 67mm filters, and is priced a few hundred dollars south of \$2,000. Most photojournalists you know, and more than a few architectural photographers, probably own this lens.
- 35mm f/1.8G AF-S. Again, I recommend the current Nikon Z 35mm f/1.8 S lens over this one, but if you already own one, you can get by just fine with this F-mount version. Only one-half stop slower than the f/1.4 wide angle above, this lens costs about \$700, and is a good performer as a fast wide-angle prime. It includes one aspheric and one ED element to provide excellent image quality, and focuses down to about 10 inches. Its chief drawback is the odd-ball 58mm filter size; if you want to avoid buying yet another polarizer or neutral-density filter set, you'll need an adapter ring that doesn't cause vignetting with your current filters. Don't confuse this with the older, less-expensive 35mm f/1.8G AF-S DX Nikkor, which is not a full-frame lens.

Wide to Medium/Long Zooms

There aren't too many "do everything" walk-around lenses for the Z6, other than the 24-70mm Z-mount lens, but this list offers some useful alternatives.

■ 24-120mm f/4G ED AF-S VR. I mentioned this lens earlier in the chapter as a basic walkaround optic. I really love the newest version of this lens. But, caveat emptor! Nikon has offered three different lenses in this focal length range, and this latest model is the good one. Accept no substitute! As I noted earlier, the original 24-120mm f/3.5-5.6 AF-D lens was produced from 1996 through 2002, and was replaced in 2003 with a version having similar specs, but an internal AF-S motor and vibration reduction. Neither lens was the sharpest optic in the drawer, but they were popular because of their useful focal length range. This latest version has a constant f/4 aperture, and produces much better image quality, with the VR making it an excellent walk-about lens for hand-held exposures. Priced in the \$1,100 range it's almost a bargain for what it does: giving you everything from moderate wide angle to short telephoto focal lengths. Last winter, when I moved my office to the Florida Keys temporarily to escape the brutal weather, I found myself unexpectedly needing to do some product photography on a seamless background. I was amazed to find that this lens functioned quite handily as a macro lens. It was even more versatile than I'd thought.

- 24-85mm f/3.5-4.5G AF-S ED VR. Introduced in June 2012 with a current affordable \$500 price tag, and intended as a "cheap" full-frame lens for Nikon's new low-end FX cameras like the D610, this zoom works just fine on a Nikon Z6. It's shorter and lighter than the 24-120mm zoom.
- 28-300mm f/3.5-5.6G AF-S ED VR. This is the closest thing Nikon offers to an "all-around" lens for F-mount and (adapted) Z-mount cameras. It's shy of two pounds at 28 ounces, fairly compact, and features the second edition of Nikon's vibration reduction technology. At a little less than \$1,000, it's fairly affordable, too.

Telephoto and Normal Lenses

The "normal" to medium telephoto range is useful for photojournalism and street photography in situations where you have room to back up and don't want the apparent distortion that wider lenses can add when some elements are particularly close to the lens. Wide-angle and perspective distortion is just fine when you want to use it as a creative element, but if not, you'll want to consider one of these lenses. They're also good for portraits for the same reason: objects that are closer to the lens (such as human noses) aren't rendered disproportionately large, with more distant objects (ears) too small (which can be the case with wide-angle lenses). Humans look more natural when photographed with lenses in this range, as longer lenses (150mm and above) tend to "flatten" faces and make them appear wider.

"Normal" is defined as focal lengths roughly equivalent to the diagonal of the image frame, which in the case of a full-frame camera is about 45mm (43.3mm precisely), and about 30mm on a DX camera like the Z6. The AFS-DX Nikkor 35mm f/1.8G lens would correspond to an inexpensive, non-FX normal lens for your camera. The FX lenses in this category qualify as normal for any full-frame camera that might be in your future, and should be considered short telephotos for your Z6. (Which makes them perfect as portrait lenses.)

- 50mm f/1.2 AI-S. I'm including this older-design, manual focus lens because quite a mystique has developed around so-called "super speed" optics, including the remarkable (and remarkably expensive) F-mount Nikon 58mm f/1.2 Noct (which can cost upward of \$3,000 on the used market) and the upcoming Z-mount reboot with the \$6,000 price tag. While both Nocts are sensational wide open, this one is merely good at f/1.2, but it's quite usable (and really sharpens up by f/2) and a *lot* more affordable at around \$700. If you *must* have the fastest lens available, consider this one. Given the very shallow depth-of-field at wide apertures, you probably would want to focus this one manually, anyway. I own one, and tend to use it more on my Nikon Df rather than with the Z6, because its true-retro design looks cool on the neo-retro Df.
- 50mm f/1.4G AF-S. This is the replacement for the D-version of this lens. It's reasonably sharp, and costs more at around \$450, but offers faster AF-S focusing. If you have a large collection of 52mm filters (which fit many old and new Nikon prime lenses), they won't fit on this lens without a step-down ring. It takes the larger 58mm variety.

- 58mm f/1.4G AF-S. If you think that eight extra millimeters of focal length can't possibly make this lens worth an extra grand more than its 50mm f/1.4 cousin described above, you're missing the point. This one is, quite simply, one of the sharpest F-mount lenses Nikon offers, even wide open, besting its 24mm, 35mm, 50mm, and 85mm f/1.4 stablemates at maximum aperture. That's what you'll be paying roughly \$1,700 for, and if you're a photojournalist or wedding photographer, you'll think it's worth it. Although it's an AF-S lens, autofocus is a bit on the slow side. I already own an old 58mm f/1.4 manual focus Nikkor, and the two lenses have nothing in common—including filter size. My 1960s-era 58mm takes Nikon's then-standard 52mm filters, and this one has a 72mm filter thread (not Nikon's 77mm "pro" size).
- 50mm f/1.8G AF-S. Nikon updated the older D-version of this lens, adding an internal Silent Wave motor for faster focusing, deleting the useful aperture ring, and almost doubling the price to \$220. This version makes sense for entry-level Nikon cameras, but is suitable for the Z6 only if you need a fast 50mm lens and can't afford the tariff on the Z-mount version.

Medium to Long Telephoto

I tend to shoot either ultra-wide, with fisheyes or lenses (for landscapes, interiors, exteriors, street photography, and for perspective exaggeration), or use this medium-to-long telephoto focal length range (for portraits, sports, fashion, and isolating subjects using selective focus). Probably 80 percent of my images are made using lenses in one of those two categories. So, I tend to lump all the lenses in this group together in my mind. They all do about the same thing and, surprisingly, almost all equally well. Here are some brief descriptions of your choices:

- 70-300mm f/4-5.6G AF. This is the low-end, bargain lens in the group, which can be found for a couple hundred bucks. It's slow, lacks VR, but you can't beat the versatility it gives you at this price.
- **70-300mm f/4.5-5.6E AF-P ED VR.** New in 2017, and now priced at about \$600, this lens replaces the older 70-300mm f/4.5-5.6G AF-S VR, which is still available for about \$750. Either of these lenses are a better choice for most than the AF lens listed above, because they add AF-S focus and vibration reduction.
- 70-200mm f/2.8G ED AF-S VR II. Anyone who can afford this lens will never regret their purchase.
- 80-400mm f/4.5-5.6G ED AF-S VR. If you're looking for a telephoto zoom with a long focal length range, and have an extra \$2,100 you don't need, Nikon may tempt you with this optically improved version, more road-hugging weight in its large frame (47 ounces), closer focusing (about 5 feet vs. 7.5 feet), and flare-thwarting Super Nano Coat. Those in the prime of life willing to sling 5 pounds of Z6 and lens around their necks will find this to be a supremely versatile optic.

Medium Telephoto

One advantage of medium telephoto prime lenses is that they are all quite fast, with maximum apertures of f/1.4 to f/4, which makes them an excellent choice for portraits, sports, animals, and other subjects that don't call for a really long lens. Their large f/stops are great for selective focus and allow you to use faster shutter speeds for hand-held shooting.

- 85mm f/1.4G AF-S. In its never-ending quest to upgrade its older AF lenses to AF-S, Nikon introduced this highly rated G version of the Cream Machine at \$1,600. It's excellent, and offers a bit more autofocus speed, but if you own the older lens, there's no pressing reason to upgrade.
- 105mm f/1.4E ED AF-S. What a dream lens for the portrait shooter! I cut my teeth on a Nikkor 105mm f/2.5 manual focus lens many moons ago, and used it for most of the portraits I shot until I purchased the 85mm f/1.4 and 70-200mm f/2.8 lenses. This lens (\$2,200) should go to the top of any people-shooting photographer's wish list. It has superb sharpness wide open at f/1.4, great bokeh, and I find that its focal length is great for head-and-shoulders portraits when you want to defocus the background, or even part of your subject. (See Figure 7.15.) The tendency of this focal length to "flatten" faces isn't noticeable with the type of subjects I shoot. It could be a good lens for intimate street photography and some sports, too.
- 300mm f/4D AF-S IF-ED. This lens isn't really a "medium" telephoto, but it is a prime lens, and I didn't want to toss it in with the more exotic lenses in the section that follows this one. I love this lens. Although I once shot sports professionally full-time, I only manage two or three events for each of my favorite sports these days (soccer, football, basketball, motor sports, hockey, volleyball, baseball, and track), and can't justify keeping the wonderful 300mm f/2.8 lens in my collection. This one is a more reasonably priced (\$1,000–\$1,500) alternative. It works fine with my Nikon teleconverters, so I can transform it into a 420mm f/5.6 (with the 1.4X converter) or 510mm f/6.3 (1.7X teleconverter) with ease. You'll probably use this lens mounted on a tripod or monopod most of the time, and, if so, you should be aware that the factory tripod mount flexes. I replaced mine with an improved mount from Kirk, and get sharper images.
- 300mm f/4E AF-S PF ED VR. We Nikon users are starting to get spoiled by the camera-freezing powers of vibration reduction, so the introduction of this replacement for the older 300mm f/4D lens was no surprise. Neither was the \$2,000 price tag. VR makes this lens much more usable hand-held than its older sibling: you can often get shake-free images at 1/250th second or even slower, something generally not possible with the non-VR version.

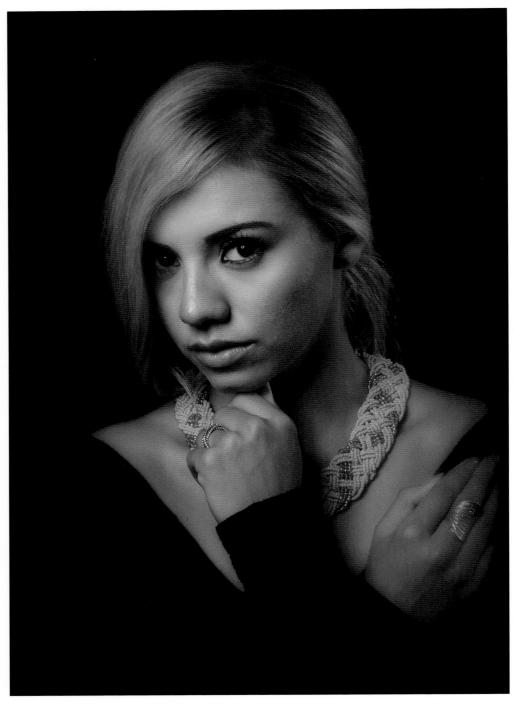

Figure 7.15 A lens with an f/1.4 maximum aperture is perfect for portrait photography.

Exotic Long Lenses

These are the lenses that most of us borrow, or lust after, and usually end up purchasing a car or a house with the funds instead. I see photographer friends hefting the 500mm f/4 or 600mm f/4 around sporting events all the time, and as I watch them huff and puff my envy evaporates. But if you're heavily involved in wildlife photography, sports, or double-naught spy activities, you can probably justify at least one of these. All are very fast, with constant maximum apertures of f/4 or better, feature the latest internal Silent Wave focus motors, and VR.

- 200-500mm f/5.6E ED AF-S VR. Given a focal length range that tops out at 500mm, this is theoretically an "exotic" long lens. But its \$1,200 price puts this super-zoom within the reach of the average Nikon-loving spendthrift. It's got vibration reduction (if you're also using it on an F-mount camera), focuses down to 7.2 feet, and has a constant maximum aperture that doesn't vary as you zoom from 200mm to 500mm. What's not to like? Well, its largest f/stop—f/5.6—is the main fly in the ointment, limiting sports shooters to daytime photography in many cases. Its best f/stops are f/8 and f/11, and even with VR you'd want to use shutter speeds of 1/2,000th second or better (unless you're after some subject motion blur to represent movement). That translates into typical settings of 1/2,000th second at f/11 and ISO 1000—in broad daylight. Wildlife photographers would probably want to use this lens mounted on a tripod, and low-light photography of any sort would call for higher ISO settings and/or a tripod. Even so, a 200-500mm zoom at this price is quite exciting, and is a reasonable substitute for the 200-400mm lens described next.
- 200-400mm f/4G AF-S ED VR II. This is an amazing lens, and one that a great many photographers who probably couldn't justify a copy end up mortgaging their houses to buy (at around \$7,000). At least, that's what I glean from the forum postings by photographers who are agonizing over being forced to sell this lens to keep the wolf at bay. It's sharp, more than 14 inches long and seven pounds in heft, and one of the most versatile lenses in this group for wildlife and sports photographers. And, it's one of the few Nikon lenses that comes with its own "protective" filter, what Nikon calls a "dedicated protective glass" (which itself is furnished with a separate case). You can slip actual 52mm filters into a slot in the rear of the lens, though. The newest version, introduced in 2010, has the nano coating for reduced flare. This is another lens that almost demands a third-party replacement for the factory tripod collar. This lens is heavy enough that you'll be using it on a tripod or monopod most of the time.
- 200mm f/2G AF-S ED VR II / 300mm f/2.8G AF-S VR II IF-ED. This pair of lenses is fast and primarily useful for sports photography under waning light conditions (both are a bit too short for wildlife in the wild). Priced in the \$6,000 range, both are fast enough to be used with Nikon's 1.4X, 1.7X, or 2X teleconverters.

■ 400mm f/2.8E AF-S FL ED VR / 500mm f/4E FL ED VR / 600mm f/4E FL AF-S ED VR / 800mm f/5.6E ED VR. A set of these four lenses, all of the new E (electronic aperture control) type, will deduct more than \$50,000 from your wallet, but they are the ultimate sports or wildlife lenses, or for capturing images of the Great Wall of China from the International Space Station. The 500mm and 600mm lenses are new versions introduced in 2015, replacing earlier models with similar performance (and price tags).

Perspective Control/Special Lenses

My first perspective control lens was a 35mm f/3.5 PC-Nikkor that I still own. It was manual focus, manual exposure, manual aperture, shifted but didn't tilt, and I had to machine down part of the sliding mechanism so it wouldn't bump against the metering head of my Nikon film camera. In those days, PC lenses were used primarily for architectural photography and some product photography to allow keeping the focal plane of the camera parallel with a subject to avoid a tilted/distorted effect.

Things have changed! Today shift/tilt photography is so popular that Nikon and other vendors are building a faux perspective/focus control capability right into the camera as a "Miniature Effect" retouching aid. While lenses like Nikon's PC-E line are still useful for their original purpose—perspective control—I've seen some absolutely brilliant portrait and wedding photography that uses tilt/shift capabilities as a dreamy focus control. Wedding guru Parker Pfister comes to mind (although he's a Canon guy; don't hold it against him), but you can find this tool used everywhere you look. The lenses currently in the Nikon lineup are listed next, along with one additional "special" lens, an odd-ball fisheye that fit nowhere else in this chapter's discussions. A new 19mm PC-E lens is rumored, but was not introduced at the time I wrote this book.

- 19mm f/4 PC-E ED. The latest addition to the Nikon perspective control line is this \$3,400 19mm ultra-wide-angle lens. When applied to architectural applications, the wider the shift/tilt lens the better, and this one beats the previous Nikkor 24mm champ, described next. It shifts plus or minus 12mm, tilts plus/minus 7.5 degrees, and has a minimum focus distance of less than 10 inches.
- 24mm f/3.5D PC-E ED. Priced in the \$2,200 range, this 24mm lens shifts plus or minus 11mm from side to side and plus or minus 8.5-degrees tilt. The mechanism rotates 90 degrees in two directions so you can apply the corrections/distortions from virtually any angle. It focuses down to about eight inches, so you can use its effects for close-ups and product/model photography. The big surprise for those who aren't old-timers is that this can be used as a *pre-set* lens. You set the f/stop you want to use on a ring and focus with the lens wide open. Then, when you're ready to shoot, press the aperture button and the lens stops down to the selected f/stop. However, Nikon has included an electronic auto aperture mechanism that can provide automatic stop-down with the Z6. The shifting/tilting mechanism precludes autofocus.

- 45mm f/2.8 PC-E ED Micro Nikkor. With the same amount of shifting/tilting available, this \$2,000-plus lens (and its 85mm counterpart, next) is classified as a macro lens, focusing down to about 10 inches and providing a half-life-size image on the sensor.
- 85mm f/2.8D PC-E Micro Nikkor. This is the PC-E lens you'd want to use for your dreamy wedding portraits. Priced at about \$2,000, it shifts and tilts the same amount as the other, and focuses down to 1.3 feet.
- I owned Nikon's exotic 7.5mm f/5.6 fisheye back in the days of film, and would have it today except that the lens required locking up the mirror and using an auxiliary viewfinder in a mode quite incompatible with any of Nikon's digital cameras. (Nikon later introduced fisheyes that didn't require mirror lock-up.) I still own Nikon's 16mm f/3.5 manual focus/pre-AI fisheye, as well as a Tokina 10-17mm fisheye zoom, a Sigma 15mm f/2.8 autofocus fisheye, and a Rokinon 12mm f/2.8 manual focus fisheye. This full-frame (non-circular image) autofocus model, which can be purchased for about \$1,000, is probably the most practical of the bunch. It fills the FX frame with lines that exhibit a gloriously frightful amount of barrel distortion. When I travel overseas, I take along my two "main" lenses (17-35mm f/2.8 and 28-200G zoom) and a fisheye "fun" lens like this one.

Macro Lenses

Some telephotos and telephoto zooms available for the Nikon Z6 have particularly close focusing capabilities, making them *macro* lenses. Of course, the object is not necessarily to get close (get too close and you'll find it difficult to light your subject). What you're really looking for in a macro lens is to magnify the apparent size of the subject in the final image. Camera-to-subject distance is most important when you want to back up farther from your subject (say, to avoid spooking skittish insects or small animals). In that case, you'll want a macro lens with a longer focal length to allow that distance while retaining the desired magnification. Nikon also makes a range of full-frame lenses that are officially designated as macro optics. The most popular include:

■ AF-S Micro-Nikkor 60mm f/2.8G ED. This type-G lens supposedly replaces an older type-D lens, adding an internal Silent Wave autofocus motor that should operate faster. It also has ED lens elements for improved image quality. However, because it lacks an aperture ring, you can control the f/stop only when the lens is mounted directly on the camera or used with automatic extension tubes. Should you want to reverse a macro lens using a special adapter (the Nikon BR2-A ring) to improve image quality or mount it on a bellows, you're better off with a lens having an aperture ring. This lens is an excellent choice if you want to capture 35mm slides using the Nikon ES-2 film digitizing adapter, which, as I write this, has been sent back to the factory, but may be available in 2019 when this book is published. It's been rumored that this macro lens itself is being revamped and will be replaced in the not-too-distant future.

- AF-S VR Micro-Nikkor 105mm f/2.8G IF-ED. This G-series lens did replace a similar D-type, non-AF-S version that also lacked VR. I own the older lens, too, and am keeping it because I find VR a rather specialized tool for macro work. Some 99 percent of the time, I shoot close-ups with my Z6 mounted on a tripod or, at the very least, on a monopod, so camera vibration is not much of a concern. Indeed, *subject* movement is a more serious problem, especially when shooting plant life outdoors on days plagued with even slight breezes. Because my outdoor subjects are likely to move while I am composing my photo, I find both VR and autofocus not very useful. I end up focusing manually most of the time, too. This lens provides a little extra camera-to-subject distance, so you'll find it very useful, but consider the older non-G, non-VR version, too, if you're in the market and don't mind losing vibration reduction features.
- AF Micro-Nikkor 200mm f/4D IF-ED. With a price tag of about \$1,800, you'd probably want this lens only if you planned a great deal of close-up shooting at greater distances. It focuses down to 1.6 feet, and is manual focus only with the Z6, but provides enough magnification to allow interesting close-ups of subjects that are farther away. A specialized tool for specialized shooting.
- PC Micro-Nikkor 85mm f/2.8D. Priced about \$2,000, this is a manual focus lens (on *any* camera; it doesn't offer autofocus features) that has both tilt and shift capabilities, so you can adjust the perspective of the subject as you shoot. The tilt feature lets you "tilt" the plane of focus, providing the illusion of greater depth-of-field, while the shift capabilities make it possible to shoot down on a subject from an angle and still maintain its correct proportions. If you need one of these for perspective control, you already know it; if you're still wondering how you'd use one, you probably have no need for these specialized capabilities. However, I have recently watched some very creative fashion and wedding photographers use this lens for portraits, applying the tilting features to throw parts of the image wildly out of focus to concentrate interest on faces, and so forth. None of these are likely pursuits of the average Nikon Z6 photographer, but I couldn't resist mentioning this interesting lens.

Mastering Light

The key tool we use to create and shape our images is light itself, in all its many forms and textures. Indeed, it's said that Sir John Herschel coined the term "photography" from the Greek words for "writing with light" in a paper read before the Royal Society in March 1839. Our dependence on the qualities of the light we use to produce our images is absolute. An adept photographer knows how to compensate for too much or too little illumination, how to soften harsh lighting to mask defects, or increase its contrast to evoke shape and detail. Sometimes, we must adjust our cameras for the apparent "color" of light, use a brief burst of it to freeze action, or filter it to reduce glare.

The many ways we can work with light deserve three full chapters in this book. This chapter introduces using *continuous* lighting (such as daylight, incandescent, LED, or fluorescent sources). I'll cover the brilliant snippets of light we call *electronic flash*, in Chapters 9 and 10.

Light That's Available

You'll often hear the term *available light*, meaning the ambient light at a scene, including whatever illumination is present outdoors during the day or at night, and that provided by lighting fixtures, windows, and other sources. In practice, available light includes any sort of illumination that's available, and can include supplementary lighting added by the photographer in the form of additional lamps, reflectors, or studio continuous light sources.

For our purposes, available light is exactly what you might think: uninterrupted illumination that is available all the time during a shooting session. Daylight, moonlight, and the artificial lighting encountered both indoors and outdoors count as continuous light sources (although all of them can be "interrupted" by passing clouds, solar eclipses, a blown fuse, or simply by switching a lamp off). Indoor continuous illumination includes both the lights that are there already (such as incandescent lamps or overhead fluorescent lights indoors) and fixtures you supply yourself, including photoflood lamps or reflectors used to bounce existing light onto your subject.

Continuous lighting differs from electronic flash, which illuminates our photographs only in brief bursts. Flash, or "strobe" light is notable because it can be much more intense than continuous lighting, lasts only a moment, and can be much more portable than supplementary incandescent sources. It's a light source you can carry with you and use anywhere. There are advantages and disadvantages to each type of illumination. Here's a quick checklist of pros and cons:

- Lighting preview—Pro: continuous lighting. With continuous lighting, thanks to the Z6's real-time sensor image through the viewfinder or LCD monitor, if you've opted to activate Custom Setting d8: Apply Settings to Live View, you'll always know exactly what kind of lighting effect you're going to get—including color balance—and, if multiple lights are used, how they will interact with each other. If the natural light present in a scene is perfect for the image you're trying to capture, you'll know immediately (see Figure 8.1).
- Lighting preview—Con: electronic flash. With flash, unless you have a modeling light built into the flash, the general effect you're going to see may be a mystery until you've built some experience, and you may need to review a shot, make some adjustments, and then reshoot to get the look you want. (In this sense, a digital camera's review capabilities replace the Polaroid test shots pro photographers relied on in decades past.) An image like the candle-lit scene in Figure 8.1 would have been difficult to achieve with an off-camera battery-powered flash unit, because it would be tricky to balance the illumination of the candles with the light from the flash. While the modeling light feature offered by some Nikon flash units can be helpful, it's not a true continuous modeling light.
- Exposure calculation—Pro: continuous lighting. Your Z6 has no problem calculating exposure for continuous lighting, because it remains constant and can be measured directly from the light reaching the sensor. The amount of light available just before the exposure will, in almost all cases, be the same amount of light present when the shutter is released. The Z6's Spot metering mode can be used to measure and compare the proportions of light in the highlights and shadows, so you can make an adjustment (such as using more or less fill light) if necessary. If you want the utmost precision, you can even use a hand-held light meter to measure the light yourself, and then set the shutter speed and aperture to match in Manual exposure mode.
- Exposure calculation—Con: electronic flash. Electronic flash illumination doesn't exist until the flash fires, and so can't be measured by the Z6's exposure sensor at the moment of exposure. Instead, the light must be measured by metering the intensity of a *pre-flash* triggered an instant *before* the main flash, as it is reflected back to the camera and through the lens. A less attractive alternative, available with higher-end Nikon flash units like the SB-5000 or SB-910, is to use a sensor built into the external flash itself and measure reflected light that bounces back, but which has not traveled through the lens. If you have a do-it-yourself bent, there are hand-held flash meters, too, including models that measure both flash and continuous light, so you need only one meter for both types of illumination.

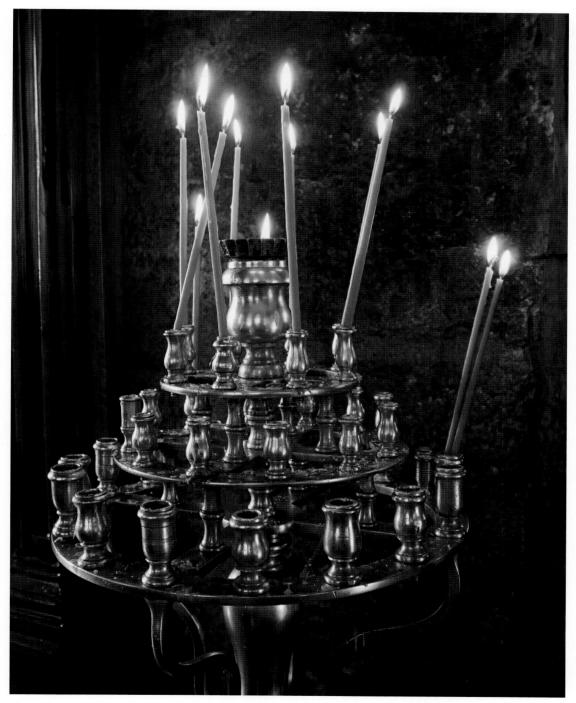

Figure 8.1 You always know how the lighting will look when using continuous illumination.

- Evenness of illumination—Pro/con: continuous lighting. Of the continuous light sources, daylight, in particular, provides illumination that tends to fill an image completely, lighting up the foreground, background, and your subject almost equally. Shadows do come into play, of course, so you might need to use reflectors or fill in additional light sources to even out the illumination further. But, barring objects that block large sections of your image from daylight, the light is spread fairly evenly. Indoors, however, continuous lighting is commonly less evenly distributed. The average living room, for example, has hot spots near the lamps and overhead lights, and dark corners located farther from those light sources. But on the plus side, you can easily see this uneven illumination and compensate with additional lamps.
- Evenness of illumination—Con: electronic flash. Electronic flash units, like continuous light sources such as lamps that don't have the advantage of being located 93 million miles from the subject, suffer from the effects of their proximity. The *inverse square law*, first applied to both gravity and light by Sir Isaac Newton, dictates that as a light source's distance increases from the subject, the amount of light reaching the subject falls off proportionately to the square of the distance. In plain English, that means that a flash or lamp that's twelve feet away from a subject provides only one-quarter as much illumination as a source that's six feet away (rather than half as much). This translates into relatively shallow "depth-of-light." I'll discuss this aspect again in Chapter 9.
- Action stopping—Pro: electronic flash. When it comes to the ability to freeze moving objects in their tracks, the advantage goes to electronic flash. The brief duration of electronic flash serves as a very high "shutter speed" when the flash is the main or only source of illumination for the photo. Your Z6's shutter speed may be set for 1/200th second during a flash exposure, but if the flash illumination predominates, the *effective* exposure time will be the 1/1,000th to 1/50,000th second or less duration of the flash, as you can see in Figure 8.2, because the flash unit reduces the amount of light released by cutting short the duration of the flash. The only fly in the ointment is that, if the ambient light is strong enough, it may produce a secondary, "ghost" exposure, as I'll explain in Chapter 9.
- Action stopping—Con: continuous lighting. Action stopping with continuous light sources is completely dependent on the shutter speed you've dialed in on the camera. And the speeds available are dependent on the amount of light available and your ISO sensitivity setting. Outdoors in daylight, there will probably be enough sunlight to let you shoot at 1/2,000th second and f/6.3 with a non-grainy sensitivity setting for your Z6 of ISO 400. That's a fairly useful combination of settings if you're not using a super-telephoto with a small maximum aperture. But inside, the reduced illumination quickly has you pushing your Z6 to its limits. For example, if you're shooting indoor sports, there probably won't be enough available light to allow you to use a 1/2,000th second shutter speed (although I routinely shoot indoor basketball with my Z6 at ISO 1600 and 1/500th second at f/4). In many indoor sports situations, the lack of available light, and the Z6's increased visual noise at settings of ISO 6400 and above, you may find yourself limited to 1/500th second or slower.

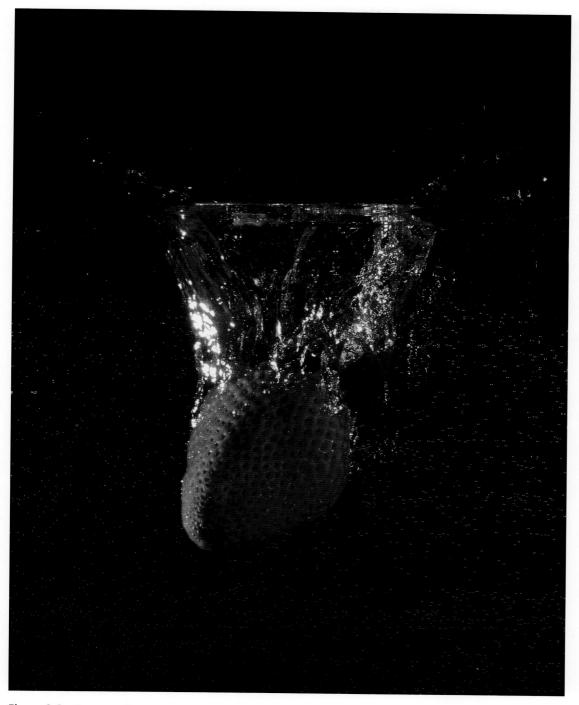

 $\textbf{Figure 8.2} \ \ \text{Electronic flash can freeze almost any action}.$

- Cost—Pro: continuous lighting. Incandescent, fluorescent, or LED lamps are generally much less expensive than electronic flash units, which can easily cost several hundred dollars. I've used everything from desktop high-intensity lamps to reflector flood lights for continuous illumination at very little cost. There are lamps made especially for photographic purposes, too. Maintenance is economical, too: many incandescent or fluorescents use bulbs that cost only a few dollars, and LED lamps are not only much less costly to operate, they are virtually immortal.
- Cost—Con: electronic flash. Electronic flash units aren't particularly cheap. The lowest-cost dedicated flash designed specifically for the Nikon dSLRs is about \$150 (the SB-300), and it is probably not powerful enough for an advanced camera like the Z6. Such basic units are limited in features, and intended for those with entry-level cameras like the Nikon D3500. Plan on spending some money to get the features that a sophisticated electronic flash offers.
- Flexibility—Pro: electronic flash. Electronic flash's action-freezing power allows you to work without a tripod in the studio (and elsewhere), adding flexibility and speed when choosing angles and positions. Flash units can be easily filtered, and, because the filtration is placed over the light source rather than the lens, you don't need to use high-quality filter material. For example, Roscoe or Lee lighting gels, which may be too flimsy to use in front of the lens, can be mounted or taped in front of your flash with ease.
- Flexibility—Con: continuous lighting. Because incandescent and fluorescent lamps are not as bright as electronic flash, the slower shutter speeds required (see "Action stopping," above) mean that you may have to use a tripod more often, especially when shooting portraits. The incandescent variety of continuous lighting gets hot, especially in the studio, and the side effects range from discomfort (for your human models) to disintegration (if you happen to be shooting perishable foods like ice cream). The heat also makes it more difficult to add filtration to incandescent sources. (It's no wonder that LED illumination is rapidly becoming the go-to continuous light source for photography.)

Continuous Lighting Basics

While continuous lighting and its effects are generally much easier to visualize and use than electronic flash, there are some factors you need to consider, particularly the color temperature of the light, how accurately a given form of illumination reproduces colors (we've all seen the ghastly looks human faces assume under mercury-vapor lamps outdoors), and other considerations.

One important aspect is color temperature. Of course, color temperature concerns aren't exclusive to continuous light sources, but the variations tend to be more extreme and less predictable than those of electronic flash, which output relatively consistent daylight-like illumination.

Living with Color Temperature

Nikon has been valiant in its efforts to help us tame the color balance monster. Some earlier Nikon pro cameras (the last one being the Nikon D2Xs) had a bindi-like white dot on their "foreheads," which measured ambient color temperature. Although this special sensor was abandoned by Nikon long before the Z6 was introduced, the technology lives on in the form of ExpoDisc filter/caps and their ilk (www.expoimaging.com), which allow the camera's built-in custom white balance measuring feature to evaluate the illumination that passes through the disc/cap/filter/Pringle's can lid, or whatever neutral-color substitute you employ. (A white or gray card also works.) To help us tangle with the many different types of non-incandescent/non-daylight sources, Nikon has provided the Z6 with seven different presets for fluorescents, sodium-vapor, and mercury-vapor illumination. If those aren't enough, you can select a specific color temperature, or capture and save up to six white balance settings for retrieval later.

In practical terms, color temperature is how "bluish" or how "reddish" the light appears to be to the digital camera's sensor. Indoor illumination is quite warm, comparatively, and appears reddish to the sensor. Daylight, in contrast, seems much bluer to the sensor. Our eyes (our brains, actually) are quite adaptable to these variations, so white objects don't appear to have an orange tinge when viewed indoors, nor do they seem excessively blue outdoors in full daylight. Yet, these color temperature variations are real and the sensor is not fooled. To capture the most accurate colors, we need to take the color temperature into account in setting the color balance (or *white balance*) of the Z6—either automatically using the camera's smarts or manually using our own knowledge and experience. Table 8.1 provides a summary of what you need to know, and where you can look for explanations. You'll find a discussion of white balance bracketing in Chapter 4.

Table 8.1 White Balance Adjustment Options			
Type of Adjustment	Options	Location	Explanation
Color balance presets	Auto (three options); Incandescent; Fluorescent (seven options); Sunlight (three options, plus adjustment); Flash	Photo Shooting menu	Chapter 11
Choose color temperature	2,500K–10,000K	Photo Shooting menu	Chapter 11
Fine-tune color balance	Adjust white balance along blue/ amber, magenta/green axes, or both	Photo Shooting menu	Chapter 11
Manual color balance	Capture white balance or use existing photo's white balance	Photo Shooting menu	Chapter 11
White balance bracketing/Bracket order	2, 3, 5, 7, or 9 bracketed images using three increments	Custom Settings menu, BKT but- ton/command dials	Chapter 4, Chapter 12

The only time you need to think in terms of actual color temperature is when you're making adjustments using the Choose Color Temp. setting in the White Balance entry within the Photo Shooting menu, which, as I'll describe in Chapter 11, allows you to dial in exact color temperatures, if known. You can also shift and bias color balance along the blue/amber and magenta/green axes, and bracket white balance.

In most cases, however, one of the three Auto settings in the Photo Shooting menu's White Balance entry—Keep White (Reduce Warm Colors), Normal, or Keep Warm Lighting Colors—will do a good job of calculating white balance for you. Auto can be used as your choice most of the time. Use the preset values (Auto₀, Auto₁, or Auto₂) or set a custom white balance that matches the current shooting conditions when you need to.

Remember that if you shoot RAW, you can specify the white balance of your image when you import it into Photoshop, Photoshop Elements, or another image editor using Capture NX-D, Adobe Camera Raw, or your preferred RAW converter. While color-balancing filters that fit on the front of the lens exist, they are primarily useful for film cameras, because film's color balance can't be tweaked as extensively as that of a sensor.

Color Rendering

Faithful color rendition goes beyond color temperature. So-called "white" light is produced by a spectrum of colors that, when added together, provide the neutral color needed for accuracy. Artificial light sources don't necessarily offer the same balanced spectrum found in sunlight. Some portions of the spectrum may be deficient or truncated, or include gaps with certain wavelengths missing entirely. Astronomers use their knowledge of which elements absorb which colors of light to calculate the makeup of distant stars using spectrographs. In photography, the analysis of spectra is used to calculate the color rendering index, which measures how accurately colors are presented.

All artificial light sources have a color rendering index (CRI). That figure is calculated by rating eight different colors on a scale of 0 to 100, based on how natural the color looks compared to a perfect or "reference" light source at a particular color temperature. A CRI of 80-plus is considered acceptable; for critical applications like photography, a CRI higher than 93 is best. Incandescent and halogen bulbs typically have a CRI of 100 compared to a reference light source at the same color temperature. Standard LED lamps are rated at 83, although some can have CRIs as high as 98. Many types of fluorescent lights fall into the CRI 50–75 range.

Vendors, such as GE and Sylvania, may actually provide a figure known as the color rendering index on the packaging using a scale of 0 (some sodium-vapor lamps) to 100 (daylight and most incandescent lamps). Daylight fluorescents and deluxe cool white fluorescents suitable for photography might have a CRI of about 79 to 95, which is perfectly acceptable for most photographic applications. Less desirable are warm white fluorescents, which may have a CRI of 55. White deluxe mercury-vapor lights are even less suitable with a CRI of 45, while low-pressure sodium lamps can vary from CRI 0 to 18. If you're using such a source not intended for photography, it may be worth your while to determine its color rendering index before you shoot.

White Balance Bracketing

As I explained in Chapter 4, with WB bracketing the Z6 takes a single shot, and then saves 2, 3, or 5 (your choice) JPEG copies, each with a different color balance. It's not necessary to capture multiple shots, as the camera uses the raw information retrieved from the sensor for the single exposure and then processes it to generate the multiple different versions. The bracketing adjustments are made only on the amber/blue axis (no bracketing in the magenta/green bias is possible), but you can select whether the bracketed shots are spread in the blue *or* amber directions (that is, each one bluer/less blue or yellower/less yellow) or balanced to provide both blue- and amber-oriented brackets.

Making these adjustments are the only times you're likely to be confused by a seeming contradiction in how color temperatures are named: warmer (more reddish) color temperatures (measured in degrees Kelvin) are the *lower* numbers, while cooler (bluer) color temperatures are *higher* numbers. It might not make sense to say that 3,400K is warmer than 6,000K, but that's the way it is. If it helps, think of a glowing red ember contrasted with a white-hot welder's torch, rather than fire and ice.

The confusion comes from physics. Scientists calculate color temperature from the light emitted by a mythical object called a black body radiator, which absorbs all the radiant energy that strikes it, and reflects none at all. Such a black body not only *absorbs* light perfectly, but it *emits* it perfectly when heated (and since nothing in the universe is perfect, that makes it mythical).

At a particular physical temperature, this imaginary object always emits light of the same wavelength or color. That makes it possible to define color temperature in terms of actual temperature in degrees on the Kelvin scale that scientists use. Incandescent light, for example, typically has a color temperature of 3,200K to 3,400K. Daylight might range from 5,500K to 6,000K. Each type of illumination we use for photography has its own color temperature range—with some cautions.

Daylight

Daylight is produced by the sun, and so is moonlight (which is just reflected sunlight). Daylight is present, of course, even when you can't see the sun. When sunlight is direct, it can be bright and harsh. If daylight is diffused by clouds, softened by bouncing off objects such as walls or your photo reflectors, or filtered by shade, it can be much dimmer, less contrasty, and more flattering for subjects such as people.

Daylight's color temperature can vary quite widely. It is highest in temperature (most blue) at noon when the sun is directly overhead, because the light is traveling through a minimum amount of the filtering layer we call the atmosphere. The color temperature at high noon may be 6,000K. At other times of day, the sun is lower in the sky and the particles in the air provide a filtering effect that warms the illumination to about 5,500K for most of the day. Starting an hour before dusk and for an hour after sunrise, the warm appearance of the sunlight is even visible to our eyes when the color temperature may dip to 5,000K–4,500K, as shown in Figure 8.3.

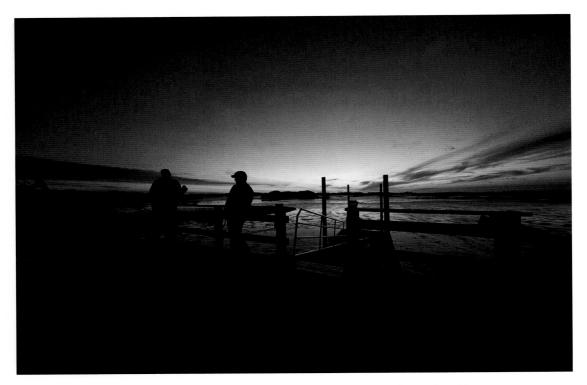

Figure 8.3 At dawn and dusk, the color temperature of daylight may dip as low as 4,500K.

Because you'll be taking so many photos in daylight, you'll want to learn how to use or compensate for the brightness and contrast of sunlight, as well as how to deal with its color temperature. I'll provide some hints later in this chapter.

Incandescent/Tungsten/Halogen Light

The term incandescent or tungsten/halogen illumination is usually applied to the direct descendents of Thomas Edison's original electric lamp. Such lights consist of a glass bulb that contains a vacuum, or is filled with a halogen gas, and contains a tungsten filament that is heated by an electrical current, producing photons and heat. Tungsten-halogen lamps are a variation on the basic lightbulb, using a more rugged (and longer-lasting) filament that can be heated to a higher temperature, housed in a thicker glass or quartz envelope, and filled with iodine or bromine ("halogen") gases. The higher temperature allows tungsten-halogen (or quartz-halogen/quartz-iodine, depending on their construction) lamps to burn "hotter" and whiter. Although popular for automobile headlamps today, they've also been used for photographic illumination.

Although incandescent illumination isn't a perfect black body radiator, it's close enough that the color temperature of such lamps can be precisely calculated and used for photography without concerns about color variation (at least, until the very end of the lamp's life). As I noted earlier, the

color rendering index of such lamps tends to be very high, so you need to account only for the color temperature.

Of course, old-style tungsten lamps are on the way out, at first replaced either by compact fluorescent lights (CFL) or newer, more energy-efficient (and expensive) tungsten and halogen lights, and, eventually by LED illumination. It appears that LED illumination is on track to supplant all of these for most applications in the near future. The other qualities of this type of lighting, such as contrast, are dependent on the distance of the lamp from the subject, type of reflectors used, and other factors that I'll explain later in this chapter.

Fluorescent Light/LEDs

Fluorescent light has some advantages in terms of illumination, but some disadvantages from a photographic standpoint. This type of lamp generates light through an electro-chemical reaction that emits most of its energy as visible light, rather than heat, which is why the bulbs don't get as hot. The type of light produced varies depending on the phosphor coatings and type of gas in the tube. So, the illumination fluorescent bulbs produce can vary widely in its characteristics.

That's not great news for photographers. Different types of lamps have different "color temperatures" that can't be precisely measured in degrees Kelvin, because the light isn't produced by heating. Worse, fluorescent lamps have a discontinuous spectrum of light that can have some colors missing entirely. A particular type of light source can lack certain shades of red or other colors (see Figure 8.4), which is why fluorescent lamps and other alternative technologies such as sodium-vapor illumination can produce strange hues, as in the figure, and ghastly looking human skin tones. Their spectra can lack the reddish tones we associate with healthy skin and emphasize the blues and greens popular in horror movies. As I mentioned earlier, their color rendering indexes are far from ideal.

Compact fluorescent lights (CFLs) are those spiraling bulbs that became popular as old-school tungsten bulbs were phased out. However, CFLs don't work in all fixtures and for all applications, such as dimmers (even if you purchase special "dimmable" CFLs), electronic timer or "dusk-to-dawn" light controllers, some illuminated wall switches, or with motion sensors. Only certain types of CFLs (cold cathode models) operate outside in cold weather; they emit IR signals that can confuse the remote control of your TV, air conditioner, etc.

Gaining in popularity are LED light sources, particularly for movies, in the form of compact units that clip onto the camera and provide a continuous beam of light to fill in shadows indoors or out, and/or to provide the main illumination when shooting video inside. Several vendors have introduced LED studio lights that are bright enough for general-purpose shooting. It's become obvious that LED illumination will soon become the most widely used continuous light source. They've already made dramatic inroads in the automotive industry for taillights, headlights, and interior illumination. Innovations like the Lume Cube, a brilliant \$80 waterproof variable-brightness LED lamp that can be triggered wirelessly, will find broader use. (See Figure 8.5.)

Figure 8.4 The uncorrected fluorescent lighting added a distinct greenish cast to this image when exposed with a daylight white balance setting.

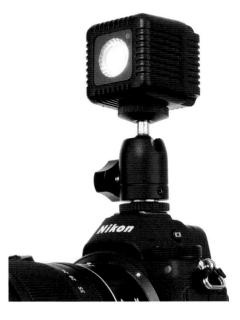

Figure 8.5
The Lume Cube.

Other Lighting Accessories

Once you start working with light, you'll find there are plenty of useful accessories that can help you. Here are some of the most popular that you might want to consider. These all work well with both continuous lighting, discussed in this chapter, as well as with electronic flash, which will be our focus in the chapter that follows this one.

Do-It-Yourself Lighting

The cool thing about continuous lighting is that anything that lights up can be used as a lighting tool for your Z6. Flashlights (for "painting with light" techniques), shop work lights, or even desktop high-intensity lamps, like the one seen in Figure 8.6, left, can be pressed into service at little or no cost (if you already happen to own something that will work). I used that desk lamp to shoot the image seen in Figure 8.6, right, simply because the lamp was bright enough to let me use a small f/stop to maximize depth-of-field, and it was really easy to see the lighting effect and move the lamp an inch or two to get different effects.

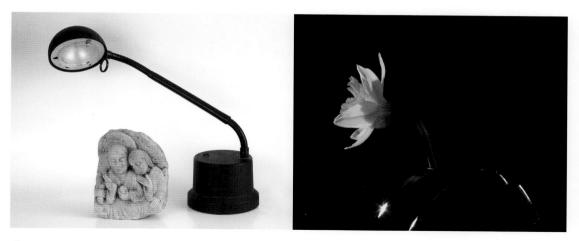

Figure 8.6 A desk lamp can be pressed into service as a light source for tabletop and macro photography.

Umbrellas

Umbrellas are just what you might think, a variation on those trusty shields-on-a-stick that protect us from the ravages of sun, rain, snow, or other elements of nature. Whether we know them as parasols (for the sun) or paraguas (for the water) on the Costa del Sol; as parapluies/ombrelles on the Riviera; or Sonnenschirme/Regenschirme (gotta love those Germans!); these inexpensive accessories are just as versatile for reflecting light as blocking it.

Indeed, you can use umbrellas in multiple roles:

- **Light reflector.** A silver umbrella can provide a softer, but not *too* soft light source, or a much softer source of illumination when a non-shiny white umbrella is used. The quality and quantity of the light that your Z6 sees can be further adjusted simply by moving the umbrella closer to your subject (for a softer illumination) or farther away (for more contrast).
- Light diffuser. A white umbrella diffuses and softens light, but a translucent white umbrella (of the "shoot-through" variety) can be reversed so that the illumination passes through the fabric and becomes even more soft and diffuse.
- **Light blocker.** Some umbrellas have a white or silver interior surface, and a black cover that prevents any light from leaking through the umbrella. Those models can be used to *block* light from other sources of illumination—even outdoors in daylight—to allow you to create subtle lighting effects.
- Light colorizer. Umbrellas may have a shiny golden, silver, or blue interior surface (as do many flat reflectors), and so can be used to add a rich warm tone, neutral sheen, or cold bluish cast to an image or shadows. You can use umbrella "colorizing" to create an effect or balance multiple light sources.
- Soft box in an instant. Many umbrellas can be fitted with a cover over their front that transforms them into a soft box. This conversion is more practical for use with electronic flash (covered in the next chapter) than for some kinds of continuous lighting, because of heat buildup. "Colder" forms of continuous lighting, such as fluorescent lights designed specially for photographic applications, can be used in soft box mode, however. Figure 8.7, left, shows both an umbrella and a soft box (described next).

Soft Boxes

Soft boxes are also handy for photographing shiny objects. They not only provide a soft light, but if the box itself happens to reflect in the subject (say you're photographing a chromium toaster), the box will provide an interesting highlight that's indistinct and not distracting.

You can buy soft boxes or make your own. Some lengths of friction-fit plastic pipe and a lot of muslin cut and sewed just so may be all that you need. Soft boxes are large square, rectangular (or round or octagonal) devices that may resemble an umbrella with a front cover, and produce a similar lighting effect. They can extend from a few feet square to massive boxes that stand five or six feet tall—virtually a wall of light. With a light source or two inside a soft box, you have a very large, semi-directional light source that's very diffuse and very flattering for portraiture and other people photography.

Tents

Tents, like the one seen at right in Figure 8.7, are useful for photographing shiny objects or any subject where you want to reduce the shadows and reflections to a minimum. The fabric of the tent is translucent, so you place the light sources around the sides or above, and a soft glow filters through to illuminate the image. You can still maintain subtle lighting effects by choosing to light up—or not light up—individual sides of the cube. The lens of the Z6 protrudes through a hole or slit in the tent, so you can photograph the shiniest subject without having you or your camera show up in the final picture.

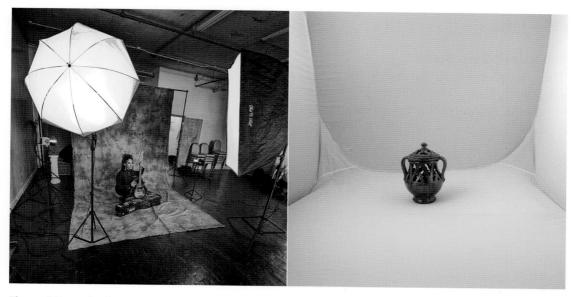

Figure 8.7 Umbrellas and soft boxes (left) can provide a soft, diffuse light source. Tents provide almost shadowless lighting for photographing shiny objects (right).

Light Stands

Both electronic flash and incandescent lamps can benefit from light stands. These are lightweight, tripod-like devices (but without a swiveling or tilting head) that can be set on the floor, tabletops, or other elevated surfaces and positioned as needed. Light stands should be strong enough to support an external lighting unit, up to and including a relatively heavy flash with soft box or umbrella reflectors. You want the supports to be capable of raising the lights high enough to be effective. Look for light stands capable of extending six to seven feet high. The nine-foot units usually have larger, steadier bases, and extend high enough that you can use them as background supports. You'll be using these stands for a lifetime, so invest in good ones. I bought my light stands when I was in college, and I have been using them for decades.

Backgrounds

Backgrounds can be backdrops of cloth, sheets of muslin you've painted yourself using a sponge dipped in paint, rolls of seamless paper, or any other suitable surface your mind can dream up. Backgrounds provide a complementary and non-distracting area behind subjects (especially portraits) and can be lit separately to provide contrast and separation that outlines the subject, or which helps set a mood.

I like to use plain-colored backgrounds for portraits, and white or gray seamless paper backgrounds for product photography. You can usually construct these yourself from cheap materials and tape them up on the wall behind your subject, or mount them on a pole stretched between a pair of light stands.

Snoots and Barn Doors

These fit over the flash unit and direct the light at your subject. Snoots are excellent for converting a light source into a hair light, while barn doors give you enough control over the illumination by opening and closing their flaps that you can use another flash as a background light, with the capability of feathering the light exactly where you want it on the background.

Electronic Flash with the Nikon Z6

The Nikon Z6 is compatible with a long list of Nikon SB-series Speedlights, dating back to the company's original professional-level flash unit, the SB-800, which was introduced in 2003. All Speedlights introduced since then use the Nikon Creative Lighting System (CLS), which allows efficient through-the-lens metering of flash exposures and wireless off-camera strobes for versatile multi-flash lighting. Although virtually everything else about the Z6 is new—from sensor to lens mount—it benefits from the availability of these mature, well-tested array of electronic flash options, including the latest SB-5000 unit, which can be triggered remotely through optical or radio links.

Some consider electronic flash a necessary evil, providing supplementary illumination that is often harsh or less natural looking, as well as difficult to use. However, what they are deriding is *bad* flash photography, as applied by photographers who don't understand how to use strobes properly, or are too lazy to fully apply the creative versatility flash offers. They may feel that Speedlights are too expensive.

Fortunately, it's easy to become adept at using electronic flash, and fully featured Nikon units like the SB-500—which I'll describe later in this chapter—can cost as little as \$250. Most settings can be adjusted using the menus built into your Z6, and even multi-flash shooting (covered in Chapter 10) can be mastered with only a few hours' practice.

Electronic flash has become the studio light source of choice for many pro photographers, because it's more intense (and its intensity can be varied to order by the photographer using the strobe's power adjustment features) and freezes action. Flash frees you from the need for a tripod (unless you want to use one to lock down a composition), and has a snappy, consistent light quality that

matches daylight. (While color balance changes as the flash duration shortens, some Nikon flash units can communicate to the camera the exact white balance provided for that shot.) And even pros will cede that an external flash mounted on the Nikon Z6 needn't be used in direct-flash mode, and has essential applications as an adjunct, particularly to fill in dark shadows or to serve as a wireless trigger for additional, off-camera strobes.

But electronic flash isn't as inherently easy to use as continuous lighting. As I noted in Chapter 8, electronic flash units do require a modest investment, don't show you exactly what the lighting effect will be (unless you use a second source or mode called a *modeling light* for a preview), and the exposure of electronic flash units is more difficult to calculate accurately.

This chapter and the next will show you how to manage all the creative and technical challenges, using optional external flash units. First, we'll look at the basics of working with flash, and then in Chapter 10, we'll explore the world of wireless flash photography.

Electronic Flash Basics

Electronic flash illumination is produced by photons generated by an electrical charge that is accumulated in a component called a *capacitor* and then directed through a glass tube containing xenon gas, which absorbs the energy and emits the burst of light. In automatic mode (which Nikon calls *iTTL*), the main flash is preceded by one or more mini-bursts which allow the Z6 to gauge how much light is bouncing back from your subject and background, and to communicate with other external flash units linked wirelessly. In practice, external strobes can be linked to the Z6 in several different ways:

- Camera mounted/hardwired external dedicated flash. Units offered by Nikon or other vendors that are compatible with Nikon's Creative Lighting System—CLS—can be clipped onto the accessory "hot" shoe on top of the camera or linked through a wired system such as the Nikon SC-28/SC-29 cables. I'll describe CLS later in this chapter.
- Wireless dedicated flash. A CLS-compatible unit can be triggered by signals produced by a pre-flash (before the main flash burst begins), which offers two-way communication between the camera and flash unit. The triggering flash can be a CLS-compatible flash unit in Master mode, or a wireless non-flashing accessory, such as the Nikon SU-800, which does nothing but "talk" to the external flashes. You'll find more on this mode in Chapter 10.
- Wired, non-intelligent mode. The Z6 does not have a dedicated old-style PC/X connector built in, but you can add one easily by sliding the Nikon AS-15 Sync Terminal adaptor into the hot shoe on top of the camera. The PC/X connector is a non-intelligent camera/flash link that sends just one piece of information, one way: it tells a connected flash to fire. There is no other exchange of information between the camera and flash. The PC/X connector can be used to link the Nikon Z6 with non-dedicated/non-CLS-friendly strobes, which can be studio flash units, manual non-CLS flash, flash units from other vendors that can use a PC cable, or even Nikon-brand Speedlights that you elect to connect to the Z6 in a non-CLS, "unintelligent" mode.

- Radio/Infrared transmitter/receivers. Another way to link flash units to the Z6 is through a radio transmitter/ receiver system, using either a dedicated radio-compatible flash unit, such as the Nikon SB-5000 (see Figure 9.1), or an add-on wireless infrared or radio transmitter, like a PocketWizard, Radio Popper, or the Godox X wireless system. These are generally mounted on the accessory shoe of the Z6, and emit a signal when the Z6 sends a command to fire through the hot shoe. The simplest of these function as a wireless PC/X connector, with no other communication between the camera and flash (other than the instruction to fire). However, sophisticated units have their own built-in controls and can send additional commands to the receivers when connected to compatible flash units. I use one to adjust the power output of my Alien Bees studio flash from the camera, without the need to walk over to the flash itself.
- Simple slave connection. In the days before intelligent wireless communication, the most common way to trigger off-camera, non-wired flash units was through a *slave* unit. These can be small external triggers connected to the remote flash (or built into the flash itself), and set off

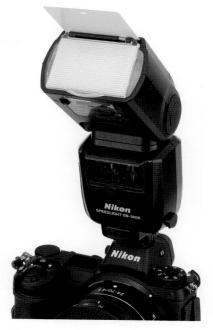

Figure 9.1 The Nikon SB-5000 offers radio control and built-in light modifiers like the bounce card shown.

when the slave's optical sensor detects a burst initiated by the camera. When it "sees" the main flash, the slave flash units are triggered quickly enough to contribute to the same exposure. The main problem with this type of connection—other than the lack of any intelligent communication between the camera and flash—is that the slave may be fooled by any pre-flashes that are emitted by the other strobes, and fire too soon. Modern slave triggers have a special "digital" mode that ignores the pre-flash and fires only from the main flash burst.

The Moment of Exposure

The Z6 has a vertically traveling shutter that consists of two curtains. Just before the flash fires, the front (first) curtain opens and moves down to the opposite side of the frame, at which point the shutter is completely open. The flash can be triggered at this point (so-called *front-curtain sync*), making the flash exposure. Then, after a delay that can vary from 30 seconds to 1/200th second (or faster when *high-speed sync*, discussed later, is used), a rear (second) curtain begins moving down the sensor plane, covering up the sensor again. If the flash is triggered just before the rear curtain starts to close, then *rear-curtain sync* is used. In both cases, though, a shutter speed of 1/200th second is the maximum that can be used to take a photo, unless you're using the high-speed 1/200th (Auto FP) sync setting.

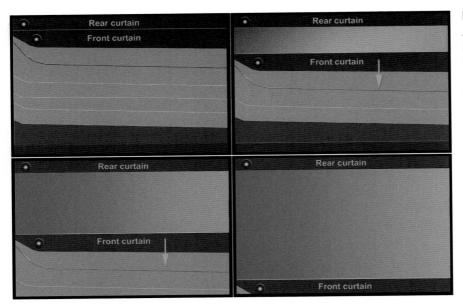

Figure 9.2
A focal plane shutter has two curtains, the lower, or front (first) curtain, and an upper, rear (second) curtain.

Figure 9.2 illustrates how this works, with a fanciful illustration of a generic shutter (your Z6's shutter does *not* look like this). Both curtains are tightly closed at upper left. At upper right, the front curtain begins to move downward, starting to expose a narrow slit that reveals the sensor behind the shutter. At lower left, the front curtain moves downward farther until, as you can see at lower right in the figure, the sensor is fully exposed.

Here's a more detailed look at what transpires when you take a photo using electronic flash, all within a few milliseconds of time. The following list assumes you are using iTTL exposure mode.

- 1. **Flash Sync mode.** After you've selected a shooting mode, choose the flash sync option available. You can access the Flash Mode entry in the Photo Shooting menu, press the *i* button, and navigate to the Flash Mode, which will be located third from the left in the top row (unless you've customized your *i* menu). If you change flash sync mode frequently, you can also define a button to summon the adjustment using Custom Setting f2: Custom Control Assignment (described in Chapter 12). I'll explain your sync options shortly.
- 2. **Metering method.** Choose the metering method you want, from Matrix, Center-weighted, Spot, or Highlight-weighted metering.
- 3. **Activate flash.** Mount an external flash (or connect it with a cable) and turn it on. A ready light appears in the viewfinder and on the back of the dedicated flash when the unit is ready to take a picture (although the flash might not be *fully* charged when the indicator first appears).
- 4. **Check exposure.** Select a shutter speed when using Manual, Program, or Shutter-priority modes; select an aperture when using Aperture-priority and Manual exposure modes.

- 5. **Preview lighting.** If you want to preview the lighting effect, assign the Preview behavior to a button (Fn1 or Fn2 are the traditional choices). Press that button to produce a modeling flash burst.
- 6. Lock flash setting (if desired). Optionally, if the main subject is located significantly off-center, you can frame so the subject is centered, lock the flash at the exposure needed to illuminate that subject, and then reframe using the composition you want. Lock the flash level using the Flash Value (FV) Lock button you designate (many assign the Fn1 or Fn 2 button to this function, using Custom Settings f2). Press the FV lock button, and the flash will emit a monitor pre-flash to determine the correct flash level, and then the Z6 will lock the flash at that level until you press the FV lock button again to release it. FV lock icons appear in the monochrome control panel and the viewfinder.
- 7. **Take photo.** Press the shutter release down all the way.
- 8. **Z6 receives distance data.** Z-mount lenses, as well as F-mount E-, D-, or G-series lenses attached using the FTZ adapter, now supply focus distance to the Z6.
- 9. **Pre-flash emitted.** The external flash sends out several pre-flash bursts. One series of bursts can be used to control additional wireless flash units in Commander mode, while another is used to determine exposure. The pre-flashes happen in such a brief period before the main flash that they are virtually undetectable.
- 10. **Exposure calculated.** The pre-flash bounces back and is measured at the sensor. It calculates brightness and contrast of the image to calculate exposure. If you're using Matrix metering (more on metering modes shortly), the Z6 evaluates the scene to determine whether the subject may be backlit (for fill flash), a subject requires extra ambient light exposure to balance the scene with the flash exposure, or classifies the scene in some other way. The camera-to-subject information as well as the degree of sharp focus of the subject matter is used to locate the subject within the frame. If you've selected Spot metering, only standard i-TTL (without balanced fill flash) is used. (See the sidebar i-TTL Flash Control.)
- 11. **Front curtain opens.** The exposure by ambient light begins when the physical shutter curtain is fully open.
- 12. **Flash fired.** At the correct triggering moment (depending on whether front or rear sync is used), the camera sends a signal to one or more flashes to start flash discharge. The flash is quenched as soon as the correct exposure has been achieved.
- 13. **Shutter closes.** The shutter closes and the live view from the sensor resumes. You're ready to take another picture. Remember to press the defined FV lock button (if used) again to release the flash exposure if your next shot will use a different composition.
- 14. **Exposure confirmed.** Ordinarily, the full charge in the flash may not be required. If the flash indicator in the viewfinder blinks for about three seconds after the exposure, that means that the entire flash charge was required, and it *could* mean that the full charge wasn't enough for a proper exposure. Be sure to review your image on the monitor to make sure it's not underexposed, and, if it is, make adjustments (such as increasing the ISO setting of the Z6) to remedy the situation.

i-TTL FLASH CONTROL

CLS-compatible flash units include up to several Flash Control modes, depending on the model. (I'll explain them all later in this chapter.) With the one you'll use most often, TTL mode, the camera calculates and sets flash exposure (but applies any flash exposure compensation you dial in, as explained later). In Manual mode, you adjust the output level of the flash.

In TTL mode, the camera selects one of two variations:

- i-TTL balanced fill-flash. The Z6 analyzes the preflash reflection from all areas of the frame, and adjusts the output to provide a balance between the main subject of your image and the background lighting.
- Standard i-TTL fill-flash. The brightness of the background is not considered in setting the flash output. This mode tends to emphasize the main subject, even if some background detail is lost. You can force the Z6 to select Standard i-TTL fill-flash by switching to Spot Metering mode. Use flash exposure compensation to adjust the main subject/background balance as required.

UNIFIED FLASH CONTROL

Nikon electronic flash units have their own sets of controls, so Nikon has implemented a feature called *unified flash control*, which simply means that with compatible CLS flash, you can change duplicated settings on *either* the flash unit or camera (or remotely using the optional Camera Control 2 software), and the adjustments are automatically made on the other device. You don't have to worry about accidentally overriding your own settings. Currently, the flash units implementing unified flash control are the SB-300, SB-400, SB-500, and SB-5000.

A Tale of Two Exposures

Calculating the proper exposure for an electronic flash photograph is a bit more complicated than determining the settings for continuous light. The right exposure isn't simply a function of how far away your subject is (which the camera can figure out based on the autofocus distance that's locked in just prior to taking the picture). Various objects reflect more or less light at the same distance so, obviously, the camera needs to measure the amount of light reflected back and through the lens.

That measurement is complicated by two things: a picture taken using flash is actually *two separate exposures*: the exposure produced by the flash itself, and the exposure that results from the continuous, ambient light that is also illuminating your subject. If the Z6's calculations are correct, the plane in which your main subject resides will be properly exposed. However, anything more than slightly in *front of* or *behind* that plane will be overexposed or underexposed (respectively), thanks to the inverse square law I mentioned in Chapter 8. To recap, the intensity of the light is inversely proportional to the square of the distance. In practice, that means a light source that is 12 feet away

from a subject provides only one-quarter as much illumination as the same source located 6 feet away. In f/stop terms, you need to open up two stops whenever the distance doubles. (See Figure 9.3.)

So, as you shoot, you need to consider "depth-of-light" (the range in which a subject is acceptably illuminated in front of and behind the plane used to calculate the exposure) in addition to depth-of-field. Fortunately, in many flash photography situations, the main subject is the closest thing to the camera, so there often won't be a problem with overexposed foreground objects.

Backgrounds, however, are another story. In daylight situations, balancing the flash and ambient illumination more or less takes care of itself automatically. Photographers generally let the daylight provide most of the exposure, and use the flash only to fill in shadows.

However, if you're photographing indoors or at night, the background, not illuminated by the flash, will appear darker than the foreground subject. Fortunately, every flash picture consists of *two* exposures, the exposure produced by the flash, and a second exposure that results from the background illumination. For the flash exposure, the shutter speed is more-or-less irrelevant, as long as you're using a shutter speed slower than the synchronization speed of the camera—1/200th second in the case of the Nikon Z6. The f/stop selected and the power output of the flash determine the exposure.

The ambient light exposure is more "normal," using both the shutter speed and aperture. Slower shutter speeds allow more ambient light to reach the sensor, and higher shutter speeds allow less. If you want to *minimize* the ambient portion of the exposure, use a higher shutter speed, up to 1/200th second when not using High-Speed Sync (discussed later in this chapter). To *maximize* the ambient exposure, use a slower shutter speed. The Z6 has a special Slow Sync shutter setting that automatically uses these slower speeds to balance flash/ambient exposures, but you can also use Custom Setting e2: Flash Shutter Speed to specify the slowest/fastest shutter speed used under normal conditions.

Figure 9.3
A light source that is twice as far away provides only one-quarter as much illumination.

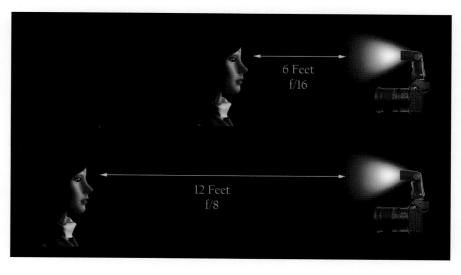

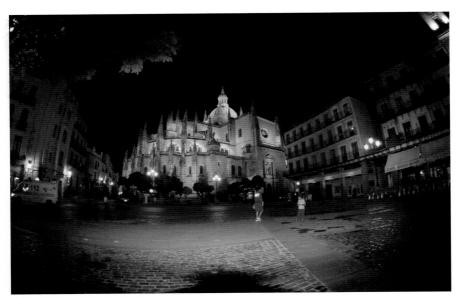

Figure 9.4
Electronic flash illuminated the foreground, and incandescent lighting illuminated the background in this mixed-lighting example.

There are several complications involved in balancing flash and ambient light exposures. So-called "mixed" lighting is one of them. Your flash is balanced for daylight, while ambient light is often incandescent or some other "warm" illumination. This mixture is exaggerated in Figure 9.4, which shows the Plaza Mayor in Segovia, Spain, with the city's cathedral in the background lit by incandescent lamps, with the foreground illuminated by flash. The solution in this case would be to install an orange-tinted "warming" filter on the flash (many Nikon Speedlights include them) to balance the flash illumination with the incandescent background.

The second problem that arises stems from the fact that while the flash exposure is concluded in an instant (typically 1/1,000th to 1/50,000th of a second), the ambient light continues for the entire time the shutter is open. So, you end up with *two* images produced by the *dual* exposures. If the subject is moving, the additional ambient light exposure produces a "ghost" image. The best way of handling that conundrum is to adjust the sync setting of the camera, and I'm going to explain how to do that shortly.

Measuring Exposure

By this time, you should be wondering how the Nikon Z6 measures the flash, as the flash burst isn't available for evaluation until it's triggered, when you press the shutter release down all the way to take the picture. The solution is to fire the flash multiple times. The first pulse is a *monitor pre-flash* that can be analyzed, then followed virtually instantaneously by a series of pulses (if required) to communicate wirelessly with any optically triggered remote flash units. (You'll find more on advanced wireless lighting in Chapter 10.) Only then is the main flash triggered, which (when shooting in autoflash mode) emits exactly the calculated intensity needed for a correct exposure. (All these pulses happen so quickly that they may appear to you to be a single burst.)

Because of the exposure calculations, the primary flash may be longer in duration for distant objects and shorter in duration for closer subjects, depending on the required intensity for exposure. This default through-the-lens evaluative flash exposure system is called i-TTL BL (for intelligent Through The Lens, Balanced Fill Flash), and can operate whenever you have attached a Nikon dedicated flash unit to the Z6. There are additional modes that will be discussed later, and not all modes are available with every flash unit, but all the modes are listed in Table 9.1. These modes are set using your particular electronic flash's controls, as described in your unit's manual.

The amount of light emitted by the flash is changed in an interesting way—interrupting the flash as the charge flows from the capacitor through the flash tube. When full power is required, either to supply the correct exposure in automatic modes or because you're using the flash in Manual mode at the full power (1/1) setting, then all the energy in the capacitor flows through the flash tube. However, if less than full power is needed, the energy is stopped partway through the exposure by opening the circuit with a solid-state switch. In the olden days this was always done using a component called a *thyristor*, but today a component called an *insulated-gate bipolar transistor*, or IGBT, is more common.

Because the current is interrupted before the full power of the capacitor is used, the resulting burst becomes shorter as the power output is reduced. For example, with some Nikon flash units you might see a burst lasting about 1/1,000th second at full power, but only a little longer than 1/10,000th second at 1/16th power, or 1/40,000th second at 1/128th power. (The SB-5000 adds a 1/256th power option, providing a 1/30,800th second exposure.) This behavior is nifty when you want to freeze really fast action, such as falling water droplets—just use a lower power output level and/or work extremely close to your subject.

Table 9.1 Flash Modes				
Mode	Metering Modes Available	Function		
TTL BL	Matrix, Center-weighted	Balanced Fill Flash.		
$Standard \ TTL$	Spot	Only flash output used in exposure calculation.		
TTL BL FP	Matrix, Center-weighted	Balanced Fill Flash, shutter speeds higher than 1/200th second available.		
TTL FP	Spot	Flash and ambient illumination not balanced, shutter speeds higher than 1/200th second available.		
AA (Auto Aperture)	N/A	Exposure measured by sensor on flash. Uses ISO and aperture information supplied by camera.		
Automatic	N/A	Exposure measured by sensor on flash. Uses ISO and aperture information input to flash by user.		
Manual	N/A	Exposure calculated by user.		

Because the full contents of the capacitor are not used with these partial flashes, the Speedlight is able to recycle more quickly, or even use the retained energy to fire multiple times in Repeating flash mode (described later in this chapter). The only downside is that shorter flash exposures tend to take on a bluish tinge as the duration decreases. That's because the burst starts out with a very cool color temperature and ends up much warmer at the end of the burst, averaging out to a hue that's pretty close to daylight in color balance. When you trim off the reddish end of the flash, your resulting image may be noticeably more blue. That's why the Flash color balance of the Z6 doesn't always produce a pleasing color rendition. You may have to fine-tune the white balance, as described in Chapter 11, or shoot RAW and correct in your image editor.

Those of you using studio flash units may be interested to know that your non-automatic strobes produce their varying power levels in a different way. With the typical studio flash, the capacitor is *always* fully discharged each time you take a picture, and then recharged *to the level you specify* for the next shot. It happens very quickly because you're using AC power or a high-voltage battery pack instead of low-capacity alkaline or rechargeable cells.

If you set the flash for 1/2 power, the capacitor (or capacitors—studio flash may use several of them) is charged only half-filled; at 1/4 power it's only replenished to 25 percent of its capacity. Then, when you take the photo, the full contents of the capacitor are sent through the flash tube. That's why you need to "dump" your studio flash when you reduce the power output from a higher level. The capacitor retains the charge that was in there before, and can't fire at the reduced capacity you want until the existing power is dumped and then replenished to the level you specify. Because of the way studio flash store and release their power, they can be designed to be more consistent at different power levels than your typical Nikon flash unit. Of course, wild color variations from flash units aren't a huge problem, but just something you should be aware of.

So, to summarize, with CLS-compatible flash units, your automatic exposure is calculated by measuring a pre-flash and determining an appropriate exposure from that. There are other exposure modes than i-TTL available from Nikon external flash units, and I'll get into them later in this chapter, but this section has described the process in a nutshell.

Guide Numbers

Guide numbers, usually abbreviated GN, were originally developed as a way of calculating exposure manually, but today are more useful as a measurement of the power of an electronic flash unit. A GN is usually given as a pair of numbers for both feet and meters that represent the range at ISO 100. For example, the Nikon SB-910 has a GN in i-TTL mode of 48/157 (meters/feet) at ISO 200 when using the coverage needed for a 35mm lens (the flash has a *zoom head* to spread/narrow the light for a range of focal lengths). To calculate the right exposure at that ISO setting, you'd divide the guide number by the distance to arrive at the appropriate f/stop.

Using the SB-5000 as an example, at ISO 100 with its GN of 113, if you wanted to shoot a subject at a distance of 10 feet, you'd use f/11.3 (or, f/11). At 5 feet, an f/stop of f/22 would be used. Some

quick mental calculations with the GN will give you any particular electronic flash's range. Many years ago Nikon offered a 45mm GN lens that could couple the f/stop setting of the lens with the focus distance. You specified the guide number of the flash using a scale on the lens itself, and as you focused closer or farther away the f/stop was reduced or increased to match. Today, guide numbers are most useful for comparing the power of various flash units, rather than actually calculating what exposure to use.

Choosing a Flash Sync Mode

In addition to the flash modes mentioned earlier, the Nikon Z6 has five *flash sync modes*, plus a sixth (High-Speed Sync, described later) that comes into play in some circumstances. The five main modes, plus Off (which disables the flash) are selected with the *i* menu or the Photo Shooting menu's Flash Mode entry. (See Figure 9.5 for the icons.) Those modes (which I've listed in logical order, so the explanation will make more sense, rather than the order in which they appear during the selection cycle) are as follows:

- Fill flash/Front-curtain sync (available in PSAM modes). This setting, available in all exposure modes, should be your default setting. In this mode the flash fires as soon as the front curtain opens completely. The shutter then remains open for the duration of the exposure, until the rear curtain closes. If the subject is moving and ambient light levels are high enough, the movement will cause that secondary "ghost" exposure that appears in front of the flash exposure.
- Rear-curtain sync (available in PSAM modes). With this setting, which can be used with Program, Shutter-priority, Aperture-priority, or Manual exposure modes, the front curtain opens completely and remains open for the duration of the exposure. Then, the flash is fired and the rear curtain closes. If the subject is moving and ambient light levels are high enough, the movement will cause a secondary "ghost" exposure that appears behind the flash exposure (trailing it). You'll find more on "ghost" exposures next. In Program and Aperture-priority modes, the Z6 will combine rear-curtain sync with slow shutter speeds (just like slow sync, discussed below) to balance ambient light with flash illumination. (It's best to use a tripod to avoid blur at these slow shutter speeds.)

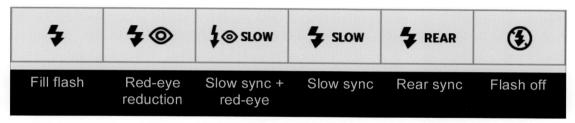

Figure 9.5 Icons for flash sync modes include fill flash/front-curtain sync, red-eye reduction, red-eye reduction with slow sync, slow sync, rear sync/slow rear-sync, and flash off.

- Red-eye reduction (available in PSAM modes). In this PSAM-compatible mode, there is a one-second lag after pressing the shutter release before the picture is actually taken, during which the Z6 uses the attached flash unit's red-eye reduction feature, causing the subject's pupils to contract (assuming they are looking at the camera), and thus reducing potential redeye effects. Don't use with moving subjects or when you can't abide the delay.
- Slow sync (available in P or A modes). This setting allows the Z6 in Program and Aperture-priority modes to use shutter speeds as slow as 30 seconds with the flash to help balance a background illuminated with ambient light with your main subject, which will be lit by the electronic flash. You'll want to use a tripod at slower shutter speeds, of course.
- Slow rear-curtain sync (available in P or A modes). With this setting, which can be used with Program or Aperture-priority modes, the front curtain opens completely and remains open for the duration of the exposure. Then, the flash is fired and the rear curtain closes. Exposures as long as 30 seconds can be used to capture background lighting under low-light conditions. The indicator is the same as Rear Sync, but when you release the flash button "Slow" appears on the monitor.
- Red-eye reduction with slow sync (available in P or A modes). This mode combines slow sync with the Z6's external flash red-eye reduction behavior when using Program or Aperture-priority modes.
- Flash off. The flash does not fire, even if powered on.

Ghost Images

The difference might not seem like much, but whether you use front-curtain sync (the default setting) or rear-curtain sync (an optional setting) can make a significant difference to your photograph if the ambient light in your scene also contributes to the image. At faster shutter speeds, particularly 1/200th second, there isn't much time for the ambient light to register, unless it is very bright. It's likely that the electronic flash will provide almost all the illumination, so front-curtain sync or rear-curtain sync isn't very important.

However, at slower shutter speeds, or with very bright ambient light levels, there is a significant difference, particularly if your subject is moving, or the camera isn't steady. In any of those situations, the ambient light will register as a second image accompanying the flash exposure, and if there is movement (camera or subject), that additional image will not be in the same place as the flash exposure. It will show as a ghost image and, if the movement is significant enough, as a blurred ghost image trailing in front of or behind your subject in the direction of the movement.

As I mentioned earlier, when you're using front-curtain sync, the flash goes off the instant the shutter opens, producing an image of the subject on the sensor. Then, the shutter remains open for an additional period (which can be from 30 seconds to 1/200th second). If your subject is moving, say, toward the right side of the frame, the ghost image produced by the ambient light will produce a

blur on the right side of the original subject image. That makes it look as if your sharp (flash-produced) image is chasing the ghost (see Figure 9.6, top), which looks unnatural to those of us who grew up with lightning-fast Justice League–style superheroes (rather than modern dancers) who always left a ghost trail *behind them* (see Figure 9.6, bottom).

So, Nikon provides rear-curtain sync to remedy the situation. In that mode, the shutter opens, as before. The shutter remains open for its designated duration, and the ghost image forms. If your subject moves from the left side of the frame to the right side, the ghost will move from left to right, too. *Then*, about 1.5 milliseconds before the rear shutter curtain closes, the flash is triggered, producing a nice, sharp flash image *ahead* of the ghost image.

EVERY WHICH WAY, INCLUDING UP

Note that, although I describe the ghost effect in terms of subject matter that is moving left to right in a horizontally oriented composition, it can occur in any orientation, and with the subject moving in *any* direction. (Try photographing a falling rock, if you can, and you'll see the same effect.) Nor are the ghost images affected by the fact that modern shutters travel vertically rather than horizontally. Secondary images are caused between the time the front curtain fully opens, and the rear curtain begins to close. The direction of travel of the shutter curtains, or the direction of your subject, does not matter.

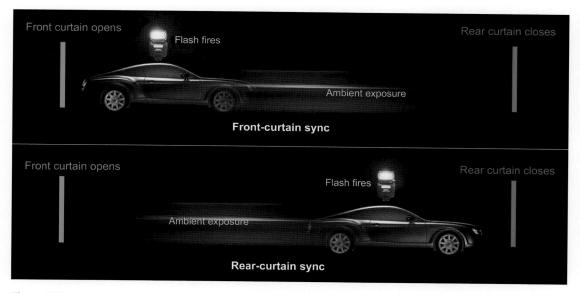

Figure 9.6 Front-curtain sync produces an image that trails in front of the flash exposure (top), while rearcurtain sync creates a more "natural-looking" trail behind the flash image (bottom).

Avoiding Sync Speed Problems

Using a shutter speed faster than 1/200th second can cause problems. Triggering the electronic flash only when the shutter is completely open makes a lot of sense if you think about what's going on. To obtain shutter speeds faster than 1/200th second, the Z6 exposes only part of the sensor at one time, by starting the second curtain on its journey before the first curtain has completely opened, as shown in Figure 9.7. That effectively provides a briefer exposure as a slit of the shutter passes over the surface of the sensor. If the flash were to fire during the time when the front and rear curtains partially obscured the sensor, only the slit that was actually open would be exposed.

You'd end up with only a narrow band, representing the portion of the sensor that was exposed when the picture is taken. For shutter speeds *faster* than 1/200th second, the rear curtain begins moving *before* the front curtain reaches the bottom of the frame. As a result, a moving slit, the distance between the front and rear curtains, exposes one portion of the sensor at a time as it moves from the top to the bottom. Figure 9.7 shows three views of our typical (but imaginary) focal plane shutter. At left is pictured the closed shutter; in the middle version you can see the front curtain has moved down about 1/4 of the distance to the top; and in the right-hand version, the rear curtain has started to "chase" the front curtain across the frame toward the bottom.

If the flash is triggered while this slit is moving, only the exposed portion of the sensor will receive any illumination. You end up with a photo like the one shown in Figure 9.8. Note that a band across the bottom of the image is black. That's a shadow of the rear shutter curtain, which had started to move when the flash was triggered. Sharp-eyed readers will wonder why the black band is at the bottom of the frame rather than at the top, where the rear curtain begins its journey. The answer is simple: your lens flips the image upside down and forms it on the sensor in a reversed position. You never notice that, because the camera is smart enough to show you the pixels that make up your photo in their proper orientation during picture review. But this image flip is why, if your sensor gets dirty and you detect a spot of dust in the upper half of a test photo, if cleaning manually, you need to look for the speck in the bottom half of the sensor.

I generally end up with sync speed problems only when shooting in the studio, using studio flash units rather than my Nikon-dedicated Speedlights. That's because if you're using "smart" flash (like one of the Nikon Speedlights), the camera knows that a strobe is attached, and remedies any unintentional goof in shutter speed settings. If you happen to set the Z6's shutter to a faster speed in S

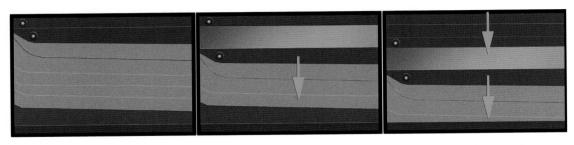

Figure 9.7 A closed shutter (left); partially open shutter as the front curtain begins to move downward (middle); only part of the sensor is exposed as the slit moves (right).

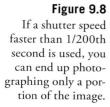

or M mode, the camera will automatically adjust the shutter speed down to 1/200th second as soon as you turn on the flash (or prevent you from choosing a faster speed if the flash is already powered up). In A or P modes, where the Z6 selects the shutter speed, it will never choose a shutter speed higher than 1/200th second when using flash. In P mode, shutter speed is automatically set from 1/60th to 1/200th second when using flash.

But when using a non-dedicated flash, such as a studio unit plugged into an adapter mounted on the accessory shoe, the camera has no way of knowing that a flash is connected, so shutter speeds faster than 1/200th second can be set inadvertently. To avoid that problem with studio flash, I strongly recommend setting your camera to Manual exposure, and using the x200 shutter speed, which is located *past* the Bulb speed when rotating the main command dial all the way to the left. You won't have to worry as much about accidentally changing the shutter speed to an unusable setting; there is no speed *beyond* x200th second, and if you nudge the main command dial to the right, in Manual exposure mode, you'll get a Bulb or Time exposure, which will immediately become evident.

High-Speed Sync

Note that the Z6 can use a feature called *high-speed sync* that allows shutter speeds faster than 1/200th second with certain external dedicated Nikon flash units. When using high-speed sync, the flash fires a continuous series of bursts at reduced power for the entire duration of the exposure, so that the illumination is able to expose the sensor as the slit moves. HS sync is set using the controls that adjust the compatible external flash. You don't need to make any special settings on the flash; the Z6 takes care of the details for you, as I'll describe in this section.

As I said earlier, triggering the electronic flash only when the shutter is completely open makes a lot of sense if you think about what's going on. To obtain shutter speeds faster than 1/200th second, the Z6 exposes only part of the sensor at one time, by starting the rear curtain on its journey before

the front curtain has completely opened. That effectively provides a briefer exposure as a slit of the shutter passes over the surface of the sensor. If the flash were to fire during the time when the front and rear curtains partially obscured the sensor, only the area defined by the slit that was actually open would be exposed.

This technique is most useful outdoors when you need fill-in flash, but find that 1/200th second is way too slow for the f/stop you want to use. For example, at ISO 200, an outdoors exposure is likely to be 1/200th second at, say, f/14, which is perfectly fine for an ambient/balanced fill-flash exposure if you don't mind the extreme depth-of-field offered by the small f/stop. But, what if you'd rather shoot at 1/1,600th second at f/5.6? High-speed sync will let you do that, and you probably won't mind the reduced flash power, because you're looking for fill flash, anyway. This sync mode offers more flexibility than, say, dropping down to ISO 100.

High-speed sync is also useful when you want to use a larger f/stop to limit the amount of depth-of-field. Select a shutter speed higher than 1/200th second, and the faster-sync speed automatically reduces the effective light of the flash, without other intervention from you.

To use Auto FP sync with units like the Nikon SB-5000, SB-910/SB-900, SB-700, SB-500, SB-R200 units and a few discontinued Speedlights like the SB-800 and SB-600, there is no setting to make on the flash itself. You need to use Custom Setting e1 to specify 1/200 s (Auto FP). When using P or A exposure modes, the shutter speed will be set to 1/200th second when a compatible external flash is attached. Higher shutter speeds than 1/200th second—all the way up to 1/8,000th second—can then be used with full synchronization, at reduced flash output. There are also situations in which you might want to set flash sync speed to *less* than 1/200th second, say, because you *want* ambient light to produce secondary ghost images in your frame. You can choose the following settings:

- 1/200 s (Auto FP). This similar setting allows using the compatible external flash units with high-speed synchronization at 1/200th second or faster, and activates auto FP sync when the camera selects a shutter speed of 1/200th second or faster in programmed and Aperture-priority modes. Other flash units will be used at speeds no faster than 1/200th second.
- 1/200 s. At this default setting, only shutter speeds up to 1/200th second can be used with flash. Note: To lock in shutter speed at 1/200th second, rotate the main control dial in M or S modes to choose the x200 setting located after the 30 s (and Time and Bulb in Manual exposure) speeds. You'd use this when working with "dumb" studio flash units.
- 1/200 s-1/60 s. You can also specify a specific shutter speed from the range of speeds 1/200th second to 1/60th second to be used as the synchronization speed for external flash units. Forcing a slower shutter speed produces a "slow sync" effect. For example, when 1/60th second has been set as the maximum flash shutter speed, ambient light is more likely to contribute to the exposure. (See Figure 9.9.) That can help balance the flash exposure with available light falling on the background (use a tripod or VR to minimize ghost images). Or, that slow shutter speed can help generate ghost images when you intentionally want them to appear in your image, say, to create a feeling of motion.

Figure 9.9
At 1/60th second, the ambient light behind the actor provided detail in the background (left). With a shutter speed of 1/200th second, the background is dark (right).

Using External Flash

In this section, we'll deal with the Nikon Creative Lighting System (CLS), which was introduced in July 2003, when the company unveiled the Speedlight SB-800, a flash unit compatible with early professional digital SLRs, such as the Nikon D2h/D2hs, and, within a few months, more affordable models like 2004's Nikon D70 and all subsequent dSLRs from the company. CLS has the following features, although not all of these are supported by every Nikon camera:

- i-TTL. Intelligent through-the-lens exposure control calculates exposure based on a monitor pre-flash that is fired a fraction of a second before the main burst, and then evaluated by the same RGB exposure sensor used for continuous light measurements. The system's intelligence allows sophisticated adjustments, such as balancing the flash exposure with the ambient light exposure, say, when you shoot in full daylight to fill in the shadows.
- Advanced wireless lighting. AWL is a system that uses the same pre-flash concept to communicate triggering and exposure information to external flash units that aren't physically linked to the camera, and located within a reasonable distance (say, about 30 feet). You may be able to divide multiple flash units into up to three different "groups," and communicate with them using your choice of any of four "channels" (to avoid having your flash units triggered by the master flash of another Nikon photographer in the vicinity). I'll explain AWL in more detail in Chapter 10.

- FV Lock. A *flash value* locking system allows you to fix in place the current flash exposure so that you can, for example, measure flash exposure for a subject that is not in the center of the frame, and then reframe while using that value for subsequent exposures. You can define the Fn button to perform this function, as described in Chapter 12. When FV lock is activated, the Z6 meters only a center area measuring 8mm even if Matrix metering has been selected, when the flash is mounted in the hot shoe. In wireless modes, metering is done using the average of the entire frame.
- Auto FP high-speed sync. Focal plane HS sync allows synchronizing an external flash while using shutter speeds faster than 1/200th second. With a compatible flash and a camera like the Z6, shutter speeds up to 1/8,000th second can be used, although only a part of the flash's illumination is used and flash range is reduced (sometimes to as little as a few feet).
- Focus assist. Although the Z6 has focus assist illumination built-in, the CLS system also allows including wide-area AF-assist illumination to be built into the front of the flash unit, or into a flash connecting cable. Auxiliary focus assist illumination offers wider and/or more distant coverage.
- Zoom coverage. Some CLS-compatible flash units have a powered zoom head built in to allow changing the area covered by the flash to match the focal length of the lens in use, as communicated by the camera to the flash itself. Zooming can also be done manually.
- Flash color information communication. The exact color temperature of the light emitted by a CLS-compatible flash can vary, based on the duration of the flash burst. The flash is initially rather blue in color, and becomes redder as the burst continues. The Speedlight is able to send information to the camera to allow adjusting white balance in AWB mode based on the true color information of the flash exposure.

If you want to temporarily disable a flash that's attached and powered up, a handy way to do this is to assign the Flash Disable/Enable function to the Fn1 or Fn2 buttons, using Custom Setting f2, as described in Chapter 12. Then, when you press the button, any external flash attached and powered up will not fire while the button is held down. This is useful if you want to temporarily disable the flash, say, to take a picture or two by available light, and then return to normal flash operation.

Using Flash Exposure Compensation

If the exposure produced by your flash isn't satisfactory, you can manually add or subtract exposure to the flash exposure calculated by the Z6. You can use the Flash Compensation entry in the Photo Shooting menu, or assign Flash Mode/Flash Compensation to a button, such as Fn1, using Custom Setting f2: Custom Control Assignment, as explained in Chapter 12. When assigned to a button, you can adjust Flash Mode by pressing the button and rotating the main command dial, and Flash Compensation by holding the button and rotating the sub-command dial. You can make adjustments from -3 EV to +1 EV in 1/3 EV increments.

As with ordinary exposure compensation, the adjustment you make remains in effect until you zero it out by pressing the Flash button and rotating the sub-command dial until 0 appears on the monochrome control panel and in the viewfinder. To view the current flash exposure compensation setting, press the Flash button. When compensation is being used, an icon will be displayed in the viewfinder and on the control panel.

As also described in Chapter 12, you can use Custom Setting e3: Exposure Compensation for Flash to balance ambient light and flash exposure over the entire frame, or just take into account the background. The option specifies how the camera modifies the flash level when you apply exposure compensation. (The Z6 has separate ambient light exposure compensation and flash exposure compensation settings.) You can adjust one or the other, or both if you are using flash. This setting affects only *exposure compensation* (the ambient kind) when you are also using flash. It determines how ambient exposure compensation is applied when some of the illumination will also come from a flash unit.

- Entire frame. When you apply ambient exposure compensation (press the EV button on top of the camera to the right of the ISO button and rotate the main command dial), both ambient and flash exposure compensation are adjusted over the entire frame. That balances the exposure for the two elements.
- **Background only.** When this option is selected *only* ambient exposure compensation is changed when you apply it; flash exposure compensation is unaffected. So exposure compensation is applied only to the background areas of your image, which are typically illuminated by ambient light. Flash exposure compensation is not affected.

EXPOSURE COMPENSATION COMBINES

An important thing to remember is that any ambient light and flash exposure compensation you specify *are combined*. So, if you select +2 EV using the Exposure Compensation button on the top of the camera (to the right of the ISO button), and then choose +2 flash exposure compensation, you end up with +4 EV added and, probably, an overexposed image.

Specifying Flash Shutter Speed

This is another way of specifying the shutter speed the Z6 will use when working with flash. Unlike Custom Setting e1: Flash Sync Speed described earlier, this setting determines the *slowest* shutter speed that is available for electronic flash synchronization when you're not using a "slow sync" mode. When you want to avoid ghost images from a secondary exposure, you should use the highest shutter speed that will synchronize with your flash. This setting prevents programmed or Aperture-priority modes (which both select the shutter speed for you) from selecting a shutter speed that captures ambient light along with the flash.

With Custom Setting e2: Flash Shutter Speed, select a value from 30 s to 1/60 s, and the Z6 will avoid using speeds slower than the one you specify with electronic flash if you don't override that decision by deliberately choosing slow sync, slow rear-curtain sync, or red-eye reduction with slow sync. If you think you can hold the Z6 steady, a value of 1/30 s is a good compromise; if you have shaky hands, use 1/60 s or higher. Those with extraordinarily steady grips or who are using vibration reduction can try the 1/15 s setting. Remember that this setting only determines the slowest shutter speed that will be used, not the default shutter speed, which is set with Custom Setting e1.

Previewing Your Flash Effect

The Nikon Z6's compatible external units, including the SB-5000, SB-910, SB-700, and some earlier models, can simulate a modeling light, in the form of a set of repeated bursts of light that allow you to pre-visualize the effect the strobe will provide when fired for the main exposure. This modeling flash, turned on or off using Custom Setting e5, is not a perfect substitute for a real incandescent or fluorescent modeling lamp, as it lasts only for a short period of time and is not especially bright. However, it does assist in seeing how your subject will be illuminated, so you can spot any potential problems with shadows.

When this feature is activated, if you've assigned the Preview (depth-of-field) behavior to a custom button, pressing that control briefly triggers the modeling flash for your preview. Selecting Off disables the feature. You'll generally want to leave it On, except when you anticipate using the depth-of-field preview button for depth-of-field purposes (imagine that) and do *not* want the modeling flash to fire when the flash unit is charged and ready. Some external flash units, such as the SB-5000 and SB-910, have their own modeling flash buttons.

Flash Control

As I noted earlier, newer Nikon electronic flash units, such as the Nikon SB-5000, SB-500, SB-400, or SB-300 Speedlights are compatible with the unified flash control system, and can be adjusted by the Flash Control setting in the Photo Shooting menu. All other Nikon electronic flash units, including the SB-600, SB-700, SB-800, SB-900, and SB-910 must be adjusted using the controls on the flash itself. Not all of the options next can be accessed by every one of the Speedlights listed. For example, with the SB-400, you can only choose between TTL and Manual exposure, plus manual output levels. Unavailable options will be grayed out. To use the Flash Control menu entry, the flash must be mounted on the Z6's hot shoe, powered up, and not set in a Remote mode.

The exact options available from the Flash Control screen will vary, depending on the capabilities of the flash unit you are using. The initial screen may include some or all of the options shown in Figure 9.10, left. The Flash Control Mode screen for the SB-5000 is shown in Figure 9.10, right. I'll discuss each of the adjustments available, whether they are chosen from the Flash Control menu or using the flash unit's own controls, in the sections that follow. Consult your flash unit's manual for the exact procedures used to make the adjustments described.

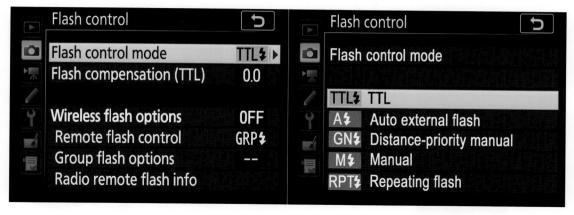

Figure 9.10 Flash Control menu (left); setting flash modes (right).

Working with Nikon Flash External Units

Nikon offers a wide range of external flash units that are compatible with CLS, ranging from the top-of-the-line SB-5000 to the entry-level SB-300, and will probably introduce more Speedlights during the life of this book. In addition, there are a number of older units that have been officially or unofficially discontinued, such as the SB-600, SB-400, SB-800, and SB-910/SB-900, which are still available, in both new and used condition. I'm going to concentrate on the most recent in the following sections.

Nikon SB-300

This entry-level Speedlight, at about \$150, is the smallest and most basic of the Nikon series of Speedlights. The SB-300 has a limited, easy-to-use feature set suited for point-and-shoot photography and some slightly more advanced techniques. Do note however that it does not support wireless off-camera flash. The SB-300 has a moderate guide number of 18/59 at ISO 100. Its main advantage, then, is to provide some additional elevation of the flash above the camera to provide an improved coverage angle and less chance of red-eye effects. Its flash head tilts up to 120 degrees, with click stops at 120, 90, 75, and 60 degrees when the flash is pointed directly ahead. It has a zoom flash head. The SB-300 is lighter in weight at 3.4 ounces than the SB-400 it replaces, and uses two AAA batteries.

Nikon SB-400

Recently discontinued, but still widely available new from many retailers, this entry-level Speedlight (see Figure 9.11) was, until the SB-300 was unveiled, the smallest and most basic of the series. The SB-400 has a limited, easy-to-use feature set suited for point-and-shoot photography and some slightly more advanced techniques. Do note however that, like the SB-300, it does not support

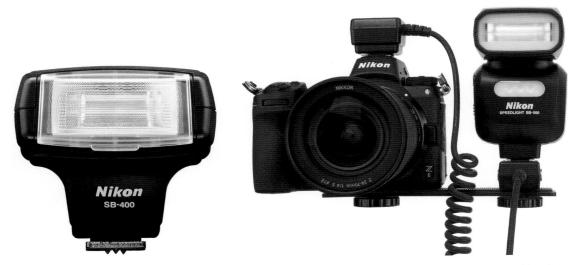

Figure 9.11 The Nikon SB-400 is an entry-level flash best suited for Nikon's entry-level dSLRs.

Figure 9.12 The Nikon SB-500 attached to an optional bracket.

wireless off-camera flash. The 4.5-ounce SB-400 has a moderate guide number of 21/69 at ISO 100 when the zooming head (which can be set to either 18mm or 27mm) is at the 18mm position. It tilts up to 90 degrees, allowing you to bounce the light off of a ceiling, but it cannot be rotated to the side.

Nikon SB-500

This Nikon flash unit (\$250) has a guide number of 24/79 at ISO 100, a speedy recycle time of about 3.5 seconds, and runs on 2 AA batteries for up to 140 flashes. It includes a built-in LED video light with three output levels, and can also be used for still photography as fill light, especially at the brightest setting. It's perfect for wireless mode (discussed in Chapter 10), with four wireless channels and two groups available in Commander mode. The SB-500's head tilts up to 90 degrees, with click-stops at 0, 60, 75, and 90. It rotates horizontally 180 degrees to the left and right, for flexible bounce-flash lighting. If you need a zoom head to adjust flash output to better distribute light at various focal lengths, you're better off with the SB-700 even with its limited zoom range (described next); this unit lacks zooming capabilities.

Figure 9.12 shows the SB-500 fastened to the optional Nikon SK-7 bracket, and linked to a Nikon Z6 through the available SC-28 cable. There are a couple advantages to this configuration. First, the side-mounting moves the flash even farther from the axis of the lens, providing additional redeye protection. You can still tilt the flash for bounce effects. I find this setup easier to hold, and not as awkward because you don't have a top-heavy flash unit mounted above the camera.

But, best of all, it's easy to uncouple the flash/SC-28 from the bracket and use both off-camera. There's no need to fuss with wireless modes, channels, groups, or other settings; the flash thinks that it's still connected directly to the Z6—which it is, of course. Another nine-foot cable, the SC-29, is available and has a built-in focus assist illuminator. I own both, but I like having the SC-29's focus-assist lamp on top of the camera, so that it is aimed at my subject should the Z6 need a bit of extra illumination for focusing. Although the SB-500 has its own focus lamp, it may or may not be pointed at your subject when it comes time to use it.

Nikon SB-700

This affordable (about \$330) unit has a guide number of 28/92 (meters/feet) at ISO 100 when set to the 35mm zoom position. It has many of the top-model SB-910's features, including zoomable flash coverage equal to the field of view of 24-120mm settings with a full-frame camera, and extrawide 14mm coverage with a built-in diffuser panel. It has a built-in modeling flash feature, and a wireless Commander mode.

But the SB-700 lacks some important features found in the SB-910 and SB-5000. Depending on how you use your Speedlight, these differences may or may not be important to you. They include:

- No repeating flash mode. You can't shoot interesting stroboscopic effects with the SB-700, as you can with the SB-5000 or older SB-910/900 units.
- No port for external power pack. Using an external battery pack, like those available from Quantum and others, can be important for wedding and event photographers who want to fire off a bunch of shots quickly, while avoiding frequent changes of the AA batteries the SB-700 uses. An external pack has another benefit: more exposures before the Speedlight slows down to prevent overheating. External batteries don't generate heat inside the flash as internal batteries do.
- No external PC/X sync socket. This option, not found on the SB-700, is of limited use for those who want to attach an off-camera flash to the camera, which does have a PC/X contact.
- Limited zoom range. The SB-700's zoom head is limited to 24-120mm, plus 14mm with the diffuser panel. The ability to match the zoom head to the focal length you're using can match the coverage to the field of view, so the flash's output isn't wasted illuminating areas that aren't within the actual frame.

Nikon SB-R200

One oddball flash unit in the Nikon line is the SB-R200. This \$165 unit is a specialized wireless-only flash that's especially useful for close-up photography, and is often purchased in pairs for use with the Nikon R1 and R1C1 Wireless Close-Up Speedlight systems. Its output power is low at 10/33 (meters/feet) for ISO 100 as you might expect for a unit used to photograph subjects that are often inches from the camera. It has a fixed coverage angle of 78 degrees horizontal and 60 degrees

vertical, but the flash head tilts down to 60 degrees and up to 45 degrees (with detents every 15 degrees in both directions). In this case, "up" and "down" has a different meaning, because the SB-R200 can be mounted on the SX-1 Attachment Ring mounted around the lens, so the pair of flash units are on the sides and titled toward or away from the optical axis. It supports i-TTL, D-TTL, TTL (for film cameras), and Manual modes.

Nikon SB-910

The Nikon SB-910 was the flagship of the Nikon flash lineup until the SB-5000 model was unveiled. However, the SB-910 remains one of the most-used Nikon flash units (along with its predecessor, the SB-900), so I'll continue to include it in my coverage of Speedlights for the foreseeable future. It's still widely available new or used for about \$400, and has a guide number of 34/111.5 (meters/feet) when the "zooming" flash head (which can be set to adjust the coverage angle of the lens) is set to the 35mm position. It includes Commander mode, repeating flash, modeling light, and selectable power output, along with some extra capabilities.

The SB-910 was basically a slight reboot of the older SB-900, which gained a bad reputation for overheating and then shutting down after a relatively small number of consecutive exposures (as few as a dozen or so shots). The SB-910 also can overheat, but features a different thermal protection system. Instead of disabling the flash as it begins warming up, the SB-910 increases the recycle time between flashes, giving the unit additional time to cool a bit before the next shot. While this "improvement" is not a real fix, it does encourage you to slow your shooting pace a bit to stretch out the number of flashes this Speedlight produces before it must be shut down for additional cooling.

Nikon estimates that you should be able to get 190 flashes from the SB-910 when using AA 2600 mAh rechargeable batteries, if firing the Speedlight at full output once every 30 seconds, with a minimum recycling time of 2.3 seconds (which gradually becomes longer as the flash heats up and the thermal protection kicks in). To get the maximum number of shots from your batteries, Nikon figures that AF-assist illumination, power zoom, and the LCD panel illumination are switched off.

There are some improvements, such as illuminated buttons and a restyled soft case, but, in general, the SB-910 is very similar to the SB-900 that we Nikon photographers have learned to know and fear. For example, you can angle the flash and rotate it to provide bounce flash. It includes additional, non-through-the-lens exposure modes, thanks to its built-in light sensor, and can "zoom" and diffuse its coverage angle to illuminate the field of view of lenses from 8mm to 200mm.

The SB-910/SB-900 also has its own powerful focus assist lamp to aid autofocus in dim lighting, and has reduced red-eye effects simply because the unit, even when attached to the Z6 and not used off-camera, is mounted in a higher position that tends to eliminate reflections from the eye back to the camera lens.

SB-5000

This \$600 Speedlight, introduced at the same time as the D5 and Z6, is the new flagship of the Nikon flash lineup. While it resembles the SB-910 and has a virtually identical guide number (34.5 meters, 113 feet), it more or less solves the overheating problem that plagued its top-line predecessors. A novel internal cooling system purportedly allows up to 90 consecutive shots, or 120 shots at five-second intervals without overheating. (Wedding photographers will love this.)

However, the big news is the addition of radio control to the optical triggering available with previous Nikon flash units that could be operated wirelessly. Radio control allows triggering the flash from a distance of nearly 100 feet—without requiring a line-of-sight connection. Best of all, you don't need to purchase two of these to use the SB-5000 wirelessly. Nikon already has a radio trigger in its product line, the WR-R10 wireless remote adapter that I have been using for years as a remote shutter release. As a trigger-only device, the WR-R10 has a longer range than the SU-800 commander used for optical wireless operation. The SB-5000 retains compatibility with Nikon's earlier optical wireless system, so your current flash units can be used with it in non-radio mode.

I power my SB-5000 (and all my other Speedlights) with Panasonic (formerly Sanyo) Eneloop AA nickel metal hydride batteries. These are a special type of rechargeable battery with a feature that's ideal for electronic flash use. The Eneloop cells, unlike conventional batteries, don't self-discharge over relative short periods of time. Once charged, they can hold onto most of their juice for a year or more. That means you can stuff some of these into your Speedlight, along with a few spares in your camera bag, and not worry about whether the batteries have retained their power between uses. There's nothing worse than firing up your strobe after not using it for a month, and discovering that the batteries are dead.

Note that the SB-5000 and many other Nikon flash units, like your camera, contains firmware that can be updated. The custom settings readouts on the flash itself will tell you what firmware version you currently have. If an update is required, you'll need to download the firmware module from the Nikon website. Load it onto a memory card, and then mount the flash on your Z6 and power it up. You'll find a fourth entry in the Firmware section of the Setup menu, marked S (for Speedlight or Strobe). The SB-910's firmware can be updated through the camera/flash connection just like the camera's own firmware.

Light Modifiers

The top-line Speedlights have a better array of included light-modifying tools than other Speedlights in the Nikon line. The standard pop-up white "card" slides out of the flash head, as shown earlier in Figure 9.1, and from another angle in Figure 9.13, left. The card reflects a little fill illumination toward your subject when the flash is tilted to bounce off a ceiling or rotated and tilted to bounce off a wall or other surface. A wide-angle diffuser also slides out and rotates to cover the front of the flash and spread the light to cover lenses with focal lengths as wide as 12mm. The included diffuser dome (see Figure 9.13, center) provides softer illumination for direct flash, with

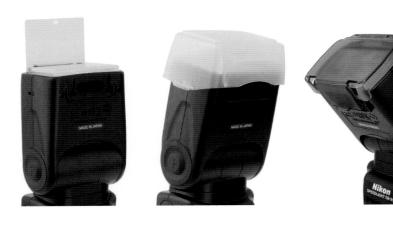

Figure 9.13 Left: The slide-out bounce card adds a kicker of light to fill in shadows or provide a catch light in the eyes of humans (or others). Center: The included diffuser dome produces a soft, flattering light. Right: The SZ-2TN incandescent filter warms the flash's illumination to match tungsten lighting.

the flash pointed at your subject, or something of a "bare bulb" effect when pointed upward. (The "bare bulb" concept dates back to film days when an electronic flash, flashbulb (!), or even an incandescent lamp was used without a reflector or shade to provide a flood of soft illumination that spread out in all directions from the source.)

Various filters are available for Nikon strobes to change the color of the light source. Two are included with the SB-910 and SB-5000, the SZ-2TN incandescent filter (shown in Figure 9.13, right) and the SZ-2FL fluorescent filter. The SJ-3 color filter set (\$28) is 20 gelatin filters in eight different colors, including blue, yellow, red, and amber. The incandescent filter is most useful, because it changes the Speedlight's illumination to match typical indoor lamps, so you can use both to light a scene without encountering a nasty mixed lighting situation. The nifty thing about the SZ-series filters is that they include a type of bar code that can be read by a sensor underneath the unit's flash head, so the strobe (and your Z6) "knows" that a particular filter has been fitted.

Other Accessories

The top-end flash units come with the AS-21 Speedlight Stand, which lets you give the strobe a broad "foot" that can rest on any flat surface when working in wireless mode. The stand has a tripod-type socket underneath, so you can also mount the flash on a tripod or light stand without needing to purchase a special adapter.

Not included are things like the WG-AS3 Water Guard, a \$35 shield used when the flash is mounted on the Z6, to protect the hot shoe contact from moisture or (more likely) driving rain in sports photography situations. Well-heeled photographers who shoot weddings or events and don't already own a Quantum battery pack may be interested in the SD-9 High Performance Battery pack (\$255), which holds up to eight AA batteries; or the (now discontinued) SK-6 Power Bracket, which could be outfitted with four AA batteries and provides a side-mounted handle as well as an auxiliary power source.

Using Zoom Heads

External flash zoom heads can adjust themselves automatically to match lens focal lengths in use reported by the Z6 to the flash unit, or you can adjust the zoom head position manually if you want to use a setting that doesn't correspond to the automatic setting the flash will use. With older flash units, like the discontinued SB-600, automatic zoom adjustment wastes some of your flash's power, because the flash unit assumes that the focal length reported comes from a full-frame camera. Because of the 1.5X crop factor when the Z6 is used in DX mode, the flash coverage when the flash is set to a particular focal length will be wider than is required by the Z6's cropped image.

You can manually adjust the zoom position yourself, using positions built into the flash unit that more closely correspond to your Z6's field of view when using the SB-5000, SB-910, and SB-900, (which do not automatically take into account the difference between FX/full-frame and DX/APS-C coverage).

Flash Modes

I introduced flash modes (as well as *flash sync* modes) earlier in this chapter. External flash units have various flash modes included, which are available or not available with different camera models, including both the latest model dSLRs, some really ancient digital SLRs, and even more aged film cameras. A table showing most of the groups is included in the manuals for the external flash units, but the table is irrelevant for Z6 users (unless you happen to own an older digital or film SLR, as well). All you really need to know is that the Z6 is fully compatible with the Nikon SB-800 and all flashes introduced since that model debuted.

To change flash mode with the SB-5000, press the rotary multi selector right button to highlight the flash mode, then rotate the multi selector to choose the mode you want. Press the center OK button to confirm. With the SB-910 or SB-900, press the MODE button on the back-left edge, then release it and rotate the selector dial until the mode you want appears on the LCD. The TTL automatic flash modes available are described next. (The SB-700 has a sliding mode selector switch to the left of the Speedlight's LCD with positions for TTL, Manual, and GN settings. Those are the only modes available with that flash when you're using it as a Master. However, when the SB-700 is used as a remote flash triggered by a Master Commander flash, it can operate in Repeating mode.)

- iTTL Automatic Balanced Fill Flash. In both Matrix and Center-weighted camera exposure modes, the camera and flash balance the exposure so that the main subject and background are well-exposed. A TTL BL indicator appears on the LCD. However, if you switch to Spot metering, the flash switches to standard iTTL, described next.
- **Standard iTTL.** In this mode, activated when Spot metering is selected (or if you've fixed the flash exposure using FV Lock), the exposure is set for the main subject, and the background exposure is not taken into account. *Only* the flash exposure is measured and used to determine exposure. A TTL indicator appears on the LCD. In either iTTL Automatic Balanced Fill Flash

or Standard iTTL modes, if the full power of the flash is used, the ready-light indicator on the flash and in the camera viewfinder will blink for three seconds. This is your cue that perhaps even the full power of the flash might not have been enough for proper exposure. If that's the case, an EV indicator will display the amount of underexposure (-0.3 to -3.0 EV) on the LCD while the ready-light indicator flashes.

- AA: Auto Aperture flash. An A indicator next to an icon representing a lens opening/aperture is shown on the LCD when this mode is selected. The SB-5000 or SB-910/SB-900 uses a built-in light sensor to measure the amount of flash illumination reflected back from the subject, and adjusts the output to produce an appropriate exposure based on the ISO, aperture, focal length, and flash compensation values set on the Z6. This setting on the flash can be used with the Z6 in Program or Aperture-priority modes. Like the A and GN modes described next, this option is a hold-over to provide compatibility with some older Nikon cameras, and not really useful for the Z6.
- A: Non-TTL auto flash. In this mode, the Speedlight's sensor measures the flash illumination reflected back from the subject, and adjusts the output to provide an appropriate exposure, without the feedback about the aperture setting of the camera that's used with AA mode. This setting on the flash can be used when the Z6 is set to Aperture-priority or Manual modes. You can use this setting to manually "bracket" exposures, as adjusting the aperture value of the lens will produce more or less exposure; the flash has no idea what aperture you've changed to.
- GN: Distance priority manual. You enter a distance value, and the SB-5000 or SB-910/SB-900 adjusts light output based on distance, ISO, and aperture to produce the right exposure in either Aperture-priority or Manual exposure modes. You can choose this option from the Flash Control menu with the SB-5000. With the SB-910/SB-900, press the MODE button on the flash and rotate the selector dial until the GN indicator appears (the GN option appears only when the flash is pointed directly ahead, or is in the downward bounce position). Then press the OK button to confirm your choice. After that, you can specify a shooting distance by pressing the Function 2 button, and then rotating the selector dial until the distance you want is indicated on the LCD. Press the OK button to confirm. The SB-5000 or SB-910/SB-900 will indicate a recommended aperture, which you then set on the lens mounted on the Z6 in Manual exposure mode.
- M: Manual flash. The flash fires at a fixed output level. Press the MODE button and rotate the selector dial until M appears on the LCD panel. Press the OK button to confirm your choice. Choose the power output level you want, down to 1/256th power with the SB-5000 and 1/128th power with most other Nikon Speedlights. Calculate the correct f/stop to use, either by taking a few test photos, with a flash meter, or by the seat of your pants. Then, set the Z6 to Aperture-priority or Manual exposure and choose the f/stop you've decided on.
- RPT: Repeating flash. The flash fires repeatedly to produce a multiple flash strobing effect. To use this mode, set the Z6's exposure mode to Manual. Then set up the number of repeating flashes per frame, frequency, and flash output level, as described in Chapter 12.

Repeating Flash

Repeating flash is a function that can be used with external flashes like the SB-5000, SB-910, and SB-900. Check your manual for the exact buttons to press to make the following settings using Manual exposure mode:

- Set flash for RPT mode. With the SB-5000, use the rotary multi selector right button (MODE button) to highlight mode, and then rotate the dial to select repeating flash. With the SB-910/SB-900, press the MODE button and rotate the selector dial until RPT is shown at upper left on the LCD. Then press the OK button to confirm.
- 2. **Choose Flash Output Level.** With these flash units, you must specify the power level of the flash. That level will determine the range of the number of flashes you can expect from the capacitor's charge. Use the flash mode controls on the SB-5000 to set output level. With the SB-910/SB-900, press the Function 2 button (on the SB-910) or the Function 1 button (on the SB-900) until the number of flashes is highlighted on the LCD (to the immediate right of the RPT indicator), and rotate the selector dial. Choose a power level from 1/8th to 1/128th power.
- 3. **Select number of shots.** Next, choose the number of shots in your series. With the SB-5000, use the Times setting to determine how many flashes to emit. With the SB-910, highlight the option by pressing the Function 3 button; it's the Function 2 button on the SB-900. The number of shots you can specify varies depending on the shutter speed and firing frequency (specified next).
- 4. **Choose frequency: how many shots per second.** This determines how quickly the series is taken. With the SB-5000, use the Hz setting. With the SB-910, highlight the option by pressing the Function 3 button; it's the Function 2 button on the SB-900.

The maximum number of shots in a series varies, depending on the shutter speed, output level, and frequency you select. The multiple flashes can be emitted only while the shutter is completely open, so a faster shutter speed limits the number of bursts that can be fired off at a given frequency. High output levels and high frequency settings both deplete the capacitor more quickly. So, the number of possible bursts will depend on the combination you choose. With the SB-910 or SB-5000, the maximum number of shots you can expect is about 90 (at 1/64th or 1/128th power), and frequencies of from 1 to 3 bursts per second. That's a large number of firings over a long period of time (30 seconds or more).

If you want very rapid bursts, expect fewer total flashes: the SB-5000 and SB-910 will give you 24 firings at 1/128th power and 20 to 100 firings per second. Still, that's quite a bit of flexibility if you think about it. You can get 24 bursts in just a bit more than one second at the 20Hz setting, or over five seconds at the 100Hz setting. I needed only four bursts to capture the plummeting lime seen in Figure 9.14. One thing you'll notice is that as moving objects slow or speed up, the distance between one "shot" in a series varies.

BURN OUT

When using repeating flash with the SB-910/SB-900, SB-700, SB-5000, or *any* large number of consecutive flashes in any mode (more than about 15 shots at full power), allow the flash to cool off (Nikon recommends a 10-minute time out) to avoid overheating the flash. The SB-5000 increases the recycling time to extend the useful period, while the SB-910/SB-900, SB-700, or SB-500 will signal you when it's time for a cooling-off period. The flash will actually disable itself, if necessary, to prevent damage.

Figure 9.14 Capturing a lime as it plunges into a half-filled fish tank.

Wireless and Multiple Flash

As I mentioned in the last chapter, one of the chief objections to the use of electronic flash is the stark, flat look of direct/on-camera flash, as you can see in Figure 10.1. But as flash wizard Joe McNally, author of *The Hotshoe Diaries*, has proven, small flash units can produce amazingly creative images when used properly.

An on-camera flash is useful for fill light or as a master flash to trigger other units; the real key to effective flash photography is to get the flash off the camera, so its illumination can be used to paint your subject in interesting and subtle ways from a variety of angles.

Of course, often, using a cable to liberate your external flash from the accessory shoe isn't enough. Nor is the use of just a single electronic flash always the best solution; two or more units can be combined in interesting ways to sculpt with light. What we have really needed is a way to trigger one—or more—flash units wirelessly, giving us the freedom to place the electronic flash anywhere in the scene and, if our budgets and time allow, to work in this mode with multiple flashes.

Nikon shooters have long had wireless flash capabilities, ever since the creation of the Nikon Creative Lighting System, described in Chapter 9. Like the i-TTL exposure system, the Advanced Wireless Lighting (AWL) system uses pre-flashes that fire before the main exposure to transmit triggering and exposure information to external flash units that aren't physically connected to the Z6. Depending on whether you're using the SB-5000 or one of the older flash units, you may be able to divide multiple flash units into as many as three different "groups" (six with the SB-5000) and communicate with them using your choice of any of up to four "channels" (to avoid interference from other Nikon photographers within range of your flash units who might be using the same channel).

Figure 10.1
Direct flash is harsh and flat.

It's not possible to cover every aspect of wireless flash in one chapter. There are too many permutations involved. For example, you can use external flash like the SB-700 or SB-5000, an SU-800 wireless trigger, or a PocketWizard-type device as the master. You may have one external "slave" flash, or use several. It's possible to control all your wireless flash units as if they were one multiheaded flash, or you can allocate them into "groups" that can be managed individually. You may select one of four "channels" to communicate with your strobes. These are all aspects that you'll want to explore as you become used to working with the Z6's wireless capabilities.

What I hope to do in this chapter is provide the introduction to the basics so that you'll have the information you need to understand the step-by-step instructions for your Speedlight using the detailed manual supplied with the unit. Once you learn how to operate the Z6's wireless capabilities, you can then embark on your own exploration of the possibilities.

Elements of Wireless Flash

Here are some of the key concepts to electronic flash and wireless flash that I'll be describing in this chapter:

- **Master flash.** The *master* is the flash (or other device) that commands each of the additional flashes when using Commander mode.
- Remote flashes. For wireless operation, you need at least one flash unit not mounted on the camera, in addition to the master device (which can be another flash or a transmitter unit).

- **Channels.** Nikon's wireless flash system offers users the ability to determine on which of four possible channels the flash units can communicate.
- **Groups.** Nikon's wireless flash system lets you designate multiple flash units in separate groups (as many as three groups, or six groups with the SB-5000). You can then have flash units in one group fire at a different output level than flash units in another group. This lets you create different styles of lighting for portraits and other shots.
- **Lighting ratios.** You can control the power of multiple off-camera Speedlights assigned to each group, in order to adjust each unit's relative contribution to the image, for more dramatic portraits and other effects.
- Control system. The SB-5000, whether used alone or with other flashes, can use either the existing optical/infrared control system deployed with earlier Speedlights or the newer radio control offered with the SB-5000 flash or with the WR-R10 as a radio trigger.

Master Flash

The master flash is the commander that tells all the other units in a setup what to do, including when to fire, and at what intensity. It communicates with your Z6, and then, when the firing parameters are determined by the camera (or you, manually), passes along the information to the individual remote flash units. Your master can be one of the following:

- An external flash with Commander capabilities. Use a Nikon SB-5000, SB-910, SB-700, SB-500, or compatible earlier units to communicate with the remote Speedlights using optical or, with the SB-5000, radio control. When used as a master flash, the external strobe must be physically connected to the Z6. You can mount the flash on the camera's accessory hot shoe, or mount it on a cable, such as the SC-28 or SC-29, and then connect the other end of the cable to the Z6's accessory shoe. (See Figure 10.2.) The master flash can be set so that it does or does not contribute to the exposure, although, because it can be used off-camera, the latter mode offers more advantages.
- The Nikon SU-800. This device is an expensive non-flash (about \$340) that does nothing but serve as an optical commander for CLS-compatible flash units (see Figure 10.3). It mounts on the hot shoe of the camera and emits infrared signals (rather than monitor pre-flashes) to trigger the remote flash units. It otherwise functions exactly like a "real" master flash, communicating to groups of Speedlights over the same channels, and allowing i-TTL exposure control. It has two main uses. One application is as a commander for Nikon's wireless "macro" lights, the SB-R200 units. In that mode, it's ideal for any Nikon dSLR, as it serves as a trigger for models without a built-in flash, such as the Z6, Z7, D850, D810, D5, D4, D4s, D3, D3s, or D3x, and some earlier models. It's also a more convenient close-range substitute for an attached master because it emits no light to cast shadows.

I like to use my SU-800 for off-camera flash with no need to fuss with a cable connection or camera-mounted master flash unit. The Robert E. Lee re-enactor was standing in the shade, and the diffused light was not harsh (which is the most common reason for adding flash fill.)

Figure 10.2 An external flash can be used as an off-camera master when connected to a cable that links it to the camera.

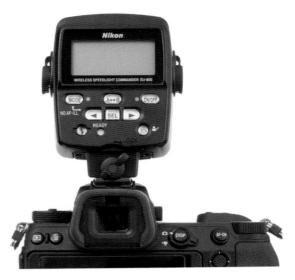

Figure 10.3 The Nikon SU-800 can serve as a master unit.

However, the difference in illumination between him *and* the background was significant, making it impossible to set an exposure that would capture both him and the flag and tent behind him (Figure 10.4, left.) I set the SB-500 to Manual exposure and 1/4 power, held it off to the left, and shot at 1/200th second and f/16 to get the photo at right. The SU-800's infrared control has an impressive 66-foot range under these conditions (that is, not under direct sunlight). It helped me enhance the image with the off-camera flash—which provided a nice catchlight in the General's eye—as the fill illumination.

- Nikon WR-R10. When working with the SB-5000 in radio control mode, this device, plugged into the remote control/accessory connector on the side of the camera, can serve as a master controller. Unless you purchased your unit very recently, you may need to send your unit in to Nikon for a firmware upgrade to Version 3.00 to allow flash control. The firmware upgrade cannot be performed by the user. To see if your unit requires an upgrade, attach it to the Z6, navigate to the Firmware Version entry in the Setup menu, and view the WR firmware notification.
- Compatible third-party triggering devices. These include models from PocketWizard and Radio Popper. The advantage of these devices is that, unlike the optical system used by Nikon's CLS products (limited to about 30 feet), third-party devices use radio control to extend your remote "reach" to as far as 1,500 feet or more. Their transmitters/receivers can work in concert with your own master flash, which controls the remote flashes normally when they're in range, with the radio control taking over when the transmitter senses that the remote flash isn't responding to the master's instructions.

Figure 10.4
A flash can provide pleasing fill illumination outdoors in the shade.

THIRD-PARTY SOLUTIONS

I'm generally covering only Nikon-branded products in this book, because there are so many third-party devices that it's difficult to sort out all the options. However, there are two product lines I've had a lot of luck with—the PocketWizard transmitters and receivers (www.pocketwizard.com) and the X-series wireless devices available from Godox (www.godox.com). These devices attach to your camera (generally by mounting on the hot shoe) and connect to your flash to allow one or more flashes to communicate with the Z6.

PocketWizard makes several products specifically for Nikon cameras, including a transmitter, which locks onto the camera's accessory shoe (a shoe-mount flash can be mounted on top of the transmitter, if you wish). Your remote flash units can use PocketWizard transceivers. The transmitter interprets the i-TTL data from the camera and converts it into a digital radio signal to command your remote flash units. Note that this radio control system is more versatile than the pulsed light pre-flashes and infrared communications the Speedlights and SU-800 use (respectively), working through walls and in bright daylight. The PocketWizard ControlTL system switches to high-speed sync mode automatically when you choose a fast shutter speed.

Cost-conscious shooters may also want to look into the Godox X-series wireless products, available in a variety of configurations. The advantage of the Godox system is that the company offers triggers, as well as both shoe mount and studio-style electronic flash units, all compatible with Nikon's CLS system. The Godox XProN TTL wireless flash trigger (\$69) can be mounted on the Z6's hot shoe, and used to control Nikon SB-series Speedlights (with the flash connected to the Godox X1R-N receiver [\$40]). No extra receiver is required for Godox's own shoe-mounted CLS-compatible flash units and studio flash.

Remote Flashes

To use the Advanced Wireless System, you'll want to work with at least one remote, or slave flash unit. You can use units that are compatible with CLS or, with the (now discontinued) SU-4 accessory, other Speedlights. The remote flash for optical control can be any unit compatible with the Creative Lighting System, including the current SB-5000 and SB-700, or simpatico discontinued models, such as the SB-910/SB-900, SB-800, or SB-600. (Of these, the SB-600 can't function as a master flash on its own.) You'll need to set the auxiliary Speedlights to remote mode. For radio control mode, at this writing only the SB-5000 is compatible as a remote. I expect additional remote flash units will be introduced by Nikon during the life of this book.

Channels

Channels are the discrete lines of communication used by the master flash to communicate with each of the remote units. The pilots, ham radio operators, or scanner listeners among you can think of the channels as individual communications frequencies.

If you're working alone, you'll seldom have to fuss with channels. Just remember that all the Speedlights you'll be triggering must be using the same channel, exactly like a CB radio or walkie-talkie. (Google these terms if you're younger than 40.) If every flash isn't set for the same channel, they will be unable to "talk" to each other, good buddy. I'll show you how to adjust channels shortly.

The channel ability is most important when you're working around other photographers who are also using the same Nikon CLS system. Each photographer sets his or her flash units to a different channel as to not accidentally trigger other users' strobes. (At big events with more than four photographers using Nikon flash, you may need to negotiate.)

Personally, I think it's unfortunate that Nikon was able to include only four channels when using optical control. Radio control is much more flexible; third parties with CLS-compatible systems offer many more channels. Godox, for example, provides 32 discrete channels and allows up to 99 different wireless ID settings, which makes signal interference highly unlikely no matter how many similar setups are in use simultaneously at a given venue. Radio control with the SB-5000 or WR-R10 offers just three channels (Ch5, Ch10, and Ch15), but the flash units are linked using pairing or a PIN code, which effectively increases the number of non-interfering connections. Don't worry about Canon or Sony photographers at the same event. Their wireless flash systems use different communication systems that won't interfere with yours.

It's always a good idea to double-check your flash units before you set them up to make sure they're all set to the same channel, and this should also be one of your first troubleshooting questions if a flash doesn't fire the first time you try to use it wirelessly.

Groups

Each flash unit can be assigned to one of three groups, labeled A, B, and C. (The SB-5000 has additional groups, D, E, and F.) All the flashes in a single group perform together as if they were one big flash, using the same output level and flash compensation values. That means you can

control the relative intensity of flashes in each *group*, compared to the intensity of flashes assigned to a *different* group. A group needs at least one flash unit, but can have more.

For example, you could assign one (or more) flash to Group A, and use it as the main light in your setup. Group B could be used as the fill light, and Group C designated as a hair or background light. The power output of each group could be set individually, so your main light(s) in Group A might be two or three times as intense as the light(s) in Group B (used for fill), while another power level could be set for the Group C auxiliary lights. You don't *have* to use all three groups, but it is an option.

But there's a lot more you can do if you've splurged and own two or more compatible external flash units. Some photographers own five or six Nikon Speedlights, including me, who has one of each model Nikon has offered, starting with the SB-800. As I mentioned, Nikon wireless photography lets you collect individual strobes into *groups*, and control all the Speedlights within a given group together. You can operate as few as two strobes in two groups or three strobes in three groups, while controlling more units if desired. You can also have them fire at equal output settings versus using them at different power ratios. Setting each group's strobes to different power ratios gives you more control over lighting for portraiture and other uses.

This is one of the more powerful options of the Nikon wireless flash system. I prefer to keep my Speedlights set to different groups normally. I can always set the power ratio to 1:1 if I want to operate the flash units all at the same power. If I change my mind and need to make adjustments, I can just change the wireless flash controller and then be able to manipulate the different groups' output as desired.

Remember that with whatever equipment you are using, outdoors if you are using optical triggering, you must have a clear line-of-sight between the master flash or SU-800 unit and sensors on the front of the slave flash units. Indoors, this requirement isn't as critical because the pre-flash and IR signals bounce off walls and other surroundings. Radio control has a longer 98-foot (30 meter) range.

Lighting Ratios

Lighting ratios are the relative proportions of the illumination among the groups, as I just described. To get the most from the CLS system, you'll want to understand how ratios work. That's a topic that deserves a chapter of its own, but many Nikon Z6 owners will already be familiar with the concept. If not, there are plenty of good books and online tutorials available.

Using Ratios

When lighting a subject, you can use several electronic flash units, as shown in the highly simplified arrangement in Figure 10.5. In this case, the main flash is an external unit placed to the left of the subject, and slightly behind her. An additional flash mounted on the Z6's hot shoe provides less intense illumination to fill in the shadows. A third flash illuminates the background, providing separation between it and the subject. All three flashes are set to the same channel, and are assigned to different groups: A, B, and C.

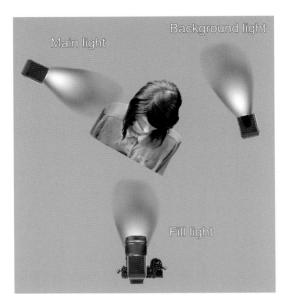

Figure 10.5
Multiple electronic flash units can be set to different intensities.

That setup makes it possible to specify Manual flash mode, in which you control the intensity of the flash, instead of TTL mode, in which the Z6 interprets the light from the preflash and adjusts output automatically. In Manual mode you can specify a different intensity to each group, with, say, the main light (Group A) firing at full power, the fill light (Group B) at 1/4 power, and the background light (Group C) at one-eighth power. The most common way to balance lights set to different power outputs is to use ratios, which are easy to calculate by setting (or measuring, with an external light meter) the exposure of each light source alone. Once you have the light calculated for each source alone, you can figure the lighting ratio.

For example, suppose that the main light for the portrait setup in Figure 10.5 provides enough illumination that you would use an f/stop of f/11. The fill light you'll be adding is less intense, set to 1/4 power, and also located farther away from the subject (or is diffused, say, with an umbrella reflector). If the fill light produces an exposure, all by itself, of f/5.6, that translates into two f/stops' difference or, putting it another way, the main light source is four times as intense as the fill light. You can express this absolute relationship as the ratio 4:1. Because the main light is used to illuminate the highlight portion of your image, while the secondary light is used to fill in the dark, shadow areas left by the main light, this ratio tells us a lot about the lighting contrast for the scene.

In practice, only the lighting ratio produced by illumination falling on the main subject "counts." The light illuminating the background is just supplementary light and in most cases need not be taken into account in calculating the lighting ratio.

In practice, a 4:1 lighting ratio (or higher) is quite dramatic and can leave you with fairly dark shadows to contrast with your highlights. For portraiture, you probably will want to use 3:1 or 2:1 lighting ratios for a softer look that lets the shadows define the shape of your subject without cloaking parts in inky blackness.

If you use electronic flash equipped with a modeling light feature (or incandescent lighting), you will rarely need to calculate lighting ratios while you shoot. Instead, you'll base your lighting setups on how the subject looks, making your shadows lighter or darker depending on the effect you want. If you use electronic flash without a modeling light, or flash with modeling lights that aren't proportional to the light emitted by the flash, you can calculate lighting ratios. If you do need to know the lighting ratio, it's easy to figure by measuring the exposure separately for each light and multiplying the number of f/stops difference by two. A two-stop difference means a 4:1 lighting ratio; two-and-a-half stops difference adds up to a 5:1 lighting ratio; three stops is 6:1; and so forth. Figure 10.6 shows an example of 2:1, 3:1, 4:1, and 5:1 lighting ratios.

Figure 10.6 Left to right: Lighting ratios of 2:1, 3:1, 4:1, and 5:1.

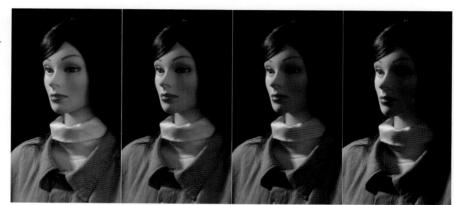

Setting Your Master Flash

Nikon's wireless flash system gives you a number of advantages that include the ability to use directional lighting, which can help bring out detail or emphasize certain aspects of the picture area. It also lets you operate multiple strobes and establish lighting ratios, as described above, although most of us won't own more than two Nikon Speedlights. You can set up complicated portrait or location lighting setups. Since the top-of-the-line Nikon SB-5000 (and former champ SB-910) pump out a lot of light for a shoe-mount flash, a set of these units can give you near studio-quality lighting. Of course, the cost of these high-end Speedlights approaches that of some studio monolights—but the Nikon battery-powered units are more portable and don't require an external AC power source.

This chapter builds on the information in Chapter 9 and shows how to take advantage of the Z6's wireless capabilities. While it may seem complicated at first, it really isn't. Learning the Z6's controls takes a lot of effort, and once you get the hang of it, you'll be able to make changes quickly.

Since it's necessary to set up both the camera and the strobes for wireless operation, this guide will help you with both, starting with prepping the camera. To configure your camera for wireless flash, just follow these steps. (I'm going to condense them a bit, because many of these settings have been introduced in previous chapters.) I'm going to assume that you're using an external flash connected to the Z6 as a master strobe. I'll use the SB-5000 in the example that follows.

Setting Commander Mode for the SB-5000

If you're using an SB-5000 as your Master flash, setting it for Commander mode for automatic, through-the-lens (TTL) exposure calculation can be done using the Flash Control entry in the Photo Shooting menu. Just follow these steps:

- 1. Mount the SB-5000 flash on the Z6's accessory shoe and power it up. The Flash Control entry in the Photo Shooting menu is grayed out if a compatible flash unit (SB-500 or SB-5000) is not mounted and turned on.
- 2. Navigate to the Flash Control entry. As with all menu functions, you can press OK or press the right directional button to select this and the following entries.
- 3. The Flash Control screen will look like Figure 10.7, left. If you have not been using your flash as a wireless master, the Wireless Flash Options choice will be set to OFF.
- 4. When wireless flash is disabled, you can access the Flash Control Mode entry and switch among TTL, Auto external flash, Guide Number (Distance Priority Manual), Manual, and Repeating Flash. (See Figure 10.7, right.)
 - Set the TTL Flash Control Mode if you want the Z6 to calculate flash exposure for the main Commander flash and remote flash units.
 - Set the TTL Flash Control Mode to Manual if you want to set the output levels for your electronic flash yourself, rather than allow the Z6 to set the output automatically. (See "Lighting Ratios," above.)
- 5. In the Flash Control screen, select the Wireless Flash Options choice, shown at left in Figure 10.8.
- 6. In the next screen, shown at right in Figure 10.8, select Optical AWL.
- 7. Next, select Remote Flash Control, as seen in Figure 10.9, left.
- 8. Select Group Flash from the screen shown in Figure 10.9, right.
- 9. You will need to specify a group, mode, and output level. Select Group Flash Options, as seen at left in Figure 10.10. If you're working in TTL mode, the screen at right in the figure appears.
 - Master Flash sets the current flash as a Commander.
 - Group A, Group B, and Group C settings specify the mode of the individual groups. (Groups D and E are available in Radio control mode with the SB-5000.) Choose from TTL, AA, M, or --. If you select -- for any flash or Group, that flash or Group will not contribute to the exposure. (For example, you can set your Master Commander flash to -- and it will trigger other flashes wirelessly, but will not emit a burst during the exposure.)
- 10. Comp. The term *Comp*. is misleading; it actually refers to output level. In the Comp. column you can specify flash exposure compensation (for TTL mode), or flash power level (for M mode).
- 11. Channel. Specify a Channel, selecting from available channels numbered 1–4. (Not all Nikon flashes can use all four channels.)

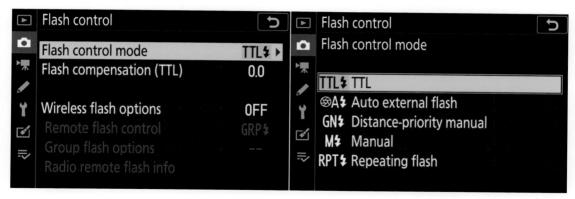

Figure 10.7 Flash control mode.

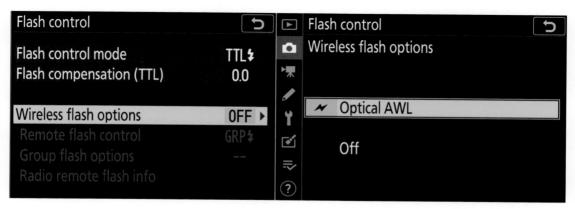

Figure 10.8 Activate Optical AWL.

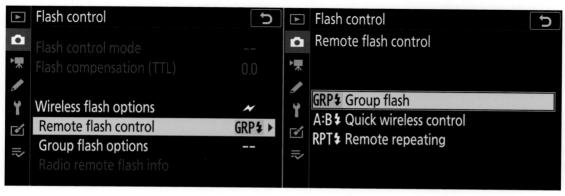

Figure 10.9 Specifying Group flash.

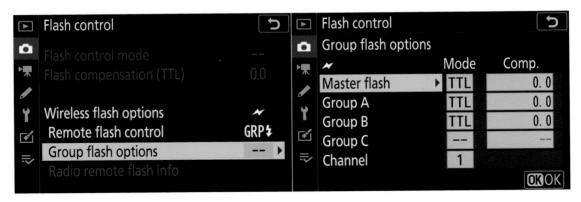

Figure 10.10 Setting group, mode, output level, and channel.

Wireless Flash Options

All adjustments of an SB-5000 or SB-500 mounted on the camera can be made using the Z6's menus. And, as I mentioned earlier, SB-910, SB-900, SB-800, SB-700, and SB-600 flash can be adjusted *only* using the controls on the flash units themselves.

Under Wireless Flash Options, you can select three wireless modes:

- Optical AWL. Optical Advanced Wireless Lighting is the traditional wireless triggering method, available when using the SB-5000 or SB-500 flash units mounted on the camera. Radio AWL can be chosen when you have the WR-R10 unit attached to the camera's 10-pin connector and are using a radio-compatible off-camera flash, such as the SB-5000/SB-500.
- Optical/Radio AWL. This option combines both modes, allowing you to use a WR-R10 unit attached to the camera to trigger radio-compatible flashes, and an additional compatible flash unit mounted on the Z6 to trigger non-radio off-camera flash as a Commander using Optical AWL. When the combined mode is selected, Remote Flash Control (described in the list following this one) is set to Group Flash automatically.
 - At this writing, the radio-controlled flash units must be SB-5000 Speedlights triggered either by another SB-5000, or by the WR-R10 transmitter mounted on the camera as a radio master. The camera-mounted optical master can be the SB-910/SB-900, SB-800, SB-700, SB-500, or SU-800 flash controller. If you're using the SB-500 as the optical Commander/master, you must choose this Optical/Radio AWL option. You do not need to specify this option with the other flash units listed; the combined mode is activated automatically.
- Radio AWL. Note that if you want to use the SB-5000 as a radio-controlled master flash, before attaching it to your camera, you should use the flash's controls to specify radio-controlled master flash mode, and choose group or remote repeating flash. Then, turn the flash off, attach the SB-5000 to the Z6, and power it up again. You will then be able to adjust the SB-5000 using the Z6's Flash Control menu, or with the controls on the flash itself.

Under the Remote Flash Control entry (shown earlier in Figure 10.9), these are your choices:

- Group flash. I described flash Groups earlier in this chapter. This entry allows you to specify separate flash control modes and flash levels for each group of remote units. When working with Optical AWL or Optical/Radio AWL, you can select the channel flashes use to communicate.
- Quick wireless control. This option is a fast way to specify flash ratios by adjusting the balance between Groups A and B, with the exposure being determined by TTL metering. That is, the camera determines the intensity of the flash units in Groups A and B, and you specify the ratio between them, with, say, Group A twice as powerful as Group B. Flash compensation for Groups A and B can also be set to add or subtract from the TTL-metered exposure.
 - You can also set the output for any Group C flashes you use manually, perhaps to provide fill light. As with Group flash, if you're using Optical AWL or Optical/Radio AWL, you can select the channel used for communication.
- Remote repeating. This option is the multi-flash version of Repeating flash, which I explained at the end of Chapter 9. It is available only when using SB-5000 Speedlights. As with the single-flash version, you can choose flash output level, maximum number of flashes (Times), and Frequency (flashes per second). As with the previous two modes, if you're using Optical AWL or Optical/Radio AWL, you can select the channel used for communication.
- Radio Remote Flash Info. If you are using radio control, this entry appears, and the flash units currently being managed are shown.

The next step is to set up each of your off-camera flashes as a remote. That's done using controls on the flash units themselves. I'll get to that after I've explained how to set Commander modes for some other Speedlights.

Setting Commander Modes for the SB-910 or SB-900

Setting Commander modes for the SB-910/SB-900 has been greatly simplified, compared to some previous Nikon Speedlights. If you'd rather use an attached flash as the master, just rotate the On/Off/Wireless mode switch to the Master position. Figure 10.11 shows the rear controls for the SB-700, SB-5000, SB-910, and SB-900.

You'll want to tell the SB-910/SB-900 which channel it is using to communicate with the other Speedlights. You'll need to do this separately for each of the SB-910/SB-900 units you are working with, if you're using more than one. Here are the steps to follow. (I recommend doing several dry runs to see how setting up multiple flashes works before trying it "live.") The steps are almost identical between the SB-910 and SB-900 (shown at the bottom of Figure 10.11), differing primarily in the Function buttons used. In each case, the buttons numbered 1 through 3 are the first three buttons just south of the LCD panel starting from left to right.

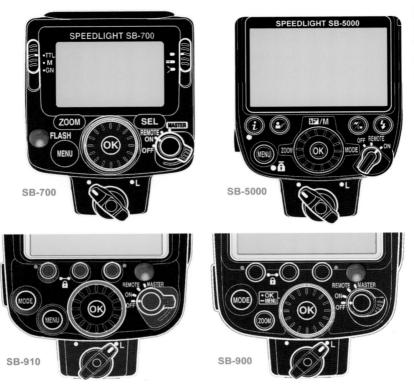

Figure 10.11 Location of the control buttons on the SB-700, SB-5000, SB-910, and SB-900 Speedlights.

Follow these steps:

- Set master flash to Commander mode. On the master flash, rotate the power switch to the Master position, holding down the center lock release button of the switch so that it will move to the Master position. (This extra step is needed because Nikon knows you won't want to accidentally change from Master to Remote.)
- 2. **Access Mode.** Press the Function 2 button (Function 1 button on the SB-900) to highlight M on the LCD. (**Note:** M in this case stands for Master, not Manual.)
- 3. **Select Mode.** Press the MODE button and then spin the selector dial to choose the flash mode you want to use for that flash unit, from among TTL, A (Auto Aperture), M (Manual), or -. Then, press OK.

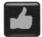

Tip

Reminder: At the - - setting, the master flash is disabled; it will trigger the other units, but its flash won't contribute to the exposure—except if you're shooting very close to the subject using a high ISO setting. If an external flash is the master, try tilting or rotating the flash head away from your subject to minimize this spill-over effect.

- 4. **Set Flash Exposure Compensation.** Press the Function 3 button (Function 2 button on the SB-900), and rotate the selector dial to choose the flash compensation level (–3 to +3) or manual power level (1/1 to 1/128). The amount of EV correction appears at the right side of the display, opposite the master flash's mode indicator.
- 5. **Specify group.** Press the Function 2 button (Function 1 button on the SB-900) to move on to the Group Selection option. Press OK to choose Group A, or rotate the selector dial to choose Group B or C, then press OK to confirm the group you've chosen.
- 6. **Set modes for group.** Once a group is highlighted, select the mode for that group. Press the MODE button and then spin the selector dial to choose the flash mode you want to use for that flash unit, from among TTL, A (Auto Aperture), M (Manual), or -. Then, press OK.
- 7. **Set Flash Exposure Compensation for group.** Press the Function 3 button (Function 2 button on the SB-900), and rotate the selector dial to choose the flash compensation level for the current group as you did in Step 3. The amount of EV correction appears at the right side of the display, opposite the group's mode indicator.
- 8. **Repeat for other groups.** If you're using Group B and Group C, repeat steps 4 to 7 to set the mode and Flash Exposure Compensation for the additional groups.
- 9. **Specify channel.** Once the modes and compensation for all the groups have been set on the master flash, press the Function 3 button (Function 2 button on the SB-900) and rotate the selector dial to set a channel number that the master flash will use to control its groups.
- 10. **Set up remote flashes.** Now take each of the remote flash units and set the correct group and channel number you want to use for each of them. I'll describe this step later.

Setting Commander Modes for the SB-700

Setting Commander modes for the SB-700 is similar in concept to the settings for the SB-910 or SB-900. The controls for the SB-700 are shown at top left in Figure 10.11. If you want to use an attached SB-700 as the master flash, follow these steps:

- Set master flash to Commander mode. On the master flash, rotate the power switch to the Master position, holding down the center lock release button of the switch so that it will move to the Master position.
- 2. **Choose mode.** There's a sliding switch on the left side of the SB-700. You can choose TTL, M (Manual), or GN modes.
- 3. **Set Flash Exposure Compensation.** Press the SEL button to select the master flash, then choose a flash compensation value/output level using the selector dial. Press OK to confirm.
- 4. **Specify group.** Press the SEL button to move on to the Group Selection option. Press OK to choose Group A, or rotate the selector dial to choose Group B. (Group C is not available with the SB-700.) Set the flash exposure compensation value for each group using the selector dial. Then press OK to confirm.

- 5. **Specify channel.** Once the modes and compensation for all the groups have been set on the master flash, press the SEL button to highlight the Channel, then rotate the selector dial to set a channel number that the master flash will use to control its groups.
- 6. **Set up remote flashes.** Now take each of the remote flash units and set the correct group and channel number you want to use for each of them.

Setting Commander Modes for the SB-500

Setting Commander modes for the SB-500 is similar in concept to the settings for the SB-5000. If you want to use an attached SB-500 as the master flash, follow these steps:

- 1. **Mount the SB-500 on the Z6 and turn on the power.** Rotate the SB-500's power switch, located on the lower-right corner of the back of the unit, to the lightning bolt icon.
- 2. On your Z6, navigate to the Flash Control entry. Under the Flash Control entry, choose Commander mode. Select TTL flash mode in the center column, and any flash compensation in the third column (Comp.).
- 3. **Specify group.** In the Z6 menu, choose Group A or Group B. (Group C is not available with the SB-500.) Choose the exposure mode and flash exposure compensation value for each group using the entries in the second and third columns.
- 4. **Specify channel.** Once the modes and compensation for all the groups have been set on the master flash, choose a Channel. The mode indicator lamp (CMD) on the flash illuminates when settings are made on the Z6.
- 5. **Set up remote flashes.** Now take each of the remote flash units and set the correct group and channel number you want to use for each of them. I'll describe this step next.

Setting Remote Modes

Each of the external remote flash units must be set to Remote mode. With the SB-5000, that's as easy as rotating the On/Off switch to the Remote position. Then press the wireless setting button located at the 11 o'clock position above the switch and choose optical, direct remote, or radio control remote modes. (I'm covering only optical triggering here.)

Here's how to set up the Nikon SB-500, SB-700, SB-900, and SB-910 Speedlights as remote slave flash units. Note that you don't need to specify compensation/output level; that's handled by the master/commander flash. You just need to set the flash to Remote, then choose Group, Channel, and Zoom head function.

- 1. **Switch flash to remote mode.** With the SB-900/SB-910 or SB-700, rotate the power switch to the Remote position, holding down the center lock release button of the switch so that it will move to the Remote position. If you're using the SB-500, you'll set remote mode in Step 2.
- 2. **Select group.** With the SB-500, rotate the power switch to A or B to correspond with the remote flash group you selected for the master flash. With the SB-910, press the Function 2 button (Function 1 button on the SB-900) and choose Group A with the selector dial, and press

- OK. With the SB-700, press the SEL button to highlight the group, then press OK. Repeat for Group B or (with the SB-900/SB-910 only) Group C.
- 3. **Set channel.** With the SB-500, set the remote flash channel to Channel 3 (the only one available with that unit). With the SB-900/SB-910, press the Function 2 button to highlight the channel. If you're using the SB-700, press the SEL button until the channel is highlighted. Then, rotate the selector dial to choose the channel number. Make sure you choose the same channel number you set earlier on the master flash. Press OK to confirm.
- 4. **Choose zoom head position.** With the SB-910, press the Function 1 button (or the Zoom button on the SB-900 or SB-700) to highlight Zoom Head Position, and choose a zoom head setting with the selector dial. Press OK to confirm. With the SB-900 and SB-700 push the Zoom button multiple times to change zoom settings. The SB-500 does not have a zoom head.
- 5. **Repeat for each remote flash.** If you're using more than one remote/slave flash, repeat steps 1 to 4 for each of the additional CLS-compatible units.

QUICK WIRELESS CONTROL

You can choose the balance between groups A and B, and set the output for Group C manually.

Radio Control

Radio control for all flashes used with Nikon dSLR and mirrorless cameras is still in its infancy. At the time I write this, only the expensive SB-5000 flash unit can be triggered by radio signals, and the only way to trigger an off-camera SB-5000 using radio control is with another SB-5000 or the Wireless Remote Controller WR-R10. So, you'll end up spending at least \$1,000 for a two-flash radio-controlled setup. Fortunately, Nikon allows you to mix optically and radio-controlled flash units. You do gain three extra groups (Groups D, E, and F, if you can afford flashes to populate them with), but only three groups (A, B, and C) can be used with Nikon's Quick Wireless Control setup. As always, I recommend consulting Nikon's 120-page guide to the SB-5000 if you want to sort out all the configurations and features of this complex flash. I can provide only an overview here, rather than a detailed how-to that explains all the available combinations.

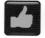

TIP

As I mentioned earlier, a more affordable radio control system is available from vendors like Godox. You can purchase inexpensive receivers/transceivers (around \$70) and some less pricey Godox flash units and retain TTL exposure calculation and control of the flash output levels right at the transmitter. Unfortunately, third-party solutions are updated more frequently than Nikon's own products (the SB-700, introduced in 2010, is still a current Nikon offering), so it's not practical to cover them in detail in a book like this. That's why I stick to describing Nikon's more stable product line almost exclusively.

The WR-R10 plugs into the remote/accessory port on the side of the Z6, as seen in Figure 10.12. You'll need to set the channel for this controller to the same channel used for your SB-5000, from Channel 5, 10, or 15. Then, you'll need to link the controller using the Wireless Remote (WR) Options entry in the Setup menu. You can connect using pairing (the most common, and easiest) or with a PIN, which is more secure and generally used only by professionals to avoid interference in environments in which there are multiple cameras being used with this same system.

Once you've set the channel on the WR-R10, press the MENU button on the SB-5000 (it's at lower left of the unit's back panel, as seen at upper right in Figure 10.11).

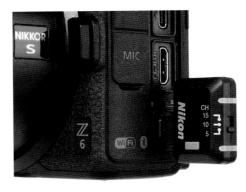

Figure 10.12 The WR-R10 plugs into the remote/accessory port.

Select CHANNEL, and press the right button on the SB-5000's rotary multi selector to set the same channel as the WR-R10. Then press the OK button on the SB-5000's multi selector.

NOTE

You *must* update the WR-R10's firmware to Version 3.0 to use radio control with your SB-5000. The update cannot be done by the user; you'll have to mail in your unit to Nikon's repair service, as I did.

From the SB-5000's MENU again, select Link Mode and choose either Pairing or PIN, to match the setting you specified in the Z6's Setup menu. Press the SB-5000's OK button to confirm. You can select PAIR>EXECUTE, and press the SB-5000's OK button to commence pairing. Once the SB-5000 and WR-R10 have been paired, you won't have to do it again. However, you can pair with a second WR-R10 if you have multiple cameras or multiple WR-R10 controllers.

Concurrent use of optical control and radio control is tricky. You must use a Speedlight *other* than the SB-5000 (such as the SB-910) as an optical master flash mounted in the hot shoe and set to trigger optically controlled remote Speedlights in Groups A, B, C, and *also* have the WR-R10 attached to the camera so it can trigger additional radio-controlled SB-5000 flashes in Groups D, E, and F. It's unlikely that you'll have such a need (or even own the appropriate flash units). This mode could come in handy if you have a complex setup and need to control some flashes at a greater distance (which radio control provides, and optical control may not).

However when using radio control, the distance between masters and remotes should be 98 feet or less. Up to 18 remote flash units can be used. Keep in mind that in radio control remote mode, the Z6's normal Standby Timer is disabled, over-riding any setting you've made in the camera. It's easy to run down your battery with extensive use, or if you forget to turn the flash or camera off.

Playback, Photo Shooting, and Movie Shooting Menus

Your Z6 has several convenient direct-access buttons (such as the ISO button on the top-right panel of the camera) and a customizable Information Edit screen that appears when you press the *i* button. However, many adjustments and settings require a trip to the Z6's extensive menu system, which has nearly 170 individual top-level entries and dozens of additional options tucked away in sub-menus. But under that thicket of choices is the kind of versatility that makes the Nikon Z6 one of the most customizable, tweakable, and fine-tunable cameras Nikon has ever offered. If your camera doesn't behave in exactly the way you'd like, chances are you can make a small change in the menus that will tailor the Z6 to your needs.

However, just telling you what your options are and what they do doesn't really give you the information you need to use your camera to its fullest. What you really want to know is *why* you would want to choose a particular option, and *how* making a particular change will help improve your photographs in a given situation. That's a big job, and I'm going to devote three entire chapters to demystifying the Z6 menu choices for you.

This chapter will help you sort out the settings for the Playback, Photo Shooting, and Movie Shooting menus, which determine how the Z6 displays images on review, and how it uses many of its shooting features to capture photos and videos. The following chapters will focus on the Custom Settings menu (Chapter 12), and Setup, Retouch, and My Menu options (Chapter 13).

TIP

While each entry in the Z6's menus will be summarized in Chapters 11, 12, and 13, some complex functions, such as flash and autofocus options, require longer explanations and step-by-step instructions. I included those descriptions in previous chapters and will not repeat that information.

As I've mentioned before, this book isn't intended to replace the Nikon manual available for your Z6, nor have I any interest in rehashing its contents. There is, however, some unavoidable duplication between the Nikon manual and the next three chapters, because, like the Nikon manual, I'm going to explain all the key menu choices and the options you may have in using them. You should find, though, that I will give you the information you really require in a much more helpful format, with plenty of detail on why you should make some settings that are particularly cryptic. Throughout, I'll indicate my personal setting preference for many of the entries.

I'm not going to waste a lot of space on some of the more obvious menu choices in these chapters. For example, you can probably figure out what the Format Card entry in the Setup menu does, and it has only two options: Yes and No. In this chapter, I'll devote no more than a sentence or two to the blatantly obvious settings and concentrate on the more confusing aspects of the Z6 setup, such as automatic exposure bracketing. I'll start with an overview of using the Z6's menus themselves.

Anatomy of the Nikon Z6's Menus

If you used any Nikon digital SLR before you purchased your Nikon Z6, you're probably already familiar with the basic menu system. The menus consist of a series of screens with entries, as shown in the illustration of the Playback menu (discussed next) in Figure 11.1.

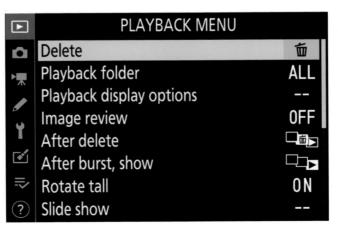

Figure 11.1
The multi selector's navigational buttons are used to move among the various menu entries shown

here.

Navigating among the various menus is easy and follows a consistent set of rules:

- View menu. Press the MENU button on the lower-right corner of the camera to display the main menu screens.
- Navigate main menu headings. Use the multi selector's left/right/up/down buttons to navigate among the menu entries to highlight your choice. Moving the highlighting to the left column lets you scroll up and down among the seven top-level menus. From the top in Figure 11.1, they are Playback, Photo Shooting, Movie Shooting, Custom Settings, Setup, Retouch, and My Menu, with Help access (when available) represented by a question mark at the bottom of the column.
- Choose a top-level menu. A highlighted top-level menu's icon will change from black-and-white to yellow highlighting. Use the multi selector's right button to move into the column containing that menu's choices. The selected top-level menu's icon will change from yellow to a color associated with that menu (blue for Playback, green for Photo Shooting, yellow-green for Movie Shooting, red for Custom Settings, orange for Setup, purple for Retouch, and gray for My Menu). The currently selected option will be highlighted in yellow, as shown in the figure. Note: You can also press the OK button of the multi selector to move into a top-level menu's entries, but it's usually simpler to just press the right button, because you'll be using the multi selector's directional buttons to navigate the menus anyway.
- Select a menu entry. Use the up/down buttons to scroll among the entries. If more than one screen full of choices is available, a scroll bar appears at the far right of the screen, with a position slider showing the relative position of the currently highlighted entry.
- Choose options. To work with a highlighted menu entry, press the OK button, the multi selector center button, or, more conveniently, just press the right button on the multi selector. Any additional screens of choices will appear. You can move among them using the same multi selector movements.
- Confirm your choice. You can activate a selection by pressing the OK button or, frequently, by pressing the right button on the multi selector once again. Some functions require scrolling to a Done menu choice, or include an instruction to set a choice using some other button.
- Exit menus. Pressing the multi selector left button usually backs you out of the current screen, and pressing the MENU button again usually does the same thing. You can exit the menu system at any time by tapping the shutter release button.
- Returning to an entry. The Nikon Z6 "remembers" the top-level menu and specific menu entry you were using (but not any submenus) the last time the menu system was accessed, so pressing the MENU button brings you back to where you left off. So, if you were working with an entry in the Custom Settings menu's Metering/Exposure section, then decided to take a photo, the next time you press the MENU button the Custom Settings menu and the Metering/Exposure entry will be highlighted, but not the specific submenu (b1 through b4) that you might have selected.

■ Accessing a frequently used entry. If you use the same menu items over and over, you can create a My Menu listing of those entries. Or, if you'd rather have a rotating listing of the last 20 menu items you accessed, you can convert My Menu to a Recent Settings menu instead. I'll show you exactly how to do that in Chapter 13.

Playback Menu Options

The blue-coded Playback menu, shown in Figure 11.1, has 9 entries where you select options related to the display, review, transfer, and printing of the photos you've taken. The choices you'll find include the entries that follow. The last entry, Rating, is not pictured in Figure 11.1, and does not appear until you scroll the listing on the screen to the bottom.

■ Image Review

■ Rotate Tall

■ Playback Folder

■ After Delete

■ Slide Show

■ Playback Display Options

■ After Burst, Show

■ Rating

Delete

Options: Selected, Select Date, All (default)

My preference: N/A

Choose this menu entry and you'll be given three choices, shown in Figure 11.2, left: Selected (to choose individual images to delete); Date (to remove all photos taken on a particular day); or All (to remove all images in the folder currently selected for playback). (See Playback Folder entry, next.)

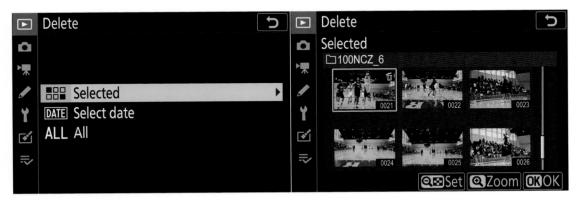

Figure 11.2 Choose selection method (left); Select individual images (right).

To select specific images or dates, follow these instructions:

- 1. **Choose Selected or Date.** Selection screens appear to allow you to choose which images to delete. To select by date, skip to Step 3.
- 2. Mark individual Selected images. Scroll through the thumbnails of the images displayed using the multi selector's directional buttons. Hold down the Zoom In button to enlarge the highlighted thumbnail to full-screen view. Press the Zoom Out/Index button to mark a highlighted image for deletion, or to unmark one that has already been marked. A trash can icon is overlaid on the thumbnail when an image is marked for removal. (See Figure 11.2, right.) When finished marking, press OK to delete. Choose Yes from the Delete? screen that appears, or No to cancel.
- 3. **Select dates.** A list of dates on which pictures were taken appears. Press the right button to checkmark a date, or to unmark a date that has been selected. Once you've highlighted one or more dates, if you're sure you want to delete all those images, press OK, and give the Z6 the go-ahead to continue on the confirmation screen that pops up.

 If you want to double-check your images before removing them, press the Zoom Out/Index button to confirm your choices, and a scrollable screen of thumbnails displaying the images for the selected dates will be shown. You can press the Zoom In button to view a full-screen version of any highlighted image. When finished, press OK to return to the previous screen. Press OK again and choose Yes from the Delete All Images Taken on Selected Date screen, or No to cancel.
- 4. Exit Delete menu. To back out of the selection screens, press the MENU button.

Using this menu to delete images will have no effect on images that have been marked with an overlaid key icon when protected using the Protect option available from the i menu that appears when you press the i button during Playback. Keep in mind that deleting images in this way is slower than just wiping out the whole card with the Format command, so using Format is generally much faster than choosing Delete: All, and also is a safer way of returning your memory card to a fresh, blank state.

Playback Folder

Options: NCZ_6, All (default), Current

My preference: N/A

Your Nikon Z6 will create folders on your memory card to store the images that it creates. It assigns the first folder a number, like 100NCZ_6, and when that folder is filled, the camera automatically creates a new folder numbered one higher, such as 101NCZ_6. A folder is completely full when it contains 5,000 images, or a picture numbered 9999. If you use the same memory card in another camera, that camera will also create its own folder. Thus, you can end up with several folders on the same memory card, until you eventually reformat the card and folder creation starts anew.

This menu item allows you to choose which folders are accessed when displaying images using the Z6's Playback facility. Your choices are as follows:

- NCZ_6. The camera will use only the folders on your memory card created by the Z6 and ignore those created by other cameras. Images in all the Z6's folders will be displayed. This is the default setting. You can rename these folders using the Storage Folder > Rename entry in the Photo Shooting menu. Personally, I feel that the space between NCZ and 6 in the folder name is a waste of good ASCII, and will recommend some alternatives later in this chapter, using the Storage Folder entry of the Photo Shooting menu.
- All (Default). All folders containing images that the Z6 can read will be accessed, regardless of which camera created them. You might want to use this setting if you swap memory cards among several cameras and want to be able to review all the photos (especially when considering reformatting the memory card). You will be able to view images even if they were created by a non-Nikon camera if those images conform to the Design Rule for Camera File system (DCF) specifications.
- Current. The Z6 will display only images in the current folder. For example, if you have been shooting heavily at an event and have already accumulated more than 5,000 shots in one folder (or an image has been stored that's numbered 9999) and the Z6 has created a new folder for the overflow, you'd use this setting to view only the most recent photos, which reside in the current folder. You can change the current folder to any other folder on your memory card using the Active Folder option in the Photo Shooting menu, described later in this chapter.

Playback Display Options

Options: Basic photo info: Focus Point; Additional Photo info: Exposure Info, Highlights, RGB Histogram, Shooting Data, Overview, None (Image only)

My preference: N/A

You'll recall from Chapter 3 that a great deal of information, available on multiple screens, that can be cycled through by pressing the DISP button when reviewing images. This menu item helps you reduce/increase the clutter by specifying which information and screens will be available. To activate or deactivate an info option, scroll to that option and press the right multi selector button to add a checkmark to the box next to that item. Press the right button to unmark an item that has previously been checked. If no boxes are checked, only the default view—the image with basic information shown at the bottom of the frame—is displayed. Your additional info options include:

- Focus point. Activate this option to display the active focus point(s) with red highlighting.
- Exposure info. Shows only frame number and basic exposure information, including release mode, shutter speed, aperture, exposure compensation, and ISO sensitivity.

- **Highlights.** When enabled, overexposed highlight areas in your image will blink with a black border during picture review. That's your cue to consider using exposure compensation to reduce exposure, unless a minus EV setting will cause loss of shadow detail that you want to preserve. You can read more about correcting exposure in Chapter 4.
- RGB histogram. Displays both luminance (brightness) and RGB histograms on a screen that can be displayed using the up/down multi selector buttons, as shown in Chapter 3. I explained the use of histograms in Chapter 4.
- **Shooting Data.** Activates the pages of shooting data shown in Chapter 3.
- Overview. Activates the overview screen shown in Chapter 3. You must scroll down the list to access this option.
- None. A screen with the image only and no photo information will be displayed.

Image Review

Options: On, On (Monitor only), Off (default)

My preference: N/A

There are certain shooting situations in which it's useful to have the picture you've just shot pop up on the monitor automatically for review. Perhaps you're fine-tuning exposure or autofocus and want to be able to see whether your most recent image is acceptable. Or, maybe you're the nervous type and just want confirmation that you actually took a picture. Instant review has saved my bacon a few times when I accidentally made an inappropriate setting (such as specifying ISO 25600 when it really wasn't needed or desirable).

A lot of the time, however, it's a better idea to *not* automatically review your shots to conserve battery power (the LCD monitor and EVF are two of the major juice drains in the camera) or to speed up or simplify operations. For example, if you've just fired off a burst of eight shots during a football game, do you *really* need to have every frame display as the camera clears its buffer and stores the photos on your memory card? This menu operation allows you to choose which mode to use. You can elect to have the review image always appear, appear on the LCD monitor only, or never appear. Unfortunately, Nikon neglected to give us an On (Viewfinder Only) option for image review, but I'm going to give you several workarounds.

- On. Image review is automatic after every shot is taken, and your image will appear in the viewfinder or on the LCD monitor (depending on which you are using).
- On (Monitor only). Image review is displayed *only* on the rear-panel LCD monitor, and then only if you are *not* currently looking through the viewfinder; to see image review, move the camera away from your eye.
- Off. Images are displayed only when you press the Playback button. Nikon, in its wisdom, has made this the default setting.

QUENCH THAT MONITOR!

When I am shooting concerts and performances where the audience area is darkened, I don't want the LCD monitor lighting up after every shot and annoying people. Even so, I may want to review my images and would like them to appear immediately—just not on the monitor. There are several ways to activate that behavior.

- If you select ON with this menu entry, if your Limit Monitor Mode Selection option (in the Setup menu, and described in Chapter 13) is set to activate Automatic Selection, as long as you keep your eye up to the viewfinder, the image preview will not appear on the monitor.
- A better choice is to disable Automatic Selection, and enable just Viewfinder Only or Monitor Only options. Then you can manually toggle between the viewfinder and monitor using the VF/Monitor button on the left side of the Z6's pentaprism. Your image review will appear *only* on the currently selected screen.
- If you absolutely want to prevent having your image review appear on the monitor, visit the Limit Monitor Mode Selection entry and disable everything but Viewfinder Only.
- A compromise is to use the Monitor Brightness entry in the Setup menu and set Manual Brightness to −5. This produces a very dark screen, which is unlikely to annoy those around you. It also makes it difficult to judge exposure from the monitor alone. (*That's what the histogram is for!*)

After Delete

Options: Show Next (default), Show Previous, Continue as Before My preference: Show Next

When you've deleted an image, you probably will want to do one of three things: have the Z6 display the next picture (in the order shot); show the *previous* picture; or show either the next *or* previous picture, depending on which way you were scrolling during picture review. Your Z6 lets you select which action to take:

- **Show next.** It's likely that you'll want to look at the picture taken after the one you just deleted, so Nikon makes this the default action.
- Show previous. I use this setting a lot when shooting sports with a continuous shooting setting. After the sequence is taken, I press the Playback button to see the last picture in the series and sometimes discover that the whole sequence missed the boat. I sometimes go ahead and press the Trash button twice to delete the offending image, then continue moving backward to delete the five or six or eleven other pictures in the wasted sequence. You'll often find yourself with time on your hands at football games, and feel the urge to delete a stinker series of shots to save your time reviewing back at the computer (plus freeing up a little space on your card).
- Continue as before. This setting makes a lot of sense: if you were scrolling backward or forward and deleting photos as you go, you might want to continue in the same direction weeding out bad shots. Use this setting to set your Nikon Z6 to behave that way.

After Burst, Show

Options: First Image in Burst, Last Image in Burst (default)

My preference: Last Image in Burst

This menu choice allows you to determine which image is shown after a continuous series of shots are captured, when Image Review is turned off. In practice, the Z6 will *not* display any images on the LCD monitor while you are shooting a burst, allowing the camera to capture frames and store them on your memory card at maximum speed. However, when the burst is complete, one image will then be shown on the screen—either the first image of the series or the last image captured. I prefer to view the final image; if it's okay in terms of exposure and focus, I can assume the others in the series are similar, and move on to initiate another burst immediately if I want. Select First Image in Burst, instead, if you want to see the initial shot and then, perhaps, continue checking subsequent photos.

Rotate Tall

Options: On (default), Off

My preference: Off

When you rotate the Z6 to photograph vertical subjects in portrait (tall), rather than landscape (wide) orientation, you probably don't want to view them tilted onto their sides later, either on the camera monitor and viewfinder or within your image viewing/editing application on your computer. The Z6 has a directional sensor built in that can detect whether the camera was rotated when the photo was taken and hide this information in the image file itself.

The orientation data is applied in two different ways. It can be used by the Z6 to automatically rotate images when they are displayed on the camera's monitor and viewfinder (when On is enabled), or you can ignore the data and let the images display in non-rotated fashion when Off is selected (so you have to rotate the camera to view them in their proper orientation). As mentioned earlier, your image-editing application can also use the embedded file data to automatically rotate images on your computer screen.

This menu choice deals only with whether the image should be rotated when displayed on the camera LCD monitor or in the electronic viewfinder. (If you de-activate this option, your image-editing software can still read the embedded rotation data and properly display your images.) When Rotate Tall is turned off, the Nikon Z6 does not rotate pictures taken in vertical orientation. The image is large on your display, but you must rotate the camera to view it upright.

When Rotate Tall is turned on, the Z6 rotates pictures taken in vertical orientation on the monitor screen so you don't have to turn the camera to view them comfortably. However, this orientation also means that the longest dimension of the image is shown using the shortest dimension of the monitor, so the picture is reduced in size (see Figure 11.3).

Figure 11.3 Rotate Tall: Off (top); Rotate Tall: On (bottom).

So, turn this feature On if you'd rather not turn your camera to view vertical shots in their natural orientation, and don't mind the smaller image. Turn the feature Off if, as I do, you'd rather see a larger image and are willing to rotate the camera to do so. Rotating the camera is no big deal, and worth the trouble in order to see the largest possible review image on the display.

Slide Show

Options: Start; Image Type: Still Images and Movies (default), Still Images Only, Movies Only, By Rating; Frame Interval: 2 (default), 3, 5, 10 seconds

My preference: N/A

The Z6's Slide Show feature is a convenient way to review images in the current playback folder one after another, without the need to manually switch between them. Re-direct the output of your camera's video to an HDTV television, and you've got an instant camera-based large-screen audiovisual extravaganza. Your options include:

■ Start. To activate a slide show, just choose Start from this entry in the Playback menu. During playback, you can press the OK button to pause the "slide show." When the show is paused, a menu pops up with choices to restart the show (by pressing the OK button again), change the interval between frames, or to exit the show entirely.

- Image Type. You can choose to display both still images and movies, still images only, movies only, or images with one to five Rating stars (or none at all). The Ratings feature means you can award a "star" value to images as you shoot, or at any later time, and then activate a slide show that displays *only* the images with a particular rating—or images with *several* ratings, say, *both* five-star and four-star photos. I'll explain Ratings in the next section. The default value is both stills and movies.
- Frame Interval. If you like, you can choose Frame Interval before commencing the show in order to select an interval of 2, 3, 5, or 10 seconds between "slides." The default value is 2 seconds.

As the images are displayed, press the up/down multi selector buttons to change the amount of information presented on the screen with each image. For example, you might want to review a set of images and the settings used to shoot them. During the show:

- **Change information.** At any time during the show, press the up/down buttons until the informational screen you want is overlaid on the images.
- Manually change frames. As the slide show progresses, you can press the left/right multi selector buttons to move back to a previous frame or jump ahead to the next one. The slide show will then proceed as before.
- Pause. Press the OK button. Highlight Restart and press OK again to resume.
- Change playback volume (for movie images only). Press the Zoom In button to increase volume, or Zoom Out to decrease.
- Exit to Playback menu. Press the MENU button to exit the slide show and return to the Playback menu. Use this option when you want to change slide show parameters.
- Exit to Playback mode. Returns to previous playback mode (full frame or thumbnail).
- Exit to Shooting mode. Tap the shutter release button.
- **Restart/Adjust.** At the end of the slide show, as when you've paused it, you'll be offered the choice of restarting the sequence, changing the frame interval, or exiting the Slide Show feature completely.

Rating

Options: Zero to five stars

My preference: N/A

The Rating option allows applying a star rating from zero to five stars for individual images. I love this feature, and not because my work is so variable that my images customarily range in quality from zero-star stinkers to five-star exhibition-worthy shots. In practice, you can use the Rating system to categorize your photos any way you choose, using a variety of parameters.

Select this menu item and the image selection window will appear. You can use the left/right directional buttons or touch screen to scroll among your images to highlight one you want to rate. To view a highlighted image full frame, press and hold the Zoom In button. Rate a highlighted image using the up/down buttons to apply a rating from zero to five stars, or tap the thumbnail on the monitor display one to five times. Press the down button to decrement stars, or to select the Trash icon to mark the picture for later deletion. Ratings cannot be applied to protected images. Press OK or tap Return to confirm and exit.

Images can also be rated during playback. When an image is shown on the screen as you review it, press the *i* button to show playback options (Rating, Select to Send to Smart Device/Deselect, Retouch, Choose Folder). Select Rating, and then use the controls to apply a rating as described above. Press OK or tap Return to confirm and exit.

I'm keen on the Rating feature because this capability is much more versatile than you might think. The stars don't have to relate to relative image quality. You can invent any other "code" you might like to apply. For example, if you like, one star can represent photos containing animals; two stars pictures with family members; three stars photos of landscapes; and so forth. Then, with the ratings applied, you can quickly access particular types of pictures.

Or, you could mark your photos to create five different slide shows (as described earlier) on a single memory card. On a lengthy European vacation, you could assign your best shots in Spain a single star; designate shots in France with two stars; those in Italy with three; Greece, four; and Germany, five stars. Then, choose By Rating as your Image Type for your Slide Show, and then activate a show using only images with a particular number of stars. Or, you could specify a show with, say, only one-star and three-star images to display a series of Spain and Italy photographs.

Photo Shooting Menu Options

The *i* menu allows you to make many of the most common adjustments, including image quality, image size, autofocus mode, white balance, AF mode, and flash settings, and can be customized to include other entries of your choice. You'll find some of these settings duplicated in the Photo Shooting menu (the first page of which is shown in Figure 11.4), along with options that you access second-most frequently when you're using your Nikon Z6, such as specifying noise reduction for long exposures or high ISO settings. You might make such adjustments as you begin a shooting session, or when you move from one type of subject to another. Nikon makes accessing these changes very easy.

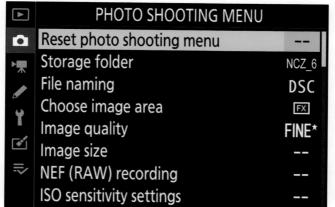

This section explains the options of the Photo Shooting menu and how to use them. The options you'll find in these green-coded menus include:

■ Reset Photo Shooting	■ Color Space	■ Flash Compensation
Menu	■ Active D-Lighting	■ Focus Mode
■ Storage Folder	■ Long Exposure NR	■ AF-Area Mode
■ File Naming	■ High ISO NR	■ Vibration Reduction
■ Choose Image Area	■ Vignette Control	■ Auto Bracketing
■ Image Quality	■ Diffraction Compensation	■ Multiple Exposure
■ Image Size	■ Auto Distortion Control	■ HDR (High Dynamic
■ NEF (RAW) Recording	■ Flicker Reduction	Range)
■ ISO Sensitivity Settings	Shooting	■ Interval Timer Shooting
■ White Balance	■ Metering	■ Time-lapse Movie
■ Set Picture Control	■ Flash Control	■ Focus Shift Shooting
■ Manage Picture Control	■ Flash Mode	■ Silent Photography

Reset Photo Shooting Menu

Options: Yes, No My preference: N/A

The Nikon Z6 has, in effect, four different kinds of resets. This is one of them.

- **Photo Shooting menu reset.** Use this option to reset the values of the current Photo Shooting menu to the values shown in Table 11.1.
- Movie Shooting menu reset. The Movie Shooting menu has its own settings, which are reset separately, as described later in this chapter.

- Custom Settings menu reset. This option, which I'll describe in Chapter 12, is used to reset the Custom Settings entries. It has no effect on camera settings or Photo Shooting menu banks.
- Setup menu reset. This option resets all settings except for Language and Time Zone/Date to their default values. Use this option with caution, as it even erases copyright information and your user settings (described in Chapter 13). In that chapter I'll also show you how to save/load settings so you can retrieve settings you saved, even after you've used the Setup menu reset.

Table 11.1 shows the default values that are set using Reset Photo Shooting Menu. If you don't know what some of these settings are, I'll explain them later in this section.

Function	Value	Function	Value
Storage Folder		Set Picture Control	Auto
Rename	NCZ_6	Color Space	sRGB
Select Folder by Number	100	Active D-Lighting	Off
File Naming	DSC	Long Exp. NR	Off
Choose Image Area	FX	High ISO NR	Normal
Image Quality	JPEG normal	Vignette Control	Normal
mage Size		Auto Distortion Control	On
JPEG/TIFF NEF (RAW)	Large Large	Flicker Reduction Shooting	Off
NEF (RAW) Recording	T	Metering	Matrix Metering
NEF (RAW) Compression NEF (RAW) Bit Depth	Lossless compressed 14 bit Flash Control Mode Wireless Flash Options Remote Flash Control	TTL Off	
ISO Sensitivity Settings Auto	Auto	Remote Flash Control	Group flash
P,S,A,M	100	Flash Mode	Fill flash
Auto ISO Sensitivity	On	Flash Compensation	0.0
Control		Focus Mode	Single AF
Maximum Sensitivity		AF-Area Mode	Single-point AF
Maximum Sensitivity Flash Minimum Shutter Speed	Same as without flash Auto	Auto Bracketing Auto Bracketing Set Number of Shots	AE & flash
White Balance Fine Tuning Choose Color Temp Preset Manual	Auto>Keep over- all atmosphere A-B:0, G-M:0 5000K d-1	Increment	1.0

Function	Value	Function	Value
Multiple Exposure Multiple Exposure Mode Number of Shots Overlay Mode Keep All Exposures Overlay Shooting	Off 2 Average On On	Time-Lapse Movie Interval Shooting Time Exposure Smoothing Silent Photography Choose Image Area	Off 5 seconds 25 minutes On Off FX
HDR (High Dynamic Ra HDR Mode Exposure Differential Smoothing Save Individual Images	nge) Off Auto Normal Off	Frame Size/Frame rate Interval Priority Focus Shift Shooting Number of Shots Focus Step Width	1920 × 1080; 60p Off 100
(NEF) Interval Timer Shooting Choose Start Day/Time Interval No. Intervals × Shots/	Off Now 1 minute 0001x1	Interval Until Next Shot First-Frame Exposure Lock Peaking Stack Image Silent Photography	0 On Don't create Off
Interval Exposure Smoothing Silent Photography Interval Priority	Off Off Off	Silent Photography	Off

Storage Folder

Options: Rename: NCZ_6 (default); Select Folder by Number: 100 (default); Select Folder from List

My preference: I use the Select Folder by Number option frequently to organize images by topic or time frame.

If you want to store images in a folder other than the one most recently created and selected by the Nikon Z6, you can switch among available folders on your memory card, or create your own folder. Remember that any folders you create will be deleted when you reformat your memory card.

Why create your own folders? Perhaps you're traveling and have a high-capacity memory card and want to store the images for each day (or for each city that you visit) in a separate folder. Maybe you'd like to separate those wedding photos you snapped at the ceremony from those taken at the reception. As I mentioned earlier, the Nikon Z6 automatically creates a folder on a newly formatted memory card with a name like 100NCZ_6, and when it fills with 5,000 images (an increase from the limitation of 999 images in most previous Nikon cameras) or a picture numbered 9999, it will automatically create a new folder with a number incremented by one (such as 101NCZ_6).

Folders are always identified using a three-digit number, followed by a five-character folder name. Although the default characters are NCZ_6, you can specify a name of your choice. To create your own folder or select an existing folder:

- 1. Access active folder entry. Choose Storage Folder in the Photo Shooting menu, and press the right multi selector button. The screen shown at left in Figure 11.5 appears.
- 2. **Choose function.** Three options are listed: Rename, Select Folder by Number, and Select Folder from List.
 - Rename. Highlight and select Rename and you'll be taken to a screen similar to the one shown at right in Figure 11.5, but with only five spaces to enter information for the naming scheme. Only numbers from 0 to 9, uppercase alpha characters, and an underline can be selected. Note that you can only change the name of your folder scheme—existing folders cannot be renamed. I like to name my folders using the scheme "NIKZ6." It does not provide any extra information beyond that of the default "NCZ_6," but it does make it very easy to differentiate between photos taken with my Z6, and those taken by another Z6 (most likely another photographer). See the next section, "Entering Text on the Nikon Z6" for a primer on using the on-screen keyboard.
 - Select Folder by Number. If you've chosen this option, a screen appears with three digits representing the possible folder numbers from 100 to 999. (See Figure 11.6.) Use the left/right multi selector buttons to move between the digits, and the up/down buttons to increase or decrease the value of the digit. If a folder already exists with the number you dial in, an icon appears showing the folder is empty, partially full, or it has 5,000 images or a picture numbered 9999 (and can contain no more images).

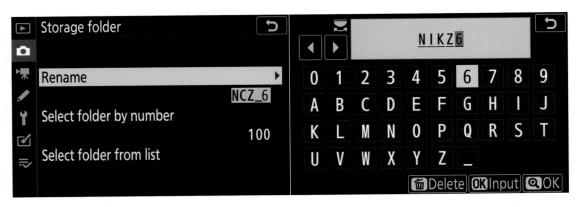

Figure 11.5 Change your folder naming scheme, create a new folder, or select an existing folder number.

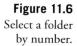

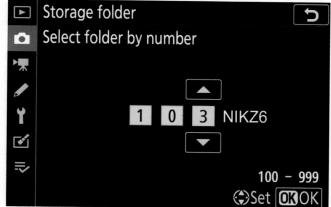

Press OK to create the new folder and make it the active folder. You'd want to use this option to create a new folder *or* when you don't know whether a folder by a particular number already exists. If a folder with that number already resides on the memory card, you can use it (if it is not full); if it doesn't exist, you can create it.

- Select Folder from List. From among the available folders shown, scroll to the one that you want to become active for image storage and playback. This feature is handy when you want to display a slide show located in a particular folder. Use this option if you know that the folder you want to use already resides on the memory card. Press OK to confirm your choice and make the folder active.
- 3. Exit menus. Press the MENU button or tap the shutter release to exit.

Entering Text on the Nikon Z6

Your Z6 offers several opportunities to enter text, so you can change folder names, insert your name as "Artist" or provide copyright information. The Nikon Z6 uses a fairly standardized text-entry screen to name files, rename Picture Controls, create new folder names, and enter image comments and other text. You'll be using text entry with other functions that I'll describe later in this book. The screen looks like the one shown earlier in Figure 11.5, right, with some variations (for example, some functions have a less diverse character set, or offer more or fewer spaces for your entries). To enter text, just use the touch screen to "type" your characters or, alternatively, use the multi selector navigational buttons to scroll around within the array of alphanumerics. (I invariably use the touch screen for this, unless I am outdoors, wearing gloves, and really, really need to enter text.)

- **Highlight a character.** Use the touch screen or multi selector keys to scroll around within the array of characters.
- Insert highlighted character. Tap the character or press the multi selector OK button to insert the highlighted character. The cursor will move one place to the right to accept the next character.

- Non-destructively move forward/backspace. Use the main command dial to move the cursor within the line of characters you've entered. This allows you to skip ahead or backspace and replace a character without disturbing the others you've entered. Although it's a bit more difficult for the ham-handed, you can also tap the left/right triangles on the screen located to the immediate left of the text entry area to move the cursor.
- Erase a highlighted character. To remove a character you've already input, move the cursor to highlight that character, and then press the Trash button or tap the trash can icon at the bottom of the screen.
- Confirm your entry. When you're finished entering text, press the Zoom In button to confirm your entry, then press the MENU button to return to the Photo Shooting menu, or twice (or just tap the shutter release) to exit the menu system entirely.

File Naming

Options: Choose three-letter prefix. Default: DSC

My preference: NZ6

The Nikon Z6, like other cameras in the Nikon product line, automatically applies a name like _ DSC0001.jpg or DSC_0001.nef to your image files as they are created. You can use this menu option to change the names applied to your photos, but only within certain strict limitations. In practice, you can change only three of the eight characters, the *DSC* portion of the file name. The other five are mandated either by the Design Rule for Camera File System (DCF) specification that all digital camera makers adhere to or to industry conventions.

DCF limits file names created by conforming digital cameras to a maximum of eight characters, plus a three-character extension (such as .jpg, .nef, or .wav in the case of audio files) that represents the format of the file. The eight-plus-three (usually called 8.3) length limitation dates back to an evil and frustrating computer operating system that we older photographers would like to forget (its initials are D.O.S.), but which, unhappily, lives on as the wraith of a file-naming convention.

Of the eight available characters, four are used to represent, in a general sense, the type of camera used to create the image. By convention, one of those characters is an underline, placed in the first position (as in _DSCxxxx.xxx) when the image uses the Adobe RGB color space (more on color spaces later), and in the fourth position (as in DSC_xxxx.xxx) for sRGB and RAW (NEF) files. That leaves just three characters for the manufacturer (and you) to use. Nikon, Sony, and some other vendors use DSC (which may or may not stand for Digital Still Camera, depending on who you ask), while Canon prefers IMG. The remaining four characters are used for numbers from 0000 to 9999, which is why your Z6 "rolls over" to DSC_0000 again when the 9999-number limitation is reached.

When you select File Naming in the Photo Shooting menu, you'll be shown the current settings for both sRGB (and RAW) and Adobe RGB. Press the right multi selector button, and you'll be taken

to the (mostly) standard Nikon text entry screen described above and allowed to change the DSC value to something else. In this version of the text entry screen, however, only the numbers from 0 to 9 and characters A–Z are available; the file name cannot contain other characters. As always, press the Zoom In button to confirm your new setting.

Because the default DSC characters don't tell you much, don't hesitate to change them to something else. I use NZ6 for my Z6 and 850 for my Nikon D850. If you don't need to differentiate between different camera models, you can change the three characters to anything else that suits your purposes, including your initials (DDB_ or JFK_, for example), or even customize for particular shooting sessions (EUR_, GER_, FRA_, and JAP_ when taking vacation trips). You can also use the file name flexibility to partially overcome the 9999-numbering limitation. You could, for example, use the template Z61_ to represent the first 10,000 pictures you take with your Z6, and then Z62_ for the next 10,000, and Z63_ for the 10,000 after that.

That's assuming you don't rename your image files in your computer. In a way, file naming verges on a moot consideration, because they apply *only* to the images as they exist in your camera. After (or during) transfer to your computer, you can change the names to anything you want, completely disregarding the 8.3 limitations (although it's a good idea to retain the default extensions). If you shot an image file named DSC_4832.jpg in your camera, you could change it to Paris_EiffelTower_32.jpg later. Indeed, virtually all photo transfer programs allow you to specify a template and rename your photos as they are moved or copied to your computer from your camera or memory card.

I usually don't go to that bother (I generally don't use transfer software; I just drag and drop images from my memory card to folders I have set up), but renaming can be useful for those willing to take the time to do it.

Choose Image Area

Options: FX (36×24) (default); DX (24×16) ; 1:1 (24×24) ; 16:9 (36×20)

My preference: FX (36×24)

Here you can specify how the Z6 uses the available image area:

- Choose Image Area. You can manually specify the image area to be used, which the Z6 will apply regardless of what type of lens is mounted on the camera. Use this option to force the image area issue (as when you're using a DX-format lens that the Z6 can't detect automatically), or to use a particular image area for all your shots in a session. Your choices include:
 - FX format (36 × 24). This is the full FX image format area, roughly 36mm × 24mm, producing a 24 MP image when Large is selected using the Image Size entry described shortly.
 - DX format (24 \times 16). This fills the image frame with the image in the center 24mm \times 16mm of the sensor, creating a 1.5X *crop factor*. (See Chapter 7 for more about the crop factor and lenses.) Your final image will be about 19.5 MP.

- 1:1 (24 × 24). An image cropped to a square may be useful to emphasize a centered image, such as a close-up of a flower, when you want to direct the eye to the middle of the frame, rather than have it roam around within your image. The resulting 30 MP photo still has outstanding resolution even though you're discarding pixels at left and right of the frame.
- 16:9 (36 × 20). This is a useful cropping that allows you to take still photos using the same 16:9 proportions as a high-definition movie frame. I like this crop when I'm producing storyboards for video productions, as my still image compositions will match the aspect ratio of the movies.

Image Quality

Options: NEF (RAW)+JPEG (Fine*, Fine, Normal*, Normal, Basic*, Basic), NEF (RAW), JPEG (Fine*, Fine, Normal*, Normal [default], Basic*, Basic), TIFF (RGB)

My preference: NEF (RAW)+JPEG Fine* for everyday shooting; JPEG Fine* for sports

As I noted in Chapter 3, you can choose the image quality settings used by the Z6 to store its files. You can use this menu entry, or, opt for the quickest way by pressing the *i* button, selecting the Image Quality entry (by default the second from the left in the top row), and either rotating the command dial or pressing the OK button to select quality from a screen of choices.

You can choose NEF (RAW) (only), NEF+ six different JPEG quality levels (Fine*, Fine, Normal*, Normal, Basic*, and Basic), or any of those six JPEG quality levels alone (with no NEF captured). TIFF (RGB) is also available. When you elect to store only JPEG versions of the images you shoot, you can save memory card space as you bypass the larger RAW files. Or, you can save your photos as RAW files, which consume more than twice as much space on your memory card. Or, you can store both at once as you shoot.

Many photographers choose to save *both* JPEG and a RAW, so they'll have a JPEG version that might be usable as is, as well as the original "digital negative" RAW file in case they want to do some processing of the image later. You'll end up with two different versions of the same file: one with a .jpg extension, and one with the .nef extension that signifies a Nikon RAW file.

To choose the combination you want using the menu system, access the Photo Shooting menu, scroll to Image Quality, and select it. Screens similar to the ones shown in Figure 11.7 (left and right) will appear. Scroll to highlight the setting you want, and either press OK or push the multi selector right button to confirm your selection.

In practice, you'll probably use the JPEG Fine* and RAW+JPEG Fine* (with the "extra quality" star) selections most often. Why so many choices, then? There are some limited advantages to using some of the higher compression and lower resolution options. Settings that are less than max allow stretching the capacity of your memory card so you can shoehorn quite a few more pictures onto a

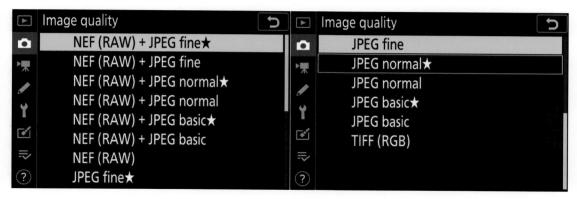

Figure 11.7 You can choose RAW, JPEG, or RAW+JPEG formats here.

single memory card. That can come in useful when on vacation and you're running out of storage, or when you're shooting non-critical work that doesn't require 24 megapixels of resolution (such as photos taken for real estate listings, web page display, photo ID cards, or similar applications). Some photographers like to record RAW+JPEG Basic so they'll have a moderate-quality JPEG file for review only and no intention of using for editing purposes, while retaining access to the original full-resolution/uncompressed RAW file for serious editing.

For most work, using lower resolution and extra compression is false economy. You never know when you might need that extra bit of picture detail. Your best bet is to have enough memory cards to handle all the shooting you want to do until you have the chance to transfer your photos to your computer or a personal storage device.

TIFF (RGB)

The TIFF format is a lossless uncompressed 8-bit format (at least, in its Nikon incarnation) that is preferred for some applications, such as stock photography. TIFFs are several times larger than RAW files, more than 60MB each when shot using the Large image size. And it takes a long time to store a TIFF file on a memory card (a second or two, at least), so most photographers don't create TIFFs in the camera. It's often a better idea to produce a TIFF file from a RAW file, because RAW/NEF files can contain up to 14 bits of information with potentially a wider range of colors captured. Nikon's TIFF format files are reduced from the 12-bit or 14-bit image captured by the sensor to just 8 bits of information per color channel. One key advantage of capturing TIFF in the camera is that the file is noncompressed, with minimal camera processing, giving you the best ready-to-use image quality outside of a RAW file.

Optimal Quality or Optimal Size?

Nikon has merged the JPEG-oriented "Optimal Quality" and "Optimum Size" options offered with previous cameras into the Image Quality entry. The difference:

- Optimal Quality (marked with a star). Choose this option if you want to maintain the best image quality possible at a particular JPEG setting and don't care if the file size varies. Because the Z6 will use only the minimum amount of compression required at each JPEG setting, file size will vary depending on scene content, and your buffer may hold fewer images during continuous shooting. If you're not shooting continuously, this setting will provide optimum image quality. Figure 11.8 shows a cropped portion of an image recorded with Optimal Quality (top) and one in which Size Priority was used to provide extra compression (bottom).
- Size Priority (no star). When this option is selected, the Z6 will create files that are fairly uniformly sized JPEG images. Because some photos have content that is more easily compressible (for example, plain areas of sky can be squeezed down more than areas filled with detail), to maintain the standard file size the camera must apply more compression to some images, and less to others. As a result, there may be a barely noticeable loss of detail in the more heavily compressed images. The uniform file size also means that the Z6's buffer will hold the maximum number of shots during continuous shooting, allowing you to shoot longer sequences without the need to pause and wait for some images to be written to the memory card. In practice, you may find you can shoot continuously until the memory card fills.

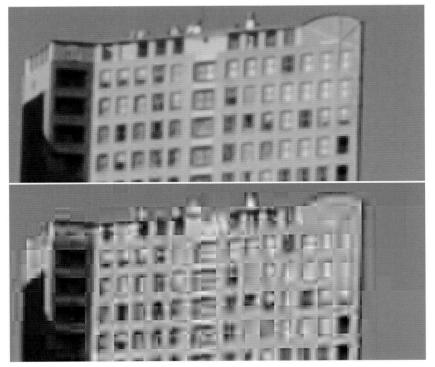

Figure 11.8
At low levels of JPEG compression, the image looks sharp even when you enlarge it enough to see the actual pixels (top); when using extreme JPEG compression (bottom), an image obviously loses quality.

JPEG vs. RAW

You'll sometimes be told that RAW files are the "unprocessed" image information your camera produces, before it's been modified. That's nonsense. RAW files are no more unprocessed than your camera film is after it's been through the chemicals to produce a negative or transparency. A lot can happen in the developer that can affect the quality of a film image—positively and negatively—and, similarly, your digital image undergoes a significant amount of processing before it is saved as a RAW file. Nikon even applies a name (EXPEED 6) to the digital image processing (DIP) chip used to perform this magic.

A RAW file is more similar to a film camera's processed negative. It contains all the information, captured in 12-bit or 14-bit channels per color (and stored in a 16-bit space), with no sharpening and no application of any special filters or other settings you might have specified when you took the picture. Those settings are *stored* with the RAW file so they can be applied when the image is converted to a form compatible with your favorite image editor. However, using RAW conversion software such as Adobe Camera Raw or Nikon Capture NX-D, you can override those settings and apply settings of your own. You can select essentially the same changes there that you might have specified in your camera's picture-taking options.

RAW exists because sometimes we want to have access to all the information captured by the camera, before the camera's internal logic has processed it and converted the image to a standard file format. Even Compressed RAW doesn't save as much space as JPEG. What it does do is preserve all the information captured by your camera after it's been converted from analog to digital form.

So, why don't we always use RAW? Some photographers avoid using Nikon's RAW NEF files on the misguided conviction that they don't want to spend time in post-processing, forgetting that, if the camera settings you would have used for JPEG are correct, each RAW image's default attributes will use those settings and the RAW image will not need much manipulation. Post-processing in such cases is *optional*, and overwhelmingly helpful when an image needs to be fine-tuned.

Although some photographers do save *only* in RAW format, it's more common (and frequently more convenient) to use RAW plus one of the JPEG options, or, if you're confident about your settings, just shoot JPEG and eschew RAW altogether. In some situations, working with a RAW file can slow you down a little. RAW images take longer to store on the memory card, and must be converted from RAW to a format your image editor can handle, whether you elect to go with the default settings in force when the picture was taken, or make minor adjustments to the settings you specified in the camera.

As a result, those who depend on speedy access to images or who shoot large numbers of photos at once may prefer JPEG over RAW. Wedding photographers, for example, might expose several thousand photos during a bridal affair and offer hundreds to clients as electronic proofs for inclusion in an album. Wedding shooters take the time to make sure that their in-camera settings are correct, minimizing the need to post-process photos after the event. Given that their JPEGs are so good, there is little need to get bogged down shooting RAW.

Sports photographers also avoid RAW files. I recently photographed an air show that was an all-day affair, and, to make sure I didn't miss any peak moments as the aircraft flyovers, military sky-divers, and other action unfolded, I set my camera at the maximum rate and fired away. I managed to shoot 7,200 photos in a single day. I certainly didn't have any plans to do post-processing on very many of those shots, so carefully exposed and precisely focused JPEG images were my file format of choice that day.

JPEG was invented as a more compact file format that can store most of the information in a digital image, but in a much smaller size. JPEG predates most digital SLRs and was initially used to squeeze down files for transmission over slow dial-up connections. Even if you were using an early dSLR with 1.3 MP files for news photography, you didn't want to send them back to the office over the telephone line communications that were common before high-speed Internet links became dominant.

HIDDEN JPEGS

You may not be aware that your RAW file contains an embedded JPEG file, hidden inside in the JPEG Basic format. It's used to provide thumbnail previews of JPEG files, which is why you may notice an interesting phenomenon when loading a RAW image into a program like Nikon Capture NX or Adobe Lightroom. When the software first starts interpreting the RAW image, it may immediately display this hidden JPEG view which has, as you might expect, all the settings applied that you dialed into the camera. Then, as it finishes loading the RAW file, the application (Lightroom in particular) uses its own intelligence to fine-tune the image and display what it thinks is a decent version of the image, replacing the embedded JPEG. That's why you may see complaints that Lightroom or another program is behaving oddly: the initial embedded JPEG may look better than the final version, so it looks as if the application is degrading the image quality as the file loads. Of course, in all cases, once the RAW file is available, you can make your own changes to optimize it to your taste.

There is a second use for these hidden JPEG files. If you shoot RAW without creating JPEG files and later decide you want a JPEG version, there are dozens of utility programs that will extract the embedded JPEG and save it as a separate file. (Google "JPEG extractor" to locate a freeware program that will perform this step for your Mac, PC, or other computer.)

But, as I noted, JPEG provides smaller files by compressing the information in a way that loses some image data. JPEG remains a viable alternative because it offers several different quality levels. At the highest quality Fine level, you might not be able to tell the difference between the original RAW file and the JPEG version.

In my case, I shoot virtually everything at RAW+JPEG Fine*. Most of the time, I'm not concerned about filling up my memory cards as I usually have my 128GB Sony G XQD memory cards, and several more Sony G and Lexar 64GB XQD cards with me. I also use a MacBook Air with an external 1TB hard drive. When shooting sports, I'll shift to JPEG Fine (with no RAW file) to squeeze a little extra speed out of my camera's continuous shooting mode, and to reduce the need to wade through eight-photo bursts taken in RAW format.

Image Size

Options: JPEG/TIFF: Large (default), Medium, Small; NEF (RAW): RAW L, RAW M, RAW S My preference: Large

The next menu command in the Photo Shooting menu lets you select the resolution, or number of pixels captured as you shoot with your Nikon Z6. You can specify those sizes separately for both JPEG/TIFF files and 12-bit lossless compressed NEF (RAW) files. (Other RAW formats are available only in Large size.) Your choices and the resolutions are shown in Table 11.2.

Select image sizes using this menu entry or by pressing the *i* button and accessing the Image Size option (located by default in the second row underneath the Image Quality setting). Rotate either command dial or press OK to select size from a screen.

Image Area	Size	Resolution
FX (36mm × 24mm)	Large Medium Small	6048 × 4024 4528 × 3016 3024 × 2016
DX (24mm × 16mm)	Large Medium Small	3936 × 2624 2944 × 1968 1968 × 1312
1:1 (24mm × 24mm)	Large Medium Small	4016 × 4016 3008 × 3008 2000 × 2000
16:9 (36mm × 20mm)	Large Medium Small	6048 × 3400 4528 × 2544 3024 × 1696

NEF (RAW) Recording

Options: NEF (RAW) Compression: Lossless compressed (default), Compressed, Uncompressed; NEF (RAW) Bit Depth: 12 bit, 14 bit (default)

My preference: Lossless compressed, 14 bit

When you've selected any NEF (RAW) setting for Image Quality, you can choose the type (amount) of compression applied to NEF (RAW) files as they are stored on your memory card, and whether the images are stored using 12-bit or 14-bit depth. The default values for type (Lossless compressed) and color depth (14 bit) work best for most situations, but there are times when you might want to use one of the other choices, as I'll explain later in this section. (Figure 11.7, earlier, shows the options available in the long, scrolling list.)

Compression is a mathematical technique for reducing the size of a collection of information (such as an image; but other types of data or even programs can be compressed, too) in order to reduce the storage requirements and/or time required to transmit or transfer the information. Some compression algorithms arrange strings of bits that are most frequently used into a table, so that a binary number like, say, 1001011011100111 (16 digits long) doesn't have to be stored as two 8-bit bytes every time it appears in the image file. Instead, a smaller number that points to that position in the table can be used. The more times the pointer is used rather than the full number, the more space is saved in the file. Such a compression scheme can be used to reproduce exactly the original string of numbers, and so is called *lossless* compression.

Other types of compression are more aggressive and actually discard some of the information deemed to be redundant from a visual standpoint, so that, theoretically, you won't *notice* that details are missing, and the file can be made even more compact. The Nikon Z6's RAW storage routines can use this kind of size reduction, which is called *lossy* compression, to reduce file size by up to about half with very little effect on image quality. JPEG compression can be even more enthusiastic, resulting in images that are 15X smaller (or more) and which display noticeable loss of image quality. You can choose NEF (RAW) compression and NEF (RAW) bit depth (see Figure 11.9, left).

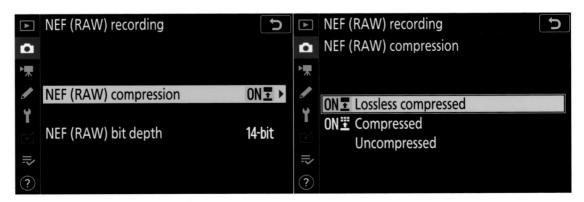

Figure 11.9 Your Image Quality choices occupy two scrolling screens.

Under Type in the NEF (RAW) Recording menu, you can select from (see Figure 11.9, right):

- Lossless compressed. This is the default setting, and uses what you might think of as reversible algorithms that discard no image information, so that the image can be compressed from 20 to 40 percent for a significantly smaller file size. The squeezed file can always be restored to its original size precisely, with no effect on image quality.
- Compressed. Use this setting if you want to store more images on your memory card and are willing to accept a tiny potential loss in image quality in the highlights, after significant editing. (I've never been able to detect any effect at all.) The Z6 can achieve from 40 to 55 percent compression with this option. It uses a two-step process, first grouping some very similar tonal values in the mid-tone and lighter areas of the image together, and then storing each group as a single value, followed by a lossless compression scheme that is applied to the dark tones, further reducing the file size. The process does a good job of preserving tones in shadow areas of an image, with only small losses in the midtone and lighter areas. The differences may show up only if you perform certain types of extensive post-processing on an image, such as heavy image sharpening or some types of tonal corrections.
- Uncompressed. NEF images are stored without any compression applied. These files are larger and take longer to write to your memory card. In practice, there is little benefit from using this option.

The Bit Depth setting is another option that looks good on paper but, in the real world, is less useful than you might think. For most applications, the default value that produces 14-bit image files is probably your best choice, especially if you're exposing images that will be combined using HDR (high dynamic range) software later. In that case, you can definitely gain some extra exposure "headroom" using 14-bit processing. The 12-bit setting saves some space and speeds up processing, but costs you a detectable amount of highlight detail.

As you may know, bit depth is a way of measuring the amount of color data that an image file can contain. What we call "24-bit color" actually consists of three channels of information—red, green, and blue—with one 8-bit bit assigned to each channel, so a 24-bit image contains three 8-bit channels (each with 256 different shades of red, green, or blue). A 24-bit color image can contain up to 16.8 million different colors $(256 \times 256 \times 256)$; you do the math). Because each of the red, green, and blue channels always is stored using the same number of bits, it's become the custom to refer only to the channel bit depth to describe the amount of color information that can be collected.

So, when we're talking about 12-bit color, what we really mean are three 12-bit RGB channels, each capable of recording colors from 000000000000 to 111111111111 hues in a particular channel (in binary), or 4,096 colors per channel (decimal), and a total of 68,719,476,736 (68.7 billion) different hues. By comparison, 14-bit color offers 16,384 colors per channel and a total of 4,398,046,391,104 (4.4 trillion) colors.

The advantage of having such a humongous number of colors for an image that will, in the end, be boiled down to 16.8 million hues in Photoshop or another image editor is that, to simplify things a little, there is a better chance that the mere millions of colors you end up with have a better chance of being the *right* colors to accurately represent the image. For example, if there are subtle differences in the colors of a certain range of tones that represent only, say, 10 percent of a channel's colors, there would be only 26 colors to choose from in an 8-bit channel, but 410 colors in a 12-bit channel, and a whopping 1,638 colors in a 14-bit channel. The larger number of colors improves the odds of ending up with accurate hues.

It's not quite that simple, of course, because bit depth also improves the chances of having the right number of colors to choose from after the inevitable loss of some information due to noise and other factors. But in the real world, the difference between 26 colors and 410 colors is significant (which is why digital cameras always capture at least 12 bits per channel), and the difference between 12 bits and 14 bits (410 and 1,638 colors, respectively, in our example) is less significant. Because there is a penalty in terms of file size and the amount of time needed to process the image as it is recorded to your memory card, 14 bits per channel is not always your best option. Your two choices look like this:

- 12 bit. Images are recorded at 12 bits per channel in the RAW file, and end up with 12 bits of information per channel that is translated during conversion for your image editor either into 12 bits within a 16-bits-per-channel space or interpreted down to 8 bits per channel.
- 14 bit. This is the default bit depth for the Nikon Z6. At this setting, the Z6 grabs 16,384 colors per channel instead of 4,096, ending up as 14 bits in a 16-channel space or reduced to 256 colors by the RAW conversion software that translates the image for your image editor. You'll find that such 14-bit files end up almost one-third larger than 12-bit files. 14-bit images are great for HDR photography.

ISO Sensitivity Settings

Options: ISO sensitivity: 100–51200, plus Lo 1 to Lo 0.3 and Hi 0.3 to Hi 2; Auto ISO Sensitivity Control: Maximum Sensitivity, Maximum Sensitivity with Flash, and Minimum Shutter Speed **My preference:** Varies by subject type

You can make direct ISO settings without resorting to this menu entry. Just press the ISO button, located just south of the shutter release, and then rotate the front control dial to switch between Auto ISO and fixed ISO settings, and the rear dial to select specific ISO values.

This menu entry has two parts, which give you more flexibility through its ISO Sensitivity and Auto ISO Sensitivity Control adjustments. The former is simply a screen that allows you to specify the ISO setting, just as you would by spinning the main command dial while holding down the ISO button on the top-right panel of the Z6. The available settings range from Lo 1 (ISO 50

equivalent) through ISO 100–51200 to Hi 1–Hi 2 (ISO 204,800 equivalent). The available settings are determined by the size of the increment you've specified in Custom Setting b1: 1/3-, 1/2-, or 1-step values. Use the ISO Sensitivity menu when you find it more convenient to set ISO using the color LCD monitor.

The Auto ISO Sensitivity Control menu entry lets you specify how and when the Z6 will adjust the ISO value for you automatically under certain conditions. This capability can be potentially useful, although experienced photographers tend to shy away from any feature that allows the camera to change basic settings like ISO that have been carefully selected. But you needn't fear Auto ISO. You can set some firm boundaries so the Z6 will use this adjustment in a fairly intelligent way.

When Auto ISO is activated, the camera can bump up the ISO sensitivity, if necessary, whenever an optimal exposure cannot be achieved at the current ISO setting. Of course, it can be disconcerting to think you're shooting at ISO 400 and then see a grainier ISO 6400 shot during LCD review. While the Z6 provides a flashing ISO-Auto alert in the viewfinder and control panel, the warning is easy to miss. Here are the important considerations to keep in mind when using the options available for this feature:

- Off. Set Auto ISO Sensitivity Control to Off, and the ISO setting will not budge from whatever value you have specified. Use this setting when you don't want any ISO surprises, or when ISO increases are not needed to counter slow shutter speeds. For example, if the Z6 is mounted on a tripod, you can safely use slower shutter speeds at a relatively low ISO setting, so there is no need for a speed bump. On the other hand, if you're hand-holding the camera and the Z6, set for Program (P) or Aperture-priority (A) mode, wants to use a shutter speed slower than, say, 1/30th second, it's probably a good idea to increase the ISO to avoid the effects of camera shake. If you're using a longer lens, a shutter speed of 1/125th second or higher might be the point where an ISO bump would be a good idea. In that case, you can turn the automatic ISO sensitivity control on, or remember to boost the ISO setting yourself.
- Maximum sensitivity/Maximum sensitivity with flash. Use these parameters to indicate the highest ISO setting you're comfortable having the Z6 set on its own. You can choose the max ISO setting the camera will use from ISO 200 up to ISO 51200, plus the two "expanded" settings all the way up to Hi 2. Use a low number if you'd rather not take any photos at a high ISO without manually setting that value yourself. Dial in a higher ISO number if getting the photo at any sensitivity setting is more important than worrying about noise. When using the Maximum Sensitivity with Flash setting, you can specify Same As Without Flash, so the camera will perform similarly both with and without an optional flash.

I've gotten surprisingly good results at ISO 25600; you should try it out yourself before ruling out this seemingly extreme ISO setting. Note that if you've selected an ISO setting that is *higher* than the Maximum Sensitivity you specify here, the Z6 will use the higher ISO value instead.

■ Minimum shutter speed. This setting allows you to tell the Z6 how slow the shutter speed must be before the ISO boost kicks in, within the range of 30 seconds to 1/4,000th second. The default value is Auto. When Auto is highlighted, press the right multi selector button, and a screen appears allowing you to fine-tune Auto to respond Slower or Faster.

If you set a value manually, 1/30th second is a good choice, because for most shooters in most situations, any shutter speed longer than 1/30th is to be avoided, unless you're using a tripod, monopod, or looking for a special effect. If you have steady hands, or the camera is partially braced against movement (say, you're using that monopod), a slower shutter speed, down to 1 full second, can be specified. Similarly, if you're working with a telephoto lens and find even a relatively brief shutter speed "dangerous," you can set a minimum shutter speed threshold of 1/250th second. When the shutter speed is faster than the minimum you enter, Auto ISO will not take effect.

Your Z6 is one smart camera in Auto ISO mode. For example, if you accidentally set a minimum shutter speed that is faster or slower than you've specified in Custom Setting e1 (Flash Sync Speed) or Custom Setting e2 (Flash Shutter Speed), the camera will instead use a minimum shutter speed that is within the range set by e1 and e2. (You'll find more on these Custom Settings in Chapter 12.)

You'll recall that Program and Aperture-priority modes can adjust the camera's shutter speed. When Auto ISO is active, the camera will adjust the ISO setting *only* if the minimum shutter speed specified here would produce underexposure. In all other cases, the Z6 will simply adjust the shutter speed to produce an appropriate exposure and not touch the ISO setting.

In addition, the camera is clever enough to try to use faster shutter speeds with telephoto lenses (which are more subject to camera-motion blur). This feature works only with autofocus lenses; older manual focus lenses not equipped with a CPU chip (described in Chapter 7) are not compatible with this extra function.

White Balance

Options: Auto: $AUTO_0$ Keep White (default); $AUTO_1$ Keep Overall Atmosphere; $AUTO_2$ Keep Warm Lighting Colors; Presets: Natural Light Auto, Direct Sunlight, Cloudy, Shade, Incandescent, Fluorescent (seven types), Flash, Choose Color Temperature, Preset Manual

My preference: AUTO₀ (Keep White)

This setting is the first on the next page of the Photo Shooting menu. (See Figure 11.10.) It lets you tweak the white balance setting the Z6 applies to JPEG images, and which it embeds in the RAW image for interpretation by your image editor when the NEF file is imported. Your camera has a bewildering array of white balance settings, including three Auto modes, and, in practice, all of them are, at best, a little bit wrong. However, many are close enough that you may not notice the difference; all the presets can be adjusted by you using white balance fine-tuning (as described in Chapter 8); and, when importing RAW files, you have even greater flexibility.

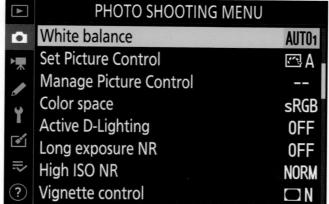

In addition to three varieties of full Auto white balance, this menu entry allows you to choose Natural Light Auto, Direct Sunlight, Cloudy, Shade, Incandescent, seven types of Fluorescent illumination, Flash, a specific color temperature of your choice, a preset value taken from an existing photograph, or a measurement you make. Some of the settings you make here can be duplicated using the Fn1 button on the front of the camera and main and sub-command dials, but the menus offer even more choices. Your white balance settings can have a significant impact on the color rendition of your images, as you can see in Figure 11.11.

Figure 11.11 Adjusting color temperature can provide different results of the same subject at settings of 3,400K (left), 5,000K (middle), and 2,800K (right).

The fastest way to change white balance settings is to use direct setting controls. Hold down the Fn1 button, then rotate the main command dial to choose one of the main settings. Your choices appear on the LCD monitor as you dial. When Auto, Fluorescent, K (Choose Color Temperature), or PRE (Preset Manual) are shown, you can also select a sub-option by holding down the Fn1 button and rotating the sub-command dial. You can also press the *i* button, select the White Balance icon (by default the first entry on the left of the second row), and rotate the main command dial and sub-command dial, as described above. I'll explain your options next.

This menu entry offers additional options, including fine-tuning presets and ability to capture and store custom preset color temperatures. Select the White Balance entry on the Photo Shooting menu, and you'll see an array of choices like those shown in Figure 11.12. (Three additional choices: Flash, K (Choose Color Temp.), and PRE Preset Manual are not visible until you scroll down to them.) If you choose Fluorescent, you'll be taken to another screen that presents seven different types of lamps, from sodium-vapor through warm-white fluorescent down to high-temperature mercury-vapor. If you know the exact type of non-incandescent lighting being used, you can select it, or settle on a likely compromise.

The Choose Color Temp. selection allows you to select from an array of color temperatures in degrees Kelvin (more on this in Chapter 8) from 2,500K to 10,000K, and then further fine-tune the color bias using the fine-tuning feature described below. Select Preset Manual to record or recall custom white balance settings suitable for environments with unusual lighting or mixed lighting, as described later in this section.

For all other settings, highlight the white balance option you want, then press the multi selector right button to view the fine-tuning screen shown in Figure 11.13 (and which uses the Auto setting as an example). The screen shows a grid with two axes, an amber-blue axis extending left/right, and

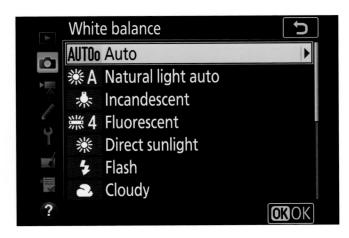

Figure 11.12
The White Balance menu has predefined values, plus the option of setting color temperature and presets you measure yourself.

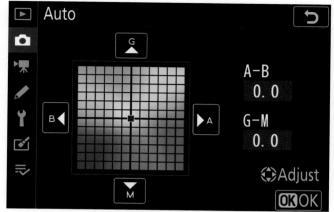

a green-magenta axis extending up and down the grid. By default, the grid's cursor is positioned in the middle, and a readout to the right of the grid shows the cursor's coordinates on the A-B axis (yes, I know the display has the end points reversed) and G-M axis at 0,0.

You can use the multi selector's up/down and right/left buttons to move the cursor to any coordinate in the grid, thereby biasing the white balance in the direction(s) you choose. The amber-blue axis makes the image warmer or colder (but not actually yellow or blue). Similarly, the green-magenta axis preserves all the colors in the original image, but gives them a tinge biased toward green or magenta. Each increment equals about five mired units, but you should know that mired values aren't linear; five mireds at 2,500K produces a much stronger effect than five mireds at 6,000K. If you really want to fine-tune your color balance, you're better off experimenting and evaluating the results of a particular change.

When you've fine-tuned white balance, either using the Photo Shooting menu options or the defined WB button (Fn1 is the default), left/right triangles appear in the white balance section of the control panel at lower right to remind you that this tweaking has taken place.

Using Preset Manual White Balance

If automatic white balance or one of the predefined settings available aren't suitable, you can set a custom white balance using the Preset Manual menu option. You can apply the white balance from a scene, either by shooting a new picture on the spot and using the resulting white balance (Direct Measurement) or using an image you have already shot (Copy from Existing Photograph). To use an existing preset or perform direct measurement from your current scene using a reference object (preferably a neutral gray or white object), follow these steps:

1. **Use gray or white reference.** Place the neutral reference, such as a white piece of paper or a gray card, under the lighting you want to measure. You can also use one of those white balance caps that fit on the front of your lens like a lens cap.

- 2. **Choose Preset Manual.** Press the *i* button, choose White Balance, and rotate the main command dial until Preset Manual (PRE) is selected.
- 3. **To use an existing preset value:** Rotate the main command dial until the white balance you have previously stored is highlighted ("slots" d-1 to d-6). (See Figure 11.14.)
- 4. **To define a new preset:** Rotate the main command dial until the slot (d-1 to d-6) you want to use as your white balance register is highlighted. (See Figure 11.15, left.) Press and hold OK until the PRE icons in the shooting display and control panel start to flash. A white balance target frame will appear. (See Figure 11.15, right.)

Figure 11.14
When you capture a scene's white balance, it will be stored in the selected slot.

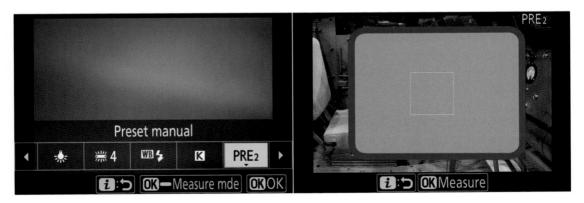

Figure 11.15 To define a new preset, highlight the slot (d-1 to d-6), left. Then capture a neutral white or gray target (right).

- 5. **Measure White Balance.** Tap the touch screen at the point where your gray or white reference appears, or use the multi selector to move the target frame over that area. (Note that you can't relocate the frame if a flash is attached.) Then press OK again *or* press the shutter release down all the way.
- 6. **Success?** If the Z6 was able to capture the white balance information, a message Data Acquired appears. If it was unable to measure white balance, you'll be asked to try again. (Try using a different target if you fail on successive attempts.)

The preset value you've captured will remain in the slot until you replace that white balance with a new captured value. It can be summoned at any time (use the *i* button menu or Fn1) and when PRE is chosen with the main command dial, select your preset by rotating the sub-command dial until the desired white balance slot is displayed on the control panel. You can also choose an existing image or protect a captured white balance from being over-written:

- 1. Choose Preset Manual from the White Balance menu.
- 2. A screen of thumbnails appears, showing the six "slots" numbered d-1 to d-6. Use the multi selector buttons to highlight one of the thumbnail slots, and press the multi selector center button.
- 3. The next screen that appears (see Figure 11.16) has four options: Fine-tune, Edit Comment, Select Image, and Protect.
 - Choose Fine-tune to fine-tune the amber/blue/magenta/green white balance of an image already stored in one of the four user slots.
 - Choose Edit Comment to add or change the comment applied to d-1 to d-6. The comment can be used as a label to better identify the white balance information in the slot, with terms

Figure 11.16
The Preset Manual screen lets you fine-tune preset white balance settings, label them with a comment, select an image to use as a white balance reference, and protect captured settings.

like Gymnasium Daytime or Rumpus Room. (The standard Z6 text editing screen shown earlier in this chapter appears.)

- Choose Select Image to view the Z6's standard image selection screen and highlight and choose the existing image you want to use. Press the Zoom In button to confirm your choice and copy the white balance of the selected image to the slot you selected in Step 2.
- Choose Protect to lock the white balance setting currently stored in the selected slot. Use this to preserve a captured white balance setting.
- 4. Press OK to confirm your white balance setting.

A WHITE BALANCE LIBRARY

Consider dedicating a memory card to stow a selection of images taken under a variety of lighting conditions. If you want to "recycle" one of the color temperatures you've stored, insert the card and load one of those images into your choice of preset slots d-1 to d-6, as described above. XQD cards are a bit pricey to make a dedicated memory card, but I have some old 16GB cards and a compatible card reader that I use for this. (Some newer card readers can't handle the original XQD media.)

Set Picture Control

Options: Auto (Default), Standard, Neutral, Vivid, Monochrome, Portrait, Landscape, Flat; Creative Picture Controls (01–20): Dream, Morning, Pop, Sunday, Somber, Dramatic, Silence, Bleached, Melancholic, Pure, Denim, Toy, Sepia, Blue, Red, Pink, Charcoal, Graphite, Binary, and Carbon

My preference: Standard: I can select other styles during RAW processing. Flat when extended dynamic range without HDR processing is needed.

Nikon has considerably expanded its Picture Control roster, adding 20 Creative Picture Controls that add special effects to your images as you shoot. The Picture Control styles allow you to choose your own sharpness (in three different ways, as I'll explain shortly), plus adjust contrast, color saturation, and hue settings applied to your images when using P, S, A, and M modes. The three types of Picture Controls available:

■ Original Picture Controls. Your Z6 has seven predefined styles, which it calls Original Picture Controls: Standard, Neutral, Vivid, Monochrome, Portrait, Landscape, and Flat. There is also an Auto setting, which examines your image and applies one of these seven controls as appropriate. Flat is a relatively new option, with an extended, low-contrast dynamic range that lends itself to fine-tuning in an image editor. Movie shooters who plan to process their clips also love the versatility of the Flat setting, which allows preserving detail in highlights and shadows when correcting (or "grading") video in advanced movie-editing software.

Note that each of the seven predefined styles has its own default settings for Sharpening (with four different sharpening modes), Contrast, Brightness, Saturation, and Hue. (Monochrome does not have Saturation or Hue settings.) For example, the default Sharpening is +4 for Vivid and Landscape; +3 for Standard and Monochrome; +2 for Neutral and Portrait; and +1 for Flat. The other settings available for the preset styles have their own defaults. Any changes you make are *edits* of the default values defined for that particular style.

- Creative Picture Controls. These are 20 new special effects styles, each assigned a number from 1 to 20. Nikon has given a fanciful name to each Creative Picture Control that more or less provides a hint to how the effect modifies your image. The available creative styles include Dream, Morning, Pop, Sunday, Somber, Dramatic, Silence, Bleached, Melancholic, Pure, Denim, Toy, Sepia, Blue, Red, Pink, Charcoal, Graphite, Binary, and Carbon. These 20 additional Creative Picture Controls offer the same parameter adjustments as Original Picture Controls, plus an Effect Level slider for specifying the *amount* of the special effects provided, on a scale from 0 to 100 in increments of 11 steps. You can edit the parameters of these Picture Controls, too. I'll explain Creative Picture Controls shortly.
- User Controls. You can define up to nine Picture Controls of your own, numbered C-1 to C-9. Each User Control is based on one of the 27 predefined styles (any of the 7 Original or 20 Creative Controls). You'll use the Manage Picture Control entry (which follows this one).

While all the canned Original and Creative Picture Controls have their preset parameters, their most valuable trait is your ability to *edit* the settings of any of those 27 styles so they better suit your taste. You can adjust the existing styles, in which case an asterisk appears next to their name in the menus, or save your adjustments as a User Control. But wait, there's more! You can *copy* these styles to a memory card, edit them on your computer, and reload them into your camera at any time. So, effectively, you can have several sets of custom Picture Control styles available: those currently in your camera, as well as a virtually unlimited library of user-defined styles that you have stored on memory cards or create using Capture NX-D or ViewNX-i (a Windows program).

Moreover, Nikon insists that these styles have been standardized to the extent that if you re-use a style created for one camera (say, your Z6) and load it into a different compatible camera (such as a Nikon D850), you'll get substantially the same rendition. In a way, Picture Control styles are a bit like using a particular film. Do you want the look of Kodak Ektachrome or Fujifilm Velvia? (Even if you've never *used* these films, you've probably seen the results they produced.) Load the appropriate style created by you—or Google to find styles created by someone else.

As I've noted, using and fully managing Picture Control styles is accomplished using two different menu entries. This entry, Set Picture Control, has two functions: it allows you to *choose* an existing Original or Creative style and to *edit* any of those predefined styles that Nikon provides. The Photo Shooting menu entry that follows this one, Manage Picture Control, gives you the capability of creating and editing user-defined styles, using one of the canned Original or Creative Picture Controls as a foundation.

Choosing a Picture Control Style

To choose from one of the predefined Original or Creative styles or to select a user-defined style you've created, (numbered C-1 to C-9), follow these steps:

- 1. Choose Set Picture Control from the Photo Shooting menu. The screen shown in Figure 11.17 appears. Remember that Picture Controls that have been modified from their standard settings have an asterisk next to their name.
- 2. Scroll down to the Picture Control you'd like to use. Initially, only the seven shown appear on the screen. As you scroll down, the final Original control, Flat, appears, followed by the Creative Controls, and, at the tail end of several screens, any User Controls you have created.
- 3. Press OK to activate the highlighted style. (Although you can usually select a menu item by pressing the multi selector right button; in this case, that button activates editing instead.)
- 4. Press the MENU button or tap the shutter release to exit the menu system.

Figure 11.17
You can choose from Auto or the six predefined Picture Controls shown here, as well as the Flat predefined control, the Creative Picture Controls, and the User Controls located farther down the scrolling list.

Editing a Picture Control Style

You can change the parameters of any of Nikon's predefined Original Picture Controls (including Auto), Creative Picture Controls, or any of the (up to) nine user-defined styles you create. You are given the choice of using the quick-adjust/fine-tune facility to modify a Picture Control with a few sliders. You can edit these controls using this Set Picture Control entry in the Photo Shooting menu, and can also edit them when you access a style from the *i* menu. To make quick adjustments to any Picture Control except the Monochrome style, follow these steps:

- 1. Choose Set Picture Control from the Photo Shooting menu.
- 2. Scroll down to the Picture Control you'd like to edit.
- 3. Press the multi selector right button to produce an adjustment screen similar to the one shown in Figure 11.18.

Figure 11.18
Sliders can be used to make quick adjustments to your Picture Control styles.

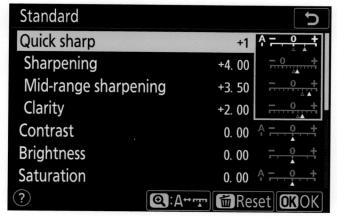

- 4. Use the Quick Sharp slider and the left/right buttons to change the three individual Sharpening adjustments (Sharpening, Mid-Range Sharpening, and Clarity) simultaneously. Alternatively, scroll down to each of those three adjustments and tweak Sharpening, Mid-Range Sharpening, or Clarity independently. (See the next section, "Super Sharpness," for an explanation of the latter parameter.)
- 5. Next, scroll down to the Contrast, Brightness, Saturation, and Hue sliders with the multi selector up/down buttons, then use the left/right buttons to decrease or increase the effects. A gray triangle will appear under the original setting in the slider as you make a change. (Saturation and Hue cannot be adjusted for Monochrome.)

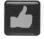

TIP

You can adjust the Auto Picture Control, but each of your modifications are applied *on top of* the Auto adjustments. That is, in Auto Picture Control mode, the Z6 will automatically adjust, say, Contrast, and then apply any contrast adjustments you have specified, in the range Auto-2 to Auto+2.

- 6. Instead of making changes with the slider's scale, when you're working with the Contrast and Saturation adjustments, you can move the cursor to the far left and choose A (for Auto) and the Z6 will adjust these parameters automatically, depending on the type of scene it detects.
- 7. Press the Trash button to reset the values to their defaults.
- 8. Press OK when you're finished making adjustments.

PICTURE CONTROLS WITH THE *i* MENU

You can also perform the exact same functions just described using the *i* menu. Just press the *i* button, navigate to the Set Picture Control icon (located by default as the first icon in the top row) and rotate the main command dial if all you want to do is select a Picture Control from a scrolling list. If you'd like to *edit* the control, press OK. The scrolling list appears as at left in Figure 11.19. When you've highlighted the control you want to edit, press the down button to produce a screen like the one seen in Figure 11.19, right. The column at the far right contains all the parameters listed in Steps 4 and 5 above, while the adjustment slider for the currently highlighted parameter appears at the bottom. Once you've made your edits, press OK to confirm and exit, or the *i* button to exit without making changes.

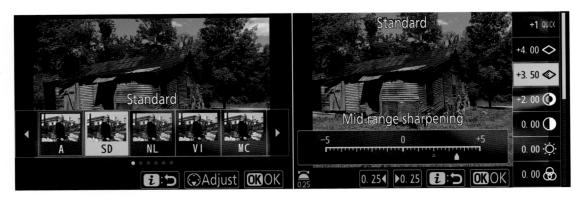

Figure 11.19 Picture Controls can be accessed and edited from the i menu.

Super Sharpness

Amateur photographers like to be told that their pictures will be "clear and sharp," a simplification of picture quality that is likely to satisfy most of them. As an enthusiast, you know that many other factors also are part of image quality, including color, tonal range, and contrast. Indeed, sharpness itself is more complex than you might expect. Other parameters, such as Contrast, Brightness, Saturation, and Hue are virtually self-explanatory, because you've probably worked with them many times in Photoshop or another image editor.

When it comes to the adjustments you can make with the Z6 in terms of sharpness, there are three different parameters, and multiple ways of controlling them. The Z6's Picture Controls have separate sliders for all three, plus a fourth slider, Quick Sharp, which adjusts all of the three simultaneously.

Here's a breakdown:

- **Sharpening.** This control affects the appearance of fine details and patterns, because it modifies the sharpness of the contours (edges) of your subjects. The lower the number, the softer those outlines will be; higher numbers produce more distinct details.
- Mid-range sharpening. Adjusts overall sharpness according to the fineness of patterns and lines in the mid-tones adjusted by the Sharpening and Clarity controls. In Movie mode, this parameter works only when Movie Quality has been set to High in the Movie Shooting menu.
- Clarity. This adjusts the overall sharpness of the image and the sharpness of thicker outlines without affecting brightness or dynamic range. Think of Clarity as a type of sharpening/enhancing effect applied to the mid-tones of an image. While sharpening generally adjusts only the contours of your subject matter, Clarity makes details sharper while maintaining the gradation of highlight and shadow areas. High values produce contrasty and vivid images with darkened colors and improved detail in the midtones. Low values reduce midtone detail and flatten colors. You might want to apply Clarity to make hazy or fog-clouded subjects look more clear without losing details, or when you want to soften hard-edge subjects. Your best bet is to play with the control to see how you like the results. The Z6 applies +1 Clarity by default to Standard, Vivid, Landscape, and Monochrome Picture Controls.

Editing the Monochrome Picture Control

Editing the Monochrome style is similar to customizing the other styles, except that the parameters differ slightly. Sharpening, Contrast, and Brightness are available, but, instead of Saturation and Hue, you can choose a filter effect (Yellow, Orange, Red, Green, or none) and a toning effect (black-and-white, plus seven levels of Sepia, Cyanotype, Red, Yellow, Green, Blue Green, Blue, Purple Blue, and Red Purple). (Keep in mind that once you've taken a JPEG photo using a Monochrome style, you can't convert the image back to full color.) To adjust Filters or Toning:

- 1. Choose Set Picture Control from the Photo Shooting menu.
- 2. Scroll down to the Monochrome Picture Control.
- 3. Press the multi selector right button to produce an adjustment screen similar to the one shown in Figure 11.20.
- 4. Set Sharpening, Contrast, and Brightness exactly as you would with the other Picture Controls.
- 5. Optionally, scroll down to Filter Effects or Toning (which appears after Filter Effects in the scrolling list and is shown at the bottom of the figure).

- 6. When Filter Effects is highlighted, you can choose Off, Yellow, Orange, Red, or Green. Press OK to finish or Trash to reset to the original values.
- 7. When Toning is highlighted, you can press the left/right buttons to choose a tone: Black/White, Sepia, Cyanotype, Red, Yellow, Green, Blue Green, Blue, Purple Blue, or Red Purple. Once you've selected a tone (other than Black/White), press the down button to move to the intensity control, then use the left/right buttons to set a toning strength from +1 to +7. Press OK to confirm, or Trash to reset.

FILTERS VS. TONING

Although some of the color choices seem to overlap, you'll get very different looks when choosing between Filter Effects and Toning. Filter Effects add no color to the monochrome image. Instead, they reproduce the look of black-and-white film that has been shot through a color filter. That is, Yellow will make the sky darker and the clouds will stand out more, while Orange makes the sky even darker and sunsets more full of detail. The Red filter produces the darkest sky of all and darkens green objects, such as leaves. Human skin may appear lighter than normal. The Green filter has the opposite effect on leaves, making them appear lighter in tone. Figure 11.21 at left shows the same scene shot with no filter, then Yellow, Green, and Red filters.

The Sepia, Blue, Green, and other toning effects, on the other hand, all add a color cast to your monochrome image. Use these when you want an old-time look or a special effect, without bothering to recolor your shots in an image editor. Toning is shown at right in Figure 11.21.

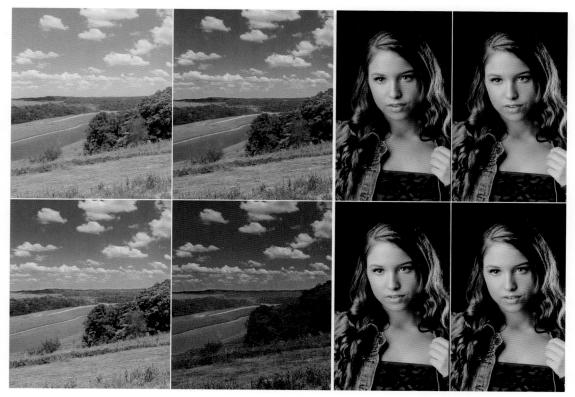

Figure 11.21 Left: Color filter effects: No filter (upper left); yellow filter (upper right); green filter (lower left); and red filter (lower right). Right: Toning effects: Sepia (upper left); Purple Blue (upper right); Red Purple (lower left); and Green (lower right).

Editing Creative Picture Controls

The Creative Picture Controls, located farther down the scrolling list after the predefined controls, have approximately the same adjustments found in the Original Picture Controls. However, you'll probably find adjusting them to be trickier, because it can be difficult to see how a particular parameter applies to a particular special effect. For example, you know that the Vivid original style emphasizes color saturation but what, exactly, goes into making, say, the Dream creative style? Simply looking at samples with a particular effect applied may not help, as you can see in Figure 11.22. The differences between many of the controls is subtle. Charcoal, Graphite, Binary, and Carbon may differ primarily in amount of contrast, for example.

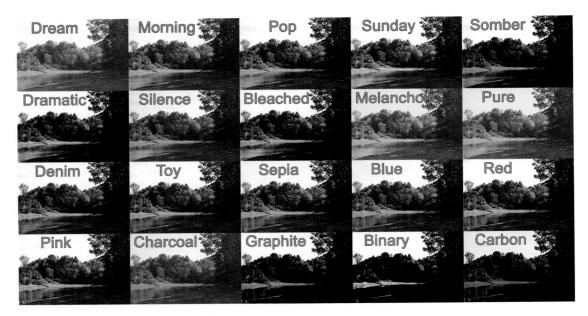

Figure 11.22 Creative Picture Controls.

Nikon provides some simplified descriptions, which may seem a little vague, like a New Age song title, forcing us poor users to evoke our own mental images with only fuzzy visual references. Nikon's summaries are along these lines (for what it's worth):

- **Dream.** Lightness, warmth, pale orange brightening darker areas with smooth edges and a soft appearance.
- Morning. Atmosphere of fresh morning air, dark areas brightened, with bluish tones with a sense of transparency. Refreshing image.
- Pop. Highest degree of saturation for more colorful tones and textures, even with brighter images.
- Sunday. Open atmosphere as if the image were captured on a Sunday afternoon. Increased contrast, blown highlights, for a stronger impression.
- Somber. Melancholic, calm atmosphere, like after a rain, with increased saturation and suppressing brightness.
- **Dramatic.** Profound expression emphasizing light and shade, suitable for dramatic expression of light.
- Silence. Transient and lonely contemplative feeling; tranquil, soft images with reduced saturation.
- **Bleached.** Serious impression with greenish, low-saturation images and metallic feel. Minutely rendered details with tasteful silvery tone.

- **Melancholic.** Retro expression with slightly melancholic atmosphere, magenta tinged, restrained sharpness and saturation.
- Pure. Soft image, as if viewed through a veil, with soft bluish tone, tranquil ambience.
- Denim. Deep tone, strong blue shifted toward cyan, high saturation.
- Toy. Inspired by toy cameras, but deeper and calmer impression, with high saturation, blue shifted toward indigo.
- **Sepia.** First of the true "color-influenced" Creative Picture Controls, provides sepia images with faded colors, similar to a colorized monochrome picture.
- Blue. Yet more melancholy, this time with a quiet, bluish tone, similar to cyanotypes.
- **Red.** Retro images with heavy red tone.
- **Pink.** No relation to Alecia Beth Moore (P!nk), but still able to deliver soft, gentle romantic tone with a pinkish atmosphere.
- Charcoal. Gentle, monochrome images resembling black-and-white drawings with minimal loss of detail in shadows and highlights, but softer edge sharpness.
- Graphite. Sharpened edges and lustrous blacks with crisp, accentuated contrast.
- Binary. Two-tone images for crisp black-and-white.
- Carbon. Stable, deep, dignified images with strong black-based gradation.

As the names and descriptions of each of these 20 Creative Picture Controls don't adequately describe their effects, my recommendation is to evaluate each individually, and use the controls to tweak them to your preferences. The Dream style is shown in Figure 11.23 as an example. You can always adjust these styles and save them under a new name as a User Control, as I'll describe in the Manage Picture Control section that follows.

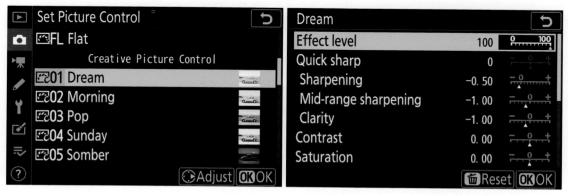

Figure 11.23 Adjusting Creative Picture Controls.

Manage Picture Control

Options: Save/Edit, Rename, Delete, Load/Save

My preference: N/A

The Manage Picture Control menu entry can be used to create new styles, edit existing styles, rename or delete them, and store/retrieve them from the memory card. Here are the basic functions of this menu item, which can be found on the Photo Shooting menu directly below the Set Picture Control entry:

- Make a copy. Choose Save/Edit (see Figure 11.24, left), select from the list of available Picture Controls, and press OK to store that style in one of the user-defined slots C-1 to C-9 (with slots C-1 to C-2 shown already occupied in Figure 11.24, right).
- Save an edited copy. Choose Save/Edit, select from the list of available Picture Controls, and then press the multi selector right button to edit the style, as described in the previous section. Press OK when finished editing, and then save the modified style in one of the user-defined slots C-1 to C-9.
- Rename a style. Choose Rename, select from the list of user-defined Picture Controls (you cannot rename the default styles), and then enter the text used as the new label for the style, using the standard Z6 text entry screen shown earlier in this chapter in Figure 11.5. You may use up to 19 characters for the name.
- Remove a style. Select Delete, choose from the list of user-defined Picture Controls (you can't remove one of the default styles), press the multi selector right button, then highlight Yes in the screen that follows, and press OK to remove that Picture Control.

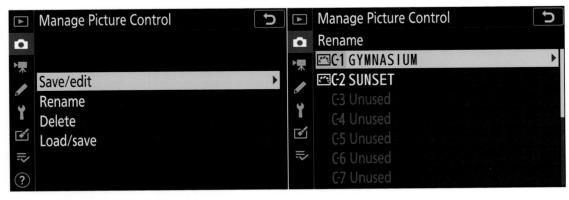

Figure 11.24 You can save, edit, rename, delete, or load and save Picture Controls (left). Picture Controls that you define can be stored in your Z6's settings (right).

■ Store/retrieve style on card. Choose Load/Save, then select Copy to Camera to locate a Picture Control on your memory card and copy it to the Z6; Delete from Card to select a Picture Control on your memory card and remove it; or Copy to Card to duplicate a style currently in your camera onto the memory card. This last option allows you to create and save on your Slot 1 card Picture Controls in excess of the nine that can be loaded into the camera at one time, for a maximum of 99 custom Picture Controls. Once you've copied a style to your memory card, you can modify the version in the camera, give it a new name, and, in effect, create a whole new Picture Control.

Color Space

Options: sRGB (default), Adobe RGB

My preference: Adobe RGB

The Nikon Z6's Color Space option gives you two different color spaces (also called *color gamuts*), named Adobe RGB (because it was developed by Adobe Systems in 1998), and sRGB (supposedly because it is the *standard* RGB color space). These two color gamuts define a specific set of colors that can be applied to the images your Z6 captures.

You're probably surprised that the Nikon Z6 doesn't automatically capture *all* the colors we see. Unfortunately, that's impossible because of the limitations of the sensor and the filters used to capture the fundamental red, green, and blue colors, as well as that of the phosphors used to display those colors on the LEDs in your camera and computer monitors. Nor is it possible to *print* every color our eyes detect, because the inks or pigments used don't absorb and reflect colors perfectly.

On the other hand, the Z6 does capture quite a few more colors than we need. A basic 12-bit RAW image contains a possible 4.3 *billion* different hues (4,096 colors per red, green, or blue channel), which are condensed down to a mere 16.8 million possible colors when converted to a 24-bit (eight bits per channel) image. While 16.8 million colors may seem like a lot, it's a small subset of 4.3 billion captured, and an even smaller subset of all the possible colors we can see. A 14-bit RAW image has even more possible colors—16,384 per color channel, or 281 *trillion* hues.

The set of colors, or gamut, that can be reproduced or captured by a given device (scanner, digital camera, monitor, printer, or some other piece of equipment) is represented as a color space that exists within the larger full range of colors. That full range is represented by the odd-shaped splotch of color shown in Figure 11.25, as defined by scientists at an international organization back in 1931. The colors possible with Adobe RGB are represented by the black triangle in the figure, while the sRGB gamut is represented by the smaller white triangle. The location of the corners of each triangle represent the position of the primary red, green, and blue colors in the gamut.

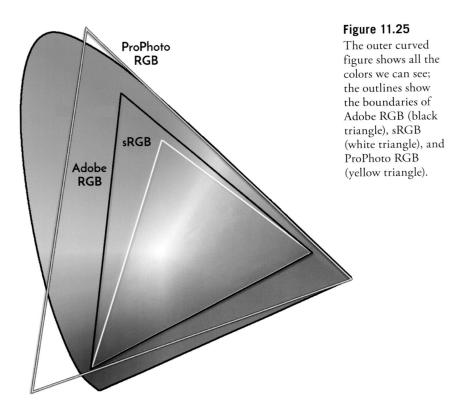

A third color space, ProPhoto RGB, represented by the yellow triangle in the figure, has become more popular among professional photographers as more and more color printing labs support it. While you cannot *save* images using the ProPhoto gamut with your Z6, you can convert your photos to 16-bit ProPhoto format using Adobe Camera RAW when you import RAW photos into an image editor. ProPhoto encompasses virtually all the colors we can see (and some we can't), giving advanced photographers better tools to work with in processing their photos. It has richer reds, greens, and blues, although, as you can see from the figure, its green and blue primaries are imaginary (they extend outside the visible color gamut). Those with exacting standards need not use a commercial printing service if they want to explore ProPhoto RGB: many inkjet printers can handle cyans, magentas, and yellows that extend outside the Adobe RGB gamut.

Regardless of which triangle—or color space—is used by the Z6, you end up with some combination of 16.8 million different colors that can be used in your photograph. (No one image will contain all 16.8 million! To require that many, only about two pixels of any one color could be the same in a 36-megapixel image!) But, as you can see from the figure, the colors available will be different.

Adobe RGB, like ProPhoto RGB, is an expanded color space useful for commercial and professional printing, and it can reproduce a wider range of colors. It can also come in useful if an image is going to be extensively retouched, especially within an advanced image editor, like Adobe Photoshop, which has sophisticated color management capabilities that can be tailored to specific color spaces. As an advanced user, you don't need to automatically "upgrade" your Z6 to Adobe RGB, because images tend to look less saturated on your monitor and, it is likely, significantly different from what you will get if you output the photo to your personal inkjet. (You can *profile* your monitor for the Adobe RGB color space to improve your on-screen rendition using widely available color-calibrating hardware and software.)

While both Adobe RGB and sRGB can reproduce the exact same 16.8 million absolute colors, Adobe RGB spreads those colors over a larger portion of the visible spectrum, as you can see in the figure. Think of a box of crayons (the jumbo 16.8 million crayon variety). Some of the basic crayons from the original sRGB set have been removed and replaced with new hues not contained in the original box. Your "new" box contains colors that can't be reproduced by your computer monitor, but which work just fine with a commercial printing press. For example, Adobe RGB has more "crayons" available in the cyan-green portion of the box, compared to sRGB, which is unlikely to be an advantage unless your image's final destination are the cyan, magenta, yellow, and black inks of a printing press.

The other color space, sRGB, is recommended for images that will be output locally on the user's own printer, as this color space matches that of the typical inkjet printer fairly closely. You might prefer sRGB, which is the default for the Nikon Z6 and most other cameras, as it is well suited for the range of colors that can be displayed on a computer screen and viewed over the Internet. If you plan to take your image file to a retailer's kiosk for printing, sRGB is your best choice, because those automated output devices are calibrated for the sRGB color space that consumers use.

BEST OF BOTH WORLDS

If you plan to use RAW+JPEG for most of your photos, go ahead and set sRGB as your color space. You'll end up with JPEGs suitable for output on your own printer, but you can still extract an Adobe RGB version from the RAW file at any time. It's like shooting two different color spaces at once—sRGB and Adobe RGB—and getting the best of both worlds.

Of course, choosing the right color space doesn't solve the problems that result from having each device in the image chain manipulating or producing a slightly different set of colors. To that end, you'll need to investigate the wonderful world of *color management*, which uses hardware and software tools to match or *calibrate* all your devices, as closely as possible, so that what you see more closely resembles what you capture, what you see on your computer display, and what ends up on a printed hardcopy. Entire books have been devoted to color management, and most of what you need to know doesn't directly involve your Nikon Z6, so I won't detail the nuts and bolts here.

To manage your color, you'll need, at the bare minimum, some sort of calibration system for your computer display, so that your monitor can be adjusted to show a standardized set of colors that is repeatable over time. (What you see on the screen can vary as the monitor ages, or even when the room light changes.) I use the Spyder5 Pro monitor color correction system from Datacolor (www.datacolor.com) for my computer's three 26-inch wide-screen LCD displays. The unit checks room light levels every five minutes, and reminds me to recalibrate every week or two using a small sensor device, which attaches temporarily to the front of the screen and interprets test patches that the software displays during calibration. The rest of the time, the sensor sits in its stand, measuring the room illumination, and adjusting my monitors for higher or lower ambient light levels.

If you're willing to make a serious investment in equipment to help you produce the most accurate color and make prints, you'll want a more advanced system (up to \$500) like the various other Spyder products from Datacolor or Colormunki from X-Rite (www.colormunki.com).

Active D-Lighting

Options: Auto, Extra High, High, Normal, Low, Off (default for most modes)

My preference: Off

Active D-Lighting is a feature that improves the rendition of detail in highlights and shadows when you're photographing high-contrast scenes. It's closely related to D-Lighting, which is a "non-active" internal retouching option available from the Z6's Retouch menu (and described in Chapter 13). Active D-Lighting, unlike the Retouch menu post-processing D-Lighting feature, applies its tonal improvements while you are actually taking the photo. That's good news and bad news. It means that, if you're taking photos in a contrasty environment, Active D-Lighting can automatically improve the apparent dynamic range of your image as you shoot, without additional effort on your part. However, you'll need to disable the feature once you leave the high-contrast lighting behind, and the process does take some time. You wouldn't want to use Active D-Lighting for continuous shooting of sports subjects, for example. There are many situations in which the selective application of D-Lighting using the Retouch menu is a better choice.

You have six choices: Auto, Extra High, High, Normal, Low, and Off (the default). You may need to experiment with the feature a little to discover how much D-Lighting you can apply to a high-contrast image before the shadows start to darken objectionably. Note that when this feature is activated, brightness and contrast Picture Control settings cannot be changed. Figure 11.26 shows a "before and after" example of Active D-Lighting applied to improve shadow detail. By the time the sample images shown have been half-toned and rendered to the printed page, the differences may be fairly subtle.

For best results, use your Z6's Matrix metering mode, so the Active D-Lighting feature can work with a full range of exposure information from multiple points in the image. Active D-Lighting works its magic by subtly *underexposing* your image so that details in the highlights (which would

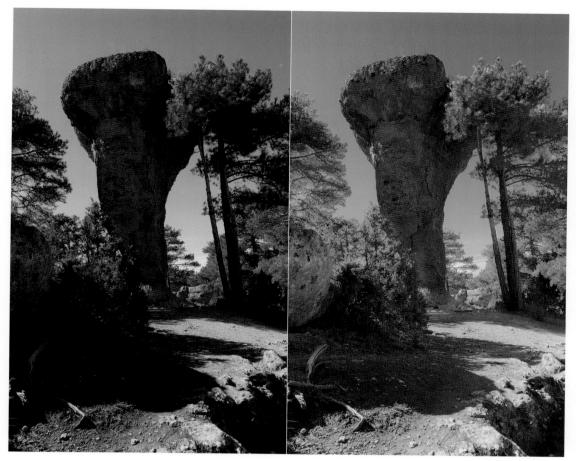

Figure 11.26 No D-Lighting (left); and high (right).

normally be overexposed and become featureless white pixels) are not lost. At the same time, it adjusts the values of pixels located in midtone and shadow areas so they don't become too dark because of the underexposure. Highlight tones will be preserved, while shadows will eventually be allowed to go dark more readily. Bright beach or snow scenes, especially those with few shadows (think high noon, when the shadows are smaller) can benefit from using Active D-Lighting.

It's important to *always* keep in mind that Active D-Lighting not only adjusts the contrast automatically of your image, it modifies exposure for both existing light and flash as well, as I've noted. Exposure for both is reduced from about 1/3 stop (at the Low setting) to as much as 1 full stop less at the Extra High setting.

Tip

In Manual exposure mode, Active D-Lighting does not adjust the exposure of your image; it simply shifts the center (zero) point of the analog exposure indicator in the viewfinder/control panel.

Nikon gives you a lot of flexibility in using Active D-Lighting. You can choose the setting yourself, or let the camera *vary* the amount of tweaking by using Active D-Lighting Bracketing. You'll find this is a useful feature, if used with caution.

Long Exposure NR

Options: Off (default), On

My preference: Off. I prefer to apply noise reduction when processing the RAW file.

Visual noise is that awful graininess caused by long exposures and high ISO settings, and which shows up as multicolored specks in images. This setting helps you manage the kind of noise caused by lengthy exposure times. In some ways, noise is like the excessive grain found in some high-speed photographic films. However, while photographic grain is sometimes used as a special effect, it's rarely desirable in a digital photograph. There are easier ways to add texture to your photos.

Some noise is created when you're using shutter speeds longer than eight seconds to create a longer exposure. Extended exposure times allow more photons to reach the sensor, but increase the likelihood that some photosites will react randomly even though not struck by a particle of light. Moreover, as the sensor remains switched on for the longer exposure, it heats, and this heat can be mistakenly recorded as if it were a barrage of photons. This menu setting can be used to activate the Z6's long exposure noise-canceling operation performed by the EXPEED 6 digital signal processor.

■ Off. This default setting disables long exposure noise reduction. Use it when you want the maximum amount of detail present in your photograph, even though higher noise levels will result. This setting also eliminates the extra time needed to take a picture caused by the noise reduction process. If you plan to use only lower ISO settings (thereby reducing the noise caused by ISO amplification), the noise levels produced by longer exposures may be acceptable. For example, you might be shooting a waterfall at ISO 100 with the camera mounted on a tripod, using a neutral-density filter and a long exposure to cause the water to blur. (Try exposures of 2 to 16 seconds, depending on the intensity of the light and how much blur you want.) (See Figure 11.27.) To maximize detail in the non-moving portions of your photos for the exposures that are one second or longer, you can switch off long exposure noise reduction.

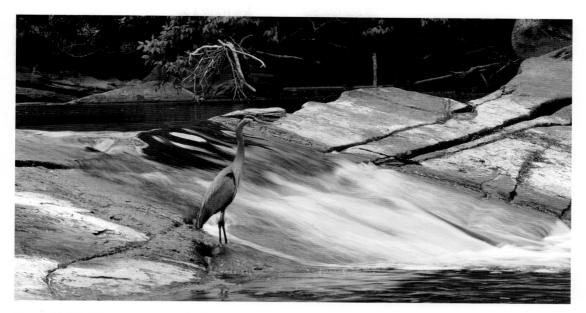

Figure 11.27 A long exposure with the camera mounted on a tripod produces this traditional moving-water photo.

■ On. When exposures are longer than one second, the Nikon Z6 takes a second, blank exposure to compare that to the first image. Noise (pixels that are bright in a frame that *should* be completely black) in the "dark frame" image is subtracted from your original picture, and only the noise-corrected image is saved to your memory card. Because the noise-reduction process effectively doubles the time required to take a picture, you won't want to use this setting when you're rushed. Some noise can be removed later, using tools like the noise reduction features built into Adobe Camera Raw.

High ISO NR

Options: High, Normal (default), Low, Off

My preference: Normal

Noise can also be caused by higher ISO sensitivity settings. The Nikon Z6 offers direct settings up to ISO 51200 and extended settings that go even higher, up to Hi 2 (the equivalent of ISO 204,800). Although it costs you some detail, High ISO noise reduction, which can be set with this menu option, may be a good option in many cases. You can choose Off when you want to preserve detail at the cost of some noise graininess, and the Z6 will apply high ISO NR only at the highest settings. Or, you can select Low, Normal, and High noise reduction, which is applied when ISO sensitivity has been set to ISO 800 or higher.

The effects of high ISO noise are something like listening to a CD in your car, and then rolling down all the windows. You're adding sonic noise to the audio signal, and while increasing the CD

player's volume may help a bit, you're still contending with an unfavorable signal-to-noise ratio that probably mutes tones (especially higher treble notes) that you really want to hear.

The same thing happens when the analog image signal is amplified: You're increasing the image information in the signal, but boosting the background fuzziness at the same time. Tune in a very faint or distant AM radio station on your car stereo. Then turn up the volume. After a certain point, turning up the volume further no longer helps you hear better. There's a similar point of diminishing returns for digital sensor ISO increases and signal amplification as well.

As the captured information is amplified to produce higher ISO sensitivities, some random noise in the signal is amplified along with the photon information. Increasing the ISO setting of your camera raises the threshold of sensitivity so that fewer and fewer photons are needed to register as an exposed pixel. Yet, that also increases the chances of one of those phantom photons being counted among the real-life light particles, too.

Fortunately, the Nikon Z6's CMOS sensor and its EXPEED 6 digital processing chip are optimized to produce the low noise levels, so ratings as high as ISO 12800 can be used routinely (although there will be some noise, of course), and even ISO 6400 can generate good results. I regularly shoot concerts at ISO 3200, and indoor sports at ISO 6400 with my Z6. I've even been impressed with results I get at ISO 25600 when High ISO NR is applied. Some kinds of subjects may not require this kind of noise cancellation, particularly with images that have a texture of their own that tends to hide or mask the noise.

Vignette Control

Options: High, Normal (default), Low, Off

My preference: Normal

Some lenses may not be up to the challenge of covering the frame evenly, producing darkening in the corners of your images at certain focal lengths. If you consistently encounter vignetting, this option may help. You can choose from High, Normal, Low, and Off. It's difficult to quantify exactly how much corner-brightening each setting provides. Your best bet is to shoot some blank walls of a single color with lenses that seem to have this problem, and try a few at each of the settings. Then select the value that best seems to counter vignetting with your particular lenses.

Diffraction Compensation

Options: On (default), Off

My preference: On

This is the first entry on the next page of the Photo Shooting menu. (See Figure 11.28.) Diffraction is a phenomenon that reduces the sharpness of your image when working at smaller f/stops, especially f/22 or f/32 (if your lens has those apertures available). It can be especially acute with cameras, like the Z6, that have exceptionally high resolution. This feature attempts to counteract that effect,

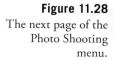

and works well enough that I leave it enabled by default. Unfortunately, Nikon doesn't deign to tell you what diffraction actually is, or how much it affects your photographs.

Introductory photo courses hammer into budding photographers the idea that smaller f/stops increase sharpness by extending depth-of-field and optimizing the optical effects of particular lenses. In practice, while few lenses are their sharpest wide open, most achieve their maximum sharpness stopped down two or more f/stops; beyond that, diffraction kicks in, and can actually help *reduce* apparent sharpness, due to scattering and interference of individual photons as they pass through smaller lens openings. In effect, the edges of your lens aperture affects proportionately more photons as the f/stop grows smaller. The relative amount of space available to pass freely decreases, and the amount of edge surface that can collide with incoming light increases.

So, an f/stop of f/11 may produce a slight loss of overall sharpness compared to an opening of f/8 (although depth-of-field will increase); and f/16 will be less sharp than f/11. With the Z6, images are softened by an almost undetectable amount at every aperture—including wide open—but diffraction becomes more noticeable only at f/stops smaller than f/11. The difference is very slight.

Theoretically, this limit on sharpness should be independent of the resolution of the sensor, or the size of the sensor. The effects of diffraction *should* be the same at, say, f/11, regardless of what type of sensor is being used. However, in practice, smaller pixels do show the effects of diffraction more readily. The diffraction produces a multi-ringed pattern called an *airy disk* (it has nothing to do with air; the phenomenon was named after scientist George Airy), and when the peak area of this disk is large enough, compared to the pixel size of the sensor, or if two disks overlap, an effect may be visible in the image.

Typically, this happens at a particular f/stop with a particular pixel size, and that f/stop is said to be the diffraction limit for that camera/sensor. Point-and-shoot cameras, with their tiny sensors, may begin to show diffraction effects at f/5.6; a cropped-sensor camera at f/11; a lower-resolution full-frame camera (like the 20MP Nikon D5) at f/16; and a camera with *extremely* small pixels, like the Nikon Z6 at f/11.

Is the sharpness lost to diffraction more objectionable than the reduced *range* of sharpness produced by less depth-of-field at wider apertures? That's up to you. For example, most of the "product" shots in this book were taken with my old Nikon D4s at f/22 or f/32, even though that camera's small pixels also are prone to diffraction effects. Given the size the images are reproduced in these pages, I felt that the increased depth-of-field of the smaller apertures was worth the possible loss of sharpness from diffraction. In other words, even though more of my subjects were in focus, the overall sharpness of the sharpest parts of the image may be less.

The photons striking the edges of the diaphragm are disrupted from their paths, and begin to interfere with those passing through the center of the lens. While this phenomenon takes place at all apertures, it is most pronounced at smaller f/stops, when the edges of the iris are proportionately larger compared to the entire lens opening.

The best analogy I can think of is a pond with two floating docks sticking out into the water, as shown in Figure 11.29. Throw a big rock in the pond, and the ripples pass between the docks relatively smoothly if the structures are relatively far apart (top). Move them closer together (bottom), and some ripples rebound off each dock to interfere with the incoming wavelets. In a lens, smaller apertures produce the same effect.

Other than the Diffraction Compensation algorithms Nikon has included in the Z6, there's no "cure" for diffraction-limited images, other than to use larger f/stops, or to apply some sharpening of the image in your editor (which is likely to be a losing cause). It is important, then, to be aware of the effects of diffraction on images captured with the Z6, and take them into account before choosing a small aperture.

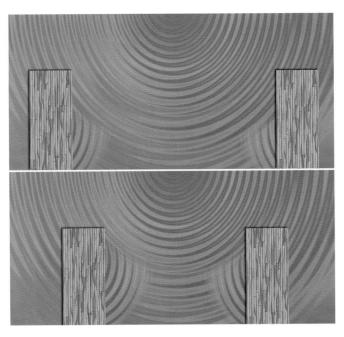

Figure 11.29 Diffraction interference can be visualized as ripples on a lake.

Auto Distortion Control

Options: On (default), Off

My preference: On

As I explained in Chapter 7, wide-angle lenses are prone to barrel distortion, in which straight lines appear to bow outward, especially near the edges of the frame. Telephoto lenses often have the opposite problem: lines may bend inward, producing pincushion distortion. Both of these types of distortion can be easily corrected in your image editor, but your Z6's digital image processing chip has similar algorithms built in and can do the job for you. Your choices are easy: just select On or Off to enable or disable this feature. Note that with some lenses, On is chosen by default and this menu entry is grayed out and unavailable.

For the process to work, the lenses must be of a type that can communicate electronically with the camera to let the Z6 know what type of lens it is working with, so that means you should be using a G- or D-type optic. The camera will warp the photo before saving it to your memory card, cropping a bit if necessary to exclude some areas of the image.

Flicker Reduction Shooting

Options: On, Off (default)

My preference: Use as needed

This option allows you to reduce or eliminate the banding, flickering, or alternate light/dark exposures that can appear when photographing under certain types of lighting, such as fluorescent or mercury-vapor sources. I find this effect quite vexing when shooting indoor sports such as basket-ball and volleyball in gymnasiums. During continuous shooting I often end up with frames that alternate between too dark and too light.

This flicker reduction feature uses the exposure meter to detect light flicker in the 100 and 120 Hz frequencies. When enabled, the camera delays shutter release timing a tiny bit to avoid the "dim" cycle of the light source, and giving you a frame that's evenly lit and fully illuminated. If you're taking photos continuously (a common mode when capturing sports), the Z6 adjusts both the release timing and frame rate so you can capture each shot during the light source's maximum output. You may notice a slight shutter lag, and a reduction in frame rate, but both are trade-offs that pay back with more usable images under these conditions.

The feature may not work well for scenes with dark backgrounds, decorative or especially bright lighting, and is not effective when making Bulb, or Time exposures, other shutter speeds slower than 1/100th second, and HDR, exposure delay mode, silent photography, and Continuous H (extended) burst shooting.

Metering

Options: Matrix (default), Center-weighted, Spot, Highlight-weighted metering

My preference: Matrix

This menu entry is a slower alternative to setting the metering mode using the *i* menu. It exists primarily so you can assign this menu entry to a custom key using the Custom Setting f2: Custom Control Assignment menu entry (explained in Chapter 12).

For example, if you tend to change metering mode frequently, even a visit to the *i* menu can be bothersome. Define, say, the Fn1 button to Metering, and each time you press that button you'll be able to rotate the command dial to flip among the four choices. Note that you can also define a button to immediately switch to a specific metering mode, so you can, for example, set Matrix as your default mode, then toggle to Spot while holding down the defined button.

I explained how to use each of these Metering modes in Chapter 4, and won't repeat that information here

Flash Control

Options: Flash control mode, Flash compensation (TTL), Wireless Flash options, Remote flash control, Group flash options, Radio remote flash info.

My preference: N/A

This entry is available only when the Nikon SB-5000, SB-500, SB-400, or SB-300 Speedlights are connected to the Z6 and powered up. I explained how to use the available options in Chapters 9 and 10 and will not duplicate that information here. All other Nikon electronic flash units, including the SB-600, SB-700, SB-800, SB-900, and SB-910 must be adjusted using the controls on the flash itself.

Before you howl "planned obsolescence!" you should know that *all* Nikon pro bodies that lacked a built-in flash have *always* required making most settings on the optional flash. The Z6's Flash Control feature is a relatively recent addition to the Nikon line, made possible by features built into the four (fairly) recent flash units cited, so you're actually gaining capability. If you connect any of the other Speedlights (I own all of them, and I tried), the Flash Control entry is grayed out.

Flash Mode

Options: Fill Flash (default), Red-eye Reduction, Rear-curtain sync, Flash Off

My preference: N/A

This setting specifies whether the Z6 uses Fill Flash, Red-eye Reduction, Rear-curtain sync, or disables the flash entirely. I explained when and why to use each of these in Chapter 9, and won't repeat that information here.

Flash Compensation

Options: +3.0 to -1.0 stops of exposure; Default: 0.0

My preference: N/A

As I explained in Chapter 9, you can use flash exposure compensation to adjust the flash output to balance the brightness of the main subject illuminated by the flash, compared to the background. Don't confuse this entry with Custom Setting e2: Exposure Compensation for Flash (described in Chapter 12), which tells the Z6 to apply flash exposure compensation to the background only, or to the entire frame. The two options work together to let you effectively balance your flash output between the two.

Focus Mode

Options: AF-S (default), AF-C, Manual Focus

My preference: N/A

This entry is a slower alternative to using the *i* menu to switch from one focus mode to another, as explained in Chapter 5. It can be assigned to a custom key if you need fast access to this setting.

AF-Area Mode

Options: Pinpoint AF, Single-point AF (default), Dynamic-area AF, Wide-area AF (Small), Wide-area AF (Large), Auto-area AF

My preference: N/A

This is the first entry on the next page of the Photo Shooting menu (see Figure 11.30). Like several entries discussed above, it duplicates its i menu counterpart, and can be assigned to a custom key for direct access. This menu entry is a slower alternative to using the i menu to switch from one focus mode to another, as explained in Chapter 5.

Figure 11.30
The next page of the Photo Shooting menu.

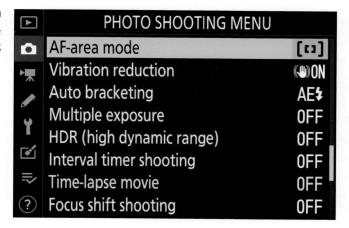

Vibration Reduction

Options: On (or Normal) (default), Spt (Sport), Off

My preference: N/A

This setting is available only with certain lenses that have vibration reduction available, and the options may vary between lenses. When VR is enabled, an indicator appears at the left side of the viewfinder or LCD monitor. Use On (or Normal; the nomenclature varies depending on the lens) for subjects that are not moving to counter camera shake or photographer jitteriness. The Sport setting is recommended for fast and unpredictably moving subjects, especially if you're panning the camera to follow their movements. In that case, in Sport mode the Z6's vibration reduction ignores side-to-side movement and corrects only camera shake in other directions. Use Off if the camera is locked down on a tripod. If you will be swiveling the camera on the tripod or using a monopod, then turning VR off is not required. If you use this setting frequently, you can assign the function to an *i* menu position using Custom Setting f1: Customize *i* menu. While the Z6 has on-sensor in-body image stabilization (as described earlier in Chapter 7), you can also use F-mount lenses with the FTZ adapter, including those that have their own vibration reduction. When using an adapted lens without VR, use this menu entry to make VR adjustments for the camera. If the adapted lens does have VR, then the switches on the adapted lens overrides any setting you make here.

In that case, the adjustments you can make must be made using the lens switches, and will vary by the type of F-mount lens you are using. If the adapted VR lens has Off, Normal, and Sport settings (the same as found in this menu entry) then VR adjustments can only be made using the lens switches. If the adapted lens has an Active setting, and you set the lens switch to Active, the Z6 uses the Normal VR setting instead.

Auto Bracketing

Options: Auto Bracketing Set (default: AE & Flash), Number of Shots (default: 0), Increment (default: 1.0)

My preference: N/A

This entry allows you to set up bracketing, a useful technique explained in detail in Chapter 4. I won't repeat the step-by-step instructions here. To recap, your options are as follows:

- **Auto Bracketing Set.** Autoexposure and Flash bracketing, Autoexposure Bracketing (only), Flash bracketing (only), White balance bracketing, Active D-Lighting bracketing.
- Number of shots. Use the left/right directional buttons or the touch screen to specify the number of shots in your bracket set (or 0 to disable bracketing entirely). Up to nine can be selected, and you can choose whether to group them around overexposure or underexposure, as described in Chapter 4.
- Increment. From 0.3- (one-third stop) to 3.0-stop increments between bracketed exposures.

Multiple Exposure

Options: Multiple Exposure Mode: On (Series), On (Single Photo), Off; Number of Shots: 2 to 10; Overlay Mode: Add, Average, Lighten, Darken; Keep All Exposures: On, Off, Select First Exposure (NEF)

My preference: Multiple Exposure Mode: On (Series); Number of Shots/Overlay Mode, varies

This option lets you combine from 2 to 10 exposures into one image without the need for an image editor such as Photoshop, and it can be an entertaining way to return to those thrilling days of yesteryear, when complex photos were created in the camera itself. In truth, prior to the digital age, multiple exposures were a cool, groovy, far-out, hep/hip, phat, sick, fabulous way of producing composite images. Today, it's more common to take the lazy way out, snap two or more pictures, and then assemble them in an image editor like Photoshop.

You can turn the Multiple Exposure feature off, direct the camera to continue taking multiple exposures until you turn it off (Series), or revert to non-multiple exposure mode after taking one picture (Single Photo). You can elect to keep all exposures, or discard all but the combined multiple exposure, and use a NEF (RAW) image on your memory card as the base photo on which subsequent pictures are overlaid. I provided a complete set of directions for using these multiple exposure features in Chapter 6, along with another example of the kind of results you can get.

You should keep in mind that some of Nikon's previous implementations of multiple exposure allowed you to choose between combining the exposures of each image to produce the final shot, or dividing the exposures equally among the shots. The Z6 has additional options, and calls the array of choices "Overlay Mode." Here's the difference:

- Add. In this mode, each new exposure is added to the previous shots. I use this when photographing a subject that is moving against a dark background. A series of renditions, each fully exposed, appears in the overlaid image to track the subject's movement. (See Figure 11.31, left.)
- **Average.** In this mode, the camera divides the overall exposure by the number of shots in the series, and gives each shot that fraction of the overall exposure. That is, for a four-shot multiple series, the specified exposure for each is set at 1/4 of the total amount. I use this when shooting subjects with a great deal of overlap. (See Figure 11.31, right.)
- **Lighten.** The Z6 compares pixels in the same position in each exposure, and uses only the brightest. This effect is similar to the Lighten blending mode in Photoshop, Lightroom, and other image-editing software.
- Darken. Similar to the Lighten blending mode, only just the darkest pixel is saved. You can use both Lighten and Darken overlay modes to create special effects like those you get in image editors.

The Z6 adds a useful feature, Keep All Exposures, which, as you might expect, tells the camera to save the individual photos used to create the multiple exposure in separate files. This capability can be useful in several ways. First, you may find that one specific frame of your multiple exposure might have made an excellent stand-alone image in its own right. When Keep All Exposures is

Figure 11.31 Multiple Exposures using Add (left) and Average (right) overlay modes.

active, you can retrieve that frame and use it as you like. In addition, having all the shots of the multiple exposure available means you can use them to create your own multi-shot image in Photoshop or your favorite image editor. I do this most often when I discover that one frame doesn't "work" for a given multiple exposure image, but the others meld together well. I can create my own version manually, adjusting brightness, contrast, or other parameters as I go, to "fine-tune" what started out as an automated multiple exposure.

Brand new is the Select First Exposure (NEF) option. If you want to overlay all your subsequent multiple exposures on top of an existing image already on your memory card (say, a background that you'd like to merge with your sequence), you can choose this setting. You'll be taken to the Z6's standard image selection screen and offered the choice of any NEF image available on your card. This is a cool way of replacing boring one-color backgrounds with something more interesting.

HDR (High Dynamic Range)

Options: HDR mode: On (Series), On (Single Photo), Off (default); Exposure Differential: Auto (default), 1 EV, 2 EV, 3 EV; Smoothing: High, Normal, Low; Save individual Images (NEF)

My preference: HDR mode: On (Series); Exposure Differential: Auto; Smoothing: No preference

I was surprised at how well Nikon has solved the hand-held auto HDR problem, because there are two stumbling blocks that, at least theoretically, should lead to less-than-awesome results. First, when your camera can perform HDR for you on the fly, there is the tendency to put the feature to work under non-optimal conditions; specifically, impromptu hand-held situations. If you've done any traditional HDR, you know that the technique works best when the camera is mounted on a

tripod, so that the bracketed exposures are virtually identical except for the exposure itself. Although all HDR software can correct for slight camera movement and align images that are slightly out of register, the results I've gotten have not been great. I expected hand-held HDR to be comparable. However, Nikon's implementation, especially in the Z6, does an excellent job.

The second theoretical weakness of the Z6's HDR feature is the limitation of combining just two shots to arrive at the final image. The best traditional HDR photos I've produced have involved at least three shots, and more frequently five or more, each separated by a stop of exposure. The Z6 takes two shots, total, and combines them. Despite these speed bumps, I've been pleased with my results. I outlined the steps in Chapter 4, and won't repeat them here.

Interval Timer Shooting

Options: Start; Start Options: Now, Choose Start Day and Start Time; Interval; No. of Intervals × Shots/Interval; Exposure Smoothing: On/Off; Silent Photography: On/Off; End Day/Time; Interval Priority: On/Off; Starting Storage Folder: New Folder, Reset File Numbering

My preference: N/A

Nikon Z6's built-in time-lapse photography feature allows you to take pictures for up to 999 intervals in bursts of as many as nine shots, with a delay of up to 23 hours and 59 minutes between shots/bursts, and an initial start-up time of as long as 23 hours and 59 minutes from the time you activate the feature. That means that if you want to photograph a rosebud opening and would like to photograph the flower once every two minutes over the next 16 hours, you can do that easily. If you like, you can delay the first photo taken by a couple hours so you don't have to stand there by the Z6 waiting for the right moment. The options are shown in Figure 11.32, and I explained how to use them in Chapter 6.

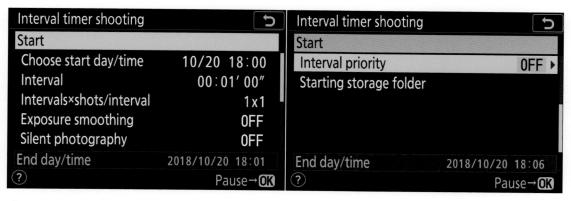

Figure 11.32 Interval timer shooting options.

Or, you might want to photograph a particular scene every hour for 24 hours to capture, say, a landscape from sunrise to sunset to the following day's sunrise again. I will offer two practical tips right now, in case you want to run out and try interval timer shooting immediately: use a tripod, and for best results over longer time periods, plan on connecting your Z6 to an external power source!

4K/8K MOVIES?

One cool thing to do with interval timer captures is to assemble the individual shots into a video with 4K or faux 8K resolution using a video image editor. I explained this feature, too, in Chapter 6.

Time-Lapse Movie

Options: Start, Interval, Shooting Time, Exposure Smoothing, Silent Photography, Image Area, Frame size/frame rate, Interval priority

My preference: None

As I said in Chapter 6, Time-Lapse movies correspond to interval timer shooting, described previously, but allow shooting video clips instead of still photographs (or a series of still photographs). The Z6 automatically creates a silent time-lapse movie at the frame resolution and rate you've selected in the Movie Shooting menu. Nikon recommends using a white balance other than Auto, and covering the eyepiece opening to prevent light from entering the viewfinder and affecting exposure. And, of course, you'll want to use a tripod and either a fully charged battery or optional AC adapter. While you can shoot 4K time-lapse video, the maximum length sequence you can capture is three minutes.

The options are very similar to those of interval timer shooting:

- Start. Unlike the similar Interval Timer found in the Photo Shooting menu, Time-Lapse Photography has no Start Options. Make your other settings, select Start, and time-lapse photography will begin about three seconds later.
- Interval. Select an interval between frames; use a longer value for slow-moving action (such as a flower bud unfolding), and a shorter value for movies, say, depicting humans moving around at a comical pace. You can select an interval from one second to 10 minutes.
- **Shooting time.** You can specify time-lapse movie duration.
- Exposure smoothing. You can turn exposure smoothing on or off. When activated, the camera adjusts the exposure of each frame to match that of the previous frame in P, S, or A mode. Smoothing can also be used in Manual mode, but, of course, the Z6 won't vary either the shutter speed *or* aperture. You must have set ISO Sensitivity to Auto. Press OK to confirm.
- Silent photography. Silences the shutter sound for unobtrusive or stealth video capture.
- Image Area. Select FX-based movie format or DX-based movie format (see Chapter 15). You can also turn Auto DX crop on or off, so the Z6 will recognize DX lenses and crop appropriately.

- Frame size/frame rate. Here you can select the frame size and frames per second setting for your time-lapse movie. You can choose from $3840 \times 2160 \ 30/15/24$ p; $1920 \times 1060 \ 60/50/30$ p (in both High Quality and Normal modes, also explained in Chapter 15); and $1280 \times 720 \ 60/50$ p formats.
- Interval priority. This setting is similar to its intervalometer counterpart, as explained previously. It takes care of situations in which the shutter speed automatically selected in Program or Aperture-priority ends up being longer than the interval between shots. When enabled, the Z6 captures the movie frame at the specified interval, even if a shorter shutter speed must be used, causing underexposure. You can activate Auto ISO Sensitivity, and select a minimum shutter speed that is shorter than the interval time. When disabled, the camera increases the interval you specified to allow correct exposure.

Focus Shift Shooting

Options: Start, Number of Shots, Focus Step Width, Interval until Next Shot, First-Frame Exposure Lock, Peaking Stack Image, Silent Photography, Starting Storage Folder

My preference: N/A

Focus stacking is a great technique that allows combining a series of photos each taken using a different plane of focus, so that they can be combined in an image editor to produce a single image with greatly enhanced depth-of-field. Macro photographers (in particular) have long used focus stacking in their work. The Z6's Focus Shift Shooting feature greatly simplifies capture of the individual shots, which can include up to 300 different images. I covered this feature in detail in Chapter 6 and will not repeat that information here.

Silent Photography

Options: On, Off (Default)

My preference: N/A

Because the Z6 has no mirror one of the ker-plunks that punctuate dSLR picture taking is eliminated. However, the camera's mechanical shutter still produces its characteristic noise as it opens and closes for each shot. Silent Photography takes advantage of the Z6's electronic shutter by relying on that component alone to capture an image. In use, the camera "dumps" the current live view image from the sensor, then activates the sensor for the interval specified by the selected shutter speed. Because the physical shutter does not open or close, the process is entirely silent. In addition, the lack of shutter motion and mirror motion means that the camera vibrates less during the actual exposure. On and Off are your only options. When active, continuous shooting is reduced in speed, and flash, the camera's beeper, long exposure noise reduction, and electronic front-curtain shutter are disabled. You may notice distortion in moving objects, especially when panning because of the Z6's "rolling shutter." (I'll tell you more about rolling shutter effects in Chapter 15.) You may also see flicker, banding, or distortion under fluorescent, mercury-vapor, or sodium lamps.

Movie Shooting Menu

Some of the Movie Shooting menu's entries duplicate the entries in the Photo Shooting menu but apply specifically to video shooting. Others are unique to movie making. For entries that overlap those used for still photography, I'll simply refer to the relevant description earlier in this chapter. Many of the movie-related choices are discussed in more detail in Chapters 14 and 15 of this book.

- Reset Movie Shooting MenuFile Naming
- Choose Image Area
- Frame Size/Frame Rate
- Movie Quality
- Movie File TypeISO Sensitivity Settings
- White Balance
- Set Picture Control

- Manage Picture Control
- Active D-Lighting
- High ISO NR
- Vignette Control
- Diffraction Compensation
- Auto Distortion Control
- Flicker Reduction
- Metering
- Focus Mode

- AF-area Mode
- Vibration Reduction
- Electronic VR
- Microphone Sensitivity
- Attenuator
- Frequency Response
- Wind Noise Reduction
- Headphone Volume
- Timecode

Reset Movie Shooting Menu

Options: Yes, No

My preference: N/A

Restores Movie Shooting menu options (only) to their default values (see Table 11.3). This is the first entry in the Movie Shooting menus (see Figure 11.33, left).

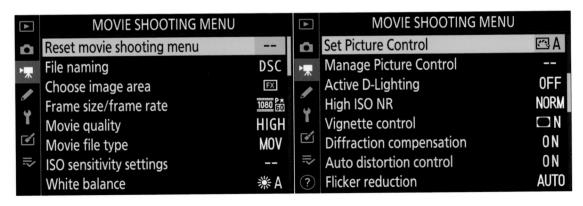

Figure 11.33 The first two Movie Shooting menus.

Option	Default	Option	Default
File Naming	DSC	Diffraction	On
Choose Image Area	FX	Compensation	
Frame size/Frame rate	$1920 \times 1080, 60p$	Auto Distortion Control	On
Movie Quality	High quality		
Movie File Type	Mov	Flicker Reduction	Auto
ISO Sensitivity Setting	S	Metering	Matrix metering
Maximum Sensitivity	51,200	Focus Mode	Full-time AF
Auto ISO Control	On	AF-Area Mode	Auto-area AF
(Mode M) ISO Sensitivity (Mode M)	100	Vibration Reduction	Same as photo settings
White Balance	Same as photo settings	Electronic VR	Off
		Microphone Sensitivity	Auto sensitivity
Fine-tuning	A-B:0 G-M:0	Attenuator	Disable
Choose Color Temp.	5,000K d-1	Frequency Response	Wide range
Preset Manual		Wind Noise Reduction	Off
Set Picture Control	Same as photo settings	Headphone Volume	15
		Timecode	
Active D-Lighting	Off	Record timecodes Count-up method Drop frame	Off
High ISO NR	Normal		Record run
Vignette Control	Normal		On

File Naming

Options: Three-character prefix; DSC is the default

My preference: None

You can specify substitutes for the DSC characters in file names created for movie files, separately from the naming format you elect for still photos. The limitations and instructions are the same as for the File Naming entry in the Photo Shooting menu.

Choose Image Area

Options: FX (default), DX

My preference: FX

As you'll learn in Chapter 15, the movies the Z6 captures are cropped from the full sensor image, to fit each movie frame into the 19:6 proportions of high-definition video. This entry determines the image area used to crop the frame while in Movie Shooting mode. (See Figure 11.34.) It is independent of the setting you specify in the Photo Shooting menu. You have two options, FX and DX:

- FX. In this mode, the Z6's 35.9mm × 23.9mm sensor area is cropped at top and bottom to fit the 19:6 aspect ratio of HD video, so the actual movie capture area measures 35.9 × 20.2mm, and represented by the outer area in Figure 11.34. The FX-based movie format means that no "lens multiplier" is applied, and, say, a 100mm lens has its normal field of view. (I explained the "multiplier" misnomer in Chapter 7.) As I'll explain in Chapter 15, the pixels are subsampled to produce the final 1920 × 1080. When shooting 4K video, a central area within the frame measuring 3840 × 2160 pixels is used instead.
- DX. When using the DX-based movie format, the image capture area measures 23.5mm × 13.2mm portion of the sensor, represented by the yellow box in the figure. This smaller field of view produces a cropped, telephoto effect. Your 100mm lens has the effective field of view of a 150mm lens. Note that Electronic VR (discussed later in this chapter) crops the image a tiny bit more.

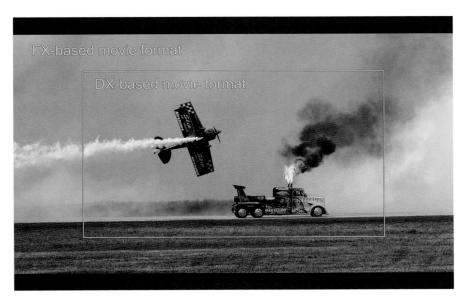

Figure 11.34 FX- and DX-based movie formats.

Frame Size/Frame Rate

Options: 4K Ultra High Definition: 3840 × 2160, 30/25p, 24p; Full HD: 1920 × 1080, 60/50p (default), 30/25p, 24p; 1920 × 1080 30/25p X4 slow-mo; 1920 × 1080 24p X5 slow-mo

My preference: Varies

Here you can select several different Ultra High Definition, Full High Definition, or Standard High Definition video formats. Ultra HD is available at 3840×2160 in 30/25/24 frames per second; Full HD at 1920×1080 resolution at 60/50/30/25/24 frames per second. As I'll explain in Chapter 15, 50/25 fps are used for PAL video systems used overseas, while the others are compatible with the NTSC system used in the USA, Japan, and some other areas. Chapter 15 will provide more information on how to select the most appropriate frame size and transfer rate, and explain your options for shooting silent slow-motion movies as well.

Movie Quality

Options: High Quality (default), Normal

My preference: High Quality when using a fast memory card

Select High Quality or Normal Quality. Your choice affects the sharpness/detail in your image and also the maximum bit rate that can be sustained and length of the movies you can record. You'll find more information on this parameter in Chapter 15.

Movie File Type

Options: MOV (default), MP4

My preference: MP4

The Z6 can use either MOV or MP4 movie formats. MP4 format is an industry standard for video. MOV, the default, is common on Macs. Most video editors can translate MP4 files into MOV and back again as long as the same codec was used for both. Your camera uses the standard H.264/MPEG-4 codec ("coder-decoder") using IPB (I-frame/P-frame/B-frame) Standard and Light. I prefer MP4, because it has better support for computers running operating systems other than MacOS. I'll explain file type considerations in more detail in Chapter 15.

ISO Sensitivity Settings

Options: Maximum Sensitivity, ISO Sensitivity (Mode M), Auto ISO control (Mode M)

My preference: Varies by light levels

My preference: Varies by light levels

Similar to the ISO settings in the Photo Shooting menu, this version allows you to select a fixed ISO setting for Manual exposure mode, from ISO 100 to Hi 2. That allows you greater control over the ISO used. When shooting movies in P, A, and S exposure modes, Auto ISO sensitivity is always used.

However, if you want to use Auto ISO in Manual exposure mode, you can turn it on or off here, and specify the *maximum* ISO that will be selected automatically, from ISO 200 to Hi 2. **Note:** Using Auto ISO in Manual exposure mode effectively gives you autoexposure *even though you're shooting in manual exposure mode.* I'll show you how to put this feature to work in Chapter 15.

White Balance

Options: Same as Photo Settings (default); Auto1, Incandescent, Fluorescent, Direct Sunlight, Flash, Cloudy, Shade, Choose Color Temperature, Preset Manual

My preference: Same as Photo Settings

Here you can select the white balance used to shoot movies; you can select from:

- Same As Photo Settings. The Z6 will use whatever white balance setting you've specified in the Photo Shooting menu, and apply it to your videos.
- Any of the other White Balance options. The selection will apply *only* to video. If you're shooting still photographs in RAW format, you might not care about the white balance setting, as you can choose any color balance you want when the file is imported into your image editor. Movie clips, on the other hand, aren't so easy to adjust (think of them as moving JPEGs which, in a sense, they are), so you might want to set a specific white balance in this menu entry.

Set Picture Control

Options: Same as Photo Settings (default); Original Picture Controls: Auto, Standard, Neutral, Vivid, Monochrome, Portrait, Landscape, Flat; Creative Picture Controls (01–20): Dream, Morning, Pop, Sunday, Somber, Dramatic, Silence, Bleached, Melancholic, Pure, Denim, Toy, Sepia, Blue, Red, Pink, Charcoal, Graphite, Binary, and Carbon

My preference: Same as Photo Settings

This is the first entry on the next page of the Movie Shooting menu. (See Figure 11.33, right, shown earlier.) You can specify Same as Photo Settings, or independently specify a Picture Control to be used only when shooting movies. The procedures for selecting and modifying a Picture Control in this menu entry is otherwise exactly the same as described earlier in this chapter. Check out the still photo discussion of Picture Controls for a complete explanation of this feature.

Manage Picture Control

Options: Save/Edit, Rename, Delete, Load/Save

My preference: N/A

This entry includes the Save/Edit, Rename, Delete, and Load/Save options that operate the same as the corresponding control in the Photo Shooting menu, described earlier in this chapter.

To recap:

- Make a copy. Choose Save/Edit, select from the list of available Original or Creative Picture Controls, and press OK to store that style in one of the user-defined slots C-1 to C-9.
- Save an edited copy. Choose Save/Edit, select from the list of available Picture Controls, and then press the multi selector right button to edit the style, as described in the previous section. Press OK when finished editing, and then save the modified style in one of the user-defined slots C-1 to C-9.
- Rename a style. Choose Rename, select from the list of user-defined Picture Controls (you cannot rename the default styles), and then enter the text used as the new label for the style. You may use up to 19 characters for the name.
- Remove a style. Select Delete, choose from the list of user-defined Picture Controls (you can't remove one of the default styles), press the multi selector right button, then highlight Yes in the screen that follows, and press OK to remove that Picture Control.
- Store/retrieve style on card. Choose Load/Save, then select Copy to Camera to locate a Picture Control on your memory card and copy it to the Z6; Delete from Card to select a Picture Control on your memory card and remove it; or Copy to Card to duplicate a style currently in your camera onto the memory card.

Active D-Lighting

Options: Same as Photo Settings (default), Extra High, High, Normal, Low, Off (default) My preference: Same as Photo Settings

Here you can specify Active D-Lighting used exclusively for movie shooting, or you can choose Same as Photo Settings (the default value) when your still and movie shooting is under similar conditions.

High ISO NR

Options: High, Normal (default), Low, Off

My preference: Normal

Movie shooting doesn't involve *long* exposures, so the Movie Shooting menu includes only a High ISO Noise Reduction entry. You can set it to High, Normal, Low, or Off. See the entry for this feature under the Photo Shooting menu, earlier in this chapter.

Vignette Control

Options: Same as Photo Settings; High, Normal (default), Low, Off

My preference: Normal

Set up this option using the same settings in the Photo Shooting menu, or choose your own.

Diffraction Compensation

Options: On (default), Off

My preference: On

This entry works the same as its Photo Shooting menu counterpart.

Auto Distortion Control

Options: On (default), Off

My preference: On

This entry also works the same as its Photo Shooting menu counterpart. With some lenses, On is activated automatically and this setting is grayed out and unavailable.

Flicker Reduction

Options: Auto (default), 50Hz, 60Hz

My preference: Auto

The flicker reduction parameters in movie shooting are slightly different from their still photography counterparts. Because movie capture is always continuous, and at 60/50/30/25/24 frames per second, the Z6 needs to know the frequency at which the light source is flickering. You can choose Auto to let the camera sense the frequency (this may be the best idea if you are unsure about the local power supply), or specify 50Hz or 60Hz as appropriate.

Alternatively, you can eschew this feature, shoot using Manual exposure, and select a shutter speed that may sync best with the light source's power (that is 1/125th, 1/60th, or 1/30th second for 60Hz and 1/50th or 1/25th second for 50Hz). I'll have additional caveats about choosing a shutter speed for movie making in Chapter 15.

Metering

Options: Matrix metering (default), Center-weighted metering, Highlight-weighted metering My preference: Matrix metering

This is the first entry on the next page of the Movie Shooting menu. (See Figure 11.35, left.) Note that Spot metering is not available in movie mode, but this entry otherwise has exactly the same options as its counterpart in the Photo Shooting menu.

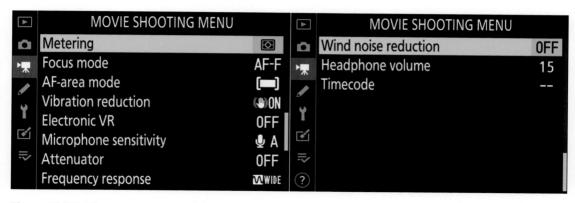

Figure 11.35 The next two pages of the Movie Shooting menu.

Focus Mode

Options: AF-S, AF-C, AF-F (full-time AF) (default), and MF

My preference: AF-F

For movie shooting, Nikon adds a full-time autofocus option (AF-F) to the AF-S, AF-C, and Manual focus modes used for still photography. You might consider it the *opposite* of AF-C: with AF-C, the Z6 starts focusing as soon as you press the shutter release halfway down, and continues until you press the release all the way down to take the picture. With AF-F, the camera starts focusing *immediately*, as soon as you rotate the still/movie switch next to the viewfinder to the Movie position. The Z6 then continues to adjust focus if you or your subject changes location, or you reframe the image. Focus is locked when you press the shutter release halfway. You can then reframe, or press the Movie button on top of the camera to begin capturing video using the focus setting you locked.

In effect, AF-F is full-time only prior to begin capture. If you want the camera to refocus during capture, use AF-C instead.

AF-Area Mode

Options: Single-point AF, Wide-area AF (Small), Wide-area AF (Large), Auto-area AF (default) My preference: Auto-area AF

The autofocus area modes available during video capture are similar to those used for still photography as described in Chapter 5, except that Pinpoint AF and Dynamic Area AF are disabled.

Vibration Reduction

Options: Same as Photo Settings (default), On (Normal), Spt (Sport), Off

My preference: Same as Photo Settings

If you want to use the same settings specified for still photography, you can keep the default setting. However, if you exclusively shoot video with the camera mounted on a tripod, you can save time by disabling VR here, and activating it only when needed.

Flectronic VR

Options: On, Off (default)

My preference: Off

Electronic VR is a type of anti-shake technology that has long been provided in pro and amateur camcorders. It's available only when shooting conventional 1080p, and *not* when shooting 1080p slow-mo or 2160p 4K video. In use, the camera reduces the frame size by about 10 percent when shooting in FX mode. It then examines successive frames looking for movement by comparing pixels that are in common between frames, and noting when the pixels representing stationary objects appear to move. It then uses the extra border area outside the frame to counteract the motion by realigning the video frames so that pixels of parts of the image that don't move between frames (such as the background when you're shooting without any intentional panning movement) match. No trimming is necessary when shooting in DX mode, as the Z6 can use the area outside the crop to align the image.

If you're shooting with the Z6 mounted on a tripod, or connected to a gimbal, shoulder, hand-held, or other type of video camera stabilizer, you can safely turn this feature off. Disable electronic VR as well when you actually want a shaky, cinéma vérité look.

Microphone Sensitivity

Options: Auto Sensitivity (default), Manual Sensitivity, Microphone Off

My preference: Varies

This entry has three options that control your Z6's built-in microphone or any external microphone you attach. You can choose Auto Sensitivity; Manual Sensitivity, to set recording levels yourself (with a handy volume meter on screen showing the current ambient sound levels); or turn the microphone off entirely if you're planning to record silent video, use another sound recording source, or add sound in post-production.

Attenuator

Options: Enable, Disable (default)

My preference: Varies

When working in noisy environments, choose Enable to reduce the microphone gain and minimize audio distortion from background sounds.

Frequency Response

Options: Wide Range (default), Vocal Range

My preference: Varies

Select from Wide Range frequency response to record a broad range of sounds, or Vocal Range to optimize audio recording for vocals. You'll find an entire section on recording sound in Chapter 15.

Wind Noise Reduction

Options: On, Off (default)
My preference: Varies

This is the first entry on the last page of the Movie Shooting menu (see Figure 11.35, right, shown earlier). Wind blowing across your microphone can be distracting. This setting reduces wind noise (and may also affect other sounds, so use it carefully) for the built-in microphones *only*. Your external microphone, like the Nikon ME-1, may have its own wind noise reduction filter on/off switch.

Headphone Volume

Options: 15 (default); Values 0-30

My preference: N/A

Use this entry in Movie mode to adjust the volume of headphones you've plugged into the Z6's headphones jack.

Timecode

Options: Record timecodes: On, On with HDMI Output, Off; Count-up method: Record Run, Free Run; Timecode origin: Reset, Enter Manually, Current Time; Drop frame: On, Off

My preference: N/A

Advanced video shooters find SMPTE (Society of Motion Picture and Television Engineers)-compatible time codes embedded in the video files to be an invaluable reference during editing. To oversimplify a bit, the time system provides precise *hour:minute:second:frame* markers that allow

identifying and synchronizing frames and audio. The time code system includes a provision for "dropping" frames to ensure that the fractional frame rate of captured video (remember that a 24 fps setting actually yields 23.976 frames per second while 30 fps capture gives you 29.97 actual "frames" per second) can be matched up with actual time spans.

As I noted in the introduction to this book, I won't be covering the most technical aspects of movie shooting in great detail (including detailed use of time codes, raw HDMI streaming, etc.). If you're at the stage where you're using time codes, you don't need a primer, anyway. However, the Time Code submenu does include the following options:

- **Record Timecodes.** Turn timecodes off or on. You can select On, or On with HDMI Output to append the time code to the HDMI video output, or Off to not use timecodes.
- Count up. Choose Rec Run, in which the time code counts up only when you are actually capturing video, or Free Run (also known as Time of Day), which allows the time code to run up even between shooting clips. The latter is useful when you want to synchronize clips between multiple cameras that are shooting the same event. When using Free Run, even if the cameras record at different times, you'll be able to match the video that was captured at the exact same moment during editing. When Free Run is selected, the time code will always be recorded to the movie file (except for HFR clips).
- Timecode Origin. Normally, the Z6 uses the camera's internal clock to specify the hours:minutes:seconds, with frames set to :00 when you begin shooting. This entry allows you to manually enter any hour:minute:second:frame of your choice, or to Reset the start time to 00:00:00:00.
- **Drop Frame.** The 30 fps setting yields 29.97 actual frames per second, 60 fps gives you 59.95 frames per second, and 120 fps provides 119.9 fps, causing a discrepancy between the actual time and the time code that's recorded. Enable and the camera will skip some time code numbers in drop-frame mode at intervals to eliminate the discrepancy. When disabled (non-drop frame mode), you may notice a difference of several seconds per hour.

The Custom Settings Menu

Unlike the Photo Shooting and Movie Shooting menu options, which you are likely to modify frequently as your picture-taking environment changes, Custom Settings are slightly more stable sets of preferences that let you tailor the behavior of your camera in a variety of different ways for longer-term use.

Some options are minor tweaks useful for specific shooting situations, or make the camera more convenient to use. Perhaps you'd like to assign a frequently used feature to the Fn button, or turn on the viewfinder grid display to make it easier to align vertical or horizontal shapes.

Best of all are the settings that improve the way the Z6 operates. Custom Setting b4, for example, provides a way to fine-tune the exposures your camera calculates for each of the metering modes: Matrix, Center-weighted, Spot, and Highlight-weighted. If you find that one or the other consistently over- or underexposes more than you like, it's easy to dial in a permanent correction. Should you feel that the Z6 is taking a few pictures that are out of focus, Custom Settings a1 and a2 can be used to tell it not to fire until optimum focus is achieved.

This chapter concentrates on explaining all the options of the Custom Settings menu and, most importantly, when and why you might want to use each setting.

Custom Settings Menu Layout

There are more than four dozen different Custom Settings, arranged in seven different categories, as shown in Figure 12.1: Autofocus, Metering/Exposure, Timers/AE Lock, Shooting/Display, Bracketing/Flash, Controls, and Movie. Some of those may seem to be an odd match. What does bracketing have to do with flash? Oh, wait! You can *bracket* flash (as well as non-flash) exposures. The category system does have an advantage. Once you're familiar with what settings are available

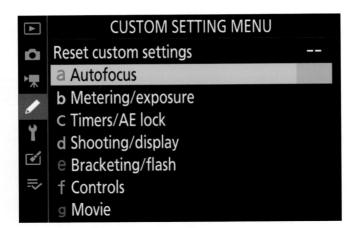

Figure 12.1
Entries are allocated among seven categories in the Custom
Settings menu.

within each category, you can select the Custom Settings menu, scroll down to the specific category you want, press the right button, and enter the Custom Settings system at that point, skipping the other entries.

However, once you get past the main Custom Settings screen, the entries are one long scrolling list, so if you've guessed wrong about where you want to start, you can enter the list at any point and then scroll up or down until you find the entry you want. Or, press the left directional key to get back to the main screen, then move down to another entry point and re-enter. The Custom Settings menu items are all color- and letter-coded: \mathbf{a} (red) for autofocus functions; \mathbf{b} (yellow) for metering/exposure; \mathbf{c} (green) for timers and AE lock features; \mathbf{d} (light blue) for shooting/display functions; \mathbf{e} (dark blue) for bracketing/flash; \mathbf{f} (purple) for adjustments to the Z6's controls; and \mathbf{g} (magenta) to assign Movie mode functions to the i menu; the Fn1, Fn2, OK, AF-ON sub-selector, and shutter buttons; and the lens control ring.

For simplicity, in this book I have been consistently referring to the Custom Settings menu entries by their letter/names, so that you always know that when I mention Custom Setting a5, I am describing the fifth entry in the Autofocus menu: Focus Points Used. That terminology makes it easy to jump quickly to the specific entry. Note that for simplicity's sake, in the figures that illustrate each of the separate Custom Settings categories in this chapter, that category's entries are shown on as few screens as possible. In practice, as you scroll through the listings, the entries for a category may be spread over several different screens.

You can select a Custom Settings function as you do any menu entry, by pressing the multi selector right button, and navigating through the screen that appears with the up/down (and sometimes left/right) buttons. Confirming an option is usually done by pressing the OK button, pushing the multi selector right button, or sometimes by choosing Done when a series of related options have been chosen.

At the top level, you'll see these entries:

■ Reset Custom Settings

■ c. Timers/AE Lock

■ f. Controls

■ a. Autofocus

■ d. Shooting/Display

■ g. Movie

■ b. Metering/Exposure

■ e. Bracketing/Flash

Reset Custom Settings

Options: Reset: Yes, No My preference: N/A

You can restore the settings of the Custom Settings banks to their default values. In Chapter 3, I provided a list of recommended Custom Settings menu bank settings for typical photo environments. Tables 12.1 to 12.7 show the default values as the Nikon Z6 comes from the factory, and after a reset. If you don't know what some of these settings are, I'll explain them later in this chapter. Be careful when changing any of your carefully tailored customized settings back to the defaults.

Function	Option	Default
al	AF-C priority selection	Release
a2	AF-S priority selection	Focus
a3	Focus tracking with lock-on	3
a4	Auto-area AF face detection	On
a5	Focus points used	All
a6	Store points by orientation	Off
a7	AF activation	Shutter/AF-ON
a8	Limit AF-area mode selection	All available
a9	Focus point wrap-around	No wrap
a10	Focus point options Manual focus mode Dynamic-area AF assist	On On
a11	Low-light AF	Off
a12	Built-in AF-assist illuminator	On
a13	Manual focus ring in AF mode	Enable

Function	Option	Default
b1	EV steps for exposure cntrl.	1/3 step
b2	Easy exposure compensation	Off
b3	Center-weighted area	12mm
b4	Fine-tune optimal exposure Matrix metering Center-weighted metering Spot metering Highlight-weighted metering	0 0 0

Function	Option	Default
c1	Shutter release button AE-L	Off
c2	Self-timer Self-timer delay Number of shots Interval between shots	10s 1 0.5s
c3	Power off delay Playback Menus Image review Standby timer	10s 1 min 4s 30s

Table 12.4 Default Custom Settings Bank Values: Shooting/Display		
Function	Option	Default
d1	CL mode shooting speed	3 fps
d2	Max. continuous release	200
d3	Sync. release mode options	Sync
d4	Exposure delay mode	Off
d5	Electronic front-curtain shutter	Disable
d6	Limit selectable image area	All available
d7	File number sequence	On

Table 12.4 Default Custom Settings Bank Values: Shooting/Display (continued)		
Function	Option	Default
d8	Apply settings to live view	On
d9	Framing grid display	Off
d10	Peaking highlights Peaking level Peaking color	Off Red
d11	View all in continuous mode	On

Function	Option	Default
el el	Flash sync speed	1/200s
e2	Flash shutter speed	1/60s
e3	Exposure comp. for flash	Entire frame
e4	Auto Flash ISO sensitivity control	Subject and background
e5	Modeling flash	On
e6	Auto bracketing (Mode M)	Flash/speed
e7	Bracketing order	MTR>under>over

Function	Option	Default
f1	Customize <i>i</i> menu	Set Picture Control; White balance; Image quality; Image size; Flash mode; Metering mode; Wi-Fi connection; Active D-Lighting; Release mode; Vibration Reduction; AF-area mode; Focus mode
f2	Custom Control Assignment Fn1 Fn2 AF-ON Sub-selector Sub-selector center Movie record Lens Fn Lens control ring	White balance Focus/AF-area modes AF-ON Focus point selection AE/AF lock None AE/AF lock Focus (M/A)

Function	Option	Default
f3	OK button Shooting mode Playback mode Zoom on/off	Reset/Select center focus point Zoom on/off 1:1
f4	Shutter spd & aperture lock Shutter speed lock Aperture lock	Off Off
f5	Customize command dials Reverse rotation Change main/sub Menus and Playback Sub-dial frame advance	Exposure Compensation: Off Shutter speed/Aperture: Off Exposure setting: Off Autofocus setting: Off Off 10 frames
f6	Release button to use dial	No
f7	Reverse indicators	-0+

Function	Option	Default
g1	Customize i menu	Set Picture Control; White Balance; Frame size and Rate/Image quality; Microphone sensitivity; Choose image area; Metering; Wi-Fi Connection; Active D-Lighting; Electronic VR; Vibration reduction; AF-area mode; Focus Mode
g2	Custom Control Assignment Fn1 Fn2 AF-ON Sub-selector center	White balance Focus/AF-area modes AF-ON AE/AF lock
	Shutter release button Lens control ring	Take photos Focus (M/A)
g3	OK button	Select center focus point
g4	AF speed When to apply	0 Always
g5	AF tracking sensitivity	4
g6	Highlight display Display pattern Highlight display threshold	Off 248

a. Autofocus

The red-coded Autofocus options (see Figure 12.2) deal with some of the potentially most vexing settings available with the Nikon Z6. After all, incorrect focus is one of the most damaging picture killers of all the attributes in an image. You may be able to compensate for bad exposure, partially fix errant color balance, and perhaps even incorporate motion blur into an image as a creative element. But if focus is wrong, the photograph doesn't look right, and no amount of "I meant to do that!" pleas are likely to work. The Z6's autofocus options enable you to choose how and when focus is applied (using the AF-S or AF-C focus mode you selected on the camera body), the controls used to activate the feature, and the way focus points are selected from the available zones.

al AF-C Priority Selection

Options: Release (default), Focus

My preference: Release

As you learned in Chapter 5, when not shooting movies, the Nikon Z6 has two primary autofocus modes, continuous-servo autofocus (AF-C) and single-servo autofocus (AF-S). (Movie mode adds a third: Full-time autofocus [AF-F].) This menu entry allows you to specify what takes precedence when you press the shutter release all the way down to take a picture: focus (called *focus-priority*) or the release button (called *release-priority*). You can choose from:

■ Release. When this option is selected (the default), the shutter is activated when the release button is pushed down all the way, even if sharp focus has not yet been achieved. Because AF-C focuses and refocuses constantly when autofocus is active, you may find that an image is not quite in sharpest focus. Use this option when taking a picture is more important than absolute best focus, such as fast action or photojournalism applications. (You don't want to miss that record-setting home run, or the protestor's pie smashing into the Governor's face.) Using this

Figure 12.2 The Autofocus options menu.

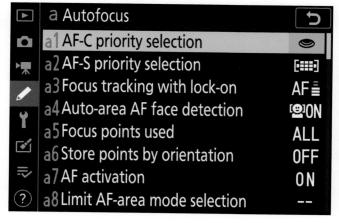

setting doesn't mean that your image won't be sharply focused; it just means that you'll get a picture even if autofocusing isn't quite complete. If you've been poised with the shutter release pressed halfway, the Z6 probably has been tracking the focus of your image.

■ Focus. The shutter is not activated until sharp focus is achieved. This is best for subjects that are not moving rapidly. AF-C will continue to track your subjects' movement, but the Z6 won't take a picture until focus is locked in. You might miss a few shots, but you will have fewer out-of-focus images.

a2 AF-S Priority Selection

Options: Release, Focus (default)

My preference: Focus

This is the counterpart setting for single-servo autofocus mode.

- Release. The shutter is activated when the button is depressed all the way, even if sharp focus is not quite achieved. Keep in mind that, unlike AF-C, the Z6 focuses only *once* when AF-S mode is used. So, if you've partially depressed the shutter release, paused, and then pressed the button down all the way, it's possible that the subject has moved and release-priority will yield more out-of-focus shots than release-priority with AF-C.
- Focus. This default prevents the Z6 from taking a picture until focus is achieved and the infocus indicator in the viewfinder glows steadily. If you're using single-servo autofocus mode, this is probably the best setting. Moving subjects really call for AF-C mode in most cases.

a3 Focus Tracking with Lock-on

Options: Blocked Shot AF Response: 5 (Delayed), 4, 3 (Normal) (default), 2, 1 (Quick)

My preference: Normal

Sometimes new subjects interject themselves in the frame temporarily. Perhaps you're shooting an architectural photo from across the street and a car passes in front of the camera. Or, at a football game, a referee dashes past just as a receiver is about to make a catch. This setting lets you specify how quickly the Z6 reacts to these transient interruptions that would cause relatively large changes in focus before refocusing on the "new" subject matter. Using the Blocked Shot AF Response slider shown in Figure 12.3, you can specify a long delay, so that the interloper is ignored, or a shorter delay, so that the Z6 immediately refocuses when a new subject moves into the frame.

A setting of 5 (Delayed) causes the Z6 to ignore the intervening subject matter for a significant period of time. Use this setting when shooting subjects, such as sports, in which focus interruptions are likely to be frequent and significant. You can also choose a setting of 1 (Quick) which tells the Z6 to wait only a moment before refocusing. Very high continuous frame rates may work better when you allow refocusing to take place rapidly, without a lock-on delay. Intermediate settings from 2 to 4 provide different amounts of delay. The middle value, 3, offers an intermediate delay before

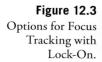

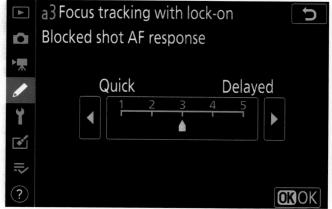

the camera refocuses on the new subject. It's often the best choice when shooting sports in either of the continuous shooting modes, as the long delay can throw off autofocus accuracy at higher frames per second settings.

a4 Auto-Area AF Face-Detection

Options: On (default), Off

My preference: On when shooting candid portraits or stage performances

The Z6's EXPEED 6 processor can analyze your image to find faces, allowing the camera to locate human subjects to autofocus on, and track them as they move. This is an incredibly powerful feature, especially for sports, stage performances, relentlessly moving children, and other action involving humans. I tend to use it for candid portraits and performances to speed up the autofocus process, and find it works best in single-shot mode or continuous frame rates in the 1–5 fps range. This menu entry allows you to turn face-detection on or off.

a5 Focus Points Used

Options: All (default), 1/2 Every other point

My preference: Depends on subject

You can choose the number of focus points available when you manually select a zone using the multi selector up/down and left/right buttons or the sub-selector joystick. You have two choices:

■ All. This is the default. Up to 493 points are available. The exact number used varies by the active AF-area mode. Pinpoint AF uses all 493; Single Point works with an array of 19 × 11 focus zones (209 in all); Wide Area (Small) uses 153 zones in a 9 × 17 array, while Wide Area (Large) has just 9 zones in a 3 × 3 array. Note that the focus frames can overlap, producing more available focus areas than the array would indicate.

■ 1/2 Every Other Point. The Z6 uses every other focus point/zone available for a given AF-area mode (with one exception). That's a reduction of greater than 2/3 of the available points/zones in each case. This can be the best choice for faster focus point selection when taking pictures of relatively large, evenly illuminated subject matter such that choosing precise focus zones is not particularly beneficial. I often use Single Point AF and enable the Every Other Point option—the available focus areas are plenty and can be set quickly as action moves around the floor when photographing basketball games. The single exception? When using Wide-area AF (Large), the nine zones remain exactly the same when you select this option.

Reminder: Keep in mind that the *actual* number of points you can choose from will vary, depending on the AF-area mode you select, and the positions at which you can place the focus frame is even larger, because focus areas can overlap. For example, when using Pinpoint AF, the Z6 allows individually selecting 493 phase detect focus points embedded in the sensor, arranged in an array 29 sensors wide by 17 sensors tall. But the position of the focus frame can be adjusted horizontally and vertically more or less continuously, giving you several hundred horizontal columns and a proportionate number of vertical rows to specify—yes, I'll say it—pinpoint focus. That can be too much precision. You'll find complete coverage of autofocus topics in Chapter 5.

a6 Store Points by Orientation

Options: On, Off (default)

My preference: On

Here you can choose whether separate focus points can be selected for landscape and portrait orientations of the camera, and whether you can select different AF-area modes in these orientations, as explained in detail in Chapter 5.

When you choose Off, the focus point will maintain the same relative position as you rotate the camera, and the AF-area mode will remain the same. Select On, and you can choose a different focus point when the camera is set to horizontal orientation, rotated 90 degrees clockwise from horizontal, or rotated 90 degrees counterclockwise from horizontal.

This is a very cool feature, and best visualized using the illustrations I supplied in Chapter 5 where Store Points by Orientation is explained in detail.

a7 AF Activation

Options: Shutter/AF-ON (default), AF-ON Only: Out-of-focus release; Enable (default), Disable My preference: AF-ON Only for anyone proficient in back button focus, described in Chapter 5

You can specify whether the camera focuses when the shutter release is pressed halfway, or disable that behavior. You'd want to disable shutter release AF activation if you elect to use *back button focus*.

Your choices are as follows:

- **Shutter/AF-ON.** Pressing the shutter release halfway *or* a button you have defined for AF activation (as described under Custom Control Assignment later in this chapter) always activates autofocus.
- **AF-ON Only.** Pressing the shutter release halfway does not activate autofocus. Instead, you can activate AF by pressing the button you've defined for that behavior using the Custom Controls commands described later, and in Chapter 5 under the back button focus section.

The Z6 allows additional fine-tuning of your AF-ON Only setting. When this option is highlighted, you can press the multi selector right button and choose from two Out-of-Focus Release options:

- **Enable.** The Z6 can take photos when the shutter release is pressed all the way down, even if you have not pressed the AF-ON button and focus has therefore *not* taken place. You might find this useful to enable grab shots that take place without warning, and you want a photo even if it may not be in perfect focus. You still have the option of activating AF by pressing the AF-ON button before you press the shutter release all the way, but if you do not, the photo will still be captured.
- **Disable.** You *must* activate AF by pressing the AF-ON button before using the shutter release to take a picture. It keeps the Z6 from taking a picture until after autofocus has been activated. This option applies only when focus-priority has been chosen for AF-C or AF-S and you are using an AF-area selection mode that allows the user to select the focus area or zones (in other words, all AF-area modes other than Auto-Area AF). This option will prevent you from accidentally taking out-of-focus pictures if you forget you are using AF-ON to activate autofocus and press the shutter release without remembering to initiate AF. This option is almost mandatory for new back button focus users, at least until pressing the AF-ON button before shooting becomes a reflex.

a8 Limit AF-Area Mode Selection

Options: Pinpoint, Single-point AF, Dynamic-area AF, Wide-area AF (Small), Wide-area AF (Large), Auto-area AF (Default is all available)

My preference: All available

AF-area modes are chosen by highlighting AF-area mode from the *i* menu, and rotating either command dial. If there are certain area modes that you don't use, you can disable them using this menu item.

Single-point AF-area mode is always available, and cannot be disabled. However you can highlight any of the others and press the right directional button to remove the check box next to that mode's label to disable it. You can thus enable Single-point AF, plus any combination of Dynamic-area AF, both Wide-area AF options, or Auto-area AF. I explained this feature in Chapter 5.

a9 Focus Point Wrap-Around

Options: Wrap, No Wrap (default)

My preference: No Wrap

This is the first entry on the second page of the Autofocus menu (see Figure 12.4). This setting is purely a personal preference parameter. When you press the multi selector left/right and up/down buttons to choose a focus point, the Z6 can be told to stop when the selection reaches the edge of the 51-point array—or, it can continue, wrapping around to the opposite edge, like Pac-Man leaving the playing area on one side or top/bottom to re-emerge on the other. (I hope I'm not revealing my age, here.) Your choices are simple; decide which behavior you prefer:

- Wrap. Pressing the left/right or up/down buttons when you've reached the edge of the focus point display wraps the selection to the opposite side, still moving in the same direction.
- No Wrap. The focus point selection stops at the edge of the focus zone array.

a10 Focus Point Options

Options: Manual Focus Mode: On (default), Off; Dynamic-area AF assist: On (default), Off My preference: Manual Focus Mode: On; Dynamic-area AF assist: Off

How do you want the focus points displayed in the viewfinder? Your choices for focus point options include:

- Manual Focus mode. When you're using manual focus instead of autofocus, the Z6 still monitors how well your image is in focus, using the active focus point. Here, you can choose how it is displayed.
 - On. Active point illumination is always shown when using manual focus. Select this option if you like to know what focus point is being used.
 - Off. Active point illumination is enabled during manual focus only during focus point selection as you move the point around the frame with the directional buttons or sub-selector.

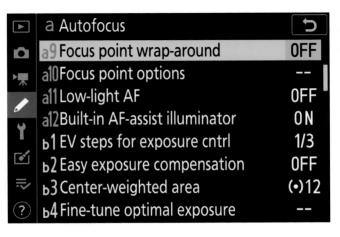

Figure 12.4
The next page of the Autofocus menu.

■ Dynamic-area AF assist. Select On to display both the focus point selected *and* the surrounding focus points when using Dynamic-area AF. Choose Off, and only the selected focus point is shown. When you're using Dynamic-area AF, you might want to choose On as a reminder that the cluster of points around the main focus point are active. However, once you become accustomed to using that AF-area mode, you can turn the display Off and slightly declutter your screen.

a11 Low-Light AF

Options: On, Off (default)

My preference: Off

Low-light AF allows the Z6 to focus more accurately under dim illumination when using AF-S. The camera boosts AF response slightly by decreasing the refresh rate of the display. Normally the display refreshes 60 times per second (that is, 60Hz), and those rapid changes limit the ability of the AF system to read the embedded phase detection pixels in the sensor and calculate focus. By slowing down the refresh rate to 30Hz, the Z6 can focus more easily under low-light conditions. Even so, autofocus may be slower when this mode is activated, so the camera warns you by showing "Low-light" on the display. The feature is disabled when you've rotated the mode dial to the Auto position. I tend to leave this setting at Off, because under truly low-light conditions I prefer to switch to manual focus and fine-tune the focus plane myself. You'll find more detailed descriptions of Phase-detect AF and other autofocus aspects in Chapter 5.

a12 Built-in AF-Assist Illuminator

Options: On (default), Off

My preference: Off

There is an LED on the left front panel (as you hold the camera). It can illuminate to provide additional lighting to improve autofocus when using the AF-S focus mode. The illuminator is effective over a very narrow range (Nikon says 3'4" to 9'10") and its anemic burst of light can be obstructed by any lens hood you have mounted, or even a stray finger. I usually disable this feature, because I shoot so many photos at concerts and other events where the AF-assist light is distracting (or even forbidden—choreographers have told me dancers may orient their twirling moves on theater lights they perceive during a spin).

a13 Manual Focus Ring in AF Mode

Options: Enable (default), Disable

My preference: Enable

This setting is one you can ignore most of the time, and Nikon makes that especially easy: it doesn't appear on the menu at all unless you have one of the very few lenses that are compatible with it. At this writing, there are only six lenses in three different focal length capable of making this entry

magically appear. They are the following AF-P optics that can be mounted on the Z6 using the FTZ adapter (I explained the difference between AF-P and AF-S lenses in Chapter 7.):

- AF-P Nikkor 10-20mm f/4.5-5.6G VR DX
- AF-P Nikkor 18-55mm f/3.5-5.6G DX (both VR and non-VR versions)
- AF-P Nikkor 70-300mm f/4.5-6.3G ED DX (both VR and non-VR versions)
- AF-P Nikkor 70-300mm f/4.5-5.6E ED VR

Note that all but the last are DX lenses. They'll work fine on the Z6; the camera will automatically switch to 19.5 MP DX "crop" mode. Those lenses and the lone full-frame lens (so far) allow using this entry to enable (or disable) the ability to fine-tune focus manually with the focus ring when the Z6 is set to an autofocus mode.

All other autofocus lenses compatible with the Z6 provide this ability automatically. When enabled, you can press the shutter release halfway down to autofocus (or press your AF-ON button), and then fine-tune focus by rotating the lens's focus ring. If at any time you want the Z6 to refocus automatically, release the shutter button or AF-ON button, and press again. You might want to disable this feature (when using an AF-P lens) to prevent accidentally straying from the Z6's autofocus adjustment. In most cases, however, it's a solution in search of a problem, and Nikon helpfully keeps this setting hidden.

b. Metering/Exposure

The yellow-coded Metering/Exposure Custom Settings (see Figure 12.5) let you define four different parameters that affect exposure metering in the Nikon Z6.

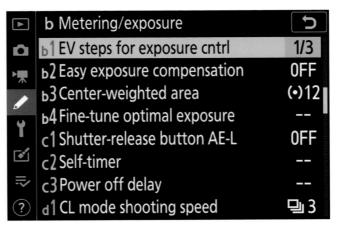

Figure 12.5
There are four metering/exposure options.

b1 EV Steps for Exposure Cntrl.

Options: 1/3 step (default), 1/2 step, 1 step

My preference: 1/3 step

This setting tells the Nikon Z6 the size of the "jumps" it should use when making exposure adjustments—either one-third or one-half stop. The increment you specify here applies to f/stops, shutter speeds, EV changes, and autoexposure bracketing. As with ISO sensitivity step value, you can select from 1/3 step (the default), 1/2 step, or 1 full step increments.

Choose the 1/3-stop setting when you want the finest increments between shutter speeds and/or f/stops. For example, the Z6 will use shutter speeds such as 1/60th, 1/80th, 1/100th, 1/125th, and 1/160th second, and f/stops such as f/5.6, f/6.3, f/7.1, and f/8, giving you (and the autoexposure system) maximum flexibility.

With 1/2-stop increments, you will have larger and more noticeable changes between settings. The Z6 will apply shutter speeds such as 1/60th, 1/125th, 1/200th, and 1/500th second, and f/stops including f/5.6, f/6.7, f/8, f/9.5, and f/11. These coarser adjustments are useful when you want more dramatic changes between different exposures.

b2 Easy Exposure Compensation

Options: On (Auto Reset), On, Off (default)

My preference: Off

This setting potentially simplifies dialing in EV (exposure value compensation) adjustments by specifying whether the Exposure Compensation button must be pressed while adding or extracting EV compensation. Because of the possibility of confusion or error, I tend to leave this setting turned off, which is the default. Your choices are as follows:

■ On (Auto reset). This setting allows you to add or subtract exposure by rotating the subcommand dial when in Program (P) or Shutter-priority (S) exposure modes, or by rotating the main command dial when using Aperture-priority (A) mode. Rotating either dial has no effect in Manual (M) exposure mode. (If you've reversed the behavior of the command dials using Custom Setting f8, the "opposite" command dial must be used to make the changes.) Any adjustments you've made are canceled when the camera is shut off, or the meter-off time expires and the Z6's exposure meters go back to sleep. That's a useful mode, because most of us have made an EV adjustment and then forgotten about it, only to expose a whole series of improperly exposed photos. You can still have "sticky" EV settings when Easy Exposure Compensation is turned on: just hold down the Exposure Compensation button when you make your changes. You can also increase the standby timer interval (using Custom Setting c3, described shortly) to a longer period so your adjustment will remain in force for a longer period of time.

- On. This setting brings the Easy Compensation mode into conformance with the Z6's behavior when the Exposure Compensation button is pressed: in either case, any EV modifications you make will remain until you countermand them. As I have mentioned several times, forgetting to "turn off" EV changes after you've moved on to a different shooting environment is a primary cause of over- and underexposure among those of us who are forgetful or who ignore the Z6's flashing EV warnings.
- Off. With this default setting, you must always press the Exposure Compensation button while rotating the main command dial to add or subtract exposure. Use this choice when you don't want any EV changes unless you deliberately make them by pressing the button.

b3 Center-Weighted Area

Options: 12mm (default), Average

My preference: 12mm

This setting changes the size of the Center-weighted exposure spot. Your choices include 12mm or full-frame average (which turns the metering mode from a center-weighted system to an old-fashioned averaging system). Check out Figure 4.6 in Chapter 4 to see the approximate area of the coverage. Note, if you're migrating from F-mount, some Nikon dSLRs allow you to change the size of the Center-weighted spot, but the Z6 gives you only the 12mm and full-screen averaging options. The spot is "fuzzy" anyway, and I've found changing the size really has very little effect most of the time.

b4 Fine-Tune Optimal Exposure

Options: Default (none), Plus or minus one stop in 1/6-stop increments for: Matrix metering, Center-weighted metering, Spot metering, Highlight-weighted metering

My preference: N/A

This setting is a powerful adjustment that allows you to dial in a specific amount of exposure compensation that will be applied, invisibly, to every photo you take using each of the four metering modes. No more can you complain, "My Z6 always underexposes by 1/3 stop!" If that is actually the case, and the phenomenon is consistent, you can use this custom menu adjustment to compensate.

Exposure compensation is usually a better idea (does your camera *really* underexpose that consistently?), but this setting does allow you to "recalibrate" your Z6 yourself. However, you have no indication that fine-tuning has been made, so you'll need to remember what you've done. After all, you someday might discover that your camera is consistently *over*exposing images by 1/3 stop, not realizing that your Custom Setting b4 adjustment is the culprit.

In practice, it's rare that the Nikon Z6 will *consistently* provide the wrong exposure in any of the four metering modes, especially Matrix metering, which can alter exposure dramatically based on the Z6's internal database of typical scenes. This feature may be most useful for Spot metering, if you always take a reading off the same type of subject, such as a human face or 18 percent gray card. Should you find that the gray card readings, for example, always differ from what you would prefer, go ahead and fine-tune optimal exposure for Spot metering, and use that to read your gray cards. To use this feature:

- 1. **Select fine-tuning.** Choose Custom Setting b4: Fine-tune Optimal Exposure from the Custom Settings menu.
- 2. **Consider yourself warned.** In the screen that appears, choose Yes after carefully reading the warning that Nikon insists on showing you every time this option is activated.
- 3. **Select metering mode to correct.** Choose Matrix, Center-weighted, Spot, or Highlight-weighted metering in the screen that follows by highlighting your choice and pressing the multi selector right button. (See Figure 12.6, left.)
- 4. **Specify amount of correction.** Press the up/down buttons to dial in the exposure compensation you want to apply. You can specify compensation up to +/- one stop, in increments of 1/6 stop, half as large a change as conventional exposure compensation. Compensation of up to one full stop (plus or minus) can be entered. This is truly *fine-tuning*. (See Figure 12.6, right.)
- 5. **Confirm your change.** Press OK when finished. You can repeat the action to fine-tune the other exposure modes if necessary.

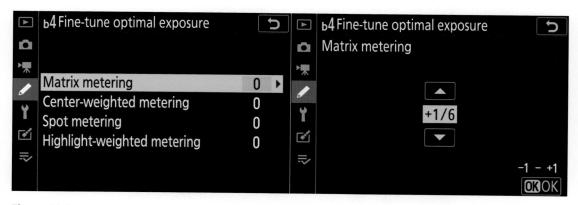

Figure 12.6 You can fine-tune any of four metering modes (left). Increments of 1/6 stop are available (right).

c. Timers/AE Lock

This category (see Figure 12.7) is a mixed bag of settings, covering how the shutter release and AE-L buttons interact (c1) and entries that adjust delay times (c2 and c3).

c1 Shutter-Release Button AE-L

Options: Off (default), On (half press), On (burst mode)

My preference: On when using back button focus, as described in Chapter 5

This is another of Nikon's easily confusing options for controlling how and when autofocus and exposure are activated and locked. The intent is to allow you to separate autofocus and autoexposure activation and locking.

- **Off.** Exposure is locked *only* when the defined AE-L/AF-L button is pressed. This is the default. The shutter release does not lock exposure.
- On (half press). Exposure locks when either the shutter release button is depressed *halfway* or the designated AE-L/AF-L button is held down. If you always want exposure locked when the shutter release is pressed halfway, use this option. That makes the most sense when you are using back button focus.
- On (burst mode). Exposure locks when the shutter release button is pressed down all the way. You'd do this during continuous shooting, when you press the shutter release and hold it down while your series of shots is captured. This option locks the exposure for the first image, ensuring that all the other images in the sequence are given the same exposure.

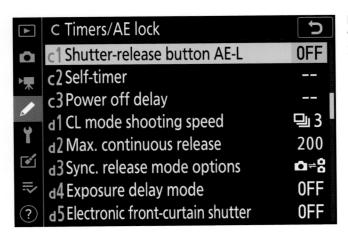

Figure 12.7The Timers/AE
Lock settings.

c2 Self-Timer

Options: Self-timer Delay (Default: 10 sec.), Number of Shots (Default: 1), Interval Between Shots (Default: 0.5 sec.)

My preference: N/A

This setting lets you choose the length of the self-timer shutter release delay.

Your options include:

- Self-timer delay. The default value is 10 seconds. You can also choose 2, 5, or 20 seconds. If I have the camera mounted on a tripod or other support and am too lazy to attach the MC-DC2 cable release (I have three, one for each camera bag, so I *always* have one available), I can set a 2-second delay that is sufficient to let the camera stop vibrating after I've pressed the shutter release. I use a longer delay time if I am racing to get into the picture myself and am not sure I can make it in 10 seconds.
- Number of shots. After the timer finishes counting down, the Z6 can take from 1 to 9 different shots. This is a godsend when shooting photos of groups, especially if you want to appear in the photo itself. You'll always want to shoot several pictures to ensure that everyone's eyes are open and there are smiling expressions on each face. Instead of racing back and forth between the camera to trigger the self-timer multiple times, you can select the number of shots taken after a single countdown. For small groups, I always take at least as many shots as there are people in the group—plus one. That gives everybody a chance to close their eyes.
- Interval between shots. If you've selected 2 to 9 as your number of shots to be snapped off, you can use this option to space out the different exposures. Your choices are 0.5 seconds, 1, 2, or 3 seconds. Use a short interval when you want to capture everyone saying "Cheese!" The 3-second option is helpful if you're using flash, as 3 seconds is generally long enough to allow the flash to recycle and have enough juice for the next photo.

c3 Power Off Delay

Options: Separate settings for Playback, Menus, Image Review, Standby Timer My preference: Varies

You can adjust the amount of time the control panel and camera EVF/LCD monitor displays remain on when no other operations are being performed. If the EH-7P Charging AC adapter is attached, the displays will remain on for the maximum amount, about 10 minutes. With the Z6, you can specify separate values for Playback (the default is 10 seconds); Menus (the default is 1 minute); Image review (default 4 seconds); and Standby Timer (default 30 seconds). Choosing a brief duration for all or each of these can help preserve battery power. However, the Z6 will always override the review display when the shutter button is partially or fully depressed, so you'll never miss a shot because a previous image was on the screen.

Sports shooters and some others prefer a longer delay, because they can keep their camera always "at the ready" with no delay to interfere with taking an action shot that unexpectedly presents itself. Extra battery consumption is just part of the price paid. For example, when I am shooting football, a standby timer of 20 seconds is plenty, because the players lining up for the snap is my signal to get ready to shoot. But for basketball or soccer, I typically set the standby timer for 30 minutes, because action is virtually continuous. My Z6 has plenty of power, and I carry two sets of spare batteries. I rarely shoot much more than 1,000 to 1,200 shots at any sports event, so that's often sufficient juice even with the standby timer set for 30 minutes or No Limit. The displays dim for a few seconds before the standby timer expires. Of course, if the standby timer has shut off, and the power switch remains in the On position, you can bring the camera back to life by tapping the shutter button.

d. Shooting/Display

This menu section (see Figure 12.8) offers a variety of mostly unrelated shooting and display options not found elsewhere, but which are not frequently changed, making them suitable for a Custom Settings entry. The figure shows only the first eight entries; you must scroll down to see the last three.

d1 CL Mode Shooting Speed

Options: 1–5 fps (default: 3 fps)

My preference: Varies

You can specify the frames per second shooting rate for Continuous (Low) speed mode from 1 frame per second to 5 frames per second. Faster rates are better for sports action, such as the image shown in Figure 12.9.

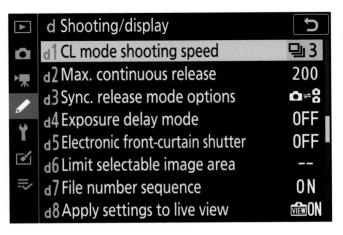

Figure 12.8
A mixed bag of entries is found in the Shooting/
Display submenu.

Figure 12.9 High frame rates can capture a critical moment when shooting sports action.

Choose one of these firing speed ranges for Continuous (Low) from among those available that is suitable for the kind of shooting environment you're in:

- Normal continuous shooting. I set my Z6 to the 1 fps rate most of the time, so that I can take multiple shots quickly without needing to press the shutter release repeatedly. A one-second rate isn't so fast that I end up taking a bunch of shots that I don't want, but it is fast enough that I can shoot a series.
- **Bracketing.** When I'm using bracketing, I generally have the Z6 set to shoot a bracketed set of three pictures: under, normal, and overexposure. With the camera set to 3 fps, I can press the shutter once and take all three bracketed shots, with basically the same framing, within about one second.
- HDR bracketing. On the other hand, if you're bracketing to combine individual images in an image editor to produce a high dynamic range photo, you'll want the exposures to be captured as quickly as possible. That will minimize any differences between the images, so they can be more easily aligned as they are merged.

- Slower action sequences. The 9 fps rate available for sports photography in Continuous High (Extended) mode often produces an embarrassing plethora of pictures that are a pain to wade through after the event is over. For some types of action, such as long-distance running, golf, swimming, or routine baseball plays, a rate of 3 to 5 fps might be sufficient. You can make this more reasonable speed available by defining it here as the continuous low speed frame rate.
- Faster action sequences. You can specify higher frame rates, up to 5 fps when you want to grab more images in a brief burst. However, in most cases, you'll use Continuous Extra High mode for this type of photography. Dialing in a slightly slower speed here makes it easy to switch back and forth between high (5 fps) and higher (9 fps) just by changing the release mode dial from Continuous Low to Continuous High (Extended).

d2 Max. Continuous Release

Options: 1-200 shots; default 200

My preference: 200 shots

Use this setting to limit the number of consecutive shots that can be taken in one burst when using continuous shooting modes. Your choices are any value between 1 and 200. Realistically, if you're shooting TIFF, Uncompressed 14-bit NEF, or RAW+JPEG, it's quite unlikely that the Z6 will actually *take* as many shots as you specify here if you hold down the shutter button long enough. As your camera's relatively small buffer fills, continuous shooting will slow down and eventually pause while the Z6 dumps pictures to the memory card. The Z6's built-in memory buffer (which stores each shot until it is written to the XQD card) will fill up somewhere between 18 and 25 shots and your capture rate will slow down. Your buffer may fill even more quickly when shooting in JPEG Extra Fine format, when Auto Distortion Control is active, or at higher ISO settings (the extra step of noise reduction is being applied). Before you curse Nikon for providing such a small buffer, keep in mind that the camera captures 46 MP images. It must convert them from the original analog signal to digital, and create a JPEG file and/or NEF (RAW) version before shuttling them through the buffer and onto your memory card. The speeds you do get are impressive enough.

Indeed, as your buffer fills, continuous shooting will slow down drastically and eventually pause while the Z6 dumps pictures to the memory card. (Use of the electronic shutter, described shortly, also reduces continuous frame advance rates.) If you find yourself waiting for the memory card to store images during continuous shooting, you might want to set a lower number, say, 30 images, so you don't have so many pictures stacked up that you're unable to continue with a subsequent shot.

Note: If you have your heart set on shooting endless sequences, you can do so. Just use any shutter speed of 4 seconds or slower in Shutter-priority or Manual exposure modes. The frame rate for such exposures will be so slow that it's effectively impossible to fill the Z6's buffer, and your camera will happily poke along capturing images for as long as you hold down the shutter release button. Whatever Maximum Continuous Release value you've set will be ignored.

Tip

If you have unwanted shots (say, you're shooting sports and you just shot a play that's a deadend, pictorially), you may be in a hurry for a full buffer to clear. Don't panic! With the fastest available XQD cards, a full buffer will finish its dump about five seconds after you stop shooting. (It's able to do this because, as I noted earlier, the Z6's buffer is actually a little on the skimpy side, at least for a camera with a 9 fps maximum burst rate.) So, stop, wait a few seconds, and resume shooting. The old ploy of holding down the Trash button while turning the camera off to clear the buffer wouldn't really save you much time.

d3 Sync. Release Mode Options

Options: Sync (default), No Sync

My preference: N/A

If you own multiple compatible Nikon cameras equipped with optional WR-1 or WR-R10 wireless remote controllers, you can configure them such that they all fire at the same time. One camera acts as a master, which controls the shutter release of the additional cameras. Sports photographers love this capability, because they can install remote cameras, say, above a basketball rim, and then position themselves along the baseline to shoot action in the paint. One click of the master camera produces shots from both angles simultaneously. (This is basically how I cover basketball games, except for the part about having a second, remote-controlled camera mounted high above the rim.)

This is a rather esoteric feature, available only to those who own, say, two or more Nikon Z6, D850, D850, or D5 cameras. Synchronized release is also available with some other models, including the D4 and D4s equipped with the optional WT-5 wireless transmitter. You can use this entry to activate or deactivate the feature, but it's probably a better idea to use Custom Setting f2 and assign Sync. Release Selection to a control, such as the Fn 1 button.

d4 Exposure Delay Mode

Options: 3, 2, 1, 0.5, 0.2 seconds, Off (default)

My preference: Off

This is a marginally useful feature (and mildly annoying if you forget to turn it off) that you can use to force the Nikon Z6 to snap a picture about 0.2, 0.5, 1, 2, or 3 seconds (your choice) after you've pressed the shutter release button all the way. It's useful when you are using shutter speeds of about 1/8th to 1/60th second hand-held and want to minimize the effects of the vibration that results when you depress the shutter button. It can also be used when the camera is mounted on a tripod, although the self-timer function, set to a two-second delay, is more useful in that scenario. When switched On, the camera will pause while you steady your steely grip on the camera, taking the picture about one second later. When turned Off, the picture is taken when the shutter release is pressed, as normal.

One interesting side-effect of this mode is that it separates the normally invisible pre-flash produced by any Z6's external flash that's connected with the delay. That can have an unwanted side-effect. For example, if you're shooting living subjects (human or animal), and set the delay for one second, your subject may be startled by the initial flash and close their eyes just before the main flash fires 1,000 milliseconds later. Longer delays can produce incorrect exposures if you happen to accidentally (or intentionally) reframe or pan during the interval between when the pre-flash fires (and the Z6 calculates exposure) and the moment when the shutter opens/flash fires to take the actual picture.

d5 Electronic Front-Curtain Shutter

Options: Enable, Disable (default)

My preference: Disable

Your Nikon Z6 has an electronic front-curtain shutter that can be used to commence an exposure without the need for the (potentially) vibration-causing physical shutter curtain. Your e-curtain is available only when you're using a shutter speed of 1/2,000th second or slower, and an ISO setting of 25600 or lower.

In use, the Z6 "dumps" the current image display on the EVF or LCD monitor, then begins exposure. The camera's mechanical rear-curtain shutter terminates the exposure. So, while the electronic front-curtain shutter is quieter, this mode isn't totally silent. Its chief benefit is avoiding a tiny amount of vibration that can occur from "shutter bounce." (The mechanical front curtain isn't totally damped after it descends.) If you really want to avoid any possibility of shutter vibration, choose the 0.2-second setting in Custom Setting d4: Exposure Delay Mode, described above.

For true silent operation, use the Silent Photography setting in the Photo Shooting menu, described in Chapter 11. With Silent Photography you can use any shutter speed—but cannot use flash (or long exposure noise reduction). In addition, the camera's beep speaker is automatically turned off and your continuous-shooting frame rate will change. With the electronic front-curtain shutter, you can use flash, but have that 1/200th second top shutter speed limitation, and your beeper will sound if enabled.

I explained front- and rear-curtain shutter components in more detail in Chapter 9.

d6 Limit Selectable Image Area

Options: All available (default); Individually disable DX, 1:1, or 16:9 formats

My preference: FX, DX, and 16:9 only enabled

The Z6 may provide you with more image area formats than you ever need—but it also gives you the ability to make any of them (except the full-frame FX choice) invisible.

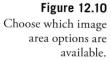

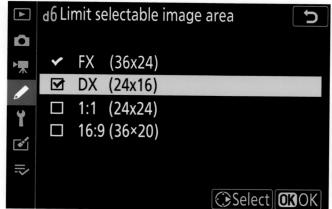

Disabling or enabling one or more image area options is easy. Highlight any format (except FX, which cannot be disabled) and press the right directional button to mark or unmark your choice. (See Figure 12.10.) You must press OK to confirm. (If you exit the screen in any way, say, by tapping the shutter button or pressing the left directional button, your changes will not be saved.) I don't use 1:1 image area much, so I disable it. I sometimes shoot in DX mode for sports to capture more compact 19.5 MP images with the DX format's 1.5X field-of-view crop. When I am taking stills to use for movie storyboards, I prefer to shoot them using the same high-definition 16:9 proportions that the movie will be captured in, so I keep that available.

The image areas you specify can be selected using the Choose Image Area entry of the Photo Shooting and Movie Shooting menus. If you mount a Nikon F-mount DX (APS-C type) lens on the Z6 using the FTZ adapter, the camera *automatically* switches to DX mode (giving you an image with only 10 megapixels of resolution); indeed, the Choose Image Area options are not available. Unfortunately, that means you can't manually change to FX mode for those lenses (some of them do cover the full frame at certain focal lengths). But when working with both Z-mount and F-mount full-frame lenses, you can choose one of the cropped image areas; the camera will enlarge the DX crop to fill the display and add black bars at top, bottom, or sides (as appropriate) to provide a visual reference for the other crops. (That's a distinct advantage this mirrorless camera has over its dSLR siblings, which must use a mask to show the image area when using the optical viewfinder.)

d7 File Number Sequence

Options: On (default), Off, Reset

My preference: On

The Nikon Z6 will automatically apply a file number to each picture you take, using consecutive numbering for all your photos over a long period of time, spanning many different memory cards, starting over from scratch when you insert a new card or when you manually reset the numbers. Numbers are applied from 0001 to 9999, at which time the Z6 "rolls over" to 0001 again.

The camera keeps track of the last number used in its internal memory and, if File Number Sequence is turned On, will apply a number that's one higher, or a number that's one higher than the largest number in the current folder on the memory card inserted in the camera. You can also start over each time a new folder has been created on the memory card, or reset the current counter back to 0001 at any time. Here's how it works:

- On. At this default setting, the Z6 will use the number stored in its internal memory any time a new folder is created, a new memory card is inserted, or an existing memory card is formatted. If the card is not blank and contains images, then the next number will be one greater than the highest number on the card *or* in internal memory (whichever is higher).
- Off. If you're using a blank/reformatted memory card, or a new folder is created, the next photo taken will be numbered 0001. File number sequences will be reset every time you use or format a card, or a new folder is created (which happens when an existing folder on the card contains 5,000 shots).
- Reset. The Z6 assigns a file number that's one larger than the largest file number in the current folder, unless the folder is empty, in which case numbering is reset to 0001. At this setting, new or reformatted memory cards will always have 0001 as the first file number.

HOW MANY SHOTS, REALLY?

The file numbers produced by the Z6 don't provide information about the actual number of times the camera's shutter has been tripped—called actuations. For that data, you'll need a third-party software solution, such as the free Opanda iExif (www.opanda.com) for Windows or the non-free (\$39.95) GraphicConverter for Macintosh (www.lemkesoft.com). These utilities can be used to extract the true number of actuations from the Exif information embedded in a JPEG file.

d8 Apply Settings to Live View

Options: On (default), Off

My preference: On, except when using studio flash

This entry tells the Z6 to provide a preview in the EVF and LCD monitor displays that reflects how your current settings of white balance, Picture Controls, and exposure compensation will affect your image when the photo is actually taken. It's a good way to preview the "look" of your image as it is adjusted by your selected settings. In Manual exposure mode, you will even be able to preview how your *exposure* will change the image; the displays will actually lighten or darken to reflect exposure changes. Sounds like a good idea, right?

However, there are times when you don't want to see the effects of the settings you've made on the screen/EVF. For example, when you are using flash in Manual exposure mode, the camera has no way of knowing exactly how much light will be illuminating your scene. You'll especially want to change this setting to Off when working with "dumb" studio strobes connected using a hot-shoe adapter with an old-school PC/X connector. After all, that f/16 aperture may be ideal for a shot exposed by your studio strobes, but the Z6 will, when this entry is set to On, show you a preview based on the ambient light, rather than the flash. The result? Your viewfinder or LCD monitor image is very, very dim. You'll want to select Off so the camera will display the electronic image to viewable levels.

However, in all other cases, at the default On setting, display in the EVF or the LCD monitor reflects the *exact* effects of any white balance, Picture Control, or exposure compensation settings you've made. In that mode, this allows for an accurate evaluation of what the photo will look like and enables you to determine whether the current settings will provide the effects you want.

The On option can be especially helpful when you're using any of the Picture Controls, because you can preview the exact rendition that the selected effect and its overrides will provide. It's also very useful when you're setting some exposure compensation, as you can visually determine how much lighter or darker each adjustment makes the image. And when you're trying to achieve correct color balance, it's useful to be able to preview the effect of your white balance setting.

If you'd like to preview the image *without* the effect of settings visible, you can set this feature to Off. Naturally, the display will no longer accurately depict what your photo will look like when it's taken. So, for most users, On is the most suitable option. Unfortunately, this setting has caused more than a few minutes of head-scratching among new users who switch to Manual exposure mode and find themselves with a completely black (or utterly white) screen. The black screen, especially, may fool you into thinking your camera has malfunctioned.

d9 Framing Grid Display

Options: On, Off (default)

My preference: Off

This entry is the first on the last page of the Shooting/Display menu (see Figure 12.11). The Z6 can display a grid of lines overlaid on the viewfinder, offering some help when you want to align vertical or horizontal lines, particularly for architectural or scenic photography. Note that the intersections of these lines do *not* follow the Rule of Thirds convention, and so are less useful for composition, assuming you want to follow the Rule of Thirds guideline in the first place. If you happen to subscribe to the Rule of Quarters, you're all set. Your options for this grid display are On and Off (the default).

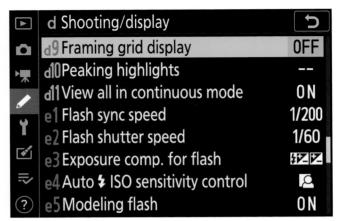

Figure 12.11
Last page of the Shooting/Display menu.

d10 Peaking Highlights

Options: Peaking Level: Off (default), Low, Standard, High; Peaking Color: Red (default), yellow, blue, white

My preference: N/A

Focus peaking is a focusing aid available to provide colored highlights around the edges of objects as they come into sharp focus. You can choose from among red, yellow, blue, or white. If your subject has a predominant color, you should select a peaking color that contrasts. For example, you might want to use yellow as your peaking tone when photographing red roses. You can change the Peak Level (sensitivity) to low, standard, or high. I explained how to use focus peaking and showed you what it looks like in action in Chapter 5.

d11 View All in Continuous Mode

Options: On (default), Off

My preference: On

This setting lets you specify whether full-frame playback is used during burst shooting live view when shooting with Continuous Low, Continuous High, and Quiet Continuous. If you select Off, the monitor playback display and the monitor backlight are turned off during continuous exposures.

e. Bracketing/Flash

There are lots of useful settings in this submenu (see Figure 12.12) that deal with bracketing and electronic flash (hence the cleverly concocted name). I provided a thorough description of using bracketing in Chapter 4, and a complete rundown of flash options in Chapters 9 and 10. In this section, I'll offer a recap of the settings at your disposal.

e1 Flash Sync Speed

Options: 1/200 s (Auto FP), 1/200 s-1/60 s (default 1/200th s)

My preference: 1/200 s (Auto FP)

As you learned in Chapter 9, the focal plane shutter in the Nikon Z6 must be fully open when the external flash fires; otherwise, you'll image one edge or the other of the vertically traveling shutter curtain in your photo. Ordinarily, the fastest shutter speed during which the shutter is completely open for an instant is 1/200th second. However, there are exceptions when you can use faster shutter speeds with certain flash units (such as the Nikon SB-5000, SB-910, SB-700, and SB-R200) for automatic FP (focal plane) synchronization. This is called *high-speed sync* (usually abbreviated HSS). The HSS feature allows you to use higher shutter speeds to supply fill flash, say, outdoors, where a shutter speed of 1/500th second might be needed to enable a wider aperture for reduced depth-of-field.

There are also situations in which you might want to set flash sync speed to *less* than 1/200th second, say, because you *want* ambient light to produce secondary ghost images in your frame. (I'll describe all these sync issues in Chapter 9.)

Figure 12.12 Bracketing and flash options are available in this menu.

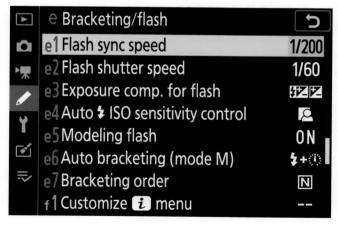

To address your choice of flash sync speeds, you can choose from the following settings:

- 1/200 s (Auto FP). At this setting, you may use individual shutter speeds up to 1/200th second with any Nikon flash. However, you can also use *faster* shutter speeds with flash units compatible with high-speed sync (such as those mentioned above). If one of those units is mounted and powered up:
 - P or A mode: The camera selects the shutter speed in both Program and Aperture-priority modes. With an HSS-compatible flash attached, the camera is free to select a shutter speed as fast as 1/8,000th second.
 - **S or M mode:** In these modes, *you* select the shutter speed, and you can select one as fast as 1/8,000th second in high-speed sync mode.
- 1/200 s-1/60 s. You can specify a shutter speed from 1/200th second to 1/60th second to be used as the synchronization speed for flash units.

LOCKING FLASH SYNC

If you want to lock the shutter speed at the maximum sync speed you've specified, rotate the main control dial to choose the xnnn setting located after the 30 s, Bulb, and Time speeds. If you've chosen 1/200 (Auto FP), that setting will display x200; If you've used the 1/200 s–1/60 s option, the lock speed, the setting will be locked at x200 to x60.

e2 Flash Shutter Speed

Options: 1/60th second (default) to 30 seconds

My preference: 1/60th second

This setting determines the *slowest* shutter speed that is available for electronic flash synchronization in the PASM exposure modes when you're not using a "slow sync" mode (described in Chapter 9). As you may know, when you're using flash, the flash itself typically provides virtually all of the illumination that makes the main exposure, and the shutter speed determines how much, if any, of the ambient light contributes to that second, non-flash exposure. Indeed, if the camera or subject is moving, you can end up with two distinct exposures in the same frame: the sharply defined flash exposure, and a second, blurry "ghost" picture created by the ambient light.

If you *don't* want that second exposure, you should use the highest shutter speed that will synchronize with your flash. This setting prevents Program or Aperture-priority modes (which both select the shutter speed for you) from inadvertently selecting a "too slow" shutter speed. You can select a value from 30 s to 1/60 s, and the Z6 will *avoid* using speeds slower than the one you specify with electronic flash (unless you've selected slow sync, slow rear-curtain sync, or red-eye reduction with slow sync, as described in Chapter 9). The "slow sync" modes do permit the ambient light to contribute to the exposure (say, to allow the background to register in night shots, or to use the ghost

image as a special effect). For brighter backgrounds, you'll need to put the camera on a tripod or other support to avoid the blurry ghosts that can occur from camera shake, even if the subject is stationary.

If you are able to hold the Z6 steady, a value of 1/30 s is a good compromise; if you have shaky hands, use 1/60 s. Those with extraordinarily solid grips, a tripod, or a lens with vibration reduction can try the 1/15 s setting (or slower when using a tripod). Remember that this setting only determines the *slowest* shutter speed that will be chosen by the camera, not the default shutter speed.

e3 Exposure Compensation for Flash

Options: Entire Frame (default), Background Only

My preference: Background Only

Use this to specify how the camera modifies the flash level when you apply exposure compensation. Keep in mind that your Z6 has separate ambient light exposure compensation and flash exposure compensation settings. They enable you to adjust one or the other, or both if you are using flash. If you remember that, you'll know that this setting affects only *exposure compensation* (the ambient kind) when you are also using flash. It determines how ambient exposure compensation is applied when some of the illumination will also come from a flash unit:

- Entire frame. When you apply ambient exposure compensation (press the EV button on top of the camera to the right of the ISO button and rotate the main command dial), both ambient and flash exposure compensation are adjusted over the entire frame. That balances the exposure for the two elements. While this works in many situations, you may find that with backgrounds and subject matter that differ widely in brightness, your results may be less than optimum.
- **Background only.** When this option is selected *only* ambient exposure compensation is changed when you apply it; flash exposure compensation is unaffected. So, exposure compensation is applied only to the background areas of your image, which are typically illuminated by ambient light. Flash exposure compensation is not affected, but can be set separately. I prefer to use this setting and control each type of exposure compensation myself.

e4 Auto Flash ISO Sensitivity Control

Options: Subject and background (default), Subject only My preference: Subject and background

This setting allows you to customize how Auto ISO sensitivity control makes its adjustments. If you choose Subject and Background, the Z6's exposure meters will take into account both your subject matter and the background, and set the flash output for a level that is more likely to balance both. If you find a disparity between foreground and subject exposures, you can use Custom Setting e3 (above), select Background Only, and tweak exposure for foreground and background separately.

e5 Modeling Flash

Options: On (default), Off

My preference: On

The Nikon Z6, and certain compatible external flash units (like the SB-5000, SB-700, and SB-910/SB-900) have the capability of simulating a modeling lamp, which gives you the limited capability of previewing how your flash illumination is going to look in the finished photo. The modeling flash is not a perfect substitute for a real incandescent or fluorescent modeling lamp, but it does help you see how your subject is illuminated, and spot any potential problems with shadows.

When this feature is activated, pressing the button you have defined as the Preview (depth-of-field) button on the Z6 briefly triggers the modeling flash for your preview. (You can define a Preview button using Custom Setting f2: Custom Control Assignment, as described later in this chapter. The Z6, by default, does not have a depth-of-field preview control.)

Selecting Off disables the feature. You'll generally want to leave it On, except when you anticipate using the depth-of-field preview button for depth-of-field purposes (imagine that) and do *not* want the modeling flash to fire when the flash unit is charged and ready. Some external flash units, such as the SB-5000 and SB-910, have their own modeling flash buttons.

e6 Auto Bracketing (Mode M)

Options: Flash/speed (default), Flash/speed/aperture, Flash/aperture, Flash only **My preference:** Flash/speed

When you are using Manual exposure mode, the Z6 allows you to specify what exposure parameters—flash output, shutter speed, and aperture—are used to create the bracketed images. Here are your options, and reasons to select each of them. Remember that these apply only when you are bracketing in Manual exposure mode.

- Flash/speed. If you've selected AE Only in Auto Bracketing Set in the Photo Shooting menu, the camera will adjust only the shutter speed during bracketed exposures. If you selected AE & Flash, instead, the camera will also adjust the flash output level when flash is used. The aperture will remain the same, making this a good choice for HDR photos, or other subjects where you want to keep the same amount of depth-of-field in successive shots.
- Flash/speed/aperture. The camera can use both shutter speed and aperture when AE Only is selected, plus flash output level if AE & Flash was selected and flash is used. This gives the Z6 the maximum amount of flexibility in choosing exposure parameter combinations. That's especially helpful when shooting bracket sequences of 7 or 9 shots (and/or with large increments, say, 3 stops, between shots). That's because such extreme adjustments in exposure may be difficult to achieve with only one or two parameters available—particularly when ambient light only is being bracketed. (The flash is able to adjust its output over a very wide range.)

- Flash/aperture. The Z6 varies aperture only if AE Only is specified, or aperture and flash output if AE & Flash is selected in the Photo Shooting menu. Your selected shutter speed remains the same, so you would want to use this if retaining the same shutter speed is important (say, when shooting sports).
- Flash only. The camera varies the flash output only when AE & Flash is active. No ambient light bracketing is done.

e7 Bracketing Order

Options: MTR > Under > Over (default), Under > MTR > Over

My preference: Under > MTR > Over, which orders frames by increasing exposure

Use this setting to define the sequence in which bracketing is carried out. Your choices are the default: MTR > Under > Over (metered exposure, followed by the version receiving less exposure, and finishing with the picture receiving the most exposure) and Under > MTR > Over, which orders the exposures from least exposed to most exposed (for both ambient and flash exposures). The same order is applied to white balance bracketing, too, but the values are Normal > More Yellow > More Blue and More Yellow > Normal > More Blue. (Nikon actually calls "yellow" by the term "amber," but I've found "yellow" easier to understand.)

This order works well if you are shooting at least three images in your sequence. If you set bracketing to just two exposures, the specified order is used, but one of the three is omitted. You'll find lots more about bracketing in Chapter 4. When doing ADL bracketing with the Z6, this setting has no effect.

f. Controls

You can modify the way various control buttons and dials perform when shooting still photos by using the options in this submenu. You can even modify the twelve adjustments that appear in the *i* menu. The seven Controls entries are shown in Figure 12.13. Note that you can also make some control adjustments for Movie mode, and I'll cover those in the section that follows this one.

f1 Customize i Menu

Options: Allows defining functions available from the i menu, including the 19 additional functions that you can use to replace or add to the 12 provided in the default version of the i menu.

My preference: Varies

If you've used previous Nikon cameras, you've probably noticed that the Z6 has fewer dedicated buttons than some of its stablemates. The D850, for example, has dedicated buttons for flash, image size/quality, metering mode, depth-of-field preview, bracketing, white balance, and focus modes, plus Help, Protect, and Picture Control functions. While two of these (white balance and focus

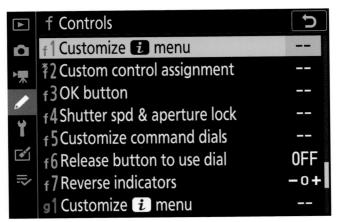

Figure 12.13 Modify the behavior of the Z6's controls with these menu options.

modes) are assigned to the Z6's pair of function buttons (Fn1 and Fn2), others are available only from the traditional menus or the i menu.

The bad news is that the 12 default entries on the *i* menu may not be ones you use often. I don't use the Z6's wireless functions or Active D-Lighting feature very often, and when I do I am willing to dive into Menuland to implement them. The rest of the time, those two functions are a waste of *i* menu real estate. The good news is that if you would rather have some other tools available in the *i* menu, there's a good chance you can replace your own "useless" *i* menu entries with those that are more to your liking. Your choices follow.

These 12 entries occupy the *i* menu by default. You can choose to keep these, move them, or replace them with other functions:

- Set Picture Control
- Image Quality
- Flash Mode
- Wi-Fi Connection
- Release Mode
- AF-area Mode

- White Balance
- Image Size
- Metering Mode
- Active D-Lighting
- Vibration Reduction
- AF/MF Focus Mode

These definable functions are already available using other direct controls on the camera. Note that White Balance, AF/MF Focus Mode, and AF-area mode buttons duplicate functions already on the default *i* menu roster. That means you can replace a redundant *i* menu or dedicated button function with another of your choice.

- White Balance (Fn1)
- AF/MF Focus Mode (Fn2+command dial)
- AF-Area Mode (Fn2+sub-command dial)
- AF-ON (AF-ON button)
- Focus Point Selection (Sub-selector joystick)
- AE/AF Lock (Sub-selector button)

These three functions are available from dedicated buttons on the camera, and need not be assigned to the *i* menu or a different button (unless that's your preference):

- ISO Sensitivity
- Exposure Compensation

■ Release Mode

These remaining functions are not, by default, available in the i menu or assigned to dedicated buttons. They are likely to be the best candidates to replace a function you don't use regularly:

- Choose Image Area
- Color Space
- Long Exposure NR
- High ISO NR
- Flash Compensation
- Auto Bracketing
- Multiple Exposure
- HDR
- Silent Photography

- Custom Control Assignment
- Exposure Delay Mode
- Electronic Front-Curtain Shutters
- Apply Settings to Live View
- Split-Screen Display Zoom
- Peaking Highlights
- Monitor/Viewfinder Brightness
- Bluetooth Connection

As noted earlier, I don't use the Wi-Fi Connection and Active D-Lighting functions very often, so I replaced them with Flash Compensation and Multiple Exposure, respectively. It was easy to do:

- 1. Choose f1 Customize *i* menu from the Custom Settings menu. The two default functions I decided to replace are highlighted by the green box at upper left in Figure 12.14.
- 2. Highlight the Wi-Fi connection icon in the top row and press OK. From the screen that appears, scroll to Flash Compensation. Press OK to select and confirm. (See Figure 12.14, upper right.)
- 3. Next, highlight the Active D-Lighting icon in the bottom row and press OK.
- 4. Navigate to the Multiple Exposure function shown in Figure 12.14, lower left, and press OK.
- 5. You'll be returned to the Customize *i* menu screen, with your changes made in the menu, as shown in Figure 12.14, lower right. Note that I placed the Flash Compensation function right next to the default Flash function.

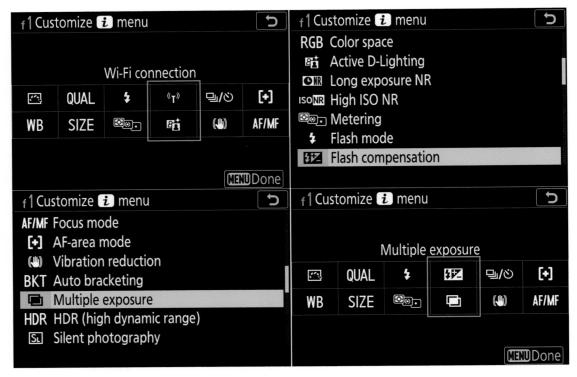

Figure 12.14 Two replaceable functions (upper left); adding Flash Compensation and Multiple Exposure (upper right and lower left); two new functions in place (lower right).

f2 Custom Control Assignment

Options: Allows defining functions for eight separate buttons

My preference: Varies

The programmable buttons are Fn1, Fn2, AF-ON, Sub-selector joystick, Center button of sub-selector, Movie Record, Lens control ring, and Lens Fn. The Lens Fn button is found only on certain Nikon lenses, generally high-end longer lenses, including the 400, 500, 600, and 800mm G and E lenses, the 200-400mm f/4G VR II, 200mm f/2G, and 300mm f/2.8G VR II.

A total of 44 *different* actions can be programmed (plus None—no action), augmenting or *replacing* the button's original function. Always consider the side-effects of choosing your own non-standard control configuration. Your custom settings can be a boon, or if you don't remember the assignments you've made as you work, a hindrance. To apply a definition, highlight the button name on the screen shown at left in Figure 12.15.

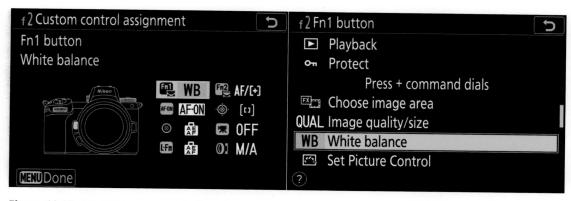

Figure 12.15 Highlight a control (left) and press OK to summon a list of possible definitions (right).

Then scroll through the list of available options, as shown at right in the figure. Some choices in the scrolling list are behaviors that require nothing more than a button press to activate. There are 22 of those in all. Nikon inserts a "Press" header at the start of the listing for those behaviors (AF-ON through Protect). For example, if a button is defined as Preview or Matrix Metering, you simply press and hold the button to activate the depth-of-field preview, or to switch from your current mode to Matrix Metering. When you release the defined button, the preview stops or the camera returns to your previous metering mode.

The other behaviors follow a header that reads "Press+Command Dials." Those options include those listed from "Choose Image Area" to "Choose Non-CPU Lens Number." Behaviors that do use the command dials produce a screen that displays the options for that behavior, plus an icon prompt representing a main or sub-command dial (or both), as seen in Figure 12.16. In that example, you'd press and hold the defined button and rotate the main command dial to change the flash sync mode, and the sub-command dial to add/subtract flash exposure compensation.

Figure 12.16
Some behaviors let you use the command dials for pairs of settings, such as flash mode and flash compensation.

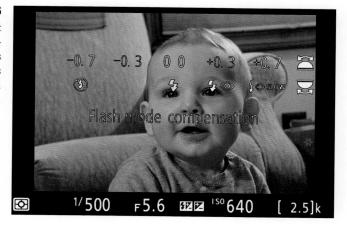

When you've selected the behavior you want, press the OK button to confirm and return to the Custom Control Assignment menu. The possible behaviors make up a complex matrix, so I'm going to present your choices in Table 12.8.

					Sub-			Lens
Buttons	Fn1	Fn2	AF-ON	Sub- selector	selector	Movie Record	Lens Fn	control ring
Default Value	White balance	Focus mode/ AF-area mode	AF-ON	Focus point selection	AE/AF lock	None	AE/AF lock	Manual/ Auto Focus
Functions								
Reset center focus point								
AF-ON								
AF lock only								
AE lock (Hold)								
AE lock (Reset on release)								
AE lock only								
AE/AF lock								
Flash value lock								
Flash disable/ enable								
Depth-of-field preview								
Matrix metering								
Center-weighted metering								
Spot metering								
Highlight- weighted metering								
Bracketing burst								

Buttons	Fn1	Fn2	AF-ON	Sub- selector	Sub- selector center	Movie Record	Lens Fn	Lens control ring
Sync. release selection								
Add NEF (RAW)								
Framing grid display								
Zoom on/off								
MY MENU								
Access top item in My Menu								
Playback								
Protect								
Choose image area								
Image quality/ size								
White balance								
Set Picture Control								
Active D-Lighting								
Metering								
Flash mode/ Compensation								
Focus/mode/ AF-area mode								
Auto bracketing								
Multiple exposure								
High Dynamic Range								

Buttons	Fn1	Fn2	AF-ON	Sub- selector	Sub- selector center	Movie Record	Lens Fn	Lens control ring
Exposure delay mode								
Shutter spd & aperture lock								
Peaking highlights								
Rating								
Choose non- CPU lens number								
Same as multi selector								
Focus point selection								
Focus (Manual/ Auto)								
Aperture								
Exposure compensation								
None								

Assignment: Convenience

The definitions you assign to your controls are highly personal, and should be implemented to reflect the features you will most need to have available at the press of a button or spin of a dial. Remember, that once you re-assign a control from its default value, you must remember it in order to avoid becoming hopelessly confused. You'll no longer be able to loan your camera to another Z6 owner without risking confusing *them* as well.

But wait, there's more! The User Settings represented by the U1, U2, and U3 positions on the mode dial, can each be populated with *their own* separate control settings. So, your Fn1 button might summon the White Balance menu when using U2, but Image Size when using U3 (if you so choose to set up the camera that way). While the Z6 offers, in effect, the ultimate in flexibility in assigning your controls, you may find that having separate control behaviors for, say, sports, landscapes, and movie shooting may not be manageable.

Even so, this section will offer some suggestions on assignments that have been useful to me, and which you might consider for your own control layout.

- Quickly switch to an alternate focus mode or AF-area mode. You might use Auto-area AF most of the time to let the Z6 select a focus point for you, yet quickly switch to Single Point mode while you hold down the defined button. You can then move the focus point around within the frame with the directional controls. The Focus mode/AF-area mode behavior allows you to press a defined button and then rotate the main dial to choose a focus mode with the main command dial, and the AF-area mode with the sub-command dial.
- Switch metering modes. If you use Matrix metering mode most of the time and want to be able to use Spot metering when appropriate, just assign a button to that function.
- **Disable/enable flash.** You can leave your external flash attached and powered up, yet disable it quickly at the press of a defined button. That would allow you to intermingle photos taken by ambient light, and those in which flash illumination is added, on the fly.
- Bracketing burst. This option adds some versatility to exposure, flash, or ADL bracketing by telling the Z6 to take all the exposures in a bracketed set in one burst. You must have activated a bracketing program, as described in Chapter 4. Perhaps you've been shooting bracketed sequences in Single-shot mode (rather than continuous mode) and decide you want to capture an entire set at once. Define a key for the Bracketing Burst function and hold it down. Then, each time you press the shutter release an entire burst will be captured. If the release mode has already been set for a continuous mode or white balance bracketing has been selected, the Z6 will capture all the exposures in the set while the shutter release is held down.
- Add a RAW image while shooting only JPEGs. When the +RAW behavior is specified, pressing the defined key tells the Z6 to shoot an additional RAW image even if the current Image Quality setting is JPEG (only) while the button is held down. That will allow you to capture a NEF image if you think you might need one later, say, to adjust color balance for a picture taken under tricky illumination.
- **Activate the framing grid.** Even if you don't use the alignment grid often, you can define a key to produce it at the press of a button.
- FAQs (Frequently Accessed Quickly). Have a menu entry you need to access quickly—and often? The Fn2 button can be defined to jump to the top item in your My Menu list (as described in Chapter 13), which can be that most-used entry. Or, you can define the Fn2 button to produce the My Menu list, which you can populate with your own personal most-used items.
- Choose Image Area. If you're shooting in FX mode and decide you want to switch to one of the crop modes (perhaps you're shooting sports and need some extra "reach"), a defined button+command dial definition can invoke the image area of your choice. Note that you can enable/disable any of the crop modes (but not FX mode) so that rotating the command dial switches among as many or as few modes as you want. I enable only DX mode when shooting sports, so I can switch quickly from FX to DX and back again.

■ Other frequently used settings. Other button+command dial definitions can let you switch exposure modes, change white balance, access multiple exposure options, or control HDR settings quickly, too.

f3 OK Button

Options: Shooting mode: Reset/Select center focus point (default), Zoom on/off, None; Playback mode: Thumbnail on/off, View histograms, Zoom on/off (default), Choose folder;

My preference: Shooting mode: Reset/Select center focus point; Playback mode: Zoom on/off

There are two groups of options available here, one for use when the camera is in Shooting mode, and another when you're reviewing images in Playback mode. In Shooting mode:

- Reset/Select center focus point. This setting lets you quickly select the center focus point in the viewfinder simply by pressing the multi selector center button.
- Zoom on/off. Use the OK button to zoom in on the area where the current focus point is located. (This would be especially useful for focusing manually.) Press a second time to return to full frame view. Press the right button to select the zoom ratio, from Low Magnification (50 percent), 1:1 (100 percent), and High Magnification (200 percent).
- None. Nothing happens when the OK button is pressed. If you find yourself sloppily pressing the OK button in the heat of the moment while shooting, use this setting to deactivate it and avoid unwanted actions.

In Playback mode:

- Thumbnail on/off. This setting alternates between full-frame and thumbnail playback.
- View histograms. When selected, a larger histogram is displayed while the OK button is pressed.
- **Zoom on/off.** Use the OK button to toggle between full-frame or thumbnail playback (whichever is active) and playback zoom. You can choose Low Magnification, Medium Magnification, and High Magnification.
- **Choose folder.** This mode pops up the folder selection screen. You can highlight a folder and press the OK button again to view the images in that folder.

f4 Shutter Spd & Aperture Lock

Options: Lock Shutter Speed/Aperture on or off (Default: Off for both)

My preference: Varies

There are times when you'll want to lock the shutter speed at a particular value when using Shutter-priority or Manual exposure modes; and times when you want to lock down a particular f/stop when using Aperture-priority or Manual exposure modes. Use this entry to lock the shutter speed

and/or aperture so it can't be changed. I use this most in the studio, when I use Manual exposure and studio lights. Once I've set the exposure for a series of shots, I lock my Shutter Speed/Aperture Lock button and freeze the settings so I don't have to worry about accidentally rotating a command dial.

If you think accessing this menu entry to lock shutter speed or aperture is needlessly complex, you're right. It makes a lot more sense to define a physical button to provide this function, as described earlier under f2: Custom Control Assignment. I assigned the function to the Fn1 button. To lock the shutter speed and/or aperture, I first set either or both to the value I want. Then, I press the Fn1 button and rotate the main command dial to lock/unlock shutter speed, and the sub-command dial to lock/unlock aperture. An L symbol appears next to the locked setting on the top control panel and viewfinder/LCD monitor displays.

Note that when the camera is set to Shutter-priority, you are able to enable/disable only the Shutter Lock function. When set to Aperture-priority, only Aperture Lock is accessible. In Manual exposure mode, you can adjust either one, and in Program mode, neither can be locked.

f5 Customize Command Dials

Options: For main and sub-command dials: Reverse rotation, Change main/sub, Menus and Playback, Sub-dial Frame Advance

My preference: Varies

This menu entry can change the behavior of the command dials. Use the available tweaks to change the behavior of the dials to better suit your preferences, or if you're coming to the Nikon world from another vendor's product that uses a different operational scheme. Keep in mind that redefining basic controls in this way can prove confusing if someone other than yourself uses your camera, or if you find yourself working with other Nikon cameras that have retained the normal command dial behavior. The reason that the dials are set for their default directions is to match the direction of rotation of the aperture ring/sub-command dial (when changing the aperture). Turning any of the three to the left decreases exposure, while rotating to the right increases exposure. Your options include:

■ Reverse rotation. This option allows you to reverse the rotation direction for Exposure Compensation and Shutter Speed/Aperture selection. You can reverse the direction for either or both. By default, rotating the main command dial counterclockwise causes shutter speeds to become shorter in Manual and Shutter-priority modes; rotating the sub-command dial counterclockwise selects larger f/stops. If you want to reverse the directional orientation of the dials (so you'll need to rotate the main command dial clockwise to specify shorter shutter speeds, etc.), put a checkmark in the box next to Shutter Speed/Aperture. To reverse direction for Exposure Compensation, put a checkmark in that box. Uncheck the boxes to return to the original Z6 scheme of things.

- Change main/sub. This option doesn't reverse directions: it swaps the functions of the two dials. You can swap the behaviors of the dials for Exposure Setting, Autofocus Setting, or both.
 - Exposure setting. Choose On, and the main dial will set the aperture in Manual and Aperture-priority modes, and the sub-command dial will adjust the shutter speed in Manual and Shutter-priority modes. (The opposite of the default assignments for these dials.) You can also choose ON (Mode A) and the main command dial will be used to set aperture in Aperture-priority mode *only*. In Manual exposure mode, main command and sub-command dials keep their default shutter speed/aperture assignments (respectively).
 - Autofocus setting. This option works in conjunction with any button you've assigned the Focus mode/AF-area mode function using Custom Setting f2. If you specify On, the focus mode can be selected with the sub-command dial, and AF-area mode with the main command dial.
- Menus and playback. You can change the orientation of the command dials when navigating menus and playback options, too. By default, the main command dial is used to select an image during full-frame playback; move the cursor left or right during thumbnail viewing, and move the menu highlighting up or down. The sub-command dial is used to display additional photo information in full-frame playback, to move the cursor up and down, and to move back and forth between menus and submenus. (Note that you can also use the multi selector directional buttons for these functions.) When set to On or On (Image Review Excluded), the functions assigned to the dials are reversed.
- Sub-dial frame advance. If you've turned the Menus and Playback option to On, you can set the sub-command dial so that while reviewing images in full-frame mode, the Z6 skips ahead either 10 or 50 frames, or allows you to select a folder.

f6 Release Button to Use Dial

Options: Yes, No (default)

My preference: Yes

Normally, any button used in conjunction with a command dial must be held down while the command dial or sub-command dial is rotated. Choose Yes for this option if you want to be able to press the button and release it, and then rotate the command dial. You can continue to make adjustments until the button is pressed again, the shutter release button is pressed halfway, or the standby timer elapses. This option can be applied to these functions:

- Choose Image Area
- Image Quality/Size
- White Balance
- Set Picture Control
- Active D-Lighting
- Metering

- Flash mode/Compensation
- Focus mode/AF-area mode
- Auto Bracketing
- Multiple Exposure
- HDR (High Dynamic Range)
- Exposure Delay Mode

- Shutter Spd & Aperture Lock
- Peaking Highlights
- Choose non-CPU Lens Number
- Microphone Sensitivity

Chose No to return to the Z6's default behavior, which requires that the button be held down while the adjustment is made. I like to use the Yes option and avoid having to remember to hold down a button while I make my changes.

f7 Reverse Indicators

Options: Direction of exposure indicators: -0+ (default), +0- My preference: -0 +

You can change the exposure indicators on the top control panel and information display so that the negative values are shown at the left (-0+) and positive values to the right, or the reverse (+0-). You might want to reverse indicators to match a "foreign" camera system you're coming to the Nikon world from, or, if you use the aperture ring on lenses that have them, to match what happens when the ring is rotated. (Older Nikon lenses have the smallest aperture on the ring to the left, and the largest to the right, so rotating the aperture ring to the right increases exposure; to the left decreases exposure.) The current directional orientation is relatively new, so you might also prefer to reverse the indicators if you're a veteran user of older cameras (Nikon D3s and before) and are disoriented by the change. My oldest camera still in frequent use is a Nikon D3200, and it uses the current scheme, so I've gone with the flow.

g. Movie

This submenu has only six settings, shown in Figure 12.17. Here you can set separately for movie shooting some of the button assignments available for still shooting. You'll find more about movie shooting in Chapters 14 and 15.

Figure 12.17
The Movie Shooting menu.

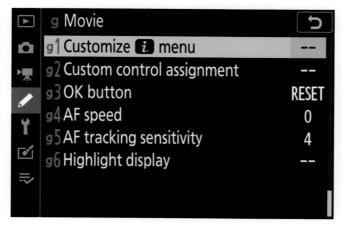

g1 Customize i Menu

Options: Allows defining functions available from the *i* menu. There are 22 different functions that you can use to replace or add to those provided in the default version of the *i* menu that's active in Movie mode.

My preference: Varies

When in Movie mode, the *i* button summons its own version of the *i* menu, with a slightly different collection of settings. The Frame Size/Frame Rate, Choose Image Area, Electronic VR, and Microphone Sensitivity options replace the Image Quality, Flash, Release Mode, and Image Size options available in still shooting mode. You can replace any of the 12 default options using this entry. Your choices include the following (options that already are assigned to buttons are noted):

- Choose Image Area
- Frame Size and Rate/ Image Quality
- Exposure Compensation
- ISO Sensitivity
- White Balance (Fn1)
- Set Picture Control
- Active D-Lighting
- Metering Mode

- AF/MF Focus Mode (Fn2+command dial)
- AF-Area Mode (Fn2+sub-command dial)
- Vibration Reduction
- Electronic VR
- Microphone Sensitivity
- Attenuator
- Frequency Response

- Wind Noise Reduction
- Headphone Volume
- Peaking Highlights
- Highlight Display
- Monitor/Viewfinder Brightness
- Bluetooth Connection
- Wi-Fi Connection

g2 Custom Control Assignment

Options: Definitions for Fn1, Fn2, AF-ON, Sub-selector button, Shutter release, button Lens control ring

My preference: N/A

You can define the action that any of these controls perform when pressed in Movie mode. Keep in mind that these settings are used only when capturing video and that the buttons not listed retain their still photography functions; in live view, the behaviors you've defined for still photography all apply (see Table 12.9).

Table 12.9 Movie Fund	tions					
Buttons	Fn1	Fn2	AF-ON	Sub- selector button	Shutter release button	Lens control ring
Default Value	White Balance	Focus/ AF-area modes	AF-ON	AE/AF Lock	Take photos	Focus (Manual/ Automatic)
Functions						
Power aperture (open)						
Power aperture (close)						
Exposure compensation +						
Exposure compensation –						
Framing grid display						
Protect						
Select Center Focus Point						
AF-ON						
AF lock only						
AE lock (hold)						
AE lock only						
AE/AF lock						
Zoom on/off						
Take photos						
Record movies						
Choose image area						
White Balance						
Set Picture Control						
Active D-Lighting						
Metering Mode						
Focus Mode/AF-area Mode						
Microphone sensitivity						
Peaking highlights						
Rating						
Focus (Manual/Autofocus)						
Power aperture						
Exposure compensation						
None						

g3 OK Button

Options: Allows defining functions for Select center focus point (default), Zoom on/off, Record movies, or None

My preference: Varies

In Movie mode you can redefine the OK button to Select Center Focus Point, Zoom On/Off, or Record Movies, or None.

g4 AF Speed

Options: Autofocusing speed (+/–5) (default: 0), When to Apply (default): Always, Only While Recording

My preference: Varies

The speed with which the Z6 autofocuses takes on a different significance when you're shooting movies, because any AF changes are recorded within the movie itself. You may want focus to change slowly as a scene unfolds and people or objects move within the frame, or the frame itself is recomposed. Or, during action sequences, you might prefer to have AF keep pace with subject and camera changes and focus rapidly. This entry lets you speed up or slow down focus speed in movie mode, using a slider moved via the touch screen or directional buttons. (See Figure 12.18.) The When to Apply option can be set to Always (in which case the camera's autofocus will refocus constantly at the speed you select) or Only While Recording (so the focus speed is changed only when you're actually capturing video). When using AF-F (full-time autofocus) you might prefer normal focusing speed (which is equivalent to +5—as fast as possible) as you compose your shot, and then have the camera switch automatically to a preferred slower speed once you start recording.

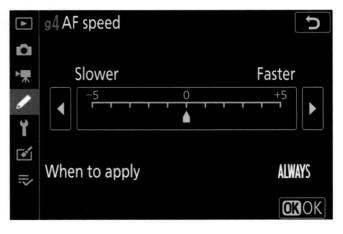

Figure 12.18Setting AF Speed.

g5 AF Tracking Sensitivity

Options: 7 (low) to 1 (high)

My preference: Varies

This is roughly the movie equivalent of Custom Setting a3: Focus Tracking with Lock-on for still photography. It specifies how quickly the Z6's AF system responds when the subject either exits the frame or something else intervenes—the referee at a football game is the classic example.

A setting of 7 (Low) causes the Z6 to ignore the intervening subject matter for a significant period of time. Use this setting when shooting subjects, such as sports, in which focus interruptions are likely to be frequent and significant. You can also choose a setting of 1 (High) which tells the Z6 to wait only a moment before refocusing. The middle value, 4 (default), offers an intermediate delay before the camera refocuses on the new subject.

g6 Highlight Display

Options: Display Pattern: Pattern 1 (forward diagonal lines), Pattern 2 (back-leaning diagonal lines), Off (default); Highlight Display Threshold: 255, 248 (default), 235, 224, 213, 202, 191, 180 My preference: 235

Video has its own version of the still photography's Highlights display ("blinkies"), commonly known as Zebra display, because it uses contrasting stripes to represent blown highlights. It warns you when the brightest areas of your image may be overexposed when capturing video—but does so *before* you begin capture. Instead of solid flashing indicators, the camera displays one of two striped "zebra" patterns in the affected areas. The zebra stripes jump out at you and make it easy to identify exactly which highlights may be overexposed. You can then adjust exposure or lighting to bring the highlights under control. You can assign Highlight Display to one of the *i* menu spots or a defined key using Custom Settings g1 or g2, respectively.

This menu entry allows you to specify how bright a highlight must be to trigger the zebra effect, using one of eight different brightness levels from 255 (100% white) to 180 (a relatively light gray). Your choice will depend on how important highlights are.

So, exactly how bright *is* too bright? A value of 255 indicates pure white, so any Zebra pattern visible when using this setting indicates that your image is extremely overexposed. Any details in the highlights are gone, and cannot be retrieved. Settings from 213 to 235 can be used to make sure facial tones are not overexposed. As a general rule of thumb, Caucasian skin generally falls in the 235 range, with darker skin tones registering as low as 213, and very fair skin or lighter areas of your subject edging closer to 248. Once you've decided the approximate range of tones that you want to make sure do *not* blow out, you can set the camera's Zebra pattern sensitivity appropriately and receive the flashing striped warning on the LCD of your camera. (See Figure 12.19.) The pattern does not appear in your final image, of course—it's just an aid to keep you from blowing it, so to speak.

Figure 12.19
The flashing stripes show an area is overexposed.

Zebra patterns are a much more useful tool than "blinkies," because you are given an alert *before* you take the picture, and can actually specify exactly how bright *too bright* is. The feature is not new: it has long been used in video equipment, dating back before the digital age. Veteran videographers will note that Nikon uses a section of the 0–255 brightness value scale, rather than the traditional IRE measure of a video signal level, in which numbers from 70 to 100/100+ are used. The Zebra feature has been a staple of professional video shooting for a long time, as you might guess from the moniker assigned to the unit used to specify brightness: IRE, a measure of video signal level, which stands for *Institute of Radio Engineers*.

The Setup Menu, Retouch Menu, and My Menu

We're not done covering the Nikon Z6's options yet. There are three more menus to deal with. These include the Setup menu (which deals with adjustments that are generally outside the actual shooting experience, such as formatting a memory card, adjusting the time, or checking your battery); the Retouch menu (which enables you to fine-tune the appearance of images by trimming, adding filter effects, or removing red-eye); and the My Menu/Recent Menu system, which can help you set up a customized menu that contains only the entries you want, or your most recently accessed entries.

Setup Menu Options

There is a long list of entries in the orange-brown coded Setup menu. The first page of entries is shown in Figure 13.1. All the Setup menu options let you make additional adjustments on how your camera *behaves* before or during your shooting session, as differentiated from the Photo Shooting menu, which adjusts how the pictures are actually taken.

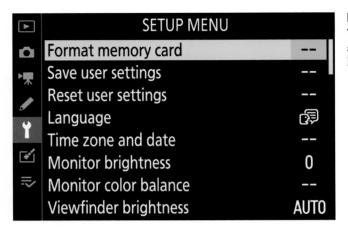

Figure 13.1
The Setup menu allows you to adjust how the Z6 behaves.

Your choices include:

- Format Memory Card
- Save User Settings
- Reset User Settings
- Language
- Time Zone and Date
- Monitor Brightness
- Monitor Color Balance
- Viewfinder Brightness
- Viewfinder Color Balance
- Control Panel Brightness
- Limit Monitor Mode Selection
- Information Display

- AF Fine-Tune
- Non-CPU Lens Data
- Clean Image Sensor
- Image Dust Off Reference Photo
- Image Comment
- Copyright Information
- Beep Options
- Touch Controls
- HDMI
- Location Data
- Wireless Remote (WR) Options

- Assign remote (WR) Fn Button
- Airplane mode
- Connect to Smart Device
- Connect to PC
- Wireless Transmitter (WT-7)
- Conformity Marking
- Battery Info
- Slot Empty Release Lock
- Save/Load Settings
- Reset All Settings
- Firmware Version

Format Memory Card

Options: Yes, No My preference: N/A

I recommend using this menu entry to reformat your memory card after each shoot. Although you can move files from the memory card to your computer, creating a blank card, or delete files using the Playback menu's Delete feature, both of those options can leave behind stray files (such as those that have been marked as Hidden or Protected). Format removes those files completely and beyond retrieval (unless you use a special utility program) and establishes a spanking-new fresh file system on the card. All the file allocation table (FAT or exFAT) pointers (which tell the camera and your

computer's operating system where all the images reside) are reset, efficiently pointing where they are supposed to on a blank card.

Save User Settings

Options: Save to U1, Save to U2, Save to U3

My preference: N/A

User settings are groups of camera shooting settings that the Z6 stores in one of three memory "slots," labeled U1, U2, and U3. Set up your camera with the settings you want to be able to recall, and save them using this menu entry. Then rotate the mode dial to the U1, U2, or U3 position when you want to access them.

Available settings include:

- Shutter speed in S and M modes
- Aperture in A and M modes
- Flexible Program settings in P mode
- Exposure and flash compensation
- Metering, Autofocus, and AF-area modes
- Flash mode
- Focus point
- Bracketing settings
- Most adjustments in Photo Shooting, Movie Shooting, and Custom Settings menus, except for those listed next

The settings you *cannot* save include:

Photo Shooting Menu:

- Storage Folder
- Choose Image Area
- Manage Picture Control
- Multiple Exposure
- Interval Timer Shooting
- Time-lapse movie
- Focus-shift shooting

Follow these steps to store your settings:

- 1. **Choose mode.** Rotate the mode dial to the shooting mode you'd like to store, such as P, A, S, or M.
- 2. **Adjust settings.** Enter the settings you want to store on the camera, using the camera controls, Photo Shooting, and Custom Settings menus. (Setup menu entries cannot be saved.)
- 3. Select Save User Settings. Navigate to this entry in the Setup menu.
- 4. **Choose memory register.** Choose Save to U1, Save to U2, or Save to U3 and press the right directional button.
- 5. Save. Choose Save Setting on the confirmation screen, or Cancel to abort.

Movie Shooting Menu:

- Choose Image Area
- Manage Picture Control

Reset User Settings

Options: Reset U1, Reset U2, Reset U3

My preference: N/A

You can return the settings stored in the U1, U2, or U3 registers to their factory default values using this menu entry. Simply select the entry, choose Reset U1, Reset U2, or Reset U3, and press the right directional button. Press OK to confirm.

Language

Options: In the Americas: English, Spanish, French, Portuguese

My preference: English, of course, but steadily improving in Spanish

Nikon's thrown us a curveball in the language option department. Instead of the couple dozen languages offered in most other Nikon cameras, Z6 bodies sold in North and South America offer only the official languages on those continents. The change was either done "for user convenience" (which is rarely true), or to prevent gray market imports from one area of the world to another.

If you'd like to see your menus and prompts in German, Japanese, or some other language, you'll need to buy a camera built for Europe or Asia, respectively. One potential (but theoretical) fix might be to install the firmware updates available from Nikon websites in, say, Germany or Japan (Version 1.01 for the Z6 was available about a month after the camera started shipping), but it would be wise to check with Nikon first to make sure that's even possible and/or won't munge your camera.

This change won't impact a large number of us, but for expats who want to use their native tongue, it's an inconvenience, at best.

Time Zone and Date

Options: Time Zone, Date and Time, Sync with Smart Device, Date Format, Daylight Saving Time (Default: Off)

My preference: N/A

Use this menu entry to adjust the Z6's internal clock. Your options include:

- Time zone. A small map will pop up on the setting screen and you can choose your local time zone. I sometimes forget to change the time zone when I travel (especially when going to Europe), so my pictures are all time-stamped incorrectly. I like to use the time stamp to recall exactly when a photo was taken, so keeping this setting correct is important.
- Date and time. Use this setting to enter the exact year, month, day, hour, minute, and second.

- Sync with Smart Device. When enabled, the Z6 will adjust its clock to the time specified by your smartphone or tablet when either is linked to the camera. Since the date/time information of the device is constantly updated by its cellular system, it's likely to be highly accurate. (See the Location Data entry described later in this chapter.)
- **Date format.** Choose from Y/M/D (year/month/day), M/D/Y (month/day/year), or D/M/Y (day/month/year) formats.
- Daylight saving time. Use this to turn daylight saving time On or Off. Because the date on which DST goes into effect each year has been changed from time to time, if you turn this feature on you may need to monitor your camera to make sure DST has been implemented correctly.

Monitor Brightness

Options: -5 to +5 (Default: 0)

My preference: N/A

Choose this menu option and a screen appears allowing you to specify brightness (see Figure 13.2). Use the multi selector up/down keys to adjust the brightness to a comfortable viewing level. Under the lighting conditions that exist when you make this adjustment, you should be able to see all 10 swatches from black to white. If the two left-end swatches blend together, the brightness has been set too low. If the two whitest swatches on the right end of the strip blend together, the brightness is too high. Brighter settings use more battery power, but can allow you to view an image on the monitor outdoors in bright sunlight. When you have the brightness you want, press OK to lock it in and return to the menu. Although the Z6 has a great viewfinder, you'll still find yourself using the monitor for both preview and review functions. I often tilt the LCD upward when shooting from low perspectives, so I don't have to crouch or kneel, or tilt it forward when I am holding the camera overhead, for a periscope view.

Figure 13.2 Choose to adjust brightness.

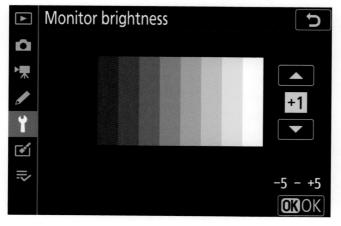

Monitor Color Balance

Options: Adjust color balance

My preference: N/A

This entry allows you to adjust the color balance of the LCD monitor using an image residing on your memory card. An adjustment screen, like the one shown in Figure 13.3, appears. The large thumbnail image at upper left will be the last photograph taken, or, if you are using Playback mode, the last photograph viewed. You can also press the Zoom Out button (located next to the lower-right corner of the monitor) to select an image on your memory card from a thumbnail list.

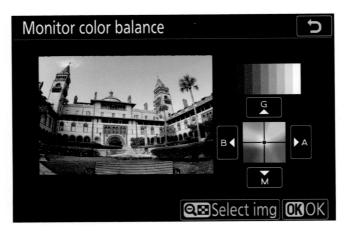

Figure 13.3 Fine-tune monitor color balance.

Use the multi selector directional buttons to bias the monitor hue along the blue/amber (left/right buttons) and/or green/magenta (up/down buttons) axes. The grayscale tone strip above helps you judge the neutrality of your selected balance settings. Press OK to confirm your adjustment. Note that changing the monitor color balance has *no* effect on the color balance of the photos you take.

Viewfinder Brightness

Options: Auto (default); Manual: -5 to +5

My preference: N/A

You can also adjust the brightness for the electronic viewfinder. Unlike the monitor brightness adjustment, the Viewfinder option includes an Auto setting that will modify brightness based on ambient light conditions. In Manual mode, while peering through the viewfinder at the grayscale patches, you can brighten/darken the display using the same plus/minus 5 range. Use the multi selector up/down keys to adjust the brightness to a comfortable viewing level. When you have the brightness you want, press OK to lock it in and return to the menu.

Viewfinder Color Balance

Options: Adjust color balance

My preference: N/A

This is the first entry in the next page of the Setup menu. (See Figure 13.4.) Viewfinder color balance is adjusted using the same procedure described above for Monitor Color Balance, while looking through the viewfinder window.

Control Panel Brightness

Options: Auto (default); Manual: 1-7; Off

My preference: Auto

The monochrome control panel on the top surface of the Z6 is a welcome addition; you can view important information from above the camera, say, when shooting with the Z6 mounted on a tripod. The light-on-dark lettering is easy to see. Select Auto to allow the camera to choose brightness based on the ambient illumination, or Off to disable it entirely. With the Manual setting, you can specify a brightness level from 1 to 7.

Limit Monitor Mode Selection

Options: Enable/Disable: Automatic Display Switch, Viewfinder Only, Monitor Only, Prioritize Viewfinder; Default: Enable All

My preference: Enable All

One of my favorite Z6 features is the ability to use the electronic viewfinder for tasks that, on a digital SLR, require looking at the LCD monitor. For example, I can keep the camera up to my eye and make menu adjustments and review images I've shot in Playback mode—even under the brightest daylight conditions.

Figure 13.4
The second page of the Setup menu.

This menu item lets you choose which monitor viewing modes are available when you press the monitor mode button (located on the left side of the Z6's "pentaprism" hump). Pressing the button repeatedly cycles among the options you've enabled. At least one *must* be enabled (you cannot disable all of them). Your options are as follows:

- Automatic display switch. The active display always switches from the monitor to the view-finder when you place your eye up to the viewfinder (or when anything else comes in proximity to the sensor located above the viewfinder window). When you remove your eye from the EVF, the display switches to the LCD monitor. This is often the most convenient mode. However, you may encounter unwanted switching if something other than your eye comes within roughly two inches of the sensor. For example, if you've swiveled the monitor and are using the touch screen, a finger may switch the display.
- Viewfinder Only. The monitor is disabled and the viewfinder is used exclusively for shooting, navigating menus, or image playback. This is my preferred mode in dark venues—especially concerts—where an illuminated LCD can distract or annoy others. I can access most camera features with the menus and viewfinder, so, for example, I don't need to fumble with my fingers to locate the ISO or Exposure Compensation direct access buttons. I also use Viewfinder Only outdoors when the monitor washes out or is difficult to view.
- Monitor Only. The viewfinder is disabled, and display is directed to the LCD monitor only. This is my choice when I'm composing and shooting using the monitor—say for macro photography or other scenes shot with the camera at waist level or lower, or mounted on a tripod. I don't want the eye sensor to switch to the EVF as I work, so I switch to the Monitor Only setting.
- Prioritize Viewfinder. With this option, when you're shooting pictures, the display is directed to the viewfinder exclusively; it turns on when you move your eye to the EVF, and turns off when you remove your eye. That saves more than a little power, especially if there are intervals when you are not taking photos at all, but don't want to turn off the Z6. (The sensor and the electronic viewfinder or sensor can always be active when the camera is powered up, in contrast to digital SLRs that are, effectively, in a low-power mode until you start using the exposure meters, autofocus mechanism, or LCD monitor.)

When you're reviewing images in Playback mode, while capturing movies, or when menus are displayed, the monitor *will* turn on when you remove your eye from the viewfinder.

Information Display

Options: Manual: Dark on Light (B) (default), Light on Dark (W)

My preference: Light on Dark

This menu entry refers to the shooting information screen that appears as you cycle through the various displays by pressing the DISP button. You can set this display to dark lettering on a light background (which you may prefer in dim locations) or light lettering on a dark background (which

is often the best choice for viewing the monitor in daylight). I prefer the light-on-dark color scheme; if ambient light is really bright, I use the viewfinder instead of the monitor anyway.

AF Fine-Tune

Options: AF Fine-Tune On/Off (default: Off), Saved Value, Default, List Saved Values My preference: N/A

Troubled by lenses that don't focus exactly where they should, producing back focus or front focus problems? No need to send your lens and/or camera into Nikon for servicing. The Nikon Z6 allows you to fine-tune focus for up to 30 different lenses. Best of all, it works perfectly with both Z-mount and F-mount lenses (using the FTZ adapter).

You'll probably never need to use this feature, but if you do, it's priceless. To fine-tune your lenses, first perform some tests to see just how much fine-tuning is required. The only problem I've run into is that with some lenses, particularly short focal length lenses, using large negative values (0 to -20) to move the focal point closer to the camera sometimes results in being unable to focus to infinity. If you run into that, you may be better off sending the lens to Nikon so they can recalibrate the focus for you.

This menu option has four choices, shown at left in Figure 13.5:

- AF fine tune (On/Off). Enable/disable application of your AF fine-tuning changes.
- Saved value. View or enter an adjustment for the lens currently mounted on your camera. (See Figure 13.5, right.)
- **Default.** Set the default value to be applied to lenses that haven't been recalibrated. You'd use this if your Z6 has a certain amount of front or back focus problems with all lenses. Use with caution, as it affects every CPU lens that you use.
- List saved values. View and delete tuning values you've saved.

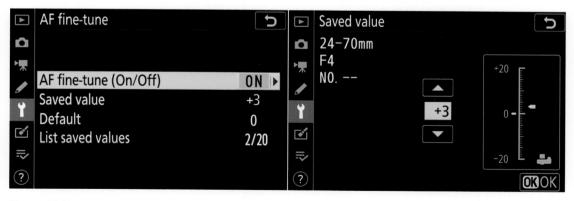

Figure 13.5 The autofocus of lenses can be adjusted here.

Because the adjustments made with the AF Fine-Tune setting are potentially so dangerous to your focusing health, I'm not even going to provide an overview in this chapter. (Knowing just enough to hurt yourself can be a real possibility.) Instead, you'll find a thorough discussion of using this feature in Chapter 7, which deals with lens issues.

Non-CPU Lens Data

Options: Lens number, Focal Length (mm), Maximum aperture

My preference: N/A

This is an odd entry, as it contributes absolutely nothing to the operation of your camera, other than enabling it to embed the focal length and maximum aperture available of some older manual focus lenses in the EXIF data embedded in your image file.

One of the best accessories for the Z6 is the FTZ adapter, which makes it easy to mount Nikon F-mount lenses to the Z6. It gives you four types of functionality in PSAM modes:

- AF-S, AF-P, and AF-I lenses, plus AF-S/AF-I teleconverters. These retain all their features, including autofocus and autoexposure.
- AF and AF-D lenses. You must focus these optics manually, but with AF-D lenses the electronic rangefinder will assist in determining correct focus. Peaking Highlights (described in Chapter 12) works with either type. You can adjust the aperture electronically and use Aperture-priority autoexposure.
- AI-P and all lenses with a CPU chip. You get manual focus only (with Peaking Highlights) and Aperture-priority exposure.
- AI, AI-S, and Series E lenses. Manual focus and manual exposure only, but you can use this menu entry to specify the maximum aperture and focal length of the lens (zoom focal length ranges are not supported). That information will be included in the EXIF metadata, but *not* the actual aperture used to take the photo. You may also be able to mount and use non-AI F-mount lenses (pre-1977), but may have mechanical interference problems.

For AI, AI-S, and Series E lenses, you'll need to specify lens focal length data and maximum aperture. The Nikon Z6 allows defining up to 20 different lenses, and you can choose any of them with a quick trip to this menu entry (or to the equivalent menu item in My Menu, described later in this chapter), or using a button defined for this feature, as described for Custom Setting f2 in Chapter 12.

To enter this information, follow these steps using the screen shown in Figure 13.6. Note that you can configure the lens's information even if the lens is not mounted on the Z6.

- 1. Choose Non-CPU lens data from the Setup menu.
- 2. Highlight Lens Number and press the multi selector left/right buttons to choose a number. If you are defining several lenses, I recommend numbering them in order of increasing focal length, or, if you prefer, in order of frequency of use.

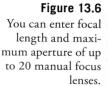

- 3. Scroll down to Focal Length (mm) and use the multi selector left/right buttons to choose a focal length between 6mm and 4000mm.
- 4. Scroll down to Maximum Aperture and use the multi selector left/right buttons to choose a maximum f/stop between f/1.2 and f/22.
- 5. Choose Done. You can now select the lens number using a button you define for the function.

Clean Image Sensor

Options: Clean Now; Automatic Cleaning: Clean at Shutdown (default), Cleaning Off My preference: Clean at Shutdown

This entry gives you some control over the Nikon Z6's automatic sensor cleaning feature, which removes dust through a vibration cycle that shakes the sensor until dust, presumably, falls off. If you happen to take a picture and notice an artifact in an area that contains little detail (such as the sky or a blank wall), you can access this menu choice, place the camera with its base downward, and choose Clean Now. A Cleaning Sensor message now appears, and the dust you noticed has probably been shaken off.

You can also tell the Z6 when you'd like it to perform automatic cleaning without specific instructions from you. Select from:

- Clean Now. Triggers the dust-shaking cycle immediately. For best results, remove the lens and point the camera downward so the dust can fall outside the camera body.
- Automatic Cleaning: Clean at shutdown. This removes any dust that may have accumulated since the camera has been turned on, say, from dust infiltration while changing lenses.
- Automatic Cleaning Off. No automatic dust removal will be performed. Use this to preserve battery power, or if you prefer to use automatic dust removal only when you explicitly want to apply it.

Image Dust Off Ref Photo

Options: Start, Clean Sensor and Then Start

My preference: N/A

This menu choice, lets you "take a picture" of any dust or other particles that may be adhering to your sensor. The Z6 will then append information about the location of this dust to your photos, so that the Image Dust Off option in Capture NX-D can be used to mask the dust in the NEF image. It does not work with small- or medium-sized NEF (RAW) images.

To use this feature, select Image Dust Off Ref Photo, choose either Start or Clean Sensor and Then Start, and then press OK. If directed to do so, the camera will first perform a self-cleaning operation by applying ultrasonic vibration to the top layer of the sensor. I recommend doing this—you might as well capture your reference photo with a sensor that is as clean as possible.

Then, a screen will appear asking you to take a photo of a bright featureless white object 10cm (about four inches) from the lens. Nikon recommends using a lens with a focal length of at least 50mm. If you're using a zoom lens, zoom to the longest focal length. Note that the dust-off information can be applied to *all* your images, not just those taken with the lens used to capture the reference photo.

Point the Z6 at a solid white card and press the shutter release. If the reference object is too dark or light, you may be asked to try again with a different object. An image with the extension .ndf will be created, and can be used by Nikon Capture NX-D as a reference photo if the "dust off" picture is placed in the same folder as an image to be processed for dust removal.

Image Comment

Options: Attach Comment, Input Comment

My preference: N/A

This is the first entry on the next page of the Setup menu. (See Figure 13.7.) The Image Comment is your opportunity to add a copyright notice, personal information about yourself (including contact info), or even a description of where the image was taken (e.g., Browns Super Bowl 2020), although text entry with the Nikon Z6 is a bit too clumsy (even when using the touch screen) for doing a lot of individual annotation of your photos. (But you still might want to change the comment each time, say, you change cities during your travels.) The embedded comments can be read by many software programs, including Nikon ViewNX-i or Capture NX-D.

The standard text-entry screen described in Chapter 2 can be used to enter your comment, with up to 36 characters available. For the copyright symbol, embed a lowercase "c" within opening and closing parentheses: (c). You can input the comment, turn attachment of the comment On or Off using the Attach Comment entry, and select Done when you're finished working with comments. If your fingers are too fat for typing on the touch screen or you find typing with a cursor too tedious, you can enter your comment in Nikon Capture NX-D and upload it to the camera through a USB cable.

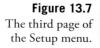

Copyright Information

Options: Attach Copyright Information, Artist, Copyright

My preference: N/A

This is an expansion of the Image Comment capability, allowing you to specify the name of the "artist" (photographer), and enter copyright information. Use the standard Nikon text-entry screen described earlier. Highlight the Attach Copyright Information option and press the right multi selector button to mark/unmark it to control whether your copyright data is embedded in each photo as taken. The touch screen comes in useful for this input, as well.

Beep Options

Options: Beep On, Beep Off (default), Volume, Pitch

My preference: Beep Off

The Nikon Z6's internal beeper provides a (usually) superfluous chirp to signify various functions, such as the countdown of your camera's self-timer, the termination of time-lapse recording, or autofocus confirmation in AF-S mode (unless you've selected release-priority in Custom Setting a2). You can (and probably should) switch it off if you want to avoid the beep because it's annoying, impolite, distracting (at a concert or museum), or undesired for any other reason. Note that the beeper is automatically squelched if you've activated Silent Photography in the Photo Shooting menu. Choose this menu entry, and select one of the following:

- **Beep On/Off.** Enable or disable the beeper.
- Volume. Select values of 1 (soft) through 3 (loud). A quarter-note icon appears in the monochrome control panel and the shooting information display.
- Pitch. Select High for a high-pitched beep, or Low for a deeper tone.

Touch Controls

Options: Enable (default), Disable touch controls, Full-frame playback flicks

My preference: N/A

This entry allows you to specify whether LCD monitor touch controls are enabled or disabled, and whether to use left/right or right/left flicks to advance to the next image during full frame playback. I described touch controls in Chapter 2.

HDMI

Options: Output Resolution (default: Auto); Advanced: Output Range, External Recording Control, Output Data Depth, N-Log Setting, View Assist

My preference: N/A

This entry deals with the Nikon Z6's High-Definition Multimedia Interface (HDMI) video connection. The port allows you to play back your camera's images on HDTV or HD monitors using a type C cable, such as the HDMI cable HC-E1, which Nikon does not provide to you, but which is readily available from third parties. I use HDMI playback for slide shows. I also captured most of the screenshot images in this book using the HDMI output and a video frame grabber. Before you link up you'll want to choose from the following options:

■ Output Resolution. Select Auto and the camera will sense the correct output resolution to use. Auto will be applied (even if you select another resolution) when the HDMI port is used to display the camera's image during movie capture, and movie playback. That limitation can be a problem; the camera may not be able to detect the required resolution in Auto mode. My BlackMagic Intensity Shuttle, for example, requires using the 1080i setting. It displays output from my Z6 at that setting in still mode, but when I change to movie mode the camera switches to Auto and the HDMI output is no longer available.

If you want to use a different resolution under other circumstances (say, when you're viewing still images), you can choose Auto, plus specific formats including 480p (640×480 progressive scan); 576p (720×576 progressive scan); 720p (1280×720 progressive scan); 1080p (1920×1080 progressive scan); or 1080i (1920×1080 interlaced scan). A 4K output option 2160p (3840×2160 progressive scan) is also available, and should be used only with a 4K-compatible device.

Note: HDMI output is disabled when your movie resolution/frame rate is 1920×1080 120/100p, or when operating the camera using SnapBridge or Camera Control 2.

- Advanced. This cryptic entry leads you to a screen where you can select more parameters:
 - Output Range. Choose Auto (the default, and the best choice under most circumstances); Limited Range; or Full Range. In most cases, the camera will be able to determine the output range of your HDMI device. If not, Limited Range uses settings of 16 to 235, clipping off the darkest (0–16) and brightest (235–255) portions of the image. Use Limited Range if you're plagued with reduced detail in the shadows of your image. Full Range may be your choice if shadows are washed out or excessively bright. It accepts video signals with the full range from 0 to 255.
 - External Recording Control. When enabled, this option allows you to use the camera controls to stop and start recording when connected to an external recorder (favored by serious videographers). The recorder must support the Atomos Open Protocol, used by the popular Atomos Shogun, Sumo, and Ninja recorders. When active, an STBY (Standby) or REC (Recording) icon appears on the monitor. To keep the camera display and HDMI output from timing out, choose Custom Setting c3: Power Off Delay and set Standby Timer to Unlimited.
 - Output Data Depth. Select from 8-bit or 10-bit output. Ordinarily, you should leave this setting at 8-bit. The 10-bit option is only compatible with certain external recorders (such as those from Atomos), and is required for using the N-Log setting (described next). You'll find more information in Chapter 14.
 - N-Log Setting. The default is Off. If you've set data depth to 10 bits, you can choose On (cannot record to card) to use N-log, an extended dynamic range format. It produces "flat"-looking footage that can be corrected using video-editing software to provide a much wider range of tones. The chief limitation is that your video cannot be saved to the Z6's memory card; it must be output to an external recorder like the Atomos Ninja V. In addition, your ISO sensitivity settings are limited. I'll explain N-Log in more detail in Chapter 14.
 - View Assist. As mentioned above, N-Log video cannot be saved on your memory card, and the Z6's displays do not provide a live preview of the footage being recorded, unless you set View Assist to On here. Most of the time, you can leave this setting at Off, because you'll be viewing your video on the external recorder's screen. Select On if you want to have the Z6 display the live image.

Location Data

Options: Standby Timer (default: Enable), Position, Set Clock from Satellite (default: Yes) **My preference:** N/A

This menu entry has options for using GPS information. You can supply the Z6 with location information from your smartphone or tablet using the SnapBridge app installed on your device. You can also clip the Nikon GP-1/GP1a Global Positioning System (GPS) accessory onto your camera's accessory shoe and plug it into the remote/device port. It has four options, none of which turn GPS features on or off, despite the misleading "Enable" and "Disable" nomenclature (what you're enabling and disabling is the automatic exposure meter turn-off):

- Standby Timer. This setting is useful when you have an external GPS receiver connected to the camera. Choose Enable to reduce battery drain by turning off exposure meters while using the GP-1/1a after the time specified in Custom Setting c3: Power off Delay: Standby Timer has elapsed. When the meters turn off, the GP-1/1a becomes inactive and must reacquire at least three satellite signals before it can begin recording GPS data once more. Setting to Disable causes exposure meters to remain on, so that GPS data can be recorded at any time, despite increased battery drain.
- **Position.** This is an information display, rather than a selectable option. It appears when the GP-1/1a is connected and receiving satellite positioning data. It shows the latitude, longitude, altitude, and Coordinated Universal Time (UTC) values. (See Figure 13.8.)
- Set Clock From Satellite. Choose Yes to allow the camera to update its internal clock from information provided by the GPS device when attached. No disables this updating feature. You might want to avoid updating the clock if you're traveling and want all the basic date/time information embedded in your image files to reflect the settings back home, rather than the date and time where your pictures are taken. Note that if the GPS device is active when shooting, the local date and time will be embedded in the GPS portion of the EXIF data.

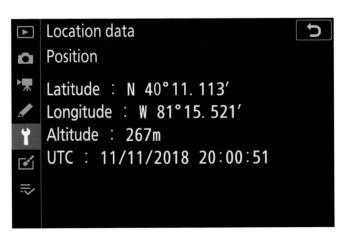

Figure 13.8
Position data is displayed when a GPS device is active and linked to satellites.

Wireless Remote (WR) Options

Options: LED lamp: On (default), Off; Link mode: Pair (default), PIN My preference: N/A

This option, which is grayed out unless the WR-R10 transmitter is plugged into the remote/accessory port on the Z6, allows you to make several settings for the Nikon WR-10 radio remote control. The system consists of the WR-T10 transmitter, shown at bottom in Figure 13.9, and the WR-R10 receiver, which is attached to the camera (see Figure 13.9, top). The set, which allows triggering cameras and compatible electronic flash units (such as the SB-5000), has a practical range of about 66 feet, and costs about \$200. (If you use one WR-R10 receiver as an intermediate master and a second on the camera, range extends to 164 feet.) A single transmitter can be used to control multiple cameras that have a receiver installed.

The system is also compatible with the WR-1, a sophisticated transceiver with a much longer (roughly 400 foot) range, 15 channels, and additional features such as more sophisticated camera group control (to fire multiple cameras simultaneously). It also costs a great deal more, at around \$650.

To use the WR-R10, insert the receiver into the remote/accessory port. Make sure the transmitter and receiver are using the same channel (15, 10, or 5), and then pair them by pressing the gray pairing buttons indicated by green circles in Figure 13.9, simultaneously. The LEDs on top of the receiver will alternate red and green to show that pairing has taken place; thereafter, the receiver's green LED will flash to indicate there is a connection.

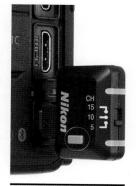

Figure 13.9 Press the Pairing buttons on the WR-R10 receiver and WR-T10 transmitter simultaneously.

TIP

While useful as a remote control, my favorite feature of the WR-10 radio control system is the ability to use the transmitter's function button to activate some other feature on the camera, such as autoexposure/autofocus lock. I'll explain those options in the next section.

This menu entry has two options, which most Z6 owners may never need to use:

- LED lamp. You can enable or disable this lamp. I sometimes turn the blinking lamp off when I am working in dark environments and don't want to distract others around me—or make them aware that I am taking stealth photos with a remote control. Disabling the LEDs also saves power, but you'll have no operational feedback when they're off.
- Link mode. You can choose whether the transmitter and receiver are linked using pairing (the usual procedure) or through a PIN, which is possible when working with the Nikon SB-5000 flash (or any radio-controlled flash Nikon may introduce after this book is written). If you're using the WR-1 transceiver, you must use pairing as the link mode.

Assign Remote (WR) Fn Button

Options: Preview, FV Lock, AE/AF lock, AE lock only, AE lock (Reset on release), AF lock only, AF-ON, Flash enable/disable, +RAW, None (default)

My preference: AF-ON

Radio remote control is cool, but I *really* like the WR-10 system's ability to trigger any of nine different features on the camera, using the transmitter's Fn button. I most often use the button to start autofocus on the Z6 using the AF-ON behavior. You might love the ability to tell the camera to add an NEF (RAW) picture to the JPEG image you've specified for that one picture, then switch back to JPEG-only mode.

Select Assign Remote (WR) Fn Button, and then choose from: Preview, FV Lock, AE/AF lock, AE lock only, AE lock (Reset on release), AF lock only, AF-ON, Flash enable/disable, +RAW, or None.

Airplane Mode

Options: Enable, Disable (default)

My preference: Enable

This is the first entry on the next page of the Setup menu (see Figure 13.10). Like the Airplane Mode on your smartphone or tablet, this option turns off the Z6's Wi-Fi and Bluetooth capabilities. I enable the feature any time I am not planning to use Bluetooth, Wi-Fi, or GPS, because it saves a lot of power.

Connect to Smart Device

Options: Pairing, Select to Send (Bluetooth), Wi-Fi Connection, Send While Off **My preference:** N/A

Use this entry to set up your SnapBridge or Wi-Fi connection to your smartphone, tablet, or computer. Wi-Fi, Bluetooth, and your Z6's other connectivity options were covered in detail in Chapter 6, and the instructions for setting up your smart device won't be repeated here.

Figure 13.10
The next page of the Setup menu.

Connect to PC

Options: On, Off (default)

My preference: N/A

You can instruct your Z6 to automatically upload new still photos (but not movies) to your smart device or computer when the camera and device are linked. If they are not connected, the Z6 will mark a maximum of 1,000 photos and upload them the next time a wireless connection is made. As I noted in Chapter 6, the Nikon Network Guide contains detailed information on using this advanced feature.

Wireless Transmitter (WT-7)

Options: Network Settings, Current Settings, Reset Connection Settings

My preference: N/A

This entry allows you to configure wireless local area network (LAN) settings. You'll find instructions for setting up this expensive accessory in the manual furnished with the WT-7 transmitter.

Conformity Marking

Options: Display only. No selections.

My preference: N/A

This entry does nothing but display the various international standards with which the Z6 complies. It's included here because Nikon can easily update the listing during a firmware upgrade. The alternative might be to print new labels (like the one with the serial number of the camera located behind the tilting LCD monitor on the Z6) each time a change is made.

Battery Info

Options: None. This screen is purely informational.

My preference: N/A

When invoked, you can see the following information:

- Charge. The current battery level, shown as a percentage from 100 to 0 percent.
- No. of shots. This shows the number of actuations with the current battery since it was last recharged. This number can be larger than the number of photos taken, because other functions, such as white balance presetting, can cause the shutter to be tripped.
- Battery Age. Eventually, a battery will no longer accept a charge as well as it did when it was new, and must be replaced. This indicator shows when a battery is considered new (0); has begun to degrade slightly (1,2,3); or has reached the end of its charging life and is ready for replacement (4). Batteries charged at temperatures lower than 41 degrees F may display an impaired charging life temporarily, but return to their true "health" when recharged above 68 degrees F.

Slot Empty Release Lock

Options: Release Locked, Enable Release (default)

My preference: Release Locked

This option gives you the ability to snap off "pictures" without a memory card installed—or to lock the camera shutter release if that is the case. It is sometimes called play mode, because you can experiment with your camera's features or even hand your Z6 to a friend to let them fool around, without any danger of pictures actually being taken.

Back in our film days, we'd sometimes finish a roll, rewind the film back into its cassette surreptitiously, and then hand the camera to a child to take a few pictures—without actually wasting any film. It's hard to waste digital film, but "shoot without card" mode is still appreciated by some, especially camera vendors who want to be able to demo a camera at a store or trade show, but don't want to have to equip each and every demonstrator model with a memory card. Choose Enable Release to activate "play" mode or Release Locked to disable it.

The pictures you actually "take" are displayed on the LCD monitor with the legend "Demo" superimposed on the screen, and they are, of course, not saved. Note that if you are using the optional Camera Control Pro 2 software to record photos from a USB-tethered Z6 directly to a computer, no memory card is required to unlock the shutter even if Release Locked has been selected.

Save/Load Settings

Options: Save Settings, Load Settings

My preference: N/A

You can store many camera settings to your memory card in a file named NCSETxxx, and then reload them later using this menu item. This is a good way to archive your favorite camera settings for the Playback menu, all Photo/Movie Shooting menus, Custom Settings menu, the Setup menu settings, and all My Menu items. You can restore your settings if you've messed them up, or save multiple sets of settings to multiple memory cards. If you own more than one Z6, this is a handy way to share settings between them. You can save only one group of settings at a time to a particular card (always in the Primary slot); the default NCSETUPK cannot be changed. Well, it *can* be changed in your computer, but if you do, the Z6 will not be able to find it on the memory card. If you want to save multiple settings, simply use multiple memory cards.

Note that storing/restoration is an all-or-nothing proposition. When you select Save Settings, all your current settings are stored on the memory card; choose Load Settings, and the camera's current settings are replaced with the values stored on the memory card.

The following settings are saved:

- Playback. Playback display options; Image review; After delete; After burst, show; Rotate tall.
- Photo Shooting menu. File naming, Choose image area, Image quality, Image size, NEF (RAW) recording, ISO sensitivity settings, White balance, Set Picture Control (Custom controls are saved as Auto), Color space, Active D-Lighting, Long exposure NR, High ISO NR, Vignette control, Diffraction compensation, Auto distortion control, Flicker reduction shooting, Metering, Flash control, Flash mode, Flash compensation, Focus mode, AF-area mode, Vibration reduction, Auto bracketing, Silent photography.
- Movie Shooting. File naming, Choose image area, Frame size/frame rate, Movie Quality, Movie file type, ISO sensitivity settings, White Balance, Set Picture Control (Custom controls saved as Auto), Active D-Lighting, Vignette control, Diffraction compensation, Auto distortion control, Flicker reduction, Metering, Focus mode, AF-area mode, Vibration reduction, Electronic VR, Microphone sensitivity, Attenuator, Frequency Response, Wind noise reduction, Headphone volume, Timecode (except Timecode origin).
- Custom Settings menu. All Custom Settings except d3.
- Setup menu. Language, Time zone and date (except Date and Time), Information display, Non-CPU lens data, Clean image sensor, Image Comment, Copyright information, Beep options, Touch controls, HDMI, Location Data (except Position), Wireless Remote Options, Assign Remote Fn button, Slot empty release lock.
- My Menu/Recent Settings. All My Menu entries, All recent settings, Active tab.

Reset All Settings

Options: Reset, Do Not Reset

My preference: N/A

This entry and the next are the sole residents of the last page of the Setup menu, and not shown in a separate figure. This one resets all settings, including Copyright Information, and other usergenerated settings, except Language and Time Zone and Date. You should save your current settings to a memory card before using this entry, just to be safe. This command requires use of a confirmation screen to make sure you don't remove your settings accidentally.

Firmware Version

Options: Display only. No selections.

My preference: N/A

You can see the current firmware release in use in the menu listing.

Retouch Menu

The Retouch menu contains the post-processing options you can apply to your images after you've taken a photo. When reviewing an image, press the *i* button, and select Retouch from the menu that pops up to jump directly to this menu and begin processing that image.

- NEF (RAW) Processing
- Trim
- Resize
- D-Lighting
- Red-Eye Correction
- Straighten

- Distortion Control
- Perspective Control
- Image Overlay
- Trim Movie
- Side-by-Side Comparison

The Retouch menu (see Figure 13.11) is most useful when you want to create a modified copy of an image on the spot, for immediate printing or e-mailing without first importing into your computer for more extensive editing. You can also use it to create a JPEG version of an image in the camera when you are shooting RAW-only photos. You can retouch images that have already been processed by the Retouch menu, except for copies created with the Image Overlay and Trim Movie > Choose start/end point options. You may notice some quality loss when applying more than one retouch option.

Important exceptions: Note that Image Overlay can *only* be accessed from this menu; it is not available from the *i* menu during image playback. Conversely, Side-by-Side Comparison is *not* available from the Retouch menu; you must invoke it during Playback by pressing the *i* button, and choosing it from *i* menu.

Figure 13.11
The Retouch menu allows simple incamera editing.

To create a retouched copy of an image:

- 1. Select an image. For most of the retouching options, you have two ways of selecting an image:
 - When accessing during Playback. Press the *i* button, choose Retouch from the screen that pops up, press the right directional button, and then select the retouching option you want to use from the Retouch menu.
 - When entering using the MENU button. Navigate to the Retouch menu and select the option you want to use. You'll be presented either with the standard Z6 image selection thumbnails, or options you can select before selecting an image to process. I'll note your options with each entry that follows.
- 2. **Choose image retouching option.** From the Retouch menu, select the option you want from those available and press the multi selector right button. The Nikon Z6's standard image selection screen appears. Scroll among the images as usual with the left/right multi selector buttons, press the Zoom In button to examine a highlighted image more closely, and press OK to choose that image.
 - **Note:** If you elect to work on an image that has been captured in dual NEF+JPEG format, *only* the NEF (RAW) image will be retouched. If you have an image on your memory card that was recorded by a different model camera, the Z6 may not be able to display or retouch the image.
- 3. **Manipulate image.** Work with the options available from that particular Retouch menu feature and press OK to create the modified copy, or Playback to cancel your changes. Keep in mind that if the delay for Menus that you've specified in Custom Setting c3: Power Off Delay expires, the Z6 will exit the menu screen and any unsaved changes canceled. You may want to select a longer power off delay for Menus.
- 4. View copy. A retouched JPEG image will be the same size and quality as the original, except for copies created using the NEF (RAW) Processing, Trim, and Resize options. Resized or Cropped copies created from NEF and TIFF images are always saved as JPEG Fine images. During review, retouched copies are overlaid with a paint brush icon in their upper-left corner.

DOUBLE DUTY

Once you've retouched an image using one of the Retouch menu's entries, you can apply most of the remaining options to the manipulated copy (except for those produced by Trim Movie). Any that are not available will be grayed out. That said, it's probably not a good idea to retouch a retouched copy, as you'll lose some image quality each time.

NEF (RAW) Processing

Options: Image Quality (Fine*, Fine, Normal*, Normal, Basic*, or Basic), Image Size (Large, Medium, or Small), White Balance, Exposure Compensation, Set Picture Control, High ISO Noise Reduction, Color Space, Vignette Control, Active D-Lighting, and Diffraction Compensation **My preference:** N/A

Use this tool to create a JPEG version of any image saved in a RAW version. You can select from among several parameters to "process" your new JPEG copy right in the camera.

- 1. **Choose a RAW image.** There are two ways to select an image: from the NEF (RAW Processing) entry in the Retouch menu, and by highlighting an NEF image during Playback and then pressing the *i* button. Choose one method and follow either Step 2a or Step 2b.
- 2a. **From the Retouch menu.** A selection options screen appears, offering three choices. Once you've made your selections, you'll be taken to the NEF processing screen shown in Figure 13.12.
 - Select Images. The standard Z6 image selection thumbnail screen showing *only* NEF files appears. Navigate among them. Press and hold the Zoom In button to temporarily enlarge a thumbnail to full screen. Press the Zoom Out/Index button to select a highlighted image. When you're done selecting, press OK to confirm.
 - Select Date. All NEF images taken on a certain date will be selected and processed.
 - Select All Images. All NEF images on your memory card will be selected and processed.
- 2b. **During Playback.** Select an NEF (RAW) image during playback. Press the *i* button and choose Retouch. You'll be whisked immediately to the NEF (RAW) Processing entry of the Retouch menu (as shown earlier in Figure 13.11). Press the right directional button to proceed to the processing screen (Figure 13.12), and only the single image you were reviewing will be processed.
 - 3. In the NEF (RAW) processing screen you can use the multi selector up/down keys to select from ten different attributes of the RAW image information to apply to the JPEG copies made

Figure 13.12
Adjust the parameters and then save your JPEG copy from a RAW original file.

of your selected image(s). Choose Image Quality (Fine, Normal, or Basic, plus * versions of each), Image Size (Large, Medium, or Small), White Balance, Exposure Compensation, Set Picture Control, High ISO Noise Reduction, Color Space, Vignette Control, D-Lighting, and Diffraction Compensation.

- 4. Press the Zoom In button to magnify the image temporarily while the button is held down.
- 5. Press the Playback button if you change your mind, to exit from the processing screen.
- 6. When all parameters are set, highlight EXE (for Execute) and press OK. The Z6 will create a JPEG file for each of the selected images with the settings you've specified, and show an Image Saved message on the monitor when finished.

Trim

Options: Various sizes
My preference: N/A

This option creates copies in specific sizes based on the final size you select, chosen from among 1:1, 3:2, 4:3, 5:4, and 16:9 aspect ratios (proportions). You can use this feature to create smaller versions of a picture for e-mailing without the need to first transfer the image to your own computer. If you're traveling, create your smaller copy here, insert the memory card in a card reader at an Internet café, your library's public computers, or some other computer, and e-mail the reduced-size version. Just follow these steps:

- 1. **Select your photo.** Choose Trim from the Retouch menu. You'll be shown the standard Nikon Z6 image selection screen. Scroll among the photos using the multi selector left/right buttons, and press OK when the image you want to trim is highlighted. While selecting, you can temporarily enlarge the highlighted image by pressing the Zoom In button.
- 2. **Choose your aspect ratio.** Rotate the main command dial to change from 3:2, 4:3, 5:4, 1:1, and 16:9 aspect ratios. These proportions happen to correspond to the proportions of common print sizes, including the two most popular sizes: 4 × 6 inches (3:2) and 8 × 10 inches (5:4).
- 3. **Crop in on your photo.** Press the Zoom In button to crop in on your picture. The pixel dimensions of the cropped image at the selected proportions will be displayed in the upper-left corner (see Figure 13.13) as you zoom. The trim sizes vary depending on the Image Size and Aspect Ratio selected. Sizes available for FX and DX modes are shown in Tables 13.1 and 13.2. The current framed size is outlined in yellow within an inset image in the lower-right corner.
- 4. **Move cropped area within the image.** Use the multi selector left/right and up/down buttons to relocate the yellow cropping border within the frame.
- 5. Save the cropped image. Press OK to save a copy of the image using the current crop and size, or press the Playback button to exit without creating a copy. Copies created from JPEG Fine, Normal, or Standard have the same Image Quality setting as the original; copies made from RAW files or any RAW+JPEG setting will use JPEG Fine compression. Note that you may not be able to zoom in on a cropped image during Playback once it has been saved.

Figure 13.13
The Trim feature of the Retouch menu allows in-camera cropping.

Aspect Ratio	Sizes Available in FX mode
3:2	5760 × 3840, 5120 × 3416, 4480 × 2984, 3840 × 2560, 3200 × 2128, 2560 × 1704, 1920 × 1280, 1280 × 856, 960 × 640, 640 × 424
4:3	5360 × 4024, 5120 × 3840, 4480 × 3360, 3840 × 2880, 3200 × 2400, 2560 × 1920, 1920 × 1440, 1280 × 960, 960 × 720, 640 × 480
5:4	5024 × 4024, 4800 × 3840, 4208 × 3360, 3600 × 2880, 3008 × 2400, 2400 × 1920, 1808 × 1440, 1200 × 960, 986 × 720, 608 × 480
1:1	4016 × 4016, 3840 × 3840, 3360 × 3360, 2880 × 2880, 2400 × 2400, 1920 × 1920, 1440 × 1440, 960 × 960, 720 × 720, 480 × 480
16:9	6048 × 3400, 5760 × 3240, 5120 × 2880, 4480 × 2520, 3840 × 2160, 3200 × 1800, 2560 × 1440, 1920 × 1080, 1280 × 720, 960 × 536, 640 × 360

Table 13.2 DX Trim Sizes		
Aspect Ratio	Sizes Available in DX mode	
3:2	3840 × 2560, 3200 × 2128, 2560 × 1704, 1920 × 1280, 1280 × 856, 960 × 640, 640 × 424	
4:3	3504 × 2624, 3200 × 2400, 2560 × 1920, 1920 × 1440, 1280 × 960, 960 × 720, 640 × 480	
5:4	3280×2624 , 3008×2400 , 2400×1920 , 1808×1440 , 1200×960 , 986×720 , 608×480	
1:1	2624×2624 , 2400×2400 , 1920×1920 , 1440×1440 , 960×960 , 720×720 , 480×480	
16:9	$3936 \times 2216, 3840 \times 2160, 3200 \times 1800, 2560 \times 1440, 1920 \times 1080, 1280 \times 720, 960 \times 536, 640 \times 360$	

Resize

Options: Select Image, Choose Size

My preference: N/A

This option creates smaller copies of the selected images. It can be applied while viewing a single image in full-size mode (just press the *i* button while viewing a photo), or accessed from the Retouch menu (especially useful if you'd like to select and resize multiple images). You might want smaller images to post on a website, or send by e-mail.

- 1. **Select image.** If accessing from the Retouch menu, you can choose to select multiple images; if you are reviewing an image during Playback and access using the *i* menu, only the image you were viewing will be processed.
- 2. **Choose size.** Next, select the size for the finished copy, from 2304×1536 (3.5MB), 1920×1280 (2.5MB), 1280×856 (1.1MB), or 960×640 (0.6 megabytes).
- 3. **Confirm.** Press OK to create your copy. Note that, as with Trim, you may not be able to zoom in on a resized image during Playback once it has been saved.

D-Lighting

Options: High, Normal, Low

My preference: N/A

This option brightens the shadows of pictures that have already been taken. Once you've selected your photo for modification, you'll be shown side-by-side images with the unaltered version on the left, and your adjusted version on the right. Press the multi selector's left/right buttons to choose from High, Normal, or Low corrections. (See Figure 13.14.) Press the Zoom In button to magnify the image. When you're happy with the corrected image on the right, compared to the original on the left, press OK to save the copy to your memory card.

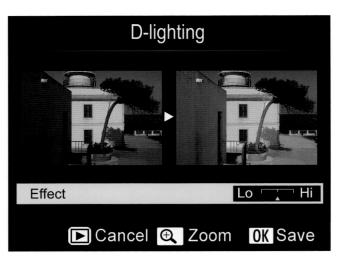

Figure 13.14
An image with dark shadows can be improved with postshot D-Lighting.

Red-Eye Correction

Options: No setting. Use function as required.

My preference: N/A

This Retouch menu tool can be used to attempt to remove the residual red-eye look that remains after applying the Nikon Z6's other remedies, such as the red-eye reduction feature of your external flash. (You can use the red-eye tools found in most image editors, as well.)

Your Nikon Z6 has a marginally effective red-eye reduction flash mode. Unfortunately, your camera is unable, on its own, to totally *eliminate* the red-eye effects that occur when an electronic flash (or, rarely, illumination from other sources) bounces off the retinas of the eye and into the camera lens. Animals seem to suffer from yellow or green glowing pupils, instead; the effect is equally undesirable. The effect is worst under low-light conditions (exactly when you might be using a flash) as the pupils expand to allow more light to reach the retinas. The best you can hope for is to *reduce* or minimize the red-eye effect.

The best way to truly eliminate red-eye is to raise the external flash up off the camera so its illumination approaches the eye from an angle that won't reflect directly back to the retina and into the lens. If your image still displays red-eye effects, you can use the Retouch menu to make a copy with red-eye reduced further. First, select a picture that was taken with flash (non-flash pictures won't be available for selection). After you've selected the picture to process, press OK. The image will be displayed on the monitor. You can magnify the image with the Zoom In button, scroll around the zoomed image with the multi selector buttons, and zoom out with the Zoom Out button. While zoomed, you can cancel the zoom by pressing the OK button.

When you are finished examining the image, press OK again. The Z6 will look for red-eye, and, if detected, create a copy that has been processed to reduce the effect. If no red-eye is found, a copy is not created.

Straighten

Options: Rotation

My preference: N/A

Use this to create a corrected copy of a crooked image, rotated by up to five degrees, in increments of one-quarter of a degree. Use the right directional button to rotate clockwise, and the left directional button to rotate counterclockwise. The amount of your correction will be visible on the display. Press OK to make a corrected copy, or the Playback button to exit without saving a copy. Note that you will lose some picture information during this process, as the Z6 must trim the edges of the rotated image to produce the rectangular final image.

Distortion Control

Options: Auto, Manual My preference: N/A

This option produces a copy with reduced barrel distortion (a bowing out effect) or pincushion distortion (an inward-bending effect), both of these forms of *peripheral distortion* are most noticeable at the edges of a photo. You can select Auto to let the Z6 make this correction, or use Manual to make the fix yourself visually. Use the right directional button to reduce barrel distortion (bowing outward of lines at the edges) and the left directional button to reduce pincushion distortion (which produces lines bowing inward). In both cases, some of the edges of the photo will be cropped out of your image. Press OK to make a corrected copy, or the Playback button to exit without saving a copy. Note that Auto cannot be used with images exposed using the Auto Distortion Control feature described earlier in this chapter.

Perspective Control

Options: Adjust tilt My preference: N/A

This option lets you adjust the perspective of an image, reducing the falling-back effect produced when the camera is tilted to take in the top of a tall subject, such as a building (see Figure 13.15). Use the multi selector buttons to "tilt" the image in various directions and visually correct the distortion.

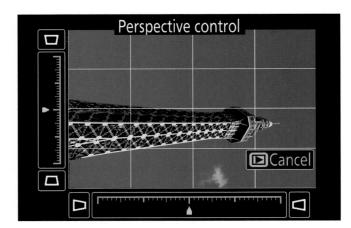

Figure 13.15
Perspective Control lets you fix "fallingback" distortion when photographing tall subjects.

Image Overlay

Options: Combine two RAW photos

My preference: N/A

This feature, and the next two, are on the last page of the Retouch menu (not shown in a figure). It allows you to combine two RAW photos (only NEF files can be used) in a composite image that Nikon claims is better than a "double exposure" created in an image-editing application, because the overlays are made using RAW data. To produce this composite image, follow these steps:

- 1. Choose Image Overlay. A screen will be displayed, with the Image 1 box highlighted.
- 2. Press OK and the Nikon Z6's image selection screen appears. Choose the first image for the overlay and press OK. You can press and hold the Zoom In button to view the thumbnail as a full-frame image. Note that only Large NEF (RAW) files with the same image area and bit depth can be selected. Small and Medium NEF (RAW) images are not available, nor can you combine FX/DX or 12-bit/14-bit images.
- 3. Press the multi selector right button to highlight the Image 2 box, and press OK to produce the image selection screen. Choose the second image for the overlay.

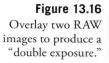

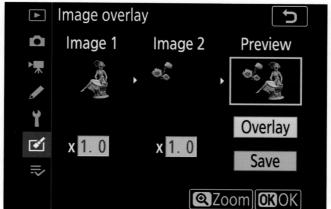

- 4. By highlighting either the Image 1 or Image 2 boxes and pressing the multi selector up/down buttons, you can adjust the "gain," or how much of the final image will be "exposed" from the selected picture. You can choose from X0.5 (half-exposure) to X2.0 (twice the exposure) for each image. The default value is 1.0 for each, so that each image will contribute equally to the final exposure.
- 5. Use the multi selector right button to highlight the Preview box and view the combined picture. (See Figure 13.16.) Press the Zoom In button to enlarge the view.
- 6. When you're ready to store your composite copy, press the multi selector down button when the Preview box is highlighted to select Save, and press OK. The combined image is stored in JPEG * format on the memory card and displayed full frame for your review.

Trim Movie

Options: Choose Start/End Point, Save Selected Frame

My preference: N/A

You can do limited editing of movies in the camera (actually, just modest trimming), choosing a start point, end point, and also storing a selected frame as a still image. I'll show you how to edit movies using this capability in Chapter 14.

Side-by-Side Comparison

Options: Examine pair of images

My preference: N/A

Use this option to compare a retouched photo side-by-side with the original from which it was derived. It is available *only* when one or more retouched images exist on your memory card to compare. Don't look for Side-by-Side Comparison in the Retouch menu. It doesn't appear there. You can invoke this option only by viewing an image during Playback and pressing the *i* button and choosing Retouch from the menu that pops up.

To use Side-by-Side Comparison:

- 1. Press the Playback button and review images in full-frame mode until you encounter either a source image that has been retouched *or* the retouched copy of that image that you want to compare. A retouched copy will have the retouching icon displayed in the upper-left corner. It doesn't matter which you choose, but you must select either an original image that has been retouched or a retouched copy of it. Then, press the *i* button, highlight Retouch, press the right directional button, and then scroll down to Side-By-Side comparison in the Retouch menu that appears.
- 2. The original and retouched image will appear next to each other, with the retouching options you've used shown as a label above the images. Note that the source image will *not* be displayed if the retouched copy was generated from an image that was marked as Protected, or which has been deleted.
- 3. Highlight the original or the copy with the multi selector left/right buttons, and press the Zoom In button to magnify the image to examine it more closely.
- 4. If you have created more than one copy of an original image, select the retouched version shown, and press the multi selector up/down buttons to view the other retouched copies. The up/down buttons will also let you view the other image used to create an Image Overlay copy.
- 5. When done comparing, press the Playback button to exit.

Using My Menu

The last menu in the Z6's main menu screen has two versions: Recent Settings and My Menu. The default mode is Recent Settings, which simply shows an ever-changing roster of the 20 menu items you used most recently. You'll probably find it more useful to activate the My Menu option instead, which contains only those menu items that you deposit there extracted from the Playback, Photo Shooting, Movie Shooting, Custom Settings, Setup, and Retouch menus, based on your own decisions on which you use most. Remember that the Z6 always returns to the last menu and menu entry accessed when you press the MENU button. So, you can set up My Menu (see Figure 13.17) to include just the items accessed most frequently, and (as long as you haven't used another menu) jump to those items instantly by pressing the MENU button.

Switching back and forth is easy. The My Menu and Recent Settings menus each has a menu choice called Choose Tab. Highlight that entry and press the right multi selector button to view a screen that allows you to activate either the My Menu or Recent Settings menu. Press OK to confirm.

I tend to include frequently used functions that aren't available using direct access buttons in My Menu. For example, I include High ISO NR, Long Exp. NR, and Battery Info there, because I may want to turn noise reduction on or off, or check the status of my battery during shooting. I *don't* include ISO or WB changes in My Menu, even though they are available in the menu system, because I can quickly change those values by pressing their dedicated buttons (the ISO and Fn1 buttons, respectively) and rotating the main and sub-command dials.

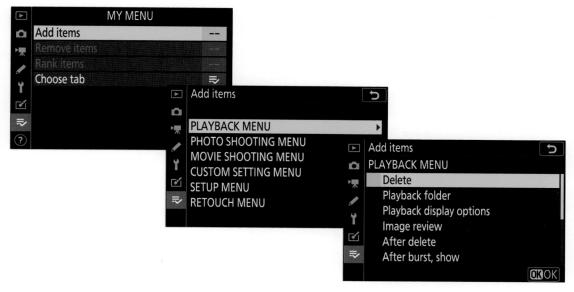

Figure 13.17 You can include your favorite menu items in the fast-access My Menu.

You can add or subtract entries on My Menu at any time, and re-order (or rank) the entries so the ones you access most often are shown at the top of the list. Here's all you need to know to work with My Menu. To add entries to My Menu:

- 1. Select My Menu and choose Add Items.
- 2. A list of the available menus will appear (Playback, Photo Shooting, Movie Shooting, Custom Settings, Setup, and Retouch menus). Highlight one and press the multi selector's right button.
- 3. Within the selected menu, choose the menu item you want to add and press OK.
- 4. The label Choose Position appears at the top of the My Menu screen. Use the up/down buttons to select a rank among the entries, and press OK to confirm and add the new item.
- 5. Repeat steps 1-4 if you want to add more entries to My Menu.

To reorder the menu listings:

- 1. Within the My Menu screen, choose Rank Items.
- 2. Use the up/down buttons to select the item to be moved, and press OK.
- 3. Use the up/down buttons to relocate the selected item and press OK.
- 4. Repeat steps 2-3 to move additional entries.

To remove entries from the list, you can simply press the Trash button while an item is highlighted in the My Menu screen. To remove multiple items, follow these steps:

- 1. Within the My Menu screen, choose Remove Items.
- 2. A list with check boxes next to the menu items appears. Scroll down to an item you want to remove and press the multi selector right button to mark its box. If you change your mind, highlight the item and press the right button again to unmark the box.
- 3. When finished, highlight Done and press the OK button.
- 4. Press OK to confirm the deletion.

Capturing Video with the Z6

Shooting movies is as easy a flipping a switch—the Photo mode/Movie mode switch located to the right of the viewfinder. If you're looking for no-fuss, casual video, after you've selected Movie mode, just rotate the mode dial to the green Auto position and press the red Movie button located on top of the Z6, just southwest of the shutter release button. Capture will start; press the Movie button again to stop recording. That's all there is to grabbing good video clips.

But if you want to go beyond "good" to "excellent," you'll want to read this chapter and the next one, which will introduce you to the full range of the Z6's sophisticated movie-making capabilities. While I listed and briefly described all the options in the camera's Movie Shooting menu in Chapter 11, there's a great deal more to learn and put into practice.

Quick Start Checklist

The following is a list of things to keep in mind as you improve your movie-making skills and take your video work to the next level. Some of these items are recaps of information you learned about still photo shooting; others are of special concern for movie-making. Even if you decide to just skim through this chapter for now, and come back for more after you've explored movie-making, you should at least read this section before you begin your epic documentary or feature production.

■ **Stills, too.** You can take a cropped high-resolution still photograph, even while you're shooting a movie clip, by pressing the shutter release all the way down. You won't miss a still shot because you're shooting video, nor will your video be interrupted. The still image is cropped to the 16:9 movie aspect ratio, and saved in the same resolution as your movie frame size, using the JPEG * quality setting. That gives you a 1920 × 1080 (2 MP) image in HD mode and a 3840 × 2160 (8 MP) image in UHD (4K) mode.

If you've chosen a Continuous release mode *only one photograph* will be taken each time you press the shutter-release button during movie capture. Up to 50 different shots can be captured while shooting one movie.

- No flash. While you can shoot still photos while capturing video, you cannot use flash when the selector switch is set to the Movie position.
- Exposure compensation. When shooting movies, exposure compensation is available in plus/minus 3 EV steps in 1/3 EV increments. (Remember that still photos offer plus/minus 5 EV steps.)
- Size matters. Individual movie files can be up to 4GB in size (this will vary according to the resolution you select), and no more than 29 minutes, 59 seconds in length. A single movie may consist of as many as eight separate files, each 4GB in size. The actual number of files and their length varies depending on the frame size and frame rate you've selected. The speed and capacity of your memory card may provide additional restrictions on size or length.
- Use the right card. You'll want to use a fast XQD card if possible. If you insist on using a slower card the recording may stop after a minute or two, given that full HD can require a transfer rate of 28 Mbps; 56 Mbps in High Quality format; and 144 Mbps when shooting 4K video. In any case, choose a memory card with at least 32GB capacity. While some older XQD cards are available in 16 GB sizes, they are likely to be too slow for the High Quality setting. I've standardized on 64GB Sony XQD Series G memory cards when I'm shooting movies; one of these cards will hold at least three to six hours of video, and have the world's fastest transfer rates (at least, as I write this) of 440MB/second read and 400MB/second write speeds. However, in any case, the camera cannot shoot a continuous movie scene for more than about 29 minutes. You can start shooting the next clip right away, though, missing only about 30 seconds of the action. Of course, that assumes there's enough space on your memory card and adequate battery power.
- Carry extra cards. You're probably used to shooting still photographs. It's easy to estimate how much of your memory card's capacity you've already consumed, and how much is left, based on the shots remaining indicator on the Z6's LCD monitor and viewfinder displays. Video usage is a bit of a different animal. While the camera does show how much space you have remaining for a clip as you shoot, it's often difficult to make the connection to the remaining capacity of your memory card. It's necessary to make a trip to the Movie Shooting menu to see exactly how much space you have left. So, the best practice is to carry along many more cards than you think you need. I stuff two 64GB XQD cards in my camera bag—enough for 6 hours of video each—but always carry along five 32GB cards as backup.
- Add an external mic. For the best sound quality, and to avoid picking up the sound of the autofocus or zoom motor, get an external stereo mic. I'll have more advice about capturing sound and describe specific types of microphones in Chapter 15.

- Minimize zooming. While it's great to be able to use the zoom for filling the frame with a distant subject, think twice before zooming. Unless you are using an external mic, the sound of the zoom ring rotating will be picked up and it will be audible when you play a movie. Any more than the occasional minor zoom will be very distracting to friends who watch your videos. And digital zoom will degrade image quality. Don't use the digital zoom if quality is more important than recording a specific subject such as a famous movie star far from a distance.
- Use a fully charged battery. A fresh battery will allow about 85 minutes of capture at normal (non-Winter) temperatures, but that can be shorter if there are many focus adjustments. Individual clips can be no longer than about 29 minutes, however.
- **Keep it cool.** Video quality can suffer terribly when the imaging sensor gets hot so keep the camera in a cool place. When shooting on hot days especially, the sensor can get hot quicker than usual; when there's a risk of overheating, the camera will stop recording and it will shut down about five seconds later. Give it time to cool down before using it again.
- Just Press the Movie button. You don't have to hold it down. Press it again when you're done to stop recording.

Lean, Mean, Movie Machine

The Z6 is an awesome video camera, one of the best ever offered by the company that introduced the first movie-making capabilities in an interchangeable-lens still camera—the Nikon D90—in 2008. And how far we've come since then! The D90 captured monaural movies using manual focus at a fixed 24 frames per second for up to five whole minutes at $1280 \times 720p$ (standard HD) resolution. If you dropped down to coarse 640×424 and 320×216 frame sizes, you could shoot a clip as long as 20 minutes.

Your Z6, on the other hand, is packed with features that owners of many dedicated video camcorders only dreamed about a few years ago. I'll explain all the features in detail later in this chapter and the next, but you should check out this list if you want an overview:

- Full HD capture. You can record full high-definition video with 1920 × 1080 resolution at 60, 30, 25, and 24 progressive scan frame rates using the full sensor. If you want some extra telephoto "reach" from video captured using only the DX (APS-C/Super 35) area of the sensor, you can select those rates plus additional frames-per-second options of 120/100p and 50p. I'll explain frame rates and other parameters later in this chapter.
- **4K video capture.** Ultra High Definition (UHD) video capture (3840 × 2160 resolution) is available at 30, 25, and 24 progressive scan rates, with both full-frame and APS-C/Super 35 crops.
- **Slow-motion video.** You can shoot Full HD video clips up to three minutes in length, slowed down by a factor of 4X and 5X, allowing you to analyze your golf swing, or shoot lifeguards running in Baywatch slow motion.

- Zebra stripe highlight display. Highlights overexposed (by a factor you can specify) can be shown with a zebra-stripe overlay. I showed you how to set the parameters for this option in Chapter 12.
- **Phase detection AF.** Fast, continuous autofocus is essential for capturing smooth movie clips, so the Z6 uses its PDAF pixels in both 4K and HD video modes.
- Focus Peaking for Manual Focus. In-focus objects can be indicated by color outlines in the display. You can find more information on this, and an illustration, in Chapter 12.
- **IBIS and Electronic VR.** Shoot SteadyCam hand-held shots without SteadyCam hardware, thanks to the Z6's in-body image stabilization (which shifts the sensor itself to compensate for motion) and an extra electronic VR mode that shifts the *image pixels* around to reduce blur from camera motion. I'll explain how electronic VR operates in more detail later in this chapter.
- **Easy AF point placement.** Use the touch screen or the sub-selector joystick to locate the active focus point accurately during capture.
- Output to an external video recorder. The Z6 is perfect for use with an external monitor, like the affordable Atomos Ninja V (\$695). It can output "clean" video through the HDMI port (more on that later) so you store your clips on an external device while previewing and viewing your movies on a large, bright screen.
- 10-bit N-log capture. As I'll explain shortly, N-log is a type of *gamma* adjustment, which allows capturing as much useful tonal information as possible, thanks to the non-linear way in which humans perceive light and color. In plain English, N-log allows the Z6 to squeeze as much of the original scene's dynamic range as possible into the video file, producing a "flat"-looking, low-contrast image that can be processed during editing to create a rich, full-range video. Nikon has added a "View Assist" function available from the HDMI entry in the Setup menu that allows you to view a "corrected" version in the camera, before actual processing (called *grading*) has taken place.
- Timecode. Your video can include embedded timecodes, which are numeric codes that can be used to synchronize, log, and identify media. I introduced the Timecode option in Chapter 11.
- Customization. You can select separate settings for still photo and movie shooting modes, in the Photo Shooting and Movie Shooting menus, allowing you to customize the operation of your Z6 for each mode.

Capturing Video

In the Movie Shooting menus (see Figure 14.1), you can make the following choices, also described in Chapter 11, along with a description of the various options each entry offers. I won't repeat that information here. Many of these entries are like those for still photography in the Photo Shooting menu.

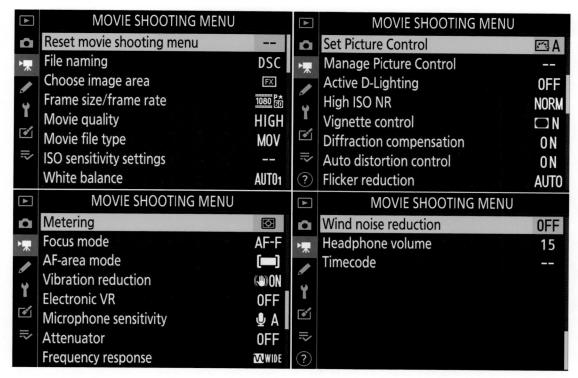

Figure 14.1 Movie Shooting menu.

- File Naming. I recommend using a different substitution in Movie mode for the default DSC characters in file names created for movie files. I use NZ6 for still photos and MOV for video files. The limitations and instructions are the same as for the File Naming entry in the Photo Shooting menu, as described in Chapter 11.
- Choose Image Area. This entry determines image area used when shooting movies. It provides two variations: FX and DX, which allow you to capture movies using what Nikon calls "FX-based movie format" and "DX-based movie format." The latter carves a 16:9 (HDTV) proportioned area from the full-frame view, as shown within the yellow box at top in Figure 14.2. Within the video arena, DX/APS-C movies are usually referred to as APS-C/Super 35, the latter being a common term for that video cropped format. Fortunately, the Z6 doesn't use a mask to mark off the cropped area. Instead, it helpfully enlarges the captured portion to fill the frame, as seen at bottom right in the figure. The normal FX-format view is shown at bottom left.

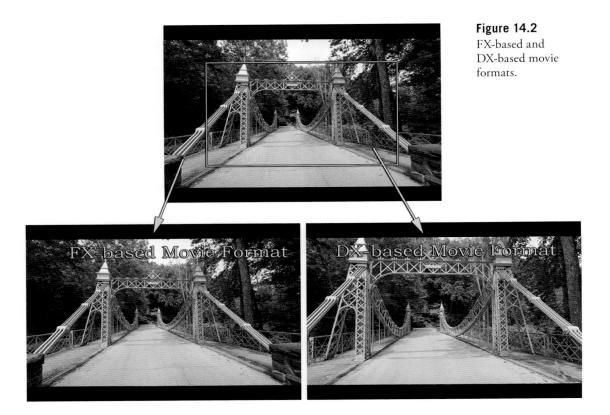

USING DX LENSES

If you use the FTZ adapter to mount a lens that the camera recognizes as a DX/APS-C lens, the Z6 will switch to DX-based movie format automatically (without the need to specify FX or DX with the Choose Image Area entry, which is grayed out, in any case). As in still photo mode, you cannot force the camera to use the DX lens as if it were a full-frame optic. Remember that the Z6 may or may not detect APS-C (DX) lenses from third-party manufacturers.

When Electronic VR is selected using the *i* button menu or Movie Shooting menu, the Z6 provides a slight additional crop (to allow adjusting the frame to compensate for camera movement). Slowmotion movies are always cropped, as I'll explain shortly.

■ Frame Size/Frame Rate. Here you can select any of 10 different video formats for conventional movies, plus three additional settings for slow-motion video. The conventional settings provide 4K video at 3840 × 2160 resolution at 30/25/24 frames per second; Full HD at 1920 × 1080 resolution at 60/50/30/25/24 frames per second; or Standard HD at 1280 × 720 resolution at 60/50 frames per second. As I explained earlier, 50/25 fps are used for PAL video systems overseas, while the other frame rates are compatible with the NTSC system used in the USA, Japan, and some other areas. See the section that follows for slow-motion video frame rates.

WHAT FRAME RATE: 24 fps or 30/60/120 fps?

Even intermediate movie shooters can be confused by the choice between 24 fps and 30/60/120 fps, especially since those are only nominal figures (with the Z6, the 24 fps setting yields 23.976 frames per second; 30 fps gives you 29.97 actual "frames" per second; 60 fps yields 59.94; while 120p yields 119.88 fps). The difference lies in the two "worlds" of motion images, film and video. The standard frame rate for motion picture film is 24 fps, while the video rate, at least in the United States, Japan, and other places using the NTSC standard, is 30 fps (60 interlaced *fields* per second). Most computer video-editing software can handle either type, and convert between them. The choice between 24 fps and 30 fps is determined by what you plan to do with your video. Your camera can also shoot at 25/50/100 fps for use with PAL systems, which don't use NTSC standards.

The short explanation is that, for technical reasons I won't go into here, shooting at 24 fps gives your movie a "film" look, excellent for showing fine detail. (I'll have more to say about that later in this chapter.)

However, if your clip has moving subjects, or you pan the camera, 24 fps can produce a jerky effect called "judder." A 30/60/120 fps rate produces a home-video look that some feel is less desirable, but which is smoother and less jittery when displayed on an electronic monitor. I suggest you try both and use the frame rate that best suits your tastes and video-editing software.

- Movie Quality. Select High Quality or Normal Quality. Your choice affects the sharpness/ detail in your image and the maximum bit rate that can be sustained and length of the movies you can record. If you have fast memory cards and will be displaying your video at larger sizes, you'll want to use High Quality, which is my preference. Note that 4K video can *only* be captured using the High Quality setting; the Movie Quality entry is grayed out when you've specified UHD capture. It's usually possible to convert a video into a lower-resolution version in a movie-editing program.
- Movie File Type. As I described in Chapter 11, you can choose MOV or MP4 file types. MOV is the preferred file type for Macintosh devices (but is also compatible with Windows), while MP4 is a more widely adopted standard compatible with Macs and PCs. Movie-editing software can convert back and forth between either.
- ISO Sensitivity Settings (for Movies). Like the ISO settings in the Photo Shooting menu, as explained in Chapter 11, this version allows you to select a fixed ISO setting for Manual exposure mode, from ISO 100 to ISO 51200, plus Hi 0.3, 0.7, Hi 1, and Hi 2. That allows you greater control over the ISO used. When shooting movies in P, A, or S exposure modes, Auto ISO sensitivity is always used. However, if you want to use Auto ISO in Manual exposure mode, you can turn it on or off here, and specify the *maximum* ISO that will be selected automatically, from ISO 100 to Hi 2.0.

- White Balance. Here you can select the white balance used to shoot movies. You can choose:
 - Same As Photo Settings. The Z6 will use whatever white balance setting you've specified in the Photo Shooting menu.
 - Any of the other white balance options. The selection will apply *only* to video. The white balance of movie clips isn't easy to adjust, so you will usually want to set a specific white balance in this menu entry, or opt for Auto white balance. I usually keep this setting the same as selected for still photos.
- Set Picture Control. You can specify Same as Photo Settings, or independently specify a Picture Control to be used only when shooting movies. The procedures for selecting and modifying a Picture Control in this menu entry is otherwise the same as described in Chapter 11. However, of special note here is the Flat Picture Control (available in both still and movie modes), which produces a dull, washed-out rendition. Why would you want that? Flat captures a wider dynamic range than other Picture Control modes, including Standard, giving you a better "raw" video image to fine-tune in your video-editing software, using your program's video color grading functions. Grading is used to adjust contrast, color, saturation, detail, black level, and white point, and is especially powerful when used with relatively flat images, like those produced by the Flat Picture Control, or with N-log gamma. As I've mentioned, I'll explain N-log in more detail later.
- Manage Picture Control. This entry includes the Save/Edit, Rename, Delete, and Load/Save options that operate the same as the corresponding control in the Photo Shooting menu, described in Chapter 11. You can make a copy of a Picture Control, save an edited copy, rename or remove a style, or retrieve a Picture Control from a memory card.
- Active D-Lighting. You can choose Same as Photo Settings, Extra High, High, Normal, Low, or Off.
- **High ISO NR.** Movie shooting doesn't involve *long* exposures, so the Movie Shooting menu includes only a High ISO Noise Reduction entry. You can set it to High, Normal, Low, or Off. See the entry for this feature under Photo Shooting menu, earlier in Chapter 11.
- **Vignette Control/Diffraction Compensation/Auto Distortion Control.** These three all operate the same as for still photo shooting, and were described in Chapter 11.
- Flicker Reduction. Choose Auto, or select either 50Hz or 60Hz, as described in Chapter 11.
- Metering. Only Matrix, Center-weighted, and Highlight-weighted metering, as described in Chapter 4, are available. Spot metering is not available in Movie mode.
- Focus Mode. In addition to AF-S, AF-C, and Manual focus, Full-time AF (AF-F) is available in Movie mode. Unlike AF-S or AF-C, the AF-F autofocus mode doesn't need to be activated by pressing the shutter release or AF-ON button; AF-F functions as its name suggests: it is active at all times when you're in Movie mode. While power consumption is greater, there is less of a lag in achieving sharp focus once you begin video capture.

- AF-Area Mode. Only Single-Point AF, Wide-Area AF (Small), Wide-Area AF (Large), and Auto-Area AF are available. Pinpoint AF is not available in Movie mode.
- Vibration reduction. This menu entry controls the Z6's built-in body image stabilization. You can choose Same as Photo Settings, On (Normal), Sport, or Off.
- Electronic VR. As I said earlier in this chapter and in Chapter 11, this electronic form of image stabilization does not shift the sensor's carrier mechanism, as IBIS does. Instead, the electronic version crops the video frame slightly, and shifts the entire frame up, down, left, right, or diagonally enough to counter some camera movement in the x and y directions. This feature is not available with frame rates 1920 × 1080 100/120p or when shooting Slo-Mo. A "waving hand" indicator appears at the right side of the display when Electronic VR is active. Maximum sensitivity for movie shooting is fixed at ISO 25600. Keep in mind that, because of the cropping, the angle of view is reduced slightly, producing a slight focal length "multiplier" effect.
- Microphone Sensitivity. This entry has three options that control your Z6's built-in microphone or any external microphone you attach. You can choose Auto Sensitivity, Manual Sensitivity to set recording levels yourself (with a handy volume meter on screen showing the current ambient sound levels), or turn the microphone off entirely if you're planning to record silent video, use another sound recording source, or add sound in post-production. (See Figure 14.3.)
- **Attenuator.** Enable this feature to minimize audio distortion from background sounds when capturing video in loud environments.
- Frequency response. Select from Wide Range frequency response to record a broad range of sounds, or Vocal Range to optimize audio recording for vocals. You'll find an entire section on recording sound in Chapter 15.

Figure 14.3

Microphone sensitivity can be set manually, using the Z6's audio meter as a reference.

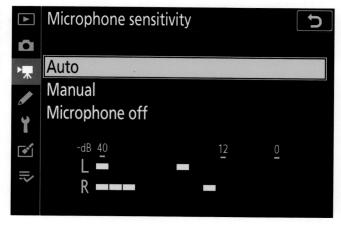

- Wind Noise Reduction. Wind blowing across your microphone can be distracting. This setting reduces wind noise (and may also affect other sounds; so, use it carefully) for the built-in microphones *only*. Your external microphone, like the Nikon ME-1, may have its own wind noise reduction filter on/off switch.
- **Headphone volume.** You can set a volume from 1 to 30; the default is 15.
- **Timecode.** As I've noted in several places in this book, including Chapter 11, advanced video editing and other software-oriented topics, such as Photoshop, are generally beyond the scope of this book. In any case, using timecodes is a fairly advanced procedure, and those who use them don't need instruction from me.
 - However, the ability to embed timecodes in video is a new and highly useful feature for Nikon interchangeable-lens cameras. As I said in Chapter 11, where all the timecode options are described, they provide precise *hour:minute:second:frame* markers that allow identifying and synchronizing frames and audio. The time code system includes a provision for "dropping" frames to ensure that the fractional frame rate of captured video (remember that a 24 fps setting actually yields 23.976 frames per second while 30 fps capture gives you 29.97 actual "frames" per second) can be matched up with actual time spans.
- Time-Lapse Movie. This corresponds to still photo mode's interval timer shooting, and, in fact, is located in the Photo Shooting menu instead of the Movie Shooting menu. It allows shooting video clips instead of still photographs (or a series of still photographs). The Z6 automatically creates a silent time-lapse movie at the frame resolution and rate you've selected in the Movie Shooting menu. The options for time-lapse photography are explained in Chapter 11 and the procedure described in detail in Chapter 6.

Slow-Motion Movies

Slow-motion video is a cool feature that allows you to reduce the apparent playback speed of your movies by 4X or 5X, so you can analyze movement, or apply the effect to your next video involving fast-moving superheroes or those intrepid Baywatch lifeguards.

In the Frame/Size/Frame Rate entry of the Movie Shooting menu, you have the option of scrolling down to select 1920×1080 settings at either $30/25p \times 4$ (slow-mo) or $24p \times 5$ (slow-mo) (both NTSC). Video intended for use in PAL countries can select $25p \times 4$ and $24p \times 5$ instead.

In slow-motion mode, the Z6 records Normal Quality video in DX-based (cropped) format, at 120/100 frames per second (NTSC/PAL) for up to no more than three minutes. When 120/100 fps video is viewed at 30/25 frames per second, the clip takes four times as long to play back; at 24 fps, the clip requires 5X the normal time. As a result, a three-minute clip will stretch to fill 12 minutes when shot at 30/25 fps, or 15 minutes at 24 fps. You can analyze your golf swing or add a slo-mo effect to your movies. While the three-minute capture rate may seem like a limitation, how often do you really want to watch 12 to 15 minutes of slow-motion "action?"

Shooting Your Movie

By this time, you're ready to capture some video. To shoot your movies, follow these steps:

- 1. **Plug in the microphone.** If you want to use an external monaural or stereo microphone with a 3.5mm stereo mini plug, attach it to the microphone jack on the left side of the camera.
- Choose an exposure mode. Select Program, Shutter-priority, Aperture-priority, or Manual
 exposure. The Z6 uses Matrix metering based on readings from the sensor itself to determine
 exposure.
- 3. **Adjust exposure.** The adjustments you can make depend on the exposure mode you select. You'll find more about exposure in the section that follows this one.
 - **Program/Shutter-priority.** Adjust only exposure compensation by pressing the EV button on top of the camera and rotating the main command dial. The screen image will brighten and darken as you make adjustments. Shutter speed and ISO sensitivity are selected for you by the Z6.
 - **Aperture-priority.** You can change the f/stop by rotating the sub-command dial, and adjust exposure compensation with the EV button and the main command dial. Shutter speed and ISO sensitivity are selected for you by the Z6.
 - Manual exposure. The main command dial changes the shutter speed (from 1/25th to 1/4,000th second), and the sub-command dial adjusts the aperture. Press the ISO button and rotate the main command dial to change the ISO sensitivity.
- 4. **Enable movie recording.** Activate movie recording by rotating the Photo/Movie switch to the Movie position.
- 5. **Choose a focus and AF-area mode.** Select from autofocus or manual focus with the *i* menu or Fn2 button. Then choose AF-S or AF-F. Select an AF-area mode.
- 6. **Set audio level.** Use the Microphone Sensitivity entry in the Movie Shooting menu to specify audio recording level, using Auto Sensitivity to allow the Z6 to set the volume, or Manual Sensitivity to adjust using an audio meter (seen at the bottom of Figure 14.3). You can also turn off audio to record a silent movie, say, if you plan to add a voice-over track, music, or other audio in post-production using your video-editing software.
- 7. **Start/Stop recording.** Press the red-dotted movie recording button to lock in focus and begin capture. Press again to stop recording. The LCD monitor display as you're capturing video looks like Figure 14.4. The viewfinder display has the same information, arranged slightly differently, and not overlaid on the image area. You can press the DISP button to increase or decrease the amount of information overlaid on the screen during movie recording.
- 8. **No flash.** You can't use electronic flash during movie recording, but you *can* use the built-in LED movie light on the Nikon SB-500 unit.

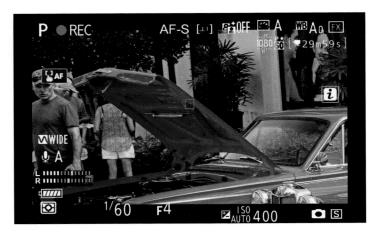

Figure 14.4
The LCD monitor display during movie capture.

Using the *i* Button

The *i* button, which is so useful in Photo mode, also offers real-time adjustment of parameters and controls while you capture your video. These are not only important for fine-tuning your movies as you capture them, but allow for some special tools that veteran videographers will know and love, but which may be new to still photographers. Here's a description of the useful options that pop up when you press the *i* button. (See Figure 14.5.) Many of these are also available in the Movie Shooting menu as explained in Chapter 11. I'll point out which settings are those you might want to use during actual capture. As I described in Chapter 12, there is a Custom Setting g1: Customize *i* button menu entry that allows you to swap out and change Movie mode *i* menu items.

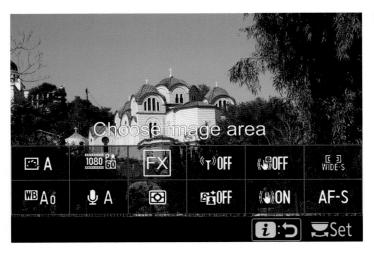

Figure 14.5 *i* button options.

- Picture Control. You can use any of the Picture Controls described in Chapter 11 in Movie mode, and specify them here.
- Frame size/rate and Image Quality. Select your frame size/rate here and choose High or Normal quality.
- Choose image area. You can select the image area for movie mode, as described earlier in this chapter.
- Wi-Fi Connection. Control your wireless connection here (or, if you prefer, substitute a function you find more useful).
- Electronic VR. Turn it on or off.
- **AF-area mode.** Choose from among the available modes.
- White balance. Set your white balance for movie shooting here.
- Microphone sensitivity. It's useful to be able to use the *i* menu while shooting video to adjust the sensitivity of your microphone on the fly. As this adjustment controls both the built-in and optional external stereo microphones, you might find yourself needing to make your mic more sensitive or less sensitive as the ambient sound conditions change. For example, if you were capturing a clip with only background sound (no vocals) and someone started using a jackhammer a block away, you might want to reduce microphone sensitivity to minimize the clamor.
- **Metering mode.** Select Matrix, Center-weighted, or Highlight-weighted. Remember that Spot is not available when shooting movies.
- Active D-Lighting. The same Very High to Low and Off settings available in the Movie Shooting menu can be chosen here.
- Vibration reduction. You can turn in-body image stabilization on and off.
- Focus mode. Choose AF-S, AF-C, AF-F, or Manual focus.

Stop That!

You might think that setting your Z6 to a faster shutter speed will help give you sharper video frames. But the choice of a shutter speed for movie making is a bit more complicated than that. First, you can't select the shutter speed at all for your movies when you're using Auto, P, S, or A exposure modes. You can select a shutter speed only if you switch to Manual exposure. Here's how it works:

■ Program and Shutter-priority modes. The Z6 selects the shutter speed (such as 1/30th second) and ISO sensitivity appropriate for your lighting conditions. Your only exposure adjustment option is to press the EV button and add/subtract exposure compensation. As you might guess, P and S modes are not the best choices for those who want to shoot creatively.

- Aperture-priority mode. This is the mode to use when you want to put selective focus to work by choosing an aperture that will provide more, or less, depth-of-field. In A mode, you can select any f/stop available with your lens, and the Z6 will choose a shutter speed and ISO setting to suit. Generally, if you choose a large aperture, the camera will lower the ISO sensitivity as much as it can, to allow sticking with a shutter speed of 1/30th second. It will then select shorter shutter speeds, if necessary, under very bright illumination. My Z6 has jumped up to 1/200th second outdoors under bright daylight when I try to shoot at f/1.8 or f/1.4. In A mode, you can still add or subtract exposure compensation.
- Manual exposure mode. In this mode, you have control of aperture, shutter speed (from 1/25th second all the way up to 1/8,000th second), and ISO—even if your settings result in video that is completely washed out, or entirely black. Because video capture is in the range of 24 to 60 frames per second, you can't select a shutter speed that is longer than the frame interval. That is, if your video mode is 1920 × 1080 at 30 fps, you can't choose a shutter speed longer than 1/30th second.

SEMI-MANUAL EXPOSURE?

The ISO Sensitivity Settings entry in the Movie Shooting menu allows you to enable a feature called Auto ISO Control (Mode M). When activated, the Z6 will attempt to adjust the ISO setting to provide the correct exposure based on the current shutter speed, aperture, and exposure compensation values you've specified. That means you can select a suitable shutter speed (subject to the recommendations described next), and an f/stop, and the Z6 will effectively provide you with autoexposure in Manual exposure mode.

So, how do you select an appropriate shutter speed? As you might guess, it's almost always best to leave the shutter speed at 1/30th second, and allow the overall exposure to be adjusted by varying the aperture and/or ISO sensitivity. We don't normally stare at a video frame for longer than 1/30th or 1/24th second, so while the shakiness of the *camera* can be disruptive (and often corrected by VR), if there is a bit of blur in our *subjects* from movement, we tend not to notice. Each frame flashes by in the blink of an eye, so to speak, so a shutter speed of 1/30th second works a lot better in video than it does when shooting stills.

Higher shutter speeds introduce problems of their own. If you shoot a video frame using a shutter speed of 1/200th second, the actual moment in time that's captured represents only about 12 percent of the 1/30th second of elapsed time in that frame. Yet, when played back, that frame occupies the full 1/30th of a second, with 88 percent of that time filled by stretching the original image to fill it. The result is often a choppy/jumpy image, and one that may appear to be *too* sharp.

The reason for that is more social imprinting than scientific: we've all grown up accustomed to seeing the look of Hollywood productions that, by convention, were shot using a shutter speed that's half the reciprocal of the frame rate (that is, 1/48th second for a 24 fps movie). Movie cameras use a rotary shutter (achieving that 1/48th second exposure by using a 180-degree shutter "angle"), but the effect on our visual expectations is the same. For the most "film-like" appearance, use 24 fps and 1/60th second shutter speed.

Faster shutter speeds do have some specialized uses for motion analysis, especially where individual frames are studied. The rest of the time, 1/30th or 1/60th of a second will suffice. If the reason you needed a higher shutter speed was to obtain the correct exposure, use a slower ISO setting, or a neutral-density filter to cut down on the amount of light passing through the lens.

A good rule of thumb when shooting progressive video (as opposed to interlaced video, which is not offered by the Z6) is to use 1/60th second or slower when shooting at 24 fps; 1/60th second or slower at 30 fps; and 1/126th second or slower at 60 fps.

Viewing Your Movies

Once you've finished recording your movies, they are available for review. Film clips show up during picture review, the same as still photos, but they are differentiated by a movie camera icon overlay and "Play" prompt. Press the multi selector center button to start playback. During playback, you can perform the following functions:

- Pause. Press the multi selector down button to pause the clip during playback. Press the multi selector center button to resume playback.
- Rewind/Advance. Press the left/right multi selector buttons to rewind or advance (respectively). Press once for 2X speed, twice for 8X speed, or three times for 16X speed. Hold down the left/right buttons to move to the end or beginning of the clip.
- **Start Slo-Mo playback.** Press the down button while the movie is paused to play back in slow motion.
- Skip 10 seconds. Rotate the main command dial to skip ahead or back in 10-second increments.
- Skip to index. Rotate the sub-command dial to skip to the next or previous index marker. If there are no indices saved, the command dial moves to the last or first frame of the clip. Movies with indices are indicated by a "paddle" icon at the top of the screen during playback.
- Change volume. Press the Zoom In and Zoom Out buttons to increase/decrease volume.
- **Trim movie/Save frame.** Press the i button and follow the steps in the next section.
- Exit Playback. Press the multi selector up button or the Playback button to exit playback.
- Return to shooting mode. Press the Movie button to return to shooting mode.
- View menus. Press the MENU button to interrupt playback to access menus.

Trimming Your Movies

In-camera editing is limited to trimming the beginning or end from a clip, and the clip must be at least two seconds long. For more advanced editing, you'll need an application capable of editing AVI movie clips. Google "AVI Editor" to locate any of the hundreds of free video editors available, or use a commercial product like Corel Video Studio, Adobe Premiere Elements, or Pinnacle Studio. These will let you combine several clips into one movie, add titles, special effects, and transitions between scenes.

In-camera editing/trimming can be done from the Retouch menu, or during Playback. The procedure is the same. To do in-camera editing/trimming, follow these steps:

- 1. **Start movie clip.** Use the Playback button to start image review, and press the multi selector center button to start playback when you see a clip you want to edit. It will begin playing. Then follow the instructions beginning with Step 2.
 - Or, you can access the Edit Movie choice in the Retouch menu when you see the clip on the screen that you want to edit.
- 2. **Activate edit.** To remove video from the beginning of a clip, view the movie until you reach the first frame you want to keep, and then press the down button to pause. The movie progress bar at the bottom left of the screen will show the current position in the movie. You can move back and forth frame by frame while the video is paused by pressing the left/right buttons or rotating the main or sub-command dials.
- 3. **Trim move.** To trim video from the end of a clip, watch the movie until you reach the last frame you want to keep and then press the down button to pause. You can jump to the next saved index point in the clip by rotating the main command dial.
- 4. **Select start/end point.** When the video is paused, press the *i* button to show the movie edit options, and select Choose Start/End Point (see Figure 14.6). You'll be asked whether the current frame should be the start or end point. Highlight your choice and press OK again.

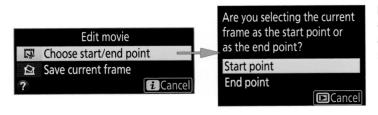

Figure 14.6 Choose editing options from this menu.

- 5. **Resume playback.** Press the multi selector center button to start or resume playback. (See Figure 14.7 for the viewfinder display; the LCD monitor display is similar.) You can use the Pause, Rewind, Advance, and Single frame controls plus the main control dial (to jump to the next saved index point) as described previously to move around within your clip. Note that your trimmed movie must be at least two seconds long.
- 6. Confirm trim. A Proceed? prompt appears. Choose Yes or No, and press OK.
- 7. Save movie. You have four choices when saving the trimmed movie:
 - Save As New File. The trimmed clip will be stored as a new file, and the original movie preserved.
 - Overwrite Existing File. The trimmed clip replaces the original movie on your memory card. Use this option with caution, as you'll be unable to restore your unedited clip.
 - Cancel. Return to the editing mode.
 - Preview. View the trimmed version. You can then save as a new file, overwrite, or cancel.

You'll see a Saving Movie message and a green progress bar as the Z6 stores the trimmed clip to your memory card. Storage takes some time, and you don't want to interrupt it to avoid losing your saved clip. So, make sure your camera has a fully charged battery before you start to edit a clip.

Figure 14.7 Edit your movie.

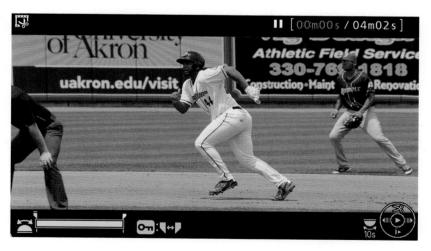

Saving a Frame

You can store any frame from one of your movies as a JPEG still, using the resolution of the current video format. Just follow these steps:

- 1. Pause your movie at the frame you want to save by pressing the down button.
- 2. Press the *i* button and choose Save Selected Frame.
- 3. Press the up button to save a still copy of the selected frame.
- 4. Choose Proceed and press OK to confirm.
- 5. Your frame will be stored on the memory card.

Tips for Shooting Better Video

Once upon a time, the ability to shoot video with a digital still camera was one of those "gee whiz" gimmicks camera makers seemed to include just to have a reason to get you to buy a new camera. That hasn't been true for a couple of years now, as the video quality of many digital still cameras has gotten quite good. Indeed, feature films have been shot entirely or in part using Nikon dSLRs, and the Showtime television series *Dexter* included many scenes captured with a Nikon D800. The Z6 really ups the ante by incorporating video capabilities that have been enhanced or simply not available with previous Nikon still cameras.

The new 10-bit N-log recording option is a stellar example, bringing advanced color- and tonal-correcting capabilities to a lightweight but powerful camera that can capture Ultra HD (4K) and HD-quality video while outperforming typical modestly priced digital video camcorders—especially when you consider the range of lenses and other helpful accessories available for it that are not possible with more limited video-only devices.

But producing good-quality video is more complicated than just buying good equipment. There are techniques that make for gripping storytelling and a visual language the average person is very accustomed to seeing, but also unaware of. After all, by comparison we're used to watching the best productions that television, video, and motion pictures can offer. Whether it's fair or not, our efforts are compared to what we're used to seeing produced by experts. While this book can't make you a professional videographer, there is some advice I can give you that will help you improve your results with the camera.

There are many different things to consider when planning a video shoot, and when possible, a shooting script and storyboard can help you produce a higher-quality video.

Using an External Recorder

If you're truly becoming an advanced videographer, you'll probably be working with the Z6's ability to output "clean" non-compressed HDMI video to an external monitor or video recorder, including the Atomos Shogun lineup, which includes versions that are quite affordable, at least in terms of professional video gear. You can choose models both with and without an external LCD monitor, and capture to solid-state drives (SSD), a laptop's internal or connected hard drive, or to CFast memory cards (the latter chiefly as a nod to those still using the "fast" version of Compact Flash cards). Such equipment allows very high transfer rates and is certainly your best choice if you're shooting 4K video.

Probably the best of the lot for Nikon Z6 owners is the Atomos Ninja V, an extremely portable unit with a 5.2-inch screen and a \$695 price tag that's currently the lowest for this type of device. (The only comparable monitor/recorder, the Video Devices PX-E5, costs \$995.) Its size is a definite

plus—if you're shooting video with a smaller, lightweight camera, you're going to need an equally compact recorder/monitor, such as the roughly 13-ounce Ninja V. Add a battery, HDMI cable, and a 2.5-inch solid state drive, and you're ready to go.

The Ninja V has HDMI input and output jacks on its left edge, which you can see in Figure 15.1. The latter allows you to daisy-chain an even larger monitor or other device. A power button, headphone jack, microphone/audio input, and remote jack reside on the other edge. The touch screen enables you to view your video and access the monitor/recorder's menus and controls, which is convenient (except outdoors in cold weather when you're wearing gloves and might wish you had a few buttons to press instead). The only other "defect" of the unit is the noise produced by its fan; even when you're using an external microphone with your Z6, the fan noise may be picked up in a quiet room.

If you're serious about video, the Nikon Z6 Filmmaker's Kit (\$3,999) is an attractive bundle that includes the Z6 with Nikkor S 24-70mm f/4 S lens, plus the FTZ adapter, the Atomos Ninja V, a Rode VideoMic Pro+ microphone, Moza Air 2 three-axis handheld gimbal, a coiled HDMI cable, and extra EN-EL15b battery.

Figure 15.1 The Atomos Ninja V monitor/recorder.

You can potentially save about \$650 over buying these components separately. Nikon is throwing in a 12-month Vimeo Pro membership and an online course in how to make music videos, hosted by Chris Hersman, a Nikon Ambassador.

Why use an external monitor/recorder like the Ninja V, when your Z6 has its own nifty monitor and can store quite a lot of video on its XQD card? From a monitor standpoint, an external unit's screen is larger, easier to see, and offers more flexibility in positioning. The Z6's screen tilts up or down; mounted on a ballhead like the one in the figure, you can adjust an external screen to any

angle, including reversing it to point in the same direction as the lens, so vloggers can monitor themselves as they record or stream their video blog.

But the best value may come from the recording capabilities of such a device. Internal video is saved to your memory card in the standard H.264/MPEG-4 Part 10 format as a MOV or MP4 file, which compresses that stream of images as much as 50X. That video has only 8 bits of information: good, but somewhat limited in the dynamic range that can be included. Depending on your scene, you may lose some detail in the highlights or shadows.

Fortunately, the Z6 can also simultaneously direct its video output through the HDMI port in "clean" uncompressed 4:2:2 10-bit UHD (ultra-high-definition) resolution. At the time I write this, your Z6 is the only full-frame mirrorless camera that can do that. You really get your two-bits' worth of information: 8-bit output gives you 16.8 million possible colors; 10-bit output is capable of more than 108 billion hues. If your video stream to the external device uses N-log, the dynamic range (overall different tones that can be captured) increases dramatically.

TECH ALERT

Unless you're venturing into professional videography, you probably aren't obsessed with all those numbers in the previous paragraph. However, if you're terminally curious, the important things to keep in mind are:

- Transfer bit rate. This is the speed the Z6 outputs its video to your memory card or external recorder. High transfer rates (such as 144 megabits per second) require fast memory cards; an external recorder should be able to suck up video as quickly as your camera can deliver it.
- Encoding. Although the "clean" video output to the HDMI port is not compressed, it is *encoded* using a procedure called *chroma subsampling*, which does reduce the amount of information that needs to be transferred. Chroma subsampling takes advantage of the fact that human beings don't detect changes in color (chroma) as easily as they do for brightness (luma). The designation 4:2:2 simply indicates that the full amount of brightness information is passed along ("4") while the two chroma values are sampled at half that rate ("2:2"). Subsampling in this way reduces the bandwidth of the otherwise uncompressed video signal by as much as one-third with no visual difference.

If you need even more control over your video output, Nikon has added firmware support for outputting video to the Ninja V that is repacked into Apple ProRes RAW video format (roughly the equivalent of still photo NEF files). RAW video was previously available only from dedicated video-only cameras.

When activated, the RAW data is output over the HDMI connection to the Ninja V, where it is stored on a removable SSD (solid state drive). When capture is completed, the SSD is connected to a computer using a USB cable. The ProRes RAW video can then be decoded and edited using compatible video software's grading, color matching, and video FX features. An extra benefit: you can retain the RAW footage for re-editing later should your needs or editing technology change; your video is, in effect, future-proof.

The HDMI port on the Z6 accepts an HDMI mini-C cable. Nikon offers the HC-E1, but I prefer to purchase less-pricey third-party cables, which I buy in convenient lengths of 3 feet, 6 feet, 10 feet, or longer. The cable can be connected to the monitor, recorder, or other device of your choice. (Some of the screenshots in this book were output to a Blackmagic Intensity shuttle that allowed capturing stills of the Z6's menus, live view, and video.) Here's a recap of the information originally presented in Chapter 13, listing what you need to know to output to the HDMI port using the Setup menu options.

- Output Resolution. Select Auto and the camera will sense the correct output resolution to use. Auto will be applied (even if you select another resolution) when the HDMI port is used to display the camera's image during movie live view, movie capture, and movie playback. I have found Auto will not work reliably with some devices, like my Intensity Shuttle, which works best when I use 1080i. If you're having difficulties, you can manually set the Z6 to one of the available output resolutions individually until you find the best setting. (See Figure 15.2.)
 - If you want to use a different resolution, specific formats include 480p (640×480 progressive scan); 576p (720×576 progressive scan); 720p (1280×720 progressive scan); 1080p (1920×1080 progressive scan); or 1080i (1920×1080 interlaced scan). A 4K output option 2160p (3840×1260 progressive scan) is also available, and should be used only with a 4K-compatible device.
- Advanced. This cryptic entry leads you to a screen where you can select five more parameters:
 - Output Range. Choose Auto (the default, and the best choice under most circumstances; it works fine with my Intensity Shuttle); Limited Range; or Full Range. The Z6 is usually able to determine the output range of your HDMI device. If not, Limited Range uses settings of 16 to 235, clipping off the darkest (0–16) and brightest (235–255) portions of the image. Use Limited Range if you're plagued with reduced detail in the shadows of your image. Full Range may be your choice if shadows are washed out or excessively bright. It accepts video signals with the full range from 0 to 255. (See Figure 15.3.)
 - External Recording Control. When enabled, this option allows you to use the camera controls to stop and start recording when connected to an external recorder (favored by serious videographers). The recorder must support the Atomos Open Protocol, used by the popular Atomos Shogun and Ninja recorders. When active, a STBY (Standby) or REC (Recording) icon appears on the live view monitor. This control is not available when shooting 4K or Slow-Mo video.
 - Output Data depth. Choose 8-bit for normal output; if you want to use N-log, select 10-bit. That will make the two entries that follow available.
 - N-Log Setting. If 10-bit data depth is enabled above, this entry is no longer grayed out and you may choose On to activate N-Log to an external recorder, as described next.
 - View Assist. If N-Log is enabled, you can also turn on View Assist, described below.

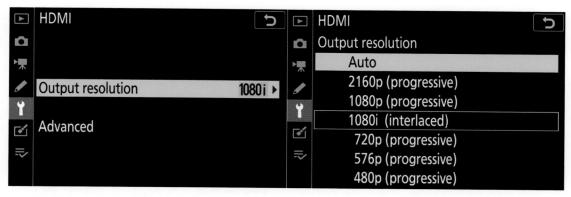

Figure 15.2 Choose output resolution.

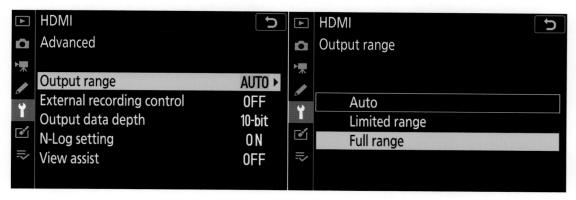

Figure 15.3 Select an output range.

As you've learned, the Z6 offers its own Log gamma adjustment, N-log, which captures a much longer dynamic range than standard gamma curves, compressing more tones into video and producing a much "flatter" (lower-contrast) raw image. Post-processing in a suitable video editor can manipulate the available tonal values (through a process called grading) to produce finished video with extended shadow detail without losing mid-tones and highlights. N-log gives you even better results than using the Flat Picture Control, which was also introduced with exactly this application in mind. The advantage of the Flat Picture Control is that you can apply it to the 8-bit output stored on your memory card; N-log 10-bit output *must* be stored on an external recorder. Of course, another way of increasing dynamic range is to religiously use the Z6's Zebra function, described earlier, so you'll know when you are risking blown highlights, and compensate for them (say, by changing your lighting).

To output using N-log to an external recorder, you must enable it, using the setting in the HDMI entry of the Setup menu (see Figure 15.4, left). The screen reminds you that if you turn N-log on, you cannot record the 10-bit output to your memory card and must have an external recorder attached. You'll find that the N-log video looks extremely flat and is difficult to evaluate on your display screen. Nikon helps you by providing a View Assist option, also within the HDMI entry, that compensates with an adjusted, more natural-looking view. (See Figure 15.4, right.)

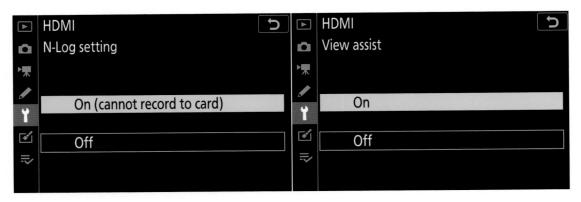

Figure 15.4 Activating N-log.

Refocusing on Focus

Although I explained the Z6's autofocus and manual focus options in Chapter 5, there are some special considerations for focus when capturing video. The availability of usable AF when capturing movies, thanks to the Z6's on-sensor PDAF, is extremely important. The camera now more quickly and reliably is able to gauge subject distance, tracking, and refocusing on subjects; you really don't want inaccurate focus in video clips, where inconsistent focus is quite obvious when the movie is viewed.

Your three autofocus modes work extremely well. AF-S focuses once, and is useful for non-moving subjects; AF-C only refocuses while you're holding down the shutter release or AF-On button. That's particularly useful when you want to retain focus on a particular subject, but refocus at your command as needed when the subject moves. AF-F (Full-time AF) is available if you need the Z6 to refocus constantly as you capture. Use Custom Setting g4: AF Speed to control whether the camera refocuses quickly to follow a moving subject, or refocuses more slowly to switch from one subject to another. Custom Setting g5: AF Tracking Sensitivity can enable/disable the Z6's ability to switch quickly when a different subject intervenes between the camera and the original subject. Both these fine-tuning behaviors can be used creatively to concentrate/deconcentrate attention on a particular subject or area of the frame.

Manual focus, with help from Focus Peaking (which is not available when using the Zebra feature), is an option, particularly for those who want to "pull" or "push" focus, a creative technique for redirecting the viewer's attention from one subject to another, located in the foreground or background. The only complications are that the Z6's electronic focus isn't particularly linear, so a certain degree of rotation of the focus/control ring doesn't result in the same amount of adjustment of the focus; in addition, experienced videographers may not like that the Nikon focus ring operates in the opposite direction of many/most other systems. While you can reverse the rotational direction of dials, you can't do that with the focus/control ring. Since focusing is "by-wire" rather than mechanical, I believe Nikon could have added this option if it wanted to.

Lens Craft

I covered the use of lenses with the Z6 in more detail in Chapter 7, but a discussion of why lens selection is important when shooting movies may be useful at this point. In the video world, not all lenses are created equal. The two most important considerations are depth-of-field, or the beneficial lack thereof, and zooming. I'll address each of these separately.

Depth-of-Field and Video

Have you wondered why professional videographers have gone nuts over still cameras that can also shoot video? The producers of *Saturday Night Live* could afford to have their director of photography use the niftiest, most-expensive high-resolution video cameras to shoot the opening sequences of the program. Instead, they opted for digital SLR cameras. One thing that makes digital still cameras so attractive for video is that they have relatively large sensors, which provides improved low-light performance and results in the oddly attractive reduced depth-of-field, compared with many professional video cameras.

But wait! you say. No matter what size sensor is used to capture a video frame, isn't the number of pixels in that frame the same? That's true—the final resolution of a full HD 1080p video image is exactly 1920×1080 pixels. For standard HD (720p) the resolution is 1280×720 pixels (which the Z6 does not offer), and for ultra HD/4K (2160p), the resolution is 3820×2160 pixels. The final resolution, at least for the most common 1080p resolution, is the same, whether you're capturing that frame with a point-and-shoot camera, a professional video camera, or a digital SLR like the Nikon Z6. But that's only the *final* resolution. The number of pixels used to *originally* capture each video frame varies by sensor size.

For example, your Z6 does *not* use only its central 1920×1080 pixels to capture a full HD video frame. If it did that, you'd have to contend with a huge "crop" factor. That doesn't happen! (See Chapter 7 for a longer discussion of the effects of the so-called "crop" factor.)

Instead, when the Z6 is set for FX-based movie format (which I'll illustrate later in this chapter), it captures a video frame using an area that stretches across the full width of the sensor, measuring 6048×3402 pixels, using the *proportions* of a 16:9 area of its sensor (rather than the full

 6048×4024 FX resolution of the sensor). That's true for *all* HD formats: standard HD (720p), full HD (1080p), and ultra HD (4K, 2160p). In fact, the Z6 is the first Nikon dSLR to use the full width of the sensor to capture 4K video. (The D850 uses a cropped section of its DX/APS-C sensor.)

The pixels within that area are then sub-sampled using techniques described in the sidebar "More Tech," using only *some* of the available photosites to reduce the captured frame to the final 3820×1260 or 1920×1080 video resolution. Your wide-angle and telephoto lenses retain roughly their same fields of view, and you can frame and compose your video through the viewfinder normally, with only the top and bottom of the frame cropped off to account for the wider video aspect ratio. (See Figure 15.5.)

Figure 15.5
The cropped video capture area for HD movies.

MORE TECH

The Z6 can capture 4K video from the full width of the sensor without *pixel binning*. Unlike its sibling, the Z7, the Z6 doesn't need to use a technology called vertical line skipping, because its lower resolution (24 MP vs 46 MP with the Z7) doesn't force the camera to "discard" lines to achieve 4K resolution. That gives the Z6 one advantage over the Z7; line skipping can result in reduced low-light efficiency, some unwanted moiré effects, and the appearances of some jagginess in diagonal lines.

In DX/APS-C/Super 35 capture mode, the Z6 oversamples each frame, and then combines them using pixel binning to create the finished video. Pixel binning is a type of algorithm that reads more pixels than the final output resolution needs ("oversampling") and then combines groups of them to produce final pixels at the appropriate resolution (say a 4K video frame) that more accurately represent the colors of the image at an increased signal-to-noise ratio (for less noise and more sensitivity in very low-light scenes). Line skipping simply ignores some sensor values. The net result is that in FX mode, the Z6 gives you a great quality 4K image, but in DX/APS-C/Super 35 mode you can end up with even better video because of the additional processing.

As you learned in Chapter 7, a larger sensor calls for the use of longer focal lengths to produce the same field of view, so, in effect, a larger sensor like the full-frame FX sensor used in the Z6 has reduced depth-of-field. And *that's* what makes cameras like the Z6 attractive from a creative standpoint. Less depth-of-field means greater control over the range of what's in focus. Your Z6, with its larger sensor, has a distinct advantage over even DX models like the D850, is miles ahead of consumer camcorders in this regard, and even does a better job than many professional video cameras. (Some professional video cameras do use large sensors.) Figure 15.6 compares some typical sensor sizes.

Figure 15.6 Relative size of full frame, APS-C, snapshot, and pro-video sensors.

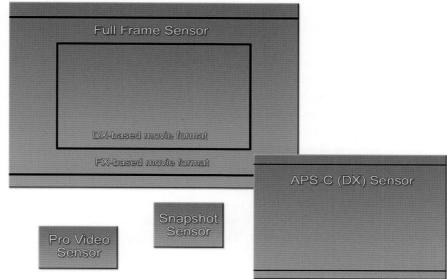

Zooming and Video

When shooting still photos, a zoom is a zoom is a zoom. The key considerations for a zoom lens used only for still photography are the maximum aperture available at each focal length ("How *fast* is this lens?), the zoom range ("How far can I zoom in or out?"), and its sharpness at any given f/stop ("Do I lose sharpness when I shoot wide open?").

When shooting video, the priorities may change, and there are two additional parameters to consider. The first two I listed, lens speed and zoom range, have roughly the same importance in both still and video photography. Zoom range gains a bit of importance in videography, because you can always/usually move closer to shoot a still photograph, but when you're zooming during a shot most of us don't have that option (or the funds to buy/rent a dolly to smoothly move the camera during capture). But, oddly enough, overall sharpness may have slightly less importance under certain conditions when shooting video. That's because the image changes in some way many times per

second (24/30/60/120 times per second with the Z6), so any given frame doesn't hang around long enough for our eyes to pick out every single detail. You want a sharp image, of course, but your standards don't need to be quite as high when shooting video.

Here are the remaining considerations:

- Zoom lens maximum aperture. The speed of the lens matters in several ways. A zoom with a relatively large maximum aperture lets you shoot in lower light levels, and a big f/stop allows you to minimize depth-of-field for selective focus. Keep in mind that the maximum aperture may change during zooming. A lens that offers an f/3.5 maximum aperture at its widest focal length may provide only f/5.6 worth of light at the telephoto position.
- Zoom range. Use of zoom during actual capture should not be an everyday thing, unless you're shooting a kung-fu movie. However, there are effective uses for a zoom shot, particularly if it's a "long" one from extreme wide angle to extreme close-up (or vice versa). Most of the time, you'll use the zoom range to adjust the perspective of the camera *between* shots, and a longer zoom range can mean less trotting back and forth to adjust the field of view. Zoom range also comes into play when you're working with selective focus (longer focal lengths have less depth-of-field), or want to expand or compress the apparent distance between foreground and background subjects. A longer range gives you more flexibility.
- Linearity. Interchangeable lenses may have some drawbacks, as many photographers who have been using the video features of their interchangeable-lens digital cameras have discovered. That's because, unless a lens is optimized for video shooting, zooming with a particular lens may not necessarily be linear. Rotating the zoom collar manually at a constant speed doesn't always produce a smooth zoom. There may be "jumps" as the elements of the lens shift around during the zoom. Keep that in mind if you plan to zoom during a shot, and are using a lens that has proved, from experience, to provide a non-linear zoom. (Unfortunately, there's no easy way to tell ahead of time whether you own a lens that is well-suited for zooming during a shot.)

Keep Things Stable and on the Level

Camera shake's enough of a problem with still photography, but it becomes even more of a nuisance when you're shooting video. The image-stabilization feature found in many Nikon lenses (and some third-party optics) can help minimize this. That's why Nikon's VR-capable zoom lenses (described in Chapter 7) make an excellent choice for video shooting if you're planning on going for the handheld cinema verité look.

The Z6 also has an *electronic VR* option, which I've described several times in this book. It's available only in 1080p mode (other resolutions, including 1920×1080 slow-motion and 4K are disabled). To recap, electronic vibration reduction reduces the frame size by about 10 percent (in FX mode only; in DX mode the camera has the pixels outside the APS-C frame to play with), and uses the extra image area to realign the frames to counteract any camera motion.

Just realize that while hand-held camera shots—even image stabilized—may be perfect if you're shooting a documentary or video that intentionally mimics traditional home movie making, in other contexts it can be disconcerting or annoying. And even VR can't work miracles. It's the camera movement itself that is distracting—not necessarily any blur in your subject matter.

If you want your video to look professional, putting the Z6 on a tripod will give you smoother, steadier video clips to work with. It will be easier to intercut shots taken from different angles (or even at different times) if everything was shot on a tripod. Cutting from a tripod shot to a hand-held shot, or even from one hand-held shot to another one that has noticeably more (or less) camera movement can call attention to what otherwise might have been a smooth cut or transition.

Remember that telephoto lenses and telephoto zoom focal lengths magnify any camera shake, even with VR, so when you're using a longer focal length, that tripod becomes an even better idea. Tripods are essential if you want to pan from side to side during a shot, dolly in and out, or track from side to side (say, you want to shoot with the camera in your kid's coaster wagon). A tripod and (for panning) a fluid head built especially for smooth video movements can add a lot of production value to your movies.

ROLL ON, SHUTTER

Another side-effect to watch out for occurs when panning or capturing moving subjects, caused by the Z6's *rolling shutter*. Because the camera captures all the horizontal lines one at a time, the last line in a frame is captured a fraction of a second later after the first line. So, if the subject or camera is moving from side to side, a vertical subject will appear to lean backward, causing what is termed a "Jell-O effect." There's no way to eliminate this defect, but you should be aware of it when shooting. You may be able to minimize capturing moving subjects, or edit offending clips out of your finished video.

Shooting Script

A shooting script is nothing more than a coordinated plan that covers both audio and video and provides order and structure for your video when you're in planned, storytelling mode. A detailed script will cover what types of shots you're going after, what dialogue you're going to use, audio effects, transitions, and graphics. A good script needn't constrain you: as the director you are free to make changes on the spot during actual capture. But, before you change the route to your final destination, it's good to know where you were headed, and how you originally planned to get there.

When putting together your shooting script, plan for lots and lots of different shots, even if you don't think you'll need them. Only amateurish videos consist of a bunch of long, tedious shots. You'll want to vary the pace of your production by cutting among lots of different views, angles, and perspectives, so jot down your ideas for these variations when you put together your script.

If you're shooting a documentary rather than telling a story that's already been completely mapped out, the idea of using a shooting script needs to be applied more flexibly. Documentary filmmakers often have no shooting script at all. They go out, do their interviews, capture video of people, places, and events as they find them, and allow the structure of the story to take shape as they learn more about the subject of their documentary. In such cases, the movie is typically "created" during editing, as bits and pieces are assembled into the finished piece.

Storyboards

A storyboard makes a great adjunct to a detailed shooting script. It is a series of panels providing visuals of what each scene should look like. While the ones produced by Hollywood are generally of very high quality, there's nothing that says drawing skills are important for this step. Stick figures work just fine if that's the best you can do. The storyboard just helps you visualize locations, placement of actors/actresses, props and furniture, and helps everyone involved get an idea of what you're trying to show. It also helps show how you want to frame or compose a shot. You can even shoot a series of still photos and transform them into a "storyboard" if you want, such as in Figure 15.7.

Figure 15.7 A storyboard is a series of simple sketches or photos to help visualize a segment of video.

Storytelling in Video

Today's audience is used to fast-paced, short-scene storytelling. To produce interesting video for such viewers, it's important to view video storytelling as a kind of shorthand code for the more leisurely efforts print media offers. Audio and video should always be advancing the story. While it's okay to let the camera linger from time to time, it should only be for a compelling reason and only briefly. Above all, look for movement in your scene as you shoot. You're not taking still photographs!

It only takes a second or two for an establishing shot to impart the necessary information. For example, many of the scenes for a video documenting a model being photographed in a rock 'n' roll music setting might be close-ups and talking heads, but an establishing shot showing the studio where the video was captured helps set the scene.

Provide variety too. If you put your shooting script together correctly, you'll be changing camera angles and perspectives often and never leave a static scene on the screen for a long period of time. (You can record a static scene for a reasonably long period and then edit in other shots that cut away and back to the longer scene with close-ups that show each person talking.)

When editing, keep transitions basic! I can't stress this one enough. Watch a television program or movie. The action "jumps" from one scene or person to the next. Fancy transitions that involve exotic "wipes," dissolves, or cross fades take too long for the average viewer and make your video ponderous.

Composition

In movie shooting, several factors restrict your composition, and impose requirements you just don't always have in still photography (although other rules of good composition do apply). Here are some of the key differences to keep in mind when composing movie frames:

- Horizontal compositions only. Some subjects, such as basketball players and tall buildings, just lend themselves to vertical compositions. But movies are shown in horizontal format only. So, if you're interviewing a local basketball star, you can end up with a worst-case situation like the one shown in Figure 15.8. If you want to show how tall your subject is, it's often impractical to move back far enough to show him full-length. You really can't capture a vertical composition. Tricks like getting down on the floor and shooting up at your subject can exaggerate the perspective, but aren't a perfect solution.
- Wasted space at the sides. Moving in to frame the basketball player as outlined by the yellow box in Figure 15.8 means that you're still forced to leave a lot of empty space on either side. (Of course, you can fill that space with other people and/or interesting stuff, but that defeats your intent of concentrating on your main subject.) So, when faced with some types of subjects in a horizontal frame, you can be creative, or move in *really* tight. For example, if I was willing to give up the "height" aspect of my composition, I could have framed the shot as shown by the green box in the figure, and wasted less of the image area at either side.

Figure 15.8
Movie shooting requires you to fit all your subjects into a horizontally oriented frame.

- Seamless (or seamed) transitions. Unless you're telling a picture story with a photo essay, still pictures often stand alone. But with movies, each of your compositions must relate to the shot that preceded it, and the one that follows. It can be jarring to jump from a long shot to a tight close-up unless the director—you—is very creative. Another common error is the "jump cut" in which successive shots vary only slightly in camera angle, making it appear that the main subject has "jumped" from one place to another. (Although everyone from French New Wave director Jean-Luc Goddard to Guy Ritchie—Madonna's ex—have used jump cuts effectively in their films.) The rule of thumb is to vary the camera angle by at least 30 degrees between shots to make it appear to be seamless. Unless you prefer that your images flaunt convention and appear to be "seamy."
- The time dimension. Unlike still photography, with motion pictures there's a lot more emphasis on using a series of images to build on each other to tell a story. Static shots where the camera is mounted on a tripod and everything is shot from the same distance are a recipe for dull videos. Watch a television program sometime and notice how often camera shots change distances and directions. Viewers are used to this variety and have come to expect it. Professional video productions are often done with multiple cameras shooting from different angles and positions. But many professional productions are shot with just one camera and careful planning, and you can do just fine with your Z6.

Here's a look at the different types of commonly used compositional tools:

■ Establishing shot. Much as it sounds, this type of composition, as shown in Figure 15.9, upper left, establishes the scene and tells the viewer where the action is taking place. Let's say you're shooting a video of your offspring's move to college; the establishing shot could be a wide shot of the campus with a sign welcoming you to the school in the foreground. Another example would be for a child's birthday party; the establishing shot could be the front of the house decorated with birthday signs and streamers or a shot of the dining room table decked out with party favors and a candle-covered birthday cake. In the example, I wanted to show the studio where the video was shot.

Figure 15.9 Use a full range of shot types.

- Medium shot. This shot is composed from about waist to head room (some space above the subject's head). It's useful for providing variety from a series of close-ups and makes for a useful first look at a speaker. A medium shot is used to bring the viewer into a scene without shocking them. It can be used to introduce a character and provide context via their surroundings. (See Figure 15.9, upper right.)
- Close-up. The close-up, usually described as "from shirt pocket to head room," provides a good composition for someone talking directly to the camera. Although it's common to have your talking head centered in the shot, that's not a requirement. In Figure 15.9, center left, the subject was offset to the right. This would allow other images, especially graphics or titles, to be superimposed in the frame in a "real" (professional) production. But the compositional technique can be used with Z6 videos, too, even if special effects are not going to be added. A close-up generally shows the full face with a little head room at the top and down to the shoulders at the bottom of the frame.
- Extreme close-up. When I went through broadcast training, this shot was described as the "big talking face" shot and we were actively discouraged from employing it. Styles and tastes change over the years and now the big talking face is much more commonly used (maybe people are better looking these days?) and so this view may be appropriate. Just remember, the Z6 is capable of shooting in high-definition video and you may be playing the video on a high-def TV; be careful that you use this composition on a face that can stand up to high definition. (See Figure 15.9, center right.) An extreme close-up is a very tight shot that cuts off everything above the top of the head and below the chin (or even closer!). Be careful using this shot since many of us look better from a distance!
- "Two" shot. A two shot shows a pair of subjects in one frame. They can be side by side or one in the foreground and one in the background. (See Figure 15.9, lower left.) This does not have to be a head-to-ground composition. Subjects can be standing or seated. A "three shot" is the same principle except that three people are in the frame. A "two shot" features two people in the frame. This version can be framed at various distances such as medium or close-up.
- Over-shoulder shot. Long a composition of interview programs, the "over-shoulder shot" uses the rear of one person's head and shoulder to serve as a frame for the other person. This puts the viewer's perspective as that of the person facing away from the camera. (See Figure 15.9, lower right.) An "over-shoulder" shot is a popular shot for interview programs. It helps make the viewers feel like they're the one asking the questions.

Lighting for Video

Much like in still photography, how you handle light pretty much can make or break your videography. Lighting for video can be more complicated than lighting for still photography, since both subject and camera movement are often part of the process.

Lighting for video presents several concerns. First off, you want enough illumination to create a useable video. Beyond that, you want to use light to help tell your story or increase drama. Let's take a better look at both.

Illumination

You can significantly improve the quality of your video by increasing the light falling in the scene. This is true indoors or out, by the way. While it may seem like sunlight is more than enough, it depends on how much contrast you're dealing with. If your subject is in shadow (which can help them from squinting) or wearing a ball cap, a video light can help make them look a lot better.

Lighting choices for amateur videographers are a lot better these days than they were a decade or two ago. An inexpensive incandescent video light, which will easily fit in a camera bag, can be found for \$15 or \$20. You can even get a good-quality LED video light for less than \$100. Work lights sold at many home improvement stores can also serve as video lights since you can set the camera's white balance to correct for any color casts. You'll need to mount these lights on a tripod or other support, or, perhaps, to a bracket that fastens to the tripod socket on the bottom of the camera.

Much of the challenge depends upon whether you're just trying to add some fill-light on your subject versus trying to boost the light on an entire scene. A small video light will do just fine for the former. It won't handle the latter. Fortunately, the versatility of the Z6 comes in quite handy here. Since the camera shoots video in Auto ISO mode, it can compensate for lower lighting levels and still produce a decent image. For best results though, better lighting is necessary.

Creative Lighting

While ramping up the light intensity will produce better technical quality in your video, it won't necessarily improve the artistic quality of it. Whether we're outdoors or indoors, we're used to seeing light come from above. Videographers need to consider how they position their lights to provide even illumination while up high enough to angle shadows down low and out of sight of the camera.

When lighting for video, there are several factors to consider. One is the quality of the light. It can either be hard (direct) light or soft (diffused) light. Hard light is good for showing detail, but can also be very harsh and unforgiving. "Softening" the light, but diffusing it somehow, can reduce the intensity of the light but make for a kinder, gentler light as well.

While mixing light sources isn't always a good idea, one approach is to combine window light with supplemental lighting. Position your subject with the window to one side and bring in either a supplemental light or a reflector to the other side for reasonably even lighting.

Lighting Styles

Some lighting styles are more heavily used than others. Some forms are used for special effects, while others are designed to be invisible. At its most basic, lighting just illuminates the scene, but when used properly it can also create drama. Let's look at some types of lighting styles:

- Three-point lighting. This is a basic lighting setup for one person. A main light illuminates the strong side of a person's face, while a fill light lights up the other side. A third light is then positioned above and behind the subject to light the back of the head and shoulders. (See Figure 15.10, left.)
- Flat lighting. Use this type of lighting to provide illumination and nothing more. It calls for a variety of lights and diffusers set to raise the light level in a space enough for good video reproduction, but not to create a mood or emphasize a scene or individual. With flat lighting, you're trying to create even lighting levels throughout the video space and minimize any shadows. Generally, the lights are placed up high and angled downward (or possibly pointed straight up to bounce off a white ceiling). (See Figure 15.10, right.)
- "Ghoul lighting." This is the style of lighting used for old horror movies. The idea is to position the light down low, pointed upward. It's such an unnatural style of lighting that it makes its targets seem weird and "ghoulish."
- Outdoor lighting. While shooting outdoors may seem easier because the sun provides more light, it also presents its own problems. As a rule of thumb, keep the sun behind you when you're shooting video outdoors, except when shooting faces (anything from a medium shot and closer) since the viewer won't want to see a squinting subject. When shooting another human this way, put the sun behind her and use a video light to balance light levels between the foreground and background. If the sun is simply too bright, position the subject in the shade and use the video light for your main illumination. Using reflectors (white board panels or aluminum foil—covered cardboard panels are cheap options) can also help balance light effectively.

Figure 15.10 With three-point lighting (left) two lights are placed in front and to the side of the subject and another light is directed on the background to provide separation. Flat lighting (right) was bounced off a white ceiling and walls to fill in shadows as much as possible. It is a flexible lighting approach since the subject can change positions without needing a change in light direction.

Audio

When it comes to making a successful video, audio quality is one of those things that separates the professionals from the amateurs. We're used to watching top-quality productions on television and in the movies, yet the average person has no idea how much effort goes in to producing what seems to be "natural" sound. Much of the sound you hear in such productions is recorded on carefully controlled sound stages and "sweetened" with a variety of sound effects and other recordings of "natural" sound. Google "Foley artist" some time and you'll discover this part of a production is, indeed, a rich and complex art form.

Tips for Better Audio

Since recording high-quality audio is such a challenge, it's a good idea to do everything possible to maximize recording quality. Here are some ideas for improving the quality of the audio your camera records:

- Get the camera and its microphone close to the speaker. The farther the microphone is from the audio source, the less effective it will be in picking up that sound. While having to position the camera and its built-in microphone closer to the subject affects your lens choices and lens perspective options, it will make the most of your audio source. Of course, if you're using a very wide-angle lens, getting too close to your subject can have unflattering results, so don't take this advice too far. It's important to think carefully about what sounds you want to capture. If you're shooting video of an acoustic combo that's not using a PA system, you'll want the microphone close to them, but not so close that, say, only the lead singer or instrumentalist is picked up, while the players at either side fade off into the background.
- Use an external microphone. You'll recall the description of the camera's external microphone port in Chapter 2. As noted, this port accepts a stereo mini-plug from a standard external microphone, allowing you to achieve considerably higher audio quality for your movies than is possible with the camera's built-in microphones (which are disabled when an external mic is plugged in). An external microphone reduces the amount of camera-induced noise that is picked up and recorded on your audio track. (The action of the lens as it focuses can be audible when the built-in microphones are active.)

The external microphone port can provide plug-in power for microphones that can take their power from this sort of outlet rather than from a battery in the microphone. Nikon provides optional compatible microphones such as the ME-1 (\$135) (see Figure 15.11) or wireless ME-W1 (\$199); you also may find suitable microphones from companies such as Shure and Audio-Technica. If you are on a quest for superior audio quality, you can even obtain a portable mixer that can plug into this jack, such as the affordable Rolls MX124 (around \$150) (www.rolls.com), letting you use multiple high-quality microphones (up to four) to record your soundtrack.

One advantage that a sound-mixing device offers over the stock Z6 is that it adds an additional headphone output jack to your camera, so you can monitor the sound actually being captured

Figure 15.11 Nikon ME-1 external stereo microphone.

by the recorder (you can also listen to your soundtrack through the headphones during play-back, which is *way* better than using the Z6's built-in speaker). The adapter has two balanced XLR microphone inputs and can also accept line input (from another audio source), and provides cool features like AGC (automatic gain control), built-in limiting, and VU meters you can use to monitor sound input.

- Hide the microphone. Combine the first few tips by using an external mic, and getting it as close to your subject as possible. If you're capturing a single person, you can always use a lapel microphone (described in the next section). But if you want a single mic to capture sound from multiple sources, your best bet may be to hide it somewhere in the shot. Put it behind a vase, using duct tape to fasten the microphone, and fix the mic cable out of sight (if you're not using a wireless microphone).
- Turn off any sound makers you can. Little things like fans and air handling units aren't obvious to the human ear, but will be picked up by the microphone. Turn off any machinery or devices that you can plus make sure cell phones are set to silent mode. Also, do what you can to minimize sounds such as wind, radio, television, or people talking in the background.
- Make sure to record some "natural" sound. If you're shooting video at an event of some kind, make sure you get some background sound that you can add to your audio as desired in post-production.
- Consider recording audio separately. Lip-syncing is probably beyond most of the people you're going to be shooting, but there's nothing that says you can't record narration separately and add it later. It's relatively easy if you learn how to use simple software video-editing programs like iMovie (for the Macintosh) or Windows Movie Maker (for Windows PCs). Any time the speaker is off-camera, you can work with separately recorded narration rather than recording the speaker on-camera. This can produce much cleaner sound.

External Microphones

The single-most important thing you can do to improve your audio quality is to use an external microphone. The Z6's internal stereo microphones mounted on the front of the camera will do a decent job, but have some significant drawbacks, partially spelled out in the previous section:

- Camera noise. There are plenty of noise sources emanating from the camera, including your own breathing and rustling around as the camera shifts in your hand. Manual zooming is bound to affect your sound, and your fingers will fall directly in front of the built-in mics as you change focal lengths. An external microphone isolates the sound recording from camera noise.
- **Distance.** Anytime your Z6 is located more than 6 to 8 feet from your subjects or sound source, the audio will suffer. An external unit allows you to place the mic right next to your subject.
- Improved quality. Obviously, Nikon wasn't able to install a super-expensive, super-high-quality microphone, even on a \$2,000 camera. Not all owners of the Z6 would be willing to pay the premium, especially if they didn't plan to shoot much video themselves. An external microphone will almost always be of better quality.
- **Directionality.** The Z6's internal microphone generally records only sounds directly in front of it. An external microphone can be either of the directional type or omnidirectional, depending on whether you want to "shotgun" your sound or record more ambient sound.

You can choose from several different types of microphones, each of which has its own advantages and disadvantages. If you're serious about movie making with your Z6, you might want to own more than one. Common configurations include:

- Shotgun microphones. These can be mounted directly on your Z6, although, if the mic uses an accessory shoe mount, you'll need the optional adapter to convert the camera's shoe to a standard hot shoe. I prefer to use a bracket, which further isolates the microphone from any camera noise. One thing to keep in mind is that while the shotgun mic will generally ignore any sound coming from behind it, it will pick up any sound it is pointed at, even behind your subject. You may be capturing video and audio of someone you're interviewing in a restaurant, and not realize you're picking up the lunchtime conversation of the diners seated in the table behind your subject. Outdoors, you may record your speaker, as well as the traffic on a busy street or freeway in the background.
- Lapel microphones. Also called *lavalieres*, these microphones attach to the subject's clothing and pick up their voice with the best quality. You'll need a long enough cord or a wireless mic. These are especially good for video interviews, so whether you're producing a documentary or grilling relatives for a family history, you'll want one of these.

- Hand-held microphones. If you're capturing a singer crooning a tune, or want your subject to mimic famed faux newscaster Wally Ballou, a hand-held mic may be your best choice. They serve much the same purpose as a lapel microphone, and they're more intrusive—but that may be the point. A hand-held microphone can make a great prop for your fake newscast! The speaker can talk right into the microphone, point it at another person, or use it to record ambient sound. If your narrator is not going to appear on-camera, one of these can be an inexpensive way to improve sound.
- Wired and wireless external microphones. This option is the most expensive, but you get a receiver and a transmitter (both battery-powered, so you'll need to make sure you have enough batteries). The transmitter is connected to the microphone, and the receiver is connected to your Z6. In addition to being less klutzy and enabling you to avoid having wires on view in your scene, wireless mics, such as the Nikon MW-W1, let you record sounds that are physically located some distance from your camera. Of course, you need to keep in mind the range of your device, and be aware of possible signal interference from other electronic components in the vicinity.

WIND NOISE REDUCTION

Always use the wind screen provided with an external microphone to reduce the effect of noise produced by even light breezes blowing over the microphone. Many mics, such as the Nikon ME-1, include a low-cut filter to further reduce wind noise. However, these can also affect other sounds. You can disable the low-cut filters for the ME-1 by changing a switch on the back from L-cut (low cutoff) to Flat. Other external mics also have their own low-cut filter switch.

Special Features

The Z6 also has two audio frequency ranges (Wide and Vocal Range) and an Attenuator, described in Chapter 11, so you can tailor your microphone capture to your subject matter (for ambient sound or voice recording). Audio levels can be adjusted while recording, and the camera's internal microphones have improved wind noise reduction.

Index

A	a13 Manual Focus in in AF Mode, Custom
A (Aperture-priority) mode	Settings menu, 391–392
equivalent exposure, 78	AA (Auto Aperture) Automatic flash mode, 263 282
locating, 25	
using, 90–92	AC adapters
A: Non-TTL auto flash, 282	EH-5b/EH-5c/EP-5b, 8
al-al3 (autofocus)	EH-7P charging, 6–7
defaults, 381	accessory shoe, 65–66
options, 43	accessory shoe cover, BS-1, 7-8
recommendations, 37	accessory terminal, 53
al AF-C Priority Selection, Custom Settings	action. See also trap focus
menu, 385-386	freezing, 242
a2 AF-S Priority Selection, Custom Settings	shooting, 158
menu, 386	Active D-Lighting option
3 Focus Tracking with Lock-on, Custom	button, 417
Settings menu, 386–387	information display, 65
4 Auto-Area AF Face-Detection, Custom	Movie menu values, 369
Settings menu, 387	Movie Shooting menu, 373
5 Focus Points Used, Custom Settings menu,	Photo Shooting menu, 352–354
387–388	recommendations, 35–36
a6 Store Points by Orientation, Custom Settings	actuations, 404
menu, 388	Add NEF (RAW) button, 417
n7 AF Activation, Custom Settings menu,	ADL (Active D-Lighting) bracketing, 104
388–389	Adobe RGB color space, 349-352
18 Limit AF-Area Mode Selection, Custom	AE lock functions, 416
Settings menu, 389	AE Lock/timers (c1-c3) recommendations, 39,
19 Focus Point Wrap-Around, Custom Settings	44, 396–398
menu, 390	AF Fine-Tune, Setup menu, 437–438
110 Focus Point Options, Custom Settings	AF Fisheye-Nikkor lenses, 237
menu, 390-391	AF lenses, 212, 214, 232
111 Low-Light AF, Custom Settings menu, 391	AF Micro-Nikkor lenses, 238
112 Built-in AF-Assist Illuminator, Custom	AF modes, choosing, 27
Settings menu, 391	

AF points	aperture
placement, 466	button, 418
storing by orientation, 140–141	exposure triangle, 75–77
AF-area modes	Manual exposure, 97
buttons and functions, 417	on/off, 420
choosing, 28-29	aperture lock button, 418
limiting selection, 389	APS-C (Advanced Photo System—Classic)
Movie Shooting menu, 375	cameras, 200
Photo Shooting menu, 361	ARNEO coating, 208
reducing options, 137	artist information display, 65
Spot metering, 87–88	Assign Remote (WR) Fn Button, Setup menu,
AF-assist illuminator, 50–51	446
AF-C (continuous-servo autofocus), 27, 132–133	Atomos Ninja V monitor/recorder, 482
AF-D lenses, 212, 214	attenuator feature, enabling, 471, 502
AF-F (Full-time autofocus), 133	Attenuator option, Movie Shooting menu, 377
AF-I lenses, 214	audio distortion, minimizing, 471
AF-ON button	audio frequency ranges, 502
default values, 416-418	audio tips, 499–502. See also sound quality
explanation, 56	Auto bracketing button, 417
functions, 416	Auto Bracketing option, Photo Shooting menu,
location, 55	362. See also bracketing
AF-P ED VR lenses, 232	Auto Distortion Control option. See also
AF-P lenses, 214	Distortion Control
AF-S (single-servo autofocus), 27, 132	Movie Shooting menu, 374
AF-S ED VR II lenses, 235	Photo Shooting menu, 359
AF-S ED VR lenses, 231	recommendations, 35–36
AF-S FL ED VR lenses, 236	Auto FP sync setting, 257, 270, 272
AF-S IF-ED lenses, 233	Auto HDR, 105–107
AF-S lenses, 214, 231–233	Auto ISO Sensitivity Control, Photo Shooting
AF-S macro lenses, 237	menu, 316
AF-S Nikkor lenses, 227–228	Auto mode, 24–25
AF-S PF ED VR lenses, 233	autoexposure bracketing, setting up, 101–102
AF-S VR II IF-ED lenses, 235	autofocus. See also trap focus
AF-S VR Micro-Nikkor lenses, 238	activation, 142
AF-S wide angle lenses, 229–230	features, 130–131
After Burst, Show option, Playback menu, 311	information display, 64
After Delete option, Playback menu, 310. See	low-light, 132
also Delete option	vs. manual focus, 129–130
AI lenses, 212–214	using, 129–130
AI-P lenses, FTZ adapter, 212–213	autofocus area modes, 133–137
Airplane Mode, Setup menu, 446	autofocus modes, 131
AI-S lenses, 212–214, 231	autofocus options (a1-a13), 37, 43
aligning shapes, 70	Autofocus/Manual focus switch, 67-68
AN-DC19 neck strap, 4–5	Automatic-area AF, 137
1.	AWL (advanced wireless lighting), 271, 285, 295

В	bracketing. See also Auto Bracketing option
b. Metering/Exposure, Custom Settings menu	ADL (Active D-Lighting), 104
options, 382, 392–395	burst function, 416
b1-b4 (metering/exposure)	and continuous shooting, 158
defaults, 382	and Merge to HDR, 107-110
recommendations, 38, 44	using, 101–104
b1 EV Steps for Exposure Cntrl., Custom	WB (white balance), 246
Settings menu options, 393	white balance, 102-104
b2 Easy Exposure Compensation, Custom	bracketing/flash (e1-e7) recommendations, 40,
Settings menu options, 393–394	45–46
b3 Center-Weighted Area, Custom Settings	BS-1 accessory shoe cover, 7-8
menu options, 394	BSI (back-side illuminated) sensor, 71–72. See
b4 Fine-Tune Optimal Exposure, Custom	also sensors
Settings menu options, 394–395	buffer capacity, 159, 401
back button focus, 146–149	bulb exposures, 166
back focus, 146, 149-150. See also focus	burst options, Playback menu, 311
backgrounds, using for lighting, 254	
backspacing/moving forward, 320	C
barn doors and snoots, 254	
batteries	c. Timers/AE Lock, Custom Settings menu options, 382, 396–398
charger MH-25a, 4	c1-c3 (Timers/AE lock)
charging, 15-17	defaults, 382
keeping spares, 6	recommendations, 39, 44
rechargeable Li-ion En-EL15b, 4	c1 Shutter-Release Button AE-L, Custom
battery compartment door, 68	Settings menu options, 396
Battery Info, Setup menu, 447	c2 Self-Timer, Custom Settings menu options,
battery pack, multi-power MB-N10, 8	397
Beep Options, Setup menu, 441	c3 Power Off Delay, Custom Settings menu
BF-N1 body cap, 5	options, 397–398
Binary Picture Control, 347	Camera Control Pro 2 software, 7
Bit Depth setting, NEF (RAW) Recording, 329	camera front, 50–54
black-and-white photos, 112	camera shake
Bleached Picture Control, 346	dealing with, 490-491
Blue Picture Control, 347	vanquishing, 165
Bluetooth and SnapBridge, 189, 192, 194–196	camera strap eyelet, 55–56
blur, reducing and adding, 93, 161–162, 168	capacitor, 256, 263-264
body cap, BF-N1, 5	Carbon Picture Control, 347
bokeh, 225-226	*Card Err (flashing) error code, 18
bounce cards, external flash, 279–280	CDAF (contrast detection autofocus), 123
	Center-weighted metering, 26, 85–86, 360, 394
	function, 416
	CFexpress cards, 9-10. See also memory cards
	CFLs (compact fluorescent lights), 249–250

channels	Connect to PC, Setup menu, 447
histograms, 117-118	Connect to Smart Device, Setup menu, 446
master flash, 287	Continuous H shooting mode, 23
wireless flash, 290	Continuous L shooting mode, 22-23
Charcoal Picture Control, 347	continuous lighting vs. electronic flash, 240-
charging AC adapter, EH-7P, 6-7	244. See also light
charging batteries, 4, 15-17	continuous shooting, 157-161
charging lamp, 55-56	continuous-servo autofocus (AF-C), 27, 132-133
Choose Image Area options	contrast, changing, 115
Movie menu values, 369	contrast detection, 123-124
Movie Shooting menu, 370	control panel, 66-67
Photo Shooting menu, 316, 321-322	Control Panel Brightness, Setup menu, 435
chroma subsampling, 483	control ring, 204
circle of confusion, 127-128	controls (f1-f7)
Clean Image Sensor, Setup menu, 439	options, 411–414
clock, setting, 15	recommendations, 41-42, 46-47, 419-420
close-up photography, A (Aperture-priority)	Copyright Information, Setup menu, 441
mode, 92	copyright notices, information display, 65
close-up shot, 495-496	Creative Lighting, 497
CLS (Creative Lighting System), 256, 260. See	CRI (color rendering index), 246
also light	crop factor, 200–202
color correction, 352	cropping images, 61
color management, 351	Custom Settings menu options
Color Space option	a. Autofocus, 381, 385–392
Photo Shooting menu, 349–352	al AF-C Priority Selection, 385-386
recommendations, 35–36	a2 AF-S Priority Selection, 386
color temperature	a3 Focus Tracking with Lock-on, 386-387
adjusting, 333	a4 Auto-Area AF Face-Detection, 387
continuous lighting, 244–247	a5 Focus Points Used, 387–388
external flash, 272	a6 Store Points by Orientation, 388
command dials, customizing, 421-423	a7 AF Activation, 388–389
Commander capabilities, 287, 294–300	a8 Limit AF-Area Mode Selection, 389
comments	a9 Focus Point Wrap-Around, 390
adding to images, 440	a10 Focus Point Options, 390-391
information display, 65	all Low-Light AF, 391
comparing photos side by side, 459-460	a12 Built-in AF-Assist Illuminator, 391
composition in video, 493-496	a13 Manual Focus in in AF Mode, 391–392
compression, NEF (RAW) Recording, 329	b. Metering/Exposure, 382, 392-395
concerts	b1 EV Steps for Exposure Cntrl., 393
S (Shutter-priority) mode, 94	b2 Easy Exposure Compensation, 393–394
shooting, 310	b3 Center-Weighted Area, 394
Conformity Marking, Setup menu, 447	b4 Fine-Tune Optimal Exposure, 394–395

- c. Timers/AE Lock, 382, 396–398
- c1 Shutter-Release Button AE-L, 396
- c2 Self-Timer, 397
- c3 Power Off Delay, 397-398
- d. Shooting/Display, 382-383, 398-406
- d1 CL Mode Shooting Speed, 398-400
- d2 Max. Continuous Release, 400
- d3 Sync. Release Mode Options, 401
- d4 Exposure Delay Mode, 401-402
- d5 Electronic Front-Curtain Shutter, 402
- d6 Limit Selectable Image Area, 402-403
- d7 File Number Sequence, 403–404
- d8 Apply Settings to Live View, 404-405
- d9 Framing Grid Display, 405–406
- d10 Peaking Highlights, 406
- d11 View All in Continuous Mode, 406
- e. Bracketing/Flash, 383, 407-411
- el Flash Sync Speed, 407-408
- e2 Flash Shutter Speed, 408-409
- e3 Exposure Compensation for Flash, 409
- e4 Auto Flash ISO Sensitivity Control, 409
- e5 Modeling Flash, 410
- e6 Auto Bracketing (Mode M), 410-411
- e7 Bracketing Order, 411
- f. Controls, 383-384, 411-423
- f1 Customize i Menu, 411–414
- f2 Custom Control Assignment, 414–420
- f3 OK Button, 420
- f4 Shutter Spd & Aperture Lock, 420-421
- f5 Customize Command Dials, 421-422
- f6 Release Button to Use Dial, 422-423
- f7 Reverse Indicators, 423
- g. Movie, 384, 423-428
- gl Customize i Menu, 424
- g2 Custom Control Assignment, 424-425
- g3 OK Button, 426
- g4 AF Speed, 426
- g5 AF Tracking Sensitivity, 427
- g6 Highlight Display, 427-428
- layout, 379-381
- recommendations, 34, 37-47
- Reset Custom Settings, 381–384
- resetting, 32

D

- d. Shooting/Display, Custom Settings menu, 382-383, 398-406
- d1-d11 (shooting/display)

defaults, 382-383

recommendations, 40, 45

- d1 CL Mode Shooting Speed, Custom Settings menu options, 398–400
- d2 Max. Continuous Release, Custom Settings menu options, 400
- d3 Sync. Release Mode Options, Custom Settings menu options, 401
- d4 Exposure Delay Mode, Custom Settings menu options, 401–402
- d5 Electronic Front-Curtain Shutter, Custom Settings menu options, 402
- d6 Limit Selectable Image Area, Custom Settings menu options, 402–403
- d7 File Number Sequence, Custom Settings menu options, 403–404
- d8 Apply Settings to Live View, Custom Settings menu options, 404–405
- d9 Framing Grid Display, Custom Settings menu options, 405–406
- d10 Peaking Highlights, Custom Settings menu options, 406
- d11 View All in Continuous Mode, Custom Settings menu options, 406

dark-frame subtraction, 100

daylight, 247-248

DC (defocus control) lenses, 214

default settings, changing, 31-34

default values option, Movie Shooting menu, 369

degrees Kelvin, 247

delayed exposures, 170-179. See also exposure

Delete option, Playback menu, 306-307. See also After Delete option

deleting images, 29, 60

Denim Picture Control, 347

depth-of-light, 242

DG lenses, 212

Di (Digitally integrated) lenses, 212

Diffraction Compensation option, Movie Shooting menu, 374

Diffraction Compensation option, Photo	e2 Flash Shutter Speed, Custom Settings menu
Shooting menu, 356–358	options, 408–409
diopter adjustment, 19, 55	e3 Exposure Compensation for Flash, Custom Settings menu options, 409
directional buttons, 11	e4 Auto Flash ISO Sensitivity Control, Custom
DISP button, 29, 55	Settings menu options, 409
display/shooting (d1-d11) recommendations, 40,	e5 Modeling Flash, Custom Settings menu
45	options, 410
Distortion Control, Retouch menu, 457. See also Auto Distortion Control option	e6 Auto Bracketing (Mode M), Custom Settings
DK-29 eyepiece, 5	menu options, 410–411
D-Lighting, Retouch menu, 456	e7 Bracketing Order, Custom Settings menu
DOF (depth-of-field)	options, 411
autofocus, 129	ED (extra-low dispersion/LD/UD) lenses, 215
circle of confusion, 128	ED AF-S VR II lenses, 232
f/stops, 74	ED AF-S VR lenses, 230, 235
previewing, 144, 416	ED AF-S wide angle lenses, 229
video, 487–489	ED VR AF-S wide angle lenses, 229
wide-angle and wide-zoom lenses, 218	ED VR lenses, 236
Dramatic Picture Control, 346	editing movies, 478–479
Dream Picture Control, 345–347	EH-5b/EH-5c/EP-5b AC adapters, 8
D-Series lenses, 214	EH-7P charging AC adapter, 6–7
dust, taking picture of, 440	electronic contacts, 50-51, 67-68
DX format	electronic flash. See also external flash; flash;
choosing, 321	wireless flash
image size and resolution, 327	vs. continuous lighting, 240–244
lenses, 201–203, 214, 468	exposure, 257–264
movie format, 370	flash sync modes, 265–269
trim sizes, 455	GN (guide numbers), 264–265
DX/APS-C/Super 35 capture mode, 488	high-speed sync, 269–271
Dynamic-area AF mode, 135–136	intensities, 292
Dynamic-area A1 mode, 133–130	overview, 255–257
_	electronic rangefinder, using, 144
E	electronic VR option, 376, 490. See also VR
e. Bracketing/Flash, Custom Settings menu	(vibration reduction)
options, 383, 407–411	encoding, explained, 483
E designation lenses, using, 214–215	EN-EL15b battery. See batteries
error code, 18	equivalent exposure, 77–78
e1-e7 (bracketing/flash)	error codes, 18
defaults, 383	establishing shot, 495
recommendations, 40, 45–46	ETTR (expose to the right), 116-117
el Flash Sync Speed, Custom Settings menu	EV changes, making, 95, 108
options, 407–408	Every Other Point setting, 134–135
•	

exposure. See also Metering/Exposure (b1-b4)	F
recommendations; delayed exposures; long	
exposures; multiple exposures; short	f. Controls, Custom Settings menu options, 383-384, 411-423
exposures calculation, 79–82	F error code, 18
compensation, 119	f1-f7 (Controls)
differential, 108	defaults, 383–384
fine-tuning, 118–120	recommendations, 41–42, 46–47
fixing with histograms, 110–118	f1 Customize i Menu, Custom Settings menu
and f/stops, 74	options, 411–414
information display, 64	f2 Custom Control Assignment, Custom
ISO settings, 98–100	Settings menu options, 414–420
and light, 74	f3 OK Button, Custom Settings menu options,
locking, 89, 148	420
moment of, 257–259	f4 Shutter Spd & Aperture Lock, Custom
semi-manual, 476	Settings menu options, 420-421
triangle, 74–75	f5 Customize Command Dials, Custom Setting
exposure compensation, 66, 273, 418	menu options, 421-422
Exposure delay mode button, 418	f6 Release Button to Use Dial, Custom Settings
exposure indicators, reversing, 423	menu options, 422-423
exposure methods	f7 Reverse Indicators, Custom Settings menu
A (Aperture-priority), 90	options, 423
choosing, 89	face detection, 387
explained, 82	Face-priority AF, 138–141
selecting, 24–25	"falling back" look, 218–219
	file information screen, 63
Exposure Smoothing, interval photography, 174	File Naming option
exposure/metering (b1-b4) recommendations,	Movie menu values, 369
exposure/metering recommendations, 38	Movie Shooting menu, 369
external flash. See also electronic flash; wireless	Photo Shooting menu, 316, 320–321
flash	recommendations, 35–36
accessories, 280	file numbers produced, actuations, 404
bounce cards, 279–280	fill-flash, 260, 360
exposure, 257–264	filter thread, 67
flash modes, 281–282	filters
light modifiers, 279–280	metering methods, 85
Nikon SB units, 275–279	vs. toning, 344–345
repeating flash, 283–284	Firmware Version, Setup menu, 449
using, 271–275	FL AF-S ED VR lenses, 236
wireless and wired, 256	FL ED VR lenses, 236
zoom heads, 281	flash. See also electronic flash; Speedlights;
external microphones, using, 499, 501–502	wireless flash
eye sensor, 55	adding on, 7
eyepiece, DK-29, 5	bracketing, 407–411
Jepiece, Dicz,	Manual exposure, 97

radio control, 301-302

Flash Compensation option, Photo Shooting	focus modes
menu, 361	button, 417
Flash Control feature, 274-275, 295, 360	choosing, 27
flash cords, SC-28 and SC-29 TTL, 9	priority, 131–133
Flash Disable/Enable function, 272, 416	focus peaking, 143, 466
flash effects, previewing, 274	focus points
flash exposure compensation, 272-273	locking, 135
flash information display, 69	options, 387–388, 390–391
Flash Mode option, Photo Shooting menu, 360	resetting center, 416
Flash mode/Compensation button, 417	selecting, 418
flash modes, 263, 281-282	Spot metering, 86–87
Flash Off option, 360	Focus Shift Shooting, 182–187, 367
flash shutter speed, specifying, 273-274. See	focus/control ring, 67–68
also shutter speeds	focus-priority, 22, 27, 147
flash sync	folder storage, 316–320
locking, 408	* For (flashing) error code, 18
modes, 265–269	Format Memory Card, Setup menu, 430–431
flash units, assigning to groups, 290-292, 295,	formatting memory cards, 20
301	Forward button, 29
Flash value lock functions, 416	
flash/bracketing (e1-e7) recommendations, 40,	frame rates, continuous shooting, 160–161 Frame Size/Frame Rate, movies/video, 369, 371,
45-46	468–469
flat lighting, 498	
Flexible Program adjustments, 78, 95	frames, saving, 480
flick gesture, 13-14	framing grid, applying, 70, 417
Flicker Reduction option, Movie Shooting menu, 374	Frequency Response option, Movie Shooting menu, 377
Flicker Reduction Shooting option, Photo	frequency response, selecting, 471
Shooting menu, 359	front focus, 149–150
fluorescent light, 249–250	front of camera, 50–54
F-mount lenses, 198–199, 438	front-curtain sync, 257-258, 267
Fn1 and Fn2 buttons, 50–51, 83, 416–418	f/stops
focal plane mark, 66–67	and exposure, 74–76
focal plane shutter, 258. See also shutter speeds	shutter speeds, 77
focus. See also back focus; manual focus;	vs. stops, 78
prefocusing	FTZ adapter, 198–199, 438, 468
auto vs. manual, 121	using, 212–213
and autofocus, 486-487	Full-time autofocus (AF-F), 133
evaluating, 152–154	functions and buttons, 416–418, 446
fine-tuning for lenses, 149–156	FV lock, external flash, 271
overview, 122–128	FX format, choosing, 321
test chart, 152-153	FX image size and resolution, 327
focus area modes, choosing, 28-30	FX lenses, 201, 203, 215
focus assist, external flash, 272	FX movie format, 370
Focus Mode option	FX trim sizes, 454
Movie Shooting menu, 375	and the state of t
Photo Shooting menu, 361	

u	HDR (High Dynamic Range)
g. Movie, Custom Settings menu options, 384,	and bracketing, 107–110
423-428	button, 417
g1-g6 (movie) defaults, 384–385	Photo Shooting menu, 317, 364–365
gl Customize i Menu, Custom Settings menu	working with, 104–110
options, 424	HDTV movie clips, shooting, 24
g2 Custom Control Assignment, Custom	headphone connector, 53
Settings menu options, 424-425	headphone volume, setting, 377, 472
g3 OK Button, Custom Settings menu options,	Help button, 57, 59
426	High ISO NR option. See also ISO sensitivity;
g4 AF Speed, Custom Settings menu options,	noise reduction
426	Movie Shooting menu, 369, 373
g5 AF Tracking Sensitivity, Custom Settings	Photo Shooting menu, 355–356
menu options, 427	recommendations, 35–36, 99–100
g6 Highlight Display, Custom Settings menu	high-contrast lighting, 113
options, 427–428	highlighted characters
gain, setting, 178	erasing, 320
geotagging, 180-182	inserting, 319
gestures, touch screen, 13	highlights, tones in histograms, 117
GGS glass screen, 15	highlights display, 63
ghost images, 266–267	Highlight-weighted metering, 26, 88-89, 360,
ghoul lighting, 498	
glass screen, GGS, 15	high-speed photography, 163. See also shutter speeds
GN (guide numbers), 264–265, 282	<u> </u>
Godox X-series wireless products, 289	high-speed sync, 257–258, 269–271 histograms
GP-1a global positioning system (GPS), 8, 65,	basics, 113–114
180–182	channels, 117–118
GraphicConverter utility, 404	
Graphite Picture Control, 347	tonal range, 111–113
gray, shades of, 117	understanding, 114–118
gray cards, 79, 81, 112	viewing, 110–111
groups, assigning flash units, 290-292, 295, 301	horizontal shapes, aligning, 70
G-series memory cards, Sony, 10	
G-type lenses, 215	1
	<i>i</i> button
H	capturing video, 474–475
	described, 57
halogen light, 248–249	Playback mode, 57–58
hand grip, 52	i menu
HD movies, cropped area, 488	choosing release mode, 22
HD video capture, 465	continuous shooting modes, 159
HDMI, Setup menu, 442–443	customizing, 411–414
HDMI audio/video cable, 8	metering modes, 26
HDMI cable clip, 4	movies, 424
HDMI connector, 53	Picture Controls, 342
HDMI/USB cable clip, 53-54	Split-screen Display Zoom, 144–146

IBIS (in-body image stabilization), 209	ISO sensitivity. See also High ISO NR option
IF (internal focusing) lenses, 215	adjusting, 28–29, 98–100
IF-ED wide angle lenses, 228	exposure triangle, 75
IGBT (insulated-gate bipolar transmitter), 263	Movie Shooting menu, 369, 371–372
illumination. See light	Photo Shooting menu, 316, 330-332
image area, choosing, 321–322, 370, 417	recommendations, 35-36
Image Comment, Setup menu, 440–441	iTTL (intelligent through-the-lens) exposure
Image Dust Off Ref Photo, Setup menu, 440	BL (Balanced Fill Flash), 263
Image Format/Quality option, 36	electronic flash, 256, 258-260
Image Overlay, Retouch menu, 458-459	external flash, 271
Image Quality option	features, 285
buttons and functions, 417	flash modes, 281-282
Photo Shooting menu, 316, 322-327	IX lenses, 215
recommendations, 35	
Image Review option, Playback menu, 309	J
image sensor	_
cleaning, 439	JPEG
features, 51	buffer capacity, 159
locating, 50	image quality options, 322
Image Size options	memory cards, 6
buttons and functions, 417	vs. RAW, 325–327
Photo Shooting menu, 316, 327	JPEG-only mode, 102–103
recommendations, 35–36	
images. See also photos	K
cropping, 61	
deleting, 29, 60	Kelvin, degrees, 247
high- and low-contrast, 113	Kodak gray cards, 81
playing back, 59–65	_
reviewing, 29–30	L
incandescent light, 248–249, 262	landscape photography
Index button, 57, 59	A (Aperture-priority) mode, 91
information display, changing, 29–30, 63,	S (Shutter-priority) mode, 93
436–437	Language, Setup menu, 432
infrared transmitter/receiver, electronic flash,	LCD monitor, 55–56. See also Split-screen
257	Display Zoom; touch screen
inserting memory cards, 19	switching to viewfinder, 21
instant switching, 83	touch operations, 12–15
internal-standard compliance, displaying, 447	LED light sources, 249–250
interval photography, 171–176	lens bayonet mount, 50–51
Interval Timer Shooting option, Photo Shooting	lens control ring, default values, 416–418
menu, 317, 365–366	lens Fn, default values, 416–418
inverse square law, 242	lens hood, 18
IS (image stabilization), 209	lens hood bayonet, 67
ISO button, 66–67	"lens map," 209
ISO noise, reducing, 71. See also noise reduction	lens mounting index, 53
5, 7 500	ichs mounting mack, 33

lens multiplier, 200-201 FTZ adapter, 198-199 lens release button, 50-51 FX, 215 lens release locking pin, 50-51 G-type, 215 lenses IF (internal focusing), 215 AF, 214, 232 IF-ED wide angle, 228 AF Fisheve-Nikkor, 237 information display, 64 AF-D, 214 IX, 215 AF-I, 214 macro, 237-238 AF-P. 214 manual focus, 122 AF-P ED VR, 232 metering, 96 AF-S, 214, 231-233 micro, 215 AF-S ED VR, 231 mounting, 17-18 AF-S ED VR II, 235 N (Nano Crystal Coat), 215 AFS-ED wide angle, 229-230 NAI (Not-AI), 216 AF-S FL ED VR, 236 NOCT (Nocturne), 216 AF-S IF-ED, 233 normal, 217, 231-237 AF-S Nikkor, 227-228 PC (Perspective Control), 216 AF-S PF ED VR, 233 PC-E ED Micro Nikkor, 237 AF-S VR II IF-ED, 235 PC-E Micro Nikkor, 237 AF-S wide angle, 229-230 recommendations, 3 AI, 213-214 setting default values, 156 AI-P, 213 short telephoto, 217 AI-S, 213-214, 231 super-telephoto, 217 categories, 217 Tamron, 212 coatings, 204 telephoto, 217, 222-226, 231-237 components, 67-68 tele-zoom, 222-226 control ring, 204 ultra-wide-angle, 217 DC (defocus control), 214 UV (ultraviolet), 216 DG, 212 UW (underwater), 216 Di (Digitally integrated), 212 VR (vibration reduction), 216 D-Series, 214 wide-angle and wide-zoom, 218-221 DX, 214 Z-mount, 203-209 E designation, 214-215 zoom, 230-231 ED (extra-low dispersion/LD/UD), 215 zoom vs. prime, 216-217 ED AF-S VR, 230, 235 light. See also CLS (Creative Lighting System); ED AF-S VR II, 232 continuous lighting vs. electronic flash ED AF-S wide angle, 229 availability, 239-244 ED VR, 236 color rendering, 246 ED VR AF-S wide angle, 229 color temperature, 244-247 fine-tuning focus, 149–156 daylight, 247-248 FL AF-S ED VR, 236 and exposure, 74–77 FL ED VR, 236 fluorescent/LEDs, 249–250 F-mount, 198-199 incandescent, 262 incandescent/tungsten/halogen, 248-249

light meter, Manual exposure, 97	Manual flash mode, 263
light meters, calibration, 81	manual focus. See also focus
light modifiers, 279-280	vs. autofocus, 129–130
light source, distance from subject, 261	benefits and problems, 122-123
light stands, using, 253	pulling and pushing focus, 486-487
light trails, producing, 169	setting, 133, 142–146
lighting	master flash
accessories, 251–254	disabling, 298
styles, 498	explained, 286
for video, 496–498	settings, 293–302
lighting ratios, wireless flash, 287, 291-293	using, 287–289
Li-ion EN-EL15b battery. See batteries	Matrix metering, 83-85, 360, 416
Limit Monitor Mode Selection, Setup menu,	matrix metering, 26
435–436	MB-N10
Load Settings option, Setup menu, 447	grip mounting holes, 68
Location Data, Setup menu, 444	multi-power battery pack, 8
locking	MC-DC2 remote control cable, 7
exposure, 89, 148	medium shot, 495-496
flash sync, 408	Melancholic Picture Control, 347
focus points, Spot metering, 135	memory card access lamp, 57-58
shutter speeds, 420	memory card door, 52
Long Exp. NR option. See also noise reduction	memory cards. See also CFexpress cards; XQD
Photo Shooting menu, 354-355	memory cards
recommendations, 35-36	adding on, 5
long exposures, 97-98, 166-169. See also	formatting, 20, 430–431
exposure	G-series, 10
long lenses, 235-236	inserting, 19
lossless compression, NEF (RAW) Recording,	SanDisk, 10
329	video, 464
low-contrast images, 113	MENU button, 11, 57–58
low-light autofocus, 132	menus
"low-speed" shooting mode, 22	navigating, 304–306
Lume Cube, 249–250	recommendations for settings, 32-34
	Merge to HDR and bracketing, 107–110
M	metering
	button, 417
M (Manual) mode, 25, 96–98	mid-tones, 80-81
M: Manual flash, 282	with older lenses, 96
macro lenses, 237–238	metering methods
macro photography, A (Aperture-priority) mode,	choosing, 25–26, 82–89
92	explained, 82
magnification, changing, 29, 143	Metering option
main command dial, 55–56	Movie Shooting menu, 374–375
Manage Picture Control option, Movie Shooting menu, 348–349, 372–373	Photo Shooting menu, 360

Metering/Exposure (b1-b4) recommendations, Movie Quality, 371 38, 44. See also exposure Reset Movie Shooting Menu, 368-369 methods vs. modes, 82 recommendations, 34 micro lenses, 215 resetting, 32 microphones, using, 53, 376, 471, 499-502 Set Picture Control, 372 mid-tones, metering, 80-81 Timecode, 377-378 midtones, tones in histograms, 117 using, 423-428, 466-472 mode dial, 25, 65-66 Vibration Reduction, 376 modeling light, 256 Vignette Control, 373 modes vs. methods, 82 White Balance, 372 monitor. See LCD monitor Wind Noise Reduction, 377 Monitor Brightness, Setup menu, 433 movie stills, continuous shooting, 161 Monitor Color Balance, Setup menu, 434 movies. See also video monitor mode functions, 425 button, 55-56 returning to shooting mode, 476 limiting selection, 435-436 shooting, 24, 473-474 monitor/recorder, Atomos Ninja V, 482 Slo-Mo playback, 476 Monochrome Picture Control, editing, 343-344 slow-motion, 472 Morning Picture Control, 346 time lapse options, 173, 176-177, 472 mounting lenses, 17-18 trimming, 459, 476, 478-479 Movie button, 66-67 viewing, 477 Movie File Type, 369, 371 viewing menus, 476 Movie Quality option, 369, 371 moving back and forth, 60 Movie Shooting menu options moving forward/backspacing, 320 Active D-Lighting, 373 multi selector, 11-12, 57-58, 418 AF-Area Mode, 375 multi selector center (OK) button, 11-12 Attenuator, 377 multiple exposures, 177-179, 317, 363-364, 417. Auto Distortion Control, 374 See also exposure Choose Image Area, 370 My Menu, using, 417, 460-462 default values, 369 Diffraction Compensation, 374 N Electronic VR, 376 N (Nano Crystal Coat) lenses, 215 File Naming, 369 NAI (Not-AI) lenses, 216 Flicker Reduction, 374 Nano Crystal Coat, 204 Focus Mode, 375 neck strap, AN-DC19, 4-5 Frame Size/Frame Rate, 371 NEF (RAW) Frequency Response, 377 adding, 417 Headphone Volume, 377 buffer capacity, 159 High ISO NR, 373 data, 102-103 ISO Sensitivity Settings, 371–372 image quality options, 322 Manage Picture Control, 372-373 memory cards, 6 Metering, 374-375 recording options, 35-36, 316, 328-330 Microphone Sensitivity, 376 Retouch menu, 452-453 Movie File Type, 371

Network Guide, 189	PC/X connector, electronic flash, 256
neutral-density filters, 85	PDAF (phase detection autofocus), 123-124
Nikon	Peak options, using with focus, 143
Commander modes, 294–300	peaking highlights button, 418
Capture software, 7	Perspective Control, Retouch menu, 458
GP-1a accessory, 180-182	perspective distortion, 218-219
Guides website, 154	phase detection AF, 124–127, 466
SB external flash units, 275-279	Photo Data displays, using, 63-65
SU-800 optical commander, 287-289	photo information displays, 69
WR-R10 master controller, 288	Photo Shooting menu options
N-log capture, 466	Active D-Lighting, 352-354
NOCT (Nocturne) lenses, 216	AF-Area Mode, 361
noise, dealing with, 99–100	Auto Bracketing, 362
Noise Ninja website, 100	Auto Distortion Control, 359
noise reduction, information display, 65. See	Choose Image Area, 321-322
also High ISO NR option; ISO noise;	Color Space, 349-352
Long Exp. NR option; wind noise	Diffraction Compensation, 356-358
reduction	File Naming, 320-321
non-CPU lens data, 418, 438–439	Flash Compensation, 361
normal lenses, 217, 231–237	Flash Control, 360
	Flash Mode, 360
0	Flicker Reduction Shooting, 359
	Focus Mode, 361
OIS (optical image stabilization), 213 OK button	Focus Shift Shooting, 367
	HDR (High Dynamic Range), 364-365
Controls entry, 420	High ISO NR, 355-356
description, 12, 58	Image Quality, 322-327
location, 11, 57	Image Size, 327
movies, 426	Interval Timer Shooting, 365–366
Opanda iExif utility, 404	ISO Sensitivity Settings, 330–332
outdoor lighting, 498	Long Exposure NR, 354–355
output range, external recorder, 485	Manage Picture Control, 348-349
over shoulder shot, 495–496	Metering, 360
overexposure, 80	Multiple Exposure, 363–364
Overlay Shooting, 70	NEF (RAW) Recording, 328–330
overview data screen, 64–65	recommendations, 33-36
	Reset Photo Shooting Menu, 315-317
P	resetting, 32
P (Program) mode, 24, 94–96	Set Picture Control, 338–347
panning subjects, rolling shutter, 490–491	Silent Photography, 367
pausing movies, 476	Storage Folder, 317–320
PC (Perspective Control) lenses, 216	Time-Lapse Movie, 366–367
PC Micro-Nikkor lenses, 238	Vibration Reduction, 362
PC-E ED Micro Nikkor lenses, 237	Vignette Control, 356
PC-F Micro Nikkor lenses 237	White Balance, 332–338

Photo shooting mode, touch screen, 13	polarizing filters, 85
photo/movie selector, 55	Pop Picture Control, 346
photos. See also images	port covers, 53
comparing side by side, 459–460 transferring to computers, 30–34	portrait photography, A (Aperture-priority) mode, 92
Picture Controls	power connector cover, 50–51
adjustments, 64	power switch, 66
choosing, 338–340	prefocusing, 187. See also focus
editing, 340–347	prime vs. zoom lenses, 216–217
with i menu, 342	programmed auto, 25
managing, 348–349	ProPhoto RGB color space, 350
setting, 417	Protect button, 417
setting and managing, 372–373	Pure Picture Control, 347
super sharpness, 342–343	Tute Ficture Control, 34/
pictures. See images; photos	D
pinch/stretch gesture, 13	R
Pink Picture Control, 347	radio control, flashes, 301-302
Pinpoint AF mode, 133–134	radio transmitter/receiver, electronic flash, 257
pitch, VR (vibration reduction), 211	Rating option, Playback menu, 313-314
pixel binning, video capture, 488	RAW data
playback	and NEF files, 102-103
canceling, 60	vs. JPEG, 325-327, 351
exiting, 476	rear-curtain sync, 257-258, 265, 267, 360
Playback button, 54–55, 417	rechargeable Li-ion En-EL15b battery. See
Playback Display Options option, Playback	batteries
menu, 308–309	recommendations for controls, 419-420
Playback Folder option, 59, 307–308	Red Picture Control, 347
Playback menu options	Red-Eye Correction, Retouch menu, 456-457
After Burst, Show, 311	red-eye reduction, 265–266
After Delete, 310	Red-eye reduction, 50-51, 360
Delete, 306–307	release modes, selecting, 21, 57, 59
Image Review, 309	release-priority, 27, 147
Playback Display Options, 308–309	remote control cable, MC-DC2, 7
Playback Folder, 307–308	remote flashes, 286, 290
Rating, 313–314	remote modes, setting, 300-301
Rotate Tall, 311–312	Reset All Settings, Setup menu, 449
	Reset Movie Shooting Menu option, Movie
Slide Show, 312–313	Shooting menu, 368–369
Playback mode	Reset Photo Shooting Menu option, Photo
button, 29	Shooting menu, 315–317
<i>i</i> button, 57–58	Reset User Settings, Setup menu, 432
touch screen, 12	resetting camera, 31-32
playing back images, 59–65	Resize, Retouch menu, 455
PocketWizard transmitters/receivers, 289	

Retouch menu options	Self-Timer
Distortion Control, 457	Custom Settings menu, 397
D-Lighting, 456	delayed exposures, 170
Image Overlay, 458–459	shooting mode, 23
layout, 450-451	Self-timer lamp, 50-51
NEF (RAW) Processing, 452–453	sensors. See also BSI (back-side illuminated)
Perspective Control, 458	sensor
Red-Eye Correction, 456–457	BSI (back-side illuminated), 71–72
Resize, 455	full-frame vs. cropped, 200-203
Side-by-Side Comparison, 459-460	video, 489
Straighten, 457	Sepia Picture Control, 347
Trim, 453–455	Series E lenses, FTZ adapter, 212
Trim Movie, 459	Set Picture Control
retouching information display, 65	button, 417
reviewing images, 29-30, 59	Movie menu values, 369
rewinding movies, 476	Movie Shooting menu, 372
RGB (red, green, blue)	Photo Shooting menu, 338-347
color space, 349–352	recommendations, 35-36
histogram, 64, 117–118	settings, resetting, 449
roll, VR (vibration reduction), 210–211	Setup menu options
rolling shutter, 490-491	AF Fine-Tune, 437–438
Rolls MX124 portable mixer, 499	Airplane Mode, 446
Rotate Tall option, Playback menu, 311-312	Assign Remote (WR) Fn Button, 446
RPT: Repeating flash, 282-284	Battery Info, 447
	Beep Options, 441
S	Clean Image Sensor, 439
	Conformity Marking, 447
S (Shutter-priority) mode	Connect to PC, 447
equivalent exposure, 78	Connect to Smart Device, 446
selecting, 24	Control Panel Brightness, 435
using, 93–94	Copyright Information, 441
SanDisk memory cards, 10	Firmware Version, 449
Save User Settings, Setup menu, 431	Format Memory Card, 430–431
Save/Load Settings, Setup menu, 448–449	HDMI, 442–443
SB external flash units, 275-279, 294-300. See	Image Comment, 440–441
also Speedlights	Image Dust Off Ref Photo, 440
SC-28 and SC-29 TTL flash cords, 9	Information Display, 436–437
selecting	Language, 432
exposure modes, 24–25	Limit Monitor Mode Selection, 435-436
focus area modes, 28–30	Location Data, 444
focus modes, 27	Monitor Brightness, 433
metering modes, 25–26	Monitor Color Balance, 434
release modes, 21	Non-CPU Lens Data, 438–439 recommendations, 34
	Reset All Settings, 449

Reset User Settings, 432	slow-motion movies, 472
Save User Settings, 431	smart devices, connecting to, 446
Save/Load Settings, 448-449	SnapBridge feature, 23, 189–196
Slot Empty Release Lock, 448	snoots and barn doors, 254
Time Zone and Date, 432–433	soft boxes, using for lighting, 252
Touch Controls, 442	software, 7
Viewfinder Brightness, 434	Somber Picture Control, 346
Viewfinder Color Balance, 435	Sony's G-series memory cards, 10
Wireless Remote (WR) Options, 445	sound quality, video, 464. See also audio tips
Wireless Transmitter (WT-7), 447	speaker, locating, 66
shadows, tones in histograms, 117	Speedlights. See also flash; SB external flash
sharpness, A (Aperture-priority) mode, 92	units
Shooting data screens, 64	adding on, 7
shooting modes, 22-23	stand, 280
shooting movies, 24	unified flash control system, 274
shooting script, using, 491-492	using, 275–279
shooting/display (d1-d11) recommendations, 39,	spherical aberration, 225
45	split-color filters, 85
Shooting/Display options, 398–406	Split-screen Display Zoom, 144-146. See also
short exposures, 163-165. See also exposure	LCD monitor
short telephoto lenses, 217	sports action
shots remaining, determining, 404	freezing, 161–163
shutter release button, 52, 66	shooting, 399
shutter speeds. See also flash shutter speed; focal	Spot metering, 26, 86–88, 360, 416
plane shutter; high-speed photography	sRGB color space, 349–352
button, 418	stage performances, shooting, 94, 310
exposure triangle, 75	steady cam, 220
and f/stops, 77	stepping motor technology, 204
locking, 420	stereo microphones, 66
Manual exposure, 97	stills, taking, 463–464
selecting, 475–477	stops
Side-by-Side Comparison, Retouch menu,	choosing number of, 108
459–460	vs. f/stops, 78
Silence Picture Control, 346	Storage Folder option, Photo Shooting menu,
Silent Photography option, Photo Shooting	316–320
menu, 367	Store Points by Orientation, 141
Single frame shooting mode, 22	storyboards, using, 492
Single-point AF mode, 134–135	storytelling in video, 493
Single-servo autofocus (AF-S), 27, 132	Straighten, Retouch menu, 457
slave connection, electronic flash, 257	streaks, creating, 169
slide gesture, 13–14	stretch/pinch gesture, 13
Slide Show option, Playback menu, 312–313	studio work
Slot Empty Release Lock, Setup menu, 448	electronic flash, 255
slow sync modes, 266	Manual exposure, 97

SU-800 optical commander, Nikon, 287–289	trimming movies, 478-479
sub-command dial, 22, 50-51	tripods, using, 68, 211, 490–491
Subject-tracking autofocus, 139–140	TTL flash modes, 263
sub-selector button, 11–12, 57, 416–418	tungsten light, 248-249
sub-selector button, default values, 416–418	two shot, 495-496
Sunday Picture Control, 346	
super-telephoto lenses, 217	11
Sync. release selection button, 417	U
sync speed problems, avoiding, 268–269	UHD (Ultra High Definition) video capture,
sync speed problems, avoiding, 200-207	465
_	ultra-wide-angle lenses, 217
T	umbrellas, using for lighting, 251–252
Tamron lenses, 212	underexposure, 80
tap gesture, 13–14	unified flash control, 260
telephoto lenses, 217, 222–226, 231–237	UPstrap, 4-5
tele-zoom lenses, 222–226	USB
tents, using for lighting, 253	3.0 Promoter Group, 10
text, entering, 319	HDMI cable clip, 4
three-point lighting, 498	cable UC-E24, 3
thumbnail images, viewing, 59, 61-62	connector, 53
TIF (RGB)	port, 30
buffer capacity, 159	user settings
image quality options, 322-323	identifying, 25
time exposures, 167	resetting, 432
Time Zone and Date, Setup menu, 432–433	saving, 431
timecode, 377-378, 466, 472	user's manuals, 5
timed exposures, 166	UV (ultraviolet) lenses, 216
Time-Lapse Movie options, Photo Shooting	UW (underwater) lenses, 216
menu, 366-367, 472	
time-lapse photography, 171–173, 176–177	V
timers/AE Lock (c1-c3) recommendations, 39,	-
44	vertical shapes, aligning, 70
Timers/AE Lock options, 396-398	Vibration Reduction option
tonal range, adjusting, 111–113	Movie Shooting menu, 376
toning vs. filters, 344-345	Photo Shooting menu, 362
top of camera, 65-67	video. See also movies
Touch Controls, Setup menu, 442	capture modes, 488
touch screen, 12-15. See also LCD monitor	capturing, 466–472
Toy Picture Control, 347	Frame Size/Frame Rate, 468–469
transfer bit rate, explained, 483	<i>i</i> button, 474–475
trap focus, 187-189. See also action; autofocus	sensors, 489
Trash button, 54-55	slow motion, 465
Trim, Retouch menu, 453-455	tips, 463–465
Trim Movie, Retouch menu, 459	video recorder, output to, 466

autofocus modes, 486–487 composition, 493–496 external recorder, 482–486 lenses, 487–489 lighting, 496–498 shooting script, 491–492 storyboards, 492 storytelling, 493 tripods, 490–491 zooming, 489–490 viewfinder color balance, 435 brightness, 434 diopter correction, 19 eyepiece/window, 54–55 monitor displays, 69–70 switching to LCD monitor, 21 Vignette Control option Movie menu values, 369 Movie Shooting menu, 373 Photo Shooting menu, 373 Photo Shooting menu, 376 vignetting, 201–202 virtual horizon display, 70 Vocal Range, 502 volume, changing for movies, 476 VR (vibration reduction). See also electronic VR option built in, 209–211 continuous shooting, 158 information display, 64 lenses, 216
composition, 493–496 external recorder, 482–486 lenses, 487–489 lighting, 496–498 shooting script, 491–492 storyboards, 492 storytelling, 493 tripods, 490–491 zooming, 489–490 viewfinder color balance, 435 brightness, 434 diopter correction, 19 eyepiece/window, 54–55 monitor displays, 69–70 switching to LCD monitor, 21 Vignette Control option Movie menu values, 369 Movie Shooting menu, 373 Photo Shooting menu, 356 vignetting, 201–202 virtual horizon display, 70 Vocal Range, 502 volume, changing for movies, 476 VR (vibration reduction). See also electronic VR option built in, 209–211 continuous shooting, 158 information display, 64 CombineZP, 187 Datacolor color correction, 352 Datacolor color calls ExpoDisc filter/caps, 245 F-mount lenses, 199 Godox X-series wireless products, 289 Graphic Converter, 404 Helicon Focus, 187 Nature Photograph, 226 Nikon Gear, 226 Vikon Gear, 226 Vik
external recorder, 482–486 lenses, 487–489 lighting, 496–498 shooting script, 491–492 storyboards, 492 storyboards, 492 storytelling, 493 tripods, 490–491 zooming, 489–490 viewfinder color balance, 435 brightness, 434 diopter correction, 19 eyepiece/window, 54–55 monitor displays, 69–70 switching to LCD monitor, 21 Vignette Control option Movie menu values, 369 Movie Shooting menu, 373 Photo Shooting menu, 376 vignetting, 201–202 virtual horizon display, 70 Vocal Range, 502 volume, changing for movies, 476 VR (vibration reduction). See also electronic VR option built in, 209–211 continuous shooting, 158 information display, 64 Datacolor color correction, 352 ExpoDisc filter/caps, 245 F-mount lenses, 199 Godox X-series wireless products, 289 GraphicConverter, 404 Helicon Focus, 187 lens conversion, 213 Nature Photograph, 226 Nikon Guides, 154 Noise Ninja, 100 Opanda iExif, 404 PhotoAcute, 187 PocketWizard transmitters/receivers, 289 registration card, 5 Rolls MX124 portable mixer, 499 Rørslett, Bjørn, 226 UPstrap, 5 White, John lens conversion, 213 wide-arge lenses, using, 218–221 Wide-arge AF, 136 wide-zoom lenses, using, 228–230 Wide-area AF, 136 wide-zoom lenses, using, 218–221 Wi-Fi computer connections, 189
lenses, 487–489 lighting, 496–498 shooting script, 491–492 storyboards, 492 storytelling, 493 tripods, 490–491 zooming, 489–490 viewfinder color balance, 435 brightness, 434 diopter correction, 19 eyepiece/window, 54–55 monitor displays, 69–70 switching to LCD monitor, 21 Vignette Control option Movie menu values, 369 Movie Shooting menu, 373 Photo Shooting menu, 375 Pocal Range, 502 volume, changing for movies, 476 VR (vibration reduction). See also electronic VR option built in, 209–211 continuous shooting, 158 information display, 64 DPReview, 226 ExpoDisc filter/caps, 245 F-mount lenses, 199 Godox X-series wireless products, 289 Graphic Converter, 404 Helicon Focus, 187 lens conversion, 213 Nature Photograph, 226 Nikon Guides, 154 Noise Ninja, 100 Opanda iExif, 404 PhotoAcute, 187 PocketWizard transmitters/receivers, 289 registration card, 5 Rolls MX124 portable mixer, 499 Rørslett, Bjørn, 226 UPstrap, 5 White, John lens conversion, 213 wide angle lenses, using, 218–221 Wide-area AF, 136 wide-area AF, 136 wide-zoom lenses, using, 218–221 Wi-Fi computer connections, 189
lighting, 496–498 shooting script, 491–492 storyboards, 492 storytelling, 493 tripods, 490–491 zooming, 489–490 viewfinder color balance, 435 brightness, 434 diopter correction, 19 eyepiece/window, 54–55 monitor displays, 69–70 switching to LCD monitor, 21 Vignette Control option Movie menu values, 369 Movie Shooting menu, 373 Photo Shooting menu, 356 vignetting, 201–202 virtual horizon display, 70 Vocal Range, 502 volume, changing for movies, 476 VR (vibration reduction). See also electronic VR option built in, 209–211 continuous shooting, 158 information display, 64 ExpoDisc filter/caps, 245 F-mount lenses, 199 Godox X-series wireless products, 289 Graphic Converter, 404 Helicon Focus, 187 lens conversion, 213 Nature Photograph, 226 Nikon Gear, 226 Nikon Guides, 154 Noise Ninja, 100 Opanda iExif, 404 PhotoAcute, 187 PocketWizard transmitters/receivers, 289 registration card, 5 Rolls MX124 portable mixer, 499 Rørslett, Bjørn, 226 UPstrap, 5 White, John lens conversion, 213 wide angle lenses, using, 218–221 Wide-area AF, 136 wide-zoom lenses, using, 218–221 Wi-Fi computer connections, 189
shooting script, 491–492 storyboards, 492 storyboards, 492 storytelling, 493 tripods, 490–491 zooming, 489–490 viewfinder color balance, 435 brightness, 434 diopter correction, 19 eyepiece/window, 54–55 monitor displays, 69–70 switching to LCD monitor, 21 Vignette Control option Movie menu values, 369 Movie Shooting menu, 373 Photo Shooting menu, 356 vignetting, 201–202 virtual horizon display, 70 Vocal Range, 502 volume, changing for movies, 476 VR (vibration reduction). See also electronic VR option built in, 209–211 continuous shooting, 158 information display, 64 F-mount lenses, 199 Godox X-series wireless products, 289 GraphicConverter, 404 Helicon Focus, 187 lens conversion, 213 Nature Photograph, 226 Nikon Gear, 226 Nikon Guides, 154 Noise Ninja, 100 Opanda iExif, 404 PhotoAcute, 187 PocketWizard transmitters/receivers, 289 registration card, 5 Rolls MX124 portable mixer, 499 Rørslett, Bjørn, 226 UPstrap, 5 White, John lens conversion, 213 wide angle lenses, using, 218–221 Wide-area AF, 136 wide-area AF, 136 wide-zoom lenses, using, 218–221 Wi-Fi computer connections, 189
storyboards, 492 storytelling, 493 tripods, 490–491 zooming, 489–490 viewfinder color balance, 435 brightness, 434 diopter correction, 19 eyepiece/window, 54–55 monitor displays, 69–70 switching to LCD monitor, 21 Vignette Control option Movie menu values, 369 Movie Shooting menu, 373 Photo Shooting menu, 356 vignetting, 201–202 virtual horizon display, 70 Vocal Range, 502 volume, changing for movies, 476 VR (vibration reduction). See also electronic VR option built in, 209–211 continuous shooting, 158 information display, 64 Godox X-series wireless products, 289 GraphicConverter, 404 Helicon Focus, 187 lens conversion, 213 Nature Photograph, 226 Nikon Gear, 226 Nikon Guides, 154 Noise Ninja, 100 Opanda iExif, 404 PhotoAcute, 187 PocketWizard transmitters/receivers, 289 registration card, 5 Rolls MX124 portable mixer, 499 Rørslett, Bjørn, 226 UPstrap, 5 White, John lens conversion, 213 wide angle lenses, using, 218–221 Wide-area AF, 136 wide-area AF, 136 wide-area AF, 136 wide-zoom lenses, using, 218–221 Wi-Fi computer connections, 189
storytelling, 493 tripods, 490–491 zooming, 489–490 viewfinder color balance, 435 brightness, 434 diopter correction, 19 eyepiece/window, 54–55 monitor displays, 69–70 switching to LCD monitor, 21 Vignette Control option Movie menu values, 369 Movie Shooting menu, 373 Photo Shooting menu, 356 vignetting, 201–202 virtual horizon display, 70 Vocal Range, 502 volume, changing for movies, 476 VR (vibration reduction). See also electronic VR option built in, 209–211 continuous shooting, 158 information display, 64 GraphicConverter, 404 Helicon Focus, 187 lens conversion, 213 Nature Photograph, 226 Nikon Guides, 154 Noise Ninja, 100 Opanda iExif, 404 PhotoAcute, 187 PocketWizard transmitters/receivers, 289 registration card, 5 Rolls MX124 portable mixer, 499 Rørslett, Bjørn, 226 UPstrap, 5 White, John lens conversion, 213 wide angle lenses, using, 218–221 Wide-area AF, 136 wide-area AF, 136 wide-zoom lenses, using, 218–221 Wi-Fi computer connections, 189 using 194, 106
tripods, 490–491 zooming, 489–490 viewfinder color balance, 435 brightness, 434 diopter correction, 19 eyepiece/window, 54–55 monitor displays, 69–70 switching to LCD monitor, 21 Vignette Control option Movie Shooting menu, 373 Photo Shooting menu, 356 vignetting, 201–202 virtual horizon display, 70 Vocal Range, 502 volume, changing for movies, 476 VR (vibration reduction). See also electronic VR option built in, 209–211 continuous shooting, 158 information display, 64 Helicon Focus, 187 lens conversion, 213 Nature Photograph, 226 Nikon Guides, 154 Noise Ninja, 100 Opanda iExif, 404 PhotoAcute, 187 PocketWizard transmitters/receivers, 289 registration card, 5 Rolls MX124 portable mixer, 499 Rørslett, Bjørn, 226 UPstrap, 5 White, John lens conversion, 213 wide angle lenses, using, 218–221 Wide-area AF, 136 wide-area AF, 136 wide-zoom lenses, using, 218–221 Wi-Fi computer connections, 189
viewfinder color balance, 435 brightness, 434 diopter correction, 19 eyepiece/window, 54–55 monitor displays, 69–70 switching to LCD monitor, 21 Vignette Control option Movie Movie Shooting menu, 373 Photo Shooting menu, 356 vignetting, 201–202 virtual horizon display, 70 Vocal Range, 502 volume, changing for movies, 476 VR (vibration reduction). See also electronic VR option built in, 209–211 continuous shooting, 158 information display, 64 lens conversion, 213 Nature Photograph, 226 Nikon Gear, 226 Nikon Guides, 154 Noise Ninja, 100 Opanda iExif, 404 PhotoAcute, 187 PocketWizard transmitters/receivers, 289 registration card, 5 Rolls MX124 portable mixer, 499 Rørslett, Bjørn, 226 UPstrap, 5 White, John lens conversion, 213 wide angle lenses, using, 218–221 Wide-area AF, 136 wide-area AF, 136 wide-zoom lenses, using, 218–221 Wi-Fi computer connections, 189
viewfinder color balance, 435 brightness, 434 diopter correction, 19 eyepiece/window, 54–55 monitor displays, 69–70 switching to LCD monitor, 21 Vignette Control option Movie menu values, 369 Movie Shooting menu, 373 Photo Shooting menu, 356 vignetting, 201–202 virtual horizon display, 70 Vocal Range, 502 volume, changing for movies, 476 VR (vibration reduction). See also electronic VR option built in, 209–211 continuous shooting, 158 information display, 64 Nature Photograph, 226 Nikon Guides, 154 Noise Ninja, 100 Opanda iExif, 404 PhotoAcute, 187 PocketWizard transmitters/receivers, 289 registration card, 5 Rolls MX124 portable mixer, 499 Rørslett, Bjørn, 226 UPstrap, 5 White, John lens conversion, 213 wide angle lenses, using, 218–221 Wide-area AF, 136 wide-area AF, 136 wide-area AF, 136 wide-zoom lenses, using, 218–221 Wi-Fi computer connections, 189
color balance, 435 brightness, 434 diopter correction, 19 eyepiece/window, 54–55 monitor displays, 69–70 switching to LCD monitor, 21 Vignette Control option Movie menu values, 369 Movie Shooting menu, 373 Photo Shooting menu, 356 vignetting, 201–202 virtual horizon display, 70 Vocal Range, 502 volume, changing for movies, 476 VR (vibration reduction). See also electronic VR option built in, 209–211 continuous shooting, 158 information display, 64 Nikon Guides, 154 Noise Ninja, 100 Opanda iExif, 404 PhotoAcute, 187 PocketWizard transmitters/receivers, 289 registration card, 5 Rolls MX124 portable mixer, 499 Rørslett, Bjørn, 226 UPstrap, 5 White, John lens conversion, 213 wide angle lenses, using, 218–221 Wide frequency range, 502 wide-angle lenses, using, 228–230 Wide-area AF, 136 wide-zoom lenses, using, 218–221 Wi-Fi computer connections, 189
brightness, 434 diopter correction, 19 eyepiece/window, 54–55 monitor displays, 69–70 switching to LCD monitor, 21 Vignette Control option Movie menu values, 369 Movie Shooting menu, 373 Photo Shooting menu, 356 vignetting, 201–202 virtual horizon display, 70 Vocal Range, 502 volume, changing for movies, 476 VR (vibration reduction). See also electronic VR option built in, 209–211 continuous shooting, 158 information display, 64 Nikon Guides, 154 Noise Ninja, 100 Opanda iExif, 404 PhotoAcute, 187 PocketWizard transmitters/receivers, 289 registration card, 5 Rolls MX124 portable mixer, 499 Rørslett, Bjørn, 226 UPstrap, 5 White, John lens conversion, 213 wide angle lenses, using, 218–221 Wide frequency range, 502 wide-area AF, 136 wide-zoom lenses, using, 218–221 Wi-Fi computer connections, 189
diopter correction, 19 eyepiece/window, 54–55 monitor displays, 69–70 switching to LCD monitor, 21 Vignette Control option Movie menu values, 369 Movie Shooting menu, 373 Photo Shooting menu, 356 vignetting, 201–202 virtual horizon display, 70 Vocal Range, 502 volume, changing for movies, 476 VR (vibration reduction). See also electronic VR option built in, 209–211 continuous shooting, 158 information display, 64 Noise Ninja, 100 Opanda iExif, 404 PhotoAcute, 187 PocketWizard transmitters/receivers, 289 registration card, 5 Rolls MX124 portable mixer, 499 Rørslett, Bjørn, 226 UPstrap, 5 White, John lens conversion, 213 wide angle lenses, using, 218–221 Wide-angle lenses, using, 228–230 Wide-area AF, 136 wide-zoom lenses, using, 218–221 Wi-Fi computer connections, 189
eyepiece/window, 54–55 monitor displays, 69–70 switching to LCD monitor, 21 Vignette Control option Movie menu values, 369 Movie Shooting menu, 373 Photo Shooting menu, 356 vignetting, 201–202 virtual horizon display, 70 Vocal Range, 502 volume, changing for movies, 476 VR (vibration reduction). See also electronic VR option built in, 209–211 continuous shooting, 158 information display, 64 Opanda iExif, 404 PhotoAcute, 187 PocketWizard transmitters/receivers, 289 registration card, 5 Rolls MX124 portable mixer, 499 Rørslett, Bjørn, 226 UPstrap, 5 White, John lens conversion, 213 wide angle lenses, using, 218–221 Wide-area AF, 136 wide-area AF, 136 wide-zoom lenses, using, 218–221 Wi-Fi computer connections, 189
monitor displays, 69–70 switching to LCD monitor, 21 Vignette Control option Movie menu values, 369 Movie Shooting menu, 373 Photo Shooting menu, 356 vignetting, 201–202 virtual horizon display, 70 Vocal Range, 502 volume, changing for movies, 476 VR (vibration reduction). See also electronic VR option built in, 209–211 continuous shooting, 158 information display, 64 PhotoAcute, 187 PocketWizard transmitters/receivers, 289 registration card, 5 Rolls MX124 portable mixer, 499 Rørslett, Bjørn, 226 UPstrap, 5 White, John lens conversion, 213 wide angle lenses, using, 218–221 Wide-area AF, 136 wide-angle lenses, using, 228–230 Wide-area AF, 136 wide-zoom lenses, using, 218–221 Wi-Fi computer connections, 189
Vignette Control option Movie menu values, 369 Movie Shooting menu, 373 Photo Shooting menu, 356 vignetting, 201–202 virtual horizon display, 70 Vocal Range, 502 volume, changing for movies, 476 VR (vibration reduction). See also electronic VR option built in, 209–211 continuous shooting, 158 information display, 64 PocketWizard transmitters/receivers, 289 registration card, 5 Rolls MX124 portable mixer, 499 Rørslett, Bjørn, 226 UPstrap, 5 White, John lens conversion, 213 wide angle lenses, using, 218–221 Wide-area AF, 136 wide-area AF, 136 wide-zoom lenses, using, 218–221 Wi-Fi computer connections, 189
Movie menu values, 369 Movie Shooting menu, 373 Photo Shooting menu, 356 vignetting, 201–202 virtual horizon display, 70 Vocal Range, 502 volume, changing for movies, 476 VR (vibration reduction). See also electronic VR option built in, 209–211 continuous shooting, 158 information display, 64 registration card, 5 Rolls MX124 portable mixer, 499 Rørslett, Bjørn, 226 UPstrap, 5 White, John lens conversion, 213 wide angle lenses, using, 218–221 Wide frequency range, 502 wide-angle lenses, using, 228–230 Wide-area AF, 136 wide-zoom lenses, using, 218–221 Wi-Fi computer connections, 189
Movie Shooting menu, 373 Photo Shooting menu, 356 vignetting, 201–202 virtual horizon display, 70 Vocal Range, 502 volume, changing for movies, 476 VR (vibration reduction). See also electronic VR option built in, 209–211 continuous shooting, 158 information display, 64 Rolls MX124 portable mixer, 499 Rørslett, Bjørn, 226 UPstrap, 5 White, John lens conversion, 213 wide angle lenses, using, 218–221 Wide-angle lenses, using, 228–230 Wide-area AF, 136 wide-zoom lenses, using, 218–221 Wi-Fi computer connections, 189
Photo Shooting menu, 356 vignetting, 201–202 virtual horizon display, 70 Vocal Range, 502 volume, changing for movies, 476 VR (vibration reduction). See also electronic VR option built in, 209–211 continuous shooting, 158 information display, 64 Rørslett, Bjørn, 226 UPstrap, 5 White, John lens conversion, 213 wide angle lenses, using, 218–221 Wide-area AF, 136 wide-area AF, 136 wide-zoom lenses, using, 218–221 Wi-Fi computer connections, 189
vignetting, 201–202 virtual horizon display, 70 Vocal Range, 502 volume, changing for movies, 476 VR (vibration reduction). See also electronic VR option built in, 209–211 continuous shooting, 158 information display, 64 UPstrap, 5 White, John lens conversion, 213 wide angle lenses, using, 218–221 Wide frequency range, 502 wide-angle lenses, using, 228–230 Wide-area AF, 136 wide-zoom lenses, using, 218–221 Wi-Fi computer connections, 189
virtual horizon display, 70 Vocal Range, 502 volume, changing for movies, 476 VR (vibration reduction). See also electronic VR option built in, 209–211 continuous shooting, 158 information display, 64 White, John lens conversion, 213 wide angle lenses, using, 218–221 Wide-angle lenses, using, 228–230 Wide-area AF, 136 wide-zoom lenses, using, 218–221 Wi-Fi computer connections, 189
Vocal Range, 502 volume, changing for movies, 476 VR (vibration reduction). See also electronic VR option built in, 209–211 continuous shooting, 158 information display, 64 wide angle lenses, using, 218–221 Wide-angle lenses, using, 228–230 Wide-area AF, 136 wide-zoom lenses, using, 218–221 Wi-Fi computer connections, 189
volume, changing for movies, 476 VR (vibration reduction). See also electronic VR option built in, 209–211 continuous shooting, 158 information display, 64 Wide frequency range, 502 wide-angle lenses, using, 228–230 Wide-area AF, 136 wide-zoom lenses, using, 218–221 Wi-Fi computer connections, 189
VR (vibration reduction). See also electronic VR option built in, 209–211 continuous shooting, 158 information display, 64 wide-angle lenses, using, 228–230 Wide-area AF, 136 wide-zoom lenses, using, 218–221 Wi-Fi computer connections, 189
wide-area AF, 136 wide-zoom lenses, using, 218–221 continuous shooting, 158 information display, 64 Wide-area AF, 136 wide-zoom lenses, using, 218–221 Wi-Fi computer connections, 189
built in, 209–211 continuous shooting, 158 information display, 64 wide-zoom lenses, using, 218–221 Wi-Fi computer connections, 189
continuous shooting, 158 information display, 64 Wi-Fi computer connections, 189
information display, 64 computer connections, 189
using 104 106
wind noise reduction, 377, 472, 502. See also noise reduction
W wired and wireless external flash, 256
warranty and registration card, 5 wireless connectivity, 189–196
waterfalls, blurring, 168 wireless flash. See also electronic flash; external
WB (white balance) flash; flash
adjusting, 28–29 elements, 286–293
adjustment options, 245 lighting ratios, 291–293
bracketing, 102–103, 256 SB units, 296–297
button, 417 third-party solutions, 288–289
library, 338 triggering devices, 288
movies, 369, 372
Photo Shooting menu, 316, 332–338

settings, 35-36

Wireless Remote (WR) Options

Fn button, 446 release modes, 23 Setup menu, 445

Wireless Transmitter (WT-7), Setup menu, 447 WR-R10 master controller, 288, 301–302 WT-7 wireless transmitter, 447 WT-7a transmitter, 189

X

x axis, VR (vibration reduction), 210 XQD memory cards, 5–6, 9–10, 401, 464. *See* also memory cards

Y

y axis, VR (vibration reduction), 210 yaw, VR (vibration reduction), 211

Z

Zebra display, 427–428, 466
Z-mount lenses, choosing, 203–209
zoom coverage, external flash, 272
zoom heads, using, 281
Zoom In button, 29, 57–58
zoom lenses, 209, 216–217, 230–231
Zoom on/off button, 417
Zoom Out button, 29, 57, 59
zoom ring, 67–68
zooming

in and out, 59–61 video, 489–490

Z-series cameras, 198-199